Apparel Product Design and Merchandising Strategies

CYNTHIA L. REGAN, PH.D.
Professor
California State Polytechnic University Pomona

PEARSON
Prentice
Hall

UPPER SADDLE RIVER, NEW JERSEY 07458

Library of Congress Cataloging-in-Publication Data

Regan, Cynthia L.
 Apparel product design and merchandising strategies / Cynthia L. Regan.
 p. cm.
 ISBN–13: 978-0-13-119759-6
 ISBN–10: 0-13-119759-2
 1. Dressmaking-Pattern design. 2. Textile fabrics. 3. Clothing trade-Management. I. Title.
 TT520.R44 2007
 646.4'040688-dc22 2007017006

I would like to dedicate this book to Ron and Jan Regan and to the past, present, and future Cal Poly Pomona Apparel Merchandising and Management students.

Editor-in-Chief: Vernon R. Anthony
Editorial Assistant: Doug Greive
Acquisitions Editor: Jill Jones-Renger
Operations Specialist: Cathleen Petersen
Production Liaison: Janice Stangel
Production Editor: Sarvesh Mehrotra
Senior Marketing Manager: Leigh Ann Sims
Marketing Coordinator: Alicia Dysart
Marketing Assistant: Les Roberts
Senior Art Director: Miguel Ortiz
Image Credit: Cooperphoto/CORBIS
Cover Designer: Ruta Fiorino, Fruti Design
Director, Image Resource Center: Melinda Reo
Manager, Rights and Permissions: Zina Arabia
Manager, Visual Research: Beth Brenzel
Manager, Cover Visual Research & Permissions: Karen Sanatar
Image Permission Coordinator: Vickie Menanteaux

Pearson Education LTD., London
Pearson Education Singapore, Pte. Ltd
Pearson Education, Canada, Ltd
Pearson Education–Japan
Pearson Education Australia PTY, Limited
Pearson Education North Asia Ltd
Pearson Educación de Mexico, S.A. de C.V.
Pearson Education Malaysia, Pte. Ltd
Pearson Education, Upper Saddle River, New Jersey

10 9 8 7 6 5 4 3 2 1
ISBN-13: 978-0-13-119759-6
ISBN-10: 0-13-119759-2

Contents

2

Developing a Company Strategy 28

3 Developing Design and Business Goals 63

6 Searching for Design Solutions: Readily Accessible Inspirational Resources

7

Searching for Design Solutions: Inspirational Travel 205

10 Selecting and Developing Fabrics: The First Piece of the Merchandise Puzzle 325

11
Merchandising the Product Line: The Final Phase **369**

Preface

The goal of *Apparel Product Design and Merchandising Strategies* is to explain the product development process, the decisions made at early stages, and how to tie a company's business strategy into developed products. Ultimately, the reader will understand that astute decision making is the key to developing successful products. This book evolved from teaching design and merchandising strategies when my students requested that I write a product development book. I listened to the voice of my consumers and created a format that my students requested: A book that includes a story; a practical, understandable approach; and Web-enabled Activities.

Rare Designs is a fictitious apparel manufacturer that student focus groups helped me conceive. The book content details concepts and terms casually mentioned in Rare Designs' story. Each chapter contains numerous activities and quotes from industry professionals. The corresponding Web page and instructor resources enables readers to link to specific company Web sites and have electronic access to book activities. The capstone is a company project included in Chapters 2–13 that enables readers to fully synthesize the design and merchandising process.

Each chapter begins with the setting of Rare Designs, in which business partners Ron and Anne and their employees learn about the product development process. Rare Designs' name stands for Ron and Anne's Rebound to Excellence. This fictional company is typical of many upstart apparel companies that start small, grow fast, and ultimately lose control. The author based the characters' dialog on actual apparel industry associates' comments as a way of explaining textbook concepts. The format of a fictional vignette and factual text helps readers fully synthesize how product development associates communicate, and how apparel associates use industry terms, the environment, their decisions, and the product development process. Student reviewers commented that the ability to go back and forth between the fictional vignette and the text helped them fully understand concepts.

Chapter 1

Product development is a comprehensive process. Its environment and sequence of activities can be hard to grasp. Chapter 1 defines apparel product development and details nonlinear factors that create a chaotic product development environment. The purpose is for students to understand that companies need a strategic design plan.

Chapter 2

Design begins with a company's vision, mission, and business strategy. Apparel executives will tell you that design does not begin with a sketch; rather it begins with a company's vision of

how they project what makes them unique from their competition. Executives implement their vision in their mission statement. Starting with Chapter 2, the text has a company project in which readers create a fictitious company and develop a product line. The Company project starts with the development of a business strategy in which students write a company description, vision, and mission statements. Shabby Chic is one student project example.

> Shabby Chic's vision is to become a leading brand name in the loungewear market, by earning our customers' trust through quality, as well as reliability. Our mission at Shabby Chic is to provide our customers with *quality* loungewear that is *fashionable, versatile,* and above all *comfortable* for years to come. We strive to include those subtle details that our consumers want and love in our garments. (A. Flanagan, Shabby Chic business strategy project, California State Polytechnic University, Pomona).

Chapter 3

Chapter 3 focuses on how apparel companies compete. To be successful, company executives must research their competition and understand their retail customers' strategy. The text explains how companies research primary data, create fashion reports, and analyze secondary data such as demographics. In the company project, such as Shabby Chic, readers conduct a demographic analysis of a potential retail customer (i.e., store) and write a fashion report about their target consumer interests. Readers understand that they need to match attributes, such as quality features, to design superior projects.

Chapter 4

A design associate makes numerous decisions to take a product from design conception through preproduction. The ultimate success of any apparel product line is dependent on precise coordination and excellent timing. Chapter 4 introduces a time and action calendar template. In each subsequent chapter, readers add activities to the time-and-action

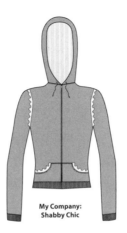
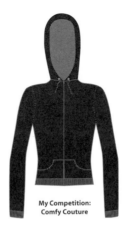

My Company:
Shabby Chic

My Competition:
Comfy Couture

Chapter 3 discusses understanding consumers and researching the competition, exemplified by Shabby Chic's comparison of a competitive garment. *(Illustrated by A. Flanagan.)*

calendar that corresponds to the chapter. By completing the time and action calendar, readers understand activity constraints in which they need to complete some activities before starting a new one. Sam Lim, Senior Partner of American Apparel notes that time efficiency is the only way American manufacturers can compete: "At American Apparel, we control production time by being vertical; thus, if there is an emergency order, we can cut, sew, and ship within 48 hours"*. For this process to occur, the design team must have the design developed, pattern created, samples tested and approved, and fabrics and findings available.

Chapter 5

Some individuals do not understand nor give the appropriate recognition to the importance of design. They will say, "No one designs anymore; apparel companies simply copy each other and then merchandise products." This incorrect perception is often due to an individual not understanding creativity. Successful apparel companies have a very specific design strategy that creative individuals use to beat their competition. While some

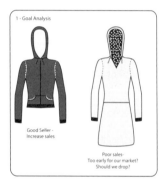
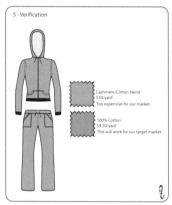

The design process is a conceptual framework that guides designers' decisions. *(Illustrated by A. Flanagan.)*

*Reprinted by permission from Sam Lim, senior partner, American Apparel, Los Angeles, CA; pers. comm., May 13, 2005.

apparel companies' strategies are fast fashion in which they do knockoff designs, many companies recognize that they achieve a strategic advantage by designing unique products. Chapter 5 introduces design thinking and process: two conceptual frameworks of creative thought and how ideas become actual designs. Design process includes actions that product development associates undergo to complete activities. This process incorporates goal analysis, problem analysis, search for these chapters detail solutions, decision making, and verification. Design thinking is the mental process an individual goes through when visualizing design. It is the essence of creativity.

Chapters 6 and 7

Chapters 6 and 7 explore design inspiration and expand on design thinking and process. Design thinking is a conceptual framework from creativity research and is intangible because a designer's output is *decisions* rather than producing a physical product. The information presented in the chapters detail how creativity occurs in an individual's brain. Chapter 6 focuses on readily accessible inspiration in or near a designer's office. Chapter 7 explores inspirational travel and further develops the reader's design thinking process.

Chapter 8

During decision making, designers and merchandisers work closely with multiple suppliers. Chapter 8 describes the wealth of available resources in apparel clusters. Designers finalize the search-for-design stage by creating theme boards. Students learn how designers focus on strategic advantage by incorporating words from their mission statement into the theme board project. For instance, in the Shabby Chic project, the student's mission statement highlighted the terms *quality, fashionable, versatile,* and *comfortable.* The student linked to comfort by developing a seasonal theme titled *Soft and Sweet.* Once designers establish themes, they involve many apparel industry associates, suppliers, and customers to evaluate and make design decisions. They shop apparel clusters to meet with suppliers and shop for resources. Designers shop specifically for colors, fabrics, and trims that tie into their theme.

Chapters 9 and 10

Chapter 9 is the beginning of merchandising the product line. Line merchandising continues through Chapter 12. An important part of this phase is that suppliers are hard at work assisting design and merchandising associates. We describe the suppliers' activities and their processes. For instance, in our Shabby Chic project example, *Blossom* is made of three different fabrications: a French terry, a cotton jersey hood lining, and 18/1 rib in eight different colors and prints.

Chapter 9 focuses on color selection and development. Merchandisers analyze an SBU's business history to determine color and fabric product assortments. Fabric development, the focus of Chapter 10, is a subdevelopment process in which textile companies develop, dye, and produce fabrics. Good communication and partnership agreements among the design team and suppliers is vital to success, especially with global textile development.

Selection of colors, fabrics, and illustrating garments.

Chapters 9–11 detail how designers and merchandisers work closely with suppliers to acquire raw materials and to develop garment illustrations. *(Illustrated by A. Flanagan.)*

Chapter 11

Chapter 11 details how merchandisers determine price tiers and develop product line definitions. They provide this information to designers which helps them develop garment styles for a product line. Chapter 11 explains design strategy in which a designer creates core, reorderable, and fashion-forward garment styles. A successful company takes a stance and conveys its unique niche. Designers interpret adjectives and other descriptive phrases in the company's mission to project their image. For instance, in our Shabby Chic's project example, the designer interpreted *fashionable*, *versatile*, and *comfortable* loungewear from the company mission statement. The figure on the next page shows *fashion* in the use of prints inside a hood and a flattering fit. The garments are *versatile* in colors selected, and the design can go with other knit tops, skirts, or pants. The fabrics selected give ambiance and actual tactile *comfort*.

Chapter 12

The development of storyboards and line sheets represents the culmination of the design process. Designers work with CAD artists and pattern makers to pull together the product line. Chapter 12 explains how designers create storyboards and line sheets. During this time, designers also work with first pattern makers to create patterns and prototypes.

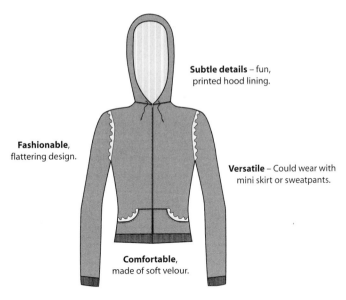

Subtle details – fun, printed hood lining.

Fashionable, flattering design.

Versatile – Could wear with mini skirt or sweatpants.

Comfortable, made of soft velour.

Apparel designers translate into product features from their company's vision and mission statements into products designed. *(Illustrated by A. Flanagan.)*

Company Projects 8 through 10 direct students on how to create color stories, fabrications, and illustrations. Company Projects 11 and 12 pull the product line together into story-boards and line sheets.

Chapter 13

Designers present their product line during line and production reviews, and associates verify their design strategy. Preproduction, operations, and production associates evaluate products to ensure they meet margin and manufacturability requirements. The final acceptance is line presentation and sale to retail customers at fashion weeks, tradeshows, and market centers. The final content presented in this book is not the end of product development; rather, completion of selling the product line to the trade begins the preproduction phase to manufacture fashion products.

Quotes were provided by apparel industry associates who work in a wide range of product development positions. Most quotes follow with a critical thinking exercise in which the students reflect on the apparel associates' comments concerning product line development, such as this one stated.

The author designed this book for a semester-long course. For instructors teaching quarter courses, they can opt to teach Chapters 1–8, with the business strategy and theme boards (Company Project 7) as final projects. They can follow with a subsequent course by teaching Chapters 9–13. This second course is adaptable to teaching with a computer graphics program during the activity or lab. Another option for quarter/short course is to

Line Sheet

Soft and Sweet – Delivery 1
Shabby Chic Sweats – Early Spring

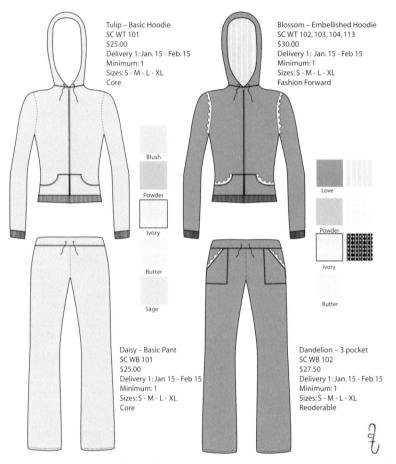

Tulip – Basic Hoodie
SC WT 101
$25.00
Delivery 1: Jan. 15 - Feb. 15
Minimum: 1
Sizes: S - M - L - XL
Core

Blossom – Embellished Hoodie
SC WT 102, 103, 104, 113
$30.00
Delivery 1: Jan. 15 - Feb 15
Minimum: 1
Sizes: S - M - L - XL
Fashion Forward

Blush

Powder

Ivory

Butter

Sage

Love

Powder

Ivory

Butter

Daisy – Basic Pant
SC WB 101
$25.00
Delivery 1: Jan 15 - Feb 15
Minimum: 1
Sizes: S - M - L - XL
Core

Dandelion – 3 pocket
SC WB 102
$27.50
Delivery 1: Jan. 15 - Feb 15
Minimum: 1
Sizes: S - M - L - XL
Reorderable

The development of storyboards and line sheets are the culmination of design decisions, as detailed in Chapter 12 and 13. *(Illustrated by A. Flanagan.)*

teach with Chapters 1–8 and 11–12. The professor can incorporate Chapters 8 and 9 on color and textile selection and development into an advanced textile course. The book's foundation on apparel business strategy and design and thinking processes are well suited to graduate or theoretical framework courses. Professors can use the wealth of reference material provided to expand these topics. The author hopes that *Apparel Product Design and Merchandising Strategies* will make teaching and learning apparel product development enjoyable for everyone.

Acknowledgments

I am grateful for being able to always rely on Ron Regan, my research associate. He provided excellent research, reflection, and suggestions for *Apparel Product Design and Merchandising Strategies*.

Alison Flanagan and Christina DeNino did a superb job in creating the illustrations for this book. Their excellent skill and ability to visualize made the written text come alive. I am truly indebted to them. I appreciate Karen Bathalter's attention to detail in drawing charts. I would also like to thank all of the students who reviewed, provided excellent suggestions for improvement, and let me use and revise their projects to fit the book's content. I especially want to acknowledge Jennifer Bonasaro, Marlo Bontempo, Jeff Courson, Rhea Fontanilla, Liann Herman, Kristina Hilton, Suzette Lozano, Rosanne Montgomery, Nina Pagtakhan, Esmy Perales, Ruby Placencia, Maria Reyes, and Kristiana Tho.

I would like to thank Brenda Carlos for her contribution to the Rare Designs fictional story. Her expertise gave the characters wonderful depth and enabled Rare Designs' environment to come alive. It was enjoyable to work with such a superb professional colleague.

Apparel product development is a complex process. Many industry experts know specific product development segments. I enlisted assistance from industry associates that knew specific product development activities, and I would like to acknowledge those who generously provided interviews, reviewed chapters, and revised chapter sections: Clint Aase, Trudy Adler, Jessica Aragon, Jennifer Barrios, Paloma Bautista, Theresa Becker, Bruce Berton, Randall Baxter, Sydney Blanton, Dov Charney, Henry Cherner, Antonio Espinas, Bruce Fetter, Phil Freese, Alison Flanagan, Jani Friedman, Ronald Heimler, Alona Ignacio, Jim Jacobs, Lonnie Kane, Aaron Ledet, Sam Lim, Lisa Mainardi, Melissa Moylan, Lisa Otoide, Alejandra Parise, Steve Pearson, Shuba Pillai, Kimberly Quan, Jennifer Quesada, Ronald Regan, Liz Riley, Kathlene Riley-King, Mike Rowley, Ram Sareen, Erin Schagunn-Bedwell, Saul Smith, Tom Tantillo, Kristiana Tho, Kathy VanNess, Eileen Wong. These interviews would not have been possible without Helen Choi's assistance. I am grateful for her superb attention to detail in documenting and refining the apparel associates' interviews.

I would also like to acknowledge my major professor Dr. Doris Kincade at Virginia Polytechnic Institute and State University and the Department of Energy in enabling me to create an apparel product development model for my PhD dissertation. Without the support from apparel associates at Wrangler, Healthtex, and Natalie Knitting, my Ph.D. dissertation would not have been possible.

Introduction to Rare Designs' Cast of Characters

The characters of Rare Designs (named for *Ron and Anne's Rebound to Excellence*) introduce themselves in their own words (in order of appearance):

Ron, Managing Partner, Rare Designs

I founded Rare Designs with my business partner Anne. I oversee the operations and production. I exercise—usually run or cycle in evenings or weekends. When I'm not surfing the Web or going to my favorite electronics store to buy the latest computer gadget, you'll find me enjoying my late-model, smoky gray Jaguar. I'm competitive and serious, and money is important to me. In college, I worked part-time in an apparel manufacturer's warehouse. Once this industry gets in your blood, you are in it for life! I met Anne after college when we both worked for a large apparel firm. It energizes me to have my own company, and Anne is a great creative partner.

Jim O'Dale, CEO, Huntington Industries

I grew up in this industry. My grandfather worked in the city (Manhattan that is) and sold fabric wholesale. He loved life and knew almost everyone in the industry. My father took over his business and expanded it. I was an industrial engineering major, and I worked in a cut and sew factory during college. After graduation, I worked in production as a cost engineer. I earned my MBA at night while I was in my 20s. I've been an apparel executive for a long time, and currently I am the CEO of Huntington Industries. We own ten apparel companies. I am a bottom-line guy, but I am looking forward to the day that I can retire and go fishing!

Kate, University Professor

My friends call me an overachiever. I graduated with a clothing and textiles degree. I worked retail for a short time. Then I went into the wholesale side. I have an aptitude for strategic thinking, so I worked my way to the executive suite quickly. My last apparel industry job was vice president of product development. I spent half the week in Los Angeles in one office and the other half of the week in New York City. While I was a VP, I went back to grad school; then I decided to leave the industry to get my PhD. I now teach apparel at a university. My lifelong dream was always to teach college students *the right way* to work in the apparel industry.

Anne, Managing Partner, Rare Designs

Ron describes me as having a flaming Irish personality even though I only have a little Irish in me. I guess it's the red in my strawberry blonde hair and my quick temper! I'm Rare Designs' managing partner. I am in charge of design and product development. I am a hard worker, detail oriented, and owning my own company gives me immense satisfaction. I graduated with a fashion degree 19 years ago. The time does go by fast! I loved making patterns in college and did not like counting inventory, which was my first apparel job. I convinced Ron to open our own business. In my spare time, I love collecting vintage jewelry, especially earrings. You'll often find me scouring craft shows and boutiques for one-of-a-kind pieces.

Lauren, Assistant Merchandiser, Rare Designs

I adore shoes and have over a hundred pairs in my closets! I just recently graduated from college as a merchandising major, and I still live at home. I've been trying to save money to get my own apartment, but each month I end up spending my money on shoes. At least my mom is a great cook. I'm known for my organizational skills. Give me a minute, and I can organize just about anything. My hands are itching to organize Tamee's office. Ultimately, I want to have Anne's job, and I also want to date Michael. He's so handsome!

Tamee, Associate Designer, Rare Designs

Since I was a small child, I have loved to sew and create my own clothes. I can't believe that I'm getting paid for what I love to do. You'd think that after a hard day at work I wouldn't want to sew. I live in a downtown loft and have set up a corner for my own studio where I can create until the wee hours of the night. My home is just like my fashion sense eclectic! My loft is filled with African art and contemporary furniture. I have a crazy cat who adopted me. He just showed up on my doorstep one day, and I couldn't turn him away. His name is Bobbin, or Bob for short.

Jason, Technical Designer and CAD Artist, Rare Designs

I live with four of my college buddies at the beach. If I had my way, I would go surfing or snowboarding every day. I work because a man's got to eat! Well, don't tell my buddies, but I do love my job. I'm a techno geek and my position at Rare Designs suits me well. I'm casual clothes are not a big deal for me, and I wouldn't ever spend the amount of money on shoes that Lauren does. I go to the beach or mountains whenever I can, so you guessed it—I have a permanent tan.

Michael, Sales Representative, Color It Greige

I graduated with a degree in marketing. I started as a sales rep 15 years ago, and now I work for Color It Greige. I love traveling and seeing new places. I'm a people person, and I have the gift of gab. I'm usually talking on the phone 12 hours a day. Looking my best is very

important, so I work out at the gym every night and buy only the best suits. I'm a connoisseur of fine wine, and my favorite outing is wine tasting. I have a couple of girlfriends. Don't tell Miss Wang, okay?

Miss Wang, Interpreter

I am single. I live in China, close to work. I am the interpreter for a host of companies including Color It Greige. I am multilingual and speak English, Mandarin, Japanese, and Korean. I'm currently studying German and French. I would like to travel someday—the United States and Europe are at the top of my list. I live with my parents and grandparents, and I have a Pekingese dog name Xiou.

Mr. Wu, General Manager, Textile Plant

I am the general manager at a textile plant in Zhejiang Province in China. We contract with Color It Greige textiles as well as many other American textile companies. I started as a chemist and worked my way up to management. I live in an apartment, and I am married with one son. My wife's parents live with us. I ride my bike to work each day. In my spare time, I am trying to improve my English.

Jaynie Lee, Pattern Maker, Rare Designs

I'm married and have a young son and daughter. I'm originally from South Carolina. I recently moved to work at Rare Designs. I learned pattern making at a two-year technical school. I love creating patterns on the computer and have an excellent eye for identifying fit problems. Being a mom and working full time keeps me busy, so my hobbies are going to soccer games, basketball games, my kids play dates, carpooling, and, of course, keeping after my husband to do his chores.

Introducing Apparel Product Development

THE CHALLENGE

Distractedly answering the telephone on the fourth ring, Kate hears a voice say, "How are you, Kate?" She immediately recognizes the voice from her past. "Jim O'Dale! It's so good to hear from you," she replies.

O'Dale gets straight to the point: "Kate, I need a favor. Ron Templeton and his partner, Anne McDonnell, the founders of one of my company's new acquisitions, Rare Designs, are in serious need of a mentor. Tell me; does mentoring fit into your academic schedule?"

Dr. Kate Roberts thinks about her busy life. She is teaching a full load at a local university and nearing a publishing deadline for a textbook she has been working on the past several years. She also serves as a board member for her favorite nonprofit organization. She is busy all the time; yet, how can she say no to Jim O'Dale, a man who mentored her as a young professional and has become her friend? "Of course, Jim, anything for you," she says.

Six weeks earlier, Ron and his partner had sold Rare Designs to O'Dale's Huntington Industries, a large apparel-manufacturing conglomerate. Ron now contemplates his mixed feelings of regret and excitement as he heads to a meeting with O'Dale and his management team. Anne stayed behind to keep the company running.

Ron thinks back to 18 years ago, when Rare Designs had quickly become a successful small business. "Although my degree wasn't in business management, and we were so young when we started, I know we had good instincts for this business," he thinks. "How did we lose control?" Ron remembers the day when he and Anne jumped at the chance to sell their business to Mr. O'Dale. Still, the operational changes—from standardizing orders, production, and inventory management, to changing design and product development—caught both of them by surprise. They regretted the loss of freedom of owning their own business. However, it wasn't difficult to forget the continual crisis management, painful cash flow problems, and profit decline that had plagued Rare Designs the past 3 years.

As Ron enters the elevator, he catches a glimpse of himself in the shiny interior walls. He is tan and trim, with crystal blue eyes. Ron approves of his tailored suit but feels a knot forming in his stomach as he thinks about the upcoming meeting with Jim O'Dale and some of the corporation's other top executives.

Just as he pushes the button for the second floor, a well-dressed man joins him. Noticing Ron's watch, the man says, "That's a really great-looking watch. I don't think I've seen one like it before. Where did you get it?"

"A friend of mine just brought it back for me from his business trip to Japan," Ron replies. "He knows how much I love gadgets! Not only is this a watch, it's an MP3 player and doubles as a USB flash drive. By the way, do you know how to get to the executive boardroom?"

"I happen to be headed there. It's easier to show you than to explain how to get there through the maze of cubicles," the man says. He extends his hand. "I'm Richard Cooper, president of RAC Industries."

Ron shakes Cooper's hand. "It's nice to meet you. I'm Ron Templeton, president of Rare Designs," he says as the two meander around the large office space.

Jim O'Dale greets them as they enter the executive boardroom. A man in his early 60s, O'Dale has a demeanor that conveys innate leadership, power, and intelligence—that commands respect. O'Dale turns to Ron and says, "I see you've met Richard, the president of our top-performing company."

By then, a number of professional-looking men and a few women executives encircle the boardroom table. "It's time we get started," O'Dale says. "Welcome to our quarterly meeting. This morning we'll cover a few items that affect each of your businesses. Then I want to spend some time focusing on our newest asset, Rare Designs. Ron Templeton is the president of the company." O'Dale motions toward Ron. "He and his partner, Anne McDonnell, started the business 18 years ago. Anne has rare, amazing design talent, and Ron has handled the operations and production. In the past few years, they've been experiencing some of the same growing pains many of you have had. I'm eager to get your input as we discuss the company's challenges."

O'Dale proceeds with the meeting by presenting the projections and results for the past year and the corporation's current status. Ron tries to focus on O'Dale's words as he drones on about the international challenges of counterfeiting, shipping and port delays, and social responsibility. Shortly, Ron begins daydreaming about his company, Rare Designs. He smiles to himself as he remembers how it all began, and O'Dale's voice becomes mere background noise. . . .

Both college graduates, he and Anne became quick friends after their chance meeting while counting inventory at the large apparel firm where they both worked. With her distinctive green eyes flashing and a swish of her shoulder-length strawberry blonde hair, Anne said, "I did not study fashion design in college to count jeans! We should be our own entrepreneurs!" His quick response was, "Why not? We have the vision and the drive; we should start our own apparel company!" As it turned out, the first year Ron and Anne made $100,000 in sales—no profit—but they were excited to have sales. Ron never had a strategic design plan and didn't think he needed one. The business was growing, and that's what counted to them.

Then, the unforeseen happened. Anne's remarkable designs became a huge success and much sought after by major retail customers. A roller coaster ride of fast growth ensued as they hired employees, pushed to meet production schedules, experienced the peaks and valleys of cash flow, and worked in the intense, nonstop environment. The excitement of peak demand for product, huge production orders, and absolute chaos—what a rush!

He and Anne experienced a financial high for a few great years. They just kept cranking out product. Within 10 years, Rare Designs had a solid market position, with $70 million in annual sales. The chaos was intoxicating. After all, when you work in the apparel industry, you don't have much time to think. He and Anne had poured

their hearts and souls into making it all work, but they could not keep up with the pace, and then they started producing internationally. Late production, canceled retail orders, and charge-backs—they had a strong niche market at one time but lost it because the company grew too fast. The great sales years were gone, and everything they had worked for was sinking. They could not get a handle on the chaos; the harder they worked, the more steeply profit declined. At the peak of their financial earnings, they had invested heavily in equipment and built their current corporate office building. Neither of them anticipated that at some point they would not be able to pay the bills.

After 3 years of low profitability, loss of leadership to low-cost competitors, and excess inventory, Ron did not realize how much design decisions affected operations and profit. Then, one day, he received a surprise telephone call from Jim O'Dale, who offered to buy Rare Designs. Ron paged Anne, and she said, "I'm coming; don't hang up the phone!"

During the negotiations involved in selling the business, Ron was determined to ensure that the employment status of all his employees wouldn't change. Many Rare Designs' employees had been with them from the beginning, and he couldn't bear to jeopardize their stability. When the sale was finalized, Ron and Anne remained as operating partners; their employees would stay, but O'Dale and his company would have management control.

Mr. O'Dale's authoritative voice brings Ron back to the present, "Ron, your company's strategy to produce salable products is no longer working. Rare Designs' product development process is in shambles, and your sales are sinking fast. You need help, and you need it now!"

O'Dale rises to his feet as he announces, "Ladies and gentlemen, let me introduce you to Dr. Kate Roberts. Many years ago, I was Dr. Roberts' mentor. With my guidance, and a lot of hard work on her part, she became financially successful as an apparel partner. When a large corporation purchased her company, she yearned for something more, something different. She left the day-to-day industry challenges, got her Ph.D., and decided to go into academia. Through consulting, she dramatically and successfully improved the product development process for other apparel companies, and now she will be helping us with Rare Designs. Kate, I happily yield the floor to you." With that, O'Dale takes his seat.

All eyes are on Kate, partly because of her exquisite tan French gabardine suit and partly because of O'Dale's introduction. Although skeptical of individuals in academia, the presidents pay rapt attention to the 45-year-old woman. They believe that if Mr. O'Dale holds her in such high regard, they should listen with open minds.

Ron concentrates intently as Dr. Roberts says, "Product development involves the organization and coordination of people, machines, and processes. It can be confusing because it is a chaotic process. How would you define *chaos*?"

"Chaos is great! It's when everything is out of control!" says one of the executives.

"Your answer reminds me of a quote attributed to the famous artist M. C. Escher:* 'We adore chaos because we like to restore order.'" The presidents nod in agreement. "*Chaos* refers to a nonlinear process. A nonlinear process, unlike a straight line, brings

*Attributed to M. C. Escher as an unsourced quotation at http://en.wikiquote.org/wiki/MC_Escher.

with it many unstable events and sends our process into many divergent directions. It gives us the feeling that an outcome is virtually impossible to predict."

Ron silently agrees. Product development is almost impossible to predict. One moment progress is being made, and the next instant it is going in the opposite direction.

"Understanding chaotic factors helps you have a smooth-running product development process. Now, I'd like for each of you to think back over some of the factors that have caused chaos in your businesses as you've developed products. Let's list some of them," Kate says.

Richard Cooper is the first president to answer: "The uncertainty of product type and life span causes chaos."

Kate turns her back to the presidents and begins to write their ideas on a flip chart. One of the female executives adds, "What about product diversity?"

"And seasonality?" one of the younger men in the room interjects.

As the brainstorming session nears completion, Kate faces the group and says, "Let's not forget the multiplicity of raw materials as well as consumer expectations. Having control of the product development process means you avoid unnecessary expenses, such as charge-backs."

"I'm all ears," Ron thinks, keenly listening to Kate, "if this professor can help us avoid charge-backs."

As Dr. Roberts concludes her talk, O'Dale rises. "I am setting the stage for a challenge. I expect to see measurable improvement in 6 months' time. Ron, Dr. Roberts has agreed to mentor you and Anne with your product development process at Rare Designs."

"Presidents, your homework is to be a resource for Ron and his partner as they work with me in restructuring Rare Designs. Ron, your homework is to read *Apparel Product Design and Merchandising Strategies*. Kate will visit your company next week."

Objectives

After reading this chapter, you should be able to do the following:

- Define *apparel product development*.
- Describe the various nonlinear apparel events.
- Distinguish between chaos and crisis.
- Comprehend the importance of having a strategic design plan.

Visualize yourself at a party. A new acquaintance asks you, "What is your job?"

You confidently reply, "I'm an apparel product developer."

The acquaintance's brows crease, "What is that?"

You stumble to form words. "Well—designing clothes: what you are wearing."

"Isn't that a dying industry?" he asks. "Clothes are all made overseas."
"No," you reply. "We design and develop clothes here."
"So *what* is it you do?" the acquaintance queries.

Design, like *product development,* is a common, but vague, term (Heskett 2002). Many individuals do not understand what *design* and *product development* mean, why design decisions are important, and how chaotic the apparel industry is. This chapter begins with some basic product development concepts: definitions of key terms, a description of the apparel industry environment, and the framework of the product development process. It continues with a section on why development is a chaotic process and ends with a discussion of why a company needs to have a strategic design plan.

Definition and Outline of Apparel Product Development

Apparel product development is a complex process (Regan 1997, 178–279). To better understand this process, let us begin by looking at the words composing the term *apparel product development* and an outline of its overall process.

The field of **apparel** is a captivating industry. It is one in which superstardom success may be achieved overnight, take years to accomplish, or never happen. The apparel industry is intensely competitive, and its fast pace and continual product change is thrilling to many people. Teresa Becker, entrepreneur and owner of Heartbreaker Fashions 👕, shared her perspective on the industry with the author:*

> Passion for this industry is essential for success. The only rule that applies to the fashion industry is that there are no rules. The business is high risk and requires the ability to invest time and resources up front before there is a payoff. Other people require payment first—from the fabric distributor to the production team to the sales representatives—but once all the bills are paid and the profits begin, there is no better feeling than seeing your original design being worn by the customer!

Apparel-manufacturing firms are a diverse group, ranging from custom dressmakers and tailors to producers of ready-to-wear apparel. The North American Industry Classification System (NAICS) (U.S. Census Bureau 2002) uniquely identifies apparel industry groups as those involved with Apparel Manufacturing (NAICS 315); Apparel, Piece Goods, and Notions Merchant Wholesalers (NAICS 4243); and Clothing and Clothing Accessories Stores (NAICS 448).

The U.S. Census Bureau classifies each apparel firm as a manufacturer, a jobber, or a contractor. An apparel *manufacturer* buys raw materials and cuts and sews its own garments within its own operation. This operation markets and sells its product to retail customers. A *jobber* buys raw materials and contracts the cutting and sewing to outside factories. Once the product is sewn, the jobber markets it. A *contractor* is an operation

*Reprinted by permission from Teresa Becker, designer/owner, Heartbreaker Fashions, Covina, CA; pers. comm., March 7, 2007.

that does not own or market its finished product. Rather, a contractor makes a product (e.g., sewing, pleating) according to specifications supplied by a manufacturer or a jobber (U.S. Census Bureau 2000).

Clothing and accessories stores sell new clothing and accessories. These stores use similar display fixtures and equipment and have physical brick-and-mortar locations. Clothing and accessories stores feature staff knowledgeable about fashion styles and color trends that meet a company's consumer preferences (U.S. Census Bureau 2002).

The domestic apparel industry is largely entrepreneurial. Small businesses with fewer than fifty employees are the norm for the industry and in 2004 represented 91 percent of all U.S. apparel companies (U.S. Census Bureau 2006). These small companies face intense pressure. One reason for this pressure is the introduction of approximately seven hundred brands each day (Hotz 2005). This sheer number of brands can lead to *market saturation*, in which a considerable number of retail or wholesale companies sell the same or similar brands in a designated market (American Marketing Association n.d.). Additional pressures include a large number of competitors, retail customer requirements, imports, and reduced time to market.

The next word, **product,** is defined at Dictionary.com (n.d.[d]) as anything produced, which can be the result of generation, growth, labor, or thought to create an idea or a product for manufacture. In business, this word means a tangible good or intangible services and knowledge that a company sells to consumers (Product Development and Management Association [PDMA] n.d.). A **consumer** is an individual who wears or uses a product.

Development originates from the word *develop,* which is defined as "to make, or to become more mature or more organized." Development is a progression from a simpler to a more advanced, mature, or complex form. An individual develops products by human or mechanical effort, or by a natural process (Dictionary.com n.d.[b], n.d.[c]).

The term *product development* refers to new products sold to existing markets (PDMA n.d.). Engineers define **product development** as the activities, tools, and methods that translate customer needs into new or revised designs. This design information is used to create, test, and refine design solutions into a manufacturable product (Carter and Stilwell Baker 1992). The product development process involves the use of strategy, organization, and concept generation to create products and marketing plans, and commercial evaluation (PDMA n.d.). New product development is the creation of an embryonic idea into a salable product or service that makes an existing product obsolete (PDMA n.d.). It can also be new business processes to streamline or make the development process more effective (Goodstein, Nolan, and Pfeiffer 1993). In the textiles industry, new product development can occur by creating innovative fabrics and fabrications. Fashion companies create new innovative products and use patented textiles in products. Levi's RedWire DLX jeans is one example. These jeans allow consumers to plug an iPod into their jeans. This innovation provides a new function for the watch fob pocket, traditionally used to hold a pocket watch. DLX jeans have an iPod control pad built into it for easy operation (Levi Strauss & Co. 2005, 3). However, successfully introducing new products such as this is difficult (Retail Forward 2003), thus many apparel designers are inspired by existing products.

Individuals sometimes confuse product development with *supply chain management.* Product development is the strategy and process of creating a product (PDMA n.d.), whereas supply chain management is the timely integration of information and processes

among suppliers, manufacturers, warehouses, and stores to ensure a competitive advantage (Handfield and Nichols 1999). Apparel associates need to understand the product development process in order to manage a company's supply chain. After all, associates can scream at a supplier to ship a product faster, but they are probably screaming because someone did not communicate a timely design decision. The design team acts as a kick-off point for other developers to start their jobs. Therefore, **apparel product development** can be defined as follows:

> *The use of a company strategy to generate design concepts that are developed from a simple idea to a more complex stage to produce a salable apparel product. This process involves the organization and coordination of people, machines, and processes.*

ACTIVITY **1.1** *Interpretation of Product Development*

Using the preceding definition, draw your interpretation of *apparel product development.*

Importance of Designers to Apparel Product Development

In business, people operate in a complicated, nonlinear environment (Gaddis 1997). For instance, as a college student, you enjoy your cell phone because it often means your friends are calling you. However, to **apparel associates,** a cell phone is a tool used to multitask, and they often use it to resolve urgent problems. Apparel associates commonly multitask by simultaneously reading and responding to e-mail, listening to a colleague, and talking to a customer or an associate on his or her cell phone, while working on a sketch or technical drawing. The ability to multitask and work in a fast-paced environment is a common requirement for product development positions.

Part of a strategic design plan is how a company hires and nurtures its creative talent. Creativity is fickle, and often executives do not understand what is important to designers. A **designer*** makes numerous decisions during the process of taking a product from design conception through preproduction. The ultimate success of any apparel product line relies on a designer's precise coordination and excellent timing.

A managerial understanding of apparel product development is important and timely for U.S. apparel manufacturers because it ensures a strategic advantage. Because design decisions are a controlling factor, people are motivated to learn about product development, designer inspiration, and triggers that cause consumers to buy a company's products. Some apparel companies, caught in a crisis state, struggle each season to develop products. These apparel executives have good intentions but often lack the foresight or resources to adequately hire or train apparel associates. Crisis is inevitable when management adopts the philosophy "We do not have time to train." One cause for crisis is a lack of action

**Designer* is a general term because apparel companies designate different titles to individuals who are involved with design activities. Job titles include designer, design associate, and associate designer.

plans for employee turnover and growth. When an employee quits, managers in such a situation simply react with the attitude "I need to hire someone with experience today!" This attitude results in hiring less-qualified employees, who perpetuate the confusion.

Picture this common scenario: On your first day working for an apparel manufacturer or a private-label retailer, you are excited with anticipation as you observe employees who are busy making telephone calls and talking to colleagues. Your boss greets you, "Welcome to the world of apparel product development! Here is your desk and computer; go get started." Then she walks out the door. A colleague looks at your wide-eyed expression and reads your mind, "What am I supposed to do?" He smiles at you, points to the computer, and says, "Do this, this, and this." "So much for training," you think, as you start working.

The CEO of Liz Claiborne supports the adage that most apparel companies do not train because they are too preoccupied with day-to-day events. He comments that apparel company success relies on training new employees and that executives are responsible for recognizing the potential of and creating a development program for all management associates (Agins 2006). When managers do not understand business processes, such as product development, the result is often the purchase of inadequate computer programs and equipment and incorrect decisions. Managers often discover their error too late and blame company associates. Individual apparel associates rarely purposely create crisis events; rather, such events usually ensue from a lack of process management.

Successful and innovative managers use rigorous hiring practices. They also provide creative associates with updated training and software tools (Florida and Goodnight 2005). One key to success is to hire educated associates who have a foundation of apparel and textile knowledge and to build training into an employee's workday. To contend with the intense pressures of the industry, successful apparel companies need educated employees with technical expertise, management skills, and an understanding of the process. The importance of having educated individuals in the apparel industry cannot be overstated. Apparel associates with an educational background in fashion, textiles, product development, and manufacture can rely on their educational foundation to answer technical questions, such as quality assurance or pattern problems (Human Resources Leadership Council 2004; Iannazzone 2004). For example, suppose an anxious international contractor calls quality assurance personnel, who in turn call the designer to substitute fabric because fabric **torque** is causing sewing problems. The educated designer can handle such a situation.

Historically, domestic manufacturing companies hired apprentices. These apprentices worked under a master craftsman's auspices to learn a trade. One advantage of this practice was that trained employees were available to fill any vacancies. Therefore, a valuable management policy is to have apprenticing programs and to cross-train product development associates. Such a policy will ensure smooth process transitioning. For instance, a technical designer who occasionally assists designers with computer-aided design (CAD) illustrations and fitting can transition into an associate designer's position. Successful apparel firms have existing trained employees who are eligible to move into new positions. One current-day example is Warnaco Swimwear's Design Apprentice program. In a discussion with the author on November 16, 2005, Executive Vice President Kathy Van Ness explained that the program involves ten students who apprentice for 3 years while attending school. They compete with one another to become the finalist whom Warnaco hires as a full-time designer.

To manage product development, an individual must understand how design decisions affect it. Designers generate salable concepts, which are the creation of a product or service. Design accounts for only 5 percent of product cost; however, design decisions control 75–80 percent of the total product cost (Carver and Bloom 1991). An individual conjures up concept ideas through human effort, called **design thinking.** Design thinking is an intangible process that an individual mentally goes through to visualize ideas. It is the essence of creativity. An observer can see design thinking only when an individual creates an output, such as a sketch, a photograph, a painting, or a model. This intangible nature of a designer's output—of making decisions rather than producing a physical product—often impedes understanding of apparel product development. A designer is an innately creative person who wants to create aesthetically pleasing and functional products. Creative individuals thrive on intellectual stimulation, want to do good work, and work for the love of a challenge. Designers need intellectual stimulation, and they capture innovative insight by eliminating distractions. Their inner drive to achieve compels them to be highly productive so that managers can trust them to manage their own workloads (Florida and Goodnight 2005). Effective product development managers are also creative. They facilitate the exchange of ideas by bringing groups of people together, generate creative capital by soliciting customers' suggestions for improvement, and allow customers to have direct access to designers (Florida and Goodnight 2005).

The Nature of Apparel Organizations

In the chapter opening story, Rare Designs is a typical apparel manufacturer. Apparel manufacturers often start as entrepreneurial ventures with few employees and an informal organizational structure. Some apparel managers operate "by the seat of their pants" and by "gut instinct." Company expansion increases the chaotic pace of product development and can be a time when managers lose control. Astute apparel executives understand that product development operates in a chaotic—but not a crisis—state.

Chaos

Nonlinear factors—product type and life span, product diversity, seasonality, multiplicity of raw materials, and consumer expectations—create a dynamic, chaotic process. In addition, the apparel industry has the potential for a company to "go on the ride"—when a company comes from nowhere to become an overnight star with high sales potential. However, according to R. Stern, a consultant at the May 2005 Fashion Business Incorporated "Financing Your Own Company" presentation in Los Angeles, CA, an apparel company may not have the infrastructure to be prepared for a growth surge, and it may consequently fail or struggle to maintain company operations. One example is the apparel company Innovo Group Inc ⬆., who popularized Joe's Jeans to high-end specialty retailers in 2002. Innovo quickly reached an exciting pinnacle, with net sales growing from $9.2 million in 2001 to $46.6 million in 2006. Yet, processes were not in place for this tremendous growth. Between 2003 and 2006, Innovo Group's revenues increased 66 percent, yet the company suffered an average annual loss of $10.9 million from decreased

margins (U.S. Securities and Exchange Commission [SEC] February 9, 2007). The primary reason for this loss was insufficient internal controls and ineffective accounting procedures. The company rectified the situation by promoting seasoned employees, increasing software training, and improving accounting procedures (Innovo Group Inc. 2006). A potential product development crisis occurs when a company's success relies on few assets. In Innovo Group's case, the company documented that the loss of Product Development Manager Joe Dahan would cause a crisis. Dahan's design team creates, develops, and coordinates Joe's Jean's product groups (SEC February 9, 2007). During Innovo's period of extensive financial loss, Joe Dahan and his creative team took a two-season hiatus, an extremely risky venture in the fickle apparel industry (Market Wire 2005). In spring 2006, Innovo reintroduced its men's denim line as a limited edition collection. The revamped product line introduced new fits, fabrics, washes, and detailing (SEC February 9, 2007). This type of chaotic, risky, but exciting "ride" is what can entice individuals to work in the apparel industry: It is nonlinear, exciting, glamorous, and always changing.

What comes to mind when you think of chaos—complete disorder, extreme confusion, bedlam, disorganization? **Chaos** is a nonlinear process in which its events are in disorder, unstable, and diverse (Murphy 1996). Nonlinear or chaotic events often have unpredictable results. Individuals can react emotionally to chaos and crisis events. Some individuals thrive in unstable and diverse environments, whereas others panic and believe any chaotic event is a crisis. In contrast with both chaos and crisis, in a linear event, results are predictable and a cause-and-effect relationship exists. For instance, a **linear change** occurs when a company changes only its competitive position (e.g., decrease in market share).

Chaos has a definite pattern; however, it is not a cause-and-effect relationship. The ever-changing business environment creates complexity in organizations (Glass 1996). In a chaotic environment, executives see expected and unexpected results. For instance, company executives who increase advertising expenditures expect sales increases; however, business is complex, and such an action can make competitors more aggressive, which may result in a loss of market share (Glass 1996). **Nonlinear change** occurs when a company modifies its own environment (e.g., strategy) as well as its competitors' (Grove 2003; Murphy 1996).

To understand nonlinearity, imagine that you are planning a dinner party. You look at cookbooks, decide on your menu, and start to make a list, but your roommate calls you to come upstairs. Upon your return to the kitchen, you cannot find your list, so you begin a new one. On your way home from work that evening, you stop at the grocery store but cannot find the shopping list. You convince yourself that you will remember everything you need, so you proceed with your shopping. After you get home and are preparing the main dish, you realize you forgot to buy the chicken. Feeling harried and irritated, you race back to the grocery store, buy the chicken, and hurry home. Your main course is simmering nicely, all is under control, and you start separating the eggs for your dessert, a chocolate soufflé. Some of the yolk sneaks into the whites, but you think, "It is not a big deal." Then, you glance at the clock, shocked to realize that your guests will arrive in a mere 20 minutes, and you dash for the shower.

One friend arrives early, takes a look at your wet hair, and says, "Isn't our dinner party tonight?"

"Of course it's tonight!" you exclaim as you welcome him in.

You resume making your chocolate soufflé, the doorbell rings, and there they are: All your friends have arrived. While everyone watches, you try to whip the egg whites—to no avail. Nervous tension mounting, you realize you made a mistake. A friend volunteers to go to the store for more eggs, and after an embarrassing delay, you finally finish your soufflé and ease it into the oven. Noticing that your friends appear restless, it dawns on you that it is 9:00 p.m. and you have not served dinner yet. Upon seating everyone at the dinner table, you finally take a deep breath. Just then, a friend sniffs and asks, "Do I smell something burning?"

"Oh no!" you cry. "The soufflé!"

As with the dinner party scenario, a chaotic system such as product development can be vulnerable to small changes, and the people within an organization can be caught off guard (Glass 1996; Murphy 1996). The dinner party scenario has the disorder, instability, and unpredictability found in chaotic, nonlinear processes. Product development has the same characteristics. The misplaced grocery list correlates to having an incomplete plan. Multiple trips to the store parallel a manufacturer's lacking the necessary raw materials. Likewise, time pressures and delays are always present in the product development process. Finally, the burnt soufflé represents not having the product ready as anticipated.

How an individual views chaos in an organization affects his or her perception. As Ron stated in the story, he liked the chaotic pace when Rare Designs was rapidly growing. Apparel associates who do not understand the product development process may draw false conclusions such as thinking the process is linear and sequential. Individuals must keep in mind that nonlinearity does not always imply a negative situation. One nonlinear example is a company with declining profits that increases its expenditures by investing in employee training and new equipment. In such an instance, sales may increase because of these enhanced processes. Another point to remember is that although chaos and nonlinearity lead to unstable influences within product development, chaotic and linear events switch back and forth. Managers need to maintain a holistic view because a single chaotic event that appears significant at one stage of the process may be insignificant in view of the entire process (Glass 1996).

Nonlinear Events

Change is the essence of fashion (Peters 1992). The apparel industry is a dynamic and fast-paced environment. This pace and energy, combined with nonlinearity, affects apparel product development (Figure 1.1). Primary nonlinear factors include product type and life span, product diversity, seasonality, multiplicity of raw materials, and consumer expectations.

Product Type and Life Span

In terms of product type, a linear example is products created for a set life span. For example, the automobile industry has a product built for an expected life span. If a consumer buys a new car, his or her expectation of how long the car will last does not change, and the consumer will expect two new cars to last the same amount of time (e.g., 8 years).

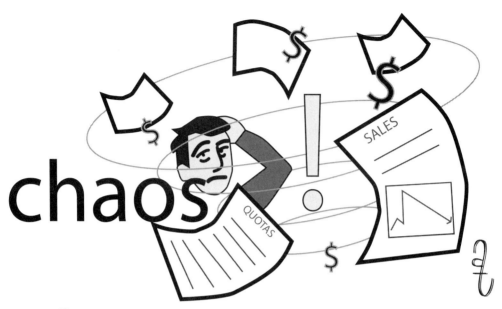

Figure 1.1 A chaotic product development process resulting from nonlinear events. *(Illustration by Alison Flanagan.)*

In contrast, apparel products have a nonlinear life span. A **nonlinear life span** means that a consumer has different expectations for different apparel products. For instance, an individual expects a Halloween costume to last one night and outerwear, such as a fur coat, to last a decade. Similarly, a consumer can buy one outfit and have varying life span expectations for the various components. For instance, if a consumer purchases the outfit shown in Figure 1.2, she might expect the trendy skirt to last one season but the classic T-shirt to last multiple seasons. Anticipating and balancing consumer life span expectations with other attributes such as quality and fashion trends can be difficult for apparel executives to accomplish.

Product Diversity

In product development, **product diversity** and the number of products produced create chaos and nonlinearity. What other industry can claim such a degree of product diversity—from thong underwear to wool overcoats? A typical apparel manufacturer develops 50–350 diverse products every 3–6 months (Regan 1997, 163). The shear number of products developed is a primary reason for chaos.

Seasonality

The apparel industry traditionally sells products to retailers on a **seasonal** basis: spring, summer, fall, and resort or holiday. Compared with other consumer goods, apparel products have an extremely short selling period and staggered delivery dates within seasons.

a b

Figure 1.2 Example of nonlinear life span expectations: (a) product with long life span expectation; (b) product with short life span expectation. *(Courtesy of Marlo Bontempo.)*

Manufacturers commonly designate a number or a date for its staggered deliveries (Frings 2005). For instance, a collection is called *Fall I, Fall II,* and *Fall III,* or it is designated as *8/1, 8/23,* and *9/23* deliveries. This seasonal selling practice is highly unpredictable and demands that successful apparel manufacturers adjust their product lines for diversity in construction techniques, garment style variation, and material types. The retailers' powerful influence adds yet more pressure on apparel manufacturers to produce a multitude of new styles. This pressure creates a need for additional product line releases within a single season (e.g., Fall I, Fall II). For example, To the Max! 👕 typifies the many manufacturers who are pressured by seasonality. According to an account representative who spoke with the author in 2004, the company handles multiple deliveries within a season by having consistent garment styling, but each delivery has different colors and fabrics.

Swimsuit manufacturers are under tremendous seasonality pressure (Figure 1.3). As a consumer, have you ever been frustrated by the limited selection if you tried to buy a bathing suit in November? Think about this question from an apparel manufacturer's viewpoint. Some apparel companies, such as Warnaco Group, Inc., operate under intense seasonal conditions. Warnaco Swimwear Inc. 👕, a division of Warnaco Group, Inc., and a leading swimsuit manufacturer, markets renowned brands such as Catalina, Anne Cole, Calvin Klein, Michael Kors, and Speedo (Warnaco Group, Inc. n.d.). Their retail customers dictate when to sell merchandise in their store. Thus, a swimsuit company's peak season is as short as 90–120 days, and merchandise must be sold by back-to-school time. Warnaco Swimwear operates year-round so apparel associates must plan for this short

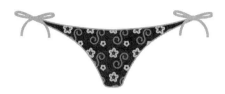

Figure 1.3 Example of a product with highly seasonal demand, which creates production challenges. *(Illustration by Karen Bathalter.)*

selling period correctly and efficiently. As Executive Vice President Kathy Van Ness stated,* "When it is snowing outside, we do not know what is going to sell—who knew that pink was going to be the hot seller 6 months ago?" Such seasonality affects the company's total production capacity. Retail customers, such as Wal-Mart, give their vendors a daily "report card" of products sold. This information sometimes comes too late to redesign a slow-selling product. Designers and merchandisers must be on target for this short selling period. According to Van Ness,*

> If a product is not sellable, speed to market does not matter, because you can sew a garment only so fast. We must design and develop products as if we were a retailer because everything has to be perfect on the floor in order to meet the consumer target.

In addition, apparel companies work on multiple seasons simultaneously (Frings 2005). Jennifer Barrios, a senior merchandiser at Quiksilver, Inc., acknowledges that working on multiple seasons creates additional nonlinearity within product development:*

> We are always working on three seasons at the same time. At this time, we are shipping samples to reps for the current season, in the prototype stage for the next season, and putting together the line plan and thinking about designing the

*Reprinted by permission from Kathy Van Ness, executive vice president, Warnaco Swimwear Inc., Commerce, CA; American Apparel & Footwear Association "Speed to Market" presentation, Los Angeles, CA, January 30, 2004.
*Reprinted by permission from Jennifer Barrios, senior merchandiser, Quiksilver, Inc., Huntington Beach, CA; pers. comm., May 9, 2006.

following season. Right now, I am approving top of production samples for Fall 2007. Prior to a top of production sample, we receive a preproduction sample, which we evaluate visually and for fit. Then we receive a size set to make sure the grading will be correct for production. When we review samples visually, we are ensuring the correct fabric, trims, and logo placements were applied. I am also in the middle of Spring 2008 development where I am reviewing fit on protos; developing colorway, trim, and material specification sheets or matrices; and receiving fabric swatches and print strike-offs or yarn dye hand looms for my designer's approval to use on salesmen samples. The designers are starting to shop and design for Fall 2008, which will be in stores 14 months from now. It will be my job very soon to hand them a line plan showing them how many SKUs to design.

Activity **1.2** *Critical Thinking*

The Quiksilver, Inc., merchandiser's comment describes an example of multitasking, which is a desired skill for individuals who work in the apparel industry. Write in your design sketchbook or journal how you can develop multitasking skills.

Multiplicity of Raw Materials

The use of **multiple raw materials** creates yet another nonlinear or chaotic influence on apparel product development. Consider a pair of jeans (Figure 1.4) that consist of cotton denim fabric, nonwoven polyester interlining, polyester embroidered brand labels, woven rayon care labels, cotton-and-polyester-blend thread in two sizes and colors, metal rivets, a metal shank fastener, a metal zipper, and cotton pocket-lining fabric. Each raw material comes from a different supplier. A manufacturing delay will occur if any one supplier fails to deliver.

An apparel product such as jeans may appear simplistic when compared with an automobile, which typically has 15,000 parts. However, compare the number of design changes between these two products. Automobile companies must address an average of two major and eight minor design changes per product (Brunnermeier and Martin 1999). In contrast, apparel companies have to handle an extraordinary amount of design changes. Companies that produce basic styles make a low of 25 products per year whereas the norm is 2,000–4,000 products per year, and trendsetting companies, such as ZARA, produce 11,000 distinct products annually (Ghemawat and Nueno 2003). Each apparel development cycle consists of 292 activities for each seasonal product produced (Regan 1997, 158, 395). Therefore, because consumers desire fashion variety, an apparel manufacturer's design changes range from a low of 7,300 to a high of more than 300,000 activities (i.e., activities multiplied by products made).

Consumer Expectations

Consumer choice is unstable and unpredictable, and it requires apparel manufacturers to create a diverse product mix. Consumers are difficult to understand and predict. Demographics and psychographics assist companies in understanding consumers; however, companies cannot rely solely on these sources because consumers are becoming

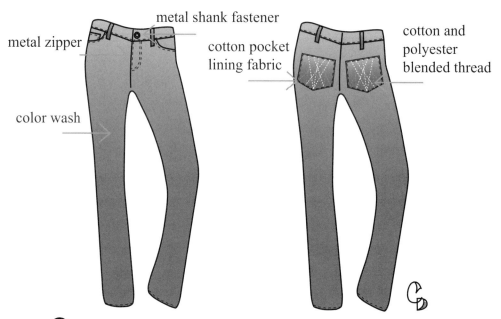

100% Cotton

97% Cotton
3% Spandex

metal shank fastener

metal zipper

cotton pocket
lining fabric

cotton and
polyester
blended thread

color wash

Figure 1.4 Jeans with multiple raw materials. *(Illustration by Christina DeNino.)*

increasingly multidimensional and complex (Retail Forward 2003). Large and small apparel companies want to understand consumer preference for continual fashion change, convenience, price, and customer service. Research on the brain indicates that a combination of memory, emotions, and biochemistry influences choices consumers make. For example, in a brain scan research study on branding, one participant stated she enjoyed buying high-fashion products, such as Prada🖳. When she was tested, her brain triggered anxiety and pain. These results suggest that the motivation for this consumer to purchase high fashion was fear of being embarrassed rather than wearing something stylish (Hotz 2005). Luxury high fashion is becoming an increasingly important category of consumer preference. For instance, premium jeans priced at more than $100 constitute approximately one-fifth of all denim sales (NPD Fashionworld 2006). Price and product value is a different, but equally important, priority because most consumers favor shopping at mass merchandisers, such as Wal-Mart or Target, or national chain stores, such as Sears or JCPenney (NPD Fashionworld 2005).

A consumer's expectation of an apparel product varies with the target market, product type, and expected product use. For instance, a bridal apparel manufacturer develops formal and informal gowns for first-time brides and previously married brides (Figure 1.5). Likewise, some target consumer groups desire the latest apparel fashions, whereas others prefer investment clothing (Brown and Rice 2001). A manufacturer

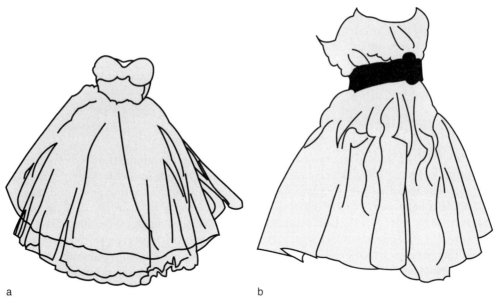

a b

Figure 1.5 Example of varying consumer expectations: adaptation of a gown for (a) first-time, or formal, brides and (b) nontraditional, or casual, brides. *(Illustration by Christina DeNino. Adapted from work by Li-Ann Herman.)*

cannot transfer consumer preference knowledge among different apparel product types. However, consumers are demanding both moderate pricing and frequent style changes, whether they buy the latest fashions or investment clothing (U.S. Bureau of Labor Statistics 2006–2007). This consumer demand for fashionable clothing has compressed the design and production cycle time. This traditional design-through-production process typically takes 18–24 months; however, apparel companies such as ZARA 👕 introduce new styles every 4–5 weeks to meet consumers' frequent style change demand (Ghemawat and Nueno 2003). Many consumers have strong opinions on purchase decisions because technology allows them easy access to product information. Thus, increasingly more consumers will seek product information independent of retailers or manufacturers (Retail Forward 2003).

Complacency

A chaotic process is ineffective when an organization's infrastructure and management create crises or when managers delude themselves into thinking that an organization is stable. Ron's reflection that he and Anne once had a strong niche market indicates a flaw within the organization. By having a niche market, customers may praise the organization for having unique, original designs. However, in such a situation, complacency may result (Heskett 2002). Complacency is tempting to many managers because their philosophy is "Why change anything if it is working?" Like Ron, many managers delude themselves by thinking that everything is okay if sales stabilize

or are on the rise—a linear, or predictable, event. However, a **knockoff,** an almost-exact copy of an original design (Keiser and Gardner 2003), can rapidly disintegrate a company's once-unique niche and cause a crisis if low-cost competitors copy designs. Sales can decrease dramatically if a company is not cognizant of chaotic events. The nonlinear or chaotic event for Rare Designs was that sales decreased even when Ron worked harder.

Crisis

Individuals often confuse *chaos* with *crisis*, although these terms are is not synonymous. A process such as product development can be effective even when defined as chaotic. **Crisis** is an emotionally stressful or traumatic situation in which a conflict peaks and must be resolved immediately to avert disaster (Dictionary.com n.d.[a]). In a crisis, individuals feel as though they cannot gain control of a situation no matter how hard they work (Figure 1.6). A crisis can occur as a result of the nature of apparel product development, entrepreneurial growth, employment of individuals who lack managerial skills, or lack of understanding about the entire process. For instance, most employees would feel crisis if they walked into work and learned that the company had just filed for bankruptcy. An individual's common reaction would be a feeling of insecurity, fear of job loss and not finding another job quickly, and fear of not receiving pay.

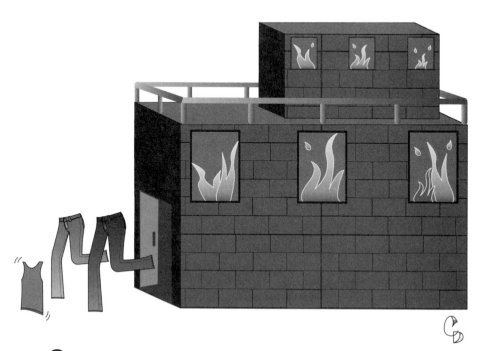

Figure ❶.❻ Crisis, an emotional and dramatic event, such as when a company's product catches on fire. *(Illustration by Christina DeNino.)*

Activity **1.3** *Distinguishing between Chaos and Crisis*

Chaos and *crisis* are not synonymous. In your journal or sketchbook, do the following:

● Write about a chaotic event that you were or a friend was involved in.
● Write about a crisis in which you thought you were in an uncontrollable situation.
● Describe how you felt during the crisis and chaotic situations.

The apparel industry changes quickly, and executives such as Ron are caught off guard. Executives' lack of preparedness for the unexpected can lead to crisis, such as when Rare Designs had declining profits and Ron was operating in an out-of-control crisis mode. Retail store mergers can easily cause chaos and sometimes crisis events for apparel manufacturers. One example of chaos created by a retail store merger is the acquisition of May Department Stores' 500 department and 800 bridal stores by Federated Department Stores, Inc. ⬆. Large retail mergers such as this take multiple years to sort out—from rebranding to closing stores to integrating merchandise assortments. Federated's acquisition of May Department Stores Inc. resulted in rebranding stores such as Robinsons-May, Rich's, and Marshall Fields to the Macy's nameplate. Federated also closed 80 of May's department stores and disposed of its bridal operations. Acquisitions such as this place the apparel manufacturer executives who sold to May Department Stores in a chaotic position. As noted by Federated in 2006, when one corporation acquires another, buyers integrate existing merchandise assortments. They often cancel or renegotiate open orders from apparel manufacturers who provided product to the acquired company. Thus, an apparel vendor who may have had a long history of selling to an acquired retail customer may no longer be able to sell product to the new corporation (SEC 2006). Some executives focus on the immediate and put out fires and fight retail customers who make demands such as charge-backs. A **charge-back** is a penalty charged by a retail customer or a factor to an apparel manufacturer after the receipt of goods. A retail **customer** is a business that buys an apparel manufacturer's product. A retail customer can charge back an apparel manufacturer when it ships products late, does not meet gross margin requirements, has poor sell through, or deviates from specifications. A **factor** is a business that floats credit to manufacturers for purchase orders. For instance, a manufacturer sells product at a trade show, and retail buyers purchase product. This merchandise will ship in 6–12 weeks, and the retail buyer negotiates when he or she will pay—for instance, net 30 days. A manufacturer may need money for cash flow, so it may sell invoices to a factor, which gives it a cash advance. If the retail customer pays late, the factor charges back the manufacturer for late payment. Although numerous reasons can be cited for why a charge-back occurs, a primary reason is that executives do not effectively manage product development. Envision a situation in which your largest customer cancels multiple upcoming orders because your company has been shipping late. Late shipment is due to a breakdown in the process—for instance, if a firm does not have a calendar for designers to adhere to. Late shipments often result in excessive customer charge-backs and the need to off-load merchandise at 10 percent of its value to discounters. If a company manufactures merchandise globally, the apparel firm must accept shipment from contractors. At California Fashion Association panel presentation ("Chargeback Reform: Current Legal Issues") in Los Angeles, CA, the panelists said that this lack of

adhering to deadlines escalates problems. For instance, if apparel associates order raw materials late, the contractor receives the materials late, and, consequently, the product ships late.

An apparel company's profitable success hinges on its managers' ability to operate an effective product development process. For instance, a men's designer may choose to create a 100 percent cotton fine-gauge sweater worn with a polo shirt and chino pants. Different countries specialize in the manufacture of different garment styles. For instance, in an interview with the author, the owner of Straight Down, Michael Rowley, acknowledged that his company, is now coordinating production among multiple countries to produce a single coordinate outfit. Although manufacturing in foreign countries is not a disadvantage, product line coordination and timing can be difficult. If the manufacturer ships one of the coordinate pieces late or incomplete, the retail customer not only will charge the manufacturer back for the full shipment, but also may sever relations and not place any future orders. If the design team consistently makes late decisions, the potential to create an out-of-control product development process escalates. This situation can lead to rush orders, more mistakes, change orders to substitute raw materials, and termination of employees—all of which result in deviations from original invoices. At the panel presentation mentioned in the preceding paragraph, the panelists confirmed that whenever a change occurs, it creates a potential charge-back situation, which in turn increases costs. Thus, a successful process depends on understanding the complexity of product development, understanding consumer preference, and hiring educated employees.

Apparel Product Development Framework and Timing

Product development requires organizing and coordinating people and integrating business units to meet strategic design objectives (Galbraith, Downey, and Kates 2002). Design process and thinking is the framework for the product development process. **Design process** is the six steps product development associates take to complete activities: This process starts with management associates' developing design and business goals and creating design objectives, called *goal analysis*. This step provides the foundation for product development associates to *analyze the design problem*. *Searching for a solution* is at the core of trying to achieve a strategic advantage. *Decision making* involves many suppliers, customers, and product development associates. *Illumination* is a designer's final decision; it synthesizes inspiration and ties design into the company strategy. The product then becomes available to the market at the *verification phase*. The design process explained in Chapter 5, describes these six steps. Although individuals often like linear, orderly processes, the design process is a chaotic, nonlinear, nonsequential process that requires multiple reiterative cycles.

Developing a product line is an ongoing, continually changing process. Product development associates traditionally use a time-and-action calendar to prepare products for line release and to determine the number of products to be ready for a set seasonal release. The traditional design and development business model is a 9-month cycle (Ghemawat and Nueno 2003). For these traditional companies, line development begins 8–12 months before delivery (Frings 2005). However, because retail customers desire

continual freshness, constant development and change is made to intersperse products throughout a seasonal release. As mentioned previously, companies such as ZARA promote a fast cycle time in which they design, produce, and deliver within 4–5 weeks (Ghemawat and Nueno 2003).

Once designers finalize decisions, they involve many support people in evaluating and making design decisions. The support associates involved include those from textile sales, CAD art, technical design, forecasting, and first pattern making. The design team's planning depends on the fabrics used and the locale of garment manufacture. At an American Apparel & Footwear Association presentation in San Pedro, CA, Port of Los Angeles Marketing Manager Marcel Van Dijk confirmed long lead times. For example, manufacturing garments in Asia and transporting the shipment to the retail customers' distribution center or store typically takes 90–95 days. The garments take 40 days to produce, 40 days to ship, 5–10 days to process through port of entry, and an additional 5 days for transport across the country (i.e., 90–95 days). He said that production in Asia and many other countries back up development more than 90 days to accommodate production and transportation time. One senior partner noted that time efficiency is the only way American manufacturers can compete: "At American Apparel we control production time by being vertical, thus, if there is an emergency order, we can cut, sew, and ship within 48 hours."*

For such a vertical situation to be implemented, the design team must be timely and organized—must have the design developed, the pattern created, samples tested and approved, and fabric and trim available. An important part of this phase is that suppliers are hard at work assisting design and merchandising associates. The various segments of fiber, textile, garment, trim, and service suppliers depend on one another. A good partnership agreement between an apparel manufacturer and its suppliers is vital to success, especially during the remaining product design phases.

The Need for a Strategic Design Plan

As a fashion student, you may think, "I know how to sketch and sew; what else is there?" However, simply creating apparel concepts is not product development. In fact, sketching and sewing have little to do with developing a successful product. Rather, companies need to plan design strategically. Sir Francis Bacon's (1597) quotation "Knowledge is power" is truly applicable to product development. **Strategy** is a company's vision, direction, and competitive advantage. Without knowledge, a company's strategy will be poor. As mentioned previously, complacency is a another risk (Heskett 2002).

Paul Charron, CEO of Liz Claiborne, commented that an apparel item is a product. It is not magical or mystical. Rather, apparel associates must analyze consumer needs and build a product to meet a specific target market. The traditional belief that apparel design is 90 percent art and 10 percent science is not valid in the current competitive marketplace (Agins 2006).

*Reprinted by permission from Sang Ho (Sam) Lim, senior partner, American Apparel, Los Angeles, CA; pers. comm., May 13, 2005.

Strategic Design Plan

- *Research trends*
- *Take an inspirational shopping trip*
- *Sketch ideas*
- *Consult with design team*
- *Choose colors*
- *Make samples*

Figure 1.7 Anne's visualization of what a strategic design plan entails. *(Illustration by Alison Flanagan and Suzette Lozano.)*

Some individuals associate design strategy with drawing or illustration. However, design is the preliminary study and plan to create a product or a service. Companies face harsh global competition. If a company does not develop a product that people want, it will not stay in business (Perks, Cooper, and Jones 2005). To survive, companies must emphasize innovativeness and creativity (Heskett 2002). The **strategic design plan,** part of strategic decision making, defines a company's uniqueness (Figure 1.7). A strategic design plan identifies what an organization is good at and conveys a clear direction. Executives measure design strategy by asking, "Are we efficiently making, delivering, and serving our core activity?" (Glass 1996). One component of the strategic design plan is that managers consider the role of how design interacts in the product development process. Managers nurture designers' skills, with the primary goal that they develop profitable products (Perks, Cooper, and Jones 2005). A strategic design plan relies on its *creative assets*—associates who can turn ideas into valuable products (Florida and Goodnight 2005). Addressing design in the strategic design plan is especially important because a designer often acts as the conduit for product development activities. Small changes that a designer makes can have a tremendous impact on product development.

The strategic design plan addresses how a company handles the design function. Designers can play one of three general roles: a functional specialist, part of a multifunctional

team, or a process leader. Traditionally, in apparel, designers are functional specialists. A *functional specialist* company assigns market identification and idea formulation to the marketing department. These designers receive initial ideas then conduct their own research and individually create ideas. Company executives restrict their design activities according to perceived commercial risk. In a *multifunctional team* environment, designers lead idea generation. These designers' primary role is communication; they also support interfacing among different functional units. For instance, they communicate directly with the pattern-making, technical design, production, and marketing departments. These designers are involved in the entire design-through-production process and are often involved in solving production problems. In a *process leader* approach, designers drive the entire product development process. They interact with customers and consumers and provide new perspectives. They are directly involved with manufacturing and product marketing (Perks, Cooper and Jones, 2005).

From the strategic design plan, company executives hire designers who have a specific set of creative skills. Companies that employ functional designers focus on traditional design skills such as having a good sense of aesthetics, being able to visualize ideas, and having technical skills (Florida and Goodnight 2005). Designers in functional design positions have varying levels of design and production involvement. A functional design position requires potential applicants to have technical skills such as knowledge of computer graphic programs, sketching ability, sewing ability, and pattern-making skills. This position also requires aptitudes of being creative, having the ability to work under pressure, and being able to work long hours to meet production deadlines (U.S. Bureau of Labor Statistics 2006–2007). Companies that desire designers to be a part of a multifunctional team emphasize communication skills, formal training, and teamwork skills. Such designers must understand the functional processes within an organization so that they can use this information to create designs (Florida and Goodnight 2005). Apparel organizations that hire designers to be a part of a team use key phrases in job ads, such as *ability to conceptualize, understand the design process, organize, manage time,* and *communicate.* A process leader company requires a designer to observe research, analyze business reports, communicate effectively, and interpret trends. Some process leader firms also want designers to be able to persuade, motivate, and become involved in relationship management (Florida and Goodnight 2005). Advertisements for job openings in a process leader firm included key phrases such as *self-starter, strong teamwork ability,* and *strong organization skills* to ensure that designers can oversee line execution from concepts through finished product. Designers also need strong sales and presentation skills to persuade management to adopt their designs. In addition, the increasingly international nature of the business requires designers to have good communication skills with global suppliers, contractors, and retail customers (U.S. Bureau of Labor Statistics 2006–2007).

SUMMARY ▬▬▬▬▬▬▬▬▬▬▬▬▬▬▬▬▬▬▬▬▬

Apparel product development is a process in which individuals visualize ideas and develop them into salable products. This nonlinear process is complex because of factors such as the nonlinear life span of products, product diversity, seasonality, the use of multiple raw materials, and consumer expectations. These transient factors are often the impetus for

individuals to work in apparel product development and for companies to strive for a smooth-running process. A crisis can occur when individuals do not separate process activities from an individual's reaction to multiple chaotic events. An apparel manager's goal is to avert a crisis and to make the product development process run smoothly.

As we progress in our study, we will explore the various product development stages and decisions made, which will enable us to create a strategic design plan. Subsequent chapters cover product development activities and the specific decisions apparel associates make. The information presented in subsequent chapters also details the interconnections of inputs and constraints needed as a design goes through the development process. The next chapter covers directives that guide the entire product development process.

PRODUCT DEVELOPMENT TEAM MEMBERS

The following product development team members were introduced in this chapter:

Apparel associates: People who work in or support product development. These individuals consist of company employees, suppliers, consultants, and service providers.
Designer: A creative individual who generates salable concepts.

KEY TERMS

Apparel: Any covering worn on a person's body.
Apparel product development: The use of a company strategy to generate design concepts that are developed from a simple idea to a more complex stage to produce a salable apparel product. This process involves the organization and coordination of people, machines, and processes.
Chaos: A nonlinear process in which events are in disorder, unstable, and diverse.
Charge-back: A penalty charged to an apparel manufacturer or supplier after the receipt of goods.
Consumer: An individual who wears or uses a product.
Consumer choice: Buying decisions consumers make. It is unpredictable and adds complexity to the product development process.
Crisis: An emotionally stressful or traumatic situation in which people in an organization need to avert disaster.
Customer: A business that buys an apparel manufacturer's product.
Design process: Six steps product development associates take to complete creative activities.
Design thinking: When designers use their senses, especially vision, to be inspired by objects. The individual goes into a deep concentration to enable his or her brain to manipulate impressions of visual media seen.
Development: To make, to become more mature or more organized.
Factor: A business that advances money to manufacturers for purchase orders.
Knockoff: An almost-exact copy of an original design.
Linear change: A cause-and-effect change in a company's competitive position (e.g., decrease in market share).

Multiple raw materials: The wide variety of materials used to make an apparel product. They add complexity to the product development process.

Nonlinear changes: Events that are difficult to predict.

Nonlinear life span: The different expectations a consumer has for how long different apparel items should last.

Product: Any object or service produced.

Product development: The activities, tools, and methods that translate customer needs into new or revised designs.

Product diversity: The breadth of available apparel products.

Seasonal: When products are sold to retailers on the basis of the seasons: winter, spring, summer, fall, and resort or holiday. This traditional selling practice requires apparel manufacturers to adjust product lines for seasonal diversity in construction techniques, garment style variation, and material types.

Strategic design plan: How a company addresses the design function—as a functional specialist, as part of a multifunctional team, or as a process leader.

Strategy: A company's vision, direction, and competitive advantage.

Torque: The twisting of a garment that occurs when the lengthwise grain is not parallel and the cross-grain is not perpendicular to the selvage (Brown and Rice 2001).

WEB LINKS

Company	URL
Federated Department Stores, Inc.	www.fds.com/home.asp
Heartbreaker Fashions	https://shop.heartbreakerfashion.com
Innovo Group Inc.	www.innovogroup.com
Prada	www.prada.com
To the Max!	www.tothemaxusa.com
Warnaco Swimwear Inc.	www.warnaco.com
ZARA	www.zara.com

REFERENCES

Agins, T. 2006. Fashion designer. *Wall Street Journal*, February 6, B1, B4.

American Marketing Association. n.d. *Dictionary of marketing terms.* http://austin.marketingpower.com/mg-dictionary.php.

Bacon, Sir Francis. 1597. *Meditationes sacrae, de haeresibus* [Religious meditations, of heresies]. http://en.wikiquote.org/wiki/Francis_Bacon.

Brown, P., and J. Rice. 2001. *Ready-to-wear apparel analysis.* 3rd ed. Upper Saddle River, NJ: Prentice Hall.

Brunnermeier, S. B., and S. A. Martin. 1999. *Interoperability cost analysis of the U.S. automotive supply chain.* National Institute of Standards and Technology (NIST) planning report 99-1. http://www.nist.gov/director/prog-ofc/report99-1.pdf.

Carter, D. E., and B. Stilwell Baker. 1992. *Concurrent engineering: The product development environment for the 1990s.* Reading, MA: Addison-Wesley.

Carver, G., and H. Bloom. 1991. *Concurrent engineering through product data standards* (NISTIR 4573). Gaithersburg, MD: National Institute of Standards and Technology.

Dictionary.com. n.d.(a). Crisis. *The American heritage dictionary of the English language.* 4th ed. Boston: Houghton Mifflin, 2004. http://www.dictionary.reference.com/browse/crisis. (accessed March 21, 2007)

Dictionary.com. n.d.(b). Develop. *WordNet 2.1.* Princeton University. http://www.dictionary. reference.com/browse/develop. (accessed March 21, 2007)

Dictionary.com. n.d.(c). Development. *Dictionary.com unabridged.* Version 1.1. Random House. http://www.dictionary.reference.com/browse/development. (accessed March 21, 2007)

Dictionary.com. n.d.(d). Product. *Dictionary.com unabridged.* Version 1.1. Random House. http://www.dictionary.reference.com/browse/development. (accessed March 21, 2007)

Florida, R., and J. Goodnight. 2005. Managing for creativity. *Harvard Business Review* 83:125–31.

Frings, G. S. 2005. *Fashion: From concept to consumer.* 8th ed. Upper Saddle River, NJ: Prentice Hall.

Gaddis, P. O. 1997. Strategy under attack. *Long Range Planning* 30:38–45.

Galbraith, J. R., D. Downey, and A. Kate. 2002. *Designing dynamic organizations: A hands-on guide for leaders at all levels.* New York: American Management Association Communications (AMACOM)/American Management Association.

Ghemawat, P., and J. L. Nueno. 2003. ZARA: Fast fashion. *Harvard Business Review,* April 1. Reprint No. 9-703-497.

Glass, N. 1996. Chaos, nonlinear systems, and day-to-day management. *European Management* 14:98–106.

Goodstein, L. D., T. M. Nolan, and J. W. Pfeiffer. 1993. *Applied strategic planning.* New York: McGraw-Hill.

Grove, A. 2003. Churning things up: Innovations with the power to transform entire industries are the Holy Grail of business strategy. Unfortunately, the innovators don't always survive. *Fortune,* August 11, 115–18.

Handfield, R. B., and E. L. Nichols. 1999. *Introduction to supply chain management.* Upper Saddle River, NJ: Prentice Hall.

Heskett, J. 2002. *Design: A very short introduction.* New York: Oxford University Press.

Hotz, R. L. 2005. Searching for the why of buy. *Los Angeles Times,* February 27, sec. A.1.

Human Resources Leadership Council. 2004. Global product development: Building a great process. Presentation given at the American Apparel & Footwear Association (AAFA) Human Resources Leadership Council meeting, April 28–May 1, Rio Grande, Puerto Rico.

Iannazzone, R. 2004. The global generation. Presentation given at the 2005 American Apparel & Footwear Association (AAFA) Human Resources Leadership Council meeting, April 28–May 1, Rio Grande, Puerto Rico.

Innovo Group Inc. 2006. Innovo Group announces series of strategic initiatives. Press release. April 3.

Keiser, S., and M. Gardner. 2003. *Beyond design: The synergy of apparel product development.* New York: Fairchild.

Levi Strauss & Co. 2005. *Levi Strauss & Co. 2005 annual financial report.* San Francisco: Levi Strauss & Co.

Market Wire. 2005. Innovo Group's Joe's Jeans on track for early spring delivery of men's denim collection. Press release. October 27.

Murphy, P. 1996. Chaos theory as a model for managing issues and crises. *Public Relations Review* 22:95–113.

NPD Fashionworld. 2005. Despite obstacles, consumers will still spend this holiday season says NPD survey. Press release. October 5.

NPD Fashionworld. 2006. NPD reports U.S. apparel industry posts growth second year in a row. Press release. February 21.

Perks, H., R. Cooper, and C. Jones. 2005. Characterizing the role of design in new product development: An empirically derived taxonomy. *Journal of Product Innovation Management* 22:111–27.

Peters, T. 1992. *Liberation management: Necessary disorganization for the nanosecond nineties*. New York: Knopf.

Product Development and Management Association (PDMA). n.d. *The PDMA glossary for new product development*. Mt. Laurel, NJ: PDMA. http://www.pdma.org/library/glossary.html.

Regan, C. L. 1997. A concurrent engineering framework for apparel manufacture. PhD diss., Virginia Polytechnic Institute and State Univ.

Retail Forward. 2003, April. *Twenty trends for 2010: Retailing in an age of uncertainty*. Columbus, OH: Retail Forward.

U.S. Bureau of Labor Statistics, U.S. Department of Labor. 2006–2007. Fashion designers. In *Occupational outlook handbook, 2006–2007 edition*. Washington, DC: U.S. Bureau of Labor Statistics, U.S. Department of Labor. http://www.bls.gov/oco/ocos291.htm.

U.S. Census Bureau. 2000, December. *Current industrial reports: Manufacturing profiles: 1998*. Washington, DC: U.S. Census Bureau. http://www.census.gov/prod/www/abs/mfg-prof.html.

U.S. Census Bureau. 2002. *2002 NAICS codes and titles* (315 Apparel Manufacturing; 4243 Apparel, Piece Goods, and Notions Merchant Wholesalers; and 448 Clothing and Clothing Accessories Stores). Washington, DC: U.S. Census Bureau. http://www.census.gov/epcd/naics02/naicod02.htm.

U.S. Census Bureau. 2006, June. *County business patterns: United States: 2004*. Table 2. United States—Establishments, employees, and payroll by industry and employment size of establishments for the United States: 2004. Washington, DC: U.S. Census Bureau. http://www.census.gov/prod/www/abs/cbptotal.html.

U.S. Securities and Exchange Commission. 2006, December 7. *Form 10-Q: Quarterly report pursuant to section 13 or 15 (d) of the Securities Exchange Act of 1934, for the quarterly period ended October 28, 2006, Federated Department Stores, Inc.* Washington, DC: U.S. Government Printing Office. http://www.sec.gov/Archives/edgar/data/794367/000079436706000217/0000794367-06-000217-index.htm.

U.S. Securities and Exchange Commission. 2007, February 9. *Form 10-K: Annual report pursuant to section 13 or 15 (d) of the Securities Exchange Act of 1934, for the quarterly period ended November 25, 2006, Innovo Group Inc.* Washington, DC: U.S. Government Printing Office. http://www.sec.gov/Archives/edgar/data/844143/000111046590700909/0001104659-07-009090-inex.htm.

Warnaco Group, Inc. n.d. *Warnaco 2004 annual report*. New York: Warnaco Group, Inc. http://www.warnaco.com/index.cfm/category/5/section/32/content/162/.

Developing a Company Strategy

THE VISION AND THE MISSION

A few days later, Kate passes the Johnson Street shopping district, which has dozens of restaurants, galleries, theaters, and boutiques, before she turns toward the industrial section of the city and heads to Rare Designs' corporate headquarters. Entering the parking lot, Kate hears the backup beeps as two big rigs are moving up to the loading docks. Rare Designs is located in a large, contemporary office building. Inside, this urban space is replete with tin ceilings, maple floors, and skylights. It has a casual, yet sophisticated, ambience. The interior has obviously been professionally designed with strong attention to detail. Behind the receptionist's desk is an impressive exposed brick wall reaching up two stories. The company's gold logo stands out against the contrast of the brick.

Kate walks up to the desk. "Good morning. I'm Kate Roberts. I have an appointment with Ron Templeton," she says.

The receptionist is on the telephone and appears to be paying bills. She quickly puts the caller on hold and pages Ron.

While waiting, Kate looks around the impressive space and notices a photograph on the adjacent wall.

"Hello, Dr. Roberts. It's good to see you again," Ron says, entering the reception area.

"Oh, just call me Kate," she replies.

"I see you've noticed the photograph of our first office building. It was an old warehouse in an industrial area. We always want to remember Rare Designs' heritage. It was a big deal when we built this building about 6 years ago.

"I feel as if I've entered a nineteenth-century loft," Kate says. "The exposed brick and skylights make this a really great space. So how are you? Are you ready to get to work?"

As they head toward Ron's office, Kate notices the respect Rare Designs' employees have for their boss. It is evident in the way they glance and smile at him as he walks by. He pauses at a young woman's desk and says, "Janey Lee, I see you're back at work. We've missed you. Are the twins feeling better?" When this brief visit ends, he and Kate proceed to his office, which is masculine and disorganized. He moves some clutter on his desk to get to the telephone. "I'm eager for you to meet Anne," he says. "She is as much a part of this business as I am."

Minutes later, Anne arrives. Kate first notices Anne's vintage crystal earrings as she gracefully enters the room. She is wearing a striking pink-and-cream floral Tencel shirtdress. Before Ron can introduce the two, Kate says, "I love your outfit. Is it a Gina Gray?"

"Thanks," Anne answers,"I love Gina Gray. Actually, this is one of my own designs." The tall, slim 39-year-old shakes hands with Kate and they settle into comfortable leather chairs.

"So, Kate, where do we start?" Ron asks.

"Let's begin with a few questions that may help me get a feel for your understanding of product development. What is Rare Designs' strategy?"

Ron grins and says, "To be successful and to make money!"

"You may have heard of Patrick Dixon, a famous business author," Kate says. "His words are applicable here: 'You can have the greatest strategy in the world, but what is the point if no one cares?' *Ron, it's obvious that your employees respect you, but are you all on the same team? Do they clearly understand the purpose of your business? Strategy guides a company's efforts. Every employee should be able to answer the question 'What do we offer that our competitors do not?'"

"In the past, we were known for our unique designs," Anne replies. "I liked to call it 'practicality with a twist.'"

"That's right, Anne," Kate says. "Brand recognition is essential and creates consumer loyalty. Strategy begins with creating well-defined vision and mission statements. Tell me: What is Rare Designs' vision?"

"Vision?" Ron's face becomes serious. "Our vision is to provide, globally, the highest-quality brand apparel with superior customer value to consumers of all ages."

Tapping her pencil on her notepad, Kate says, "That includes everyone in the world; but what does it mean?"

Looking confused, Ron answers, "We will provide high-quality apparel to anyone."

Anne jumps in, "Ron, get real! We don't design for children, men, or teens. Our focus has always been women's apparel."

"Does your vision statement provide clear, easily understood future goals?" Kate asks. "And does it state unique competencies?" She pauses. "Okay, before we discuss your vision statement, we need to define your mission statement."

"Isn't a mission statement the same thing as a vision statement?" Ron asks, thoroughly confused by now.

"In the business world, they are two separate focuses," says Kate. "Your vision is your future, and your mission statement reflects why your company exists, what its function is, and how your vision will be implemented."

Glancing skeptically at Kate, Anne asks, "What do vision and mission statements have to do with designing products?"

"Well, customers judge Rare Designs' products according to how well they think the products match the company's mission," Kate says.

"How do our customers know what our mission is?" Anne asks.

"You convey your mission to your customers by your actions, your heritage, and the products you offer them," Kate replies.

"You mean my designers can't have freedom to be creative and design what they want?" Anne cries.

"No, they cannot. Creativity is important, but the bottom line is that your designs must sell."

*Quotation in Patrick Dixon, *Building a Better Business* (London: Profile Books, 2005), 233.

Ron interjectes, "We know that all too well. Anne presented a line to our retail customers last season, and they told us flat out, 'Your product line is too contemporary, and the price point is too high. Our customers aren't ready for such drastic design changes.' Anne and her team reworked the line, but by doing that, we ended up shipping orders way behind schedule. Consequently, our retail customers refused the orders and we had to dump everything at a discounter. Although we were relieved to sell our goods, it meant losing most of our profit."

Kate responds, "Our challenge is this: to work together to develop a strategy that projects a positive future direction for Rare Designs. Ron, your assignment is to write your vision statement, then your mission statement. And you'll do it—with my help."

"As I understand it," Ron says, "a vision statement and a mission statement are just the beginning. You said earlier that we translate our vision and our mission into strategies, which is a written report that analyzes our company's product lines. Whew, that sounds like a lot of work." He leanes back in his chair.

Anne says, "I'm confused! I'm still having a problem connecting our company's vision and mission statements with product design. How do the first two influence the latter?"

Kate sees that this road might have a few twists and turns along the way. She patiently answers, "As Rare Designs' partners, you and Ron need to translate your vision and mission statements into a core strategy, which is a product, an operations, or a customer strategy."

"Doesn't having a formal core strategy infringe on a designer's creative freedom?" Anne asks.

"Interesting question," Kate answers. "The answer is yes and no. Any company strategy impinges on creative freedom. However, you must keep in mind that you are designing apparel for your consumers, not just your designers' preference. A core strategy provides guidance, a purpose, and a yardstick by which to measure successful designs. The product development team's objective is to design products that meet those needs."

Anne, nodding her head, looks at Ron and says, "I understand where she's going, Ron. What I'm beginning to see is that I need to put this information down on paper so that, **going forward**, my associates' decisions will be consistent with my design direction. It will help me because I won't have to correct my design team's mistakes."

Kate smacks both hands on the arms of the leather chair and says, "Exactly! If a product line is developed without clear direction, it will not sell, because the design team didn't have a finger on the pulse of its consumer." Pointing to Anne, she says, "So, Anne, your job is to put your strategies in writing and to assign responsibilities to your product development associates."

Anne gives a tight smile. "That I can do; I'm good at telling others what to do," she says.

Grinning, Ron agrees. "She sure is—She tells me what to do all the time."

It is time to break for lunch. The women head out as the telephone on Ron's desk rings. The caller is Richard Cooper, the president of RAC industries. "Hello, Richard! Thanks for returning my call. Kate Roberts has been here all morning. You remember the professor that Mr. O'Dale asked to mentor us? Yes, it's going well except I'm confused at this point. We've been talking about strategies and mission statements." He listens to Richard's response and says, "Oh, I think I get it; you're saying that core strategies detail how a company will achieve its goals. So, if we

make an improvement, in all likelihood our competitors will be making a more significant improvement. If we want to offer the highest-quality brand apparel with superior customer value, we need to prove to consumers that we actually offer these attributes. Wow, I think we need to start working on our strategy right now. Thanks for the call, Richard."

After lunch, the meeting reconvenes. Ron shares the highlights from his talk with Richard Cooper and reiterates the need to develop their strategy immediately.

"We have to start working on our company strategy right now? Our fall line is going to be released next week!" Anne says, panic clearly written on her face.

Kate sets her pad and pen on Ron's desk and gives Anne a direct look. "Think about it this way: Rare Designs is operating in a crisis state right now. When you work in a crisis state, you create additional work. By having a clear strategy and writing your vision and mission statements, you prevent crisis. So although writing your strategy seems overwhelming, it is actually a preventive measure. You cannot drop everything and change tomorrow—You're right. So you develop a time line in which your company can make the transition productively yet efficiently."

Ron feels beads of perspiration starting to form on his temples and asks, "What happens when a company doesn't have a strategy?"

"The product development process goes into crisis mode, products are shipped late, and ultimately sales and profit decline," Kate replies. "So, let's roll up our sleeves and get to work!"

Later, Ron hunches over his desk as he crumples and tosses another wad of paper onto the floor. "Who needs a vision statement? What I need is another hot seller that all our customers just have to have!"

"What are you trying to do?" Anne asks. "Create Mount Everest out of paper?"

"Yeah, well, you try writing the vision and mission statements!" Ron exclaims.

Anne offers, "Rare Designs' vision is to provide unique, art-inspired, youthful, professional women's clothing that help them perform their jobs better."

"OK, smarty-pants, are you going to tell me that came out of your head magically—just like that," Ron snaps his fingers at her, "while I've been sweating bullets over this?"

"Of course . . . I am the creative one; remember?" Anne teases.

Objectives

After reading this chapter, you should be able to do the following:

- Write a vision statement.
- Write a mission statement.
- Understand how apparel companies create an identity for a specific target consumer.
- Write a description of an apparel company, its target consumer, and the products it has designed.
- Write a core strategy from a product, an operations, or a customer perspective that corresponds to your company description.

Success for an individual or an apparel company is not achieved magically. Any individual can dream, but most successful business people have a specific vision. A few individuals will gamble with no strategy, adopting the ideology "Who has time to create a plan when you are in the thick of things?" Often, these individuals fail. Successful business executives frequently attribute their success to developing a focused plan, executing plans better than their competitors do, and keeping a close eye on their strategic plan when chaotic events change the marketplace.

Developing a company strategy is a comprehensive activity that many apparel companies describe in their annual reports. Common strategic activities include developing an overall company strategy, writing a vision statement, writing a mission statement, and selecting a core strategy. Figure 2.1 is a flowchart that graphically represents these activities. A **flowchart** shows a process (Wikipedia contributors n.d.[a]). **Process theory** says that an activity, such as design, has inputs that, when conducted, lead to certain outputs (Wikipedia contributors n.d.[b]). Apparel associates do not necessarily complete the flowchart activities in sequence, because, as Chapter 1 conveys, product development is a chaotic process. On a flowchart, annotations of *yes* and *no* indicate whether an individual can continue forward or must loop back through a sequence of decisions.

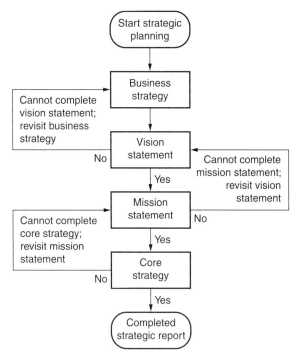

Figure 2.1 Flowchart of primary activities a company must complete to create a company strategy. *(Illustration by Karen Bathalter.)*

Company Strategy and the Product Development Process

Strategy is an integral component to a company's success that is a discipline in itself.* The focus of this chapter is to learn how a company strategy directs the product development process. Product development directives include vision and mission statements and core strategies. A company strategy provides insight into the importance new products play in corporate growth.

You may question the need to understand *vision, mission,* and *core strategy* because your ideal is to design clothes, or you may share Ron's goal for Rare Designs: "To be successful and to make money." However, to attain success, company associates must be convinced that products will sell, make a difference, and be superior to existing products. Profit is the result of a company's strategy; it is not a company's sole purpose. By having a strategy, a company can efficiently serve a market, anticipate market behavior, and have the infrastructure (e.g., machinery) necessary to meet market demands (Robert 2000). A company determines its strategy according to how it views itself. An obvious example is an apparel manufacturer that views itself as a clothing producer; however, companies view themselves in many ways. Some companies see themselves as a provider of a service of economic value (Markides 2000; Robert 2000). Byer California 👕 is an example of an economic value provider whose company strategy is to enable their consumers to have fashionable styles quickly in a budget price range. Byer's designers develop budget-priced children's, juniors, and misses' clothing designs from existing designs that they knock off (Byer California n.d.). Operations and production associates then work in a short time frame to "byerize" garment designs. According to Vice President of Operations Bill Scott, in a conversation with the author in October 2002, the company term *byerize* means they react quickly to efficiently manufacture garments to meet lower-cost targets.

Strategy must guide a company's efforts. Without a plan, the vision statement and company strategies are simply words on paper. To create successful products, associates must be able to state the company's mission and to describe how their job relates to achieving company goals (Harvard Business School 2005). Company associates must link the strategy with product development. Company strategy, defined by a company team, has three primary purposes: to define which markets the company will target, to determine the products offered to the company's target customers and consumers, and to provide an infrastructure that supports the company strategy (Markides 2000; Wery and Waco 2002–2003).

Company executives use company strategy to guide product design and development. For example, The Gap, Inc.'s 👕 strategy for its three main divisions—Gap, Old Navy, and Banana Republic—is entrepreneurial, allowing each division to have its own passion, creativity, and energy. The corporate goal is to deliver flexible offerings of style, service, and value to its consumers. Division executives interpret the corporate strategy to meet individual target markets, to determine the merchandise mix, and to meet marketing needs.

The Gap, Inc.'s entrepreneurial strategy provides its product development teams with clear direction: The Gap division focuses on casual clothes in which designers update best-selling styles, colors, and fabrics (Gap Inc. n.d.[c]). Its product line features casual classic apparel styles in all categories (Gap Inc. n.d.[e]). Banana Republic's vision is casual

*See the following texts on strategy: Gill, Nelson, and Spring (1996); Markides (2000); Robert (2000); and Wery and Waco (2002–2003).

luxury, emphasizing sophisticated, fashionable collections of tailored and casual clothing, and Old Navy's vision is to provide value for the whole family in an innovative shopping environment (U.S. Securities and Exchange Commission [SEC] March 28, 2006).

Old Navy's Web site and advertising consistently emphasize value pricing (Old Navy n.d.). Product development associates also aim to make consumers' shopping experience innovative and analogous to participating in fun activities (such as sports). To help accomplish this goal, they use bright, contrasting colors. Thus, during design review, Old Navy product development associates could evaluate designs by asking, "Will our consumers view this product as having value?" "Does it inspire our consumers?" "Can we show this product in an innovative manner?"

ACTIVITY 2.1 *Determining Company Strategy*

Look at Old Navy's Web site: www.oldnavy.com/browse/home.do.

- How does Old Navy achieve value?
- Identify three innovative product designs.

Look at Banana Republic's Web site: www.bananarepublic.com/browse/home.do.

- How does Banana Republic convey sophistication?
- Look at the zoom detail of Banana Republic products. How do they reveal quality construction?

Having a company strategy is essential, but it does not guarantee success. For example, Warnaco Group, Inc. 👕, is a huge apparel company, with 2006 net revenues of $1.8 billion, that sells highly recognized brand names such as Calvin Klein sportswear, Speedo and Catalina swimwear, and Warner's lingerie. Warnaco Group, Inc., underwent chapter 11 reorganization in 2002 after filing for bankruptcy in June 2001. Reorganization takes many years, and it involves risk. One reorganization effort was to revise Warnaco's mission statement to the following: "to become the premier global, branded apparel company" (SEC March 7, 2007, 36). To achieve its mission, Warnaco Group, Inc., has tried several diversification strategies and groups its brands into core, fashion, and designer brands. Some of Warnaco Group's diversification strategies have been successful, whereas others have not: In particular, the Calvin Klein European jeans sportswear and accessories acquisition has been a fruitful business venture; however, the purchase of OP (i.e., Ocean Pacific), A•B•S by Allen Schwartz, J.Lo by Jennifer Lopez, and Axcelerate has not (SEC March 7, 2007).

Company executives who do not have a strategy are gambling with high stakes. When a company does not have a good strategy, employees are unfocused, are indecisive, do not time product introduction correctly, and are impatient for results. Operationally, such a company has unclear planned targets and lacks direction. A weak company strategy does not align employee competencies or company operations with product success potential (Gill, Nelson, and Spring 1996; Wery and Waco 2002–2003).

One imperative is that apparel executives and associates use the company strategy to create company vision and mission statements. Companies create a vision so that they project a consistent image and strategy to customers and consumers. At the same time,

Figure 2.2 Representation of the idea that a product development strategy is analogous to a football strategy.

company executives want to meet consumers' needs by developing products that consumers do not currently have (Figure 2.2).

Vision Statement

Executives plan their company's future direction and goals, which they write in a **vision statement.** Embedded in a vision statement is the executives' knowledge and foresight, which are used to project the company's philosophy, beliefs, viewpoint, and character. An effective vision statement aligns a company's values with its products and brands. Although brief, a vision statement is important so that company executives can create synergy to bridge the gap that exists among the past, present, and future. Executives develop vision statements primarily to provide a common goal, and to control its destiny (Abrahams 1995; Davidson 2002; Goodstein, Nolan, and Pfeiffer 1993; Granger and Sterling 2003; Robert 2000; Williams and Smith 2003). Apparel associates recognize that controlling their

company's destiny means they do not operate in isolation; rather, they must be astutely aware of the competition and the environment. In an interview with the author, the general merchandise manager of Bronco Bookstore commented,*

> Our competition is alternate clothing styles that students wear, brands such as Abercrombie & Fitch ⬆️. Selling a brand is huge. A company, such as Abercrombie & Fitch, sells a brand as much as they sell merchandise. College students wear a uniform: Eight out of ten wear layers that consist of a tank top, T-shirt, sweatshirt, and denim. They wear layers because our weather is cold in the morning and hot midday. We always have to keep in mind that value is important, and brand is a part of value. In college, social status, talking the right way, and wearing the right clothes is very important. Now and in the future, we will focus on marketing our brand.

ACTIVITY 2.2 *Critical Thinking*

A vision statement includes a company's future direction and goals.

* What did the general merchandise manager of Bronco Bookstore state was his company's future direction?
* What is your ideal future goal for your apparel company?

Writing an Effective Vision Statement

Simply having a vision statement does not guarantee future success. An effective vision statement is clear and well written. It is successful if employees throughout an organization can use it to analyze critical issues the company faces, to create a product strategy, and to make people accountable for the future product direction (Granger and Sterling 2003; Robert 2000; Williams and Smith 2003).

As mentioned previously, executives use a vision statement to project a company's philosophy, beliefs, viewpoint, and character (Figure 2.3). American Apparel ⬆️, a blank sportswear manufacturer, did so in its 2003 vision statement:*

> At American Apparel, we make sweatshop-free T-shirts. Our goal is to seek profits through innovation not exploitation. We are not about *made in USA*. We are about American values. We believe in the American dream; we want to do more for our customers and our employees. We are pro–workers' rights—whether in Los Angeles, or anywhere in the world. We manufacture in the United States not because we are crazy flag fanatics. We manufacture in the United States, particularly Southern California, because it is the most vibrant T-shirt market in the world, and therefore the most efficient place to manufacture our T-shirts.

Clearly, American Apparel's belief is that many apparel companies benefit from exploitation. Its company philosophy and viewpoint is to *not* exploit. One goal of the

*Reprinted by permission from Clint Aase, CCR, assistant director, General Merchandise, Bronco Bookstore, California State Polytechnic University, Pomona, CA; pers. comm., April 20, 2006.
*Reprinted by permission from Dov Charney and Sang Ho (Sam) Lim, senior partners, American Apparel, Los Angeles, CA.

Figure 2.3 Interpretation of words from a vision statement representing a company's viewpoint and philosophy. *(Illustration by Christina DeNino.)*

vision statement is to enable employees to be proud of their job and company. American Apparel creates synergy by being pro–workers' rights and by manufacturing products domestically. The company is sincere about promoting American values, not about merely marketing a promotional slogan. The sincerity behind these values is what provides the synergy to its employees.

Embedded in effective vision statements are company executives' past, present, and future. Managers begin by querying about the company's past and about its current status (Robert 2000). Let us analyze Levi Strauss & Co.'s vision statement to understand how companies use the concept of the past, present, and future in a vision statement. Levi Strauss & Co. titled its vision the "LS & CQ. Way." Company executives implement this guide to direct company associates. The company's vision is this: "People love our clothes and trust our company. We will market the most appealing and widely worn casual clothing in the world" (Levi Strauss & Co. n.d.[b], 11; SEC February 12, 2003, 5).

An organization such as Levi Strauss & Co. must rely on its authenticity and founding principles to proclaim its philosophy (Collins and Porras 1996). To predict

a company's future business environment, company executives use its past foundation. Like many large domestic apparel manufacturers, Levi Strauss & Co. has undergone multiple business transformations. It started as a dry goods business in the 1850s, entered the international export business in the 1950s, introduced business casual wear in the 1980s, and most recently created distinctive products for multitier retail channels. Levi Strauss & Co. addresses its future vision of marketing "the most appealing and widely worn casual clothing" by broadening its product availability, redesigning core products, continually creating new concepts and innovations, and revitalizing styles for fit, fabric, and finishes (SEC February 14, 2006). In 2004, the company fulfilled this vision by being the number one jeans brand (NPD Group 2005). It references its past by proclaiming, "People love our clothes." A company cannot make such a statement arbitrarily, with nothing to support the claim. Levi Strauss & Co. substantiates its declaration both by citing its 150-year history and by being one of the world's leading apparel brands and creating Levi's jeans, which it says is the original, authentic, definitive jean (SEC February 14, 2006). Levi jeans have remained a symbol of American culture throughout Levi Strauss & Co.'s long history (Levi Strauss & Co. n.d.[a]). Consumer experience warrants trust in this company. In fact, some consumers swear by Levi's quality. For example, the author's father exclaimed a few years ago, "I guess it's all right that this rivet just fell off my Levi jacket; after all, it's 48 years old."* Levi Strauss & Co. supports its vision phrase "and trust our company" by developing quality products and earning consumers', colleagues', and society's trust. Company associates accomplish this by participating in and launching extensive philanthropic efforts and by implementing responsible and ethical business practices (Levi Strauss & Co. n.d.[a]).

The objective of a vision statement is to provide a company's employees with a clear direction and clear goals. A vision must enable employees to feel a sense of pride, accomplishment, and value about what they contribute to the organization. For instance Berkshire Hathaway owns Russell Corporation ⏏, a large manufacturer of athletic and collegiate apparel. (SEC March 1, 2007). Russell Corporation has the following vision: "To provide the highest quality branded and private label apparel and textiles with superior customer value and unparalleled service, globally to consumers of all ages through selected channels of distribution" (U.S. Department of Labor n.d.[a]). This company supplements its vision with the catchphrase "Do the right things for the right reasons" as part of its philosophy of corporate responsibility (Russell Corporation 2003). Russell Corporation's strong, vibrant vision statement provides employees with a clear understanding of its philosophy and a sense of pride and accomplishment.

However, more important than providing employees with direction and a sense of pride, a company must put its vision statement into practice. For instance, Russell Corporation provides "superior customer value" by favoring any vendor who exceeds its country's national legal and ethical standards (U.S. Department of Labor n.d.[a]). Thus, Russell Corporation encourages its vendors to be socially responsible and to provide better employee working conditions.

*Reprinted by permission from Ronald Regan; pers. comm.

ACTIVITY **2.3** *Examining Company Vision Statements*

A NASDAQ list of apparel companies can be found at the following Web site: www.nasdaq.com/reference/BarChartSectors.stm?page=sectors&sec=textile-apparel~clothing.sec&level=2&title=Textile%2dApparel+Clothing.

1. Go to the Web site and choose a company from the list.
2. Click on the company symbol, which is to the left of the company name.
3. Click on the Hoover's profile icon to go to the company overview.
4. Click on the company's Web site link (under the company address).
5. Click on "About us," "Corporate overview," "Investor relations," "Investor over-view," or the like. Read about the company. If the vision statement is not on that page, you may have to look at the mission statement or values statement page, or you may need to look in the company history or core beliefs section.
6. Analyze whether the company's vision is clear and well defined.
7. Look at the company's products. Do they reflect the company's vision? Why or why not?

Relating the Vision Statement to Product Development

The company **president** is responsible for aligning associates with a company's vision (Hunter 2002). Managers need to translate a vision statement into action items so that, subsequently, apparel associates can be accountable for strategic goals and objectives. A vision statement should provide clear direction for the product development team so that the products designed match the company's vision. Product development associates use the company's vision to clarify product features, target markets, customer needs, and business goals. To be interpreted properly by product development associates, a vision statement must include unique company competencies that are stable, obvious, and easily understood. Company profits decline when design and product development is misaligned with the strategy. Losing strategic focus is a common problem (Wery and Waco 2002–2003). Let us look at how the vision statement for The Gap, Inc., influenced design decisions.

The Gap, Inc.'s vision is "to be the global leader in specialty apparel retailing" (Gap Inc. n.d.[e], 5). In its 2001 annual report, the CEO for The Gap, Inc., stated, "We're committed to delivering the quality, value, style and fashion our customers expect and love from Gap, Old Navy and Banana Republic" (Gap Inc. n.d.[c], 1). However, in 2001, the CEO's letter to shareholders indicated that the company had forgotten to stay true to itself in offering consistency, simplicity, and the right product and assortment mix. In 2005, the CEO noted that the company's three distinct brands (Gap, Old Navy, and Banana Republic) were its greatest assets (Figure 2.4) (Gap Inc. n.d.[e]).

The Gap, Inc., CEO also noted that although the previous 5 years had been a challenge because consumers had not accepted the company's product mix, executives remained committed to its strategic direction (Gap Inc. n.d.[e]). The CEO said, "I'm

a

b

Figure ❷④ Comparison of (a) Gap and (b) Banana Republic merchandise.

proud that we have set the company on a course for sustainable, long-term health" (Gap Inc. n.d[e], 2). One strategic direction has been for The Gap, Inc.'s international design teams to work with its local merchandising and marketing groups (SEC March 28, 2006). For example, Old Navy's strategic direction in 2001 focused too much on teenagers and not enough on family value, so The Gap, Inc., executives repositioned Old Navy to offer value and trend-right products (Figure 2.5) (Gap n.d.[e]). Old Navy's designers now travel to factories to shorten their decision response time and bring trend items into stores faster. By revisiting The Gap, Inc.'s vision and holding true to it, Old Navy experienced a sales rebound and became the best-selling division, accounting for 47 percent of The Gap, Inc.'s net sales in 2006 (SEC April 2, 2007). One of the best compliments about a store is when a consumer states something such as this about Old Navy: "The prices, for the quality, are the best. . . . I didn't need any of this stuff, but I bought it" (Earnest 2003a, 3).

Figure 2.5 Old Navy merchandise assortment.

Implementation and change can be difficult, however. The Gap, Inc.'s CEO noted that shareholders continued to be dissatisfied with the company's business performance. Although overall The Gap, Inc., net sales have been relatively flat, Gap brand sales have significantly declined (i.e., Gap division net sales loss of $643 million between 2003 and 2006) (Gap Inc., n.d.[b]). This sales loss indicates that the Gap division continues to struggle with offering the appropriate merchandise mix to consumers (Earnest 2003a). Thus, another strategic directive for The Gap, Inc., has been to expand its brand presence. As a result, executives launched a new brand, Forth & Towne, in August 2005. It was unsuccessful and closed after 18 months (Moore 2007). To expand its brands, The Gap, Inc., then launched Piperlime 👕, an online shoe store, in October 2006 (SEC December 1, 2006).

Beginning in 2003, even though executives recognized that implementing change can be difficult, they mandated several company directives (Gap n.d.[d]). One directive was that all employees must understand the company's values and mission. Another directive was for The Gap, Inc., design teams to change from a design-intuitive approach to an approach in which associates listened more closely to customers and worked with company vendors early in product development. This change has been difficult because using design intuition is a common approach in the apparel industry. The change was necessary, however, because the Gap division must win back disappointed customers. The current directive for the Gap division is for its design teams to reestablish the distinctive product design of the brand, to create core designs that are true to the Gap division's heritage, and to develop quality products faster (Gap n.d.[e]).

Mission Statement

Thinking about the Rare Designs' story, you may empathize with Anne's question "What do vision and mission statements have to do with designing products?" Dr. Roberts responded, "Customers judge Rare Designs' products according to how well they think the products match the company's mission." A **mission statement,** more specific than a vision statement, defines a company's purpose and what it wants to accomplish (Abrahams 1995; Krattenmaker 2002). A mission statement is what a company implements to attain its vision. For instance, American Apparel (n.d.) states that its purpose is to be time efficient and to respond faster to market demand. This philosophy allows the company to remain competitive:*

> American Apparel is a vertically integrated manufacturer and retailer of clothing for men, women, kids and dogs. Meaning, we've consolidated all stages of production under one roof at our downtown Los Angeles factory—from the cutting and sewing, right through to the photography and marketing.
>
> Ultimately, it is this system that allows us to stay competitive while paying the highest wages in the garment industry. Because we don't outsource to local or developing-nation sweatshops (or to ad agencies, for that matter) the entire process is time-efficient, and we can respond faster to market demand.

*Reprinted by permission from Sang Ho (Sam) Lim, senior partner, American Apparel, Los Angeles, CA.

Writing an Effective Mission Statement

For a company's mission to be successful, associates must focus on, implement, and execute plans better than their competitors do. A successful mission statement does the following:

- Describes the company's competitive distinction
- Creates employee awareness
- Is clearly interpreted
- Inspires employee commitment

The goal of a mission statement is to help employees determine a company's purpose and to align employees in the same direction (Brown 1997). Let us consider the difference between a vision and a mission. A *vision* is a future projection (Abrahams 1995). A hypothetical company Made 4 Kidz' uses an emotional or a moral viewpoint for its vision that many children in the world are not loved and do not have comfort, thus the company strives to provide love and comfort to children: "We want to provide the most comfortable clothes to your children and share our deepest love with every child in the world."*

In contrast, Made 4 Kidz' *mission* is as follows:

> Every mother in the world cares about her kids. At Made 4 Kidz, we care about every child. Our company knows what is best for your child and for other children all around the world. We create our products with high-quality materials and design. Our mission is not only to provide our children here, in the United States, with the most comfortable clothes in the world, but also to share love and comfort with less-fortunate children in other countries. We care and want to distribute some of our profits to them. We believe that many people share our vision. Hence, let our company lead you to be a loving mom to your children and to help care for children around the world.

Made 4 Kidz' competitive distinction is to offer interesting garment designs that are made from high-quality fabrics. The company makes employees and consumers aware that less-fortunate children live in our world. Made 4 Kidz exists to design comfortable children's clothes and is committed to sharing some of its profits to assist less-fortunate children. Designers interpret words and phrases from a company mission statement to create its product line themes and garment designs. Made 4 Kidz' designer interpreted the company's philanthropic efforts from its mission statement in Figure 2.6.

Including the Proper Components

The first part of a mission statement (a company's purpose) answers the question "Why does this company exist?" Executives may answer this question with yet another question: "How do we increase society's wealth, provide employment opportunities, or create meaningful work for employees?" (Tagiuri 2002b). A company may exist for many reasons, but a common reason for a manufacturing company to exist is to provide employment in a community (Goodstein, Nolan, and Pfeiffer 1993; Krattenmaker 2002). Executives need to address why a company exists because doing so creates a company's authenticity. Adhering to its authenticity—no matter how large the company grows—is fundamental to a company's success (Cox 1996).

*Reprinted by permission from Kristiana Tho, student, California Polytechnic University, Pomona.

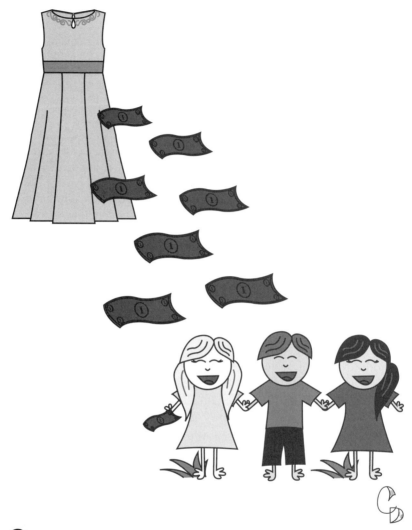

Figure 2.6 Translation of why a company exists, from a mission statement that includes the goal of giving to less-fortunate children. *(Illustration by Christina DeNino. Adapted from work by Kristiana Tho.)*

ACTIVITY 2.4 *Mission Statement Components: Part 1*

The first part of a mission statement explains a company's purpose for existing. If you started your own apparel business today, why would your apparel firm exist?

The second part of a mission statement (what the company wants to accomplish) requires an answer to the question "What is the company's function?" **Function** refers to the company's major activity or fundamental objectives (Goodstein, Nolan, and Pfeiffer 1993). Some examples include a developer of store brands, an apparel manufacturer, and a cut-and-sew operation.

ACTIVITY 2.5 *Mission Statement Components: Part 2*

The second part of a mission statement explains what the company wants to accomplish. What would your company's function be?

Companies often expand a mission statement to include long-term objectives, fundamental principles, and core strategies. A good mission statement clarifies leadership ideas and company values, as well as the company's response to changing conditions. An effective mission statement guides employee behavior: It clarifies leadership ideas and company values, improves coordination, reduces the need for excessive supervision, and facilitates performance appraisals (Tagiuri 2002a). Benefits of a mission statement include empowering employees to make better and independent decisions, helping them develop managerial skills, and advising them about what to expect for performance appraisals and rewards (Tagiuri 2002a).

VF Corporation 👕, one of the largest U.S. apparel manufacturers, earned more than $6 billion in 2006 (SEC February 27, 2007). The company owns many apparel brands, including Wrangler, Lee, and Nautica (SEC March 10, 2005). Its corporate vision is to continue to grow VF by building lifestyle brands that excite consumers around the world. The company expanded its vision to include core strategies, which are to build new lifestyle brands, to identify specific brands, to market to a specific channel of distribution, to expand its market share with large retail customers, and to expand its brands internationally (SEC March 10, 2005; VF Corporation n.d.[a], n.d.[b]). Some lifestyle brands acquired include Vans, Nautica, and Reef (SEC February 27, 2007). VF Corporation confirms Tagiuri's (2002a) comment that a mission statement motivates employees to be involved and have a sense of ownership. VF notes that one goal was to make its employees its most important resource. The company achieved this initiative by adding top apparel associate talent in strategic planning, customer teams, and acquisitions. VF Corporation notes that having excellent people is why it is successful. The corporation believes in treating its associates with honesty, integrity, consideration, and respect (VF Corporation n.d.[c]). VF states that its values extend externally to contractors who must apply its internal high standards to the manufacture of their products (U.S. Department of Labor n.d.[b]).

ACTIVITY 2.6 *Understanding Long-Term Objectives, Fundamental Principles, and Core Strategies*

Look at VF Corporation's values statement at www.vfc.com/subpages/value statement. php.

- List one long-term objective, one fundamental principle, and one core competency.
- Identify an employee performance expectation.

Conveying a Rational, an Emotional, or a Moral Focus

Some companies write mission statements that convey their philosophy, principles, and values. These statements are written from a rational, an emotional, or a moral viewpoint.

A **rational approach** is to the point (Krattenmaker 2002). An example of a rational approach is to give customers the best value for their money or to stress quality over price (O'Reilly 2000; Tagiuri 2002b). Hanesbrands Inc. ⊤ has a well-known portfolio of lingerie and undergarment brands, including Bali, Wonderbra, Barely There, and Hanes. The corporation's mission statement has a rational focus: "Our mission is to grow earnings and cash flow by integrating our operations, optimizing our supply chain, increasing our brand leadership and leveraging and strengthening our retail relationships" (SEC February 22, 2007, 48).

An **emotional or moral approach** inspires people and appeals to safety, pride, love, humor, or moral values (Krattenmaker 2002; O'Reilly 2000; Tagiuri 2002b). Levi Strauss & Co. ⊤ uses a combined emotional and moral approach in its expanded mission statement description. The company identifies four core values in its statement: empathy, originality, integrity, and courage. These core values guide company associates' behavior, decisions, and philosophy (Levi Strauss & Co. n.d.[a], 6). A mission statement is an important document that product development associates use to create a design strategy and seasonal product lines. Let us consider how a company accomplishes this, with Levi Strauss & Co. as an example.

To Levi Strauss & Co., *empathy* means to walk in its consumers', retail customers', and employees' shoes (Levi Strauss & Co. n.d.[a]). To empathize with consumers, Levi Strauss & Co. built its heritage on producing durable, quality clothing and creating designs that appeal to consumers throughout the world. The company shows empathy for its retail customers by developing product assortments that are distinctly different for each retail channel (SEC February 14, 2006). The company's executives recognized the changing consumer shopping trends by expanding the company's available products to fill a broad range of consumers' demands (SEC February 12, 2003). Beginning in 2002, Levi Strauss & Co.'s executives started the "sell where people shop" strategy. The organization has achieved breadth from selling the Levi Strauss Signature brand for value-conscious consumers in mass merchandise stores and premium products such as the Special Edition Levi's Red Tab line in high-end department stores (SEC February 14, 2006).

To the company, *originality* means Levi's is an American icon. Company executives believe that Levi's stands for independence, idealism, and social change (Levi Strauss & Co. n.d.[c]). Executives will translate key words in a mission statement into a company strategy. For instance, Levi Strauss & Co translates *originality* to "innovate and lead from the core." This strategy becomes a design team directive to create innovative, trend-right and quality products for specific consumer and retail segments (SEC February 13, 2007). Levi Strauss & Co. achieves this by actively designing, trademarking, patenting, and protecting hundreds of uniquely created products. Some recent innovations include Levi's RedWire, a trademark for premium jackets, jeans, overalls, pants, shorts, and T-shirts. RedWire DLX jeans is a new innovation that allows the consumer to plug an iPod into the jeans (Figure 2.7). The designers uniquely redesigned the watch fob pocket, which was traditionally designed to hold a pocket watch. The RedWire DLX watch fob pocket has an exterior control pad that enables the consumer to easily operate an iPod (Levi Strauss & Co. n.d.[a], 3). Company executives indicate that original trademark designs are one of its most valuable assets; in fact, the company owns more than five thousand trademark registrations (SEC February 14, 2006).

Levi Strauss & Co.'s third core value, *integrity*, is the company's promise to be honest with and trustworthy to its employees and society. One example is the company's compre-

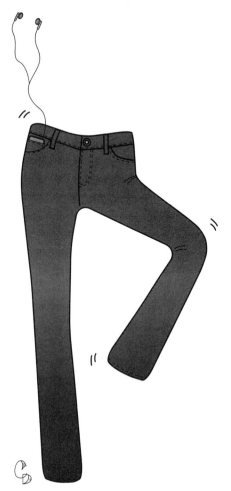

Figure 2.7 Design innovation: an interpretation of jeans with iPod tunes.*(Illustration by Christina DeNino.)*

hensive code of conduct to ensure safe and healthy working conditions for all its employees. (U.S. Department of Labor n.d. and Contractors) The company also follows originator Levi Strauss's tradition and engages in community service. Some of its philanthropic efforts include supporting employee volunteerism, helping alleviate poverty for women and children by improving working conditions, and breaking the poverty cycle by providing life skills education and financial programs (Levi Strauss & Co. n.d.[a]).

Finally, the company defines *courage* as willingness to challenge convention. The company demonstrates its courage by claiming, "We learn from our mistakes. We change. This is how we build our brands and grow our business" (Levi Strauss & Co. n.d.[c]; SEC February 12, 2003). The company underwent tremendous challenges as it transitioned from having $7 billion in sales to its current $4 billion. As a result, the company has invested in people to develop their skills and improve its operational capability (Levi Strauss & Co. n.d.[a]).

ACTIVITY 2.7 *Understanding a Company's Function*

Many apparel company mission statements clearly describe why the company exists, its function, and its long-term objectives. Phillips–Van Heusen Corporation 👕 is one example. The Phillips–Van Heusen Corporation (n.d., 1) mission statement says that the company has a macrovision in which company executives align their multiple brand, price, and channel strategies on the basis of their analysis of consumer market trends and the condition of the retail industry. Read the Phillips–Van Heusen corporate strategy at www.pvh.com/InvestorRelAnnualReports.html and dissect it to answer the following questions:

- Why does the corporation exist?
- What is the function of the Phillips–Van Heusen Corporation?
- What are the corporation's long-term objectives, fundamental principles, and core strategies?

Recognizing the Need for an Effective Mission Statement

An ineffective mission statement can be costly to a company. A mission statement can become ineffective for a number of reasons: incorrect or improper implementation of it, incorrect timing of a company strategy, and changing market conditions (Wery and Waco 2002–2003). A company president's or a CEO's job is at risk if company employees do not follow through with strategies translated from the mission statement.

Core Strategies

Executives cannot simply sit down and compose their company strategy, vision statement, and mission statement. Rather, they must critically assess and respond to their *internal* and *external environments*—specifically, how their products compete in the marketplace. **Internal environment** refers to a company's strengths and weaknesses. **External environment** refers to any outside influence that affects a firm's purpose (Lorsch 1987).

In Rare Designs' situation, Ron reflected that they had a strong niche market at one time but lost it because the company grew so fast. The company experienced two simultaneously chaotic events: exponential growth and an influx of low-cost competitor knockoffs. Ron needed to react to both situations to maintain Rare Designs' competitive advantage—something he did not do. Had he reacted, he could have taken a linear or a nonlinear approach. A *linear* reaction is the decision to not compete or to reduce costs. A *nonlinear* reaction is to develop strategic partnership agreements with suppliers to codevelop innovative new products (Grove 2003). Whether a manager's reaction is linear or nonlinear, the next step is to extract a **core strategy** from the mission statement.

In relation to product development, a mission statement focuses design efforts, defines goals, creates a schedule, and provides design guidelines. The mission statement forces a product development team to think critically about product design (Otto and Wood 2001). Associates need to translate the mission statement into an action plan so that they are clear about what they can and cannot do (Abrahams 1995).

=Measure of Success

Figure 2.8 Translation of what quality means from one company's mission statement.*(Courtesy of Suzette Lozano.)*

Company executives derive a core strategy from words and phrases in a mission statement. For example, the vision statement for OshKosh B'Gosh 👕 says, "[Our] vision [is] to become the dominant global marketer of branded products for children ages newborn to ten" (SEC March 14, 2005, 3). The company's mission statement has five core themes: quality, durability, style, trust, and a heartland image (SEC March 14, 2005, 3). The OshKosh B'Gosh target consumer is a middle to upper socioeconomic status. To fulfill the company's vision and mission, OshKosh B'Gosh designers create innovative designs that have classic styling. Quality is an important feature (Figure 2.8), so the company uses high-quality fabrics and construction (SEC March 14, 2005).

In 2006, Carter's, Inc. 👕 acquired Oshkosh B'Gosh. Carter's, Inc. states that its corporate goal for both the Carter's and the OshKosh business segments is to deliver high-quality core products at moderate (i.e., value) price points (SEC February 28, 2007, 3). The company states that it is committed to its core themes of quality, durability, style, and trust (SEC February 28, 2007). As mentioned in the preceding paragraph, company associates translate individual words in a mission statement into a core business strategy. Consider the word *quality*, which can be translated into an objective. A designer could state an objective such as "to design products from high-quality raw materials." To meet this objective, both the designer and the raw materials purchaser would have to work together to select and buy fabric, thread, and trim that would pass quality control tests (e.g., dimensional stability, tear strength).

ACTIVITY 2.8 *Using Action Words in a Mission Statement*

For your company,

- List some action words or phrases that you will include in your mission statement (e.g., products that are *high quality, authentic,* or *market right*).
- Describe your long-term objectives.
- Draft a mission statement by combining Activities 2.6 and 2.7 with this activity.

A core strategy derived from a mission statement details how an organization will achieve its goals. An example of a core strategy may be creating innovative products, being a reliable manufacturer, or providing exceptional service. Company associates use these directives for guidance in leadership, values, product lines change, division coordination, and delegation. In essence, core strategies address why a company does things a certain way (Goodstein, Nolan, and Pfeiffer 1993). Product development associates must thoroughly understand product line strategies to successfully develop competitive products.

Company associates from multiple departments often form a team to write a core strategy. Inherent advantages of this team writing effort are company loyalty among associates, a feeling of ownership, and implementation of the company's vision and mission statements (Abrahams 1995; Goodstein, Nolan, and Pfeiffer 1993).

A product line strategy is how associates in a division will achieve company goals. The goal of a core strategy is to address a company's internal and external environments while adhering to company authenticity (Collins and Porras 1996; Lorsch 1987). To clarify this point, let us revisit Carter's, Inc. This corporation has four distinct product categories: baby, sleepwear, play clothes, and accessories (SEC February 28, 2007). Because product strategies affect designers' decisions, Carter's, Inc., play wear designers for toddlers' and children's lines know that each garment designed must be appropriate for play. This core strategy allows the designers breadth and latitude in creating designs for a wide range of activities—from bicycling to playing with dolls. However, the strategy also limits the designers from creating holiday dresses, christening gowns, and similar garments that do not fit the company's strategic *play clothes* requirement.

Activity 2.9 *Visualizing Action Words from a Mission Statement*

For your company, sketch a garment idea that reflects one word or phrase from your mission statement draft (Activity 2.8).

Contextualizing Core Strategies

The context of a product line strategy must focus on a customer, a consumer, or both. Although the terms *customer* and *consumer* seem simple, they are often misconstrued. A **customer** is the person who buys a product. An apparel manufacturer's customer is the retail buyer who purchases its product. For example, a Wal-Mart 👕 retail buyer who purchases Hanes T-shirts for resale is a Hanesbrands Inc. customer. In contrast, a **consumer** is a person who buys and wears a product. A college student who buys and then wears a college logo sweatshirt is an apparel manufacturer's *and* a retailer's consumer. The misunderstanding often stems from the fact that *customer* also refers to an individual who buys a garment in a retail outlet for another consumer. For example, the term *customer* applies to a mother who buys clothing for her child (Figure 2.9).

Developing Three Types of Core Strategies

Company associates develop core strategies for each product line once they decide whether a product line will have a customer or a consumer focus. Companies use three types of core strategies: product, operations, and customer. Although a company may claim that it adopts all three strategies, it tends to focus on its strongest directive (Galbraith, Downey, and Kates 2002).

Product Core Strategies

A company that has a **product core strategy** embraces a *new product* development philosophy. Associates in such a company develop products far superior to existing products with the goal of making existing products obsolete (Product Development and Management

a b

Figure 2.9 Difference between (a) customer and (b) consumer: A customer buys an apparel product, whereas a consumer wears it. *(Courtesy of Esmeralda Perales.)*

Association [PDMA] 2003). An apparel product core strategy emphasizes developing new, innovative clothing designs that are not yet on the market. A company with such a strategy extensively trademarks or patents original designs, new concepts, inventions, raw materials, or fabrications. Product line success is measured by the number of new products introduced, the revenue earned from the new products, and the market share. Many athletic apparel companies embrace a product core strategy. Two of these are NIKE, Inc. and Patagonia Inc. . The following NIKE™ statement embraces a product core strategy (SEC July 29, 2005):

> We believe that our research and development efforts are a key factor in our past and future success. Technical innovation in the design of footwear, apparel, and athletic equipment receive[s] continued emphasis as NIKE strives to produce products that help to reduce injury, aid athletic performance and maximize comfort. (p. 5).

An individual might mistakenly think that a product core strategy refers to haute couture or designer-brand companies that present product lines at international fashion weeks. However, the styles presented there vary. Some companies offer garment designs based on adaptations of historic costumes. Such styles do not have a product core strategy because they are not new developments. In contrast, companies that devise a dramatic new silhouette, new fabrics, or new fabrications—such as Christian Dior's 1940s New Look collection when it was introduced—do have a product core strategy. Product core companies meet an unmet consumer niche, develop new raw materials, or create a new product design. The new product can be a raw material used in a product, a garment design, or both. High-end specialty retailers always desire new, innovative products.

a b

Figure 2.10 Example of a product core strategy: (a) T-shirt with innovative quick-drying fabric that replaces (b) the limp, wet T-shirt. *(Illustration by Christina DeNino.)*

Patagonia, Inc., is an outdoor athletic apparel company whose mission is to create the best products that do not harm the environment. Its product core strategy is to create simple, utilitarian products that provide solutions to environmental problems. Patagonia's primary products include apparel for outdoor sports such as climbing, snowboarding, and skiing. In an interview with the author in 1993, Kate Laramundy, a former head designer at Patagonia, noted that the company conducts extensive laboratory and field tests on all its products. To implement the company's product core strategy, Patagonia's associates work with textile suppliers to develop new, recyclable fabrications such as Capilene and Regulator (Patagonia n.d.). Capilene is a quick-drying fabric designed to draw moisture away from the skin, used specifically for apparel worn for high-sweat performance sports (Figure 2.10) (U.S. Patent and Trademark Office n.d.[a]). Regulator is a composite fabric made from recyclable polyester or polyamide, designed for use in waterproof, breathable stretch garments (U.S. Patent and Trademark Office n.d.[b]).

ACTIVITY 2.10 *Understanding the Product Core Strategy*

Look at Patagonia's Web page (www.patagonia.com) and examine at least two products. Select "More info" and read the product description.

- How do the Patagonia products you selected match the company's product core strategy?
- For your company, describe one way in which you could incorporate a product core strategy.

Operations Core Strategies

Many apparel manufacturers adopt an **operations core strategy** as their primary focus. They implement an operations core strategy to improve efficiency. A company uses this approach to produce, sell, and deliver products faster than rivals do (Porter 1996).

Company executives implement an operations core strategy by emphasizing efficiency, automation order fulfillment, logistics, supply chain management, and standardization. Companies with an operations core strategy measure their strategic performance by cost, quality, and consistency (Galbraith, Downey, and Kates 2002). In design, apparel companies that primarily knock off existing designs use an operations core strategy. To **knockoff** is to directly incorporate another individual's creative design, and a **knock off** is a copy or a re-creation of the overall style and appearance of an existing product (Figure 2.11) (Eckert and Stacey 2003a; 2003b; Keiser and Garner 2003). In manufacturing, commodity apparel products (e.g., socks, undergarments, basic knit T-shirts) frequently require an operations core strategy. Competition and pricing are so keen for national chains (e.g., Mervyn's) and mass merchandisers (e.g., Target) that the companies supplying product to these retail customers must have an operations core strategy.

Apparel Holdings Group (AHG), a U.S. apparel manufacturer owned by Jonathan Spier, implemented operational effectiveness to turn around the company. In 2000. Spier purchased Periscope, an unprofitable company with sales of $50 million. According to Spier at the American Apparel & Footwear Association "Speed to Market" presentation in Los Angeles, CA, on January 30, 2004, AHG's sales had grown 600 percent—to $300 million—by 2003. Operational effectiveness is not simply a sales increase, however; it is a change in how a company operates. A company achieves operational effectiveness when it delivers greater value to customers at a comparable value or lower cost (Porter 1996). Spier attributed his success to launching the Caribbean Joe 👕 apparel brand, which is the synergy of fashion and technology. He noted that retail customers expect apparel manufacturers to identify and respond to the latest fashion directions within 90 days. Periscope was low tech when Spier bought the company. He noted that, at the time, one person in the company was a half-time receptionist who also handled the company's information technology. To achieve operational

a b

Figure 2.11 (a) High-end designer product. (b) Knockoff product created by designers working for an operations core strategy company. *(Illustration by Christina DeNino.)*

effectiveness, Spier integrated technology throughout all company processes, from pattern making, to charge-back management, to sales force presentation (Black 2004).

Customer Core Strategies

A company that implements a **customer core strategy** creates value by customizing existing products. With a customer core strategy, the customer designs the product for a manufacturer. Many apparel manufacturers that produce products for private-label retailers use a customer core strategy. The term *customer core strategy* may lead you to believe that such a strategy takes consumers' needs into consideration. It means, instead, however, that a manufacturer delegates design decisions to the customer. A customer core strategy requires a long-term partnership between the contractor and the customer, instead of the more common supplier-partner relationship, which is fickle and seasonal. Apparel companies that emphasize private labels or licensing are typically customer based.

One example of a company that has this type of strategy is The Walt Disney Company ⌂, which has partnered with Fortune Fashions. The Walt Disney Company retails its products both through a long-term license agreement with The Children's Place ⌂, which purchased the Disney Stores in 2006, and on its Disney.com Web site. The Walt Disney Company controls the design and sale of its licensed merchandise, which includes company characters such as Mickey Mouse (SEC November 22, 2006). In a conversation with the author in 1998, Ava Chatterton, Fortune Fashion's vice president of human resources, described how a customer core strategy works with a company such as Walt Disney. The Walt Disney Company product development associates develop seasonal themes, conceptualize designs, and develop specifications. Fortune Fashion's a long-term contractor with The Walt Disney Company, provides embroidering and screen-printing services. Fortune Fashions' **merchandisers** work closely with customers like Disney to ensure character integrity and product direction. In a customer core strategy, designs originate from customers (e.g., Disney). Upon development of a theme, such as "Remember the Mouse," Disney designers draw conceptual designs and send them to Fortune Fashions' artists to develop embroideries or screen prints. Once the screen prints are developed, Disney associates must approve the artwork.

ACTIVITY 2.11 *Distinguishing Among Product, Core, and Operations Strategies*

Read VF Corporation's core strategy, which follows, and decide whether it is a product, an operations, or a customer core strategy (SEC March 10, 2006):

> For over 100 years, VF has grown by offering consumers high quality, high value branded apparel and other products. Management's vision is to continue to grow VF by building lifestyle brands that excite customers around the world. Lifestyle brands, representative of the activities that consumers aspire to, will generally extend across multiple product categories and therefore have greater opportunity for growth. VF follows an overall strategy of identifying specific brands to market to a specific channel of distribution. Accordingly, products and brands are sold through specialty store,

department store, mid-tier, chain store and discount store channels. In addition, many products are available through VF-operated retail stores, as well as through licensees and distributors dedicated to offering these products directly to consumers. To provide these products across this broad distribution network, VF has implemented a strategy that combines efficient and flexible internally-owned manufacturing with the sourcing of finished goods from independent contractors. As a result, VF satisfies the needs of millions of apparel consumers around the world. (p. 2)

Shifting the Primary Core Strategy

A company's primary core strategy should remain consistent, giving company products authenticity and consistency to meet consumer expectations. However, apparel companies find that the competitive nature of the industry sometimes requires a core strategy shift. A company may revise and update its core strategy when it undergoes internal pressures (e.g., margins are decreasing) or when external factors intervene (e.g., new competitors are capturing market share). The Wet Seal, Inc. ⬚ is a fashion-conscious juniors specialty retailer that owns Wet Seal and Arden B. Wet Seal's target consumer is a fashion-conscious junior who desires moderate-priced, fashionable, brand-name apparel and accessories. Arden B targets women who are 25 to 45 years old that want contemporary branded apparel (SEC April 14, 2007). The styles are feminine, contemporary, and sophisticated (SEC April 13, 2006, 2). The Wet Seal, Inc., notes that its success depends on its associates' ability to anticipate changing consumer fashion tastes and on their ability to respond to shifting fashion trends. The Wet Seal, Inc., expects its design and buying teams to create its product line strategy on the basis of its mission statement and to develop an appropriate mix of appealing merchandise in a timely manner that satisfies the fashion preference of its target market (SEC April 14, 2007, 6).

Juniors' clothing is a highly volatile apparel sector. Starting in 2002, The Wet Seal, Inc., began a sales slide that resulted in firing its long-time CEO (Earnest 2003b; SEC February 7, 2003; March 31, 2003). In 2002, the company strategy was to develop a sophisticated product line. In hindsight, executives noted that during that year their consumers were gravitating toward a more basic, junior look. Because of an unclear fashion direction and incorrect anticipation of consumer style preferences, the company withstood severe markdowns, closed 152 stores, and reevaluated its growth strategy (SEC April 13, 2006). In 2006, the company reported a 45 percent sales increase; however, the operating loss remained significant ($12.8 million) (SEC April 14, 2007).

Starting in 2005, The Wet Seal, Inc., shifted its design practices from a product core strategy to an operations core strategy. Its operations strategy is to offer lower prices, deliver new merchandise frequently, and offer a broader assortment of styles. Changing strategy is not easy for a company, however, as evidenced by The Wet Seal, Inc.'s quarterly up-and-down gains and losses in 2006 (SEC April 2007). As part of The Wet Seal, Inc.'s new strategy, product development teams create seasonal themes and then work closely with domestic vendors to develop theme colors, fabrics, and garment designs. Its designers capture timely hot-selling fashions by developing fewer original designs, focusing on identifying fast-selling competitor merchandise, and knocking off competing designs. Most of The Wet Seal, Inc.'s merchandise is contracted with domestic apparel contractors—many of whom are small operations—to get a quick production turnaround time (SEC April 13, 2006).

ACTIVITY 2.12 *Change in a Company's Core Strategy*

Look at The Wet Seal, Inc.'s Web page: www.wetsealinc.com. Two parts of the company's strategy are to offer lower retail prices and to offer a broader assortment of trendy merchandise (SEC April 13, 2006). Do you think the merchandise represented matches its core strategy? Explain why or why not.

Using Core Strategies in Market Positioning

A company positions its products in the market on the basis of its core strategy. When a company develops a new product line, it devotes its most concentrated efforts to the core strategy. A company can also adjust its market positioning to address decreasing product sales or if its competitors are infiltrating its market.

Sometimes, retail customers and manufacturers differ in their core strategies. In such a case, company executives must direct the product development team about how to interpret the core strategy and how to work with retailers whose core strategies differ from the company's. Corporations such as Federated Department Stores 👕 and Neiman Marcus 👕 have exclusivity arrangements with national brands or designer goods. Such arrangements require these apparel manufacturers to offer products exclusively for Bloomingdale's, Macy's, or Neiman Marcus (i.e., the products are not available in other retail stores) (Federated Department Stores n.d.; SEC September 16, 2005). An exclusivity arrangement is difficult to adhere to if the apparel manufacturer has an operations core strategy and is set up to offer frequent delivery of same-style merchandise to multiple retailers.

SUMMARY ▰▰▰▰▰▰▰▰▰▰▰▰

A team is necessary to create, write, and implement a company's vision statement, mission statement, and core strategy. A vision statement conveys a company's philosophy, beliefs, viewpoint, unique character, and future direction. To create a vision statement, executives use their knowledge of a company's past to project its future philosophy and goals. A mission statement, written from a rational, an emotional, or a moral perspective, details how a company will implement its vision. The product development team uses the company's core strategy to develop its products. Upon creation of a core strategy, the product development team develops a business plan, which is the focus of Chapters 3 and 4. The business plan includes formulation of an action plan, a merchandise strategy, and retail, consumer, and competitor market analyses.

COMPANY PROJECT 1
BUSINESS STRATEGY REPORT—PART 1 ▰▰▰▰▰▰▰

Project Goal

One part of learning about product development is to create an apparel-manufacturing scenario. This textbook includes a company project. The project activities guide you from design through product development. A completed project consists of a business strategy report, a

time-and-action calendar, an inspiration-illustrated theme or mood boards, concept boards, and sales sheets. The goal of Company Project 1 is multifold: to create a company name and a brief company description, to write a vision statement, to write a mission statement, and to identify a core strategy. Be sure to include the following sections:

Company Name and Description

Write your company name and describe your target consumer, the products designed, their uniqueness, and the price category of the products.

Vision Statement

Write your company's vision statement so that it has company belief, viewpoint, and character components.

Mission Statement

Write an effective mission statement that includes the three main components: the reason your company exists, its major function, and its long-term objectives. Include action words in your mission statement that you can use later to develop your product line.

Core Strategy

Write your core strategy from a product, an operations, or a customer perspective.

PRODUCT DEVELOPMENT TEAM MEMBERS

The following product development team members were introduced in this chapter:

Merchandisers: Merchandisers are individuals who combine creativity with business planning. They are responsible for and plan a product line, an inventory, strategic business unit quantities, continuity of creative ideas, and forecasting. They are also responsible for analyzing profitable and unprofitable designs and for ensuring that product development associates adhere to calendar goals.

President: The president is a top executive manager. His or her product development responsibilities include overseeing drafting of and adherence to policy, vision, and mission statements; guiding the company's direction and growth; and addressing critical issues facing product lines. In a publicly owned business, the president also answers to shareholders, who are often concerned with company profitability.

KEY TERMS

Consumer: An individual who buys and wears a product.
Core strategy: A strategy derived from a mission statement that details how an organization will achieve its goals. A company has a product, an operations, or a customer focus.
Customer: The individual who buys a product.

Customer core strategy: A focus in which the customer designs the product for a manufacturer.

Emotional or moral approach: An approach to a mission statement that inspires people and appeals to safety, pride, love, humor, or moral values.

External environment: An outside influence that affects a company's purpose.

Flowchart: A diagram showing a process or sequence of decisions, with feedback loops.

Function: A company's major activity or fundamental objectives.

Going forward: A change from past action to improve the future, such as improving past season sales or a merchandise strategy.

Internal environment: A company's strengths and weaknesses.

Knock off: A verb meaning to directly incorporate another individual's creative design.

Knockoff: A noun meaning a copy or re-creation of the overall style and appearance of an existing product.

Mission statement: A written statement that defines why a company exists (its purpose), what it wants to accomplish (its function), and how it will implement its vision.

Operations core strategy: A focus on improving efficiency.

Process theory: The idea that when activity inputs are conducted, certain outputs result.

Product core strategy: A focus on developing products far superior to existing products with the goal of making existing products obsolete.

Rational approach: A factual, straightforward approach to a mission statement.

Vision statement: A written statement of a company's future direction and goals.

WEB LINKS

Company	URL
Abercrombie & Fitch	www.abercrombie.com/anf/index.html
American Apparel	www.americanapparel.net
Byer California	www.byer.com
Caribbean Joe	www.carribeanjoe.com
Carter's, Inc.	www.carters.com
The Children's Place	www.childrensplace.com
Federated Department Stores	www.fds.com/home.asp
The Gap, Inc.	www.gapinc.com/public/About/about.shtml
Hanesbrands Inc.	www.hanesbrands.com/hbi/en-us/
Levi Strauss & Co.	www.levistrauss.com
Neiman Marcus	http://phx.corporate-ir.net/phoenix.zhtml?c=118113&p=irol-overview
NIKE, Inc.	www.nike.com/nikebiz/nikebiz.jhtml?page=0
OshKosh B'Gosh	http://corp.oshkoshbgosh.com/index.html
Patagonia, Inc.	www.patagonia.com
Phillips–Van Heusen Corporation	www.pvh.com
Piperlime	www.piperlime.com/browse/home.do?cid=15956&tid=PLGO930&kwid=1
Russell Corporation	www.russellcorp.com
VF Corporation	www.vfc.com

Wal-Mart www.walmart.com/apparel
The Walt Disney Company http://corporate.disney.go.com
Warnaco Group, Inc. www.warnaco.com
The Wet Seal, Inc. www.wetsealinc.com

REFERENCES

Abrahams, J. 1995. *The mission statement book: 301 Corporate mission statements from America's top companies*. Berkeley, CA: Ten Speed Press.

American Apparel. n.d. Mission statement. http://www. americanapparel.net/mission.

Black, S. 2004. The entrepreneur who could. *Apparel*, February 23. http://apparelmag.com/ articles/past-issues.shtml (accessed February 24, 2004).

Brown, T. 1997. Turning mission statements into action. *Harvard Management Update*, September 1, 4–6. Reprint No. U9709B.

Byer California. n.d. About us. http://www.byer.com/about.html.

Collins, J., and J. Porras. 1996. *Built to last: Successful habits of visionary companies*. New York: HarperCollins.

Cox, C. 1996. Linking purpose and people. *Training and Development* 50:67–68.

Davidson, H. 2002. Make visions and values work. *People Management* 8 (19): 56–57.

Dixon, P. 2005. *Building a better business*. London: Profile Books.

Earnest, L. 2003a. Apparel retailer seeking cohesive strategy to bridge generation gap. *Los Angeles Times*, February 28, sec. C.1.

Earnest, L. 2003b. The Wet Seal fires CEO as sales, earnings drop. *Los Angeles Times*, February 7, sec. C.1.

Eckert, C., and M. Stacey. 2003a. Adaptation of sources of inspiration in knitwear design. *Creativity Research Journal* 15:355–59.

Eckert, C., and M. Stacey. 2003b. Sources of inspiration in industrial practice. The case of knitwear design. *Journal of Design Research* 3 (1): 1–18.

Federated Department Stores. n.d. *2005 Annual report*. http://www.federated-fds.com/ir/ann.asp.

Galbraith, J., D. Downey, and A. Kates. 2002. *Designing dynamic organizations: A hands-on guide for leaders at all levels*. New York: American Management Association Communications (AMACOM)/American Management Association.

Gap Inc. n.d(a). Company fact sheet. http://www.gapinc.com/public/Investors/investors.shtml.

Gap Inc. n.d(b). Investors: Quarterly sales by division. http://www.gapinc.com/public/Investors/ investors.shtml.

Gap Inc. n.d(c). Letter to shareholders. In *2001 Annual report*. San Francisco, CA: Gap Inc. http:// www.gapinc.com/public/Investors/inv_fin_annual_reports_and_proxy.htm.

Gap Inc. n.d(d). Letter to shareholders. In *2003 Annual report*. San Francisco, CA: Gap Inc. http:// www.gapinc.com/public/Investors/inv_fin_annual_reports_and_proxy.htm.

Gap Inc. n.d.(e) Letter to shareholders. In *2005 Annual report*. San Francisco, CA: Gap Inc. http://www.gapinc.com/public/Investors/inv_fin_annual_reports_and_proxy.htm.

Gill, B., B. Nelson, and S. Spring. 1996. Seven steps to strategic new product development. In *The PDMA handbook of new product development*, ed. M. D. Rosenau, A. Griffin, G. A. Castellion, and N. F. Anschuetz, 19–33. New York: Wiley.

Goodstein, L. D., T. M. Nolan, and J. W. Pfeiffer. 1993. *Applied strategic planning: A comprehensive guide*. New York: McGraw-Hill.

Granger, M., and T. Sterling. 2003. *Fashion entrepreneurship: Retail business planning*. New York: Fairchild.

Grove, A. 2003. Churning things up: Innovations with the power to transform entire industries are the Holy Grail of business strategy. Unfortunately, the innovators don't always survive. *Fortune* 148 (3): 115–18.

Harvard Business School. 2005, November 21. *Marketing strategy: How it fits with business strategy.* Boston: Harvard Business School Press. Also published as Chapter in *Harvard Business Essentials: Marketer's toolkit: The 10 strategies you need to succeed* (2006).

Hunter, S. 2002. Create company alignment with powerful vision. *Journal of Property Management* 67 (2): 74.

Keiser, S., and M. Garner. 2003. *Beyond design: The synergy of apparel product development.* New York: Fairchild.

Krattenmaker, T. 2002. Write a mission statement that your company is willing to live. *Harvard Management Communication Letter,* March 1, 3–4. Reprint No. C0203D.

Levi Strauss & Co. n.d(a). *2005 Annual financial report.* San Francisco, CA: Levi Strauss & Co. http://www.levistrauss.com/Financials/AnnualReports.aspx.

Levi Strauss & Co. n.d(b). Letter from the CEO. In *2002 Annual report.* San Francisco: Levi Strauss & Co.

Levi Strauss & Co. n.d(c). Values and vision. http://www.levistrauss.com/Company/ValuesAndVision.aspx.

Lorsch, J. W. 1987. Note on organization design. *Harvard Business Review,* January 30 (rev.), 1–21. Reprint No. 9-476-094.

Markides, C. 2000. *All the right moves: A guide to crafting breakthrough strategy.* Boston: Harvard Business School Press.

Moore, A. 2007. Gap to close Forth & Towne stores, focus on core brands. *MarketWatch,* February 26. http://www.marketwatch.com/news/story/gap-close-forth-towne/story.aspx?guid=%7BDE7D9E5C-3745-425C-B8B2-3EAB4C33F5AB%7D.

NPD Group. 2005. Fast facts. Top 5 jeans brands—Total adult, 2004. *NPD Insights,* January (28): 1. http://www.npdinsights.com/corp/enewsletter/html/archives/january2005/fast_facts.html.

Old Navy. n.d.. Home page.http://www. oldnavy.com/browse/home.do.

O'Reilly, W. T. 2000. How to get employees to buy into your mission: Use internal marketing. *Harvard Management Communication Letter,* October 1, 3. Reprint No. C0010D.

Otto, K., and K. Wood. 2001. *Product design: Techniques in reverse engineering and new product development.* Upper Saddle River, NJ: Prentice Hall.

Patagonia. n.d. Company info: Our reason for being. http://www.patagonia.com/web/us/contribution/patagonia.go?assetid=2047.

Philips–Van Huesen. n.d. *Annual report 2005: Corporate strategy.* http://www.pvh.com/InvestorRel_AnnualReports.html.

Porter, M. E. 1996. What is strategy? *Harvard Business Review,* November 1, 61–79. Reprint No. 96608.

Product Development and Management Association [PDMA]. 2003. Glossary: The PDMA glossary for new product development. http://www.pdma.org/library/glossary.html.

Robert, M. 2000. *The power of strategic thinking: Lock in markets, lock out competitors.* New York: McGraw-Hill.

Russell Corporation. 2003. Corporate responsibilities: Overview. http://www.russellcorp.com/html2003/code/respons_overview.htm.

Tagiuri, R. 2002a. *Major dimensions of company mission.* Harvard Business School Note 902-426. Boston: Harvard Business School Press.

Tagiuri, R. 2002b. *Purposes and functions of a mission statement and guidelines.* Harvard Business School Note 902-425. Boston: Harvard Business School Press.

U.S. Department of Labor n.d(a). Russell Corporation vendor policy. http://www.dol.gov/ILAB/media/reports/iclp/apparel/5c25.htm.

U.S. Department of Labor n.d(b). VF Corporation contractor terms of engagement. http://www.dol.gov/ILAB/media/reports/iclp/apparel/5c34.htm.

U. S. Department of Labor n.d(c). Levi Strauss Global Sourcing & Operating Guidelines http://www.dol.gov/ILAB/media/reports/iclp/apparel/5c14.htm

U.S. Patent and Trademark Office. n.d.(a). Capilene. http://www.uspto.gov/main/ trademarks.htm.

U.S. Patent and Trademark Office. n.d.(b). Regulator. http://www.uspto.gov/main/trademarks.htm.

U.S. Securities and Exchange Commission. 2003, February 7. *Form 8-K: Current report, February 6, 2003, The Wet Seal, Inc.* Washington, DC: U.S. Government Printing Office. http://www.sec.gov/Archives/edgar/data/863456/000104746903004396/a2102660z8-k.htm.

U.S. Securities and Exchange Commission. 2003, February 12. *Form 10-K: Annual report for the fiscal year ended November 24, 2002, Levi Strauss & Co.* Washington, DC: U.S. Government Printing Office. http://www.sec.gov/Archives/edgar/data/94845/000103221003000174/d10k.htm.

U.S. Securities and Exchange Commission. 2003, March 31. *Form 10-K: Annual report for the fiscal year ended February 1, 2003, The Wet Seal, Inc.* Washington, DC: U.S. Government Printing Office. http://www.sec.gov/Archives/edgar/data/863456/000101706203000660/d10k.htm.

U.S. Securities and Exchange Commission. 2005, March 10. *Form 10-K: Annual report for the fiscal year ended January 1, 2005, V. F. Corporation.* Washington, DC: U.S. Government Printing Office. http://www.sec.gov/Archives/edgar/data/103379/000089322005000519/w06467e10vk.htm.

U.S. Securities and Exchange Commission. 2005, March 14. *Form 10-K: Annual report for the fiscal year ended January 1, 2005, OshKosh B'Gosh, Inc.* Washington, DC: U.S. Government Printing Office. http://www.sec.gov/Archives/edgar/data/75042/000095013705002975/c92767e10vk.htm.

U.S. Securities and Exchange Commission. 2005, July 29. *Form 10-K: Annual report for the fiscal year ended May, 31, 2005, NIKE, Inc.* Washington, DC: U.S. Government Printing Office. http://www.sec.gov/Archives/edgar/data/320187/000095012405004551/v10583e10vk.htm.

U.S. Securities and Exchange Commission. 2005, September 16. *Form 10-K: Annual report for the fiscal year ended July 30, 2005, The Neiman Marcus Group, Inc.* Washington, DC: U.S. Government Printing Office. http://www.sec.gov/Archives/edgar/data/819539/ 000104746905022992/a2162885z10-k.htm.

U.S. Securities and Exchange Commission. 2006, February 14. *Form 10-K: Annual report for the fiscal year ended November 27, 2005, Levi Strauss & Co.* Washington, DC: U.S. Government Printing Office. http://www.sec.gov/Archives/edgar/data/94845/000095013406002782/f17124e10vk.htm.

U.S. Securities and Exchange Commission. 2006, March 10. *Form 10-K: Annual report for the fiscal year ended December 31, 2005, V. F. Corporation.* Washington, DC: U.S. Government Printing Office. http://www.sec.gov/Archives/edgar/data/103379/000089322006000503/w18296e10vk.htm.

U.S. Securities and Exchange Commission. 2006, March 28. *Form 10-K: Annual report for the fiscal year ended January 28, 2006, The Gap, Inc.* Washington, DC: U.S. Government Printing Office. http://www.sec.gov/Archives/edgar/data/39911/000119312506064998/d10k.htm.

U.S. Securities and Exchange Commission. 2006, April 13. *Form 10-K: Annual report for the fiscal year ended January 28, 2006, The Wet Seal, Inc.* Washington, DC: U.S. Government Printing Office. http://www.sec.gov/Archives/edgar/data/863456/000119312506079663/d10k.htm.

U.S. Securities and Exchange Commission. 2006, November 22. *Form 10-K: Annual report for the fiscal year ended September 30, 2006, The Walt Disney Company, Inc.* Washington, DC: U.S. Government Printing Office. http://www.sec.gov/Archives/edgar/data/1001039/000119312506241109/d10k.htm.

U.S. Securities and Exchange Commission. 2006, December 1. *Form 10-Q: Quarterly report for the quarterly period ended October 28, 2006, The Gap, Inc.* Washington, DC: U.S. Government Printing Office. http://www.sec.gov/Archives/edgar/data/39911/000119312506245289/d10q.htm.

U.S. Securities and Exchange Commission. 2007, February 22. *Form 10-K: Transition report for the transition period from July 2, 2006, to December 30, 2006, Hanesbrands Inc.* Washington, DC: U.S. Government Printing Office. http://www.sec.gov/Archives/edgar/data/1359841/000095014407001518/ g05542e10vkt.htm.

U.S. Securities and Exchange Commission. 2007, February 27. *Form 10-K: Annual report for the fiscal year ended December 30, 2006, V. F. Corporation.* Washington, DC: U.S. Government Printing Office. http://www.sec.gov/Archives/edgar/data/103379/000089322007000491/w30596e10vk.htm.

U.S. Securities and Exchange Commission. 2007, February 28. *Form 10-K: Annual report for the fiscal year ended December 30, 2006, Carter's, Inc.* Washington, DC: U.S. Government Printing Office. http://www.sec.gov/Archives/edgar/data/1060822/000110465907014975/a07-5344_110k.htm.

U.S. Securities and Exchange Commission. 2007, March 1. Form 10-K: Annual report for the fiscal year ended December 31, 2006, Berkshire Hathaway Corporation. Washington DC: U.S. Government Printing Office, http://www.sec.gov/Archives/edgar/data/1067983/0000950134 07004573/0000950134-07-004573-index.htm

U.S. Securities and Exchange Commission. 2007, March 7. *Form 10-K: Annual report for the fiscal year ended December 30, 2006, The Warnaco Group, Inc.* Washington, DC: U.S. Government Printing Office. http://www.sec.gov/Archives/edgar/data/801351/000095013607001438/file1.htm.

U.S. Securities and Exchange Commission. 2007, April 2. Form 10-K: Annual report for the fiscal year ended, February 3 2007, The Gap Inc., Inc. Washington DC: U.S. Government Printing Office, http://www.sec.gov/Archives/edgar/data/39911/000119312507070941/d10k.htm

U.S. Securities and Exchange Commission. 2007, April 2. Form 10-K: Annual report for the fiscal year ended, November 26, 2006, Levi Strauss & Company. Washington DC: U.S. Government Printing Office, http://www.sec.gov/Archives/edgar/data/94845/000095014907000037/f26939e10vk.htm

U.S. Securities and Exchange Commission. 2007, April see U.S SEC Feb3. *Form 10-K: Annual report for the fiscal year ended January **, 2007, The Wet Seal, Inc.* Washington, DC: U.S. Government Printing Office. http://www.sec.gov/Archives/edgar/data/863456/xxxx/xxx.htm.

U.S. Securities and Exchange Commission. 2007, April 14. Form 10-K: Annual report for the fiscal year ended February 3, 2006, The Wet Seal, Inc. Washington DC: U.S. Government Printing Office, http://www.sec.gov/Archives/edgar/data/863456/000119312507082978/d10k.htm

U.S. Securities and Exchange Commission. 2007, April 14. Form 10-K: Annual report for the fiscal year ended, February 3, 2007, The Wet Seal. Washington DC: U.S. Government Printing Office, http://www.sec.gov/Archives/edgar/data/863456/000119312507082978/d10k.htm

VF Corporation. n.d.(a). *2004 Annual report.* Greensboro, NC: VF Corporation. http://phx.corporate-ir.net/phoenix.zhtml?c=61559&p=irol-reports.

VF Corporation. n.d.(b). About VF. http://www.vfc.com/sub_pages/about_vf.php.

VF Corporation. n.d.(c). VF values statement. http://www.vfc.com/sub_pages/value_statement.php.

Wery, R., and M. Waco. 2002–2003. Why good strategies fail. *PRTM's Management Journal for Technology Driven Businesses: Insight* 14 (2): 5–8.

Wikipedia contributors. n.d.(a). Flowchart. *Wikipedia, The free encyclopedia.* http://en.wikipedia .org/wiki/Flowchart (accessed March 8, 2007).

Wikipedia contributors. n.d.(b). Process theory. *Wikipedia, The free encyclopedia.* http://en .wikipedia.org/wiki/Process_theory (accessed February 19, 2007).

Williams, D., and N. Smith. 2003. Masterplans: The limits of visions. *Regeneration & Renewal* 20 (July 18): 1–2.

BIBLIOGRAPHY

If you want to learn more, the following are good guides:

Goodstein, L. D., T. M. Nolan, and J. W. Pfeiffer. 1993. The process of envisioning. In *Applied strategic planning: How to develop a plan that really works,* by L. D. Goodstein, T. M. Nolan, and J. W. Pfeiffer, 37–54. New York: McGraw-Hill.

Robert, M. 2000. *The power of strategic thinking: Lock in markets, lock out competitors.* New York: McGraw-Hill.

Developing Design and Business Goals

THE TRIED AND TRUE AND THE NEW

A crowd of Saturday shoppers jostles Anne as she heads toward the escalator in Von Moritz busy department store. The sweet smell of perfume and cologne from the first-floor cosmetics department mingles with the scent of cappuccino from the coffee kiosk. Going up the escalator, Anne can still hear the classical music drifting up from the ebony grand piano in the lobby. She steps off the escalator on the second floor and heads toward the misses' career department. She notes the difference in ambience between this store and the discount store she just left. "There's no denying it—Von Moritz has class," she thinks.

She recalls her earlier conversation with Kate, who assigned her to write a fashion strategy report. Anne shakes her head at the thought of her mistake—thinking it would be a review of current colors and silhouette trends. Kate explained that instead it was primary data collection, in which she would observe consumers at events, shopping, or personally analyzing competing brands.

"Isn't everyone our competitor?" Anne recalls asking Kate. She was surprised at Kate's answer: "No: your direct competitors are the companies whose brands are hanging on the store fixtures to the front, left, and right of your label."

Anne's eyebrows, furrow as she absently mouths the fashion report questions and directives Kate gave her: "Is your merchandise hanging on a fixture in the front, center, or back of a retail department?" "Is a strong brand label next to yours?" "What are shoppers saying?" "Evaluate your competitors' strengths and weaknesses."

She scans the career wear department, noticing a product mix of dressy pants, blouses, tops, jackets, and sweaters. "The lighting in this store really complements the designs," she thinks, comparing it with the fluorescent lighting in the discount store. She spots a new label, J Jerome Designs, prominently displayed front and center, whereas Rare Entities, her label, is in the middle with the other branded merchandise. She fingers a JMA Studio sweater and thinks, "Nice yarn. It's 30-single, cotton-cashmere blend; we should be using this yarn." She looks critically at the fixtures near Rare Entities. "I need to check out the JMA Studio and DW 4 Women Web sites and note which other retail stores carry their brands."

A nearby shopper comments to her friend, "I bought some Rare Entities a few years ago. The styles were so unique, but look at these styles. I could never wear these to work—they're too tight and not professional enough."

Irritably, Anne thinks, "I can't believe we missed the mark!"

"May I help you?" asks a sales associate.

Anne, nervously tapping her shoe, gives the girl a quizzical look and says, "I'm curious. I haven't seen J. Jerome Designs before, and their garments are so prominently located in the department. Is it a best-selling brand?"

"Yes, it is," the sales associate answers. "It's one of our private-label brands. Von Moritz Department Stores bought us out several months ago, and they believe in increasing exclusive private-label merchandise. Personally, I like brands, but don't tell my store manager that!"

"Thanks; I appreciate your help," Anne says, thinking, "Interesting retail strategy; more competition, just what we need." She races down the escalator to the front door, pausing briefly in the jewelry department to check out the latest additions to Fucilla's Tuscan line. She fingers some earrings crafted with topaz beads and freshwater pearls and thinks of several outfits that would work with them. But this is no time to shop. She is on a mission....

Early Monday morning, Anne walks into Ron's office and smacks her sketchbook onto his desk, frantically exclaiming, "I need the mission statement right now!"

"As you request, partner," Ron says, cheerfully. "Our team worked hard to create it." He hands her a copy:

> Rare Designs listens to the voice of our consumers to create innovative product features. We offer our young, upcoming female career consumers fashionable, high-quality, functional, professional apparel with a unique twist that has competitive value. We believe we can compete by having a strong team of suppliers, customers, and employees working in an open, communicative, and creative environment.

Calming down, Anne says, "I like it. Good teamwork."

"'Mission is at the heart of what you do as a team. Goals are merely steps along the way to achievement,'"* Ron says. He grins. "Kate sure likes to quote Patrick Dixon; doesn't she?"

Intently studying the copy of the new mission statement, Anne says, "Our goal now is to find out all we can about Von Moritz Department Stores. They bought out our best retail account and they are promoting their cheaper private-label merchandise."

"Let's go and see what Lauren found," Ron says as he heads for the door.

Anne flashes her partner a quick smile and races him down the hall toward Lauren's office. "What did you find out about our retail customers?" Anne calls out to her assistant merchandiser, Lauren Hirokawa, a recent college graduate who finished at the top of her class. For years, Anne had served as the company's top designer and merchandiser. She is now grooming Lauren to take over the merchandiser spot. Before Lauren can answer, Anne points to Lauren's lime-green sling-back shoes. "Nice shoes. Are those Bargonies?"

Lauren nods and says, "You better believe they are—and don't ask me how much they cost!" Getting down to business, she continues, "Our best retail customer, Von Moritz, is emphasizing loyalty by limiting the number of suppliers; but, in exchange, they want exclusive styles that cannot be found at their competition."

Some employees think the petite young woman with shiny black hair is a little too cheerful and eager to please, but Ron and Anne appreciate her enthusiasm and

*Quotation in Patrick Dixon, *Building a Better Business* (London: Profile Books, 2005), 66.

efficiency. Her organizational skills are evident in her office. The sleek, immaculate desk is topped with matching lime-green accessories. Even her pens and pencils complement the decor, which carries through to the color-coded file folders.

Just then, Jason Todd comes rushing down the hall, wearing jeans and a baby blue T-shirt. His blond hair has the unkempt look. "Sorry to interrupt you guys, but I'm headed across the street to Line Creek Coffee for an espresso. Do you want me to get you anything?" Even though he looks like a teenager, Jason is a seasoned professional. He wears two hats at Rare Designs: CAD artist and technical designer. After writing down the drink orders, he disappears after his favorite beverage.

"Let's see. Where were we?" Ron asks. "Oh, I know. We're talking about Lauren's findings about our best retail customers. It sounds like what she found is different from what you heard on Saturday when you visited a number of retailers; right, Anne?"

"Most of our retail customers state that they will not buy more than 2–10 percent from any one apparel manufacturing customer," Lauren says. "But, if you look at their purchase figures, you'll see that if a retailer purchases 12 million dollars' worth of goods annually, we could potentially sell up to 1.2 million dollars' worth to one account! That's a substantial amount of money."

"Good point. What about Von Moritz and our other top customers' strategies for the upcoming year?" Ron asks.

"Their retail strategy is to change from regional to corporate buying so that their buyers purchase for all store divisions."

"Good work, Lauren," Anne says. "Along with understanding our retail customers' merchandise strategy, we need to thoroughly understand their core consumer."

"Is that my next assignment?" Lauren asks. "Do I get to go to the stores, shop, and observe customers?"

"*Consumers*," Anne corrects.

Ron rolls his eyes and says, "No, Lauren. You get to go back to your computer and look up U.S. census data."

"Census data?" Lauren grits her teeth and wrinkles her nose. "That sounds boring."

"It's all in how you look at things. Demographics are secondary research data that can be used to analyze trends. Forecasters use this research technique all the time." Ron points to the computer screen as he recalls his last conversation with Kate. "Secondary data are retrieved from sources like the U.S. Census Bureau, which we can use to analyze the income and education patterns of consumers who shop at our retail accounts. We can then compare that information with psychographic trends."

The smell of coffee wafts into the room, with Jason following. Handing out the coffee orders, he asks, "What have I missed?"

"We were discussing psychographic trends," Ron says.

"Ah, the elusive consumer. It sounds like a marketing class I once took. If you were to describe me, it would be snow bum and snowboarding any chance I get," Jason says wistfully, referring to his last winter venture. He continues, "Anne, I have a question about these competitor garments."

Before Anne can answer, Lauren interrupts, "Now I'm excited! I love analyzing information. This is like solving a complex problem. Let me at it!"

Objectives

After reading this chapter, you should be able to do the following:

- Identify the various types of product developers.
- Define *strategic business unit* and *product line*.
- Collect primary data on target market preferences.
- Use U.S. census data to analyze a retail customer's demographics and see how this information helps apparel associates understand consumers.
- Write a merchandise strategy currently used by a retail firm.
- Compare competing apparel product lines.

You want to create your own product line, but where do you start? You may think the first step is to illustrate design concepts, but it is not. Before ink touches paper, the merchandising process begins. **Merchandising** is "the process of planning, developing, and presenting product lines for identified target markets" (Kunz 2005, 6). After defining a company's vision, mission, and strategy, apparel associates begin to plan seasonal product lines. This process involves developing design and business goals.

This chapter starts with a discussion of the different types of product developers and individuals responsible for developing such goals. Sections on the role of branding and licensing, strategic business units, and the role of profitability follow. Finally, the three main components of developing design and business goals are covered: product line conceptualization, market analysis, and brand marketing strategy development.

From this discussion, you should be able to infer the main point of this chapter: Making design and business decisions is tricky. In the real world, long before design concepts are illustrated, company executives conduct extensive research or hire service firms to analyze the continually changing needs and wants of consumers and the retail markets available.

Types of Product Developers

Product developers can be apparel manufacturers (wholesalers), private-label retailers, or both. These organizations have individuals from multiple departments who work together to plan and execute product development (Product Development and Management Association [PDMA] n.d.). The distinction is that some organizations take ownership of design and development, whereas others jointly design and develop products using resources from multiple firms. An individual needs to research the business model of a company to understand how it organizes product development.

Apparel Manufacturers

A **manufacturer** is a single or multiunit establishment that makes products in a primary industry and may also make products in a secondary industry. An **industry**, such as apparel, is a group of establishments with similar production processes (U.S. Census Bureau n.d.[f], n.d.[g], n.d.[h] 622). The traditional definition of an **apparel manufacturer** is an establishment that either purchases or makes fabric that it cuts and sews to make a garment (U.S. Census Bureau n.d.[b]). In the past, many apparel manufacturers have had a business model in which employees designed, developed, produced, and distributed wholesale apparel goods (i.e., a vertical operation). American Apparel (n.d.) 👕 is still this type of manufacturer.

However, because of intense competition and high U.S. labor costs, most apparel companies are no longer vertical. They no longer own and conduct their own production. In fact, many apparel manufacturers are emerging into design, development, and marketing firms rather than having a primary emphasis on manufacturing products. NIKE, Inc., 👕 and Levi Strauss & Co. 👕 are two renowned companies that design, market, and wholesale products (U.S. Securities and Exchange Commission [SEC] July 29, 2005; February 14, 2006). These apparel manufacturers use company-owned or independent contractors, located throughout the world, to produce apparel products. Russell Corporation 👕 made its move to this type of business model beginning in 1998 and has continued to restructure to become more of a marketing company and less of a manufacturer (SEC March 17, 2005).

As a result of globalization of the apparel industry, a clear definition of the term *apparel manufacturer* no longer exists. VF Corporation 👕 is a good example. It owns and operates cut-and-sew manufacturing facilities in Mexico and Central America, Poland, Turkey, and Malta. This corporation still considers itself an apparel manufacturer, even though it recently switched from producing in VF Corporation–owned facilities to manufacturing with contractors (SEC March 10, 2006; February 27, 2007).

An apparel manufacturer can also be a company on the production end of private-label retailing (see next section). Tarrant Apparel Group 👕 designs and sources products for private-label retailers such as Alain Weiz for Dillard's Department Stores and Souvenir by Cynthia Rowley (SEC January 31, 2007).

Regardless of the murky definition, all apparel manufacturers share these attributes:

- They originally file with the North American Industry Classification System (NAICS) as operating as a manufacturer (not a retailer) and continue to use this classification.
- They sell wholesale products to retailers.
- They may also own their own retail stores.
- They often focus on having a strong brand name for the products produced.

Private-Label Retailers

A **retailer** is a store or nonstore establishment that sells to consumers (U.S. Census Bureau n.d.[h]). A **private-label retailer** develops, coordinates production of, and markets its own proprietary brands for sale in its own stores. **Private label** means an apparel manufacturer makes the merchandise specifically for one retail customer (Standard & Poor's

2005). For example, Pacific Sunwear of California, Inc. develops 30–32 percent private-label sports (surf and skate) merchandise and 16 percent hip-hop proprietary **branded merchandise** (SEC March 31, 2006). A private-label retailer, such as Macy's Merchandising Group , works jointly with apparel manufacturers to develop concepts and to **source** and market its private-label merchandise. Some highly successful Macy's private labels include I•N•C, Charter Club, Alfani, and Style & Co. Macy's private-label programs account for approximately 17 percent of Macy's total sales (SEC April 13, 2006). An apparel manufacturer benefits from developing private-label merchandise because retail customers pay for its marketing and advertising (Standard & Poor's 2005). Developing proprietary brands also differentiates retailers' merchandise assortments and delivers value to consumers (Figure 3.1).

Companies Involved in Both Wholesaling and Retailing

Some apparel companies are involved in both wholesaling and retailing. A company that does both not only designs, markets, and wholesales branded apparel to retail customers, but also markets directly to consumers through a chain of specialty retail stores. Jones Apparel Group, Inc. and Quiksilver, Inc. are this type of companies. Jones Apparel Group owns multiple retail stores, including Nine West, Easy Spirit, and Bandolino (SEC

Beauty Within
for Myladies Lingerie
BWWS001
Black/Pink
Delivery: 3/1 - 4/5
Sizes: 16-22

Figure 3.1 Creation of Beauty Within, a private-label product line designed to make plus-size women feel special. *(Illustration by Alison Flanagan. Adapted from work by Jen Bonasoro and Kristina Hilton.)*

February 28, 2006). Quiksilver primarily sells wholesale products in specialty and department stores. It also has its own Boardriders Club and DC Shoes retail stores (SEC September 14, 2004).

The Role of Branding and Licensing

Branding is an important component of apparel manufacture. A **brand name,** or trademark, is a distinct name or design that distinguishes one seller's goods or services from those of another (PDMA n.d.). Apparel manufacturers create brands to identify one item, or a family of items, for sale in retail outlets. For example, Byer California 👕 has multiple brands, including A. Byer, Amy Byer, Byer Too!, and AGB (Byer California n.d.).

In contrast, apparel companies may acquire a license to produce products under a specific name (Figure 3.2). The manufacturer (licensor) pays a royalty, or percentage of sales, to a designer (licensee) for the use of his or her name. For example, Jones Apparel Group, Inc., is the licensor for Givenchy (the licensee), which develops costume jewelry (SEC February 28, 2006). The licensor benefits because **licensed goods** are a new source of income. The licensee benefits because this arrangement increases his or her name recognition, and the licensee receive royalties.

Strategic Business Units

Team Leaders

The **vice president of product development,** design directors, and merchandisers lead product development associates in planning and developing design and business goals for an identified target market (Regan 1997, 180). Design directors and merchandisers

a b

Figure 3.2 (a) Brand name vs. (b) licensed name. A brand name is a distinct name, whereas apparel manufacturers pay a royalty to use a specific name owned by a licensee. *(Illustration by Christina DeNino.)*

are accountable for a **strategic business unit (SBU)**. An SBU is an entity—a company division, a product line within a division, a single product, or a brand—that a merchandiser plans independently from other company business operations (Kotler and Kelter 2007).

Apparel-manufacturing firms designate the title "design director" or "merchandiser" to the SBU leader, whereas private-label retailers designate the title "merchandiser." A **design director** guides the design team in developing creative concepts, adhering to calendar schedules, and making the company's various SBUs more cohesive with regard to color, silhouette, and fabric direction. In contrast, according to Stephen Pearson, executive vice president for Guess? Inc., private-label retail merchandisers are less involved with design and have a more traditional merchant's role*. This role involves developing—and analyzing—assortment planning, financial matrices, customer accounts, and consumer target markets. In this book, the term **design director** is used to designate the associate who oversees creative activities, and the **merchandiser** is the associate whose primary role is business planning (Figure 3.3).

Formation

Companies organize the development of products into SBUs. Executives divide a company into SBUs for better manageability. Common ways to form SBUs are according to the same end use, a common feature, or gender. *End use* means a generic product classification, such as shorts or pants. A brand name, such as Rare Entities, is an SBU division by common feature. Gender SBU designations are misses', boys', men's, and children's wear, for example. To differentiate SBUs, apparel manufacturers refer to a classification system such as the NAICS for product codes (U.S. Census Bureau n.d.[d]). Apparel manufacturers adapt, shorten, or customize the standard classification phrases to suit their needs. For example, a company might shorten the NAICS classification "Women's and girls' knit shirts and blouses" to "Knit tops."

Design and Business Goals

Apparel manufacturers and private-label retailers refer to their company mission statements and core strategies, explained in Chapter 2, to create SBU strategic plans. The goal of strategic planning is to maintain an appropriate fit among the organization's goals, its capabilities, and changing marketing conditions (Armstrong and Kotler 2007; Investorwords.com n.d.). Strategic plans provide overall company direction for development, marketing, finance, engineering, and manufacturing (Rosenau and Moran 2001). Company executives use strategic plans to translate long-term goals into business objectives.

Annually, merchandisers analyze the overall business of their SBUs and create design and business goals, which become part of the company's strategic-planning process

*Reprinted by permission from Stephen Pearson, executive vice president and supply chain officer; Guess? Inc.: pers. comm., May 30, 2007

a b

Figure 3.3 (a) Visual merchandiser, distinct from (b) a merchandiser who works for an apparel manufacturer or a private-label retailer.

(Regan 1997, 180). Merchandisers write a **design-and-business-goals report,** which they subsequently use to guide the development of branded, licensed, and private-label products. Figure 3.4 outlines components that go into the design-and-business-goals report for an SBU.

The Role of Profitability

Apparel executives measure design and business goals by profitability. Apparel-manufacturing executives and retailers relish the times when their business planning proves to be accurate and pays off with increased sales, such as when Pacific Sunwear of California's sales increased 54 percent in 2003 (Goldman 2003).

Sales per square foot, net sales, and gross margin are common quantitative measures of profitability (Standard & Poor's 2005).

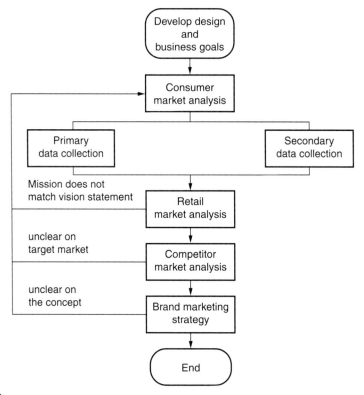

Figure ③.④ Flowchart depicting how to develop design and business goals for a strategic business unit. *(Illustration by Karen Bathalter.)*

Sales Per Square Foot

Retail customers provide a sales-per-square-foot figure to each of their apparel vendors. It is reported as an overall figure or sales generated per brand. For instance, Hot Topic, Inc. 👕 reported an average of $500 **sales per square foot** in 2005, which was high compared with that of other specialty stores (e.g., $370/sq ft) (SEC March 28, 2007). Hot Topic's executives attributed their success to actively soliciting and encouraging customer feedback. They use this information to keep their merchandise current (SEC March 28, 2007).

Net Sales

Net sales—sales minus customer returns and allowances—is another measure of a company's profitability (Wikipedia contributors n.d.). Net sales growth or decline indicates whether a company's products appeal to its consumer target market (SEC February 26, 2007); thus, net sales results are important to the product development team. However, predicting products that will sell successfully is difficult because, as Federated Department Stores, Inc. 👕 noted, "fashion and retail industries are subject to sudden shifts in consumer trends and consumer spending" (SEC April 13, 2006, 7). A company will compare

its net sales growth or decline for corresponding periods (i.e., 2006 vs. 2005 sales). For instance, True Religion Apparel, Inc. ⬛—a company that sells a premium denim brand in luxury department stores—reported a 36 percent net sales increase in 2006. True Religion Apparel executives reacted to this sales growth by adding new sportswear and licensed products to its existing denim product line (SEC March 16, 2007).

Gross Margin

Gross margin, another quantitative measure, is calculated as net sales minus cost of goods sold and is expressed as dollars or as a percentage (Standard & Poor's 2005). For an apparel manufacturer, cost of goods sold includes labor, purchased finished goods, raw materials, and overhead costs incurred in the production process (SEC March 10, 2006). Company executives evaluate company divisions by their gross margin performance (SEC February 26, 2007). Merchandisers successfully meet margin goals by offering products that meet target market preferences (SEC March 24, 2006). Their objective is for select products to become hot sellers for their retail customers and ultimately the consumer.

Components of Design-and-Business-Goals Development

During strategic planning, executives detail the core and product line strategies of each SBU. Every season, the design director, the merchandiser, and the vice president of the product line develop SBU design and business goals. Design goals are a result of analyzing the target consumer, retail merchandise strategy, and competitors of an SBU. Business goals are quantitative decisions made to operate a profitable business (Regan 1997, 180).

If you were to look at a merchandiser's job qualifications, you would see key phrases such as *analyze, develop, and communicate seasonal strategies; lead the merchandising team; implement strategic plans; ensure financial success;* and *develop long-term business, product, and financial strategies* (Gap n.d.; VF Corporation n.d.). Merchandisers need these skills to conduct the comprehensive design-and-business-goals activity. They use the company's mission statement to conceptualize their line for a target market and to develop a brand marketing strategy. When a merchandiser finalizes the design and business goals, they are just the starting point for many activities, including the development of line plans and sales packages (Regan 1997, 180).

When merchandisers focus on their design and business goals, they visualize how to create superior products that meet target consumers' needs, salable retail products, and strategies that beat the competition. The purpose of the SBU is having formal design and business goals is to increase or maintain the salability of products in the current competitive retail environment. Apparel associates refer to *developing design and business goals* as a global term for a group of activities, that include:

1. *Product line conceptualization:* Creating a product line definition, product line categories, and a product line strategy
2. *Market analysis:* Understanding the target consumer market, the current retail market, and the competitor market
3. *Brand marketing strategy development:* Determining what products to offer, which fashion direction to take, and the competitive advantage of the SBU (Regan 1997, 181)

In the Rare Designs story, Anne, vice president of product development, commented, "I have this information in my head. I need to put this information down on paper so going forward my associates' decisions are consistent with my design direction." A well-defined market concept leads to clear goals and a consistent direction and results in a smoother product development process.

Product Line Conceptualization

A **product line** is a group of closely related merchandise items, within an SBU, that function similarly, are sold to similar customer groups, are marketed to similar retail store types, or fall within given price ranges (Figure 3.5) (Armstrong and Kotler 2007). For instance, Pacific Sunwear of California's SBUs are its retail outlets: Pacific Sunwear (or PacSun), d.e.m.o., One Thousand Steps, and Pacific Sunwear Outlet (or PacSun Outlet). PacSun 👕 and PacSun Outlet stores both specialize in casual wear inspired by board sport apparel. The d.e.m.o. stores specialize in fashion-focused street wear apparel, which is inspired by hip-hop music and celebrities (SEC March 31, 2006). One Thousand Steps is a specialty footwear store with an assortment of casual, fashion-forward, and branded styles for 18- to 24-year-old consumers (Pacific Sunwear of California, Inc. 2006).

A product line is a division of a company's SBUs. For instance, each PacSun SBU has four product lines: Girls Apparel, Guys Apparel, Accessories, and Footwear (SEC March 31, 2006). Jones Apparel Group sets its SBU by brand (e.g., Jones New York). It then

Figure 3.5 Example of a juniors' product line.

subdivides each SBU brand into the product groups of career and casual sportswear, jeans wear, dresses, suits, and lifestyle apparel (SEC February 26, 2007).

Developing SBU product lines can be compared to investing in the stock market: The more breadth to a portfolio, the less individual risk. Apparel manufacturers target one or multiple market segments, which compose a specialized target within a classification. A small apparel manufacturer creates a product line that targets one retail store type (e.g., specialty stores), whereas a midsize to large manufacturer has multiple SBUs, each targeting one or more retail store types.

Retail Store Types

A manufacturer needs to match its SBU product line with its customers. How do apparel associates gain insight into retail store types? One source is the U.S. Census Bureau's annual *Estimates of Monthly Retail and Food Services Sales by Kind of Business* report, which provides dollar sales figures for all retail and food services. The categories pertinent to the field of apparel include general merchandise stores, specialty clothing and clothing accessories stores, and nonstore retailers (U.S. Census Bureau n.d.[a]). In 2006, most consumers shopped at general merchandise stores (53.0 percent), followed by nonstore retailers (26.5 percent). Specialty clothing and clothing accessories was the third-highest retail sales category; 20.5 percent of all consumers shopped in these stores (U.S. Census Bureau n.d.[e]).

General Merchandise Stores

General merchandise stores comprise superstores, discount stores, and conventional department stores. A **superstore** offers a wide assortment of merchandise, includes a full-line supermarket, and occupies a large physical space (e.g., 187,000 sq ft). A **discount store** also offers a wide assortment of general merchandise, but only a limited food assortment (SEC March 27, 2007). A **conventional department store** offers a wide range of soft lines and hard lines. *Soft lines* include men's, women's, and children's apparel and accessories. *Hard lines* include home furnishings, housewares, and home accessories (SEC April 13, 2006). Most general merchandise consumers (54 percent) shop at warehouse clubs and superstores. Mammoth retailer Wal-Mart ⬜ accounts for a tremendous amount of annual general merchandise sales, reporting a whopping $345 billion in sales in 2006 (SEC March 27, 2007). Wal-Mart dominates apparel sales. Its soft goods and domestics SBU has sales of $51.75 billion annually. Its jewelry and shoes SBUs each account for an additional $3.45 billion (SEC March 27, 2007).

Discount stores are the second-highest general merchandise store category and account for 24.3 percent of all consumer purchases (U.S. Census Bureau n.d.[e]). Target Corporation ⬜, a discount retailer, has sales of more than $59 billion annually, and its apparel and accessories SBU accounts for approximately $13 billion (i.e., 22 percent of annual sales) (SEC March 15, 2007; Target Corporation n.d.[b]). Conventional department stores (e.g., Macy's) account for 15 percent of general merchandise store sales (U.S. Census Bureau n.d.[e]).

An apparel manufacturer that produces broad product lines (e.g., T-shirts to dresses) meets the needs of conventional department stores, which sell wide merchandise assortments. If an apparel manufacturer's goal is a high sales volume, its product lines

are best suited to be sold at discount stores or warehouse clubs and superstores, which feature lower-priced, high-volume merchandise mixes (Armstrong and Kotler 2007). Large apparel manufacturers sell to multiple retail channels. For instance, Liz Claiborne Inc. 👕 has multiple SBU product lines that target different market segments. Its Ellen Tracy, Inc. 👕 line sells in upscale department and specialty stores and targets an upper socioeconomic status market segment. Neiman Marcus 👕, a conventional department store, works with Liz Claiborne, Inc. to offer specialized Ellen Tracy product groupings (SEC September 16, 2005). First Issue, another Liz Claiborne brand, is an exclusive line for Sears, Roebuck and Co. 👕, which targets a budget market segment (SEC March 1, 2006).

Specialty Clothing and Clothing Accessories Stores

Within the specialty clothing and clothing accessories category, most consumers shop at family clothing stores (e.g., Kohl's; 52.8%), followed by women's specialty stores (e.g., Chico's; 25%), shoe stores (12.2 percent), and men's specialty stores (6.2 percent) (U.S. Census Bureau n.d.[e]). An apparel manufacturer that produces only knit sweaters may target specialty stores as its primary retail customer because such stores often feature narrow product lines (e.g., sweaters) and offer a broad assortment within in a line (e.g., a rainbow of colors and sizes).

Nonstore Retailers

Nonstore retailers include all companies selling e-commerce and mail order merchandise (U.S. Census Bureau n.d.[c]). Although the U.S. Census Bureau 👕 combines apparel with all merchandise categories, many retailers consider nonstore retailing a viable growth opportunity (SEC September 16, 2005; March 24, 2006). For example, Nordstrom, Inc. 👕 commented that many of its online consumers later shop at its stores (SEC March 23, 2007).

ACTIVITY 3.1 *Analyzing SBUs*

Look at the Jones New York Web page (www.jonesnewyork.com/maincontent 36418673.do) to analyze how the company's SBU's are organized (e.g., collection, sport). U.S. Jones New York product lines are divided by theme (e.g., expedition), fabrication (e.g., cashmere), or style (e.g., bohemian). How have Jones New York SBUs differentiated their products (e.g., price, lifestyle)?

Consumer Market Analysis

Picture yourself as a merchandiser. You know your job—to develop design and business goals—but how do you do so? When defining *merchandising*, Kunz (2005) used the term *identified target markets*, so the first step in developing design and business goals is to analyze the target market of an SBU. A **target market** is the customers or consumers, who share common needs or characteristics, whom a company serves or wants to serve (Armstrong and Kotler 2007). To design products that meet retail customers' needs, merchandisers analyze target market economic patterns, demographics, market trends, and psychographics. An apparel manufacturer must match its own consumer demographics

with those of its retail customers. Designers want to think all consumers will like their products, but such is not the case. Rather, only certain consumers will buy their products. An SBU **core consumer** is an individual, within a target market, who repeatedly buys and wears an apparel manufacturer's brand. Thus, to understand core consumers, merchandisers must conduct research on their retail customers. The more focused apparel associates are on their target market, the more easily they can design successful products.

How does an apparel manufacturer or retailer learn about its target market? You can visualize this process by imagining you will design garments for some friends. If you were to design for a select group, such as your friends, they would be your target market. Some questions you would ask your friends would address their age, household income, store preference for clothes, and lifestyle activities. Paloma Bautista, a former design assistant for True Meaning, described her core consumer as follows:*

> At True Meaning, we create one product line. Our core strategy is to be a line that both a daughter and a mother could wear. Our styles are contemporary and sell at stores such as Nordstrom, Saks Fifth Avenue, and boutiques. We also sell private label to retail customers such as Stein Mart. We try to keep our garments stylish so that both a 22-year-old woman and a 45-year-old woman would feel comfortable wearing them. For instance, we have similar-styled pants in both a lower waist and a higher waist, but now the higher waist is coming back.

ACTIVITY 3.2 *Critical Thinking*

Knowing your target market is crucial to your success in the apparel industry.

- Relate the design assistant's description to the information you need to capture about your target market.
- Write a list of questions you should ask individuals so that you capture the type of detail described in Bautista's quotation.

The ability of apparel associates to understand SBU consumer preferences affects a company's market share. **Market share** is a percentage of industry sales that a specific company controls (Harvey 2006). An individual calculates market share as a percentage of a business in relation to an entire industry (e.g., apparel manufacturing) or an industry segment (e.g., children's clothing). Because a merchandiser is accountable for market share, he or she must synthesize the target market for age, type of employment, shopping patterns, lifestyle, products purchased, garment preferences, and brand perception.

One excellent way for apparel associates to learn about their target market is to analyze primary and secondary data. Target market characteristics continually change, thus ongoing primary and secondary data collection is necessary to develop accurate SBU product line plans.

*Reprinted by permission from Paloma Bautista, former design assistant, True Meaning, Vernon, CA; pers. comm., April 6, 2006.

Figure ③.⑥ Living the Culture, a designer's interpretation of clothes that would attract an alternative clothing consumer, identified from primary data collected at a nightclub. *(Illustration by Alison Flanagan. Adapted from work by Ruby Plasencia.)*

Primary Data Collection

Primary data collection means that an individual, such as an apparel associate, personally gathers information for analysis. This person gathers primary data in several ways: observing consumers, conducting surveys, leading focus groups, and interviewing individuals (Figure 3.6).

Interviewing provides designers with excellent insight. This form of primary data collection allows consumers to express their needs and identify potential design improvements that designers had not considered. To understand the nuances that a designer can glean from interviewing, read this quotation from a plus-size consumer who expressed her clothing needs to the author in March 2007:*

> I made the step over into plus sizes some years back; I wasn't always a plus size. I really hadn't a clue until I outgrew regular sizes. Some people are plus size all their life, but if you aren't, it's a real shocker—degrading and hurtful—to have to walk into a completely separate department. You feel as though you are announcing to the world "I'm now officially fat!" Why can't retail stores have just one misses'

*Reprinted by permission from Kathleen Riley-King, consumer; pers. comm., April 1, 2007.

department in which garment sizes continue past size 12 to 18, 20, and beyond? I often look longingly at a clothing style in the regular misses' section and see no reason why the style could not also be offered in plus sizes. I often feel as though the current plus-size styles say "old lady." We like to be hip, too. I like classy, stylish, tailored-looking clothing, and it seems to be in short supply for plus sizers like me.

ACTIVITY **3.3** *Critical Thinking*

In the preceding quotation, the plus-size woman discusses some frustrations with current apparel offerings.

- What did this interview tell you about the plus-size consumer that written literature would not?
- Write an interview question that you could ask your consumer about his or her clothing needs.

Hot Topic ⬆ is a private-label retailer whose associates use primary data collection extensively. Its employees use these data to write fashion reports. A **fashion report** is a written summary of an associate's primary data collection. Merchandisers use the fashion report to identify new products and assortments. For instance, Hot Topic focuses on 12- to 22-year-old males and females who are passionate about music. The company notes that music and pop culture are a strong influence on this target audience. Two Hot Topic design goals are to react quickly to trends and to be the first to identify music artists who have strong appeal for their core consumer. A company philosophy is to listen to the customer. Hot Topic apparel associates collect primary data attending concerts and monetoring music videos to identify new music and pop culture trends (SEC March 28, 2007).

Apparel associates in the industry often cite the motto "Observe it; work it; live it." Hot Topic's apparel associates follow this creed. Some of the primary data collection they conduct includes monitoring new music played on the Internet, visiting nightclubs, attending musical concerts, viewing music videos, and attending events that attract their target consumers. Another primary data collection approach they use is gathering information from Hot Topic's sales associates. These associates greet shoppers who provide the apparel associates with information about new music and fashion trends. Hot Topic apparel associates then write a fashion report and give it to the product development team (Allers 2003; SEC March 22, 2006).

Likewise, other apparel companies, such as Patagonia, Inc. ⬆, require apparel associates to understand the products they design by experiencing their core consumer's lifestyle, or "living it." Patagonia, Inc., emphasizes this philosophy by hiring associates who share a love of the outdoors, a passion for quality, and a desire to make an environmental difference (Patagonia, Inc. n.d.).

When collecting primary data, designers need to be keen observers and write notes on interesting ways consumers wear and use products. For instance, Hot Topic's Torrid buyers listen closely to their consumers' needs. Torrid's target market is plus-size young women aged 15–29 years who desire beautiful, feminine, sexy clothing (SEC March 14, 2007). Hot Topic associates gather consumer comment cards and postings on Torrid's Web site. On the basis of the information gathered, their buyers then create and test new

styles to gauge their consumers' response (SEC March 22, 2006). Alona Ignacio, a designer for Seril, noted the following about creating new styles:*

> You need to visualize people wearing your designs. You could ask yourself, "Would I wear it or would I like to see this on other people?" You cannot design based only on your personal taste; you need to think about your consumer. Your own intuition plays an important role to determine whether you are going in the right direction. If you have your heart in creating your product, it is going to show.

ACTIVITY 3.4 CRITICAL THINKING

Think about your company project. How does your personal taste differ from your target market's preferences?

The **focus group** is also used to identify core consumer preferences. In this method, a trained interviewer focuses the conversation of a small group of individuals who represent the company's core consumer on important issues (Figure 3.7) (Armstrong and Kotler 2007). For example, a focus group may evaluate products according to consumer purchase attributes (e.g., fit, comfort). The advantage of using focus groups is that participants are usually honest (sometimes brutally so), give impromptu answers, blindly review products, and compare multiple competing brands. Eileen Wong, a technical designer for Marciano, cited an example of a typical focus group topic:*

> One of our focus group meetings addressed fit and fit process concerns. We had mock fit sessions to determine the best garment fit, problem areas we needed to work on, vendor-related issues, sizing issues, model issues, and inconsistency among garment styles. We also discussed how other departments affected the work flow of the technical design team.

ACTIVITY 3.5 *Critical Thinking*

Set up a focus group scenario for your company project.

- Identify individuals who should participate in the focus group (e.g., customers, suppliers, consumers).
- Identify an important price, quality, style, or construction attribute that would be beneficial to discuss.
- Write two or three pertinent questions to ask the focus group participants.

Secondary Data Collection

Information that already exists is called secondary data (Armstrong and Kotler 2007). Apparel manufacturers and retailers use secondary data sources to profile their target market and to determine product preferences. These sources include electronic information systems, nongovernmental statistical data, and government data. Therefore, secondary data collection is when an individual analyzes information or figures from previously gathered data.

*Reprinted by permission from Alona Ignacio, designer/product development, Seril, Vernon, CA; pers. comm., April 12, 2006.
*Reprinted by permission from Eileen Wong, technical designer, Marciano, Los Angeles, CA; pers. comm., January 24, 2006.

Figure 3.7 Focus group of moms reviewing baby clothing. *(Illustration by Alison Flanagan, Esmeralda Perales, and Kristiana Tho.)*

Most commonly, companies analyze demographics. **Demographics** are group classifications determined by analyzing variables such as age, gender, family size, income, or occupation (Armstrong and Kotler 2007). Companies use demographics to identify target market characteristics (Figure 3.8). For instance, Pacific Sunwear identifies its demographics as men and women aged 12–24 years. Its primary demographic audience also lives in coastline states. Although Pacific Sunwear has stores across the United

Figure ③.8 Consumer demographic representation. *(Illustration by Christina DeNino and Esmeralda Perales.)*

States, its top four retail locations are California, Florida, Texas, and New York (SEC March 31, 2006).

Apparel companies sometimes hire marketing services to analyze target market demographics. However, small apparel manufacturers may not be able to afford such services. An individual can access *electronic information systems* that provide valuable secondary data on target markets through university libraries, public libraries, or subscription. Electronic information systems provide financial and corporate profile documents about public and private apparel companies. Well-known electronic information systems include Yahoo! Finance ⬆, the Electronic Data Gathering, Analysis, and Retrieval (EDGAR) system ⬆, and LexisNexis. For example, Hot Topic, Inc., indicates that its competition is teen-focused retailers. A LexisNexis (2006b) search of the Hot Topic company yields a Hoover's article that describes Hot Topic's main product lines as novelty T-shirts, men's and women's apparel, and body jewelry. In its SEC (March 22, 2006) annual report, Hot Topic noted that its apparel retail competition includes Abercrombie & Fitch ⬆; Pacific Sunwear of California, Inc.; and Forever 21, Inc. ⬆. In accessories, its retail competition includes Claire's stores and Spencer Gifts.

An apparel associate can further research a company's competitors by using LexisNexis and the competitors' company Web sites. For example, Gadzooks has been one of Hot Topic's keen competitors. Both stores target teenagers and offer products inspired from magazines, music, movies, and television, with occasional shock appeal (LexisNexis 2003; SEC May 2, 2002). In 2003, Gadzooks filed bankruptcy and Forever 21 purchased it (SEC February 22, 2005). Forever 21 is a retailer that prices its clothes 2 percent lower than those of its competitors (LexisNexis 2006a). As a result, this acquisition changed Hot Topic's competitive environment because Forever 21's vision is to offer inexpensive, trendy, fast fashion.

Market-Research Services

Apparel market research services are a *nongovernmental statistical data* source. These firms compile apparel-related demographic and psychographic trend information. Market research companies benefit apparel clients by cross-referencing primary and secondary data. Such thorough investigation increases accuracy so that their clients can make astute decisions. For example, a market research firm will cross-reference shopper demographics (e.g., age, gender, geographic region) with psychographics (e.g., lifestyle, purchase behavior), fashion, and shopping attitudes (Figure 3.9) (NPD Fashionworld n.d.).

Large, broad-based apparel marketing services include Retail Forward ⬆, NPD Fashionworld ⬆, and Just-style ⬆. Some market research services specialize; for example, Alloy Media + Marketing ⬆ and Teen Research Unlimited ⬆ focus on teen consumers (MarketWatch, Inc. n.d.; SEC May 2, 2002; Teen Research Unlimited n.d.). These services provide valuable information. For example, Hot Topic says that according to Teen Research Unlimited, the American teenage demographic group is growing. This group spends approximately $104 a week and has extensive purchasing power (SEC March 22, 2006).

Retail customers will sometimes provide demographics to their suppliers. Sharing target market demographics assists both apparel manufacturers and retail customers in developing salable products. For example, Target is a general merchandise store. Its core consumer is a 41-year-old college-educated individual with a household income of

a

b

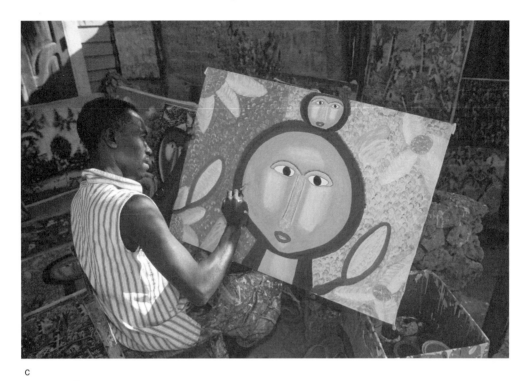

c

Figure 3.9 Psychographic examples showing consumer hobbies: (a) mountain biking, (b) gardening, (c) painting.

$58,000, and 43 percent of its core consumers have children living at home. Target has an online partner program in which it shares critical business information with its vendors (Target Corporation n.d.[a], n.d.[b]).

ACTIVITY 3.6 *Collecting Secondary Data*

Go to the Target Corporation Web site: www.target.com.

- Select the product category you are developing (e.g., toddler boys' clothing).
- Compare three brands and prices within that category (e.g., Levi Strauss Signature, Genuine Kids from OshKosh, and Cherokee).
- Compare the styles, prices, and fabrics among the three brands for one garment style (e.g., cargo shorts), and write your comparison.
- Referring to Target's consumer profile definition, describe how each brand appeals to its core consumer.

Government Data Sources

The U.S. Census Bureau is an excellent *government data* source. The Population Reference Bureau ⌂ provides information on population characteristics (AmeriStat 2002; Populaton Reference Bureau n.d.). One population trend is an increase in the

number of Asian Americans who live predominantly in metropolitan areas (Lott 2004). Whereas some apparel companies opt to disregard ethnic demographic trends, companies that are more astute consider these demographics when designing products. For example, the designers for George, a Wal-Mart private label, considered ethnicity when developing some of their designs, such as a more conservative neckline style for an existing shirt to meet South Korean consumer modesty requirements (White and Zimmerman 2003).

Although apparel manufacturers sell to multiple retail customer accounts, a merchandiser typically analyzes target market demographics for only the top accounts. The merchandiser creates one target market profile by synthesizing the demographic results from these accounts. If a retail customer does not provide core consumer information to its suppliers, apparel associates can use American FactFinder, a secondary data source, published by the U.S. Census Bureau. American FactFinder profiles U.S. citizens according to selected social, economic, and housing demographics. Apparel associates can obtain a general profile of a retailer's target market by analyzing a demographic sample of retail store locations. An individual can use American FactFinder to analyze social, economic, and housing demographics by zip code. In zip code analysis, the primary target market is assumed to be people who live in the same zip code as that of the retail store location and draws additional shoppers from surrounding areas. However, a zip code analysis does not work for retail locations that are tourist destinations. Let us sample Neiman Marcus department store locations to understand how to interpret American FactFinder demographic information.

ACTIVITY **3.7** *Analyzing Demographics*

In this activity, targeting men who shop at Neiman Marcus is used as an example only. You may use a different private-label retailer, a conventional department store, or a mass merchandiser. You will be simultaneously using American FactFinder on the Internet and also Excel.

1. Go to the Web site of a retail store at which you would like to sell your products (e.g., Neiman Marcus, www.neimanmarcus.com). Select the "Store locations" function. Choose five U.S. store locations where you would like to sell your merchandise. (Table 3.1 shows Neiman Marcus locations in five U.S. cities.). Write down each store location zip code.

2. Go to the U.S. Census Bureau's American FactFinder Web site: http://factfinder. census.gov/home/saff/main.html?_lang=en.

3. Visually locate "Get a Fact Sheet for your community." Type one of the zip codes from step 1 into the "city/town, county, or zip" search box (e.g., 60611).

4. Open up Table 3.1, an Excel template from the companion textbook Web page.

5. Use the instructions in the following table. Going row by row, read the instructions (if any) on the left and respond to the instructions on the right by typing the specified information into the Excel template (Table 3.1 on the Web site):

On American FactFinder Web site	In Excel template
	In row 1, replace "(e.g., Neiman Marcus)" with the name of the retailer you chose.
	In row 3, replace the zip codes that currently exist with your own. Type in the name of each city in row 2, directly above each corresponding zip code.
"General Characteristics." Click on the "show more" button beside	Type the gender of your target consumer (e.g., "Male") in column A. In column B, type in the number stated for the percentage of the gender. (*Note:* Type in the *decimal* number—e.g., for 6.0%, type .06; for 68.2%, type .682; the percentage calculation is built into the template cells.)
	Type in your target market age descriptor in column A and the percentage of individuals in this age category in column B. For instance, if you were designing young men's suits, you would type "Age: 25-34 years" in column A and the corresponding percentage (e.g., .256 for Chicago) in column B.
	Type in the race (or races) you want to target. Type the percentage for "One race" or for each race. If you are not targeting a race, type "One race" and the corresponding percentage (e.g., .983 for Chicago). If you are targeting a specific race (e.g., Asian men), type in the corresponding percentage for each race.
	Type in the household type. For instance, if you are targeting single men, type "Householder living alone." Type in the corresponding percentage.
Click the "back" button and scroll down to "Social Characteristics." Click on "show more."	Type in the educational attainment level you want to target (e.g., "Education: Bachelor's degree"). Type in the corresponding percentage. Use school enrollment if your target consumer is in school.
	Type in the marital status of the consumer you want to target. Add the percentages and type in the total. For instance, if you are targeting all single men, add the "Never married," "Widowed," and "Divorced" percentages. Type in the corresponding total percentage (e.g., .553 for Chicago).
Click the "back" button and scroll down to "Economic Characteristics." Click on "show more."	Type in the employment status. For instance, if you are targeting only employed men, type "Employed." Type in the corresponding percentage.

(continued)

On American FactFinder Web site	In Excel template
	Type in the occupation. For instance, if you are targeting men in management positions, type "Management, professional, and related occupations." Type in the corresponding percentage.
	If relevant, type in the industries in which your target consumer is employed. For instance, if you are targeting men employed in apparel manufacturing, type both "Professional ... services" and "Manufacturing." Type in the corresponding percentages.
	Type in the income bracket for your target consumer. This figure should match the income bracket targeted by the retail store you selected. As some generalizations, luxury department and specialty stores (e.g., Neiman Marcus) target the top three income brackets, department stores (e.g., Macy's) target the three midrange income brackets, and general merchandise stores (e.g., Wal-Mart) target low-income to middle income brackets.
	Repeat the preceding sequence for your next four zip codes and fill in the next four columns (C–F) instead of column B.
	Note the averages in the right column (G). This cell has the Excel formula to calculate an average (i.e., =average b2:f2) automatically built in.

6. Write one or two sentences describing your target market—the one identified in Company Project 1: Business Strategy Report—Part 1 (see Chapter 2).
7. Write a demographic analysis of your target consumer. Use the narrative example in Figure 3.10 as a template.

Psychographics

A merchandiser conducts a psychographic analysis to obtain a complete core consumer picture. **Psychographics** are analyses of different groups on the basis of generation, social class, lifestyle, activities, or personality characteristics (Armstrong and Kotler 2007). A psychographic analysis often categorizes consumers by generations because these groups share similar technology, historic events, and business patterns. Generation categories are *Traditionalists*, born before 1946; *Baby Boomers*, born between 1946 and 1964; *Generation X*, born between 1965 and 1981; and *Millennials*, born between 1982 and 2000.

Let us use Rare Designs' target market to understand a psychographic analysis. The company's mission statement says the target market is "youthful professional women who desire clothing that helps them better perform their job." Anne, Rare Designs' vice president of product development, would translate this description as a Millennial female aged

Table 3.1 Sample Zip Code Analysis for Five Neiman Marcus Stores

Retail customer: (e.g., Neiman Marcus)

Store locations	Chicago, IL 60611	Boston, MA 02116	Dallas, TX 75225	Beverly Hills, CA 90212	Atlanta, GA 30326	Average
General Characteristics						
Male	46.6%	50.9%	46.1%	44.3%	54.0%	48.4%
Age: 25–34 years	25.6%	27.0%	8.6%	17.4%	34.5%	22.6%
One race	98.3%	98.1%	99.5%	96.4%	98.7%	98.2%
Householder living alone	61.6%	58.8%	31.7%	45.7%	61.7%	51.9%
Social Characteristics						
Education: Bachelor's degree	33.8%	35.0%	45.8%	33.7%	49.5%	39.6%
Marital status: Single (never married, widowed, and divorced men)	55.3%	64.8%	34.4%	52.7%	59.1%	53.3%
Economic Characteristics						
Employed	68.2%	69.0%	56.5%	63.0%	82.1%	67.8%
Management, professional, and related occupations	70.1%	62.0%	66.0%	62.6%	70.5%	66.2%
Professional, scientific, management, administrative, and waste management services	24.7%	25.2%	22.4%	21.8%	29.1%	24.6%
Manufacturing	6.0%	6.0%	4.5%	5.6%	9.8%	6.4%
Household income: $100,000–$149,999	13.4%	12.5%	12.8%	11.6%	31.9%	16.4%
Household income: $150,000–$199,999	7.3%	6.4%	7.9%	7.1%	5.3%	6.8%
Household income: $200,000 or more	15.1%	12.8%	28.8%	11.7%	8.6%	15.4%

Table 3.1 provides a general Neiman Marcus target market profile, representing 19 percent of the store locations. These shopping destinations are in large metropolitan areas.

The target market for my company is single, young men aged 25–34 years who have a college degree and are working in management positions. Because I will produce fashion-forward high-quality men's suits, I am targeting men who live in large metropolitan areas, shop in luxury department stores, and have a high income.

Demographic trends show that luxury stores (Neiman Marcus) are located where slightly less than half the population is male (48%). Slightly more than half the male population living in these large metropolitan areas is single (53 percent) and lives alone (52 percent). My men's suits product line will target men in professional or scientific positions who might be expected to wear a suit to work. In these metropolitan areas, men in these careers account for approximately 25 percent of the men in management or professional positions. In these Neiman Marcus store locations, 15–16 percent earn either $100,000–$149,999 or $200,000 or more. Because 23 percent are 25–34 years old in these metropolitan areas, a guesstimate is that 3.7 percent of young professional men earn a high income (.23 * 16 %).

Figure 3.10 Analysis of Table 3.1.

22–35 years who has a professional, a managerial, or an administrative career (Figure 3.11). Anne could seek target market psychographics by searching for "Millennial consumers" on the Internet or in electronic information systems (e.g., LexisNexis, WilsonWeb), by hiring a market research service (e.g., NPD Fashionworld), or by analyzing U.S. Bureau of Labor Statistics information. A Millennial psychographic summary indicates that such a consumer is from a diverse ethnic background, is technologically savvy, and will need a college degree. The United States will continue to be a melting pot of ethnically diverse individuals, many of whom will desire a strong link to their heritage (Chao 2001). Millennials tend to be confident, goal oriented, and achievement oriented. They believe in the future, are team players, and give back to their community (Raines 2002). Most Millennials will work in service professions, which require at least an associate's degree (U.S. Bureau of Labor Statistics 1999). Many Millennials will gravitate toward the primary employment growth areas—education, health care, social assistance, and professional and business services (U.S. Bureau of Labor Statistics 2005). However, Millennials will be mobile and able to transfer skills to a diverse range of careers rather than be tied to one particular industry or job title (Chao 2001).

Even though apparel companies conduct or contract for extensive demographic and psychographic analyses, pinpointing consumer desires is difficult. Many apparel companies, such as Hot Topic and Pacific Sunwear, indicate that they do not attempt to dictate fashion; rather, they identify and react to emerging trends (SEC March 22, 2006; March 31, 2006). Apparel manufacturers and private-label retailers must react to what the consumer wants.

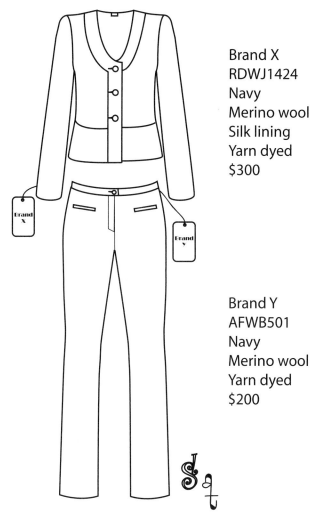

Brand X
RDWJ1424
Navy
Merino wool
Silk lining
Yarn dyed
$300

Brand Y
AFWB501
Navy
Merino wool
Yarn dyed
$200

Figure 3.11 An apparel outfit for Rare Designs' demographic of a youthful profession-al female aged 22–35. *(Illustration by Alison Flanagan and Suzette Lozano.)*

Retail Market Analysis

To be successful, apparel designers need to understand and analyze current retail events and business trends. An understanding of retail customers enables a designer to match his or her product line with a retailer's merchandise mix. At a Fashion Group International presentation panel members emphasized that apparel designers must design and develop salable garments. He said that the true measure of garment success is when the retailer sells the garment to consumers.

An apparel manufacturer's SBU product line must be in concert with its retail customers' store types and merchandise strategy. Achieving this alignment is tricky because the fashion retail environment is highly competitive and the industry has the reputation of being "here

today, gone tomorrow." Apparel producers must stay abreast of the store "selling du jour"—from investment firm Texas Pacific Group's buying Neiman Marcus, to Federated Department Stores' buying May, to Target's selling Mervyn's and Marshall Fields (SEC September 16, 2005; April 13, 2006; March 15, 2007). Retail consolidation and ownership change can significantly affect apparel manufacturers, especially if one retail customer accounts for a substantial portion of their business. For instance, Federated Department Stores accounts for approximately 24 percent of Liz Claiborne's sales (SEC March 1, 2006). When Federated bought Robinsons-May, the purchase altered multiple product development attributes and planning.

To compel shoppers into their stores, retailers continually change to distinguish themselves from their competitors. Consumers cross-shop at all store types, but a merchandiser focuses on individual SBU product lines. A core consumer typically buys comparable products at the same store type—for example, commodity clothing (e.g., T-shirts) at a general merchandise store or career clothing (e.g., suits) at a specialty store.

Once apparel associates select their target store type, they need to match the market segment with that of their retail customer and their core consumer. One vitally important point is that apparel manufacturers not only must match their market segment with the retail store type, but also must be cognizant of a retail customer's merchandise strategy. **Merchandise strategy** is the part of a retailer's business plan in which company executives translate financial goals into objectives for products purchased and developed. Apparel associates who understand a retail customer's merchandise strategy have a win-win opportunity, because such an understanding yields a correct target market match, stronger brand recognition, and higher sales.

Discovering a retail customer's merchandise strategy entails being a sleuth; apparel associates must discover "customer secrets." This information is not truly secret; it is available but requires diligence to find. Public corporations own most U.S. general merchandise stores, conventional department stores, specialty stores, and other retail establishments. Public corporations file annual 10-K reports with the Securities and Exchange Commission (SEC). Executives discuss merchandise strategy in 10-K and 8-K reports and the CEO letter to shareholders (see the SEC's EDGAR system). Another source of retail strategies is electronic information services (e.g., Hoover's), which analyze both public and private companies.

Let us use Rare Designs as an example. Anne would concentrate on her top three or four retail accounts. Rare Designs' products sell in conventional department stores. If Rare Designs' major retail customers were Bloomingdale's (i.e., Federated Department Stores), Nordstrom, and Macy's (i.e., Federated Department Stores), Anne would discover the following merchandise strategies.

Federated Department Stores has made significant changes since 2003. The corporation identified Macy's as its primary nameplate, and it consolidated business strategy, merchandising, and buying to the corporate level (SEC April 13, 2006). The advantage of this approach is to have one centralized organization develop and execute consistent corporate merchandise strategies (SEC December 7, 2006). One disadvantage is the loss of individuality for each retail division. By selling to Federated Department Stores, an apparel manufacturer could find its product in one or more store divisions: Macy's Central, Macy's East, Macy's Florida, Macy's West, Macy's Northwest, or Bloomingdale's. Two Federated Department Stores' corporate goals are to simplify pricing and to differentiate merchandise assortments so that they are appealing, compelling, and plentiful, but not overwhelming (SEC December 7, 2006). Department stores, such as Macy's, traditionally offer a wide merchandise assortment of men's, women's, and children's apparel, as well as hard-line goods

such as home furnishings. Federated has collaborated with established vendors to offer unique brands and private-label merchandise sold exclusively in their stores (SEC April 13, 2006). One partnership example is American Rag Cie 👕, which involves an exclusive arrangement between Macy's Merchandising Group and manufacturer Tarrant Apparel Group. The American Rag Cie product line is vintage-inspired clothing with the unique twist of some one-of-a-kind clothing styles (Business editors 2003; Federated Department Stores, Inc. n.d.). Bloomingdale's distinguishes itself from Macy's by basing its strategy on delivering distinctive fashion merchandise and a high level of personalized attention to its upscale clientele (Business editors 2003; Federated Department Stores, Inc. n.d.).

Two corporate Nordstrom strategies are to enhance the company's merchandise offerings and to improve its consumers' shopping experience (SEC March 23, 2007). Women's apparel accounts for 35 percent of total sales; shoes, 20 percent; men's apparel, 18 percent; and accessories, 10 percent (SEC March 23, 2007). Within women's apparel, Nordstrom executives are targeting specific merchandise strategies to capture consumer preferences for garment style, fit, price, and occasion. Their merchandise strategy is to offer consumers a wide selection of designer and high-quality merchandise in fashion departments that fit individual lifestyles (SEC March 24, 2006). Their competitive strategy is to offer consumers depth of selection, value, and quality products from unique vendors (such as Juicy Couture 👕 and Tommy Bahama 👕), none of which solely accounted for more than 2 percent of net purchases in 2002 (SEC April 17, 2003; Tice 2003).

Once apparel associates identify retail customer merchandise strategies, they need to match the retail customers' direction with that of their own company. For example, Rare Designs targets a Millennial consumer. This type of consumer commonly multitasks and is technologically savvy (Raines 2002). As vice president of product development, Anne would need to address multitasking and technology in the design of Rare Designs' garments. Some options could be to provide specialized pockets for PDAs or cell phones or to use advanced fabrications. These design options are in concert with one of Nordstrom's merchandise strategies, which is to offer newness in all its product categories (SEC March 23, 2007).

Competitor Market Analysis

Apparel manufacturers, private-label retailers, and retail customers commonly state that the fashion industry is intensely competitive. Many firms say they continuously evaluate and respond to consumers' changing preferences (SEC February 28, 2006). Apparel companies commonly analyze their competitors. An apparel associate identifies competitors from a consumer's perspective by asking, "If I were a consumer shopping for my garments, which brand would I as a consumer purchase over mine and why?" Thinking that everyone will like your garments would be an ego booster but a grave mistake. Remember how angry Anne got when a shopper said her garments were not professional. That shopper will either buy a garment from Rare Designs' competition or not buy at all. You must be objective and evaluate competition from a consumer's perspective. An **apparel competitor** thus sells similar goods to the same consumers, market segment, and store type. This rival has a positive or negative impact on company market share.

Apparel associates have difficulty predicting what a competitor plans to do because competitors are never idle; therefore, apparel associates need to be diligent to continually understand companies with which they directly compete. Merchandisers commonly comparison shop to analyze the service their competition offers. **Comparison shopping** refers to apparel associates' study of rival products sold in retail store accounts. When apparel

associates comparison shop, they visually evaluate competing products. A visual evaluation is a review of displays for fashion leadership, price differentials, assortment breadth, new items, and best-selling items (Cash, Wingate, and Friedlander 1995). Comparison shopping gives apparel associates insight into products that is not quantitatively reported or available through other secondary information. A merchandiser will pick up nuances offered to retail accounts, such as the fixtures used, types of tags, and reordering capabilities. Branded merchandise has competition from other brand competitors, but also from private-label merchandise, as Shuba Pillai, Target executive team leader softlines noted,*

> "At Target, we encourage our guest to comparison shop. Target specifically positions its merchandise so that we place private label merchandise next to like-item branded goods. This way our guest can compare the two products. Target remerchandises product every two weeks Placements in our department are key to sales: We put new merchandise on the front racks, because it tends to increase sales; whereas, clearance merchandise is never put in the first two rows."

ACTIVITY 3.8 *Critical Thinking*

Think about the Target district team leader's quotation in relation to creating your product line. Visualize a scenario in which a retail customer places your apparel brand next to private-label merchandise priced 30 percent less.

- What value will you put into your product to entice the consumer to buy your more expensive item?
- If your retail customer places your merchandise in the back of the store, how will you get the consumer to stop and look at your products?

A competitor market analysis is a critical comparison of an apparel manufacturer's SBU product line and competing products. A competitive analysis allows manufacturers and private-label retailers to see new market opportunities, sell similar products, distinguish their products from competing products, and maintain exclusivity arrangements among competing retail customers. As with retailers, competing apparel companies discuss their company direction and strategy in SEC 10-K annual reports and 8-K current reports. Electronic information services (e.g., LexisNexis and Yahoo! Finance) provide links to articles on corporate finance and news, public and private company strategies, and profitability figures. Using these resources, apparel manufacturers and private-label retailers evaluate their competition often. After one such evaluation, Jones Apparel Group indicated that it has better processes and systems in place than those of its competitors. It believes that its business division can react more quickly to market trends, is better able to meet a sudden demand for a particular fashion design, and can more efficiently fill reorders of merchandise for its retail customers (SEC February 26, 2007).

Whereas an individual SBU has multiple competitors, apparel associates focus on rivals within the same market segment and store type. How do apparel associates discover competitors' strategies and the locations where they sell their products? Apparel associates

*Reprinted by permission from Shuba Pillai, Softlines Executive Team Leader—Softlines, Target Corporation, Upland, CA; pers. Comm.., May 25, 2007. This is a personal statement. The views and opinions expressed in this quote do not necessarily reflect those of my employer. Target has no affiliation with the comments from its associates.

competitors' strategies and the locations where they sell their products? Apparel associates discover competitor information by searching primary and secondary data collections. For brand recognition, apparel companies hire service firms to conduct focus groups, or their own merchandise associates seek out information. Some apparel manufacturers have retail merchandise associates who analyze competing apparel manufacturers' Web pages. They search a competitor's site for its store locator, which identifies the company's primary retail customers. The merchandise associates shop retail accounts to evaluate technical construction, visual displays, and product quality, and they talk to retail sales associates to determine whether their company is market responsive and well defined in retail accounts. Merchandisers also analyze competing products to determine whether their company prices are comparable with those of competitive products.

A merchandiser must first understand whether his or her products target the same consumer. Designers and merchandisers evaluate competing products for technical differences in styling, pricing, and quality. Assume you identified Norton McNaughton ⌂ as a competitor. By looking at top public apparel corporations, you would find that Jones Apparel Group owns Norton McNaughton. Each Jones Apparel Group differentiates its brands by distinctive styling, pricing strategy, distribution channel, and target consumer. Norton McNaughton's target consumer is a woman age 25–55 with an annual income of $20,000–$50,000 who buys moderately priced career and casual clothing (February 2, 2001). Norton McNaughton is a moderate-priced apparel brand with a retail price range of $29–$121. Its product development team creates collection-based product lines with coordinating blouses, casual tops, jackets, sweaters, and skirts (SEC February 26, 2007).

ACTIVITY 3.9 *Analyzing Competitors*

For your company, comparison shop two rival product lines at two retail stores.

- Visually evaluate your competitors' displays for fashion leadership, price, assortment breadth, new items, and best-selling items.
- How does your competitors' merchandise presentation compete with the one you plan to create?

Merchandisers and designers complete the market analysis by critically evaluating the aesthetic attributes and technical specifications of competing products, as well as consumer purchase attributes. To do so, they conduct a Web page analysis or comparison shop competing products. *Aesthetic evaluation* means to assess products for formal, expressive, or symbolic qualities (Fiore and Kimle 1997). Aesthetic attributes include updated styling, current use of fabrics and fabrication, and product value. Reviewing products for aesthetics can reveal whether product lines appeal to consumer psychographic preferences (e.g., classic or trendy appearance).

Technical evaluation is a comparison of quality attributes. Merchandisers evaluate their products against those of the competition for fiber content, fabrication, construction quality (e.g., stitches per inch, stitch type, seam type), trim, and hardware. *Consumer purchase attributes* are the target consumers' top reasons for purchasing a product (e.g., professional image, ease of care).

In April 2006, Alona Ignacio, a designer, provided the author with some insight into aesthetic and technical evaluation:*

> When we started our new luxury accessory line, we researched the market and shopped the stores. We examined our potential competing products for quality and overall styling. We designed our line and started to sample, but then found we needed to take a step back to fine-tune the line. By fine-tuning, I mean we needed to update our metal hardware and other details. The purses in the designer market had the brand on the hardware. For example, Gucci had its logo on all its hardware, even on the zipper pull. This finding created time pressures because we reviewed our materials and decided to customize our hardware. Another detail that we needed to address was to include authenticity cards. We saw that in high-end accessories it is common to provide authenticity cards that have an explanation of the materials, their origin, and the company's mission.

ACTIVITY 3.10 *Critical Thinking*

Aesthetic attributes and technical specifications are important to the success of a design.

- What fiber types and fabrications will you use for your product line?
- How does this selection meet your target market's needs?

ACTIVITY 3.11 *Analyzing Columbia Sportswear*

Look at Columbia Sportswear Company's advertising and its products for one product line (e.g., men's) at www.columbia.com.

- On the basis of the pictures shown, identify several consumer purchase attributes (e.g., comfort, professional image).
- How has Columbia Sportswear achieved breadth of consumer psychographics (e.g., sun protection vs. collegiate)?

Brand Marketing Strategy Development

A merchandiser completes the understanding design-and-business-goals activity by developing an SBU brand marketing strategy. Brand strategy is a discipline in itself.* From a merchandising perspective, **brand marketing strategy** is a statement about the fashion direction of an SBU, its competitive advantage strategy, and its value to customers and consumers. The merchandiser is responsible for using existing brand strategies. Advertising and marketing personnel are the primary associates responsible for developing concrete ideas and executing brand marketing for existing product lines. For example, merchandisers may

*Reprinted by permission from Alona Ignacio, Designer/Product Development, Seril, Vernon, CA; pers. comm., April 12, 2006.

*For more information on brand strategy, go to the *Journal of Product Innovation Management* Web site at www.blackwellpublishing.com/journal.asp?ref=0737-6782 and click on "Latest issue." Next, locate the "Quick Search" box, choose to search in "All Journals," and type "brand strategy" in the search box. Many articles on the topic will come up.

challenge marketing associates about whether the brand strategy is consistent with consumer target needs, retail customer strategies, or product offerings. Merchandise associates become involved with existing brand strategy by following through with details—for instance, approving brand labels or using new logos on sales sheets.

When a company develops a new product line, merchandisers are involved in developing brand strategy discussions. A merchandiser provides information to marketing associates for them to create brand marketing strategy ideas. A merchandiser's primary role is to approve of product literature that accompanies the product and to sell the brand concept to retail buyers. If retail customers disapprove of new brand directions, the merchandisers act as a liaison between the retail customers and the marketing associates to reposition the company's strategy.

SUMMARY

Much detail goes into understanding and developing design and business goals. Apparel associates do not design clothes on the basis of what they like; rather, an understanding of consumers, retailers, and competitors is critical. From the concepts covered, you may begin to understand why a merchandiser's job requires 5 or more years of experience. Merchandisers are responsible for design and business goals. These comprehensive goals cover synthesizing consumer information, understanding the ever-changing retail climate, and conducting competitor market analyses. Such activities require synthesis of primary and secondary data, the results of which merchandisers must incorporate into their product lines. Although consumer, retail, and competitor market analyses are often consolidated in a written report, the knowledge a merchandiser frequently recalls when he or she reviews new seasonal garment designs and product lines is also part of the analyses. Chapter 4 introduces a time-and-action calendar and numeric planning.

COMPANY PROJECT 2
BUSINESS STRATEGY REPORT—PART 2

Following is a continuation of the business strategy report you started in Chapter 2. Turn in this section with Company Project 1 from Chapter 2. Be sure to include the following written sections:

Description of Retail Store Type

- Identify the primary store type (i.e., mass merchandiser, conventional department store, specialty store, or nonstore retailer) that you want to sell products to.
- List three existing retail customers, within this store type, that you will target.
- Identify your strategic business unit (SBU) (e.g., skirts) and list two to four products you will design.

Fashion Report Using Primary Data

Use a primary data collection technique to obtain information on your target consumer's clothing preferences. Primary data collection techniques include consumer observation,

surveys, focus groups, and interviews. Write one to three survey questions, observe ten individuals, or interview a focus group panel. Then, write a fashion report that summarizes the most frequently identified reasons for purchasing clothing. A fashion report highlights major trends that consumers indicate as important or emerging trends that designers should consider when they are creating a product line.

Survey Suggestion

- Identify ten individuals who are in your consumer target group.
- Ask your potential consumers their top three reasons for purchasing the products you plan to design. For example, you might ask a professional, "What are the top three reasons you would buy pants and a top to wear to work?" One typical reason would be "The outfit would last for at least 3 years."
- Analyze the qualitative information gathered.

Consumer Observation Suggestion

- Observe ten shoppers in a mall who are shopping for products similar to those you plan to design.
- Go into a retail store that sells products you want to design. Ask retail sales associates which brands are important and why.

Demographic (Zip Code) Analysis

- Use Activity 3.7 to complete a demographic (zip code) analysis.
- Select a retail customer to whom you want to sell your product (e.g., Nordstrom), and go to its Web site. Select five store locations and write down their zip codes.
- Follow the specific instructions in Activity 3.7, using the zip codes of the target retail customer to whom you want to sell your product line. (See Table 3.1 for an example.)
- Write a one-paragraph description of the demographics of your consumer. Your written analysis should describe the zip code demographics. (See Figure 3.10 for an example.)
- Write a summary of how your target consumer's background and lifestyle would potentially influence your product line.
- Describe how a zip code analysis influences the product line you plan to create.

Retail Customer Merchandise Strategy

- Select three public corporation retail customers to whom you would like to sell your product line. The retail customers selected should be competing companies within the same store type (e.g., conventional department store retailers). If you want to sell your line in small boutiques, select the closest specialty store retailers. If you want to develop a private label, identify the retail customer for whom you would develop the line (e.g. Victoria's Secret).
- A merchandise strategy identifies the important goals for the retail customer. Refer to the Retail Market Analysis section of this chapter. Using the retail market analysis narrative description as a guide, write a one-paragraph description of each retail

customer's business or merchandise strategy. To obtain your information, use the following Web links:

- *NASDAQ listing of specialty stores:* www.nasdaq.com/reference/BarChartSectors. stm?page=sectors&sec=apparel~stores.sec&level=2&title=Apparel+Stores. Click on the company symbol. Scroll to the bottom of the company's summary quote and read the company description. Click on "More." Read the "Business" section to find the retail customer's current merchandise strategy.
- *NASDAQ listing of department stores:* www.nasdaq.com/reference/BarChartSectors. stm?page=sectors&sec=department~stores.sec&level=2&title=Department+Stores. Click on the company symbol. Scroll to the bottom of the company's summary quote and read the company description. Click on "More." Read the "Business" section to find the retail customer's current merchandise strategy.
- *NASDAQ listing of mass merchandisers:* www.nasdaq.com/reference/ BarChartSectors.stm?page=sectors&sec=discount~variety~stores.sec&level=2&title =Discount+Variety+Stores. Click on the company symbol. Scroll to the bottom of the company's summary quote and read the company description. Click on "More." Read the "Business" section to find the retail customer's current merchandise strategy.
- *SEC filings:* www.sec.gov/edgar/searchedgar/webusers.htm. Choose "Companies & Other Filers." Type the company name (try variations if necessary—e.g., *Wal-Mart* must be typed "Wal Mart"). Click on "Find Companies." Click on the CIK number beside the appropriate company name. Type in the form type: 10-K (annual report) or 8-K (current report). Click on "Retrieve Selected Filings." Choose the html or text version of the desired report. Click on the "Document" number to call up the report. Read the introduction (often called *Business* or *General Business*) and management discussion sections of the 10-K and 8-K reports.
- *LexisNexis:* This academic electronic database is available through university library subscription only. Search by company information.
- *Yahoo! Finance:* http://biz.yahoo.com/ic/320.html. Select "Company Index" and then the company name.
- *Corporate Web pages:* Click on the "Investor Relations" tab. Click on "Annual Reports" or "Background Information." This chapter includes the names of many top retail corporations.

PRODUCT DEVELOPMENT TEAM MEMBERS

The following product development team members were introduced in this chapter:

Design director: An individual who guides the design team in developing creative concepts, adhering to calendar schedules, and making the company's various SBUs more cohesive with regard to color, silhouette, and fabric direction.

Merchandiser: An individual whose primary role is business planning. He or she develops and analyzes assortment planning, financial matrices, customer accounts, and consumer target markets.

Vice president of product development: This individual, also called *vice president of a product line*, is at the top of the product development organization. The title

depends on company size; in a small company, the president may handle product line responsibilities. A vice president of product development writes strategy, is responsible for and oversees continuity of products across company product lines, and analyzes product line profitability and critical product line issues.

KEY TERMS

Apparel competitor: A rival company that sells similar goods to the same consumers, market segment, and store type. Has a positive or negative impact on a particular company's market share.

Apparel manufacturer: Traditionally, an establishment that either purchases or makes fabric that it then cuts and sews to make a garment. More recently, no longer a vertical operation, instead uses company-owned or independent contractors, located throughout the world, to produce apparel products.

Branded merchandise: Merchandise with a brand name.

Brand marketing strategy: A statement about the fashion direction of an SBU, its competitive advantage strategy, and its value to customers and consumers.

Brand name: A distinct name or design that distinguishes one seller's goods or services from those of another.

Comparison shopping: A visual evaluation of rival products sold in retail store accounts.

Conventional department store: Store that offers a wide range of soft and hard lines.

Core consumer: An individual, within a target market, who repeatedly buys and wears an apparel manufacturer's brand.

Demographics: Group classifications determined by analyzing variables such as age, gender, family size, income, or occupation (Armstrong and Kotler 2007).

Design-and-business-goals report: A report in which apparel associates interpret a company's mission statement into business plans for SBU product lines.

Discount store: Store that offers a wide assortment of general merchandise, but only a limited food assortment.

Fashion report: A written summary of an associate's primary data collection.

Focus group: A small group of individuals whom a trained interviewer focuses on talking about important company issues (Armstrong and Kotler 2007). A primary data collection technique.

Gross margin: Net sales minus cost of goods sold, expressed as dollars or as a percentage. One measure of a company's profitability.

Industry: A group of establishments with similar production processes.

Licensed goods: Products produced under a specific name. The manufacturer (licensor) pays a royalty, or percentage of sales, to a designer (licensee) for the use of his or her name.

Manufacturer: A single or multiunit establishment that makes products in a primary industry and may also make products in a secondary industry.

Market share: A percentage of industry sales that a specific company controls.

Merchandise strategy: The part of a retailer's business plan in which company executives translate financial goals into objectives for products purchased and developed.

Merchandising: "The process of planning, developing, and presenting product lines for identified target markets" (Kunz 2005, 6).

Net sales: Sales minus customer returns and allowances. One measure of a company's profitability.

Primary data collection: When an individual personally gathers information for analysis.

Private label: A type of merchandise made by an apparel manufacturer specifically for one retail customer (Standard & Poor's 2005).

Private-label retailer: A company that develops, coordinates production of, and markets its own proprietary brands for sale in its own stores.

Product line: A group of closely related merchandise items, within an SBU, that function similarly, are sold to similar customer groups, are marketed to similar retail store types, or fall within given price ranges.

Psychographics: Analyses of different groups on the basis of generation, social class, lifestyle, activities, or personality characteristics (Armstrong and Kotler 2007).

Retailer: A store or nonstore establishment that sells small quantities or merchandise to consumers.

Sales per square foot: One measure of a company's profitability, provided by retail customers to each of their apparel vendors. Reported as an overall figure or sales generated per brand.

Secondary data: Information that already exists—data in electronic information systems, nongovernmental statistical data, and governmental data.

Secondary data collection: When an individual analyzes information or figures from previously gathered data.

Source: To locate a contractor or supplier.

Strategic business unit (SBU): An entity—a company division, a product line within a division, a single product, or a brand—that a merchandiser plans independently from other company business operations (Kotler and Keller 2007).

Superstore: Store that offers a wide assortment of merchandise, includes a full-line supermarket, and occupies a large physical space (e.g., 187,000 sq ft).

Target market: The customers or consumers, who share common needs or characteristics, whom a company serves or wants to serve (Armstrong and Kotler 2007).

WEB LINKS ▬▬▬▬▬▬▬▬▬▬▬▬▬

Company	URL
Abercrombie & Fitch	www.abercrombie.com/anf/index.html
A•B•S by Allen Schwartz	www.absstyle.com/shop.php
Alloy Media + Marketing	www.alloymarketing.com
American Apparel	www.americanapparel.net
American Rag C[ie]	www.americanragcie.co.jp/info/index.html
Byer California	www.byer.com

Electronic Data Gathering, Analysis, and Retrieval (EDGAR) system	www.sec.gov/edgar/searchedgar/webusers.htm
Ellen Tracy, Inc.	www.ellentracy.com
Federated Department Stores, Inc.	www.federated-fds.com/home.asp
Forever 21 Inc.	www.forever21.com
Hot Topic, Inc.	www.hottopic.com
Jones Apparel Group, Inc.	www.jny.com/index.jsp
Juicy Couture	www.juicycouture.com
Just-style	www.just-style.com
Levi Strauss & Co.	www.levistrauss.com
Liz Claiborne Inc.	www.lizclaiborneinc.com/ourbrands/brand_index.htm
Macy's Merchandising Group	www.federated-fds.com/support/mmg.asp
Neiman Marcus	http://phx.corporate-ir.net/phoenix.zhtml?c=118113&p=irol-overview
NIKE, Inc.	www.nike.com/nikebiz/nikebiz.jhtml?page=0
Nordstrom, Inc.	http://about.nordstrom.com/aboutus/?origin=footer
Norton McNaughton	www.jny.com/brand.jsp?event=brands
NPD Fashionworld	www.npd.com/corpServlet?nextpage=fashion-categories_s.html
Pacific Sunwear of California, Inc.	http://phx.corporate-ir.net/phoenix.zhtml?c=83185&p=irol-1RHome
PacSun	http://shop.pacsun.com/webapp/wcs/stores/servlet/StoreCatalogDisplay?storeId=10001&catalogId=10001&langId=-1
Patagonia, Inc.	www.patagonia.com
Population Reference Bureau	www.prb.org
Quiksilver, Inc.	www.quiksilverinc.com/index.aspx
Retail Forward	www.retailforward.com
Russell Corporation	www.russellcorp.com/html2003/code/main.htm
Sears, Roebuck and Co.	www.sears.com/sr/javasr/vertical.do?BV_UseBVCookie=Yes&vertical=CLTH
Target Corporation	http://sites.target.com/site/en/corporate/page.jsp?contentId=PRD03-000482
Tarrant Apparel Group	www.tags.com
Teen Research Unlimited	www.teenresearch.com/home.cfm
Tommy Bahama	www.tommybahama.com/index.jsp
True Religion Apparel, Inc.	www.truereligionbrandjeans.com
U.S. Census Bureau	www.census.gov/prod/ec02/02numlist/02numlist.html
VF Corporation	www.vfc.com
Wal-Mart Stores, Inc.	www.walmart.com/apparel
Yahoo! Finance	http://biz.yahoo.com/p/320conameu.html
	http://biz.yahoo.com/ic/320.html

REFERENCES

Allers, K. L. 2003. Retail's rebel yell: Earlobe plugs? Check. Skull-and-crossbones thongs? Check. Hot Topic brings teen angst to a suburban mall near you. *Fortune*, November 10, 137–42. http://money.cnn.com/magazines/fortune/fortune_archive/2003/11/10/352853/index.htm.

American Apparel. n.d. Mission. http://www.americanapparel.net/mission/.

Ameristat. 2002, May. *A first look at Asian Americans in the census.* http://www.prb.org/Template. cfm?Section=PRB&template=/ContentManagement/ContentDisplay.cfm&ContentID=7821.

Armstrong, G., and P. Kotler. 2007. *Marketing: An introduction.* 8th ed. Upper Saddle River, NJ: Pearson/ Prentice Hall. http://wps.prenhall.com/bp_armstrong_mai_8/0,11474,2842200-,00.html.

Business editors. 2003. Federated Department Stores & Tarrant Apparel Group announce multi-year exclusive distribution agreement: Companies partner to introduce American Rag, a new retail collection. *Business Wire*, April 3. http://www.findarticles.com/p/articles/mi_m0EIN/ is_2003_April_3/ai_99551351.

Byer California. n.d. About us. http://www.byer.com/about.html.

Cash, R. P., J. W. Wingate, and J. S. Friedlander. 1995. *Management of retail buying.* 3rd ed. New York: Wiley.

Chao, E. 2001. *Report on the American workforce.* Washington, DC: U.S. Department of Labor. d.e.m.o. n.d. Company: About us. http://www.demostores.com/webapp/wcs/stores/servlet/ PSNonShop?section=COMPANY&storeId=10001&catalogId=10002&langId=-1&.

Dixon, P. 2005. *Building a better business.* London: Profile Books.

Federated Department Stores, Inc. n.d. *2005 Annual report.* http://www.fds.com/ir/ann.asp.

Fiore, A. M., and P. A. Kimle. 1997. *Understanding aesthetics for the design and merchandising professional.* New York: Fairchild.

Gap Inc. n.d. Department descriptions: Merchandising. http://www.gapinc.com/public/ Careers/car_wwd_hqdepts. shtml.

Goldman, A. 2003. Pacific Sunwear profit soars 54%. *Los Angeles Times*, November 11, sec. C.2.

Harvey, C. R. 2006. *Hypertextual finance glossary.* http://www.duke.edu/~charvey/Classes/wpg/ glossary.htm.

investorwords.com. n.d. Strategic planning. http://www.investorwords.com/4774/strategic_ planning.html.

Kotler, P., and K. L. Keller. 2007. *A framework for marketing management.* 3rd ed. Upper Saddle River, NJ: Pearson/Prentice Hall. http://wps.prenhall.com/bp_kotler_framework_3/ 0,11805,3087255—3087256,00.html.

Kunz, G. I. 2005. *Merchandising: Theory, principles, and practices.* 2nd ed. New York: Fairchild.

LexisNexis. 2003. *Hoover's company profile: Gadzooks, Inc.* Hoover no. 44437.

LexisNexis. 2006a. *Hoover's company profile: Forever 21, Inc.* Hoover no. 103504.

LexisNexis. 2006b. *Hoover's company profile: Hot Topic, Inc.* Hoover no. 47342.

Lott-Tamayo, J. 2004, January. *Asian-American children are members of a diverse and urban population.* Population Reference Bureau. http://www.prb.org/Articles/2004/AsianAmericanChildren AreMembersofaDiverseandUrbanPopulation.aspx

MarketWatch, Inc. n.d. Corporate overview: Alloy, Inc. http://www.corporate-ir.net/ireye/ ir_site.zhtml?ticker=ALOY&script=2100.

NPD Fashionworld. n.d. Products and services: Special products. http://www.npd.com/ corpServlet?nextpage=retailer_s.html.

Pacific Sunwear of California, Inc. 2006. Pacific Sunwear opens first One Thousand Steps stores. News release (April 7). http://phx.corporate-ir.net/phoenix.zhtml?c=83185&p=irol-newsArticle&ID=840258&highlight=

Patagonia, Inc. n.d.. Jobs. http://www.patagonia.com/web/us/contribution/patagonia.go? assetid=4491 (accessed December 31, 2003).

Population Reference Bureau. n.d. Home page. http://www.prb.org.

Product Development and Management Association (PDMA). n.d. *The PDMA glossary for new product development*. Mt. Laurel, NJ: PDMA. http://www.pdma.org/library/glossary.html.

Raines, C. 2002. *Managing Millenials*. http://www.generationsatwork.com/articles.htm.

Regan, C. L. 1997. A concurrent engineering framework for apparel manufacture. PhD diss., Virginia Polytechnic Institute and State Univ.

Rosenau, J. A., and D. L. Moran. 2001. *Apparel merchandising: The line starts here*. New York: Fairchild.

Standard & Poor's. 2005, May 30. *Apparel and footwear industry survey*. New York: Standard & Poor's.

Target Corporation. n.d.(a). Corporate fact card. http://investors.target.com/phoenix.zhtml?c=65828&p=irol-irhome.

Target Corporation. n.d.(b). Partners online: Vendors. http://www.partnersonline.com/web-app/pol/home/entryHome.jsp.

Teen Research Unlimited. n.d. Home page. http://www.teenresearch.com/home.cfm.

Tice, C. 2003. Bringing Nordstrom back: Retailer's family-style approach pays off with turnaround. *Puget Sound Business Journal*, December 29. http://seattle.bizjournals.com/seattle/stories/2003/12/29/story5.html.

U.S. Bureau of Labor Statistics. 1999. Millennial themes: Age, education, services. *Monthly Labor Review: The Editor's Desk*, December 1. http://www.bls.gov/opub/ted/1999/Nov/wk5/art03.htm.

U.S. Bureau of Labor Statistics. 2005. BLS releases 2004-14 employment projections. Press release. December 7. Washington, DC: U.S. Department of Labor. http://www.bls.gov/news.release/ecopro.nr0.htm.

U.S. Census Bureau. n.d.(a). *2002 NAICS definitions* (44–45 Retail Trade). http://www.census.gov/epcd/naics02/def/NDEF44-45. HTM.

U.S. Census Bureau. n.d.(b). *2002 NAICS definitions* (315 Apparel Manufacturing). Washington, DC: U.S. Census Bureau. http://www.census.gov/epcd/naics02/def/NDEF315. HTM#N31521.

U.S. Census Bureau. n.d.(c). *2002 NAICS definitions* (454 Nonstore Retailers). Washington, DC: U.S. Census Bureau. http://www.census.gov/epcd/naics02/def/NDEF454.HTM#N454.

U.S. Census Bureau. n.d.(d). *2002 Numerical list of manufactured and mineral products*. Washington, DC: U.S. Census Bureau. http://www.census.gov/prod/ec02/02numlist/02numlist.html.

U.S. Census Bureau. n.d.(e). *Estimates of monthly retail and food services sales by kind of business: 2006*. Washington, DC: U.S. Census Bureau. http://www.census.gov/mrts/www/data/html/nsal06.html.

U.S. Census Bureau. n.d.(f). *Glossary of terms*. Washington, DC: U.S. Census Bureau. http://bhs.econ.census.gov/BHS/glossary.html#S.

U.S. Census Bureau. n.d.(g). *Statistical abstract of the United States* (Section 21, Manufactures). Washington, DC: U.S. Census Bureau. http://www.census.gov/prod/www/statistical-abstract.html.

U.S. Census Bureau. n.d.(h). *Statistical abstract of the United States* (Section 22, Wholesale and retail trade). Washington, DC: U.S. Census Bureau. http://www.census.gov/prod/www/statistical-abstract.html.

U.S. Securities and Exchange Commission. 2001, February 2. *Form 10-K: Annual report for the fiscal year ended November 4, 2000, McNaughton Apparel Group Inc.* Washington, DC: U.S. Government Printing Office. http://www.sec.gov/Archives/edgar/data/917692/000095013001000569/0000950130-01-000569-0001. txt.

U.S. Securities and Exchange Commission. 2002, May 2. *Form 10-K: Annual report for the fiscal year ended February 2, 2002, Hot Topic, Inc.* Washington, DC: U.S. Government Printing Office. http://www.sec.gov/Archives/edgar/data/1017712/000101968702000787/hottopic_10k-020202.txt.

U.S. Securities and Exchange Commission. 2003, April 17. *Form 10-K: Annual report for the fiscal year ended January 31, 2003, Nordstrom, Inc.* Washington, DC: U.S. Government Printing Office. http://www.sec.gov/Archives/edgar/data/72333/000089102003001270/v89013e10vk.htm.

U.S. Securities and Exchange Commission. 2004, September 14. *Form 10-Q: Quarterly report for the quarterly period ended July 31, 2004, Quiksilver, Inc.* Washington, DC: U.S. Government Printing Office. http://www.sec.gov/Archives/edgar/data/805305/000095013704007704/a01824e10vq.htm.

U.S. Securities and Exchange Commission. 2005, February 22. *Form 8-K: Current report, February 16, 2005, Gadzooks, Inc.* Washington, DC: U.S. Government Printing Office. http://www.sec.gov/Archives/edgar/data/924140/000095013405003490/d22691e8vk.htm.

U.S. Securities and Exchange Commission. 2005, March 17. *Form 10-K: Annual report for the fiscal year ended January 1, 2005, Russell Corporation.* Washington, DC: U.S. Government Printing Office. http://www.sec.gov/Archives/edgar/data/85812/000095014405002793/g92021e10vk.htm

U.S. Securities and Exchange Commission. 2005, July 29. *Form 10-K: Annual report for the fiscal year ended May 31, 2005, NIKE, Inc.* Washington, DC: U.S. Government Printing Office. http://www.sec.gov/Archives/edgar/data/320187/000095012405004551/v10583e10vk.htm.

U.S. Securities and Exchange Commission. 2005, September 16. *Form 10-K: Annual report for the fiscal year ended July 30, 2005, The Neiman Marcus Group, Inc.* Washington, DC: U.S. Government Printing Office. http://www.sec.gov/Archives/edgar/data/819539/000104746905022992/a2162885z10-k.htm.

U.S. Securities and Exchange Commission. 2006, February 14. *Form 10-K: Annual report for the fiscal year ended November 27, 2005, Levi Strauss & Co.* Washington, DC: U.S. Government Printing Office. http://www.sec.gov/Archives/edgar/data/94845/000095013406002782/f17124e10vk.htm.

U.S. Securities and Exchange Commission. 2006, February 28. *Form 10-K: Annual report for the fiscal year ended December 31, 2005, Jones Apparel Group, Inc.* Washington, DC: U.S. Government Printing Office. http://www.sec.gov/Archives/edgar/data/874016/000087401606000010/form10k_2005.htm.

U.S. Securities and Exchange Commission. 2006, March 1. *Form 10-K: Annual report for the fiscal year ended December 31, 2005, Liz Claiborne, Inc.* Washington, DC: U.S. Government Printing Office. http://www.sec.gov/Archives/edgar/data/352363/000035236306000071/liz10k2005.htm.

U.S. Securities and Exchange Commission. 2006, March 10. *Form 10-K: Annual report for the fiscal year ended December 31 2005, V. F. Corporation.* Washington, DC: U.S. Government Printing Office. http://www.sec.gov/Archives/edgar/data/103379/000089322006000503/w18296e10vk.htm.

U.S. Securities and Exchange Commission. 2006, March 22. *Form 10-K: Annual report for the fiscal year ended January 28, 2006, Hot Topic, Inc.* Washington, DC: U.S. Government Printing Office. http://www.sec.gov/Archives/edgar/data/1017712/000119312506060796/d10k.htm.

U.S. Securities and Exchange Commission. 2006, March 24. *Form 10-K: Annual report for the fiscal year ended January 28, 2006, Nordstrom, Inc.* Washington, DC: U.S. Government Printing Office.http://www.sec.gov/Archives/edgar/data/72333/000095012406001459/v18665e10vk.htm.

U.S. Securities and Exchange Commission. 2006, March 31. *Form 10-K: Annual report for the fiscal year ended January 28, 2006, Pacific Sunwear of California, Inc.* Washington, DC: U.S. Government Printing Office. http://www.sec.gov/Archives/edgar/data/874841/000095013706003975/a18811e10vk.htm.

U.S. Securities and Exchange Commission. 2006, April 13. *Form 10-K: Annual report for the fiscal year ended January 28, 2006, Federated Department Stores, Inc.* Washington, DC:

U.S. Government Printing Office. http://www.sec.gov/Archives/edgar/data/794367/000095015206003165/l19117ae10vk.htm.

U.S. Securities and Exchange Commission. 2006, December 7. *Form 10-Q: Quarterly report for the quarterly period ended October 28, 2006, Federated Department Stores, Inc.* Washington, DC: U.S. Government Printing Office. http://www.sec.gov/Archives/edgar/data/794367/000079436706000217/thirdq2006.htm.

U.S. Securities and Exchange Commission. 2007, January 31. *Form 10-K/A: Amendment 1: Annual report for the fiscal year ended December 31, 2005, Tarrant Apparel Group.* Washington, DC: U.S. Government Printing Office. http://www.sec.gov/Archives/edgar/data/944948/000117091807000062/sam07-019.txt.

U.S. Securities and Exchange Commission. 2007, February 26. *Form 10-K: Annual report for the fiscal year ended December 31, 2006, Jones Apparel Group, Inc.* Washington, DC: U.S. Government Printing Office. http://www.sec.gov/Archives/edgar/data/874016/000087401607000006/form10k_2006.htm.

U.S. Securities and Exchange Commission. 2007, February 27. *Form 10-K: Annual report for the fiscal year ended December 30, 2006, V. F. Corporation.* Washington, DC: U.S. Government Printing Office. http://www.sec.gov/Archives/edgar/data/103379/000089322007000491/w30596e10vk. htm.

U.S. Securities and Exchange Commission. 2007, March 14. *Form 8-K: Current report, Exhibit 99.1, Hot Topic, Inc.* Washington, DC: U.S. Government Printing Office. http://www.sec.gov/Archives/edgar/data/1017712/000119312507054549/dex991.htm.

U.S. Securities and Exchange Commission. 2007, March 15. *Form 10-K: Annual report for the fiscal year ended February 3, 2007, Target Corporation.* Washington, DC: U.S. Government Printing Office. http://www.sec.gov/Archives/edgar/data/27419/000104746907001800/a2176656z10-k .htm.

U.S. Securities and Exchange Commission. 2007, March 16. *Form 8-K: Current report, Exhibit 99.1, True Religion Apparel, Inc.* Washington, DC: U.S. Government Printing Office. http://www.sec .gov/Archives/edgar/data/1160858/000095012407001572/v28440exv99w1.htm.

U.S. Securities and Exchange Commission. 2007, March 23. *Form 10-K: Annual report for the fiscal year ended February 3, 2007, Nordstrom, Inc.* Washington, DC: U.S. Government Printing Office. http://www.sec.gov/Archives/edgar/data/72333/000095013407006483/v28408e10vk.htm.

U.S. Securities and Exchange Commission. 2007, March 27. *Form 10-K: Annual report for the fiscal year ended January 31, 2007, Wal-Mart Stores, Inc.* Washington, DC: U.S. Government Printing Office. http://www.sec.gov/Archives/edgar/data/104169/000119312507065603/d10k.htm.

U.S. Securites and Exchange Commission. 2007, March 28. *Form 10-K Annual report for the fiscal year ended February 3, 2007,* Hot Topic, Inc. Washington DC: U.S. Government Printing Office. http//sec.gov/Archives/edgar/data/1017712/000119312507067476/d10k.htm

VF Corporation. n.d. Current job opportunities at VF. http://jobsearch.vfc.newjobs.com (accessed March 15, 2005).

White, E., and A. Zimmerman. 2003. Bargain clothes by George. *Wall Street Journal,* December 26, sec.B.1–B.2.

Wikipedia contributors. n.d. Gross sales. *Wikipedia, The free encyclopedia.* http://en.wikipedia .org/wiki/Gross_sales (accessed July 28, 2006).

Planning Product Development

A TIME AND A PLACE

A few days later, Kate walks through the halls of Rare Designs' corporate headquarters on her way to a meeting with Ron, Anne, and some of their staff members. As she rounds the corner and goes past the design workroom, she spots something new—a colorful fabric wall hanging. Kate had walked these halls on previous occasions and is surprised she hadn't noticed it before.

As she examines the wall hanging more closely, she detects a herd of elephants basking in the sun. The vivid colors also attracted Kate's attention. Her love affair with fabric and design dates to her early years in the apparel industry. She reaches out to touch the fabric just as a tall, young woman enters the room. "It's an African batik; isn't it cool? I just bought it online. The elephants are so unique! I collect African art." Tamee laughs as she looks down at her batik wraparound skirt. "As you can tell, I love batik fabric!" Tamee has a knack for combining eclectic pieces of clothing and accessories and has always been able to carry off the bohemian chic look. Today is no different. Her chocolate brown and teal skirt is accented with three belts of various sizes and textures, and several long necklaces drape her brown camisole.

"I see you've met Tamika, my assistant designer," Anne says as she enters the design workroom.

Kate smiles and extends her hand. "It's nice to meet you, Tamika. I'm Kate Roberts."

"So you're Dr. Kate! I've heard you're stirring things up around here, and that's probably good. Hey, just call me Tamee."

Anne motions to them and says, "Let's go. The others are waiting for us."

"You're keeping us busy," Ron says to Kate as the three women enter the conference room. He sets his new PC on the boardroom table and quickly opens a file with some notes he has made for the meeting.

Just then, all eyes turn toward Lauren, whose pink, four-inch-heel Mario Aribe alligator pumps announce her arrival as they click across the wooden floor. "I really liked doing the demographics analysis," she comments to Ron and Anne. She then turns toward Kate. "You must be the professor; I'm Lauren. It's nice to meet you. What's that?" she asks, pointing to a colorful chart with a series of interesting lines.

Kate had noticed Lauren's impeccable taste in shoes during her previous visits but hadn't had the chance to meet Lauren in person. "So; you're the lucky one who got to work on the demographics analysis. This is a time-and-action calendar. Today, we'll organize your process by creating a work-flow plan and deciding which season generates the highest sales," Kate says.

"I love being organized; I live for my PDA!" Lauren grins.

"Does she ever! She sends me e-mails all the time," Jason says, rising to his feet and extending his hand. "Hi, Dr. Kate. I'm Jason. Here at Rare Designs I wear two hats: CAD artist and technical designer."

Kate responds, "It's nice to meet you, Jason."

"We've always analyzed Rare Designs' sales annually rather than season to season, and I have a gut feeling that spring is our best sales season," Ron interrupts, hoping to speed up the meeting.

"We need to quantify which season is Rare Designs' strongest and identify the most important trade shows to attend in order to sell the line to eager buyers," Kate answers confidently. "Trade shows are important to the product development calendar because they set the season release when buyers can place orders."

"In the past, we didn't show our line at any trade shows. We simply sold it through sales representatives at the market centers, so our deadline was market week. But sometimes we didn't have samples ready," Ron says.

"And that is why your sales were unpredictable, up one season, down the next, then the downslide because your orders weren't filled on time," Kate replies. "My goal is to help Rare Designs be organized and ship on time, which will improve your reputation. Having great design potential is not enough; you need to set deadlines each season."

Before the meeting breaks up, Kate hands Ron a list of trade show resources and suggests that Lauren and Jason assist him in finding the apparel release dates for women's career wear and in identifying the most important shows. Turning to Lauren and Jason, Kate says, "Once you review the options, put together a list of potential events. Oh, and Ron, may I have a few minutes with you?"

Before Kate can start on the list of additional items to discuss with Ron, Lauren pops her head back into the conference room and says, "I'm fairly computer savvy, but I need a little help knowing where to search to find the trade show dates."

Kate takes the resource list out of Ron's hand and gives it to Lauren. "Look over this list and pay careful attention to the Fashion Industry Information Services Web site for trade shows and see what you can find. Make sure you look at the New York pier shows; we could be overlooking potential customers by not considering those shows."

"Jason and I will get right on it!" Lauren says as she hurries away, eager to start the new project. For the next two hours, Lauren and Jason sit glued to their computer screens as they develop a list of potential shows while Kate finishes her meeting with Ron by discussing dynamic work-flow systems.

After the meeting ends, Lauren enters Ron's office. "Jason and I have some suggestions for the right trade show for our career line," she says. "The sheer number of trade shows is exciting; did you know that there is even a trade show for dog accessories?" She laughs. "But, seriously, after researching the trade show Web sites and talking to show marketers, we now have a suggested date for our season release."

"Good work! Now, according to what I've just learned from Kate, it's time to work backward from the date of the trade show and come up with our calendar," Ron says.

"Work backward? That doesn't sound very productive!" Lauren exclaims, her eyebrows knitting.

Ron shifts his weight in the chair and remembers what Kate told him about using the dynamic work flow. "Well—We need to set up our activities, such as planning,

product design, preproduction, materials management, sourcing, production, and quality assurance."

Lauren scowls. "That sounds complicated!"

"It sounds a lot worse than it is. Kate explained that we add in Rare Designs' activities, such as identifying our target market and doing a retail merchandise strategy analysis."

"I've already done that," Lauren says.

"Hey, you guys, look what I found," Jason says, joining the impromptu meeting. "A list of some of the other major apparel manufacturers' schedules and when they will be presenting their lines to their retail customers."

Ron grins. "Great! So, then we take their schedules and apply them to our calendar, each with a deadline. That way we can keep track of where we are, where we should be, and what will be next." Forming a fist, Ron exclaims, "Having a calendar is vital; we can't be late shipping product! It's how we communicate to all of Rare Designs' associates and our supply chain partners about when we need things."

"Okay; I see why this calendar is so important," Lauren concedes. "Let me give you the information I found, and we'll create an accurate and reliable calendar. I think our hard work will get us an A+ from Dr. Roberts."

"But more important, I believe it will give us the competitive edge we need to move this company in the right direction," Ron says, feeling better about the direction his company is now heading.

A few days later, Kate meets with Anne, Ron, and Lauren. "The next step is to develop your business plan for each SBU."

"What's an SBU again?" Lauren asks.

"Strategic business unit," Ron answers, stretching his tight shoulder muscles. "We have three: Rare Entities, our career line; Rare Casual, our sportswear line; and Rare Expectations, our day-to-evening line."

Anne tugs at one of her antique garnet earrings. "Kate, while you're at it, could you please tell us what should be in a business plan?"

Kate answers, "Developing a minimum plan is an important first planning step so that you can see quantified trends for your upcoming line."

"What does that mean?" Anne asks.

"Developing a minimum plan means the merchandiser looks at the business history of your previous season, such as sell-through reports and fast-selling garment styles. Your *sell through*—what the consumer actually purchased in a retail store—is this year's beginning minimum plan number. So the merchandiser has to be thinking a year ahead."

"I love analyzing numbers," Lauren grins. "I was a whiz in my retail math class."

"Now we've switched to forward thinking! An operations guy like me would love to have numeric forecasts a whole year in advance!" Ron says, laughing.

"Isn't it hard to predict?" Anne asks.

"To quote several famous people, 'Prediction is very difficult, especially if it is about the future,'" Kate answers, smiling. "A business history report is the use of your past volume to project an initial classification estimate. You work as a team to calculate an estimate of styles for an upcoming season. Developing a minimum plan prevents overdevelopment. At first, you will probably think a minimum plan impinges on your creativity, but it is better to focus your best efforts on a select number of styles than to work hard on styles that will be thrown out at line review.

review. Lauren needs to analyze key item, sell-in, and sell-through reports. I would suggest that you meet as a team, including Tamee, and discuss quantified numbers, such as which items are on the downtrend and which are on the uptrend. As a result of your meeting, you will have guidelines on which categories will be strong sellers."

"Isn't it important to know what we sold to our retail customers?" Anne asks.

"Sell through is more important. *Sell in*—what you sold to your retail customers—does not account for a charge-back for merchandise put on sale, arriving late, or returned."

"Charge-backs! I get nightmares just hearing the word!" Ron says.

"I get to analyze more reports! I like that!" a cheerful Lauren chips in, writing copious notes.

"That's one advantage of being part of Huntington Industries," Kate says. "In a few weeks, it will add Rare Designs to its product data management and other corporate databases. You'll have access to its extensive business planning." She adds, with a twinkle in her eye, "Of course, product data management will allow Jim O'Dale to keep track of Rare Designs' timeliness, too."

"Hmmmm," Ron says, glancing at Anne mischievously. "It sounds like we have a lot of work to do. . . . Why don't *you* get started"

Objectives

After reading this chapter, you should be able to do the following:

- Understand how a season release date is the starting point for creating a product development time-and-action calendar.
- Determine the interdependencies and time constraints involved in creating a time-and-action calendar.
- Understand the inputs to a minimum plan, including key item, sell-in, and sell-through reports.
- Calculate a numeric minimum plan for a strategic business unit (SBU) classification.

As a student, you have deadlines when class projects and assignments are due. Imagine that you receive a course outline with a description of assignments and projects—but no deadlines. How would you react? Would you promptly ask your instructor about project due dates? Would you procrastinate starting a project because you think the instructor is responsible for informing you? Would you take the initiative to work on a project without a known due date to avoid the panic of an unexpected deadline? Now, add the complexity of working with multiple colleagues and companies but not having project deadlines. Would your colleagues be confused? Certainly. Deadlines are important, especially when many individuals work together. In an interview, Ronald Heimler, president

and owner of Walter Heimler, Inc., commented to the author on the pace of the apparel industry:*

We are engaged in the fashion accessory industry. As Tom Friedman has stated in his book *The World Is Flat*, we find our industry part of this technology-flattened world. It is fast, furious, and unforgiving! It is challenging to service our retail customers' needs for styling, price, quality, and delivery demands.

ACTIVITY **4.1** *Critical Thinking*

How can you develop your professional skills and work ethics so that you can perform well in the fashion industry, which is "fast, furious, and unforgiving," as company president Ronald Heimler noted?

Having set deadlines is part of an apparel associate's everyday work life. This chapter focuses on planning. The first topic discussed is time-and-action calendars, which apparel associates commonly use to manage the complexity of the product development process. Figure 4.1 outlines the steps to take to create a time-and-action calendar. The second topic is planning numeric quantities, which is the first step in creating a seasonal product line.

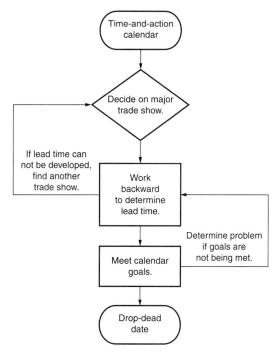

Figure 4.1 Flowchart showing the steps that must be taken to create a time-and-action calendar. *(Illustration by Karen Bathalter.)*

*Reprinted by permission from Ronald Heimler, president and owner, Walter Heimler, Inc., New York, NY; pers. comm., May 9, 2006.

Time-and-Action Calendar

Apparel associates use a *time-and-action calendar*, also called a *work flow*, to establish and adhere to deadlines. The **time-and-action calendar** is a schedule for an entire year, including multiple seasons. Its purpose is to organize everyone involved (Figure 4.2). Quality Assurance Manager Erin Schagunn-Bedwell, from American Apparel, commented to the author on the environment of the industry and the benefits of using a calendar:*

> At American Apparel, we are always up against urgent deadlines and have requirements in order to be the first on the market with the hottest items. I think this is what makes this company so exciting. We currently do not use a product development calendar; however, we are looking to restructure the product development department to incorporate a tool like the calendar. The organization that the calendar provides would help us a great deal to execute styles we produce for a particular season. Most of our items are year round, but for those few seasonal exceptions, timing is everything. For instance, last year we released a new design too late. It was a snow vest, but it was not ready until the end of winter. Of course it would not sell, because we were headed into spring! The calendar would have been useful in this case. This year, the snow vest was released on time and sales were much better.

Figure 4.2 The challenge of creating a time-and-action calendar: Multiple apparel associates, suppliers, and retail customers must be involved.

*Reprinted by permission from Erin Schagunn-Bedwell, quality assurance manager, American Apparel, Los Angeles, CA; pers. comm., February 22, 2006.

She also noted that a product development calendar has limitations:*

> Some of the challenges that we are experiencing with developing a calendar is that our company is very reactive to our designers. Following strict calendar deadlines is not always favorable to what our designers are trying to achieve.

Apparel companies use a calendar to manage the complexity and volume of products flowing between a manufacturer and its supply chain partners (Freeborders n.d.). Historically, most apparel-manufacturing companies were *vertical operations*, in which apparel associates worked in one building. So, if you needed a pattern, for example, you could run down the hall to the pattern maker and ask, "Hey, Claudia, where is my prototype?" You could talk to her in person to make any needed pattern changes. Current-day apparel manufacturing is global, so an apparel associate cannot physically run to, say, El Salvador on any given day and ask, "Hey, Claudia" Thus, communication of deadlines is important not only among internal colleagues, but also with a company's suppliers, contractors, and outside sources. The time-and-action calendar is one means of such communication.

A time-and-action calendar is a time-constraint work flow of activities. Table 4.1 shows a one-season time-and-action calendar. The time-and-action calendar takes into account departmental and supplier interdependencies, development time, and calendar activities. Subsequently in this section, each of these three components is discussed in more detail separately. In simple terms, a time-and-action calendar establishes deadlines to ensure that the development team can deliver product in time for it to be presented at the sales meeting and subsequently submitted to production.

Time-and-action calendars can be static or dynamic. Table 4.1 shows a *static* time-and-action calendar. Many apparel companies use a computer spreadsheet program to create static time-and-action calendars. One disadvantage of this type of calendar is that it does not inform you of when an activity is late. In Table 4.1, the first column lists activities. The third row shows the time allotted for seasonal development, broken down by workweek. Bars indicate the start and completion times for an activity; for example, the first activity, "Write/revise mission statement," starts on April 17 and ends on April 23.

To facilitate tracking styles and orders with supplier constraints, apparel companies often use a *dynamic* work flow. A dynamic work flow is part of **product data management or product life cycle management (PDM/PLM) system,** which is real-time electronic product development, production planning, and scheduling. *Product data management (PDM) and product life cycle management (PLM)* are synonymous terms. PDM/PLM is accomplished with a computer software program designed to facilitate time, to allow collaboration, and to coordinate customer-supplier time constraints. According to both Gerber Technology 🔲 (n.d.) and Jani Friedman—former senior vice president of business development at Freeborders 🔲 (pers. comm., 2004) and currently a principal at a consumer products corporate development firm—using a PDM/PLM program facilitates communication through a shared database and Internet resources in order to communicate schedules, track preproduction, identify bottlenecks, and determine what causes process delays. The

*Reprinted by permission from Erin Schagunn-Bedwell, Quality Assurance Manager, American Apparel, Los Angeles, CA; pers. comm., February 22, 2006.

Table 4.1 One-Season Time-and-Action Calendar Template

TRADE SHOW: COLLECTIVE AT THE NEW YORK PIER SHOWS (SEPTEMBER 4)

Activity	Week	1	2	3	4	5	6	7	8	9	10	11	12	13	14	15	16	17	18	19	20	21	22
	Date	4/3	4/10	4/17	4/24	5/1	5/8	5/15	5/22	5/29	6/5	6/12	6/19	6/26	7/3	7/10	7/17	7/24	7/31	8/7	8/14	8/21	8/28
Write/revise mission statement		▓																					
Write core strategy			▓																				
Conduct primary and secondary data collection			▓	▓																			
Calculate minimum plan			▓																				
Search online fashion forecast services				▓																			
Read published literature				▓																			
Collect visual images				▓																			
Sketch				▓																			
Review museum, entertainment and sport resources				▓																			
Review retail store trends					▓																		
Attend European textile, prefabric, and apparel shows					▓	▓																	
Observe consumers					▓																		
Create theme board						▓																	
Visit fiber marketing and color						▓																	
Visit textile services, converters and manufacturers						▓																	
Key to seasons:																							
Fall		▓																					
Winter		█																					
Spring		▓																					
Summer		█																					

primary advantage of using PDM/PLM programs is that they track activities in real time (Freeborders 2006).

Table 4.2 shows what a dynamic work flow looks like. Companies that create PDM/PLM programs customize database requirements to match a company's activities and time line. In dynamic work flows, colors designate responsible functional departments. For example, in Table 4.2, the merchandising department activities ("SBU business planning" and "Business analysis meeting and delegate tasks") might be pink, and the design department activities ("Design exploration," "Create theme board," and "Shop NY apparel cluster and visit suppliers") might be blue. The database program triggers when to start an activity (i.e., "Started"). "Not started" means the activity will occur in the future. An activity that occurs late, such as "Write/revise mission statement" in Table 4.2, changes color (e.g., would appear red). When an activity occurs late, an exception report is sent to the associates' supervisor.

Next, the three main components of a time-and-action calendar—departmental and supplier interdependencies, development time, and calendar activities—are discussed. This section ends with a discussion of adherence to the calendar.

Departmental and Supplier Interdependencies

Individual companies customize dynamic PDM/PLM activities to meet their needs; however, a generic work flow has six groupings: planning, product design, preproduction, materials management, sourcing, production, and quality assurance. Although the scope of this

Table 4.2 Dynamic Work Flow

PLM Work Flow					Today's date: 23-May	
	TRADE SHOW: NEW YORK PIER SHOWS					
Activity	Status	Due date	Planned start date	Planned end date	Actual start date	Actual end date
Write/revise mission statement	Late	16-May	17-Apr	15-May	19-Apr	
SBU business planning	Started	8-May	1-May	8-May	1-May	8-May
Business analysis meeting and delegate tasks	Started	8-May	1-May	8-May	3-May	
Design exploration	Started	5-Jun	8-May	5-Jun	9-May	
Create theme board	Not started	5-Jun	29-May	3-Jun		
Shop NY apparel cluster and visit suppliers	Not started	29-May	29-May	5-Jun		

textbook involves mainly the front end of the dynamic work flow—planning and product design—all six groupings are briefly discussed next as an introduction to the concepts.

Planning

According to Jani Friedman, former senior vice president of business development at Freeborders, **planning** is the development of an SBU business plan. It includes the creation of business goals and financial targets, business analysis, and creation of minimum plans for *stock-keeping unit* (SKU; pronounced "skew"). Planning also includes addressing **design objectives**, which comprises deciding on, developing, and submitting colors, themes, fabrics, and styles, and managing SKUs.

Product Design

Friedman also explained that **product design** consists of sketching, specification creation, fabric development, raw materials sourcing, and preliminary costing. **Design review** occurs in this grouping as well; it is a series of line meetings in which associates evaluate products purchased during the environmental search, create new prototypes, and redesign existing prototypes to fit within financial and aesthetic design targets.

Preproduction

Preproduction begins with the designers' or merchandisers' disseminating line sheets to product development associates. A **line sheet** is either an electronic or a paper form that lists the style, fabric, color, sizing, prices, and instructions for a garment (Figure 4.3). Upon receiving a line sheet, product development associates can start meeting their seasonal development responsibilities. The associates involved include those in preproduction, which includes **marker making** (i.e., pattern-piece layout used in cutting garments), purchasing, engineering, forecasting, operations, and manufacturing (Regan 1997, 197). According to Jani Friedman, a company organizes preproduction activities by season and in-house delivery date. Preproduction activities include technical design, engineering evaluation, and sample production. **Technical design** is the creation of specifications, production patterns (i.e., new and existing garments), and special operations (e.g., embroideries, screen prints, hand looms). **Engineering evaluation** is the calculation of landed cost comparisons from vendors, and routing. **Sample production** includes issuing samples—cutting, sewing, and finishing garments. Technical designers inspect and evaluate the garments to ensure they meet measurement specifications. This process involves collaboration among product development, operations, and production associates. Issuing samples is the process of tracking each style by receipt of submission dates, pattern, instructions, and submission to sewing operators. Once the contractors cut and sew samples, they send the samples back to the merchandisers or designers to approve or correct (Regan 1997, 276–77). Merchandisers and designers usually approve samples in one of three ways: in person, through teleconferencing, or by e-mail. Production sample approval is referred to colloquially in the industry as **top of production.**

RARE DESIGNS LINE SHEET

Date Input: _____20-July_____ Product Line Code: ___RE___
Year/Season: _____Spring_____ Product Line Desc.: ___Career___
Merchandiser: _____Lauren_____
Product Category: _____Rare Entities_____
Fabric Description: _____Wool, silk lining_____
Vendor: _____

SKU	Fabric Code	Color Name	Delivery Date	Sales Est.	Sizes	Samples	Yards
REJ1001	001, 014	Whisper	2/1-3/15	1000	2-14	30	2000

SKETCH:

COMMENTS:

Please furnish pattern information to: Lauren

Target Selling Price: $73.50

Figure 4.3 Example of a Rare Designs in-progress line sheet. *(Illustration by Alison Flanagan and Suzette Lozano.)*

Materials Management

Materials management occurs simultaneously with preproduction activities. In this process, raw materials are ordered and received at contractor or manufacturing facilities. Design associates submit line sheets to operations and support services. Within operations, a company has purchasing, forecasting, and marker making associates. Fabric and trim buyers issue purchase orders and work with suppliers on sample yardage, quality assurance tests, minimum orders, and delivery dates. Forecast associates work closely with merchandisers. At budget review, associates finalize line plans for dollar commitment, quantities, gross margin, pricing, vendor terms, and acceptable delivery dates. Operations associates work closely with the marker-making department (Regan 251, 253, 265). Once a marker (i.e., pattern layout) is completed, operations associates determine spreading and cutting instructions and electronically send or mail markers to contractors (Regan 1997, 268).

Sourcing and Production

Sourcing and production involves developing a sample package and setting up the complex production process. A sample package brings together the production patterns, special operations, engineering routings (i.e., sewing instructions), and cost of each garment style. A sample package is constrained by the completion of activities within preproduction and materials management. For example, contractors use production fabric for garment samples; thus, purchasing must complete the purchase order so that contractors receive this yardage. Production scheduling involves the decisions, coordination, and logistics of raw materials, cutting, and garment sewing among agents, contractors, and suppliers (Regan 1997, 275–76).

Quality Assurance

The **quality assurance** phase occurs simultaneously with materials management. Quality assurance associates develop standards and are responsible for testing materials. If quality assurance associates identify fabric defects or the materials do not pass tests, these associates notify the designers or merchandisers. Designers decide whether to accept the fabric. Merchandisers negotiate the price with textile suppliers or replace the inferior fabric with something better. Production associates review samples for equipment, cost, and sewing problems. Designers or merchandisers evaluate a sample and sign off that they accept its appearance, and production associates sign off that they accept its construction and cost target (Regan 1997, 258, 272–73, 278).

Development Time

An apparel company working on a traditional time line completes product development in 22 weeks (Regan, Kincade, and Sheldon 1998). Innovative companies—such as ZARA, a private-label retailer—shorten design and development time to 5 weeks. ZARA's innovative approach requires continuous, year-round design and development, rather than seasonal (Ghemawat and Nueno 2003).

Merchandisers indicate that unexpected events often make staying on a time-and-action calendar schedule challenging. For example, a company may add a product line, hire new employees, or experience tremendous internal growth. Regardless, retail customers do not want to feel the repercussions of an apparel company's time management problems. Each apparel associate must realize that his or her actions affect other associates who are trying to complete their jobs. Ronald Heimler, president and owner of Walter Heimler Inc., explained,*

> Creating a fashion product is a collaborative effort and you are partner in a retail customer's performance and profitability. Any party in the development process that is off schedule becomes the weakest link. It will affect the opportunity to present the product and make the sale on the supplier side, and create a merchandising dilemma on the buyer side. Retail buyers have little patience for not meeting a schedule. If you disappoint them, they will look elsewhere.

ACTIVITY 4.2 *Critical Thinking*

According to company president Ronald Heimler, "Any party in the development process that is off schedule becomes the weakest link."

- When you work on a team project, how can you prevent a person from being the weakest link?
- What is your weakness when you work with others?
- How can you improve your communication skills so that your team will deliver its project on time?

Calendar Activities

Imagine that your boss asks you to create a time-and-action calendar. You might despair, thinking "Where do I start?" One important point to remember is that creating a work flow is not any one person's responsibility. Rather, the company president will organize a cross-functional team. The **vice president of strategic planning,** vice president of product development, design directors, and merchandisers will lead the creation of the time-and-action calendar. This work-flow team must be knowledgeable about product development, materials management, production, and quality assurance activities. To accomplish this, the team will interview company associates about the time needed to complete their activities.

Setting up a time-and-action calendar begins by establishing, first, the final deadlines and, second, intervening deadlines to ensure completion. This backward flow dictates the date when associates must make design decisions for timely delivery of the product. If you were to create a time-and-action calendar for the first time, you would first need to know apparel season release dates for your market classification. The dates of the apparel fashion week, trade show, or market week at which an apparel manufacturer presents products is the *seasonal development deadline.* In contrast, the **season release date** is the calendar day when the design and merchandising team presents the product line and samples to the retail trade or to

*Reprinted by permission from Ronald Heimler, president and owner, Walter Heimler, Inc., New York, NY; pers. comm., May 9, 2006.

manufacturing representatives. This presentation is a formal line review and sales forecast meeting. It is called a *season release*, or the *on sale date*, because the designers and merchandisers release the product to be sold to the wholesale trade (Regan 1997, 199). The apparel release date and market classification are interrelated because some companies present products at fashion weeks (e.g., a designer), whereas others present products at market weeks (e.g., specialty markets) or trade shows. Because retail customers want to see, touch, and feel real products when they make purchase decisions, manufacturing representatives must have actual garments to show to the trade at fashion weeks, sales meetings, trade shows, and market weeks.

An apparel manufacturer determines its final deadline by its most important selling season and where it presents its SBU product lines to the trade. Apparel products are available year round; however, apparel associates start the calendar with the release date for the highest-selling season. Some apparel manufacturers, such as VF Corporation (e.g., Wrangler, Lee) and Levi Strauss & Co., indicate that seasonality does not dramatically affect their product development process and that their first- through third-quarter sales are approximately equal and their fourth-quarter sales are only slightly higher (U.S. Securities and Exchange Commission [SEC] February 13, 2007; February 27, 2007). Seasonality does affect many apparel classifications, however. For example, The Gap, Inc., indicates that fall (fourth-quarter) sales account for 30–40 percent of its annual sales, and Quiksilver, Inc., notes that back-to-school (August–October) sales constitute 32 percent of its annual sales (SEC January 17, 2006; March 28, 2006). For companies for which seasonality does not have a sales peak, the work flow is essentially the same. However, manufacturers that specialize in one classification have sales peaks. According to Liz Riley,* marketing coordinator at California Market Center, in an interview with the author, men's spring delivery features board sports, urban, athletic, and licensed goods. Fall delivery is most important for children's, juniors', women's dresses, designer, career, and embellished classifications. Men's fall delivery is most important for designer wear, suiting, men's furnishings (i.e., shirts, ties), and sportswear. Women's spring delivery is most important for sportswear, bridal and evening dresses, swimwear, and resort wear. The owner of a specialty leather store in New Mexico confirmed in a conversation with the author that fall delivery is his most important. As a store owner, he needs to have merchandise in the store when it has the highest demand. Leather goods sell primarily in the fall, so for his niche, trade shows that feature fall delivery, such as the February MAGIC (Men's Apparel Guild in California) show, are important, whereas those that feature spring delivery are not.

Apparel associates organize the time-and-action calendar according to the traditional seasons of selling products to retailers: spring, summer, fall, and holiday or resort (Figure 4.4). Depending on the target market of the SBU, an apparel manufacturer may have one release (e.g., Fall) or multiple releases (e.g., Fall I, Fall II) for a seasonal product line.

The first step in creating a work flow is to set the season release date. To do this, the time-and-action calendar team must distinguish whether the company will present lines at fashion weeks, market weeks, or both. The company needs prototypes at fashion weeks, whereas they need garment samples at trade shows and market weeks. For apparel manufacturers with New York showrooms, the apparel release date coincides with New York Apparel Market week. New York is the first U.S. market to open seasonal lines to the trade. Apparel manufacturers who show during New York Apparel Market week must have samples ready to present to buyers at permanent and temporary showrooms throughout the city.

*Reprinted with permission by Liz Riley, former manager, California Market Center, Los Angeles, CA: pers. comm., May 2005.

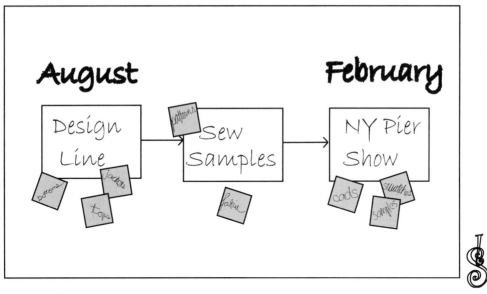

Figure 4.4 Ron's hallway with poster of a Rare Designs time-and-action calendar draft. *(Courtesy of Suzette Lozano.)*

Some apparel manufacturers release their lines during international fashion weeks. A **fashion week** is a centralized venue in which designers show their product lines at fashion shows. U.S. fashion week shows present young up-and-coming major designers, such as Jennifer Nicholson 👕, and established major designers, such as Carolina Herrera 👕. The international fashion scene is held in Milan, Paris, London, and New York (Davis 2003). International fashion weeks are exclusive; they allow only select **bridge,** couture, and designer product lines. For example, Calvin Klein (CK) Collection, owned by Phillips–Van Heusen, targets a higher price point and is sold in CK stores and luxury department stores. CK Collection presents product lines at the Milano Moda Uomo show in Milan, Italy (Camera Nazionale della Moda Italiana 👕 n.d.; SEC April 14, 2006). Major fashion weeks, trade shows, and market weeks are listed at the Web sites of InfoMat Inc. (a fashion industry search engine) 👕, *California Apparel News* 👕, and Apparel Search 👕 (ApparelNews.net 2007; ApparelSearch.com n.d.; InfoMat n.d.).

Other apparel manufacturers release their apparel lines at trade shows or market centers. Companies that show lines at a trade show target specialty stores and small, independent retailers. Trade shows specialize in market segments; for example, a large men's trade show is the MAGIC (Men's Apparel Guild in California) 👕 show, and the *Women's Wear Daily (WWD)* MAGIC show is the corresponding women's show. Trade shows and market weeks typically occur several months after fashion weeks. For instance, Italy's Milano Moda Uomo fall fashion week was January 14–18, 2007, and the MAGIC trade show was 5 weeks later (February 13–16, 2007). Ten weeks later, March 23–27, 2007, was the Los Angeles Fall I Market (InfoMat n.d.).

Table 4.3 lists major fashion weeks, trade shows, and market weeks. The Web site links list the current trade show or fashion week event dates. The product development team must complete samples 1 week before a trade show begins to allow for transport time.

Table 4.3 Apparel Season Release Dates

Trade Show Guides

Guide	Web site
InfoMat Inc. (a fashion industry search engine)	www.infomat.com/calendar/index.html

Men's Clothing: Fall-Winter Apparel Release

Month	Major show (sponsor)	Location	Web site	Product type
Jan.	Pitti Immagine Uomo	Italy	www.pittimmagine.com/en	Men's clothing
	Milano Moda Uomo (Camera Nazionale della Moda Italiana)	Italy	www.cameramoda.it/eng	Men's luxury ready-to-wear and designer clothing
	Mode à Paris (Fédération Française de la Couture)	France	www.modeaparis.com/va/index.html	Designer ready-to-wear collections
Feb.	Mercedes Benz Fashion Week	United States	http://www.mbfashionweek.com/newyork/	Men's designer apparel
	MAGIC (Advanstar Communications)	United States	http://show.magiconline.com/magic/v42/index.cvn	Men's apparel

Men's Clothing: Spring-Summer Apparel Release

Month	Major show (sponsor)	Location	Web site	Product type
June	Pitti Immagine Uomo	Italy	www.pittimmagine.com/en	Men's clothing
	Milano Moda Uomo (Camera Nazionale della Moda Italiana)	Italy	www.cameramoda.it/eng	Men's luxury ready-to-wear and designer clothing
June–July	Mode à Paris (Fédération Française de la Couture)	France	www.modeaparis.com/va/index.html	Designer ready-to-wear collections
Aug.	MAGIC (Advanstar Communications)	United States	http://show.magiconline.com/magic/v42/index.cvn	Men's apparel

Table 4.3 *(Continued)*

Women's Clothing: Fall-Winter Apparel Release

Month	Major show (sponsor)	Location	Web site	Product type
Jan.	New York Women's Apparel Fall I Market (New York Fashion Council)	United States	www.infomat.com/calendar/IN FSN0000041.html	Women's designer, bridge, and better clothing
Jan.–Feb.	New York Women's Apparel Fall II Market (New York Fashion Council)	United States	www.infomat.com/calendar/inf sn0000052.html	Women's designer, bridge, and better clothing
Feb.	Prêt à Porter Paris	France	www.pretparis.com/en	Women's European ready-to-wear clothing
	London Fashion Week	England	www.londonfashionweek.co. uk/?display=flash	Moderate, better, and contemporary clothing
	Milano Moda Donna (Camera Nazionale della Moda Italiana)	Italy	www.cameramoda.it/eng	Women's luxury ready-to-wear and designer clothing
Feb.	Mercedes Benz New York Fashion Week	United States	http://www.mbfashionweek. com/newyork/	Men's designer apparel
Feb.–Mar.	Mode à Paris (Fédération Française de la Couture)	France	www.modeaparis.com/va/ index.html	Designer ready-to-wear collections
Mar.	Mercedes-Benz Los Angeles Fashion Week (Mercedes-Benz)	United States	http://mbfashionweek.com/ losangeles/	Los Angeles designer apparel, sportswear

Women's Clothing: Spring-Summer Apparel Release

Month	Major show (sponsor)	Location	Web site	Product type
Sept.	New York Women's Apparel Spring I Market (New York Fashion Council)	United States	www.infomat.com/calendar/ INFSN0000081.html	Women's designer, bridge, and better clothing

(Continued)

Table 4.3 *(Continued)*

Women's Clothing: Spring-Summer Apparel Release

Month	Major show (sponsor)	Location	Web site	Product type
	London Fashion Week	England	www.londonfashionweek.co.uk/?display=flash	Moderate, better, and contemporary clothing
	Milano Moda Donna (Camera Nazionale della Moda Italiana)	Italy	www.cameramoda.it/eng	Women's luxury ready-to-wear and designer clothing
	Prêt à Porter Paris	France	www.pretparis.com/en	Contemporary, bridge, and designer clothing
Sept.	Mercedes Benz New York Fashion Week	United States	http://www.mbfashionweek.com/newyork/	Women's designer apparel
Sept.–Oct.	Mode à Paris (Fédération Française de la Couture)	France	www.modeaparis.com/va/index.html	Designer ready-to-wear collections
Oct.	Mercedes-Benz Los Angeles Fashion Week (Mercedes-Benz)	United States	http://mbfashionweek.com/losangeles/	Los Angeles designer apparel, sportswear

Children's Clothing: Fall-Winter Apparel Release

Month	Major show (sponsor)	Location	Web site	Product type
Jan.	Pitti Immagine Bimbo	Italy	www.pittimmagine.com/en/fiere/bimbo	Children's wear
	Children's Club (ENK International Trade Events)	United States	www.enkshows.com	Children's wear
Feb.	Kid's Fashion	France, Netherlands, Germany	http://www.kidsfashionfairs.com/	Children's wear
	MAGIC Kids (Advanstar Communications)	United States	http://show.magiconline.com/magic/v42/index.cvn	Children's moderate, contemporary, and bridge clothing

Table 4.3 *(Continued)*

Children's Clothing: Spring-Summer Apparel Release

Month	Major show (sponsor)	Location	Web site	Product type
June	Kid's Fashion	France, Netherlands,	http://www.kidsfashionfairs.com/	Children's wear
June–July	Pitti Immagine Bimbo	Italy	www.pittimmagine.com/en/fiere/bimbo	Children's wear
Aug.	MAGIC Kids (Advanstar Communications)	United States	http://show.magiconline.com/magic/v42/index.cvn	Children's moderate, contemporary, and bridge clothing
Oct.	Children's Club (ENK International Trade Events)	United States	www.enkshows.com	Children's wear

Unisex Specialty Market Shows: Fall-Winter Apparel Release

Month	Major show (sponsor)	Location	Web site	Product type
Jan.	Action Sports Retailer (ASR)	United States	www.asrbiz.com/asr/index.jsp	Action sports and youth apparel
Feb.	International Swimwear/Activewear Market (ISAM)	United States	www.isamla.com	Swimwear, resort wear

Unisex Specialty Market Shows: Spring-Summer Apparel Release

Month	Major show (sponsor)	Location	Web site	Product type
Aug.	International Swimwear/Activewear Market (ISAM)	United States	www.isamla.com	Swimwear, resort wear
Sept.	Action Sports Retailer (ASR)	United States	www.asrbiz.com/asr/index.jsp	Action sports and youth apparel

At this point, you might think, "I have the product development end date; now what?" One deadline is too overwhelming for a process as complex as apparel product development. Apparel associates meet to discuss the time needed to execute a product line (e.g., 22 weeks) and the quantifiable intermediate activities that must be completed to meet the final deadline. The team that develops the calendar must understand time constraints. Time is important because an apparel season release date does not change; lateness of any activity delays other product development associates from conducting or completing their jobs. Time constraints vary depending on the products created. Apparel associates work backward from the season release date to complete seasonal product development, as company president and owner Ronald Heimler confirmed:*

> For product development, we work backward from the presentation date to the time when development or sourcing has to commence. Development time accounts for component and supplier sourcing, sample development, and time in transit from foreign factories to our showroom to present to retail buyers. In the accessories industry the development cycle can be as short as 1 week and up to 6 weeks if it is complicated or there are issues to resolve. For production, it is a similar process. We work backward from the request delivery dates to the date we need to confirm an order. To produce accessories, production time can take 6 weeks for air shipments and up to 12 weeks for boat shipments.

A **drop-dead date** is apparel associates' colloquial term for season release and set time constraints within product development. The term *drop dead* is appropriate because unexpected events can happen that intensify the stress of project completion. A crisis could occur if a company's products are lost in transit or someone steals them before a show opens. An apparel manufacturer must have product to sell, even if employees must stay up all night to resew samples before a trade show opens.

As an apparel associate, your goal is to produce a garment. The garment comprises a pattern, fabric, thread, buttons, and so forth. Unless you make all these products yourself, you must work with other individuals. These people need time to do their jobs to get the product to you. Therefore, you could create a calendar by devising a flowchart in which you think in the context of what you need, when you need it, and how much time is required to get the product to you. As a result of this interrelationship with other company associates, suppliers, and contractors, product development has set, nonnegotiable dates. Consider fabric as an example. You first need to select the garment color, because dyeing the fabric would make no sense if you do not know the color. A budget apparel manufacturer often buys in-stock fabric from a vendor's open line, so the designers select from the available color selection. These vendors may ship fabric within as few as 5 working days; therefore, in such cases, the fabric constraint is 1 week before the manufacturer needs the fabric (e.g., to sew samples to sell at a trade show).

In contrast, moderate, better, and luxury apparel manufacturers often develop custom colors and fabrics. Doing so involves the textile supplier, which also has development and production time constraints. For instance, Jennifer Barrios, senior merchandiser at Quiksilver, Inc., told the author that textile suppliers must have 45 days to knit or weave fabric. Therefore,

*Reprinted by permission from Ronald Heimler, president and owner, Walter Heimler Inc., New York, NY; pers. comm., May 9, 2006.

designers and merchandisers must select and develop all colors and fabric designs before the 45-day deadline. To select colors, the designers need design inspiration, visits to forecast services, and participation in color concept meetings to submit the color card to the textile manufacture representative. Textile chemists need a set time frame to develop recipes, conduct lab dips, and submit samples back to manufacturer representatives to have colors approved. Likewise, for a custom print, submitting a print idea, gaining approval of the idea, creating technical print specifications, and approving fabric strike offs can take 12 weeks. This process pushes the initial fabric submission deadline 12 weeks from when production needs sample fabric. Thus, the work-flow team must build all these time constraints into the calendar.

Time to market is a continual concern for many apparel manufacturers. Therefore, many companies compress the time-and-action calendar to a minimum time frame.

Many managers use project management tools, such as a Gantt chart. **Project management** is how a manager monitors time and manages employees who work on large projects, such as product development and production, in which products need to be delivered within a specified time frame. A Gantt chart is a project management tool that shows a time line of activities. The activities in the time line are called a *work breakdown structure* because the time line shows the activity sequence and corresponding constraints (Wood and Pascarella 2004). For instance, a designer needs to select colors before buying fabric.

Ronald Heimler, president and owner of Walter Heimler Inc., explained to the author how his company deals with time constraints:*

> At Cool Stuff USA we do utilize a time-and-action process for product development and production, but it is not a highly formalized system because of the uncertainty and speed of our market. We are working in a highly compressed time frame of less than 8 weeks from design to delivery in some cases. It is not only helpful to adhere to a schedule, but critical. It is useless to finish new products that are not in sync with presentation dates. It is important that all the parties involved be on the same schedule; this includes suppliers, designers and salespeople from the supplier side. Even the customer needs to be involved since there is often information needed with regard to color, packaging, testing and approvals that has to be incorporated with the development, costing and production. It is a highly orchestrated event in an extremely low-cost industry.

ACTIVITY 4.3 *Critical Thinking*

Think of a large group project, such as a course term paper and presentation, that has a set deadline.

- Write a list of activities you and your team members need to complete to finish the project.
- Write a list of deadlines for each activity.
- Evaluate whether you can complete these activities and what will happen if you miss the deadlines.

*Reprinted by permission from Ronald Heimler, president and owner, Walter Heimler Inc., New York, NY; pers. comm., May 9, 2006.

Calendar Adherence

Simply having a time-and-action calendar does not ensure success; rather, apparel associates need deadline reminders. A time-and-action calendar is based on the idea that everything will run perfectly smoothly. A merchandisers' performance is based on on-time execution of their product lines. Associates refer to *on-time performance* as *meeting calendar goals*. A **calendar goal** is the delivery of a quantified product on a specific date. Although associates' responsibilities vary by company, on-time performance is an important component of employees' annual performance reviews. Design directors manage their design team and are accountable for their apparel associates' completion of activities. For instance, if a CAD artist does not meet deadlines, the design director is accountable. This on-time performance, or meeting calendar goals, is meeting deadlines that affect other internal departments or suppliers. A calendar goal quantifies each activity that involves other apparel associates, so that everyone can stay on schedule. Meeting calendar goals quantifies the completion of a set number of products for release to the next step. For example, if a design director requests development of eight new prints from one vendor, print submission is staggered (e.g., two each week) so as not to backlog other processes if the supplier is late. Thus, the designer's calendar goal is to select print swatches and submit two per week to the CAD artist for coloration (see Table 4.4).

Calendar goals are static (as shown in Table 4.4) or dynamic when built into a PLM computer software system. When meeting calendar goals is troublesome for a product line team, the pressure builds because the season release date is fixed. "Whatever works" is one adage company executives often use to ensure that associates meet deadlines.

Table 4.4 Calendar Goals (Example Activities)

Event	Plan	Actual	9/4	9/11	9/18	9/25	10/2	10/9	10/16	10/23	10/30	11/6
SBU: Rare Entities												
Season: Spring												
Release:												
Select prints	9	9	1	3	2	3						
New prints	8		2	2	2	2						
Submitted												
Recolored prints	2					2						
Submitted												
Approve prototypes	75											
New styles	35						5	7	7	6	5	5
Approved												
Carryover	40						7	6	7	7	7	6
Approved												
Approve lab dips	40		13	13	14							
Approved												

Company executives may try to "fix" consistent lateness by pushing design decisions earlier, but this alone becomes a problem. Design directors must balance the completion date of an activity with decision points of major retail customers. If designers make initial decisions too early, they cannot get accurate feedback from retail customers because it does not correspond with the timing of their buying decisions. Consequently, a decision made too early usually causes excessive product line corrections. Equally troublesome, late decisions, can cause a crisis scenario. A design director's goal is to make sure decisions are correct and to not make excessive product line adjustments. Executives simply hold to the view "Do not make excuses. Just meet the deadline." Jennifer Barrios, senior merchandiser at Quiksilver, Inc., commented to the author on meeting calendar goals:*

> I live by the calendar—without it, I would not know what I am doing. Things can easily get behind schedule. You always want to react to what is happening in the market, but there is a point when you need to cut it off and address some things in the next season's line. You have to compromise or you will be changing things all the time.

ACTIVITY 4.4 *Balancing Design Modifications and Time*

The senior merchandiser at Quiksilver, Inc., mentioned that you must balance market trends with staying on schedule. To understand this concept, do the following activity with a colleague:

- Individually illustrate a purse or cut a picture of a purse from a magazine.
- Individually make a list of the supplies needed to produce your purse.
- Share your illustration and supply list with your colleague. Illustrate a new purse design with some attributes from your design and some from your colleague's.
- Revise your supply list, using a different-color pen or pencil than that of your original. Cross out supplies you do not need and add supplies you need.
- Assume you already bought the original supplies for your purse and you need to cut and sew your purse by tomorrow. Write your reaction to now having to return supplies you do not need and buying new supplies you do need.
- Estimate how long creating a pattern and subsequently sewing this product will take.

SBU Business Planning

Once company associates establish their time-and-action calendar, the merchandiser starts SBU business planning. As mentioned in the PDM/PLM discussion, *planning* is the development of an SBU business plan. **Business planning** is the creation of quantified goals, which includes determining a minimum plan and understanding the marketing concept. A **minimum plan** is a quantitative analysis of an SBU product line. When developing a minimum plan, a merchandiser reflects on and reviews trends for each classification within the

*Reprinted by permission from Jennifer Barrios, Senior Merchandiser, Quiksilver, Inc., Huntington Beach, CA; pers. comm., May 9, 2006.

SBU, then creates a plan for each, including determining unit quantities and managing the number of garment styles for an upcoming season (Regan 1997, 180). Many factors are unknown when merchandisers develop minimum plans, so they rely on quantified information.

As a student, you are familiar with quantified goals. For example, the first day of class, you receive a course outline. The outline states that depending on the specific point-value range you earn, you will receive a grade of A, B, or C. Likewise, the successfulness of predicting and selling products is part of a merchandiser's performance evaluation. A merchandiser must have the ability to communicate well, to be a good problem solver, to make quick decisions, to take risks, and to evaluate qualitative and quantitative data to forecast demand. Communication and problem-solving skills are important because merchandisers often work closely with other employees to design products, discuss quality problems, or resolve shipping challenges. Although a merchandiser's job is part *qualitative*, in which he or she follows fashion trends and evaluates the company's competitors, he or she uses *quantitative* skills to evaluate inventories, to avoid supply-chain time delays, and to forecast product demand (U.S. Bureau of Labor Statistics, U.S. Department of Labor 2006–2007).

To write minimum plans, a merchandiser depends on apparel associates from design, marketing, merchandise support, and forecasting. Other apparel associates provide SBU design and business information if the projected goals affect their business processes. These associates include individuals from distribution, fabric development, human resources, finance, international sourcing, manufacturing, product development, quality assurance, and retail operations.

To visualize the business-planning process, picture an apparel associate with multiple computer reports spread out on a desk. Sydney Blanton, owner of Amelie, described to the author one method of planning a category:*

> The way I calculate minimum plan is by total dollar quantity for a category. I always look at my figures in total dollar amount, rather than units, because I am paying in money [not units]. For instance, if I dedicate $8,000 for sweaters, I buy as many units as I can. When I buy new styles, I spread my risk and I will not place a large order. I feel it is less risky to buy across categories rather than putting too much money into one product line.

A company's ultimate quantifiable objective is to be profitable. However, many steps must be taken before a company can realize this goal. Figure 4.5 shows a flowchart of business-planning activities that culminate in a minimum plan.

The Minimum Plan

To create a minimum plan, a merchandiser analyzes internal reports—business history, key item, sell-in and sell-through, SKU management, and growth category reports (Regan 1997, 181). If the minimum plan is for a new SBU, the merchandiser will not have quantified information to rely on and must "guesstimate" the minimum plan. Finally, the merchandiser will factor in "soft information" when developing a minimum plan.

The SBU minimum plan is a numerical forecast of the growth or decline of an SBU classification. The minimum plan guides development, product presentation, and production processes (Glock and Kunz 2005). A merchandiser calculates a minimum plan by inputting

*Reprinted by permission from Sydney Blanton, Owner, Amelei, Claremont, CA; pers. comm., May 1, 2006.

Figure 4.5 Steps a merchandiser must complete to create a minimum plan.
(Illustration by Karen Bathalter.)

the total unit production for the previous year and the ratio for product lines within the SBU (e.g., Tops, 70%, in Table 4.5). On the basis of strategic-planning meetings, the merchandiser then inputs the projected increase or decrease in growth for each classification (e.g., −5%).

For instance, a merchandiser will decrease a classification percentage if the company had excessive markdowns or inventory at the end of a season. Conversely, he or she will increase a classification percentage if the previous season showed strong sales or the company depleted its inventory.

Table 4.5 Calculation of SBU Growth or Decline

Minimum plan classification				Production last year
				24,000
	Ratio	+/- growth	Total units	Projection this year
Tops	70%	-5%	16,800	15,960
Bottoms	30%	6%	7,200	7,632
Total	100%		24,000	23,592

Activity 4.5 *Understanding Classification Growth or Decline*

To understand how an increase or decrease in demand for a classification affects numerical projections, refer to Table 4.5.

● Change the Tops and Bottoms ratios (together, they must equal 100%).
● Change the percentage of growth (or decline).
● Write down the total projection for this year.

Use of Internal Reports

Merchandisers use various reports to create the core strategy for an SBU. Some common reports include business history, key item, sell-in and sell-through, SKU management, and growth category reports.

Business History Reports A **business history analysis** is the use of past volume (data from business history reports) to project an initial seasonal volume estimate (e.g., 100,000 units). Company executives establish an SBU volume based on the company's strategic-planning objectives. For example, one SBU objective may be to maintain price per unit, gross margin, and quantity shipped; a different objective may be to increase business at a rate of 2 percent a year. External factors, such as retail customer organizational changes, affect the initial seasonal volume estimate for an SBU. For instance, if one SBU targets conventional department stores, and sales are declining for this store type, company executives will reduce the total dollar amount allocated to the SBU.

Key Item Reports A **key item** report lists fast-selling garment styles from previous seasons. Key items may be the reason an entire SBU classification is successful. A merchandiser analyzes key item trends from past seasons to create the product line strategy for an SBU (Regan 1997, 181).

A minimum plan is set 9 months to 1 year in advance. Merchandisers plan on the basis of what the company's sales representatives booked and sold in retail stores; for instance, they use sales booked in spring 2009 to plan spring 2010. Sales representatives will inform merchandisers of current sales information—for example, colors they see trending down or trending up. Coordinating timing with the retail customers' schedule is important in business planning. If a merchandiser works too far in advance of the retail customers' schedule, effectively planning the business of an SBU is difficult. Because merchandisers plan 1 year in advance, they do not have complete sales figures: Current-season merchandise is still for sale in retail stores and consumers may not have purchased the goods yet. Thus, because knowing the sell through is important, predicting the key items or growth categories is difficult.

Quiksilver, Inc., Senior Merchandiser Jennifer Barrios noted that merchandisers also need to anticipate whether a style that sold well was for one season only or if it may have a significant impact on future seasons. On the one hand, if a style had high bookings for one season only, it will have no impact on the minimum plan for the next year. On the other hand, if it continues to increase in popularity, merchandisers will need to increase the minimum plan for this style, or reallocate selling styles to develop new prototypes.

Sell-in and Sell-through Reports Merchandisers refer to selling reports to look at the increase or decrease in volume for a classification. Two quantifiable design measures are *sell in* and *sell through*. **Sell in** refers to the dollar amount of branded products that an apparel manufacturer sells to retail customers. Quiksilver, Inc., Senior Merchandiser Jennifer Barrios noted that **bookings,** a type of sell in, are represented by the dollars and units that sales representatives have written on purchase orders at trade shows or have sold directly to territory accounts.

In contrast, **sell through** refers to the amount consumers actually purchased at a retail store. Merchandisers are accountable for a successful sell through to their retail customers' accounts (Regan 1997, 181). A retail customer will share sell-through information with large-account apparel manufacturers. Sell-through figures are more important than sell-in information because merchandisers may look at a best-selling sell-in style and at first think the style is great. They may even form plans for the designer to create a similar garment for an upcoming season. However, merchandisers must consider sell through, because consumers may not have actually purchased the style after it was placed in the retail store, or it may have sold at only a marked-down price. Conversely, an item that was not booked in high quantities may have sold quickly once placed in the store.

SKU Management Reports The vice president of product development gives a budget report to merchandisers. From the budget, the merchandisers determine the number of SKUs they can support in their SBU—for instance, 35 SKUs in woven shirts. From this number, the vice president of product development calculates the expected dollar volume of the SBU.

Many designers fall into the habit of overdeveloping SKUs. **Overdevelopment** refers to when designers create more SKUs than the budget allows. For example, they design and develop 45 SKUs with the idea that they will drop some styles at the design review stage, just before season release. This practice creates non-value-added activities and excess work for technical designers, merchandise associates, pattern makers, and sample sewers. Therefore, according to Jennifer Barrios, senior merchandiser at Quiksilver, Inc., astute merchandisers hold designers to the budgeted SKU numbers (e.g., 35) and work with the designers to make better, more thoughtful decisions earlier in the design process.

Growth Category Reports A **growth category report** shows whether an SBU classification is trending up or trending down (Regan 1997, 181). **Trending down** is an apparel industry colloquialism meaning the production volume is declining for a specific SBU classification. An example of a downtrend scenario is as follows:

> A shorts classification sold 100,000 units 4 years ago and 100,000 units 3 years ago. However, 2 years ago, sales decreased and the classification sold only 80,000 units, so this year the merchandiser projects sales of 60,000 units.

Trending up, another colloquialism, means the production volume for a specific SBU classification is increasing—for example, a suit classification sold 100,000 units 3 years ago and 115,000 units 2 years ago.

ACTIVITY 4.6 *Analyzing Trends*

Four years ago, Rare Designs sold 25,000 low-waist pants; 3 years ago, 19,000; 2 years ago, 50,000; and last year, 65,000. Is Rare Designs' pants category trending up or down?

Guesstimation

A new SBU does not have a business history. Therefore, the vice president of product development must create a production volume **guesstimate.** Merchandisers talk to manufacturing representatives to gather "soft information" (discussed in the next section) to help obtain the guesstimate. The minimum plan guesstimate is based on the following formula (Figure 4.6):

(No. of sizes) × (No. of colors) × (No of garment styles) × (No. of expected accounts)
= Minimum plan

For example,

4 sizes × 6 colors × 20 styles × 50 accounts = 24,000 units

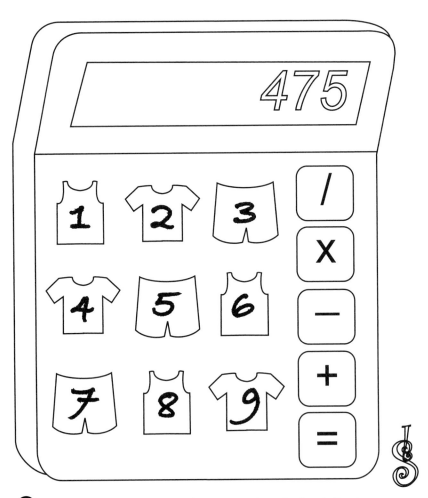

Figure 4.6 Computation of minimum plans: Anne, Rare Designs' director, uses a specially designed calculator to do so. *(Courtesy of Suzette Lozano.)*

ACTIVITY 4.7 *Creating a New SBU*

Assume you are starting a new dress SBU. You want to sell one of each size and color to small retail boutiques. Calculate a minimum plan with 5 sizes, 8 colors, and 15 styles, which you expect to sell to 75 accounts.

Soft Information

A merchandiser will supplement the company strategy and numerical projections with "soft information." **Soft information** includes the merchandiser's "gut feeling" and information obtained from querying retail buyers and salespeople. Minimum plan numbers obtained with the aid of soft information are not arbitrary, however, because merchandisers are accountable for managing bottom-line profitability, margin results, and market share (Kunz, 1998).

Alternative Calculation Method

Another way to calculate a minimum plan is to base garment projections on raw materials quantities or manufacturing constraints. Michael Rowley, president of Straight Down Clothing Co., explained this concept to the author:*

> The textile supplier determines our quantity. If we place a minimum order of 2,000 yards, it has to be a home run. We preview a style to buyers using the minimum quantity as the amount available. For example, if for style 1611 we have to order 300 yards per color, I look at how many of that color sold after 5 weeks. If our account representatives sold 200 styles of a color, then I up the fabric quantity to 900 yards.

ACTIVITY 4.8 *Critical Thinking*

Suppose you must create a minimum plan based on raw materials quantity.

- Create a style number.
- You placed a fabric order that has a minimum quantity of 1,000 yards in 3 colors. If the fabric yield (i.e., yardage) of a shirt is 2 yards, how many shirts will you create in each color?

Development of the Seasonal Plan

The merchandiser starts with a global number, called **seasonal volume,** to calculate how many styles to create and manufacture. The merchandiser does not know what garments look like at this point; rather, a minimum plan is a numerical estimate. The seasonal volume represents SBU manufacturing styles, which are the number of garments projected for production. Seasonal volume is a dollar goal that the merchandiser is expected to

*Reprinted by permission from Michael Rowley, President, Straight Down Clothing Co., San Luis Obispo, CA; pers. comm., January 10, 2005.

Table 4.6 Seasonal Volume Predictions Using Hypothetical Numbers

Seasonal volume estimate			
		Total units to sell	100,000
		Pants total units	87,000
Pants	87%		
1st quarter	22%	Number of units	19,140
2nd quarter	22%	Number of units	19,140
3rd quarter	27%	Number of units	23,490
4th quarter	29%	Number of units	25,230

attain. Merchandisers work with manufacturing representatives to entice them to book an expected quantity. They try to book more than is required by the minimum plan quantities, because they know from experience that some retail customers will cancel orders. The sales representatives estimate the quantity they think will sell. Merchandisers then use company averages to estimate seasonal sales.

For instance, Levi Strauss & Co. stated that its Levi's brand accounts for 70 percent of sales; Dockers, 20 percent; and Signature, 10 percent. Levi Strauss & Co.'s pants classification constitutes approximately 87 percent of total units sold (SEC February 14, 2006). If this company wanted to create a new pants division, it would first determine the closest category (i.e., Levi's, Dockers, or Signature) and multiply by the corresponding percentage. It would then use company quarterly sales averages to calculate the annual minimum plan. For example, Levi Strauss & Co.'s first- through fourth-quarter sales were 23, 23, 25, and 29 percent, respectively (SEC February 13, 2007).

A company uses its quarterly sales to create a minimum plan. A merchandiser types in the total number of SBU units (e.g., 100,000 units) and the percentage allocated for its products (e.g., in Table 4.6, the Pants category accounts for 87 percent of the SBU sales). The merchandiser then types in the sales percentage for each quarter. The production quantity is calculated by multiplying the quarterly sales percentage by the total number of units for each product. For example, using the numbers in Table 4.6, a merchandiser would multiply 87,000 units by 22 percent (i.e., first-quarter sales percentage). Thus, the merchandiser would plan to sell 19,140 units during the first quarter. The merchandiser would then multiply Pants Total Units by second, third, and fourth quarter anticipated sales percentages.

From the manufacturing style total, a merchandiser calculates selling styles. **Selling styles** are a numerical estimate of how many individual garments to design and develop. To calculate selling styles, merchandisers use the information from consumer, retail, and competitor market analyses (see Chapter 3). The merchandiser cross-references these external influences with internal company reports. During line-planning meetings, the merchandiser justifies the preliminary line plan numbers to the vice president of product development.

Most apparel manufacturers calculate production in individual units. The merchandiser calculates selling styles by dividing the average production quantity per style (e.g., 1,500) into the total units planned per quarter, or 19,140 ÷ 1,500 = 13, for the first quarter shown in Table 4.7. Merchandisers obtain the production quantity per style and total production numbers from internal planning reports. Thus, the merchandiser using

Table ⁴·⁷ Calculation of Selling Styles

Seasonal volume estimate			Unit	Selling Styles
		Total planned production for SBU	100,000	
		Pants total units	87,000	
		Average production per style	1,500	
Pants	87%			
1st quarter	22%	Number of units	19,140	13
2nd quarter	22%	Number of units	19,140	13
3rd quarter	27%	Number of units	23,490	16
4th quarter	29%	Number of units	25,230	17
Selling styles = Total production quantity ÷ Average production per style				

Table 4.7 would develop 13 selling styles for the first quarter. Later in the process, the design team would assign a SKU number to each of the 13 selling styles. The selling styles would then be categorized into new prototypes and existing prototypes. A **new prototype** is a garment style that the company has not previously sold. An **existing prototype** is an established garment in a product line or one to which minor design changes are made to update the style. The number of new and existing prototypes, expressed as a percentage, depends on information gleaned from developing design and business goals.

Merchandisers are the gatekeepers for managing SKU numbers as well as balancing the resources needed to develop new prototypes or to revise existing prototypes. A merchandiser uses qualitative information to determine the percentage of new versus existing prototypes. For instance, some reasons to decrease the number of new prototypes are loss of market share, new competitors' encroaching on your brand, or a retail buyer's opinion that the product line lacks newness. Reasons to increase the number of existing prototypes include a strong sell through, a retail buyer's demand for existing styles, or a cost-saving measure.

ACTIVITY 4.9 *Calculating New and Existing Prototype*

Merchandisers determine the number of selling styles in a product line. This figure represents the number of prototypes designers can develop for an upcoming season.

- Calculate a minimum plan (Table 4.8):
 Selling styles: Manufacturing units ÷ Average quantity per style
 Total prototypes: Same number as selling styles
- Determine your new and existing prototypes:
 New prototypes = .40 × Total prototypes
 Existing prototypes = .60 × Total prototypes
- Justify the numbers on the basis of your consumer, retail, and competitor market analyses.

Table 4.8 Calculation of New and Existing Prototypes

Minimum Plan	
Classification: Tops	
Manufacturing styles (units)	50,000
Average quantity per style	2,000
Selling styles	
Total prototypes	
New prototypes (40%)	
Existing prototypes (60%)	

The Action Plan

Once merchandisers calculate a preliminary line plan, they write an **action plan.** The purpose of the action plan is to translate business goals into measurable objectives and identify the person responsible for ensuring that the objectives are met (Table 4.9). The primary purpose of measurable objectives is to make company associates accountable for their actions. Merchandisers write down a goal, a measurable objective, and the name of the person responsible for meeting the goal. For example, if merchandisers want to increase market share, they identify the specific competitors that are targets. They then assign an associate to conduct a competitor market analysis. Merchandisers and associates work together to develop a strategy with a competitive advantage over the competitors' strategies.

SUMMARY

This chapter addresses how apparel associates organize and plan product development. A company team first creates a time-and-action calendar. This calendar communicates specific activity deadlines to associates. Because apparel associates do not work alone, they depend on their suppliers' constraints to set calendar goals. One performance measure in apparel associates' annual performance review is whether they consistently meet their calendar goals. A merchandiser creates an SBU business plan, which is a quantitative analysis of a product line. Chapter 5 covers creative inspirational activities in which designers develop product lines.

Table 4.9 Action Plan

Business goal	Measurable objective	Who
Increase market share.	Analyze DW 4 Women's product line and strategy.	Anne
Increase sales of new prototypes.	Calculate percentage of new prototype sell through.	Lauren

COMPANY PROJECT 3
TIME-AND-ACTION CALENDAR CREATION ▬▬▬▬

1. Look up the fashion week or trade show website for your company's consumer target market from Table 4.3, (e.g., Men's sportswear)
2. Look at the list of members or exhibitors.
3. Decide which fashion week or trade show is in concert with the product line you will create. To determine this, link to the member/exhibitor name from the webpage or search the exhibitor names on the Internet by typing the name inside quotation marks. For example, in the Milano Moda Uomo show "Brioni" was an associate (i.e., exhibitor). A name search linked its website as < www.brioni.com > Brioni states they are a producer of high-quality Italian suits. If you are developing high-quality men's clothing, then the Milano Moda Uomo show would be appropriate, whereas street fashion is not but would instead be appropriate at the MAGIC trade show.
4. In the time-and-action calendar (Table 4.10), row two, type the name and date of your trade show (e.g., September 4).
5. In row 4, move your cursor to week 22 (column W) Type your season release date. This date is *five workdays* before your fashion week or tradeshow date (e.g., 8/28). Working right to left, place your cursor in column V. Subtract 5 workdays from the season release date (date in column W). Type the date (e.g., 8/21). Each column represents one workweek. Repeat by subtracting 5 working days for each column and type the date until you get to column B.
6. In cell A5 type, *Write/revise vision and mission statement.*
7. Put your cursor in cell B5. Use the fill tool (paint bucket icon) to fill the cell with one color. This color represents your season you will be developing (e.g., spring). In the key to seasons at bottom of the page, fill the cell with the same color for the appropriate season.
8. In cell A6 type, *Write core strategy.*
9. In cell A7 type, *Conduct primary and secondary data collection.*
10. In cell A8 type, *Calculate minimum plan.*
11. Designate one week for the activities in rows 7-8. These activities take place at the same time and are one week after write/revise mission statement. (Place your cursor in column C6:C8 and fill the cells with color).
12. Your time-and-action calendar should look like Table 4.10

PRODUCT DEVELOPMENT TEAM MEMBERS ▬▬▬▬

The following product development team members were introduced in this chapter:

Vice president of strategic planning: An individual who oversees company and SBU planning, the time-and-action calendar, and future company growth.

KEY TERMS ▬▬▬▬

Action plan: Translation of business goals into measurable objectives and identification of the person responsible for ensuring that the objectives are met.
Bookings: The dollars and units that sales representatives have written on purchase orders at trade shows or have sold directly to territory accounts. A type of sell in.

Table 4.10 One-season Time-and-Action Calendar

TRADE SHOW: COLLECTIVE AT THE NEW YORK PIER SHOWS (SEPTEMBER 4)

Activity / Week	1	2	3	4	5	6	7	8	9	10	11	12	13	14	15	16	17	18	19	20	21	22
Date	4/3	4/10	4/17	4/24	5/1	5/8	5/15	5/22	5/29	6/5	6/12	6/19	6/26	7/3	7/10	7/17	7/24	7/31	8/7	8/14	8/21	8/28
Write/revise mission statement	▓																					
Write core strategy		▓																				
Conduct primary and secondary data collection		▓																				
Calculate minimum plan		▓																				

Key to seasons:

Fall	
Winter	
Spring	
Summer	

Bridge: A ready-to-wear classification of clothing between better and designer, in both cost and style. A bridge product line (e.g., Calvin Klein Classics) usually has a more unique style than better clothing but costs less than designer apparel.

Business history analysis: The use of past volume to project an initial seasonal volume estimate.

Business planning: Creation of quantified product line objectives.

Calendar goal: Delivery of a quantified product on a specific date to meet a deadline that affects other internal departments or suppliers. On-time performance.

Design objectives: Part of planning. Deciding on, developing, and submitting colors, themes, fabrics, and styles, and managing SKUs.

Design review: Part of product design. A series of line meetings in which associates evaluate products purchased during the environmental search, create new prototypes, and redesign existing prototypes to fit within financial and aesthetic design targets.

Drop-dead date: Apparel associates' colloquial term for seasonal release and set time constraints within product development.

Engineering evaluation: Calculation of landed cost comparisons from vendors, and routing.

Existing prototype: An established garment in a product line or one to which minor design changes are made to update the style.

Fashion week: A centralized venue in which designers show their product lines at fashion shows.

Growth category report: A report showing whether an SBU classification is trending up or trending down (Regan 1997, 181).

Guesstimate: A minimum plan estimated from soft information. Used for new SBUs, which do not have a business history.

Key item: A type of report that lists fast-selling garment styles from previous seasons.

Line sheet: An electronic or a paper form that lists the style, fabric, color, sizing, prices, and instructions for a garment.

Marker making: Pattern-piece layout used in cutting garments.

Materials management: One of the six groupings of a generic work flow. Process in which raw materials are ordered and received at contractor or manufacturing facilities. Occurs simultaneously with preproduction activities.

Minimum plan: A quantitative analysis of an SBU product line; a numerical forecast of the growth or decline of an SBU classification, including lot numbers, line size, and units.

New prototype: A garment style that the company has not previously sold.

Overdevelopment: When designers create more SKUs than the budget allows.

Planning: One of the six groupings of a generic work flow. The development of an SBU business plan.

Preproduction: One of the six groupings of a generic work flow. The process beginning with the designers' or merchandisers' disseminating line sheets to product development associates.

Product data management or product life cycle management (PDM/PLM): Real-time electronic product development, production planning, and scheduling. A computer software program designed to facilitate time, to allow collaboration, and to coordinate customer-supplier time constraints.

Product design: One of the six groupings of a generic work flow. Consists of sketching, specification creation, fabric development, raw materials sourcing, and preliminary costing.

Project management: How a manager monitors time and manages employees who work on large projects, such as product development and production, in which products need to be delivered within a specific time frame.

Quality assurance: One of the six groupings of a generic work flow. Designation of quality standards to guide the testing and acceptance of raw materials and finished products. Occurs simultaneously with materials management.

Sample production: Issuing samples—cutting, sewing, and finishing garments.

Seasonal volume: A dollar goal the merchandiser uses to calculate how many SBU styles to create and manufacture.

Season release date: The final deadline to complete seasonal product development. Also called the *on sale date*.

Sell in: The dollar amount of branded products that an apparel manufacturer sells to retail customers.

Selling styles: A numerical estimate of how many individual garments to design and develop.

Sell through: The amount consumers actually purchased at a retail store.

Soft information: A merchandiser's "gut feeling" and information obtained from querying retail buyers and salespeople.

Sourcing and production: One of the six groupings of a generic work flow. Developing a sample package and setting up the complex production process.

Technical design: Creation of specifications, production patterns (i.e., new and existing garments), and special operations (e.g., embroideries, screen prints, hand looms).

Time-and-action calendar: A schedule for an entire year, including multiple seasons. Also known as a *work flow*. However, *calendar* typically refers to a static diagram, created on a computer spreadsheet, whereas *work flow* refers to the use of product data management or product life cycle management (PDM/PLM) software to create a schedule.

Top of production: A colloquial phrase referring to production sample approval.

Trending down: An apparel industry colloquialism meaning the production volume is declining for a specific SBU classification.

Trending up: A colloquial phrase that means the production volume for a specific SBU classification is increasing.

FORMULAS

These formulas are to be used with the Excel templates in the tables in this chapter:

Classification growth or decline (see Table 4.5)

1. Type in the total product quantity for a classification.
2. Type in the percentage allocat for each classification.
3. Type in the percentage increase or decrease desired.

Minimum plan guesstimate
(see text)

$$(\text{No. of sizes}) \times (\text{No. of colors}) \times (\text{No. of garment styles}) \times (\text{No. of expected accounts}) = \text{Minimum plan}$$

Minimum plan created from a fabric order
(see text)

$$(\text{fabric quantity} \div \text{Fabric yield for a style}) \div (\text{No. of colors}) = \text{Minimum plan}$$

Seasonal volume plan estimate
(see Table 4.6)

1. Total production quantity \times Classification percentage = Total units for classification
2. Projected quarterly sales percentage \times Total units for classification = No. of units for quarter

Selling style estimate
(see Table 4.7)

Total units planned per quarter \div Average production quantity per style

New and existing prototype estimate
(see Table 4.8)

1. Calculate the selling style estimate (Total units planned per quarter \div Average production quantity per style).
2. Determine the percentage of new prototypes. Multiply the percentage times the selling styles.
3. Determine the percentage of existing prototypes. Multiply the percentage times the selling styles.

WEB LINKS

Company	URL
American Apparel	www.americanapparel.net
Apparel Search	www.apparelsearch.com/Apparel_Search_2.htm
California Apparel News	www.apparelnews.net/TradeShows/index.html
California Market Center	http://californiamarketcenter.com/
Camera Nazionale della Moda Italiana	www.cameramoda.it/eng/
Carolina Herrera	www.carolinaherrera.com/content.htm
Freeborders	www.freeborders.com/industries/PLMSuite.html
Gap Incorporated	http://www.gapinc.com/public/index.shtml
Gerber Technology	www.gerbertechnology.com/gtwww/03Prods/pdm/Pdmfuncs.htm
InfoMat Inc.	www.infomat.com
Jennifer Nicholson	www.jennicholson.com
Levi Strauss & Company	http://www.levistrauss.com/
MAGIC	http://show.magiconline.com/magic/v42/index.cvn
Men's Apparel Guild in California (MAGIC)	http://show.magiconline.com/magic/v42/index.cvn#
VF Corporation	http://www.vfc.com/

REFERENCES

ApparelNews.net. 2007. *Tradeshow calendar 2007*. http://www.apparelnews.net/TradeShows/index.html.

ApparelSearch.com. n.d. Trade fairs and runway shows. http://www.apparelsearch.com/Apparel_Search_2.htm (accessed April 13, 2007).

Camera Nazionale della Moda Italiana. n.d. Members. http://www.cameramoda.it/eng/soci/perprotag.php.

Davis, M. 2003. *Fashion 101: An introduction to the world of fashion: From the point of view of a fashion editor*. http://www.fashionwindows.com/fashion_review/nyfw/F04.asp.

Freeborders. n.d. Product lifecycle management: FB Workflow: Increase visibility and manage key milestones throughout the product lifecycle. http://www.freeborders.com/industries/Workflow.html.

Freeborders. 2006, September. Freeborders Product Lifecycle Management (PLM) solutions. http://www.freeborders.com/i/pdf/fb_plm_brochure_Sept06.pdf.

Friedman, T. 2005. *The world is flat*. New York: Farrar, Straus and Giroux.

Gerber Technology. n.d. Technology solutions for apparel & retail. http://www.gerbertechnology.com/default.asp?contentID=55.

Ghemawat, P., and J. L. Nueno. 2003. *ZARA: Fast fashion* (Harvard Business School Case 703–497). Boston: Harvard Business School Publishing.

Glock, R. E., and G. I. Kunz. 2005. *Apparel manufacturing: Sewn product analysis*. 4th ed. Upper Saddle River, NJ: Prentice Hall.

InfoMat. n.d. Calendar. http://www.infomat.com/calendar/index.html (accessed April 30, 2007).

Kunz, G. I. 1998. *Merchandising: Theory, principles, and practice*. New York: Fairchild.

Regan, C. L. 1997. A concurrent engineering framework for apparel manufacture. PhD diss., Virginia Polytechnic Institute and State Univ.

Regan, C., D. Kincade, and G. Sheldon. 1998. Applicability of the engineering design process theory in the apparel design process. *Clothing and Textile Research Journal* 16 (1): 36–46.

U.S. Bureau of Labor Statistics, U.S. Department of Labor. 2006–2007. Purchasing managers, buyers, and purchasing agents. In *Occupational outlook handbook, 2006–2007 edition*. Washington, DC: U.S. Bureau of Labor Statistics, U.S. Department of Labor. http://www.bls.gov/oco/ocos023.htm.

U.S. Securities and Exchange Commission. 2006, January 17. *Form 10-K: Annual report for the fiscal year ended October 31, 2005, Quiksilver, Inc.* Washington, DC: U.S. Government Printing Office. http://www.sec.gov/Archives/edgar/data/805305/000095013706000457/a16046e10vk.htm.

U.S. Securities and Exchange Commission. 2006, February 14. *Form 10-K: Annual report for the fiscal year ended November 27, 2005, Levi Strauss & Co.* Washington, DC: U.S. Government Printing Office. http://www.sec.gov/Archives/edgar/data/94845/000095013406002782/f17124e10vk.htm.

U.S. Securities and Exchange Commission. 2006, March 28. *Form 10-K: Annual report for the fiscal year ended January 28, 2006, The Gap, Inc.* Washington, DC: U.S. Government Printing Office. http://www.sec.gov/Archives/edgar/data/39911/000119312506064998/d10k.htm.

U.S. Securities and Exchange Commission. 2006, April 14. *Form 10-K: Annual report for the fiscal year ended January 29, 2006, Phillips–Van Heusen Corporation*. Washington, DC: U.S. Government Printing Office. http://www.sec.gov/Archives/edgar/data/78239/000104746906005175/a2169334z10-k.htm.

U.S. Securities and Exchange Commission. 2007, February 13. *Form 10-K: Annual report for the fiscal year ended November 26, 2006, Levi Strauss & Co.* Washington, DC: U.S. Government Printing Office. http://www.sec.gov/Archives/edgar/data/94845/000095014907000037/f26939e10vk.htm.

U.S. Securities and Exchange Commission. 2007, February 27. *Form 10-K: Annual report for the fiscal year ended December 30, 2006, V. F. Corporation*. Washington, DC: U.S. Government Printing Office. http://www.sec.gov/Archives/edgar/data/103379/000089322007000491/w30596e10vk.htm.

Wood, D., and M. Pascarella. 2004. *Essentials: Microsoft Project 2003*. Upper Saddle River, NJ: Prentice Hall.

Setting the Stage: Design Thinking and Design Process

OPPOSITE SIDES OF THE COIN: NUMBERS AND CREATIVITY

Tamee slams her pen onto the desk and watches as it ricochets against the wall, onto the windowsill, and down to the floor. "Aughh! No more! I can't take it!" she exclaims.

"What's the problem?" Anne asks, rushing into the design workroom. "I heard you all the way down the hall."

"I feel like I've been dumped on! Lauren just handed me a stack of reports. This one shows our best selling regions. This one gives a rundown on which styles sold best last season, and here's one that tells me which price tiers to use for my new designs. Then Jason comes in and tells me there's a problem with our specs on REWT1001. He said the sample measurements are too small. Early this morning, Ron told me that our production on REWJ1001 and REWB2001 are supposed to have matching purple hues, but the shipping clerk told him the jackets and pants are different intensities. Plus, I have an urgent fax from Michael at Color it Greige, who tells me there is a problem with the fabric I ordered. *And* I have to approve these production samples and, and . . ."

"Stop! Take a deep breath," Anne says. "Do you remember your last interview before being hired? We talked about the need to multitask in this fast-paced environment. It sounds like today has been a really good test. My advice would be prioritize your workload. And like I said, don't forget to breathe."

Tamee slumps over her desk; lets out a weak, audible sigh; and says, "Yes, ma'am, I'll try."

Anne taps her chin with her index finger. "On second thought, Tamee, why don't you get out of the office for a while and head over to Marina Towers? You can watch people there as the professionals from all the offices come and go during their breaks. We need a strong design strategy for our next product line. Look for colors, patterns, and styles that inspire you. It can trigger some new design ideas. Don't forget to take your sketchbook. I'll stay and deal with the fax from Michael. When you come back this afternoon, we can talk about what you see and look at the paperwork piling up on your desk. And, don't forget that we have a meeting with Kate at 2:00."

"I'll be back long before the meeting," Tamee replies. Her chunky bracelets clang as she hops up, grabs her sketchbook, and bounds out the door.

Promptly at 2:00 p.m., Kate walks into the conference room and eyes the table filled with stacks of paper. "I see Mr. O'Dale is keeping you busy, Ron," she says.

"Huntington Industries has so many more policies and procedures," Ron notes, shaking his head.

"Oh—but these reports are fantastic!" A voice startles them from the corner of the room; it is Lauren working at her laptop from behind one of the huge stacks of reports. "I didn't know you were in here," Ron says.

"Oh, sorry about that! I've been here most of the morning working on these retail-selling reports. I can see where they will help us analyze geographic sales trends and then if we compare them to our line sheets, we'll be able to see which colors and details sold. I hope we continue with Huntington Industries' business management service," she says.

Tamee, full of energy, bursts into the room. "This is so great! I went to Marina Towers, like Anne suggested, and watched some of our 'target consumers.' At noon, everyone was headed outside to lunch. I overheard one woman complaining to a friend. She said, 'I try so hard to look professional for work. My whole image is ruined when my employee badge dangles from this hideous lanyard.' That gave me a great idea—We could create a line of women's clothing with a loop or some classy way to attach an employee badge! Isn't that great?"

"I like your attitude, Tamee," Kate says. "It reminds me of what Lou Holtz, one of the most successful college football coaches, once said: 'Ability is what you're capable of doing. Motivation determines what you do. Attitude determines how well you do it.'"*

Anne walks into the room and notices a change in Tamee's countenance. She remarks, "You sure look happier than you were this morning."

Tamee shares her new idea with Anne.

"That's an interesting idea, Tamee. It has potential. Well, let's get started. I'm sure we have a lot to do," Anne replies.

Kate nods her head. "You are getting to know me, Anne. Today, I want to talk about the design process. Rather than the notion that creativity is uncontrollable, unpredictable, and chaotic, the design process provides a framework for understanding how designers make decisions and come up with solutions."

Anne responds, "I should know this; I've been designing for 18 years."

"Yes; it will sound familiar to you. I am sure you will appreciate having Ron and Lauren understand the designers' thought processes, though," Kate points out.

Anne laughs, "I *would* like that; when we're designing, Ron just shakes his head at us. Our creativity drives him crazy."

"Well, Ron, let me help you make some sense out of what your designers go through. There are five phases in the design process: goal analysis, problem analysis, search for design solutions, decision making, and verification. The first is goal analysis. So, what are your goals for the Rare Entities product line?" Kate says.

"To make money!" Ron interrupts.

"Nice try, Ron; but making a profit is a measure of whether you are successful, not the goal. Anne?"

"I think our goal should be to figure out what we are doing." Tamee arched her eyebrow. "That would be a challenge given how many things I'm asked to do at one time!"

"I appreciate your enthusiasm, Tamee. Anne, what do you think?" Kate asks.

*Attributed to Lou Holtz as an unsourced quotation at http://en.wikiquote.org/wiki/Success.

"I've always been proud of my design talent and creating unique garment details that other brands do not have. I'm pondering Tamee's idea of the employee badge loop. One goal of the Rare Entities product line could be to develop designs that meet functional requirements of young professional women. Her idea ties back into our mission statement, which is to develop professional apparel with a unique twist."

"Excellent! The next design phase is problem analysis. This is where the design team delegates tasks. As you are aware, designing garments takes tremendous coordination."

"So . . ." Ron says. "To do this, I simply look at our employees' job descriptions. For instance, Anne and Lauren are responsible for developing the minimum plan."

"Yes, that's right; a merchandiser has the important role of analyzing sell-in, sell-through, and key items," Kate replies.

"The sales trends are really interesting, Kate," Lauren chips in. "In our jacket classification, we sell the most in the Midwest; our blouses are big sellers in that region, too. But, we actually sell most of our skirts and pants in the upper Northeast, especially around New York City. I wonder why our sales are split like that—tops in the Midwest and bottoms in the Northeast. The sales report also broke it down by garment style, and REJ1001, our collarless jacket, sold really well in the Northeast. The other jackets, well, they bombed—I mean didn't sell well."

"The next phase is searching for design solutions. Tamee, do you want to try this one?" Kate asks.

"Searching, hmm, exploring ideas seems more logical. Like what I did this morning with the badge loop idea?"

"Yes," Kate says. "Design inspiration and watching consumers is one approach. It doesn't have to be a structured activity, though. Designers need to spend time examining objects, images, or places to trigger design thinking, which I will explain in detail to the two of you later this afternoon." Kate gestures toward Anne and Tamee.

"Sounds like a waste of time to me," Ron says with a frown.

"Creativity is the key to having a strong design strategy. Without inspiration, you would be just like everyone else; and low-cost competitors could easily copy your designs. It is crucially important to invest in designing products that make a difference. Let's move on to the next phase, which is decision making, in which you concentrate intently on a design to imagine new product ideas. The final phase of decision making is illumination. I like to think of it as the 'aha' experience," Kate says.

"I'm surely not as artistic and creative as Anne," Tamee says. "She can get inspiration by just looking out the window. When I design, it's like I go into a trance as the ideas come to me. Then I sketch, revise my designs, and decide which one I want to use."

Kate nods at Tamee and says, "Well, then, you've probably had some experience with the last phase, which is verification. The design team will evaluate your sketches, choose one to develop and create a sample from your design."

"That's what we do at our design review," Anne says.

"It sounds like the design process is a puzzle; you simply put the pieces together to create a unified product line." As Ron says this, Kate smiles broadly, recognizing that her students have learned some important lessons.

"Kate, you've put creativity in a whole new light for me. I can't wait to get started," Tamee says enthusiastically.

Kate looks at Tamee and notes that her youthful, flawless, skin radiates a new glow. Kate says with a wink, "That's what I like—enthusiasm—go for it, Tamee!"

Objectives

After reading this chapter, you should be able to do the following:

- Practice design thinking.
- Distinguish among the different design process stages: goal analysis, problem analysis, search for design solutions, decision making, and verification.
- Understand the design team and time as a performance measure.

Becoming a designer* requires experience. A design career track starts with becoming a design assistant. With experience, successful individuals can then be promoted to associate designer, senior designer, and design director positions, respectively. Experience is an important attribute of design; it is an intrinsic knowledge of design thinking and design process. Design thinking and design process are two conceptual frameworks that apparel industry associates refer to as *design experience*. Astute apparel associates recognize that although no set "recipe" works for everyone; all design fields—whether engineering, architecture, or fashion—have a common process. Design thinking and design process come from a broader theory; engineering design (Chen and Doumeingts 2001; Pahl, Badke-Schaub, and Frankenberger 1999). Design thinking and design process occur simultaneously and are difficult to differentiate; nevertheless, for simplicity, each is discussed separately, in this chapter. Apparel design is similar to creating consumer and durable goods products, involving a multitude of aesthetic and technical factors, tight deadlines, and cost targets. These factors require designers to rely on and communicate with many individuals to formulate ideas into a product. In addition, one small design change can have a radical effect on appearance or make the cost of a product prohibitive (Eckert and Stacey 2003a, 2003b).

*The term *designer* is a general term used to designate design responsibilities. Companies designate these responsibilities to senior designers, associate designers, or design assistants. Some apparel companies do not have designers and designate these responsibilities instead to merchandisers, associate merchandisers, or assistant merchandisers.

This chapter starts with a discussion on how a design team works. Then, design thinking—how individuals think during the creative process—is addressed. The following section covers how apparel associates use the design process to create goals, organize team members' tasks, inspire team members, make decisions to create seasonal product lines, and hold members accountable for their actions.

The Design Team

Designers work individually and in a team (Figure 5.1). Each person must have a clear role because he or she creates a partial solution and then comes together with other individuals as a team to develop products (Pahl, Badke-Schaub, and Frankenberger 1999). Designers create conceptual designs. Their actions and decisions become a starting point for other product development individuals, such as technical designers, who develop detailed specifications, and pattern makers, who are responsible for fit and pattern development (Eckert 2001). Although some companies rely on a single design expert, many apparel companies, such as Nike 👕, use a team approach. Nike's design team consists of young-minded people who can relate to the athletic market—the products of which an athlete can be proud to wear and claim ownership (Rikert and Christensen 1984). For instance, Nike Incorporated brings in athletes to wear test products (SEC July 28, 2006). A design team must successfully collaborate and communicate to create successful products (Eckert 2001). In Nike Incorporated's

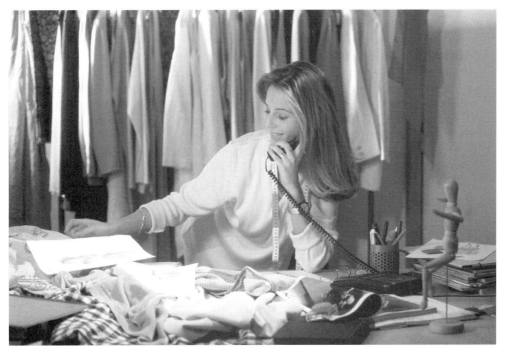

Figure 5.1 A designer working in a design room.

case, specialists in biomechanics, exercise physiology, engineering, and industrial design collaborate to create apparel, footwear, and equipment designs. An external advisory committee, consisting of coaches, orthopedists, and podiatrists, review designs and analyze materials. Nike Incorporated notes that this team approach helps athletes wear a comfortable product while also improving their performance potential and reducing injury (SEC July 28, 2006). Some innovation experts advocate having creative designers whose primary responsibility is to generate ideas and having other associates handle implementation. Their belief is that creative people are innovative but do not understand how an organization must operate to produce a product. Likewise, they believe companies are in the business of making money, so associates must implement ideas to make a profit (Levitt 2002).

Target Stores 👕 implements this philosophy. It hires well-regarded, exclusive-name designers, such as Patrick Robinson, who previously worked for Giorgio Armani and Anne Klein. Target controls most of its design and product development. Designers report to one person, such as the director of marketing planning. For each designer, Target provides numerous resources to assist him or her in developing concepts. For instance, the Target designer has access to a library of fabrics for ready adoption into a product line, can quickly locate fabrics through Target's extensive sourcing network in Asia, and can reduce sample-making process time by using Target's in-house manufacturing network (Agins 2007).

Design Thinking: The Creative Person's Mental Process

Creativity is one of the most misunderstood, unclear concepts in the business environment. Yet, a designer's design thinking is one of the most important business assets because creative, strong ideas are the impetus for developing salable, competitive product lines. Developing a successful, creative product line is crucial to manufacturers. These companies need creative individuals to develop innovative products that are competitive and strategically superior. Creative individuals pioneer new technologies and increase a company's growth (Florida and Goodnight 2005). Nevertheless, executives may criticize the emergence of ideas because they cannot quantitatively measure ideas. These individuals want to see the work in process—the intermediate steps—and predict project completion (Lawson et al. 2003). Executives should think of creativity as the everyday task of putting together nonobvious connections (Inspiring Innovation 2002). Consider this scenario: You spent the day searching the Internet and reading consumer and trade magazines, looking for a multitude of visual images. At the end of the day, the company president walks up to your desk.

> "What are you working on?" she asks.
> "I spent the day getting some great ideas for our next product line," you reply.
> "Great. Show me some of your ideas."
> "I have a few pictures, but most of the ideas are in my head," you respond.
> "Yeah, sure; you were just goofing off," she scoffs as she walks off.

A designer's brain visualizes a multitude of ideas, which he or she uses to create designs (Dahl, Chattopadhyay, and Gorn 2001). Often, designers go through design inspiration and design-thinking processes hundreds of times to create one seasonal product line. A designer's thought

process is different from creating art. **Design** is a process that solves a real-world problem and is the development of a novel product (Cross 1997). Art centers on an individual's self-motivation to express his or her inner thoughts (Lawson 1990). An artist conveys fashion by drawing the human figure to communicate mood, style, and attitude (Stipelman 2005). An individual intertwines design process activities as he or she mentally conducts design thinking. A designer uses **design thinking** to imagine, draw, access long-term memory, and reinterpret products (Purcell and Gero 1998). Designers use visualization skills in which they start anywhere within the process, or take in everything at once; this process is called *design thinking* (Figure 5.2) (Edwards 1999; Taura, Takahiro, and Ikai 2002).

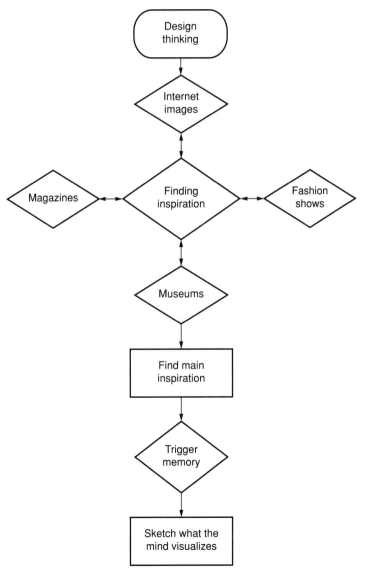

Figure 5.2 Flowchart showing design thinking. *(Illustration by Karen Bathalter.)*

How do designers become inspired? Any object, image, scene, or abstract idea can be a source of inspiration. Designers use inspirational sources to formulate goal analysis, become inspired, and create individual designs (Eckert and Stacey 2003a; 2003b). Imagine yourself as a designer. You sit at your desk and think, "Today, I am going to be creative and design." Then, you sit and stare and nothing comes to mind. You start to panic, thinking, "Uh-oh, designer's block! What shall I do?" An individual cannot turn on creativity such as when he or she conducts routine tasks; rather, design inspiration is unpredictable. Designers have hectic and frequently interrupted daily work routines, so they manipulate their environment to promote inspiration and creativity. With experience, they become acclimated to working under time pressures (Florida and Goodnight 2005). Planned creative time is important because transitioning from an analytical to an intuitive creative state requires a mental shift (Edwards 1999). This *shift* may require designers to take a sketching break, a drive, or a walk somewhere outside the office.

Designers use their senses, especially vision, to achieve design inspiration. Design thinking is how a creative individual's brain manipulates impressions as they view visual media. An individual may not be conscious of creative moments because design thinking is highly intuitive, visual, artistic, responsive to aesthetics and emotions, and nonsystematic. It allows a person to form impressions and create ideas (Goldschmidt 1994). While conducting these activities, designers study an object and go into a deep concentration in which they see profound details.

ACTIVITY 5.1 *Design-thinking practice one*

Designers commonly need visual objects to go into a design-thinking mode. Practice your intuition and creativity by doing the following activity.

- Go to and explore the World Association for Zoos and Aquariums (WAZA) Web site http://www.waza.org/network/?main=zoos. Select a zoo in bold font to go to its Web site. Locate a photograph of an animal.
- Go into a design-thinking mode by studying the animal's image.
- Trace the animal, reptile, or fish using the layer menu in Adobe Illustrator, or print the photo and manually trace it.
- Close your eyes and imagine ways to change your animal drawing. Change your illustration by scaling the image, duplicating it, and/or re-coloring it. Refer to Figure 5.3 for an idea.

When individuals go into a design-thinking mode, they can generate ideas by using imagery (Goldschmidt 1994). These mental processes are ambiguous, artistic, intuitive, and responsive to aesthetics and emotions (Bender 2003; Purcell and Gero 1998). Designers may close their eyes to visualize relationships, and if a person speaks to them, they have difficult thinking in words and responding (Edwards 1999; Verstijnen and Hennessey 1998). When an associate reveals a design problem, he or she may literally talk to him- or herself. Verbal expression allows designers to explore and understand the design problem and to understand relevant conceptual issues or constraints. Talking to themselves or others actually frees designers' working memory so that they can access additional knowledge from their mind (Purcell and Gero 1998). When designers examine visual media, such as a painting (e.g., art), they store ideas

a b

Figure 5.3 Using design thinking to create an idea from an animal: (a) Original photo.
(b) Idea created from photo.*(Photo courtesy of Pearson Asset Library. Illustration by Christina DeNino.)*

in their short-term memory for later reinterpretation and emergence of new ideas
(Purcell and Gero 1999).

ACTIVITY 5.2 *Design-thinking practice two*

When designers go into a design-thinking mode, they use existing art and aesthetic
objects to visualize relationships and create imagery. Practice your visualization skills
by doing the following exercise.

- Click on the New York Metropolitan Museum of Art Permanent Collection at http://
 www.metmuseum.org/Works_of_Art/collection.asp.
- Select one of the permanent collections (e.g., American Paintings and Sculpture).
- Select the Collection Highlights link, and find a painting or sculpture that interests you.
- Quiet your environment and concentrate deeply on the image.
- Close your eyes and visualize relationships.
- Manually sketch the image that comes to mind (not necessarily the image you see).
- Print the visual image and place next to your sketch.
- Write a brief description of what inspired you about the painting or sculpture.

Figure **5.4** Combining multiple images during design thinking: Tamee's combination of a Kashmir goat and a cashmere sweater for Rare Designs' product line.*(Courtesy of Esmeralda Perales.)*

A creative person's brain isolates visual information into small units. The individual then groups the information by symbol, silhouette, form, or visual similarities (Figure 5.4). Designers tear pictures out of magazines and books, search for visual images, and collect textiles and other decorative objects to spark inspiration (Eckert and Stacey 2003b). They synthesize an object, analyze ways to change it, and refine their ideas (Chen and Doumeingts 2001). Designers have strong mental imagery and often tell colleagues their ideas are in their minds. Often, designers mentally create, evaluate, and then discard designs without sketching (Eckert and Stacey 2003b).

Design Process: The Activities

After reading the preceding section, you may think, "I have so many questions! If design inspiration is not sequential, where do designers start, what is the purpose, and how do they conduct each activity?" This section is a discussion of each design process step and its corresponding activities. The **design process*** is the set of activities that a designer conducts (Figure 5.5). Although designers prefer to rely on experience rather than a set procedure, they solve a design problem by understanding requirements and using a series of steps to generate a conceptual solution. The design process comprises distinct problem-solving phases that involve preliminary, refined, and detailed designing (Figure 5.5) (Lawson et al. 2003; Wikipedia 2006). These phases are goal analysis, problem analysis, search for design solutions, decision making, and verification. For each

*Engineering design literature is consistent in the usage of the term *design process*. Authors use inconsistent terms to describe each phase; however, process descriptions are similar.

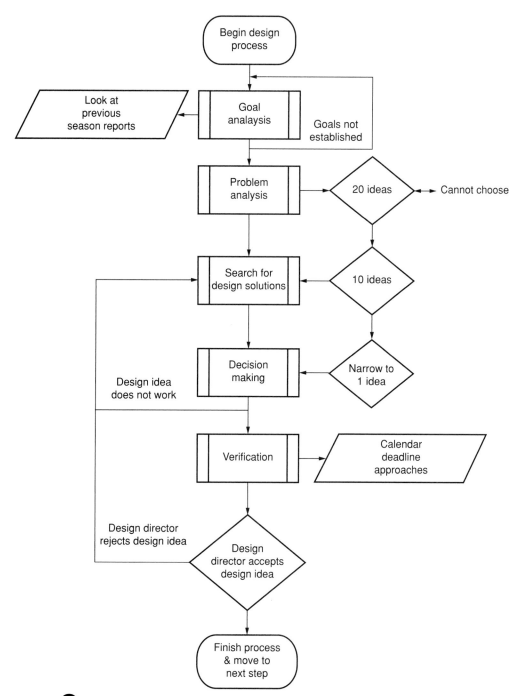

Figure 5.5 Flowchart showing the design process. *(Illustration by Karen Bathalter.)*

design phase, the design team receives inputs and creates a result (Pahl, Badke-Schaub, and Frankenberger 1999).

Making a design decision is complex because it is cyclic; it has multiple feedback loops and no correct or incorrect answer (Goel 1995). Industry associates not involved in design often mistakenly think that design inspiration activities are sequential (Lawson 1990; Lewis and Samuel 1988). Another misunderstanding is that apparel associates engage in each activity once and then move on. Instead, this creative process involves reiterative activities; for example, a designer may explore an idea from items purchased in a foreign or domestic market, refine the idea, become dissatisfied, and go back to idea exploration. Often, such reiterative activities occur when a designer is dissatisfied (Regan, Kincade, and Sheldon 1998). However, rather than going back to the beginning, designers look for a starting point from a previous inspirational source (Eckert and Stacey 2003a; 2003b).

Goal Analysis: Business Analysis Meeting

Although apparel associates would enjoy designing anything they like, reality requires inspiration for a product line to be focused. Thus, the first design process phase is goal analysis. **Goal analysis** is recognition that a problem exists and a desire to solve it (Pahl, Badke-Schaub, and Frankenberger 1999). *Goal analysis* is not a term apparel associates usually use. Rather, companies use activity terms that define goal analysis, such as *business analysis meeting* or *defining the product line* (Regan 1997, 180). As a novice, you might imagine the design team sitting around a conference table as someone says, "Time to get inspired!" An experienced design team would chuckle at this thought, knowing that design inspiration does not happen that way; instead, the first step is to discuss the direction of seasonal product lines (Figure 5.6).

The purpose of goal analysis is to define goals, difficulties, and challenges. One challenge is that design problems are vague (Lewis and Samuel 1988; Pahl and Beitz 1988). For example, a designer will contemplate, "This style is so tired. We have used the same design for four seasons; it needs to be updated." During goal analysis, the design team identifies design tasks and core strategies, such as maintaining a consistent apparel line definition and customer loyalty (Regan, Kincade, and Sheldon 1998). The team follows company constraints such as its mission statement, calendar adherence, the budget, and the SBU direction when forming design requirements (Regan 1997, 180). Some individuals may discuss requirements and store them in their short-term memory, whereas others may write a formal report (Pahl, Badke-Schaub, and Frankenberger 1999). Aaron Ledet*, director of engineering for VF Imagewear, told the author in an interview that for some new product lines the design team responds to a request for proposal. With other product lines, the design director and merchandisers write a business strategy report, which is part of a company's strategic planning process. The process is less formal for existing product lines and consists of meetings or individuals' verbally defining the apparel line for the new season (Regan, 1997, 181).

You may wonder, "Why is creating design goals important?" The answer is profit. Any designer can complete individual design process activities, such as that shown in Figure 5.5,

*Reprinted with permission by Aaron Ledet, director of engineering, VF Imagewear, Nashville, TN; pers. comm., March 2006.

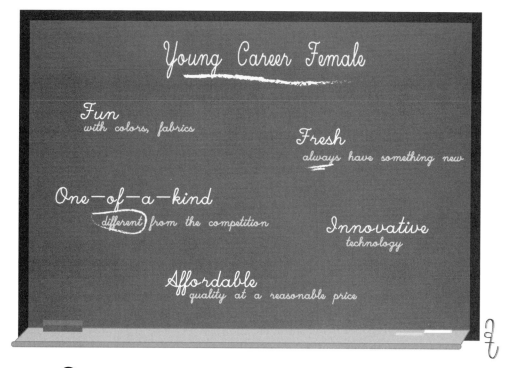

Figure 5.6 Brainstorming ideas of ways to meet target market needs. *(Illustration by Alison Flanagan.)*

but the difficult part is to synthesize the individual activities into a cohesive whole. A design team that successfully meets its design goals equals a profitable product line. Astute company executives are cognizant that an increase in sales does not necessarily equate with profitability. If the design team does not properly formulate a design problem, team members will spend excessive time gathering information, repeating design questions, and continually restructuring design requirements (Pahl, Badke-Schaub, and Frankenberger 1999). Apparel companies constantly stress analyzing goals because in this highly competitive world, new rivals and innovative products will potentially decrease a company's market share. Designers must understand how global business and trends influence fashion (Eckert and Stacey 2003a, 2003b). Quiksilver, Inc. 👕, a lifestyle apparel company defined competitive reality in the apparel industry in its 2006 annual report: "The apparel, sporting goods, and footwear industries are each highly competitive, and if we fail to compete effectively, we could lose our market position" (SEC January 11, 2007). Quiksilver noted three key factors to retain its competitive position: (1) introduce stylish products that are innovative and technologically advanced, (2) maintain brand authenticity, and (3) respond to fast changing market demand (SEC January 11, 2007). Quiksilver's statement is relevant for all apparel manufacturers that want to succeed. In

an interview with the author, one senior merchandiser emphasized the need to have a well-organized plan:*

> If you do not have a clear direction, you end up dropping a huge percentage of the line. You have only so many SKUs and you have to account for unexpected things happening. You may run late and then you do not get to put in the extra 10 percent at the end. It helps to have a clear SKU plan so that you can devote more time to each piece.

Creating a clear design direction is an important attribute of the goal analysis phase. A clear design direction consists of consumer target market identification, product line strategy, an apparel line definition, and line fabrication (Regan 1997). The design team conducts a demographic and psychographic analysis, as described in Chapter 3, to develop a clear target market definition. The apparel line definition consists of a clear distinction of how the SBU product line differs from other business units and how the company will create a competitive design advantage. The design team may also choose fibers, yarns, or fabrication, for example, high-performance fabrics to present a competitive design, or soft and flowing fabrics to promote aesthetic attributes.

Goal analysis is a written description, often included in an SBU business analysis report. You can understand how company associates write goal analysis by reviewing J. Jill's ⬜ business strategy. J. Jill is a private-label retailer. The company has two business units: (1) direct sales, which accounted for $208.1 million in 2006 net sales, and (2) retail stores which accounted for $241 million in 2006 net sales (SEC 2007 April 10) J. Jill's target consumer is a high-income woman age 35 and older. Its target psychographic definition includes active women who express graceful confidence and have strong connections to friends, family, and community. The J. Jill brand merchandising strategy is to offer designs that are feminine, comfortable, trend relevant, sophisticated, and casual. J. Jill uses a design approach that shows products that express individuality and artistic simplicity (4). The Talbots, Inc., ⬜ a former competitor, bought J. Jill in 2006. (SEC 2007 April 10). The Talbots, Inc. has implemented new merchandising leadership for the J. Jill brand. The revised goal is to broaden the appeal of the brand's merchandise. Company directives can provide very specific design direction. For instance, in the future J. Jill's color range will be more neutral, subtle, and wardrobe-building colors. Garment embellishments will shift from heavy to subtle and sophisticated detailing. In addition, the company will develop new prototypes to promote newness and innovation (SEC 2007 April 10).

ACTIVITY **5.3** *Understanding the correlation between strategy and product design*

The products that a design team creates should visually represent its SBU goals. Analyze J. Jill's Web site at http://www.jjill.com to determine whether current products meet the target market and direction outlined in the preceding paragraph.

- Review the garment photographs for three categories within one SBU (e.g., misses pants, sweaters, or jackets).
- For each SBU, identify the unique strategic design position for the target market.
- Explain whether you think J. Jill's current strategic direction is successful.

*Reprinted by permission from Jennifer Barrios, senior merchandiser, Quiksilver, Inc., Huntington Beach, CA; pers. comm., May 9, 2006.

Problem Analysis

Designers are accountable for a clear, well-defined design problem (Goldschmidt 1994) and must communicate their ideas to team members (Stempfle and Badke-Schaub 2002). This accountability is a challenge because the design team works with numerous company associates, suppliers, contractors, and retail buyers within a tight time period to design and develop products. To make a design concept a real product, a designer relies on other associates to complete tasks. **Problem analysis** consists of subdividing a design problem among the design team. Each individual systematically creates ideas, and the design team combines these efforts to create the final product (Pahl, Badke-Schaub, and Frankenberger 1999). The goal of problem analysis is to relate a company's strategic advantage to the product lines being developed. *Problem analysis*, not a common apparel industry term, consists of meetings in which the design team uses the company's mission to conceptualize the product line for an identified target market. Merchandisers provide direction to designers on core strategy, product line strategy, and line fabrication. Design directors provide direction to associates on the product line, core market, consumer purchase trends, and product category offerings (Regan 1997, 181). An important attribute of the problem analysis phase is that product development associates understand a company's core strategy. We use product core strategy that Quiksilver implements to understand the problem analysis phase.

> We are a globally diversified company that designs, produces, and distributes branded apparel, wintersports and golf equipment, footwear, accessories, and related products. Our apparel and footwear brands represent a casual lifestyle for young-minded people that connect with our boardriding culture and heritage, while our wintersport and golf brands symbolize a longstanding commitment to technical expertise and competitive success on the mountains and on the links. We believe that surfing, skateboarding, snowboarding, skiing, golf, and other outdoor sports influence the apparel choices made by consumers as these activities are communicated to a global audience by television, the Internet, movies, and magazines. People are attracted to the venues in which these sports are performed and the values they represent, including individual expression, adventure, and creativity. (SEC 2007, January 11, 6)

A design manager directs designers to use the strategy defined by the company to develop seasonal product lines. This strategy directs designers on how and what to seek during the search-for-design solutions stage. For instance, Quiksilver designers need to synthesize boardriding or wintersports and the individual expression and creativity expressed by its target consumers who participate in related sporting events.

Consistency in design also helps reinforce the authenticity and credibility of a brand. Jennifer Barrios, a senior merchandiser for Quiksilver Edition, explains the strategy used by her company.*

> One way to create consistency is to incorporate a signature color or logo. Quiksilver uses a red box label with the company's mountain wave logo. The Quiksilver Edition

*Reprinted by permission from Jennifer Barrios, senior merchandiser, Quiksilver, Inc., Huntington Beach, CA; pers. comm., May 9, 2006.

line uses an orange box with the original mountain wave logo inside an oval. Within certain seasons, artwork is used throughout the line to pull all the pieces together. For example, you might find the same bit of art screen printed in the inside of a jacket or embroidered on a shirt. Trims are also often color coded to show that particular garments in the line are meant to tell a story together.

ACTIVITY 5.4 *Critical Thinking*

In its product core strategy mentioned earlier, Quiksilver communicates its development of innovative products and its commitment to board sports and golf apparel. The company creates identified brand image, quality, and design attributes through logos.

- Review your company operation, product, or customer core strategy.
- Create a product line strategy that conveys to consumers why they should buy your product and be loyal to your brand. Use Quiksilver's product core strategy to guide how you write your answer.

Merchandisers and designers have specific problem analysis responsibilities. Merchandisers review reports and provide general guidelines to designers (Figure 5.7).

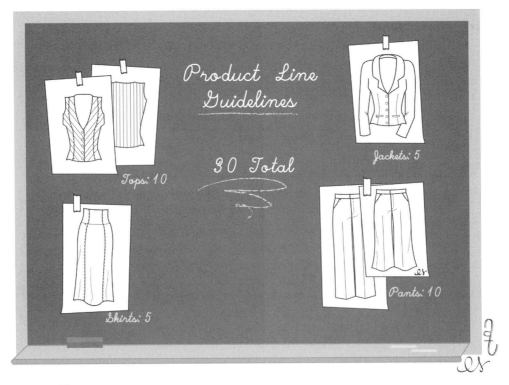

Product Line Guidelines

30 Total

Tops: 10

Jackets: 5

Skirts: 5

Pants: 10

Figure 5.7 Example of guidelines, such as the number of garments in a product line, that all apparel manufacturers need to establish. *(Illustration by Alison Flanagan and Esmeralda Perales.)*

Specific reports include reviewing best-selling styles, prices, fabrics, colors, and silhouettes. Thus, a design team creates apparel products on the basis of historical sales trends, perceived current and future fashion trends, and consumer feedback. The design team then defines the seasonal apparel line and identifies the directional strategy, color preferences, stock-keeping unit (SKU) quantity, and silhouettes (Regan 1997, 183). Price is another important factor. **Price tiers** are different levels of wholesale and retail price points. The merchandisers plan a specific percentage of products to be at a lower and a higher retail price point. One senior merchandiser at Quiksilver provided the author with an example of guidelines given to designers:*

> At Quiksilver, we try not to give our designers too many limitations. However, we do need to work within particular price tiers based on our target customer's price sensitivity. Price tiers are different levels of wholesale and retail price points that our garments are built for. We determine how many styles are built for a certain price point by looking at last year's bookings. We're currently shifting our business up because our customer is now more willing to buy higher priced product as long as the value is built into it. For example, last year, most of our walkshort business was centered on $49.50. In recent seasons, styles in the $50–$60 price range are booking better.

ACTIVITY 5.5 *Critical Thinking*

The senior merchandiser from Quiksilver described price tiers as one constraints in creating a product line. In your product line,

- What will be the retail price of your product?
- How will you create value in the product?

Search for Design Solutions

Design inspiration is creative, and designers will say it is the most rewarding part of their job. Although inspiration does not have a set sequence, in the design process a search for solutions occurs once after the design team has a clear strategic position and has delegated tasks. A **search for design solutions** involves devising creative ideas to meet the design task (Pahl, Badke-Schaub, and Frankenberger 1999). The purpose of searching for design solutions is for designers to use their mind to solve design tasks, such as meeting customer needs that the design team established in the problem analysis phase (Figure 5.8) (Friedman 2003). Because apparel firms are individualists, synonyms for *search for design solutions* include *design, information,* and *market research* (Eckert 1997; Pitimaneeyakul, LaBat, and DeLong 2004; Regan, Kincade, and Sheldon 1998).

Designers use many resources in or near their office and from inspirational travel to search for design solutions. Inspiration occurs from conscious actions, by chance, or from random sources: in an individual's office, in a dream, at home, or while traveling. Designers will investigate several ideas simultaneously, or an object seen may become the starting point for an idea. Designers search a wide variety of objects to create ideas, quickly evaluate

*Reprinted by permission from Jennifer Barrios, Senior Merchandiser, Quiksilver, Inc., Huntington Beach, CA; pers. comm., May 9, 2006.

Figure 5.8 Rare Designs' idea to meet a target market need by integrating an employee badge holder into their career line of products. *(Illustration by Alison Flanagan.)*

them, discard poor solutions, and accept workable ideas (Stempfle and Badke-Schaub 2002). Specific activities include photographing, reading published literature, buying reference items, sketching, and obtaining tear sheets (Regan 1997, 182). A colloquial industry phrase is *being a sponge* because these apparel associates seek inspiration and absorb information from their surroundings.

A designer's memory is especially important during a search for design solutions. Designers use an object as a starting point and memory experiences to create multiple product variations (Pahl, Badke-Schaub, and Frankenberger 1999). Designers sketch to

store ideas in their short-term memory and to communicate ideas to other associates. For an individual's brain to think in design terms, he or she must first classify groups of objects or ideas (Lawson 1990). For example, Anne Cole designs her swimwear around black as the core color. Thus, each season, Anne Cole's search for design solutions centers on how to create newness and use colors that work with black (Merchandiser, Warnaco Swimwear, conversation with author, April 2004).

Inspiration is a high-level stimulation of the mind or emotions that moves the intellect such so that it prompts creative thinking and results in the invention of a product (Dictionary.com n.d.). In this context, the product is the designer's conceptual ideas. For example, conceptual design decisions are a designer's selection of colors, textures, concepts, and themes for a seasonal product line. A creative individual has the ability to be inspired and create linkages from observing and studying ordinary objects (Figure 5.9). He or she will visualize these linkages into new creations (Lawson 1990).

Figure 5.9 A designer absorbed in searching for solutions by looking at various design-inspiration resources. *(Illustration by Christina DeNino.)*

Decision Making

During **decision making,** the design team analyzes solutions in which evaluation is often subjective. Designers will mentally visualize, sketch detailed concepts, analyze design concepts, and select the best one (Pahl, Badke-Schaub, and Frankenberger 1999). Designers sketch to communicate ideas for understanding, decision making, and evaluation (Rodgers, Green, and McGown 1998). They often create concept sketches to communicate ideas and for the design team to evaluate. Apparel designers have vivid imaginations and use this skill to create concrete ideas (Eckert and Stacey 2003a, 2003b). Creative people can visualize, imagine, create new combinations of ideas, transform ordinary data into new creations, and draw pictures of perceptions (Edwards 1999). An apparel designer's ability to visualize garments is a highly desirable skill (Eckert and Stacey 2003a, 2003b; Stacey, Eckert, and McFadzean 1999).

Creative thought occurs when a designer combines, mutates, or makes analogies. This creative process leads to **illumination,** which is the creative leap. Illumination is the result of decision making in which a designer's inspirational search ideas come together. Illumination occurs for designers when they conjure a mental image of a complete, detailed design. Designers refer to illumination as the "ah ha" experience because they arrive at a sudden new perspective. To reach illumination, designers combine or mutate multiple existing designs and mix them to create a new idea or product (Figure 5.10). *Combining* is linking two separate objects to create a new idea—for example, drawing a purse flap design that folds like a window shade. *Mutation* is removing parts of or modifying of an existing design (Cross 1997).

ACTIVITY 5.6 *Combining Image*

- Cut out three or four magazine pictures, or obtain three or four electronic images from the Internet using a graphic program such as Adobe PhotoShop or Illustrator.
- Cut out the magazine pictures or place the electronic images next to one another.
- Cut or crop and combine shapes to create a new image.
- Trace the image. (Use tracing paper or layers in Adobe Illustrator.)
- Create a new illustration (manual or CAD) from your image.

Verification

Managing the highly subjective inspiration process is challenging; however, design becomes unruly and costly to companies that do not have the proper mind set or management. **Verification** is holding the design team accountable for their solutions. The purpose of verification is to determine whether a design solution is viable (Lewis and Samuel 1988). During the verification phase, the design team obtains customer responses, creates the design package, approves it, and releases it to development.

Apparel manufacturers and private-label retailers allow for creativity, but they hold designers also fiscally responsible for their designs. Designers, design managers, merchandisers, and the vice president of product development each have an important role in ensuring that the designs developed meet company constraints. Universal design constraints are the SBU direction, company mission statement, calendar adherence, and the budget (Regan

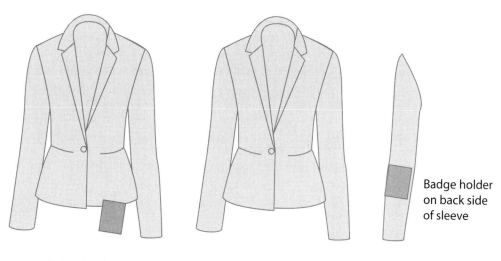

Badge holder
on back side
of sleeve

Badge holder
on hem of
jacket

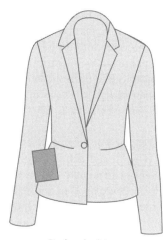

Badge holder
at waist

Figure 5.10 Ideas of different ways to incorporate an employee badge into a garment.

1997, 180). Although inspiration and constraints seem incongruous, designers can be more creative with increased restrictions and less creative when they have free reign (Purcell and Gero 1998). There is a fine balance, however. A company that constrains too tightly will hinder creativity. Experienced designers learn how to be creative within company constraints; in essence, they make do with what they have (Eckert and Stacey 2003a, 2003b).

Designers are primarily responsible for creating designs that meet the SBU direction and company mission. Designers continually verify that they made correct decisions while they

searched for design solutions. For example, as they are looking at art, they may decide whether it fits into their selected theme (Eckert and Stacey 2003a, 2003b). If a designer or other individuals are not satisfied with the results, they go back to previous design process stages.

Design directors ensure that designers meet the company's mission statement when they are developing product lines (Regan 1997, 180). The mission statement is a constraint because designers must create garments that meet the company's consumer needs while maintaining a fashionable context (Eckert and Stacey 2003a, 2003b). Meeting this mission statement constraint means that the SBU has a competitive advantage and it follows the company's strategic plan. Part of the strategic plan is an SBU product line definition and a unique and strategic position for the core target market. Designers must synthesize their target market and core consumer needs by visualizing them wearing proposed designs; otherwise, they may create unusable images (Dahl, Chattopadhyay, and Gorn 2000). Designers evaluate fashion weeks, trade shows, and trend forecast presentations on the basis of both the retail customer and consumer context. A design introduced at a fashion week may be terrific, but too early for the SBU consumer. Conversely, designers view other fashion collections in the context of their consumer. They might make comments such as "That blouse would be too sexy" or "That dress would be too prudish." Designers become frustrated when the design director "reels them in" by deleting ideas and criticizing work. However, if results are incompatible with a company's product line strategy, design managers will stop idea development (Lewis and Samuel 1988; Pahl and Beitz 1988).

Design directors manage the design budget. This constraint means that the design team has spending limits on purchasing inspiration ideas and samples. Apparel companies designate a cost center entitled **design or sample costs** to account for inspirational expenditures. Design inspiration expenses include travel, trade publications, subscriptions to trend resources, and reference garment purchase. According to Steve Pearson, former executive vice president of merchandising and product development at J. Jill, in an interview with the author in February 2004, design directors' fiscal measurement is meeting SBU sales goals and staying within their design cost budget.

Merchandisers critically evaluate designs for their predicted outcome (e.g., projected quantity sold) and the feasibility of alternative design ideas (e.g., design detail or color changes). Merchandisers rely on selling reports, such as sell-in and sell through, explained in Chapter 4. An SBU that does not have clear direction will have weak sell-in and sell-through figures. Merchandisers often concentrate on the top three or four because they accounts account for a significant percentage of sales. Retail buyers evaluate a product line based on whether it matches their retail merchandise strategy.

The vice president of product development evaluates SBU direction by whether it meets retail customer and consumer needs and expectations, and a merchandiser's timeliness of introducing new products. This individual holds designers accountable by using performance measures, such as develop to adopt. A **develop-to-adopt ratio** is the number and type of concept drawings a designer creates versus final styles realized in the product line plan. This measure ensures that designers create ideas that match the company's target market and cost structure. The develop-to-adopt ratio holds designers accountable because if they do not know their consumer, they will buy inappropriate inspirational material or observe the wrong consumers (Figure 5.11), as confirmed by Steve Pearson in an interview with the author in May 2007. A designer must remember that the *ideal* consumer is not always the actual consumer. Kate Laramundy, a former head designer at Patagonia,

Tell me again... How do sweats and swimsuits fit into the Rare Designs young career female?

Figure 5.11 Poor example of reference garments purchased for design inspiration: Such garments need to relate to the product being created. *(Illustration by Alison Flanagan. Adapted from work by Kristina Hilton.)*

provided the author with an example: A designer for an ultimate sports manufacturer may mistakenly think the core consumer is a young, athletic, competitive adult, when it may be the older spectator whose hobby is watching competitive sports. If this company's designer buys reference items that appeal to the younger consumer, the designs may have a low develop-to-adopt ratio because the designs would not appeal to the older consumer.

SUMMARY

Design process steps appear detailed and complex, yet these activities may occur within minutes. The entire design-thinking process goes through a designer's head as he or she takes a fleeting glance at a picture in a book and sketches it (Eckert and Stacey 2003a; 2003b). The quickness of this process is the excitement of design thinking. Once designers understand the design problem, they take further steps to solve it (Lawson 1990). Designers use many resources to search for solutions. Chapter 6 provides resources accessible to designers in their office to search design for inspiration.

COMPANY PROJECT 4: IDEA FILE

Description

Designers tear out pictures from magazines, books, and other print media to spark inspiration. Collect print material or electronic images and organize them for later reference. Do not restrict your design thinking; collect any image that interests you. Designers organize an idea file so that they can easily retrieve the desired pictures.

Manual Idea File

1. Collect 20 tear sheets from print materials (e.g., magazines; wallpaper samples, catalogs) or two-dimensional objects (leaves, flowers).
2. Organize the materials into three general categories and two subcategories (e.g., Entertainment: celebrity gowns, celebrity casual clothes).
3. Neatly cut the picture edges. Do not paste pictures on paper; only include the tear sheet.
4. Label category names on manila folders or an accordion folder. Place materials in folders.
5. Write a table of contents.
6. Write references for the tear sheets and notes about the images.

Electronic Idea File

1. Start by creating an organization system. Create folders inside your computer's My Pictures folder or download electronic images as instructed by a photo management software program. Some photo management programs are Picasa (http://picasa.google.com) or Kodak Easy Share (http://www.kodak.com/global/en/service/ downloads/din_ekn026079.jhtml?pq-path=4509).
2. Start an Internet search engine (e.g., Internet Explorer, Firefox, Mozilla, Safari).

3. Go to an image search site: Alta Vista (http://www.altavista.com/image/default), Google Image Search (http://images.google.com/), Netscape Network—Photography (http://channels.netscape.com/search/default.jsp), or Yahoo Picture Gallery (http://gallery.yahoo.com/).
4. Type key words (e.g., "koala bears").
5. Click on a thumbnail image for a larger picture.
6. On the picture, hold down the right mouse button to save the image to a disk. Save to a designated folder. Be sure to write down reference and copyright information.

KEY TERMS

Decision making: The stage in which a designer mentally thinks about impressions and reinterprets and organizes them.

Design: A process that solves a real-world problem and is the development of a novel product.

Design process: Distinct problem-solving phases that involve preliminary, refined, and detailed designing; goal analysis, problem analysis, search for design solutions, decision making, and verification.

Design or sample costs: A budget item that accounts for inspiration expenses such as travel, trade publications, subscriptions to trend resources, and reference garments.

Design thinking: When designers use their senses, especially vision, to be inspired by objects. The individual goes into a deep concentration to enable his or her brain to manipulate impressions of visual media.

Develop-to-adopt ratio: The number of illustrations or ideas that a designer creates versus the number adopted at line review.

Goal analysis: The stage in which a designer wants to solve a design problem.

Illumination: When a designer makes a mental creative leap. The "ah ha" experience.

Price tiers: Different levels of wholesale and retail price points.

Problem analysis: When design team subdivides a design problem into tasks.

Search for design solutions: The stage in which designers actively engage in design inspiration and use their visualization skills to produce ideas and search for design solutions to create or revise new products.

Verification: The design process stage in which designers determine whether an idea or a sketch is satisfactory or unsatisfactory.

WEB LINKS

Company	URL
Nike, Incorporated	http://www.nike.com/index.jhtml
	http://sites.target.com/site/en/corporate/page.jsp?contentId=PRD03-
J. Jill	www.jjill.com
Quiksilver, Inc.	www.quiksilver.com/index_main.aspx
Talbots	http://www1.talbots.com/talbotsonline/index.aspx?BID=
Target Corporation	http://sites.target.com/site/en/corporate/page.jsp?contentID=PRD03-000482

REFERENCES ▰▰▰▰▰▰

A.B.S. by Allen B. Schwartz, "Allen B. Schwartz, Founder, and Design Director," 2005, http://www.absstyle.com/shop.php (1 February 2005).

Agins, T. 2007. Boss talk (A special report): Goodbye, mainstream: Where do you find the latest fashion trends these days? Everywhere, says David Wolfe. *Wall Street Journal*, January 22, sec. R.7.

Bender, B. 2003. Task design and task analysis for empirical studies into design activities. *Journal of Engineering Design* 14:399–408.

Chen, D., and G. Doumeingts. 2001. Towards a formal understanding of design process: Contribution to the development of a general theory of design. *IEEE*, July, 723–26.

Cross, N. 1997. Descriptive models of creative design: Application to an example. *Design Studies* 18:427–55.

Dahl, D., W. A. Chattopadhyay, and G. J. Gorn. 2000. The importance of visualization in concept design. *Design Studies* 22:5–26.

Dictionary.com. n.d. http://dictionary.reference.com.

Eckert, C., 1997. Design inspiration and design performance, in *Textiles and the information society*. Paper presented at the 78th world conference of the Textile Institute in association with the 5th Textile Symposium, Thessalonike, Greece, 369–387.

Eckert, C. 2001. The communication bottleneck in knitwear design: analysis and computing solutions. *Computer-Supported Cooperative Research* 10 (1): 29–74.

Eckert, C., and M. Stacey. 2003a. Adaptation of sources of inspiration in knitwear design. *Creativity Research Journal* 15:355–59.

Eckert, C., and M. Stacey. 2003b. Sources of inspiration in industrial practice. The case of knitwear design. *Journal of Design Research* 3 (1): 1–18. http://www.inderscience.com/browse/index.php?journalCODE=jdr.

Edwards, B. 1999. *The new Drawing on the right side of the brain: A course in enhancing creativity and artistic confidence*. Revised and expanded ed. Los Angeles: J. P. Tarcher/Putnam.

Florida, R., and J. Goodnight. 2005. Managing for creativity. *Harvard Business Review* 83 (7): 124–31.

Friendman, K. 2003. Theory construction in design research: Criteria, approaches, and methods. *Design Studies* 24 (6): 507–22.

Goel, V. 1995. *Sketches of thought*. Cambridge: MIT Press.

Goldschmidt, G. 1994. On visual design thinking: The Vis kids of architecture. *Design Studies* 15(2): 158–74.

Hanks, K., and L. Belliston. 1977. *Draw! A visual approach to thinking, learning, and communicating*. Los Altos, CA: William Kaufmann.

Inspiring Innovation (2002 August). Inspiring Innovation. *Harvard Business Review Online* Reprint #R0208B. Boston: Harvard Business School Publishing. WilsonWeb.

Keiser, S. J., and M. B. Garner. 2003. *Beyond design: The synergy of apparel product development*. New York: Fairchild.

Lawson, B. 1990. *How designers think*. 2nd ed. London: Butterworth Architecture.

Lawson, B., M. Bassanino, M. Phiri, and J. Worthington. 2003. Intentions, practices and aspirations: Understanding and learning in design. *Design Studies*, 24 (4): 327–39.

Levitt, T. (2002 August). Creativity is not enough. *Harvard Business Review Online*. Reprint #R0208K. Boston: Harvard Business School Publishing. WilsonWeb.

Lewis, W. P., and A. E. Samuel. 1988. *Fundamentals of engineering design*. Upper Saddle River, NJ: Prentice Hall.

Pahl, G., and W. Beitz. 1988. *Engineering design: A systematic approach*. Edited by K. Wallace. Berlin: Springer-Verlag.

Pahl, G., P. Badke-Schaub, and E. Frankenberger. 1999. Resume of 12 years interdisciplinary empirical studies of engineering design in Germany. *Design Studies* 20 (5): 481–94.

Pitimaneeyakul, U., K. L. LaBat, and M. R. DeLong. 2004. Knitwear product development process: A case study. *Clothing and Textiles Research Journal* 22: 113–21.

Purcell, A. T., and J. S. Gero. 1998. Drawings and the design process. *Design Studies* 19 (4): 389–30.

Regan, C. 1997. A concurrent engineering framework for apparel manufacture. PhD diss., Virginia Polytechnic Institute and State Univ.

Regan, C., D. Kincade, and G. Sheldon. 1998. Applicability of the engineering design process theory in the apparel design process. *Clothing and Textile Research Journal* 16 (1): 36–46.

Rikert, D., and C. R. Christensen. 1984. Nike, *Harvard Business Review,* Reprint #9-385-039, 16 October, WilsonWeb.

Rodgers, P. A., G. Green, and A. McGown. 1998. Visible ideas: Information patterns of conceptual sketch activity. *Design Studies* 19 (4): 431–53.

Rodgers, P. A., G. Green and A. McGown. 2000. Using concept sketches to track the design process. *Design Studies* 21 (5): 451–64.

Stacey, M., C. Eckert, and J. McFadzean. 1999. Sketch interpretation in design communication. ICED 99 Communication and cooperation of practice and science: Proceedings of the 12th International Conference on engineering design. Munich, Germany: Technische Universitat Muchen, 923–28.

Stempfle, J., and P. Badke-Schaub. 2002. Thinking in design teams: Analysis of team communication. *Design Studies* 23 (5): 473–95.

Stipelman, S. 2005. *Illustrating fashion: Concept to creation.* 2nd ed. New York: Fairchild.

Taura, T., T. Takahiro, and T. Ikai. 2002. Study of gazing points in design situation: A proposal and practice of an analytical methods based on explanation of design activities. *Design Studies* 23 (2): 165–85.

U.S. Securities and Exchange Commission. 2003, March 28. *Form 10-K: Annual report for the fiscal year ended December 28, 2002, The J. Jill Group, Inc.* Washington, DC: U.S. Government Printing Office. http://www.sec.gov/Archives/edgar/data/910721/000104746903010776/a2106198z10-k.htm.

U.S. Securities and Exchange Commission. 2006, March 16. *Form 10-K: Annual report for the fiscal year ended December 31, 2005, The J. Jill Group, Inc.* Washington, DC: U.S. Government Printing Office. http://www.sec.gov/Archives/edgar/data/910721/000110465906017312/a06-5438_110k.htm.

U.S. Securities and Exchange Commission. 2006, July 28. *Form 10-K: Annual report for the fiscal year ended May 31, 2006, Nike Incorporated.* Washington, DC: U. S. Government Printing Office. http://www.sec.gov/Archives/edgar/data/320187/000119312506156152/d10k.htm.

U.S. Securities and Exchange Commission. 2007, January 11. *Form 10-K: Annual report for the fiscal year ended October 31, 2006, Quiksilver Incorporated.* Washington, DC: U.S. Government Printing Office. http://www.sec.gov/cgi-bin/browse-edgar?type=10-K&dateb=&owner=include& count=40&action=getcomany&CIK=0000805305.

U.S. Securities and Exchange Commission. 2007, April 10. *Form 10-K: Annual report for the fiscal year ended February 3, 2007, The Talbots, Inc.* Washington, DC: U.S. Government Printing Office. http://www.sec.gov/Archives/edgar/data/912263/000095013507002170/b64813tie10vk.tm.

Verstijnen, I. M., and J. M. Hennessey. 1998. Sketching and creative discovery. *Design Studies.* 19: 519–46.

Wikipedia. n.d. Design process. http://en.wikipedia.org/wiki/Design_process.

Searching for Design Solutions: Readily Accessible Inspirational Resources

INSPIRATION AT YOUR FINGERTIPS

The morning sun shines through the wraparound windows of Anne's corner office and makes intricate patterns on the maple floors. A healthy potted palm sits in the corner against the exposed brick wall. Looking at her computer monitor, Anne tugs at her 1940s shell-shaped Bakelite earrings. Even though she is alone in her office, she blurts out, "Wow! Look at all this information! It's great that Kate got us a trial subscription to Online Fashion Services. The information's all organized according to color trends, prints, fabrics, runway shows—you name it, it's here."

"Look at what?" Lauren asks with a puzzled expression. "I heard you talking to yourself in here and wanted to make sure you hadn't fallen off the deep end." Stepping into Anne's office to look at the computer screen, Lauren says, "That looks more colorful than my usual merchandising numbers."

"How much does it cost?" Ron says, entering Anne's office and handing her a cup of coffee. "Remember—we're committed to keeping the budget Huntington Industries set for us!"

"Not even a 'good morning'? Just 'How much does it cost?'!" Anne glances at Ron and frowns, then returns her gaze to the computer screen. "I can't believe we used to try to manually gather all the cuttings and reference items on the latest trends in color, prints, fabrications, and silhouettes. Just think of all the time we've wasted, and we couldn't even begin to gather the information they've prepared here." Anne continues to click on various links, her eyes glazed over in wonder. "Look at this! They have the best-selling colors and styles from both the Première Vision and the Expofil shows. Now we'll have color-forecasting, yarn, fabric, and print trends at our fingertips! Ron, this is well worth the money!" she says. But by then, Ron has headed on to his office.

"I liked helping you organize some of your research," Lauren says hesitantly, thinking that now she won't be able to sneak a peek at the newest shoe trends while she organizes Anne's idea file.

"You can still help me organize trends, Lauren. But this is a better use of our time. Look! They organize the information by market segment. I can focus on women's but also see what's important in juniors' or men's, just in case an important trend is surfacing. I'm going to do as much research as I possibly can before lunch, and later you can help me create an electronic idea file. I took some notes while Kate showed Tamee and me how to do it, but you are so much better at organizing than I am."

"Let me see if I get it," Lauren says.

Anne stands up. "Here, sit down at my computer and try it out."

Lauren takes Anne's place in front of the computer. "Okay, your notes say to use an image search engine to find photographs, and you have a note here about looking for impressionist artists. So, I go to the image search engine, type in 'impressionist' and . . . wow! Look how cool! There are hundreds of paintings here! So you select which tear sheets you want. . . . I'll set up some folders for you, so all your inspirational material will be organized." The ringing phone startles Lauren.

It's Ron. "Lauren, I wasn't sure if you were still with Anne, but I need your help with the calendar."

"Oh, okay, Ron," Lauren says, slowly dragging her eyes away from the computer screen showing an online fashion forecasting service's prediction of spring shoe styles. She gets up and says to herself "At least the ballet slippers I'm wearing today will still be in style for this spring."

Down the hall in her office, adjacent to the design workroom, Tamee is thumbing through a trade publication and spots a design that catches her eye. "I might want to look at this again," she thinks as she tears it from the magazine. She looks at all the stacks on the floor—and her desk covered with CAD illustrations—and debates where to put her new find. Just then, Lauren makes a detour and walks in.

"I don't understand how you can get any work done in this messy room. Look at all the trash on the floor and all the cuttings tacked onto that bulletin board. Even your computer has stuff piled on top of it," Lauren says, as she begins to crumple up the papers on the floor and throw them into the trash can.

Tamee jumps up and grabs Lauren's arm, causing her to stop midway to the trash can. "Wait! Those are my ideas! This isn't messy. All this is giving me inspiration. Besides, I love chaos! I do my best work under chaotic circumstances. And this isn't *total* chaos. I have my own system. It may seem disorganized to you, but I know which stack is which and where to find what I need." She frowns, letting go of Lauren's arm. "No one understands my system, and that's just fine with me. To me, piling is filing. At least no one will ever be able to steal my ideas and designs!"

Kate and Anne, who had been casually talking in the hall on their way to their next meeting, stop and listen to the confusion in Tamee's office. Leaning through the doorway, Kate interjects one of her famous quotes. "You see, Lauren, Thomas Edison once said, 'To invent, you need a good imagination and a pile of junk.'* Designers physically rearrange pictures, then go into a design-thinking mode to visualize mental images. Design thinking comes in many different ways. Travel inspires some designers; some choose to look at trend books, trade publications, and Internet image searches; and still others simply have ideas brewing in their head."

"Oh, I had no idea. I am so sorry," Lauren says. "I thought all this was in the way. I'm so used to organizing everything. That's the only way I can get any work done. I would be happy to help you organize all this. I'll label and color code file folders for you! Before you know it, everything will have a place, and it will all be so easy to find!"

"Thanks for your offer and your enthusiasm, but I prefer things just the way I have them," Tamee says. "This craziness works for me. I like getting my inspiration from the art and pictures around me. It helps me concentrate."

Just then, Tamee catches sight of Jason returning from his latest coffee run. "JASON!" she calls loudly. "I need you to create some CAD illustrations from my ideas."

*Attributed to Thomas Edison at http://en.wikiquote.org/wiki/Invention.

Sipping a steaming hot latte, Jason nonchalantly steps into the room onto one of Tamee's inspiration piles.

"You're stepping on my cashmere goat and French inspiration!" Tamee exclaims. "I did an image search on cashmere earlier, and up pops this picture of a goat—I had forgotten that cashmere comes from goats."

"What do French goats have to do with designing career clothing?" Jason asks, stepping off the pile of papers.

"French is one idea, and cashmere is another. For one of our jackets, Tamee might want to create a curly, untamed, wool fabrication, just like on these goats," Anne says, pointing to the picture and defending her assistant.

"Jason, Tamee's really getting the idea behind design thinking and how one idea triggers another," Kate says, smiling.

"And I'm so relieved! I thought when you said 'design *process*' it had to be an exact sequence. Now I understand that is not what you were saying. I can see some great designs from these pictures!" Tamee says.

"Come on, Lauren," Kate says, trying to drag a reluctant Lauren out of the room. "We need to help Ron with the minimum plan."

"I guess I'd better get back to work," Lauren sighs. "Ron also needs help with the calendar."

"And I'll get to those illustrations for you, Tamee," Jason says as he deposits his empty cup in her trash can and heads through the door into the adjacent design workroom.

Anne stays behind to console her assistant. "We creative people are so misunderstood! Just remember, Tamee—as Dan Zadra said, 'Chances are, the more puzzled looks your idea creates, the better your idea is.'"*

*Quotation in Dan Zadra, *Together We Can: Celebrating the Power of a Team and a Dream* (Lynwood, WA: Compendium, 2001), 41.

Objectives

After reading this chapter, you should be able to do the following:

- Synthesize search-for-design-solutions activities in which designers use Internet services, published literature, and sketching.
- Conduct decision-making activities by gathering and organizing information from visual media, tear sheets, and electronic images.
- Write search and decision activities on the time-and-action calendar and understand how other activities depend on completing them.
- Describe how online fashion forecasting services assist the design team.
- Experience design thinking.
- Understand sketching and its purpose.

Chapter 5 introduced the five phases of the design process. This chapter details one design process phase in which designers engage in a search for design solutions. When designers search through informational resources, ideas inspire them (Taura, Takahiro, and Ikai 2002). Search for design solutions warrants detail because design inspiration is an important component of a company achieving a design strategy in the competitive apparel industry. To do so, designers use a variety of resources to create design concepts for their product lines. Inspiration possibilities are endless; however, the purpose of this chapter is to describe the framework designers typically use to search for design solutions. During this process, they collect reference items that they use for inspiration. To collect these items, designers subscribe to Internet trend services, read published literature, gather visual images, sketch, and visit museums and entertainment and sports events. This chapter includes a description of how apparel designers combine ideas, reinterpret concepts, or make analogies to create new ideas for products. Visualization activities are provided as well.

Designers constantly explore a multitude of resources—during the workday, in the evening, and on weekends. They cannot turn inspiration on or off at will. Therefore, for designers to be able to do their jobs well, executives should set time aside for designers to explore inspirational resources.

Time Designated for Inspiration

Apparel companies designated a set time (e.g., 2 weeks) in the time-and action calendar for designers to shop foreign and domestic markets, buy reference items, photograph, read published literature, and sketch (Regan 1997, 183). Designers at other companies, such as ZARA, travel internationally once or twice annually for the company's primary collections (e.g., spring, fall). Their designers use information throughout the year to create multiple product line releases (Ghemawat and Nueno 2003). Another approach is to physically place designers in apparel clusters, such as New York City, to allow the design team continuous access to trends (SEC March 14, 2005). According to designer Kimberly Quan in an interview with the author in May 2006, if designers are located at corporate headquarters, they often travel to apparel clusters multiple times annually. Other apparel companies rely solely on online fashion forecast services or published literature in lieu of designers travel.

ACTIVITY **6.1** *Creating a Time-and-Action Calendar: Continued*

Using Table 4.10 and referring to Company Project 3 in Chapter 4, add search-for-design solutions activities to your time and action calendar, along with a corresponding timeline for completing these activities.

- In cell A9 type "Search online fashion forecast services".
- In cell A10 type "Read published literature".
- In cell A11 type "Collect visual images".
- In cell A12 type "Sketch".
- In cell A13 type "Review museum, enterainment, and sport resources".
- Designate one week for the activities in rows 9-13. (Recognize that inspiration is ultimately an ongoing process). These activities take place at the same time and start upon completion of calculate minimum plan. (Place your cursor in column D9:D13 and fill the cells with color.) Your calendar should look like Table 6.1.

Table **6.1** Addition of design inspiration activities to time-and-action calendar.

TRADE SHOW: COLLECTIVE AT THE NEW YORK PIER SHOWS (SEPTEMBER 4)

Activity	1	2	3	4	5	6	7	8	9	10	11	12	13	14	15	16	17	18	19	20	21	22
Week / Date	4/3	4/10	4/17	4/24	5/1	5/8	5/15	5/22	5/29	6/5	6/12	6/19	6/26	7/3	7/10	7/17	7/24	7/31	8/7	8/14	8/21	8/28
Write/revise mission statement	■																					
Write core strategy		■																				
Conduct primary and secondary data collection		■																				
Calculate minimum plan		■																				
Search online fashion forecast services			■																			
Read published literature			■																			
Collect visual images			■																			
Sketch			■																			
Review museum, entertainment and sport resources			■																			
Key to seasons:																						
Fall	■																					
Winter	■																					
Spring		■																				
Summer																						

Online Fashion Forecasting

The fashion world is ever changing, so designers must constantly stay aware of fashion trends, events, and news. You might think that one appealing way to do so would be to get out of the office and go shopping at the world's best-known fashion centers, such as Paris and Milan. Although traveling is one resource senior designers sometimes use (see Chapter 7), designers often dedicate time in their office to develop seasonal product lines. So, to stay current, they use trend services to search for design ideas.

Online fashion *forecasting services,* available by subscription, allow designers ready access to global information (Figure 6.1). The purpose of these services is to provide information, trend synthesis, and trend prediction. Online fashion forecasting services either cover a wide scope of market segments or focus on specific categories. For example, Worth Global Style Network (WGSN) 👕 provides information on the men's, women's, juniors', and children's wear; swimwear; intimates; denim; active sports; accessories; interiors; and footwear markets (WGSN n.d.[b]). Likewise, Fashion Snoops 👕 specializes in trends in the infants' and toddlers', girls', boys', junior ladies', denim, and young men's market segments (Fashion Snoops n.d.). In contrast, Fashion Information Ltd. (n.d.) 👕 focuses on only women's wear.

These services keep pace with the fast-changing apparel industry. They provide clients with trade show coverage, store merchandise photographs, market analysis reports, and design tools, as well as apparel news, textile resources, e-commerce, licensing information, and production technology (Fashion Information Ltd. n.d.; WGSN n.d.[b]).

Figure 6.1 A spectrum of design ideas created by Internet trend services.*(Illustration by Christina DeNino. Adapted from work by Nina Pagtakhan and Esmeralda Perales.)*

Trade Show Coverage

In a 2004 interview with the author, Melissa Moylan, head merchandiser at Fashion Snoops, one of the online fashion services, said that such services provide their clients with coverage of international fashion runway shows and apparel and textile trade shows (Fashion Information Ltd. n.d.; Fashion Snoops n.d.; WGSN n.d.[a]). Designers rely on Internet services to inform them about global yarn, textile design, and fabric shows. Trend services present multiple viewpoints and a synthesis of trade show information.

You may think that visiting the Internet site of a trade show and evaluating it yourself would be easier—and less expensive—than using a service; however, it is not. Textile trade show Web sites focus only on show information (e.g., attendance, best-selling products). For example, during the show Première Vision's daily newspaper, *Day by Day*, informs show visitors of the show organization, attendance, general fabric trends, available services, seminars, and best sellers (Première Vision n.d.). In contrast, Internet fashion services provide trade show reviews that cater directly to a client's specific market needs. For instance, Fashion Snoops reports on textile trends relevant to the children's, juniors', and young men's market segments (Figure 6.2). It includes photographs of color predictions, yarns, fabrics, new fabrications, finishes, dye techniques, color mixing, textures, and prints (Fashion Snoops 2004b, 2004c, 2004d).

A subscription to online fashion forecasting services may appear to be expensive (e.g., $2,500–$9,500 annually). However, major fashion trade show coverage, which spans the globe from New York to Tokyo, is only one of the many offerings these services provide designers. It is time and cost prohibitive for designers to attend the multitude of apparel and textile trade shows covered by the online fashion forecasting services. To put this in perspective, the cost for an annual subscription to an online fashion forecasting service is comparable to the travel cost of one international trip with two designers who travel from the United States to two European cities.

Store Merchandise Photographs

Online fashion forecasting services photograph merchandise in a variety of global retail stores. Some important locations are Amsterdam, Berlin, London, Los Angeles, Miami, Milan, New York, Paris, and Tokyo. These photographs augment senior designers' travel and allow them to have frequent access to store merchandise information. Trend services provide detailed information on fabrications, embellishments, and garment styling. By analyzing merchandise in multiple cities, designers can synthesize current garment designs and fabrication trends. For instance, they may see that European merchandise features vintage screen prints or that young men's shirts combine striped, plaid, and solid woven fabrics (Fashion Snoops 2004a).

Market Analysis Reports

Design directors and merchandisers can synthesize market trends faster, easier, and more efficiently when they use online fashion forecasting services. WGSN focuses on strategy and decision-making information that design directors and other executives find useful. Feature articles cover major retail changes, stock market analyses, mergers and acquisitions,

Figure 6.2 A designer's inspiration from an online fashion forecasting service showing a child's purse. *(Illustration by Christina DeNino.)*

international trade, and market research (WGSN n.d.[a]). Fashion Snoops market analysis information focuses on competitor analyses, sell-through reports, and industry segment analysis (Fashion Snoops n.d.).

Design Tools

The purpose of using online fashion forecasting services is to develop insight and to visualize concepts. A designer's design thinking is stimulated by reviewing existing designs. For instance, online fashion forecasting services will photograph couture and designer collections shown in global fashion weeks and retail store merchandise collections located throughout the world. The photographs show the garment colors, silhouettes, and close-up embellishment details. The trend-service artists illustrate the designs from the merchandise collections and provide garment measurement specifications. A client can download the illustrations to a graphic illustration program for further examination, inspiration, or manipulation (Fashion Snoops n.d.).

An outsider may criticize this activity by saying designers simply knock off existing couture or fashion designer collections. Although only a fine line exists between borrowing and knocking off a design, the two can be distinguished. **Borrowing** means to obtain ideas and solutions by adapting existing elements or by using designs for inspiration and creating an entirely new design (Eckert and Stacey 2003a, 2003b). In contrast, as described in Chapter 2, to knock something off means to directly incorporate another individual's creative design (Keiser and Garner 2003).

In April 2006, one design assistant explained to the author how she uses Internet fashion services and noted that designers need to react to retail customers' needs:*

> Our company primarily focused on women's contemporary jackets. Since then, our product line is expanding into coordinate blouses and pants. For design inspiration, we rely on WGSN. We work off their ideas and then focus on the details—for example, the trimming or inside jacket lining. In the past, our core strategy was to have unique embellished jackets with a lot of beading. Our retail customers got tired of beading, so we are switching away from that. Right now, the trend is nice silk prints, so we are doing some print jacket linings that coordinate with blouse fabric. Our consumer does not have to wear the jacket and blouse together, but she could.

ACTIVITY 6.2 *Critical Thinking*

The design assistant quoted in the preceding paragraph explained specific, unique features her company offers that distinguish its products from those of competitors.

- Brainstorm two ideas about how your product line will be unique.
- Write down the names of your top three competitors.
- Describe how your brand ideas differ from those of your competitors.

*Reprinted by permission from Paloma Bautista, former design assistant, True Meaning, Vernon, CA; pers. comm., April 6, 2006.

ACTIVITY 6.3 *Exploring Online Fashion Forecasting Services*

The preceding paragraphs describe information available from online fashion forecasting services. To understand how a designer uses online fashion forecasting services, explore the following:

1. *Worth Global Style Network (WGSN):* www.wgsn-edu.com/edu/ (enrollment for an academic account or trial service is necessary)
2. *Fashion Snoops:* www.fashionsnoops.com/index.html (log in as a visitor)

Second,

- Describe a current fashion trend common to both trend services.
- How can you use this trend in creating your product line?

Published Literature

Designers are avid readers and use a variety of print and electronic resources, including visual media, trend books, magazines, and newspapers. They develop ideas from resources provided by services, suppliers, and visual media (Regan 1997, 183). **Reading published literature** is one way a designer reviews print and electronic publications to trigger visualization and inspiration. Designers need to gain insight into which trends are fashionable for an upcoming season. They accomplish this task by reading forecasting literature and magazines. Designers peruse magazines from a different perspective than that of consumers; they specifically look for themes, colors, styles, and novel features (Figure 6.3) (Eckert and Stacey, 2003b).

Perusing the hundreds of available resources can be fun, but it is also challenging to devote the time needed to review the multitude of publications. For instance, NIKE Inc. designers have access to at least 150 monthly publications on a multitude of topics,

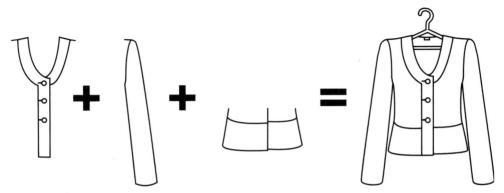

Figure 6.3 New design created by combining images, such as a placket, a sleeve, and a band, from different sources. *(Courtesy of Suzette Lozano.)*

including architecture, sports, and art. In addition, NIKE librarians research requested motifs and art forms.

When designers read literature, they have the ability to remember the numerous images. By absorbing images, they develop their own language, which they use to converse with other design associates (Eckert and Stacey 2000, 2003b).

ACTIVITY 6.4 *Learning Fashion Terms in Multiple Languages*

To learn about the language of fashion around the globe, consult Collezioni Online, which offers an electronic multilanguage dictionary of fashion terms: www. logosdictionary.org/pls/dictionary/new_dictionary.index_p.

1. Type a garment term (e.g., *skirt*).
2. Click on the term by the "English" category.
3. Click on "translation" under the appropriate definition to see this word in multiple languages.

Trade Publications

Designers use trade publications to create mental ideas, sketch, or compile design inspiration files. **Trade publications** are books, newspapers, and magazines that target individuals who work in the industry (i.e., the trade) and specialize in one or more apparel industry segments (e.g., children's) or specific locations (e.g., London). The primary purpose for trend publications is to allow designers to learn about new, exciting trends and to borrow and create ideas for fabrics, silhouettes, trims, and colors.

Designers subscribe to trade publications directly or through agents. **Agents** are individuals who have the right to represent specific trade publications in regional markets (e.g., Carlin International 🗗). Agents sell these publications through trade shows, Internet sites, or direct mail.

Trend Books

A **trend book** is a limited-edition publication that specializes in color forecasting or market segments (e.g., children's, active). Traditionally trend books were solely printed publications; however, may trend books are now available electronically through online subscription from agents. Trend books include illustrations, concepts, photo reports, color projections, and fabric swatches. Designers peruse trend books at trade shows, but because these books are expensive (e.g., $300–$1,600), designers must be selective. Some trend books are photo reports of couture and fashion designer collections, grouped by color, fabrication, or theme. These photographs help designers identify categories, perceive design similarity, and recognize what is fashionable (Eckert and Stacey 2003b). Therefore, agents

often assist designers in selecting the correct trend books for their needs. One agent explained her role to the author in 2003:*

> When I talk to designers, I ask them what they manufacture and what season they are designing for. This way I can direct them to the most useful product. I represent several different color-and trend-forecasting products. These "products" are primarily in book form but may be augmented with CDs. A swimwear designer needs a forecast report that focuses on swimwear only; a lingerie designer, only lingerie; men's wear designers look at young men's and men's forecasting; children's wear designers look at infants', babies', kids', and juniors' reports. Women's wear is altogether different, requiring continuously current (e.g., monthly) information as well as long-range forecasts for misses', juniors', and women's apparel.

Color-forecasting trend books include those by Global Color Research Limited 👕 and International Colour Authority 👕 (Global Color Research Limited n.d.; International Colour Authority n.d.). Trend books offer a wealth of information on specialized markets such as interiors, yarns, graphics, lingerie, and knitwear. Other trend book publishers include Carlin International, Doneger Creative Services 👕, Mode . . . Information 👕, Peclers Paris 👕, Promostyl 👕, and the Tobē Report 👕 (Carlin International n.d.[a], n.d[b]; Promostyl n.d.). Some publishing companies specialize in one market segment. For instance, Mudpie 👕 features children's wear (Figure 6.4) (Mudpie n.d.) 👕.

ACTIVITY 6.5 *Critical Thinking*

The agent who was quoted discussed the importance of focusing on specific needs.

- Look at the following trend forecast services and identify how they assist designers:
 Carlin International: www.carlin-groupe.com/home_uk.html
 Global Color Research Limited: www.global-color.com
 Mode . . . Information: www.modeinfo.com/mi/en/modeinformation_index.jsp
 Mudpie: www.mudpie.co.uk
 Peclers Paris: www.peclersparis.com
 Promostyl: www.promostyl.com/anglais/accueil.php
- Which trade publications can help you develop your specific product line? Why?

Trade Newspapers and Magazines

Designers also read trade newspapers to update themselves on consumer preferences, industry influences, terms, and events. Fairchild Publications, Inc. 👕, publishes an assortment of apparel trade periodicals, such as *Women's Wear Daily (WWD)* 👕 and *Daily News Record (DNR)*. Foreign apparel trade publications include *Sportswear International* 👕, *L'Officiel* 👕, *Collezioni* 👕, and *Drapers* 👕. Business Journals, Inc. 👕, publishes men's and accessories trade magazines. *Le Book* 👕, a huge catalog of graphics from global resources, is available in Paris, London, and New York editions.

*Reprinted by permission from Trudy Adler, agent, Trudy Adler Design Service, Santa Monica, CA; pers. comm., November 7, 2003.

www.onlinefashionservice.com

Kid's trends

Possible screenprint

Figure 6.4 Design inspiration from terms for a specific consumer group, featured by an online trend service.*(Illustration by Christina DeNino.)*

Consumer Publications

Designers read a wide variety of consumer magazines: a sampling of topics includes art, architecture, entertainment, sports, and global fashion. Consumer fashion literature helps designers to understand current fashion trends, become inspired, and predict the correct timing for introducing styles to their target market (Eckert and Stacey 2001). They read foreign and domestic consumer magazines for multiple design inspiration reasons, which include analyzing consumer lifestyles, competitor advertisements, and products featured in retail stores.

Designers take one of two approaches when they read consumer magazines. When they take a **systematic approach,** they have specific goals in mind—for instance, a predetermined theme (e.g., nautical) or color. Designers use a **haphazard approach** when they flip through magazines and tear out pages of anything of interest (Figure 6.5).

A **tear sheet** is a magazine picture, an art book, a catalog, a trend report, a photograph, a sketch, a graphic print, or any two-dimensional object. The purpose of tear sheets is to collect ideas for design elements, garment designs, or anything of interest to create a new seasonal line (WGSN n.d.[a]) or to convey a certain mood and provide a vocabulary for new inspirations (Eckert and Stacey 2003a 3, 2003b).

Large apparel magazine publishers and trade publications that link to consumer publications include *California Apparel News* 👕, Condé Nast 👕, Gruner + Jahr 👕, Hearst Corporation 👕, Lagardère 👕, Made-In-Italy 👕, and Time Inc. 👕. Joseishi 👕 publishes multiple Asian fashion publications. Apparel industry associates also read e-zines, which are online magazines. *California Apparel News* 👕 links to a variety of e-zines.

Figure **6.5** Picture torn from a magazine for idea inspiration. *(Illustration by Christina DeNino.)*

In an interview with the author, one store owner discussed reading fashion publications for buying and merchandising ideas:*

> I am an avid reader of fashion publications. I subscribe to *WWD*, five e-zines, and sites such as couturecandy.com and splendora.com. I am constantly looking at other retail store Web sites. I especially like looking at Chicago retail store Web sites, because their stores are more mainstream and Chicago is closer to my California contemporary customer. I categorize products by colors and shapes from multiple Web sites. During the New York shows, I listen to the Webcasts to see what the designers are showing.

ACTIVITY **6.6** *Critical Thinking*

- Look at five retail Web sites. Determine the target audience, demographics, and psychographics for each site.
- Look at five e-zines or magazines. What message does each ezine or magazine convey about the fashions shown?

Visual Images

Designers absorb information quickly. Visual images are useful for associates as an external memory device so they can recall design details. Designers often look at visual images such as a garment, art object, or item from nature for inspiration (Eckert and Stacey 2003a). Lisa Otoide,* SMA Accessories Production Assistant from Hurley � shared her perspective: "The best inspiration can come from unexpected sources. Things from the past inevitably inspire new fashions; things we may think of as ordinary everyday objects can spark new patterns, designs, or colors. The best inspiration comes from an open mind and the ability to think out of the box."

Designers purposely seek inspiration by looking at visual images. Some resources include art books, trend service publications, consumer magazines, and trade publications (Regan 1997, 182). Designers also gather information or cuttings from suppliers. According to a Quiksilver senior merchandiser, Jennifer Barrios, a **cutting** is a swatch of a design or fabric from a textile studio, a trend service, a textile vendor library, or a color service.*

ACTIVITY **6.7** *Design Thinking*

Designers will quickly look and tear out images from magazines to look for objects that inspire them to create a specific design or expressive mood. Quickly read magazines using both a haphazard and a systematic approach. Look for visual images that inspire you to create a theme for your product line.

*Reprinted by permission from Sydney Blanton, owner, Amelie, Claremont, CA; pers. comm., May 1, 2006.
*Reprinted by permission from Lisa Otoide, SMA Accessories production assistant, Hurley, Costa mesa, CA April 2007.
*Reprinted by permission from Jennifer Barrios, senior merchandiser, Quiksilver, Inc., Huntington Beach, CA: pers. comm., May 9, 2006.

- Use a haphazard approach to look through one consumer magazine. Collect 5 to 6 images.
- Use a systematic approach by selecting a color or a theme in advance and then look for your specific color or theme in one consumer magazine. Collect 5 to 6 images.
- You can use print magazines or links to online magazines from these publishers.
 - Condé Nast: www.condenast.co.uk/
 - Hearst Publications: http://central.hearstmags.com/
 - Gruner+Jahr: www.guj.de/index_en.php4?/en/produkte/zeitschrifit/zeitschriftentitel/vera_i.php4
 - Lagardére: www.lagardere.com/us/sites/index.cfm?id=2
 - Time Incorporated: www.tunewarber.com/corp/businesses/detail/time_inc/index.html
- Cut or tear pictures that are of interest from the magazines. Arrange your magazine pictures in a temporary collage on a table. Go into a design-thinking mode: study the images from your magazine pages closely. Close your eyes, then open them after 20 seconds.
- Write or sketch themes, colors, or novel features that your mind visualized from your collage of pictures. Write or draw 2 to 3 ways that you could use your magazine images in a garment.

Electronic Tear Sheets

You might think that because we live in an electronic world, manually tearing pictures out of magazines would be an antiquated practice. In reality, some individuals prefer having hard copy, other designers create a virtual idea file by using their computer and gathering electronic images, and still other individuals do both. An **electronic tear sheet** is a digital picture. Designers use image search engines to gather electronic tear sheets to identify themes, color projections, and trends and to find design inspiration. These search engines include AltaVista Image Search 👕, Google Image Search 👕, and Yahoo! Gallery 👕. Designers begin this type of search by starting with an idea and typing in a key word (e.g., *tiger*). The image search engine retrieves a thumbnail image library on the computer screen.

The U.S. government and special interest groups have extensive photograph collections that designers can use for inspiration. Some resources include the National Park Service 👕 Geology Image Sources 👕 NASA's Our Earth as Art image database 👕 Library of Congress Prints & Photographs Reading Room 👕, and Smithsonian Images 👕. In addition, the University of California at Berkeley 👕 has thousands or electronic images of animals, plants, and landscapes.

Designers evaluate and select inspirational images on the basis of such criteria as colors and textures. For instance, an animal skin may become inspiration for faux fur collars, fabric prints, or fabric textures. Designers view, evaluate, and save selected images to folders for easy retrieval.

Astute designers who save electronic images abide by copyright laws, which protect published and unpublished artistic work. A designer may use any published or unpublished image for personal use (e.g., inspiration) but cannot reproduce the image in commercial form without paying copyright fees to the originator. Copyrights protect authors of published and unpublished "original . . . literary, dramatic, musical, artistic, and certain other intellectual works" and give these authors the right to authorize other individuals to reproduce, perform, create variations of, or distribute their work for a specified time (U.S. Copyright Office n.d.). If apparel associates want to use an image commercially, the apparel manufacturer's legal department should search the U.S. Copyright Office ⬇ databases to locate permissions information.

Reference Items

Collecting reference items is an activity in which a designer collects objects or cuttings. Collecting reference items has two distinct purposes: inspiration and communication. A designer's inspiration can come from visualizing memories or using his or her imagination. **Memory visualization** means that when a designer looks at an object, it triggers recall of something the designer has experienced, and the designer's brain visualizes a variety of images. One disadvantage of using only memory visualization is that it can confine and stagnate idea creation. In addition to using memory, designers strive to create the unexpected by using their imagination. **Imagination visualization** is novel; in this type of visualization, a designer combines previously seen images to create a new idea (Dahl, Chattopadhyay, and Gorn 2001). For instance, a designer may create a new fabric print by combining two unlike images such as tiger skin and flowers.

Designers also collect reference garments or cuttings to communicate to other apparel associates. Showing an actual image or object to an associate can sometimes better convey an attitude, a design detail, or an idea. Designers have vivid mental images of designs they want to create, so they may sketch an idea or show other individuals a reference item, indicating that they want a particular design detail, such as a stitch pattern. At this stage of the design process, designers communicate ideas even though the design is still in the conceptual stage and numerous changes may be made before the design team accepts it into the product line (Stacey, Eckert, and McFadzean 1999).

Idea File

An **idea file,** or reference library, is the manual or electronic organization of tear sheets (Figure 6.6). Designers categorize tear sheets according to design elements, variations, garment types, colors, graphic ideas, or other memory triggers (Eckert and Stacey 2000). Although highly individualistic, an idea file is most often organized by primary categories and subcategories. One example is to have primary categories such as Lifestyle, Apparel Styles, and Entertainment. Subcategories further delineate; for example, the Lifestyle category may be divided into Bohemian and Romantic. The organization of a virtual idea file, similar to manual organization, starts with the creation of computer file folders (e.g., Lifestyle—Romantic) in which to save the images.

Figure 6.6 Organization of tear sheets into an electronic or a manual idea file.
(Illustration by Christina DeNino. Top right photo by Greg Vaughn/PacificStock.com.)

Once designers create an idea file, they physically rearrange pictures by combining and restructuring the images. In addition to cutting shapes and combining images, designers may sketch or trace elements from the pictures. Doing so enables them to make new discoveries. During this process, designers go into a design-thinking mode to visualize mental images. Reviewing existing objects helps them visualize and promotes design thinking. They refine designs by mentally thinking about impressions, reinterpreting them, and creating new ideas (Pahl and Beitz 1988; Purcell and Gero 1998).

Designers can often imagine new designs in extensive detail. For example, a designer who visited a tropical beach may be inspired by its colors and incorporate the colors into fabric prints or its texture into garment details (Eckert and Stacey 2003a, 2003b).

Sketching

Sketching is a common inspirational activity because it helps designers find a direction and solve design problems. A **sketch** is a quickly drawn, unstructured pictorial representation of design ideas. **Sketching** is the process of thinking and understanding that allows a designer to formulate and visualize verbal expression of thoughts and ideas for later expansion and evaluation (McGown, Green, and Rodgers 1998; Rodgers, Green, and McGown 2000). Sketches are not well-defined concepts and are often doodles, random pencil marks, scribbles,

or partial shapes. These partial or random concepts do not have a specific interpretation but are, rather, a starting point from which forms emerge (Goldschmidt 1994; Purcell and Gero 1998). Sketching allows a designer to try an idea out on paper.

Illustrations differ from sketches (Figure 6.7). Illustrations are formal, carefully rendered drawings that communicate a fashion statement, a product design, product marketing information, or technical construction details (Tate 2004). Illustration

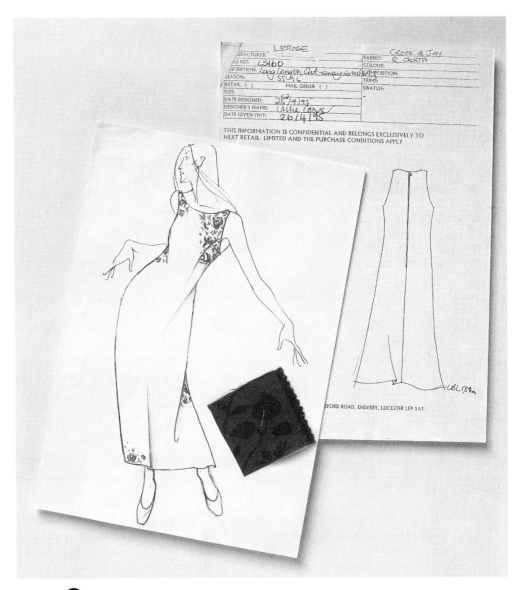

Figure 6.7 (a) A fashion sketch and (b) a technical drawing.

a b

Figure 🔵**6.8** Sweatshirt design: (a) flat illustration and (b) technical drawing. *(Illustration by Alison Flanagan. Adapted from work by Jeff Courson.)*

marketing information, or technical construction details (Tate 2004). Illustration occurs during later product development stages. Examples of illustrations include garment flats, technical illustrations, and fashion art. **Flat illustrations** communicate garment details on storyboards. Designers and merchandisers use storyboards to communicate product designs to internal company associates and to sell designs to retail customers (Tate and Edwards 1987). **Technical illustrations** are drawings of garments, without the figure of a person, that convey construction specifications such as stitching and seam information (Figure 6.8). **Fashion art** is used in advertisements, allowing artists to exaggerate a silhouette and omit details to convey an attitude and create product desirability (Stipelman 2005). If designers consistently render formal designs too early, they may freeze design development by being too rigid and definite (Goel 1995); therefore, sketching is more desirable than illustrating in the early stages of design development.

Process of Sketching

Designers sketch objects in a quick and natural manner without contemplation and often write notes on their drawings to clarify visual ideas (Hagen 2005; Hanks and Belliston 1977). This seemingly simple task has an important role in inspiration: Sketching allows designers to be spontaneous and create numerous ideas, attitudes, garment details, and options (Hagen 2005). Designers sketch to record impressions of an inspirational item into their memory. A sketch can also effectively convey differences among similar products.

When sketching, a designer perceives the details of an object (Figure 6.9). He or she takes in a mental picture, holds the image in memory, then draws the image on paper (Edwards 1999). To perceive objects for inspiration requires training. Designers learn that

Figure 6.9 Stimulation of design thinking by looking at an object such as a fish. *(Illustration by Christina DeNino.)*

they need to block out all distractions and purposely quiet their environment. They will then use a trained eye to perceive a visual object in their mind while concurrently evaluating and changing the object as the hand draws it on paper (Hanks and Belliston 1977). They may sketch an object and immediately jump to sketching a different design, or they may draw subsequent sketches that refine the first idea (Rodgers, Green, and McGown 2000).

Sketching is not a requirement for visualizing design ideas; in fact, many designers draw from or reason about examined objects and store ideas in their short-term memory for later recall. Rather, individuals use sketches as *external memory*, because they are a record of real or imagined images at a particular point in time (Purcell and Gero 1998). Designers allow an imagined image to emerge, and, by capturing its essence, they create a new drawing. Later, they transform their sketches by adding, deleting, modifying, or replacing details (McGown, Green, and Rodgers 1998). Alona Ignacio, an associate

designer and production manager for the Seril division of Streets Ahead, commented on the transformation of ideas:*

> I am constantly using computer graphics programs. For example, I import my flat sketches from [Adobe] Illustrator and then scan in fabric into [Adobe] PhotoShop. Then I can render the fabric into the flat sketches to give it a more realistic image. There is a lot of layering involved when you use Photoshop and that is how I can create different techniques with my illustrations.

An individual can sketch at any point in the design process; however, many designers sketch early to record thoughts and capture imagined ideas (Goldschmidt 1994; Purcell and Gero 1998). Designers often sketch anytime they see an interesting object (Hagen 2005). During design inspiration, they sketch or photograph when they visit art galleries or museums, observe consumers, shop retail stores, and attend trade shows. Creative individuals use an easily accessible sketchbook to record notable images, including thoughts, inspirations, problems, pleasures, discoveries, or observations (Tate 2004).

Purpose of Sketching

The purpose of sketching is to record clues from visual objects, develop emerging designs, and communicate concepts to other people. Design inspiration is creative, and sketching allows designers to understand an object as a whole (e.g., a garment), as well as its parts (e.g., a collar). Sketching has multiple benefits: to create a visual representation of a viewed object, to visually recall an object from memory, to communicate an imagined idea, and to refine ideas. By sketching, designers understand how an object, such as a garment, is put together; what its parts are; and how different components are related (Hanks and Belliston 1977). A sketch is also useful because it allows the designer to make judgments about the function of an object (e.g., how it is sewn) or its consequences (e.g., the cost to construct it) (Laseau 2004; Purcell and Gero 1998; Rodgers, Green, and McGown 2000). When designers draw an entire garment, the purpose is to capture the styling or line of the garment, or the impression or feeling of an object. For example, when artists sketch a jacket, they capture its silhouette, garment details, seam line placement, and texture. A partial sketch can emphasize close-up details such as texture (e.g., herringbone weave), pattern combinations, shading, or intricacy (Barnes 1988; Tate 2004).

Sketching is the epitome of design thinking. Conceptual knowledge is gained and problem solving occurs when designers see, interpret, evaluate, imagine, and reinterpret designed objects (Purcell and Gero 1998). Designers engaged in design thinking do not simply record an idea; rather, they develop emerging ideas through sketching (Goldschmidt 1994). Insight into a designer's mode of thinking can be gained by understanding **emergence.** When an individual engages in design thinking, the person's brain solves or reinterprets, or new perspectives emerge. The individual then physically draws what the brain visualizes (Goldschmidt 1994; Purcell and Gero 1998).

*Reprinted by permission from Alona Ignacio, associate designer/production manager, Streets Ahead, Seril division, Vernon, CA; pers. comm., April 12, 2006.

Sketching provides insight into a designer's problem-solving process because it is tangible and other associates can see what the designer is thinking. Some designers develop concepts in their mind and sketch only when they want to communicate their ideas to other people (Eckert and Stacey 2003a, 2003b). Other company associates often need the visual communication a sketch provides (Regan, Kincade, and Sheldon 1998). A sketch is also beneficial because it shows interrelationships that words alone cannot convey (McGown, Green, and Rodgers 1998).

Museum, Entertainment, and Sports Resources

Any artifact or image can inspire designers. In this section, four inspirational resources are highlighted: museum artifacts, couture and fashion designers, entertainment, and sports. Although these topics do not preclude the many other inspirational resources that are readily available to designers, the discussion of them outlines a process that design students can follow for similar topical research.

In a interview with the author, one designer explained the importance of immersing yourself in a consumer's lifestyle:*

> To obtain a full spectrum of ideas, the best thing to do is to go to recreational places that your target market attends in addition to shops and department stores. For example, for us in the "tween" division, we went to some boutiques such as Limited Too, department stores, and the Gwen Stefani concert. Comparing consumers' fashions at the concert and at Limited Too allowed us to really understand the needs of our customer.

Museum Artifacts

Designers commonly develop themes for a seasonal product line. Many art and historic artifacts inspire designers to develop particular themes. Designers do not limit themselves and often use historic pattern designs from objects such as wallpaper, fine art, embroideries, rugs, and ornamental objects (Eckert 1997). To collect reference items on costumes, many designers travel to museums and art galleries (Figure 6.10). To augment travel, designers use libraries and museum Web sites to create an electronic idea file. Designers interested in U.S. history, memorabilia, and world culture can search The Library of Congress 👕. Those interested in state and city history can refer to Liblinks.org 👕, which links to state libraries, some of which have visual databases.

Designers tie together trend forecasts and artifacts to create a theme (Eckert 1997). They often want to search a multitude of visual images to learn about the art, design, historical significance, and cultural influences of the particular historical period of an artifact. Museums provide an excellent resource for searching visual images. An Internet search of museums and art galleries does not replace a visit; nevertheless, to create their seasonal product lines, designers can collect electronic tear

*Reprinted by permission from Alejandra Parise, freelance designer, Melrose East, Covina, CA; pers. comm., April 30, 2007.

Figure 6.10 Inspiration from a historic garment style, such as cinched sleeves. *(Courtesy of Suzette Lozano.)*

sheets from museum image archives of permanent collections and determine the locales of most interest. The Museums around the World 🔲 Web site is a comprehensive directory of museum resources by country, region, and city. Musée 🔲 is an organization designed to stimulate interest in cultural institutions. It lists international museum exhibitions by product category (e.g., fashion). Art galleries are another reference source. Artnet (n.d.) 🔲 provides a resource for individuals to research fine art paintings.

ACTIVITY 6.8 *Becoming Inspired from Museums*

Explore two museums, each from a different country, at http://icom.museum/vlmp/world.html or www.musee-online.org/home.asp.

- Find one inspirational item from the museums' collections. Study the object.
- Collect electronic tear sheets and organize them by topic.
- Using a graphics program, such as Adobe Illustrator, place multiple images on a page. Group the images to create a single theme.
- Study the images and write down garment ideas you envision from them.

Couture and Fashion Designers

Designers study couture and fashion designers to synthesize garment components, such as necklines, or design principles used, such as proportion (Figure 6.11) (Eckert 1997). They will also study couture and fashion designs from global fashion weeks. Fashion photographs portray a clear mood, context, and image of garments, which assists designers' inspiration (Eckert and Stacey 2003b). Photographers and trend services traditionally sold designers photographs of global fashion shows. However, the popularity of the Internet has made instantaneous electronic images available for designers to study. Resources include Style.com 👕. At this Web site, a designer can use the "power search" function to search its 7-year history of prominent couture designers for specific garment styles. Each season Style.com authors write a review of couture and fashion designers' collections. Some of these reviews include the designer's inspiration. Likewise, a subscription to *FashionWindows* 👕 allows designers access to an extensive library on couture fashion designers. A designer may study fashion weeks and designer collections to synthesize his or her mood, collection context, and perceived image of the target consumer. Images from global fashion weeks are available during events from show sponsors, such as 7th on Sixth Inc. and IMG Fashion 👕. WireImage 👕 has an archive of global fashion weeks. Understanding target consumers is important for design inspiration and creating products that appeal to the group. The Google Trends 👕 search engine is a "digital crystal ball," one resource for learning about consumer interests. It tracks consumers' search patterns and online news articles on a specific topic (Daum 2006).

Figure 6.11 Inspiration from a portion of a garment, such as the button detail. *(Courtesy of Suzette Lozano.)*

ACTIVITY 6.9 *Combining Objects to Create a New Design*

The purpose of this activity is to combine different garment style characteristics from existing designs in order to create a new novel design. Review two fashion shows from Style.com (www.style.com/fashionshows/powersearch) or WireImage (www.wireimage.com/default.asp?).

- Save the electronic images.
- Place the images into a graphics program, such as Adobe Illustrator, and create a new layer.
- Trace one garment silhouette and two garment components or style details, each from a different image.
- Study your illustration and evaluate how you have created a novel design.

Entertainment Sources

Entertainment provides another avenue for design inspiration. Entertainment inspiration can come from fashion gossip, celebrities, motion pictures, and television. Daily Candy ⊤ and Splendora ⊤ feature fashion and celebrity gossip. New markets, such as New Zealand's fashion site ⊤, can break designers from a stagnant mind-set. Designers in select markets, such as children's clothing, closely follow upcoming movies and television shows. These designers read *Variety* magazine ⊤ and follow major studio movie premieres for influential movies and celebrities. Resources include the Motion Picture Association of America ⊤, which links to major movie studios, and the Broadcast Education Organization, which links to television, cable, and studio Web sites ⊤.

ACTIVITY 6.10 *Getting Design-Thinking Inspiration from Celebrities*

Go into a design-thinking mode and become inspired by fashion gossip or celebrities' fashion from Daily Candy (www.dailycandy.com) or Splendora (www.splendora.com).

- Select a fashion influence, icon, or celebrity. Read the information and draw a sketch of what you are visualizing from the information you read. You can either manually sketch or place an electronic image and trace using a graphics illustration program.
- To trace using a graphic illustration program.
 - Save an electronic image to your "My Pictures" folder.
 - Go to the file menu and drag down to place. Select your image from your My Pictures folder. Place the image on layer one. Lock the layer.
 - Add a new layer and title it "Sketching."
 - Trace the garment silhouette using the pen tool.
- Evaluate and refine your sketch. Write what you need to change, and redraw the image so that the idea will fit into your garment line.

ACTIVITY **6.11** *Becoming Inspired from Movies*

Visit the Motion Picture Association of America Web site (www.mpaa.org) or that of the Broadcast Education Organization (www.beaweb.org/mediasites.html).

- Select a movie studio, television network, or cable network. Choose a specific movie trailer or television show.
- Go into a design-thinking mode. Study the movie, celebrity, or set design, and visualize how you can use a garment or an accessory worn.
- Sketch two garment detail, component, or style ideas using a graphic illustration program. See Activity 6.10 on how to trace using a graphic illustration program.

Sports Events

Sports are another source of inspiration for designers. Three primary sports events that have an impact on athletic fashions are the Olympic games, the Tour de France, and the soccer World Cup. High-performance materials and aerodynamic curves that originate from competitive athletic apparel inspire designers when they review technical materials for creating sportswear or athletic apparel (Mod'Amont n.d.[a]). For instance, Europe's grand ski resorts inspired Carolina Herrera for her fall 2004 collection. Her product line used luxury winter fabrics, including cashmere, alpaca, bulky knits, and soft leathers, in warm winter colors (brown, deep blue, wine, and black) (Ozzard 2004). To review some of the latest athletic designs and textiles, designers peruse the Olympics 👕 multimedia Web link. The locale of the Olympics is another strong influential trend factor. For example, the 2010 Winter Olympics are in Vancouver, WA, and the 2012 Summer Olympics are in London, England. These locales will influence apparel color combinations, silhouettes, and fabrications.

Sports celebrities and international events are other design resources. The British Broadcasting Corporation (BBC) 👕 provides world coverage of professional sports. The BBC's photo gallery inspires designers with pictures of popular athletic clothing styles and sports celebrity fashion statements. World-class athletes are influential in the design of selected apparel products, such as boys' clothing. The International Association of Athletics Federations 👕 provides athlete biographies and statistics, which are useful in sports-trend identification.

ACTIVITY **6.12** *Becoming Inspired from Sports*

Visit one sports site from the following Internet resources: the BBC (http://news.bbc.co.uk/sport), the Olympics (www.olympic.org/uk/utilities/multimedia/gallery/indexuk.asp), or the International Association of Athletics Federations (www.iaaf.org/index.html).

- For your product line, sketch or use a graphic illustration program to trace one garment, fabrication, or color-blocking idea from an athlete's uniform.
- Write how you could incorporate this idea into your product line.

SUMMARY ▰▰▰▰▰▰▰▰▰▰▰▰

Designers search for design solutions from a variety of resources. Inspiration comes from everything from Internet trend services, to trade and consumer magazines, to art and museum artifacts. Designers need to stay current on fashion trends, entertainment news, and movies that influence their target market. This chapter provides in-depth resources that are readily accessible to designers. If you explored the Web sites and links as you read this chapter, you probably found that you spent hours searching and finding inspirational images. Chapter 7 discusses traveling outside the office to shop foreign and domestic markets.

COMPANY PROJECT 5: SKETCHING ▰▰▰▰▰▰▰▰

Description

The purpose of Company Project 5 is to practice design thinking and sketching. Designers use a **croquis** (kroh-kee) to illustrate designs. To sketch, you should use a croquis because its scale is standard in the apparel industry.

1. Scan a croquis from a book and save it as a .PDF file. Write down your reference citation information for the croquis image.
2. Open a new graphic drawing (e.g., Adobe Illustrator). Open the .PDF image. Create a new layer and title the layer "Image." Lock the croquis layer.
3. Select five Web sites described in this chapter and save five electronic fashion images. Write the complete reference citation for each and save it on a "References" page.
4. Place one electronic image in the graphics illustration program. Go to the file menu and drag down to place. Select your image amd scale it to the size of the croquis.
5. Add a new layer and title it "Drawing." Lock your electronic image layer.
6. Trace a portion of your electronic image—for instance, a collar, sleeve, belt, or shoe. Be sure to close your shape. Fill your shape with a color.
7. Repeat steps 4–6 with your next electronic image. Create five fashion sketches.

KEY TERMS ▰▰▰▰▰▰▰▰▰▰▰▰

Agents: Individuals who have the right to represent specific trade publications in regional markets.

Borrowing: Obtaining ideas and solutions by adapting existing elements or by using designs for inspiration and creating an entirely new design. Different from knocking off.

Collecting reference items: An activity in which a designer collects objects.

Croquis: A base figure (typically nine heads tall because this is the accepted proportion for fashion illustration) on which a designer draws a design of a garment. Many croquis drawings are usually done before the final garment illustration is completed. *Nine heads* means that if you measure the head on the croquis, nine heads stacked together equals the height of the sketch. Pronounced "kroh-kee."

Cutting: A swatch of a design or fabric from a textile studio, a trend service, a textile vendor library, or a color service.

Electronic tear sheet: A digital picture.

Emergence: A new perspective that occurs during design thinking.

Fashion art: Illustrations in which artists exaggerate a silhouette and omit details to convey an attitude and create product desirability.

Flat illustrations: Storyboards on which garment details are communicated.

Haphazard approach: The approach designers use when they simply tear pages of anything of interest out of magazines.

Idea file: A reference library consisting of manually or electronically organized tear sheets.

Illustrations: Formal, carefully rendered drawings that communicate a fashion statement, a product design, product marketing information, or technical construction details.

Imagination visualization: A type of visualization in which a designer combines previously seen images to create a new idea.

Memory visualization: A type of visualization in which a designer looks at an object, it triggers recall of something the designer has experienced, and the designer's brain visualizes a variety of images.

Online fashion forecasting services: Trend services that provide clients with frequent more online information.

Reading published literature: An activity in which designers read or peruse trade and consumer publications, Internet resources, or other supplier information.

Sketch: A quickly drawn, unstructured pictorial representation of design ideas.

Sketching: The process of creating design ideas that are quickly drawn, unstructured, or random concepts.

Systematic approach: The approach designers use to read magazines when they have specific goals in mind—for instance, a predetermined theme (e.g., nautical) or color.

Tear sheet: A magazine picture, an art book, a catalog, a trend report, a photograph, a sketch, a graphic print, or any two-dimensional object collected for design inspiration.

Technical illustrations: Drawings of garments, without the figure of a person, that convey construction specifications such as stitching and seam information.

Trade publications: Literature and magazines written for an industry associate who specializes in one or more apparel industry segments or specific locations—for example, the children's market or London.

Trend book: A limited-edition publication that specializes in color forecasting, photographs, style forecasting, or market segments.

WEB LINKS

Company	URL
AltaVista Image Search	www.altavista.com/image/default
Artnet	www.artnet.com
British Broadcasting Corporation (BBC)	http://news.bbc.co.uk/sport
Broadcast Education Organization	www.beaweb.org/mediasites.html
Business Journals, Inc.	www.busjour.com
California Apparel News	www.apparelnews.net/Links/pubs.html
	www.apparelnews.net/Links/zines.html
Carlin International	www.carlin-groupe.com/home_uk.html

Collezioni	www.logos.info/home.php
Condé Nast	www.condenast.co.uk
Daily Candy	www.dailycandy.com
Drapers	www.drapersonline.com
Fairchild Publications, Inc.	www.fairchildpub.com
Fashion Information Ltd.	www.fashioninformation.com/index.htm
FashioNZ	www.fashionz.co.nz
Fashion Snoops	www.fashionsnoops.com/index.html
FashionWindows	www.fashionwindows.com/default.asp
Global Color Research Limited	www.global-color.com
Google Image Search	http://images.google.com
Google Trends	www.google.com/trends
Gruner + Jahr	www.guj.de/index_en.php4?/en/produkte/zeitschrift/zeitschriftentitel/vera_i.php4
Hearst Corporation	http://central.hearstmags.com
Hurley	http://www.hurley.com/hurley/index.shtml
IMG Fashion	www.img-fashion.com
InfoMat	www.infomat.com
International Association of Athletics Federations	www.iaaf.org/index.html
International Colour Authority	www.internationalcolourauthority.com
Joseishi	www.joseishi.net/vivi/index.html
L'Officiel	www.jaloufashion.com
Lagardére	www.lagardere.com/us/sites/index.cfm?id=2
Le Book	www.lebook.com/gb/index.htm
Liblinks.org	www.liblinks.org
Library of Congress Prints and Photographs	http://www.loc.gov/rr/print/catalog.html
The Library of Congress	www.loc.gov/index.html
Made-In-Italy	www.made-in-italy.com/fashion/publications/index.htm
Mode . . . Information	www.modeinfo.com/mi/en/modeinformation_index.jsp
Motion Picture Association of America	www.mpaa.org
Mudpie	www.mudpie.co.uk
Museums around the World	http://icom.museum/vlmp/world.html
Musée	www.musee-online.org/home.asp
NASA Our Earth as Art	http://earthasart.gsfc.nasa.gov/image_index.html
National Park Service Geology Image Sources	http://www2.nature.nps.gov/geology/education/images.cfm
New Zealand	www.thread.co.nz
NIKE, Inc.	www.nike.com/nikebiz/nikebiz.jhtml?page=0
Olympics	www.olympic.org/uk/utilities/multimedia/gallery/index_uk.asp
Peclers Paris	www.peclersparis.com
Promostyl	www.promostyl.com/anglais/accueil.php
Smithsonian Images	http://smithsonianimages.si.edu/siphoto/siphoto.portal?_nfpb=true&_pageLabel=home
Splendora	www.splendora.com
Sportswear International	www.sportswearnet.com
Style.com	www.style.com/fashionshows/powersearch
The Doneger Group	http://www.doneger.com/web

Time Inc.	www.timewarner.com/corp/businesses/detail/time_inc/index.html
Tobē Fashion Retail Consultants	http://www.tobereport.com/default.asp
University of California at Berkeley	http://calphotos.berkeley.edu/
U.S. Copyright Office	www.copyright.gov
Variety	www.variety.com/index.asp?layout=front_page
WireImage	www.wireimage.com/default.asp
Women's Wear Daily (WWD)	www.fairchild.pub.com/wwd.cfm
World Association of Zoos and Aquariums (WAZA)	www.waza.org/network/?main=zoos
Worth Global Style Network (WGSN)	www.wgsn.com/public/home/html/base.html
Yahoo! Gallery	http://gallery.yahoo.com
Zoom Look Book	www.zoomlookbook.com/SIA

REFERENCES

Artnet. n.d. Home page. http://www.artnet.com.

Barnes, C. 1988. *The complete guide to fashion illustration.* Cincinnati, OH: North Light Books.

Carlin International. n.d.(a). Home page. http://www. carlin-groupe. com/home_uk.html.

Carlin International. n.d.(b). Trends spotting. http://www.carlin-groupe.com/home_uk.html.

Dahl, D. W., A. Chattopadhyay, and G. J. Gorn. 2001. The importance of visualization in concept design. *Design Studies* 22 (1): 5–26.

Daum, M. 2006. Googling with the best of intentions: Search engines are seeing our inner shopper, but are we selling ourselves short? *Los Angeles Times,* July 8, sec. B.15. http://pqasb.pqarchiver.com/latimes/advancedsearch.html.

Eckert, C. 1997. Design inspiration and design performance. Paper presented at the 78th World Conference of the Textile Institute in association with the 5th Textile Symposium, Thessalonika, Greece.

Eckert, C., and M. Stacey. 2000. Sources of inspiration: A language of design. *Design Studies* 21 (5): 523–38.

Eckert, C. M, and M. K. Stacey. 2001. Designing in the context of fashion—Designing the fashion context. In *Designing in the Context: Proceedings of the 5th Design Thinking Research Symposium,* ed. Peter Llyoyd and Henri Christiaans, 113–29. Delft, Netherlands: Delft University Press. http://design.open.ac.uk/dtrs5/index.html.

Eckert, C., and M. Stacey. 2003a. Adaptation of sources of inspiration in knitwear design. *Creativity Research Journal* 15 (4): 355–84. http://www.cse.dmu.ac.uk/~mstacey/pubs/adaptation-a.s.html.

Eckert, C., and M. Stacey. 2003b. Sources of inspiration in industrial practice. The case of knitwear design. *Journal of Design Research* 3 (1): 1–18. http://www.inderscience.com/search/index.php?action=record&rec_id=9826&prevQuery=&ps=10&m=or.

Edwards, B. 1999. *The new Drawing on the right side of the brain: A course in enhancing creativity and artistic confidence.* Rev. and exp. ed. Los Angeles: Tarcher/Putnam.

Fashion Information Ltd. n.d. Home page. http://www.fashioninformation.com/index.htm.

Fashion Snoops. n.d. Online.trend.services: Available.online.services. http://www.fashionsnoops.com/about_us/online.html.

Fashion Snoops. 2004a. By city. http://www.fashionsnoops.com (accessed March 17, 2004). Membership required.

Fashion Snoops. 2004b. Shows: Mini Snoops boys' fall preview 2005. http://www.fashionsnoops.com (accessed March 17, 2004). Membership required.

Fashion Snoops. 2004c. Tool box: Expofil. http://www. fashionsnoops. com (accessed March 17, 2004). Membership required.

Fashion Snoops. 2004d. Tool box: Première Vision '05. http://www.fashionsnoops.com (accessed March 10, 2004). Membership required.

Ghemawat, P., and Nueno J. L. (2003 April 1) L. Zara: Fast Fashion. *Harvard Business Review*, Article Reprint #9-703-497. Boston: Harvard Business School Publishing. WilsonWeb.

Global Color Research Limited. n.d. Home page. http://www.global-color.com.

Goel, V. 1995. *Sketches of thought*. Cambridge: MIT Press.

Goldschmidt, G. 1994. On visual design thinking: The vis kids of architecture. *Design Studies* 15 (2): 158–74.

Hagen, T. 2005. *Fashion illustration for designers*. Upper Saddle River, NJ: Prentice Hall.

Hanks, K., and L. Belliston. 1977. *Draw! A visual approach to thinking, learning, and communicating*. Los Altos, CA: William Kaufmann.

International Colour Authority. n.d. Home page. http://www.internationalcolourauthority.com.

Keiser, S. J., and M. B. Garner. 2003. *Beyond design: The synergy of apparel product development*. New York: Fairchild.

Laseau, P. 2004. *Graphic thinking for architects and designers*. New York: Wiley.

McGown A., G. Green, and P. A. Rodgers. 1998. Visible ideas: information patterns of conceptual sketch activity. *Design Studies* 19 (4): 431–53.

Mod'Amont. n.d.(a). Fashion guidelines: Technopole. http://www.modamont.com/anglais/parcours/004.htm.

Mod'Amont. n.d.(b). Press files: Mod'Amont's 17th session, February 25–28, 2004, spring/summer collections 2005. News release. http://www.modamont.com/anglais/presse/009.htm.

Mudpie. n.d. Mudpie books. http://www.mudpie.co.uk.

Ozzard, J. 2004. Runway review: Carolina Herrera. *Style.com*, February 9. http://origin.www.style.com/fashionshows/collections/F2004RTW/review/CHERRERA.

Pahl, G., and W. Beitz. 1988. *Engineering design: A systematic approach*, ed. K. Wallace. Berlin: Springer-Verlag.

Première Vision. n.d. *Day by day* (newspaper .PDF files available only for four days at a time). http://www.premierevision.fr/?page=33&lang=en.

Promostyl. 2006. Request for documentation. http://www.promostyl.com/anglais/trendoffice/trendoffice.php.

Purcell, A. T., and J. S. Gero. 1998. Drawings and the design process. *Design Studies* 19 (4:) 389–430.

Regan, C. L. 1997. A concurrent engineering framework for apparel manufacture. PhD diss., Virginia Polytechnic Institute and State Univ.

Regan, C., D. Kincade, and G. Sheldon. 1998. Applicability of the engineering design process theory in the apparel design process. *Clothing and Textile Research Journal* 16 (1): 36–46.

Rodgers, P. A., G. Green, and A. McGown. 2000. Using concept sketches to track the design process. *Design Studies* 21 (5): 451–64.

Stacey, M. K., C. M. Eckert, and J. McFadzean. 1999. Sketch interpretation in design communication. In *Proceedings of the 12th International Conference on Engineering Design (ICED '99)*, ed. U. Lindemann, H. Birkhofer, H. Meerkamm, and S. Vajna, vol. 2, 923–28. Munich, Germany: Technical University of Munich.

Stipelman, S. 2005. *Illustrating fashion: Concept to creation*. 2nd ed. New York: Fairchild.

Tate, S. L. 2004. *Inside fashion design*. 4th ed. Upper Saddle River, NJ: Prentice Hall.

Tate, S. L., and M. S. Edwards. 1987. *The complete book of fashion illustration*. 3rd ed. Upper Saddle River, NJ: Prentice Hall.

Taura, T., T. Takahiro, and T. Ikai. 2002. Study of gazing points in design situation: A proposal and practice of an analytical method based on explanation of design activities. *Design Studies* 23 (2): 165–85.

U.S. Copyright Office. n.d. *Circular 1: Copyright Office basics*. http://www.copyright.gov/circs/circ1.html#cno.

U.S. Securities and Exchange Commission. 2005, March 14. Form 10-K: Annual Report for the fiscal year ended January 1 2005 OshKosh B'Gosh. http://www.sec.gov/Archives/edgar/data/75042/000095013705002975/0000950137-05-002975-index.htm

Worth Global Style Network. n.d.(a). Sitemap: Directory tour. http://www.wgsn.com/public/home/html/base.html.

Worth Global Style Network. n.d.(b). Trend analysis: Sector-specific trends. http://www.wgsn.com/public/home/html/base.html.

Zadra, D. 2001. *Together we can: Celebrating the power of a team and a dream*. Lynwood, WA: Compendium.

Searching for Design Solutions: Inspirational Travel

SHOP AND LOOK UNTIL YOU DROP

"That will be fifty dollars for the extra luggage," the airline ticket agent says to Tamee.

"You're going to be sorry you brought so much luggage," Anne says to Tamee as they go through airport security. "I've found it helps to pack light on business trips."

Once they are settled into the flight, Anne says, "Let's use this time to finish up where we left off in the office. We need to formalize Rare Designs' design process, as Kate suggested."

Anne feels a little nervous, knowing that this season's designs must please her consumers, as well as O'Dale and Huntington Industries. She looks at her journal. "First, our theme needs to be artistic, professional, and unique, which links to our mission statement. We have always looked for design inspiration. Kate calls that 'searching for design solutions.' I have planned this design inspiration trip to include a visit to a variety of museums, as well as the Première Vision trade show. Let's keep our eyes open for the design inspiration we need to guide our next product line."

"Okay, but you left us plenty of time for shopping, didn't you?" Tamee asks worriedly.

"Of course!" Anne replies. "I love to scout the boutiques on Rue Saint-Honoré."

"Ron won't let us come home unless we make decisions," Tamee teases. "What was the last phase of the design process, according to Kate? I forget."

"Verification, which ensures that our seasonal product line matches our strategy, target market, and cost structure. Remember, Ron said he will calculate a design-to-adopt ratio on everything we buy."

Arriving the next morning, a flustered Tamee clambers out of the taxi after a nerve-racking ride. "I would never want to drive here! Our driver cut in and out of traffic, and all those scooters!" The driver scowls at Tamee's three large, heavy suitcases, leaving them outside the quaint hotel on the Left Bank. Tamee is surprised to hear Anne speaking French to the hotel's reception clerk and whispers loudly, "I didn't know you speak French! What did you just say?"

"I've found it helps to know a few foreign language phrases," Anne replies. "I just requested a room with a river view. The Seine should be beautiful this time of year. Let's head to our room, unpack, and take a quick power nap. I'm feeling some jet lag."

That afternoon, they set out to explore the city. Anne knows she and Tamee need to follow Kate's recurring advice: "Stay focused on Rare Designs' target consumer."

"I think we should immediately head to Avenue Montaigne to go trend shopping," Anne says. "They have an impressive array of upscale women's clothing

stores. Let's look at the artists' booths along the River Seine before we go to the boutiques, though."

At the artists' booths, Tamee tries to imagine what the world-famous boutiques will look like. She flips through a stack of old French books at a rare book kiosk. Wishing she could speak French, she spots a book with a faded blue cover. The title is in English! *Famous American Quotes*. "Finally! A book I can read," she thinks. Upon opening the book, Tamee is greeted with the musty smell of days gone by. Thumbing through the pages, she spies a quote by Mark Twain that Kate would love: "Clothes make the man. Naked people have little or no influence on society."* She knows she has to buy it for Kate. "She'll get a kick out of the fact that I found this great American quote book in France," Tamee thinks as she pays the vendor.

Another book catches her attention. It features the work of French artists. "Look at this Renoir, Anne. I remember studying this particular painting in an art history class. I love his use of the dark blue against the vibrant red. Maybe this would work for our inspiration piece," Tamee says, not realizing Anne has gone on to a vintage jewelry booth down the street.

"I thought we were supposed to stay focused on finding our inspiration," she mutters to herself as she spots Anne.

Tamee leaves the Renoir book and joins her boss. "Were you talking me? Sorry, but I couldn't resist checking out these vintage Chanel earrings. If we hurry, we might get that taxi," Anne exclaims, grabbing Tamee by the arm.

Once on the avenue, the ladies spy an inviting boutique and head inside. "Look at the trim on this blouse; isn't it wonderful? I'd love to use something like this for one of our blouses next season," Anne says.

"It's beautiful, but it seems like a waste to buy it. I'll just sketch a picture of the trim." Tamee is lost in thought as she mentally envisions how to use the trim in a variety of designs and is startled by a tap on her shoulder.

"Mademoiselle, excusez-moi, what are you doing? You have a lot of nerve, coming into our store and stealing our designs! La sortie, now!" the store manager, clearly irritated, pushes Tamee toward the exit.

"Oh, wait, I was just using it for reference—to get some ideas—I can buy the blouse. Will you stop pushing?" Tamee's eyes dart around the store, trying to locate Anne, who has wandered down the avenue and is staring intently at a store display in the window of the adjacent boutique.

Tamee quickly exits the store. "You'll never guess what just happened!" she exclaims to Anne. "The shopkeeper yelled at me and kicked me out of her boutique for sketching this trim."

"Oh, I should have warned you about that. It's probably wise to mentally store the images and sketch them once you leave," Anne says, recalling a time when she was scolded in Italy for doing the same thing. "Look at these colors! I love the sage green and purple combination. The sage green reminds me of a favorite green jumper. My mom made it when I was probably 10 years old. I wanted to wear it everywhere; it was so cute and comfortable."

Several hours later, Tamee says, "Anne, my hand aches from sketching, and my feet hurt; can we get something to eat?"

*Mark Twain, quoted in "BrainyQuote: Mark Twain Quotes" (2006). http://www.brainyquote.com/quotes/authors/m/mark_twain.html.

"And I thought you were the consummate shopper!" Anne says. "Isn't it fun to see the emerging trends?" She looks at Tamee, who is rubbing her feet, and realizes that she, too, is exhausted. "All right, let's go to a café and rest while we discuss how we can translate some of your sketches into our product line."

The next morning, they take the Métro to the Porte Maillot-Parc stop and the shuttle to the Première Vision Pluriel textile show. The buzz and hum of the city invigorates the women as they anticipate the activities of the day.

"I haven't been to Première Vision in years; the Paric des Expositions is so large! Look! There's the entrance to Expofil and Mod'Amont, too; they used to be separate shows," Anne says.

Tamee is in awe of the crowds. "There are so many people shopping for fabrics. Première Vision is huge! Look!" Dashing over to a fabric swatch mounted on a wall, she exclaims, "I love this fabric!"

"Before we get lost among the vast array of fabrics, we need to make a plan. Let's go to Draperie/Suiting first for suiting and career fabrics and then go to Expofil to see the yarns this afternoon. I also think it would be beneficial to attend one of the trend-forecasting seminars. We really need to squeeze that in."

"Oh, this reminds me of a huge fabric store except it's just swatches!" Tamee points. "I need to take a photo of that!" she says, grabbing her camera cell phone. "I'm in heaven!"

"No photos, Tamee; trade shows have strict rules."

"I can sketch in here, can't I?"

"Of course you can sketch. But stop pointing! Let's split up and meet back at the entrance to Draperie/Suiting in about an hour," Anne says, remembering the fabulous jewelry cases located near that area.

As they leave Première Vision to go to expofil and look at yarn, Tamee remarks, "Oh, look! They have the 'Bests of the Day.' Plumeria is one of the featured colors. I love any purple color!."

Anne is fingering a soft cashmere-blend yarn and thinks, "I just want to touch everything. This cashmere blend is so soft. There are hundreds of new yarns and textures! I have so many ideas."

Several hours later, they walk along the River Seine. Tamee's eyes dance as she says, "I saw thousands of fabric and yarn samples today. My head is full of design ideas! I need to sketch, so I can free up some brainpower for tomorrow." It suddenly starts to rain, and they dash into the nearest café.

"This café looks good. It's in a perfect location, right in the center of the city. Oh, good, it's a cybercafé. We can e-mail our digital photos to Jason, so he can start creating some CAD illustrations. You know, Tamee, you really need to learn how to sketch with a computer graphic program."

Tamee tries to defend herself, but Anne rambles on. "Let's get a window seat and watch all the people pass by. I absolutely love to see how people combine outfits and colors. I just don't know how they do it. Look at those shoes! Lauren would love them!" Anne says, grabbing Ron's hi-resolution digital camera. "I'll e-mail these digital photos to Lauren back in the office. I'm sure she will enjoy them. Consumers can be so inspiring and Parisians have such a sense of style. I have noticed how professional the women dress. They are always so polished and dressed up. Oh, look at those beautiful earrings!"

The waiter comes over. "Mademoiselle?"

"Montres-moi le menu?" Anne asks the waiter.

"What did you say?" a wide-eyed Tamee asks.

Anne smiles. "I asked him to show us the menu."

Tamee surveys the choices and asks, "What is Poulet au grain roti au Romarin?"

Anne thinks about it a minute and translates, "It's marinated chicken breast with French fries and roasted eggplant. That sounds yummy. Should we both order that?"

Just as lunch is served, the storm passes and the sun pops through the clouds. "I love how fresh the world looks after it rains," Anne says while she concentrates on taking photos of the fashions that pass them by. "I'm so glad Ron trusted me with his fancy camera. You know Ron. He always has the latest, greatest toys. This one is so light and easy to use. I can't believe how many photos I've taken so far and . . . Look over there! I love her style; it's so street couture! That color is wonderful. We should try to incorporate that into our line! And her skirt; that fabric looks so soft and comfortable. I know our consumers would wear that in a heartbeat."

Tamee joins the search and spots a mature gentleman across the street. "Anne, take a picture of that man's sweater. I love the color and the texture. We could develop a texture like that for dressy knit pants. And if we incorporate the trim from the blouse we saw in the other store, we can make a fabulous outfit! . . . That's the third dog I've seen in this restaurant. Can you imagine taking your little Tigger out to a restaurant? Now I see what you mean about the importance of broadening your horizons and exploring different cultures. We've been here just 24 hours and I have a million new design ideas. I've seen things I can't believe. I'm excited, inspired, and energized," Tamee says with a huge grin on her face.

Anne glances at her watch. "Dépêche-toi, Tamee! Eat quickly! We'd better hurry to get to the Musée d'Orsay before it closes."

Anne quickly pays and they walk to the Métro station to ride the train to Assemblée National and walk to the museum. "I want to go to the nineteenth-century art exhibit first. I think we can apply the trend forecast information with inspiration from Impressionist art."

Anne and Tamee walk through the Musée d'Orsay, a historic train station turned into a museum. Taking in all the beautiful Impressionist artwork, Anne suddenly stops. "Look at this Monet painting! Can you believe his use of soft greens and purples?" she whispers as she tugs on Tamee's sleeve to get her to stop and look at the painting. "The water has such a calming feeling; it's absolutely gorgeous. What do you think? Is this the inspiration we've been looking for?"

"It's beautiful," Tamee says. "Not only is the color stunning, but look at the use of texture and the flow. I think this is it. I can see it in our line for next season. This is what Rare Designs needs to get back on track. We're getting our design edge back, and I can't wait to get started on it!" Tamee says, focusing on the painting, studying the technique and how she can incorporate the interesting use of texture into her designs.

"I'm glad you agree. I can visualize so many different sweater and blouse combinations using these glorious colors," Anne says contentedly.

"Let's head back to the hotel so I can get started sketching some print ideas right away! I need to pack, too, so we can head off to Milan tomorrow."

Objectives

After reading this chapter, you should be able to do the following:

- Understand the importance of inspirational travel.
- Explain where designers shop for reference items.
- Describe how designers use visualization skills when they buy reference items.
- Draw sketches to learn how this task assists associates in the design-thinking process.
- Recall different types of European trade shows.
- Recognize the importance of observing consumers.
- Understand how an apparel trend forecaster conducts research and links dissimilar information to predict trends.
- Explain how art galleries and museums can aid inspirational travel.
- Write inspirational activities on the time-and-action calendar and understand their dependence on completing other activities.

Imagine being paid for sitting in a French bistro drinking café au lait and watching passersby. Believe it or not, the design team sometimes does exactly this to become inspired. In fact, shopping foreign and domestic markets is a valid design inspiration activity. Astute apparel companies encourage **inspirational travel,** allow for flexible work time, and reward designers who take the initiative to expose themselves to a variety of inspirational resources (Eckert 1997).

Designers' search for design solutions comes from any source. Interpreting fashion is a craft. This interpretation process, called design thinking, requires designers to immerse themselves into inspirational activities—from the global fashion weeks, to watching consumers on the beach, to quick adoption of fads from music and pop culture (Agins, 2007). Whereas Chapter 6 focuses on resources close to a designer's office, this chapter covers mainly activities that designers participate in during inspirational travel: reviewing retail store trends, sketching, attending trade shows, and observing consumers. In addition, this chapter includes a discussion of how reference resources, such as trend forecast services and art galleries and museums, can be consulted before, during, or after a trip to enhance inspirational travel.

The chapter begins with several sections addressing the importance of international design inspiration trips, the associates who go, the types of observations made, common destinations, and design thinking. Each country has a personality and a cultural essence that designers experience while traveling. This experience includes observing people's habits and attitudes and attending social and cultural events.

No matter where designers observe, they engage in **design thinking** (i.e., they use images to reinterpret or conceive of new products). For each observational activity, design thinking becomes a building-block process in which designers make connections among a variety of objects and products. The following description highlights the design inspiration process (U.S. Securities and Exchange Commission [SEC], April 17, 2007):

Table 7.1 Addition of Inspirational Travel Activities to Time-and-Action Calendar

Activity	TRADE SHOW: NOUVEAU COLLECTIVE AT THE NEW YORK PIER SHOWS (SEPTEMBER 4)																					
Week	1	2	3	4	5	6	7	8	9	10	11	12	13	14	15	16	17	18	19	20	21	22
Date	4/3	4/10	4/17	4/24	5/1	5/8	5/15	5/22	5/29	6/5	6/12	6/19	6/26	7/3	7/10	7/17	7/24	7/31	8/7	8/14	8/21	8/28
Write/revise mission statement	▓																					
Write core strategy		▓																				
Conduct primary and secondary data collection		▓																				
Calculate minimum plan		▓																				
Search online fashion forecast services			▓																			
Read published literature			▓																			
Collect visual images			▓																			
Sketch			▓																			
Review museum, entertainment and sport resources																						
Review retail store trends				▓																		
Attend European textile, prefabric, and apparel shows				▓																		
Observe consumers				▓																		

Key to seasons:

	1	2	3	4	5	6	7	8	9	10	11	12	13	14	15	16	17	18	19	20	21	22
Fall	▓																					
Winter	█																					
Spring	▓																					
Summer	█																					

The [Wet Seal's] merchandising team for each retail concept develops fashion themes and strategies through assessing customer responses to current trends, shopping the European market and the appropriate domestic vendor base and through the use of fashion services and gathering references from industry publications. After selecting fashion themes, the design and buying teams work closely with vendors to use colors, materials and designs that create images consistent with the themes for our product offerings. (p. 6)

ACTIVITY **7.1** *Time-and-Action Calendar: Continued*

Using Table 4.10 and referring to Company Project 3 in Chapter 4, add inspirational travel activities to your time and action calendar, along with a corresponding timeline for completing these activities.

- In cell A14 type "Review retail store trends".
- In cell A15 type "Attend European textile, prefabric, and apparel shows".
- In cell A16 type "Observe consumers".
- Designate one week for the activities in rows 14–16. These activities take place at the same time and start upon completion of calculate minimum plan. (Place your cursor in column E14:E16 and fill the cells with color.) Your calendar should look like Table 7.1.

Importance of Inspirational Travel

Today's consumers demand unique fashions that give them the ability to be an individual (Agins 2007). The ability for designers to create unique, good-selling designs takes concentrated effort. This focused creative effort is the primary reason for inspirational travel. Traveling allows designers to conceive new ideas, to give their products a strategic advantage, to get a fresh point of view, to observe fashions in multiple venues, and to be fashion-forward. Astute apparel companies realize they can obtain a high return on investment with inspirational travel (Eckert 1997).

New Ideas

Inspirational travel gives the design team an opportunity to see best-selling apparel brands, fabric lines, retail store trends, and trade shows. Designers sketch and buy inspirational material as a result of such observation (Regan 1997, 182). Travel offers a venue for designers to view multiple stimuli that they translate into designs (Eckert and Stacey 2003a, 2003b). Inspirational travel is important for designers to be able to conceive of new ideas because designers frequently work in isolation and inspiration often occurs outside the office (Eckert 1997).

Senior designers who work for manufacturers or private-label retailers travel internationally once or twice a year to develop seasonal product lines. The timing of European

design inspiration trips often coincides with that of biannual European fashion weeks or textile and apparel trade shows. Assistant and associate designers *earn* inspirational travel trips as they are promoted to more responsible positions.

Before traveling, designers read literature and study trend service information to gain a feeling for current trends (Eckert 1997). During the flight, if not before, the design director confirms the design goals of his or her strategic business unit (SBU)—for instance, the products designed must have unique needlework and fabrication. For the upcoming season, designers and merchandisers must search global trends and create garments that either functionally or aesthetically meet their target market's needs. Designers search for design solutions by trend shopping abroad. They do not isolate one inspirational activity from another during their travel; however, for clarity, such activities (e.g., reviewing retail store trends, attending trade shows, and observing consumers) are discussed separately in this chapter.

The design decision-making phase occurs simultaneously with the inspirational search as designers evaluate trend services and products shown at trade shows. Illumination occurs when designers create theme boards, which provide a direction for their product line. Figure 7.1 shows a flowchart of inspirational activities designers engage in during travel and colminates in creating theme boards.

Strategic Advantage

One reason astute executives support inspirational travel is because this activity gives their company's products a strategic advantage. Designers who travel abroad absorb themselves in the essence of a country's culture, art, attitude, and events. The result is unique, fashion-forward designs. Jones Apparel Group Inc. ⬚ is a good example of a company that recognizes the value of inspirational travel. It acknowledges that its design staff creates distinctive garment styling and incorporates contemporary trends into classic designs. Therefore, its designers, typical of designers at other apparel manufacturers, purposely travel throughout the world to stay current with fashion trends and to identify the direction for colors, themes, fabrications, and silhouettes (SEC February 28, 2006).

Fresh Point of View

Important design inspiration locations include Europe, Asia, and major U.S. markets (SEC February 28, 2006). Some individuals may question the need for designers to physically travel to different locales. Kathy Van Ness, former executive vice president of Warnaco Swimwear Inc., explained:*

> Designers and merchandisers often travel to Europe for a fresh point of view on trends and what is happening on the streets. Walking, window-shopping, and seeing how consumers dress in Europe reveal a very different picture from that in the USA. Designers may see fashion looks on the streets of NYC, but consumers in the USA are more inclined to dress for comfort versus fashion.

*Reprinted by permission from Kathy Van Ness, former executive vice president, Warnaco Swimwear Inc., Los Angeles, CA; pers. comm., June 21, 2006.

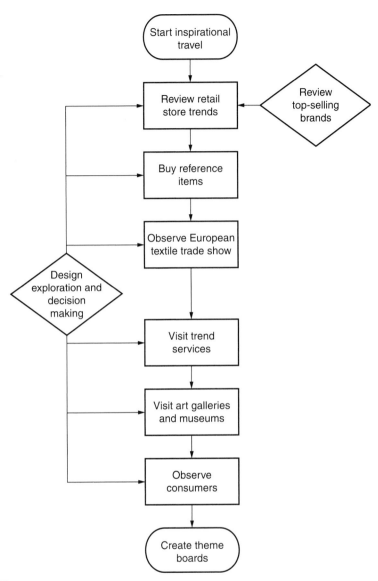

Figure **7.1** Search-for-design solutions and decision-making activities. *(Illustration by Karen Bathalter.)*

Multiple Venues

By traveling, the design team can see fashions in several venues in one trip. Planning is extremely important before visiting the multiple venues so that the team returns with tangible information. The senior design team compresses travel, often visiting three countries in 1 week. A typical itinerary is to spend 1 day in Paris, France, at a textile trade show; 1 day at a trend service, museums, and art galleries; and 1 day observing consumers and

shopping on the Right Bank. Then, they may fly to Milan, Italy, for 2 days to see a textile trade show, shop in the Golden Quadrangle, visit museums, and watch consumers. Finally, they may fly to London, England, to shop Oxford Street stores, preview trends at a forecast service, observe consumers, and view museum costume exhibits.

In each venue, designers need to go where they think they can find inspiration. For instance, a men's career designer would go to the business district to observe consumers and the fabrics worn.

Creative individuals use their imagination to combine images (Dahl, Chattopadhyay, and Gorn 2001). For example, a designer might combine a garment idea from a London boutique with that from a Milanese individual's outfit. Visits to additional venues lead to a designer's decision-making process. For example, if while trend shopping Milan's Golden Quadrangle, a designer sees similar fashion trends in London, this finding verifies his or her trend interpretation.

Assistant Market Analyst Jessica Aragon at Directives West explained to the author that apparel executives also travel to stimulate their fashion-forward thinking:*

> The purpose of traveling is because Europeans are ahead of domestic trends. We relay the travel information back to our clients through conference calls or reports. European stores are ahead of the domestic market. For instance, leggings were hot in Europe about 6 months before they became a major trend here in the States. In Europe, there's much more variety to what people wear. In London, even though everyone shops at Top Shop and H&M, the European consumer puts his or her own style onto it. In the United States, it seems that consumers copy whoever is the hip person, rather than trying to create their own style, but maybe that is just West LA.

Review of Retail Store Trends

As an apparel student, you may think, "Shopping can inspire me." Shopping is a fun activity that designers participate in when they search for design solutions. However, the type of shopping they do is "work shopping," not personal shopping. In this context, **trend shopping** is observing or purchasing numerous objects and then making connections between what is available and what is needed or desired. Trend shopping, also called *scouting*, involves purchasing items that provide a kernel of an idea involving a product component that can be copied or an entire design that can be used (Hine 2002). Such items are called **reference items.** A designer may also adopt design elements such as colors, textures, lines, and silhouettes from garments he or she sees.

Reviewing retail store trends means designers purchase products, photograph window and interior displays, sketch ideas, and evaluate how a store combines product assortments. Designers evaluate current garments in retail stores for their aesthetics, individual components, or functionality. Designers shop places that offer aesthetics that appeal to their consumers. Effective reference-item buying requires designers to know

*Reprinted by permission from Jessica Aragon, assistant market analyst, Directives West, Los Angeles, CA; pers. comm., April 14, 2006.

their core consumers' requirements. Alejandra Parise, freelance designer at Melrose East, explained:*

> It is imperative for a designer to understand that work shopping is not shopping for oneself, but rather for your target customer. You are literally trying to see garments, graphics, and trims through your customer's eyes. This way, a designer can be truly successful.

ACTIVITY **7.2** *Critical Thinking*

To practice work shopping,

- Choose a consumer target market to which you do not belong (e.g., male high school student).
- Visit a retail store and identify trends that cater specifically to this market.

Designers shop a variety of stores targeting different market segments. They review retail store trends, evaluate competitive garments, and define how their garments fit their market (Eckert and Stacey 2000). Design directors purchase inspirational reference items to use as a late addition to the current-season product line and for development 12–18 months in advance. At times, trend shopping is easy, and at other times it is incredibly difficult. Designers buy reference items from all price ranges, including those of their market segment (e.g., female juniors) and those from other sectors (e.g., male urban wear) for design inspiration. The primary reasons for purchasing reference items are inspiration, memory triggers, and evaluation of fit and construction. Designers buy garments that have an important aesthetic element or technical feature. Reference garments need to fit with their design plan or be used to communicate aesthetic or functional aspects (Eckert 1997; Eckert and Stacey 2003a, 2003b).

Where Designers Shop

Picture yourself as a new design entrepreneur. If you were to buy reference items, where would you go? Although designers have the freedom to choose to travel to any country for design inspiration, they often shop when they travel for other business meetings or events. Quiksilver's senior merchandiser Jennifer Barrios told the author that merchandisers travel to Asia to meet with garment contractors and during such visits, merchandisers may make an additional appointment to view a textile vendor's presentation. Likewise, designers make use of market weeks by shopping trendy boutiques in SoHo, New York City; Miami, FL; or Los Angeles, CA. Designers also travel solely for inspiration. Designers can get inspiration from all over the globe in which they often combine elements. For instance, a designer may discover and combine design elements from the seemingly dichotomous Scandinavian and African cultures to create a brightly colored fabric print with irregular patterns, scribbles, and strong brush strokes (Williams 2007).

*Reprinted by permission from Alejandra Parise, freelance designer, Melrose East, Covina, CA; pers. comm., February 5, 2006.

Although no single set locale for trend shopping exists, designers commonly shop international apparel clusters in London, Milan, Paris, and Tokyo. Other influential fashion centers include Germany and São Paulo (Eckert 1997; Worth Global Style Network [WGSN] 2005b). Designers consider these locales meccas of art with a forward-trend direction. As in the United States, European cities offer shopping regions from which designers may choose. Designers have historically traveled to Europe to see regional brands and products. With the onset of online shopping, however, European shops often offer the same brands available in the United States, and their high-end market is less influential than in the past (Moore 2005). Nevertheless, the product offerings differ somewhat. Kathy Van Ness, former executive vice president of Warnaco Swimwear, explained to the author how European stores differ from those in the United States:*

> The retail shops in Europe are less generic, unlike the specialty chains and departments stores where the storefront windows and looks can be the same from city to city or mall to mall [in the United States]. European shops are small boutiques, and each retail shopkeeper has his or her own point of view. By looking at the boutiques in Milan, Florence, Paris, and London, you can begin to see which trends are emerging. From there, you now begin to look and plan for ways to translate these trends from the streets, runways, and storefront windows into fresh merchandise for your own USA consumer.

Activity 7.3 *Critical Thinking*

The apparel executive mentioned in the preceding paragraph indicated that most designers physically travel to foreign countries; however, visiting country tourism Web sites can provide a germ of an idea.

- Engage in virtual travel to different countries by using the British Broadcasting Corporation's country profiles; these profiles cover the history, political structure, and geography of each country: http://news.bbc.co.uk/2/hi/country_profiles/default.stm.
- Also visit individual country Web sites (e.g., www.ireland.ie). These sites have links to national tourism bureaus, which provide background on art, culture, and famous locales.
- Which locale is most important for developing your product line? Explain why.

Destination: London

Designers often travel to London to see its dichotomy of fashion trends, which range from youth and alternative fashions to tailored clothing. As in most metropolitan areas, London offers a multitude of shopping areas, so designers look for regional stores and products made exclusively for the British market. British department stores have a strong influence on regional fashion (Eckert 1997; Moore 2006b). Designers shop a variety of stores—from London's upscale luxury department stores to specialty stores. The haute

*Reprinted by permission from Kathy Van Ness, former executive vice president, Warnaco Swimwear Inc., Los Angeles, CA; pers. comm., June 21, 2006.

couture specialty shops, found on New Bond Street, represent classic British designers and companies such as Vivienne Westwood 👕, Alexander McQueen 👕, Pringle of Scotland 👕, and Mulberry 👕 (Moore 2006b). Designers who are looking for popular midpriced fashions visit London's West End specialty and department stores. According to Ronald Heimler, president and owner of Walter Heimler Inc., one rich shopping district is Oxford and Regent streets, which has department stores such as England's Selfridges & Co. 👕, Marks & Spencer 👕, House of Fraser 👕, and John Lewis 👕 (BBC World Service n.d.).

Topshop 👕 is a frequently visited Oxford Circus store. It is known as the world's "cheap chic store" and purposely copies designer and fashion week clothing styles and sells them at lower prices (Figure 7.2). This store features three hundred product lines each week and sells seven thousand lines per season, which attracts an average of twenty-four thousand visitors a day who check out the fast-moving trends (Moore 2004a, 2006b). H&M 👕, an Oxford Circus flagship store, is a Swedish private-label retailer that employs more than one hundred designers to create its collections (Figure 7.3). Its design team consists of in-house designers, pattern makers, and buyers, who develop fashion and quality at competitive prices (H&M n.d.).

Brompton Road and High Street feature upscale department stores and chain stores such as Harrods 👕 and Harvey Nichols 👕. Harrods is known for its food court, toys, and accessories. Regent Street features classic British stores such as Liberty 👕 and Aquascutum 👕, which is known for its selection of tailored clothing.

London boutiques offer another inspirational source. Some shopping locales include Burlington Arcade 👕, Browns 👕 of South Molton Street, and St. Christopher's Place 👕.

Figure 7.2 Topshop, a popular British private-label retailer. *(Photograph reprinted by permission from Ronald Heimler, London, UK.)*

Figure 7.3 Oxford Circus, the locale of many specialty retailers, including H&M.
(Photograph reprinted by permission from Ronald Heimler, London, UK.)

London's East Side and Camden in North West London hold the British version of swap meets, with shops and stalls of up-and-coming designers and arts and crafts (BBC World Service n.d.; Fodor's n.d.[a]; Frommer's n.d.[b]). Designers seek the vendor stalls in Camden Town for creative, emerging trends. Camden Market 👕 is a flea market with semipermanent stalls in old mill buildings (Figure 7.4). According to Ronald Heimler, president and owner of Walter Heimler Inc., this locale is inspiring to designers because the vendors offer cutting-edge styling. London is also renowned for its emerging urban, street-wear, and alternative clothing styles. Music, clubbing, and youth-inspired fashions dictate new British alternative clothing styles. The London Edge trade show 👕 features alternative fashions such as punk, rockabilly, underground, and biker (London Edge n.d.).

Figure 7.4 Camden Market, which offers interesting emerging fashion styles.
(Photograph reprinted by permission from Ronald Heimler, London, UK.)

Heimler explained how he uses some of the London locales for design inspiration:*

I go to High Street for designer fashions, to understand new colorations, fabrications, and style. Oxford Street is known for mainstream British seasonal looks, while Camden Town for emerging urban and street-wear looks. Other locations that I visit include Brick Lane, Spittlefields, and Portebello Road to get inspiration from vintage merchandise.

ACTIVITY 7.4 *Becoming Inspired from Existing Fashion*

Go to the Topshop Web site at www.topshop.com or to the BBC list of regional shopping at www.bbc.co.uk/worldservice/specials/1711_Shopping.

- Select two products to inspire you in developing your product line.
- Save the electronic images.
- Place the images into a graphic illustration program, such as Adobe Illustrator, and create a new layer.
- Trace one garment silhouette.
- Write notes about what you would change to incorporate it into your product line.

Destination: Milan

Fabrics and shoes have long been Italy's fashion strength. Designers from many market segments seek out Italy's textile and accessory districts to see their interesting use of fabrications and trims. Made-In-Italy 👕 (n.d.) is an organization that presents information on Italian shopping venues and designers.

Milan is a busy metropolis historically known for its textile manufacture. It is renowned for its fashion diversity—from Italian couture designers to trendy boutiques—and rivals Paris and New York in the presentation of its top-quality, top-tier clothing. Designers consider the Prada 👕 flagship store a mecca for fashion associates. Its locale is near the Galleria, Vittorio Mengono, in Milan's city center (Moore 2005). Although specialty stores are located throughout the world, designers need to visit the flagship stores of important global retailers. A **flagship store** offers experimental designs, innovative merchandise displays, and trend-setting ideas, and it best conveys a company's vision.

The Golden Quadrangle features Milan's couture and international design houses, including Dolce & Gabbana 👕, Armani 👕, and Gianfranco Ferré 👕 (Fodor's n.d.[b]). Italian department stores include la Rinascente 👕, which is known for its lingerie and shoes as well as where Armani began his fashion career. Famous designer fashions and lifestyle information can be found at 10 Corso Como 👕.

Italy's fast fashion is primarily located in Corso Vittorio. Some renowned specialty stores include Sisley 👕 and United Colors of Benetton 👕 (Moore 2005). Benetton, an Italian private-label retailer, notes that its corporate philosophy is to blend its strong Italian character, style, quality, and passion (United Colors of Benetton n.d.).

Designers are inspired by Milan's street fashion, which can be found in locales such as Corso di Porta Ticinese. Retail boutiques and Italian consumers offer a creative energy

*Reprinted by permission from Ronald Heimler, owner and president, Walter Heimler Inc., New York, NY; pers. comm., June 27, 2006.

unique to this region (Moore 2005). Corso di Porta Ticinese is one locale that has concept stores, independent boutiques, and vintage stores offering inspiring design ideas. **Concept stores** are those in which retailers test new products and include such brands as Levi's and Diesel.

Designers can find unique inspirational items at vintage boutiques, which include ethnic and tribal pieces. These stores offer a wealth of inspiration. Designers may see ethnic items from countries such as Bulgaria and Sudan, unusual products such as purses made from recycled skateboards, or trendy items such as Miss Sixty (Moore 2005). Sixty Group is an Italian apparel manufacturer that offers brands such as Miss Sixty, Energie, and RefrigiWear. This Italian apparel manufacturer is renowned for creating innovative men's and women's sportswear and work wear with a strong brand identity (Sixty Group n.d.).

Destination: Paris

Design inspiration can come from French window displays, couture shops, vintage fashion, or brocantes (i.e., secondhand shops). In Paris, store window displays are attractive and enticing, and the creation of these displays is considered an art form (Beatty 2004). Parisian couture boutiques such as Balenciaga and Yves Saint Laurent and cutting-edge stores such as Colette Paris are found on Rue Saint-Honoré. These shops offer consumers designer and couture fashions.

Traditional Parisian fashion has strict tailoring, geometry, and minimal surface embellishment. Many French couturiers still use this famous French signature on their current-day collections. For instance, Stefano Pilati, from the house of Yves Saint Laurent, continues to feature his signature tweed suits and chain borders, and Riccardo Tischi, from the house of Givenchy, emphasizes geometric shapes, for example, in his precision-cut black dresses and militaristic skirt designs (Figure 7.5) (Moore 2006a).

Although couture designs are too expensive for many price points that designers create (e.g., $3,500 for a suit), they shop Parisian couture houses to see how the famous designers interpret what their target consumer wants. As with consumers at all price points, women who buy couture fashion do not allow fashion to dictate their preferences. Therefore, some couture houses are successful, whereas others are not. For instance, Tom Ford at Yves Saint Laurent alienated older consumers, even though he built a strong new consumer group. In contrast, Oscar de la Renta has been consistently successful at interpreting and designing practical garments for his target consumer, the professional woman (Anand, Carpenter, and Jayanti 2005).

Boulevard Haussmann is another French inspirational region, known as the "department store district." Stores include Printemps Department Store, a luxury market department store, and Galeries Lafayette. According to Ronald Heimler, president and owner of Walter Heimler Inc., the Left Bank stores have junior trends and emerging urban and street-wear looks. The Marais and Saint Germain regions have stores featuring avant-garde styles. The Marais and Saint Germain districts are known for classic sophistication, provide inspiration for designing upscale career and classic styles.

Nontraditional retail outlets can also inspire designers. Some of these outlets include Parisian flea markets, brocantes (secondhand shops), the Place des Victoires (Parisian dime stores), and the stalls in front of the department stores on Boulevard Haussmann. These retail outlets feature a wide variety of French vintage art and fashion (Fodor's

Figure 7.5 House of Dior, Avenue Montaigne, Paris, France.

n.d.[c]; Frommer's n.d.[c]). One example of inspiration resulting from trend shopping at such outlets is Banana Republic's spring 2004 line: Banana Republic's design team found inspiration for camisoles and tops with lace trim from shopping London, Paris, and New York City flea markets and vintage stores (Beatty 2004).

Destination: Tokyo

Designers characterize Japanese fashion as traditional and innovative. Japanese consumers demand short fashion cycles, high quality, and brand names (Yoko 2007). Traditional Japanese consumers desire beauty and traditional art. These Japanese consumers are important to the luxury fashion market, accounting for a significant market share for companies such as Louis Vuitton (Sanchanta 2006a). In addition, Japan leads innovation in consumer trends, influenced by pop culture and street couture, and in manufacturing innovation in fiber and textile processing (Yoko 2007). Louis Vuitton's president commented, "What happens in Tokyo will happen elsewhere in the world tomorrow" (Sanchanta 2006a).

Japanese consumers, especially those who are 12–35 years old, are fashion sensitive. They spend a large amount of discretionary income on fashion goods. For instance, many younger Japanese consumers desire products that no one else has. This has led to a trend in purchasing exclusive limited edition products (Sanchanta 2006b).

Trend shoppers watch Tokyo closely because it is now a strong fashion center, with an eclectic variety of stores and fashion items (Lal and Han 2005). Japanese luxury and specialty store products and visual displays inspire designers. Jessica Aragon, an assistant market analyst at Directives West comments, "Our Directives West owner visits Japanese stores. The Japanese have very innovative store window displays, such as suspending garments from the ceiling. She finds out what is going on and we relay that information to our clients."*

International luxury designers, such as Yves Saint Laurent, Dior, and Gucci, have a strong presence in Tokyo's Omotesando district. Omotesando Hills 👕 mall is a modern glass building in the heart of Tokyo's trendiest shopping district (Hirano 2006; *Women's Wear Daily* 2006b). Tadao Ando features smaller boutiques that offer custom-made products (*Women's Wear Daily* 2006a). Likewise, luxury fashion companies, such as Burberry Blue Label, offer the Japanese consumer exclusive, limited-edition accessories and ready-to-wear collections (Guerra 2006; Hirano 2006; *Women's Wear Daily* 2006b).

Department stores are a dominant Japanese business channel (Lal and Han 2005). Three notable Japanese department stores are Mitsukoshi 👕, Takashimaya 👕, and Seibu 👕. The first, Mitsukoshi, is one of Japan's oldest stores, founded in 1673. It features luxury goods and a trained sales staff. Mitsukoshi is credited with establishing Japan's retail business practices, including selling products with a fixed price rather than bartering, which was common in the seventeenth century, and abolishing the zauri system. In the zauri system, clerks brought requested merchandise from a storeroom for the consumer to see, rather than displaying goods on the sales floor. Mitsukoshi trains its sales associates to have special skills; among the associates are a cashmere expert, a fashion fitter, and a color coordinator (Mitsukoshi, Ltd n.d.). The second store, Takashimaya 👕, features boutique chains located within its department stores. "Style and Edit" for women and "Case Study" for men, offers a classy, unique merchandise mix that focuses on consumer needs for improved health, safety, and peace of mind (Takashimaya Company Limited, n.d.). Seibu 👕, the third store, is Japan's largest department store. It has a lively atmosphere and provides a wide variety of merchandise, including that of both Japanese and Western designers (Frommer's n.d.[a]).

The Japanese consumer is less receptive to specialty store retailing, especially cheap fast fashion, than to other retail channels. The Shimamura district offers fashionable products for 25- to 45-year-old female consumers (Lal and Han 2005). The Shinjuku, Shibuya, and Harajuku regions offer other fashion-forward looks. In an interview with the author, Ronald Heimler, president and owner of Walter Heimler Inc., said that designers can see many trends in locales such as Shimo-Kitazawa, which is noted for its vintage products, and Akihabara, which features electronics stores. Shibuya, famous for its colorful neon lights, is a renowned Tokyo shopping district. Some Shibuya specialty stores offer inspirational eclectic designs such as jackets designed to be worn upside down or made with purposely misaligned buttons. Harajuku is a mazelike neighborhood renowned for gatherings of individuals dressed in wild and dramatic clothing. It offers secondhand, alternative, and fashion-forward shops. The visual merchandising at these boutiques is notable, including tree trunks that pave the floor, a mechanized dry-cleaning rack for T-shirts, and a children's hypnotic wonderland (Guerra 2006).

*Reprinted by permission from Jessica Aragon, assistant market analyst, Directives West, Los Angeles, CA; pers. comm., April 14, 2006.

How Designers Study Products in a Retail Setting

Designers synthesize trends they see in multiple regions and stores. One design goal is to identify garment categories (e.g., capris) and similar features (e.g., slash pockets) across competing products. Designers use either a systematic or a haphazard approach to review store trends. Those who use a systematic approach select a particular region and preplan store or museum visits. Conversely, those using a haphazard approach may quickly peruse store merchandise on the way to a business appointment (Dahl, Chattopadhyay, and Gorn 2001).

Designers buy reference garments not only to communicate to colleagues but also to use as a memory trigger. A **memory trigger** is product in the marketplace or an existing object from which a designer can directly incorporate or modify elements to create an original idea (Dahl, Chattopadhyay, and Gorn 2001).

Designers try to determine whether striking features of garments are unique to a designer or label or are examples of categories that are forming new trends (Eckert and Stacey 2003a, 2003b). When designers products, they use both visualization and their imagination (Dahl, Chattopadhyay, and Gorn 2001). They often talk to other associates, referencing what they saw in stores and fashion magazines and while observing consumers. When they evaluate products in stores, designers visualize consumers wearing or using the designs. For instance, two designers might have the following conversation:

"What a cute collar!"
"This would be a hot seller for us. We could incorporate it into style WT3145—but what do you think? The scallop edge is too much; isn't it?"

Imagine a designer trying to explain this collar to a pattern maker or technical designer at the home office without having a sample. Doing so would be extremely difficult. Consequently, visually showing an example to convey garment components, aesthetics such as color, or function such as garment construction is much easier. Designers know communication is important to persuade and motivate product development associates to carry through with their design concepts (Perks, Cooper, and Jones 2005).

ACTIVITY 7.5 *Verbalizing a Visual Image*

Explain a "cute collar" to a colleague—without drawing, pointing to an object, or showing a sample.

One major challenge for designers is to create styles that fit consumer target market needs while also trying to create a distinctive product line. One approach is to review existing products. Designers shop all marketing channel levels, from luxury to budget. Products offered by market leaders often show new fabrications or technical features. When comparing competing brands, designers see their rivals' trend interpretations, which is an advantage because such companies target the same consumer.

Designers store visual images in their short-term memory to use for a variety of garment features. They have a vivid, detailed, visual memory, which they use when

trend shopping in retail stores. Experienced designers envision detailed, realistic garment images that can be likened to a photograph (Eckert and Stacey 2003). A designer often transforms visual images by adding, deleting, modifying, or replacing elements (Figure 7.6) (Goldschmidt 1994).

Designers often base decisions on their previous product line successes or failures. Their recall helps them as they evaluate historical styles that reappear in the marketplace (Eckert and Stacey 2003a, 2003b). For example, if they see the reappearance of a Victorian corset in a store, they may respond, "When we tried corset styles, the response was horrible; skip that!"

Many designers use carefully honed observation, research, and analysis skills when conducting activities such as inspirational shopping (Perks, Cooper, and Jones 2005). Successful designers use observational and research skills to synthesize fashion, garment fit, and styles. Designers use analysis skills to reject outdated silhouettes and accept those that would be appealing to their target consumer (Eckert 1997). They study and discuss the details of a garment: its wearability, style, and proportion; ways to combine features; and reconstructions of previous designs seen. They can be interested in the entire garment, or in details, such as necklines or pockets. They carefully evaluate garment construction, measurements, and fit, and they purchase garments to measure and take apart to evaluate the construction (Eckert 1997). Designers also analyze textile fabrication. For example, a knit designer may draw a texture to copy or re-create later (Eckert and Stacey 2003a, 2003b).

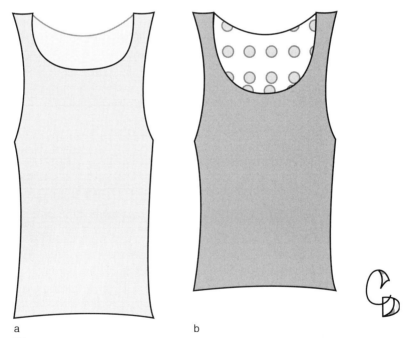

a b

Figure 7.6 Example of how a garment is transformed from (a) the original into (b) one adopted into a product line. *(Illustration by Christina DeNino)*

Why Designers Sketch during Trend Shopping

As mentioned in Chapter 6, sketching is an important part of trend shopping. Designers often quickly sketch places, garments, details, or fabrications (Figure 7.7). When designers sketch, they may dash outside because store owners often do not allow photographs or illustrating products inside their businesses. Designers study the sketches they make and modify them to combine multiple inspirational elements. For instance, they may use a garment silhouette seen in one store, the detailed construction from another garment, and trims and embellishments from a third garment. Once back at their office, designers may review ideas with colleagues and make additional changes.

The sketches designers create are drawn quickly, are vague, lack logic, and may be out of sequence. Designers tend to be brief, vague, and cryptic in their unique shorthand notation during the visual-thinking process. Quick sketching facilitates transformations, is open ended, and can have multiple interpretations (Goldschmidt 1994).

Designers use imagery (i.e., the set of mental pictures produced by memory or imagination) as part of the creative problem-solving process. Trend shopping allows designers to obtain objects that they can reinterpret. Sketching maximizes the conditions an individual needs to reinterpret and imagine and thus be able to create transformations of an original object. Later, in their mind's eye, designers reinterpret these images and conceive of new ways of seeing designs (Figure 7.8) (Purcell and Gero 1998). Designers often develop a garment style reference library to assist them with design thinking; for example, they catalog sketches by silhouette type. They can then refer to the library whenever they need inspiration (Regan 1997, 186).

Figure **7.7** Tamee's sketch from a French historical site. *(Illustration by Christina DeNino.)*

Figure 7.8 One of Tamee's ideas of how to incorporate a French icon into an accessory. *(Illustration by Christina DeNino.)*

Some designers adapt fashions from trend-setting global fashion weeks in Milan, Paris, London, and New York. As recently as 1997, it was common to have a 2-year delay for fashions presented at fashion weeks to become available for sale in department stores. However, fashion week Webcasts allow retail trend directors, such as those from JC Penney, Wal-Mart, Target, and Dillard's, instantaneous access and the ability to identify trend-setting styles that their consumers will buy. These retail customers work with in-house designers or contract with apparel manufacturers to have "cheap chic" merchandise adapted from global fashion weeks in stores within 60 days (O'Connell 2007).

Some designers use silhouettes from existing garments. They do not see this adaptation as copying but as improving an existing design. They select and adapt prominent garment features to match their theme and color palette (Eckert 1997).

Another approach is for designers to analyze and select store offerings for peak popular styles. They knock off the styles while demand is high. ZARA is one company that uses this **fast-fashion** approach. Its designers knock off styles from fashion weeks and trade shows. The company executives' philosophy is that they "do not want to be the first" in fashion—they follow. They let someone else make the mistakes" (McAllister 2006, 28). Timing is critical for apparel manufacturers that knock off existing styles and, in the case of ZARA, its designers develop more than 60 percent of their styles during the current selling season. Traditional apparel manufacturers develop only 20 percent of their styles in the current season. ZARA produces products quickly by using regional factories (McAllister 2006).

Attendance at European Textile, Trim, Prefabric, and Apparel Trade Shows

Designers and trend directors attend trade shows for inspiration. For instance, JC Penney's trend director purposely went to Sweden to get ideas for new denim washes, details, and garment fit (O'Connell 2007). Textile fabrics, fabrications, and colors can be a company's strategic advantage. Also, designers attend trade shows to efficiently locate resources. A **trade show,** in this context, is the wholesale offering of raw materials or services. Trade shows are often international events; however, they are typical of the society, cultures, and traditions of their locale (Hine 2002). For example, the mission of the Italian fashion industry is to offer distinctive original products. The Italians' taste for elegance and living well influences the clothing and textiles they offer. This cultural influence translates into the Italian textile industry. Many Italian firms produce niche luxury fabrics that other companies cannot easily replicate (Bruni 2004; Sistema Moda Italia 2005).

Attending trade shows is not only an inspirational activity for designers, but also a time for entering the decision-making phase of the design process. The following subsections cover designer evaluation skills, types of trade shows and their primary locales.

Trade Show Evaluation Skills

Trade shows inspire designers, offer them a fresh viewpoint, and are an important part of visualizing new garment ideas. For instance, the juxtaposition of African and Scandinavian cultures may not even occur to an apparel designer, but seeing such fabric designs may be the impetus for a seasonal apparel product line (Williams 2007).

At a trade show, a designer who is interested in purchasing fabric evaluates swatches at booths where vendors sell art prints and fabric swatches (Première Vision 2006a). Vendors display swatches on hangers, tables, or racks (Color Plate 1). Designers write notes about vendors, style names, prices, and minimums. (A **minimum** is the lowest quantity a buyer can purchase; minimum quantities vary among suppliers and fabric types.)

Designers purchase fabric and trim samples to create their own fabric textures, prints, or woven designs. They often search for fabrications that spark their imagination (Eckert and Stacey 2003a, 2003b). They look for interesting or novel features, mentally manipulate the forms, imagine themselves using the forms, or transform a viewed object into a product (Purcell and Gero 1998). One important reason for designers to physically travel to trade shows is that doing so allows them to combine objects. For example, they may visualize a particular vendor's fabric, seen at a trade show, on a garment they see in a store in another city.

Designers are also inspired by textile motifs. They do not limit themselves to fabrications they use in product lines; rather, they remain open to many possibilities. For example, a carpet motif may inspire a knitwear designer to create intricate stitching details, such as intarsia, in a sweater. (Eckert 1997; Eckert and Stacey 2003a, 2003b).

Creativity occurs when a designer uses previous conceptual knowledge to analyze designs (e.g., fabrics) (Purcell and Gero 1998). Items that stimulate creativity are novel,

ambiguous, and support emergence or reinterpretation. A designer can form mental images from objects by focusing on their visual (e.g., brightness and color) and spatial attributes (size and location) (Purcell and Gero 1998). For example, a designer looking at a fabric may form a mental image of how to emphasize the textile coloration by adding trims and buttons. Alternatively, if the designer looks at a textile with small geometric shapes (e.g., small diamonds), he or she may be inspired to create a new fabrication of alternating large and small geometric motifs.

Designers make many decisions at apparel and textile trade shows, including whether an idea is unique and whether it fits the company's design strategy. For example, Lonnie Kane, CEO and president of Karen Kane Inc. 👕 told the author that the company's design strategy is comfort, ease, luxury, and longevity. Because Karen Kane strives to create clothes polished enough for work yet sufficiently relaxed for weekends, some of her fabric selection decisions are whether the fabric is easy to maintain, can travel well, and is durable (Karen Kane, Inc. n.d.).

To make decisions, designers need to develop skills in design thinking and critical evaluation. A designer must clearly define the direction for a seasonal product line to effectively shop trade shows. Design-thinking skills require expertise in spotting a trend and mentally translating it into a garment. Designers need to recognize what is fashionable and what is not for their consumers or must be able to visualize how to change a pattern design to make it fashionable (Eckert and Stacey 2003a, 2003b). In addition to considering aesthetics, designers evaluate designs for their salability and wearability. Although numerous options are available to designers, their thorough understanding of their target market enables them to narrow their choices.

European Textile and Trim Trade Shows

The largest biannual Italian and French textile and trim trade shows are in Paris, Milan, and Florence. Among the most renowned shows are Première Vision Pluriel, Pitti Immagine Filati, and Expofil (Eckert 1997).

Many apparel industry associates—such as senior designers, trend forecasters, textile associates, fiber associates, and the press—attend these shows. Designers preplan their trade show visits. By preregistering, they receive a show guide to help them select product categories, review vendor products, and set appointments. The shows organize and display products by categories (e.g., Draperie/Suiting). Such organization allows a men's career designer, for example, to streamline shopping by spending the majority of time with textile vendors that sell men's suiting and shirting fabric.

Some trade show producers such as Interstoff, 👕 which offers the shows Texworld and Interstoff Asia, commission trend forecasters to issue color and trend guides for customers who attend shows (South China Morning Post 2006). Textile associates, including studio managers and manufacturer representatives, also shop these shows. They gather inspirational ideas for their customers who do not have an opportunity to travel (Regan 1997, 185).

Apparel manufacturers and private-label retailers that place importance on new yarns and fabrications shop the European textile shows. For example, Lonnie Kane said for his wife, Karen Kane, a designer of women's contemporary clothing, often uses fabrics as the design inspiration for developing a seasonal product line.

Color Plate ❶ Designers will select yarns from tradeshows to go into knit garments.
(Illustration by A. Flanagan)

Color Plate ❷ Fabric display at a European textile tradeshow. *(Illustration by A. Flanagan)*

Color Plate ③ Compiling visual pictures to create a theme board. *(Illustration by A. Flanagan.)*

Color Plate ④ Finished Rare Designs Beauté theme board. *(Illustration by A. Flanagan.)*

Cotton Association
of America
Spring/Summer

Nature

Coral Reef

Classic Touch

Color Plate 5 Yarn swatches from a fiber organization. *(Illustration by A. Flanagan.)*

Color Chart

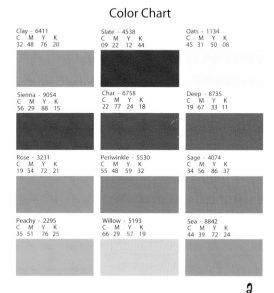

Clay - 6411	Slate - 4538	Oats - 1134
C M Y K	C M Y K	C M Y K
32 48 76 20	09 22 12 44	45 31 50 08

Sienna - 9054	Char - 6758	Deep - 8735
C M Y K	C M Y K	C M Y K
56 29 88 15	22 77 24 18	19 67 33 11

Rose - 3231	Periwinkle - 5530	Sage - 4074
C M Y K	C M Y K	C M Y K
19 54 72 21	55 48 59 32	34 56 86 37

Peachy - 2295	Willow - 5193	Sea - 8842
C M Y K	C M Y K	C M Y K
35 51 76 25	66 29 57 19	44 39 72 24

Color Plate 6 Example of a color palette trend prediction from a trend resource.
(Illustration by A. Flanagan.)

Rare Designs Core Color & Multiple Color Deliveries

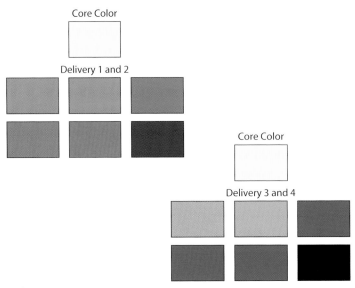

Color Plate 7 Rare Entities core color and multiple color deliveries. *(Illustration by A. Flanagan.)*

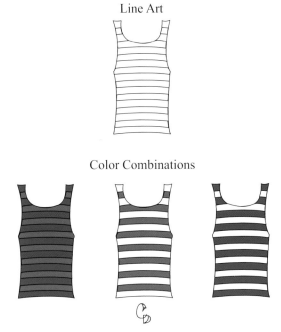

Color Plate 8 Line art filled with multiple color combination ideas. *(Illustration by C. DeNino.)*

In a different interview with the author Stephen Pearson, executive vice president for Guess? Inc., said that apparel companies place varying importance on the venues shopped. For example, at his former company, J. Jill, the design strategy was to focus on printed fabrics and textures. The company's knit designers attend the Italian show Pitti Immagine Filati, whereas other product designers attend the French Première Vision Pluriel show.

The French Shows

In France, when designers walk into the Parc des Expositions de Paris–Nord Villepinte convention center, they see signs for the Première Vision, Expofil, Indigo, Le Cuir à Paris, and Mod'Amont shows. Considered the world's premiere textile show, Première Vision Pluriel 👕 is the largest and most famous biannual European textile and trim trade show, attracting fifty thousand visitors (Première Vision Pluriel 2006a). This show offers an 18-month advance look at seasonal fabric and yarn swatches, innovative fibers, yarn treatments, fabrications, colors, and prints (Color plate 1). The February textile show focuses on spring-summer collections, whereas the September show focuses on fall-winter collections. Designers compare attending Expofil, a show dedicated to apparel textiles and yarns, to shopping in a candy store; more than thirteen hundred exhibitors offer thousands of fabric and yarn styles (Première Vision Pluriel n.d.). Not only is Première Vision a trade show, but it also provides buyers the opportunity to study early color predictions. Première Vision presents color predictions by family groupings; for instance, spring 2007 groupings were calm, pale tones and washed-out, faded, bright, and incandescent colors that contrasted with neutral and subtle minerals and materials.

To assist buyers in selecting fabrics, the organizers of the show divide it into four-fabric areas. Première Vision groups forums by fabrication: active, fancy, relaxed and tailored. Additional forums feature the latest products from weavers and a general forum has displays, which capture a designer's imagination. The actualization forum features best-selling fabrics available for immediate delivery (Première Vision Pluriel 2007). Première Vision's Fashion Information 👕 publishes show photographs (Première Vision Pluriel, 2007).

ACTIVITY 7.6 *Experiencing a Première Vision Trade Show*

- Go to the Première Vision Web site: www.premierevision.fr/?page=01&lang=en
- Place cursor on "Exhibitors" *and* click *on* "Exhibitor's Search."
- Click on "Go to the Interactive Map/Guide of Première Vision."
- Select product (general fabric type). For instance, Tamee would be interested in Draperie/suiting fabric for Rare Entities women's career jackets, pants, and skirts.
- Click on a textile vendor. Click on the textile manufacturers Web site from the pop-up window. Read the textile manufacturers information. For example, Bacci F. Ili Lanificio SpA is an Italian vertical textile manufacturer located in Florence: www.fratellibacci.it/
- Read descriptions for different fabric vendors and find four fabrics you would like to use for your product line (e.g., track pants for women).

- Describe fabrics or fabrications that you could use for your product line. Include fabric details. For instance, Bacci F. lli Lanificio SpA features cashmere and cashmere-blended fabrics. Fabrications include solids, checks, plaids, and tweeds suitable for men's or women's career apparel.

Apparel manufacturers that use knitted or yarn dye fabrics find yarn trade shows important for discovering new fiber, yarn, and fabric innovations. Expofil 👕 is a renowned French juried yarn and fiber exhibition. Whereas Milano Unica 👕 is the primary Italian yarn and fabric trade show. European spinners focus on high-quality yarns designed for niche markets. Yarn and fiber vendors show flat knit yarns 12–15 months in advance and woven and circular knits 18–22 months in advance (Color Plate 2). The fiber and yarn companies set a precedent for new fiber combinations, yarn combinations, and technological developments (Borland 2007). One new fiber combination is Siboo, a viscose fiber derived from bamboo. Siboo can be 100 percent fiber or blended with other natural fibers such as silk or soy. New yarn combinations include multiple blends of fibers such as wool, linen, Tencel® and organic cotton in a high yarn twist. European shows exhibit concept garments with new technology. One example is a knit that releases moisturizers into the skin (Borland 2006).

The Italian Shows

Historically, Italy, which has roots in its traditional desire for elegance and living well has been a world leader in producing luxury fabrics. Therefore, not surprisingly, Italy's strategic advantage is to meet the needs of luxury designers (Bruni 2004). One effort to do so is to produce exquisite Italian textile designs, a feat that is accomplished with the aid of several major Italian trade shows.

With six hundred vendors and more than thirty thousand visitors biannually, Milano Unica 👕 is an Italian textile fair that combines five textile exhibitions (Epiro, 2007):

1. *Ideabiella* 👕 features luxury wool, linen, cotton, and silk (Milano Unica n.d.[a]).
2. *Ideacomo* 👕 predominantly features silk, but also has luxury cotton and wool fabrications (Milano Unica n.d.[b]).
3. *Moda In* 👕 categorizes its fabric offerings by sport and casual, women's apparel, knits, and accessories (e.g., hats) (Epiro 2007).
4. *Prato Expo* 👕 provides textile services such as trend research, textile marketing, and trade show organization (Milano Unica n.d.[c]).
5. *Shirt Avenue*, 👕 as the name implies, features fine shirting fabrics (Milano Unica n.d.[d]).

Fabrications, fibers, and colors are for proposed styles 1 year in advance. Milano Unica is important to the Italian textile industry due to intense competition from emerging textile countries such as China, India, Brazil, and Vietnam. The show features high-quality textiles and new fabrications (Figure 7.9) (Epiro 2007).

The Pitti Immagine 👕 Filati trade show promotes Italian yarns used for knit fabrics (Color plate 2). This trade show features educational seminars and a select group of over 100 vendors. Pitti Immagine Filati is an exceptional exhibition of knitted fabrics displayed as art forms, sculpture renditions, and mannequin vignettes (Pitti Immagine Filati 2007). Its focus is to provide vision for the market and consumers and a preview of trends and styles

a b

Figure 7.9 Fabric desing interpreted from adjectives 'luminosity and harmony' from a European spring/summer yarn tradeshow trend description. *(Illustration by Christina DeNino.)*

(Pitti Immagine n.d.). When visiting such shows, a designer's visual and tactile senses are at their peak as he or she imagines the wonderful products that can be created with these knitted fabrics and yarns.

ACTIVITY 7.7 *Identifying Yarn Resources from an Italian Trade Show*

Pitti Immagine Filati, www.pittimmagine.com/en/fiere/filati/ held in Florence, Italy, is an exquisite focused art exhibition of knit fabrics and yarns.

- Click on "Exhibitors List" and then on a specific vendor's name. You can sort vendors by country locale.
- Select a yarn vendor that has a Web page and go to the yarn manufacturer's Web site. On the Web page, select "Collections" or "Designs" to find yarn photographs.
- Read descriptions and find two yarns you would like to use for knit garments in your product line.
- Describe the yarns you selected for your product line. Include yarn details, if provided by the vendor. For instance, Alpes Manifattura Filati (www.alpesfilati.com/inglese/home.htm) offers flexibility to a company because they offer a wide range of Italian natural and manufactured yarns in multiple counts and yarn gauges.

Prefabric Trade Shows

Textile stylists create **prefabric,** which is original paintings and design concepts that textile manufacturers or converters develop into fabrications (Regan 1997, 193). Indigo 👕 is one of the largest international prefabric tradeshows (Dennis 2006). Indigo is a leading exhibition specializing in textile design and creation of design concepts for print design, embroidery, and appliqué for knitted and woven fabric designs. Lisa Mainardi, a prefabric trade show producer, explained the importance of a such a show:*

> Textile design is prefabric and where fashion begins. Textile design studios are the unsung heroes of the fashion industry because they create the art that is translated into products. Their work ranges from hand paintings and embroideries, to digital computer files. Most art studios participate in textile design trade shows. It is advantageous for buyers to shop trade shows, such as Indigo, to explore the wealth of resources, including trend displays, seminars, and numerous vendors. Trade shows are efficient for designers because they can comparison shop among various textile studios before making decisions and purchases. Designers can buy already-designed items. For example, a T-shirt designer could purchase a garment-shaped design, which means the actual print or embroidery is engineered to be at an exact garment location.

Trim and Embellishment Resources

A garment is not complete without trims and findings. **Trims** is a general term referring to decorative embellishments placed on a garment. Textile trims range from netting to fringes, to braids, to pom-poms. **Findings** are functional; the term is most commonly associated with fasteners (e.g., zippers and buttons) and construction components (e.g., labels) (Brown and Rice 2002).

An embellishment or a finding can spark design illumination (i.e., the "ah ha" experience). For example, in a conversation with the author, a designer from Nautica said that among the many tear sheets Nautica swimwear designers collected was one that showed an O-ring on sandals. This O-ring became a primary inspirational source for several swimsuit designs. The designers created a bikini top centered by an O-ring and another design with an O-ring on the sides of a bikini bottom.

A designer may search trend services to research trims and findings. Forecast services, such as WGSN 👕, project trim and embellishment trends (e.g., buttons, snaps), new applications, and construction features. Designers often nurture preliminary ideas from inspirational searches (Goel 1995) and save them to use later.

Using the trend forecast information, designers shop various resources to buy trims and findings as well as to find inspiration. Designers often purchase interesting trims and embellishments during inspirational travel. Mod' Amont 👕, a Parisian trade show, and Accessories the Show 👕, a U.S.-based trade show are important trade shows that highlight emerging trends in textile trim, leather goods, and accessories (Accessories the Show n.d.; Groves 2007). Trims are an important design attribute and often trigger an inspirational idea for a complete garment. Figure 7.10 For

*Reprinted by permission from Lisa Mainardi, Prefabric Trade Show producer, DIRECTION, NewYork; pers. comm., April 5, 2004.

Figure 7.10 Fabric display at a European textile tradeshow. *(Illustration by Alison Flanagan.)*

instance, if Mod'Amont features zippers in exaggerated sizes, lace inspired by geometric jewelry and Art Deco motifs, or decorative fasteners in tarnished finishes (Foreman 2007; Mod'Amont n.d.), it may inspire designers to use the trim, find coordinating fabric, and create compatible garment silhouettes. Other resources include InfoMat ⬦, which lists trim suppliers, Accessories magazine ⬦, and the online services of findings manufacturers such as American Button ⬦.

ACTIVITY 7.8 *Visiting a Trim Show*

Go to the Moda In Web site: www.modain.it/ehtm/home.asp.

- Click on "Photogallery."
- Click on "Trend Presentation."
- Click on a picture and browse to see fabrics and textile paintings.

European Apparel Trade Shows

Apparel trade shows, listed in Table 4.3 in Chapter 4, are another design inspiration source. Although retail buyers are the primary target market of apparel trade shows, wholesale industry associates sometimes attend. Designers visit major trade shows and market weeks pertinent to their market, For example, a women's undergarment designer may visit Interfilière Lyon ⬦, a major lingerie fabric show that corresponds with Lyon, Mode City ⬦, which features lingerie and beach apparel (Interfilière Lyon n.d.; Lyon, Mode City n.d.).

Designers visit apparel trade shows to become inspired and to evaluate how foreign apparel manufacturers present their lines to their market. European apparel manufacturers show their seasonal apparel lines in booths designed according to themes. German apparel manufacturers commonly create coordinated collections with knit and woven fabrics. The collections include select fashion-forward garments designed to draw customers' attention rather than to be sold in high quantities (Eckert 1997).

At these shows, designers see a multitude of creative representations and learn how manufacturers work a theme. For instance, many German apparel manufacturers produce entire collections using coordinated colors and structural design elements (Eckert 1997). Designers evaluate product lines at trade shows for the possibility of adapting prints, textures, fabrics, or silhouettes into their own product lines.

ACTIVITY 7.9 *Shopping an Italian Apparel Trade Show*

Global regions feature a distinctive apparel look. Shop one Italian apparel trade show that is most applicable to the products you wish to design: www.pittimmagine .com/en/

Uomo	Men's clothing
Bimbo	Children's, Maturity, and Juniors clothing
Filati	Women's clothing
Tocuh!, NeoZone, and Cloudnine	Accessories
Modaprima	Women's clothing for specialty and department stores

- Click on "Exhibitors List" and then on a specific vendor's name. You can sort vendors by country locale and goods (garment type).
- Select a vendor that has a Web page, and go to the apparel manufacturer's Web site. On the Web page, select "Collections" or "Season" for photographs.
- Sketch a garment component (e.g., collar, sleeve, neckline) that interests you. Write notes on how you could incorporate the idea into an original design.

Observation of Consumers

Although clothing styles are becoming increasingly global, cultural differences inspire designers. When they travel, designers engage in **consumer observation.** This activity means that designers visually evaluate what consumers wear. When designers observe consumers, they tend to go into a mode of design thinking in which they imagine, draw, access long-term memory, and reinterpret the scene. Observing consumers is a part of the search-for-design solution process in which designers lock images into their memory. An individual's short-term memory rapidly deteriorates when using visualization alone. Thus, it is important for designers to document consumer observation by taking photographs (digital or print) or sketch when they see interesting garments or outfit combinations. When designers share information among themselves, they often refer to artifacts seen when developing garment ideas. To outsiders, designers' conversations sound like a foreign language because only the designers experienced or saw the artifacts (Stacey, Eckert, and McFadzean 1999).

Design inspiration can come from street fashion or events such as parties (Eckert 1997). **From the street** is a colloquial phrase that refers to design inspiration resulting from consumer observation (Frings 2005). **Street couture** is a similar phrase that means the juxtaposition of fashion week styles with a consumer's unique twist on putting an outfit together (Figure 7.11). E-zines, such as *Catwalk Queen* ⬆, feature street couture.

Figure 7.11 Tamee's sketch of a zipper treatment, inspired by offerings a trim tradeshow. *(Illustration by Suzette Lozano.)*

In addition to observing consumers in foreign countries, designers travel to where their consumers live and shop. Boutiques are an important inspirational source because they offer unique and risk items in their assortments. Designers shop where target consumers congregate to see what they wear for specific activities. Ronald Heimler, president and owner of Walter Heimler Inc., described consumer observation as follows:*

> Trend shopping or spotting is both challenging and inspirational. You never quite know what might inspire your creativity. It could be celebrity or media driven, art, consumer products, the natural environment or people on the street going about their daily routines. You have to be aware and alert and be able to interpret what you see. I call it an "organic process" that sort of grows on you.

ACTIVITY 7.10 *Critical Thinking*

The president in the above quote mentions designers need be alert and to interpret what they see.

- Observe your target consumer in three different locales.
- Sketch one idea for each locale, and write notes about consumer preferences for styling, colors, and current fashion trends.

*Reprinted by permission from Ronald Heimler, owner and president, Walter Heimler Inc., New York, NY; pers. comm., June 27, 2006.

Reference Resources That Enhance Inspirational Travel

You might reflect, "I shop for fabric, I get inspired, and I create designs. This is not too hard." However, when designers create seasonal product lines, trade shows and consumer observation are only two pieces of the inspirational puzzle. Additional reference resources available in both the United States and in foreign markets include personal visits to trend services, art galleries, and museums. Some of these resources are best used before inspirational travel, some can be used only during such travel, and still others are best consulted after travel.

Trend Forecast Services

Let us continue our inspirational quest by considering services that help designers learn about trend directions. **Trend forecast services** charge clients an annual membership fee. Client services include prearranged on-site trend presentations, a subscription to Web-based services, and trend reports. Seeing an on-site presentation is advantageous to designers because trend forecasters personalize the presentation to meet a company's specific needs. In addition, associates can touch and see actual objects and have access to historical trend libraries. A trend service analyzes emerging trends and provides an interpretation of future seasons 18–24 months in advance. Its goal is to provide clients with specific ways to discover new niches, brands, and strategies (Figure 7.12). Designers benefit because trend services conduct extensive research for each seasonal projection. Another advantage of trend services is that designers can plan designs knowing that solid research backs their product line plans (Sunshine 2002; WGSN–edu 2006). Alejandra Parise, freelance designer at Melrose East, highlighted some trend service benefits: "We use Trends West publication because it focuses on silhouettes, fabrics, prints, and graphics.

a b

Figure **7.12** Inspiration from a Gothic window to create a unique neckline. *(Illustration by Suzette Lozano.)*

They publish a booklet, in a convenient form, which has styles they predict will be big on the West Coast."*

Trend forecasters have extensive experience researching fashion, interiors, design, journalism, and media. An effective trend forecaster has an instinct for upcoming color trends and significant experience in working with numerous industry professionals (Global Cosmetic Industry 2007). Many trend forecasters rely on their understanding of consumer psychology and having a "street sense" to identify trends rather than using analytical tools (Momphard 2007).

Europe is the primary locale for renowned trend forecast services. British trend forecast services include the following:

- Colour Design Research Center 👕
- Global Color Research Limited 👕
- Worth Global Style Network (WGSN) 👕

Among French trend forecasters are these:

- Carlin International 👕
- Peclers Paris 👕
- Promostyl 👕

ACTIVITY 7.11 *Critical Thinking*

First, explore two of the six following trend forecast Web sites:

1. Colour Design Research Center: www.colourdesign.com/Default2.htm
2. Global Color Research Limited: www.global-color.com
3. Worth Global Style Network: www.wgsn.com/public/html/flash.htm or www.wgsn-edu.com/edu
4. Carlin International: www.carlin-groupe.com/home_uk.html
5. Peclers Paris: www.peclersparis.com
6. Promostyl: www.promostyl.com/anglais/accueil.php

Second,

- Compare the services offered by the two trend forecast companies.
- What type of job skills do you need to develop to become a forecaster?

Trend forecasters assist companies by focusing on upcoming strategies for their product lines (Momphard 2007). Trend forecast services benefit designers by helping them have a broader understanding of their target market demographics (Galadza 2007). The design team not only listens to trend forecast presentations in offices (e.g., London, New York, Tokyo), but also uses extensive information available through subscriber services. An additional service includes market segment predictions 3–5 years in advance (Carlin International n.d.; Promostyl n.d.).

Trend forecasters meet with colleagues from the interior, fashion, cosmetic, and paint industries to predict trends (Colorful Inspiration 2007). Many industry experts belong to

*Reprinted by permission from Alejandra Parise, freelance designer, Melrose East, Covina, CA; pers. comm., February 5, 2006.

the Color Marketing Association. Their members meet annually to collaborate in workshops to create seasonal color palettes (Galadza 2007).

Trend forecasters examine colors and trends from a macro view (*South China Morning Post* 2006). Forecasters study many intertwining aspects to predict trends, including business trends, consumer behavior, demographics, economics, geography, international media, lifestyle trends, and social-economic trends (Galadza 2007; Global Cosmetic Industry 2007).

Seasonal trend indicators result from extensive research and observation. For example, WGSN's think-tank experts identify cultural indicators and long-term trends that affect fashion industries. These experts look for innovation by tracking demographic trends, cultural moods, and consumer patterns. As a result, they can link dissimilar information found in the media, lifestyle monitoring, trend research, and business resources to color, key items, textiles, and styling (WGSN 2003a).

Trend forecasts predict cultural and consumer trends, which involves defining society's core values and consumer issues. For instance, a trend forecaster may predict an increase in community and family values and in connecting with other individuals. Such a forecast is not made arbitrarily. To arrive at such conclusions, researchers synthesize information from sociology, culture, technology, business, and philanthropy. *Sociological trends* include family values, marriage, and the balancing act between work and family (WGSN 2005a). *Cultural trends* are beliefs and customs of a group of people. A cultural fashion trend can include art, fashion, literature, music, nature, people, and travel (Colorful Inspiration 2007). "Green-tailing" is an example of a cultural trend. Green-tailing means companies make a real contribution to the environment (Momphard 2007). For example, The Timberland Company 👕 pledges "environmental stewardship" in which it reduces its production impact on the environment and pays its employees to participate in volunteer services (The Timberland Company n.d.). *Technological predictions* include the need to balance computer use with human interaction. Wikipedia, an open-source Internet site, is an example. *Open source* means users can contribute to the contents of a Web page (WGSN 2005a). *Business trends* are discovered from source material from retail, real estate, and economic markets. One business trend is to make retail stores a place to visit, meet friends, and have an enjoyable time. *Philanthropy* is a love or care for humankind. Buying socially responsible products is an example of a philanthropic trend (Momphard 2007).

Apparel designers need not only easy access to trend information, but also knowledge about how to interpret this information in terms of the fashion world. For instance, a bridal designer must be cognizant of the postponement of the marriage milestone, which would mean the average bride's age would be older. This trend could lead to the need for more flexible, creative bridal gowns.

Art Galleries and Museums

Visiting museums and art galleries expands an individual's horizons, and the result of such expansion is often inspiration. These places offer a wealth of resources for studying art periods, artists, and the multitude of visual arts—from culture (e.g., Black musicians), to antiquities (e.g., Egyptian tombs), to technology (e.g., the history of aviation). Designers go to large and small museums and art galleries for a vast cultural aesthetic experience. They take in as much information as possible but at the same time hope to become inspired by specific art forms. Inspiration can come from every imaginable art form, object, graphic, or

fashion item. Designers review art (e.g., paintings, sculpture) and draw symbols, impressions, or silhouettes that promote design thinking. Art pertaining to personal interests inspires designers, especially art from which they can create moods, cultural associations, color schemes, motifs, or shapes (Eckert and Stacey 2003a, 2003b) (Figure 7.13.) A designer's approach to art-inspired product lines is varied, but they tend to fall into a heuristic or planned approach. Designers who become inspired without a plan use a **heuristic approach.** A designer will look for decorative patterns, ornaments, and motifs from a wide variety of objects. For example, when designers visit museums and art galleries, they may be inspired to

Figure 7.13 Street couture mixes high fashion with sportswear worn by consumers. *(Illustration by Nina Pagtakhan.)*

capture ornamental patterns for a fabrication by looking at embroideries, carpets, or ceramic tiles (Eckert 1997). Conversely, some designers use a **planned approach** in which they do extensive searching on a specific topic before traveling. A designer with a planned approach searches the Internet and books for art forms, fashion, travel, art literature, books, films, international art, design exhibitions, and underground trends. This planned approach means that when designers view an inspirational source, they are inspired to formulate or use their memory, develop a plan, or use an alternate source (Eckert and Stacey 2003a).

Design thinking is pinnacle when designers combine dissimilar historic periods, objects, or design elements. Designer Carolina Herrera exemplifies this by her inspiration that combined elements from a portrait by a Norwegian artist who was popular in the late 1800s and Horst, a fashion photographer (Wikipedia n.d. [a]; Wikipedia n.d. [b]). From this design inspiration, Herrera created elegant dresses and tops using geometric designs and understated embellishment (Women's Wear Daily 2007).

Using a planned approach, designers could use valuable services from The Metropolitan Museum of Art (the Met) 👕. Let us use Carolina Herrera's inspiration example. The Met has an extensive collection of historical costume and period decorative arts books. My Met Museum 👕 allows registered members to collect a virtual gallery of art pieces from the Met's permanent art collection. A designer such as Herrera could search the Met's Costume Institute or Antonio Ratti Textile Center for Edvard Munch and select visual images to add to her My Met Gallery. A designer, such as Herrera, could also search *Watsonline* 👕, the museum's online library service, for Horst to search the catalog. Designers can then make an appointment with the museum curator and go peruse pertinent books (Metropolitan Museum of Art n.d. [a], n.d. [b]).

Activity 7.12 *Design Thinking*

The online services of the Metropolitan Museum of art are valuable resources to the designer.

- Click on this link to the Metropolitan Museum of Art's permanent collection: www.metmuseum.org/Works_of_Art/collection.asp. Then click on one collection (e.g., American Paintings and Sculpture).
- Click on Collection Highlights.
- Scroll through the collection until you find an art piece that interests you. Click on the photo to enlarge it.
- Narrow your focus to one small painting detail (e.g., a sleeve, face, tree branches).
- Sketch a design idea from this detail.

Note that if you actually visited the Metropolitan Museum of Art and viewed the original work, you would probably have an entirely different reaction.

Decision Making

Design illumination occurs when a designer makes a literal translation, a modification, or a symbolic interpretation. As a designer visually looks at art objects, his or her memory prioritizes and organizes light, color, and contour into meaningful patterns and forms.

When the designer views a visual object, such as Dutch art, his or her memory selects what to ignore and what to remember (Goldschmidt 1994). The individual then makes a literal translation or modifies the object into a simplistic or symbolic design (Purcell and Gero 1998). A **literal translation** is a designer's use of a design element, such as texture, that is the same as or close to the original inspirational source. **Modification** is the transformation of a design element by multiplying, deleting, and changing proportion to create a new design. Designers may simplify complex inspirational sources by selecting specific design elements (e.g., line, shape) or deleting details or intricacy from the inspirational source. Designers express abstract meanings through **symbolic interpretation,** such as deriving geometric shapes, color schemes, or cultural icons (Eckert and Stacey 2003a, 2003b). The recognition of this symbolism leads to the recall of relevant, often abstract, knowledge from the designer's long-term memory. A designer may call on imagery when viewing art. Imagery involves minimal use of drawing; rather, it allows abstract conceptual knowledge to emerge in the mind (Purcell and Gero 1998).

ACTIVITY 7.13 *Understanding a Designer's Inspiration*

Go to Style.com: www.style.com

- Click on "Fashion Shows". Select one fashion designer.
- Read the runway review and identify the designer's inspiration. Repeat with another designer until you find an inspiration that triggers your interest. Write down inspiration phrases.
- Using visual image search engines, input the key phrases you identified (e.g., Scotland, Lady Macbeth). Image search engines include AltaVista Image Search (http://www.altavista.com/image/default) and Google Image Search (http://images.google.com).
- Collect a group of pictures that represent the designer's inspiration. Print them.

Designers often use historical costumes and designs (Eckert and Stacey 2003b). They physically travel to view visual objects because they respond to different aesthetic and emotional needs, not necessarily rational ones (Goldschmidt 1994). For example, British designer Alexander McQueen combined his family heritage with historic inspiration. McQueen captured inspiration from a distant ancestor hung for witchcraft in Salem, Massachusetts. His collection showed sadistic leather breastplates, crescent headpieces, and tribal masks (Moore 2007).

When designers view visual objects, the objects provide clues that trigger the designers' long-term memory. They then isolate, recombine, or decipher the clues into a meaningful context (Figure 7.14) (Goldschmidt 1994). Eckert and Stacey (2003a) isolated the thought process of designers as they look at inspirational sources. They mentally ask themselves questions such as these:

- How can I create a design?
- What is the design's emphasis?
- Can I make a literal translation?
- Can I use design elements?

Fashion Forward
RSWD210 a b
Vivian Dress

Figure ⑦.14 (a) Dress design inspired by (b) historical and vintage fashion worn by Sophia Loren in the 1950s movie *The Pride and the Passion. (Illustration by of Rosanne Montgomery.)*

- Can I use the source in another manner?
- Can I develop the idea further?

The exciting part of design thinking is that two designers can look at the same art object and find, organize, and place importance on different clues.

Sketching at a museum or at an art gallery assists designers in reaching the illumination stage because sketching allows an individual's design thinking to emerge. Designers often immediately start sketching when they view inspirational sources, such as paintings, sculptures, or other artwork in museums and art galleries. Upon completion of a preliminary sketch, they evaluate the sketch, think about what is missing, view the inspirational source, and either add to the sketch or create a new sketch. To refine an idea, they subsequently use their own sketches rather than referring back to the inspirational source (Eckert and Stacey 2003a, 2003b). They then reinterpret the sketch so that it emerges from one idea to another idea, with analogous elements. Another approach is to sketch a preliminary idea, then draw multiple images with the same silhouette but different detailing. Synthesizing information from art pieces lends itself to later reinterpretation of preliminary sketches. This reinterpretation results in new knowledge that allows a designer to move toward the creation of a new product. When observers evaluate a designer's reinterpretations, they see incremental decision made rather than large changes (Purcell and Gero 1998).

ACTIVITY 7.14 *Engaging in Design Thinking by Using Historical Costume Inspiration*

Let us experience design thinking by using historical costumes as an inspirational source:

- Visit Internet sites for historical costume visual resources:

 The Costume Gallery: www.costumegallery.com
 Written historic costume descriptions: http://fashion-era.com
 Costume decade search (e.g., 1940s) on image search engines: www.altavista.com/image/default
 Costume Museum, Bath, England: www.museumofcostume.co.uk
 Victoria and Albert Museum: www.vam.ac.uk
 Musée de la Mode et du Textile: www.lesartsdecoratifs.fr/fr/02museemode/index.html

- Study one image.
- Sketch your inspiration from this image, using a computer graphics program.
- Study the image.
- Evaluate in your mind what is missing or needs to change.
- Revise your original sketch.

Apparel Company Design Inspiration Best Practices

Eckert (1997) recommended that design inspiration be a valued activity. Eckert noted that apparel companies need to invest in design inspiration by doing the following:

- Investing in and allowing inspirational travel to be a part of the workday (not extra hours)
- Supporting flexible work hours during design inspiration so that designers can work when they are most creative
- Keeping a company archive of art and design books to which designers have easy access
- Maintaining a historical library of the company's seasonal designs
- Creating an archive of reference garments to allow designers the opportunity to study design elements thoroughly
- Rewarding designers who go to venues such as museums for inspiration for new design ideas

SUMMARY

Shopping foreign markets, which involves visiting retail stores, trade shows, and observing consumers is an important design inspiration activity. This chapter describes the multitasking that designers do when they travel. When senior designers return, they convey information to company associates gleaned from the foreign and domestic shopping trips. Designers commonly create theme boards of European trends and a possible inspiration direction, and write a trend report. Senior designers orally present foreign shopping trip information to the design team during design review meetings. The objects, places, and

people that the senior designers experience during inspirational travel sparks design thinking. Designers need to engage in design thinking in order to reinterpret or conceive new products.

COMPANY PROJECT 6 FASHION FORECASTING ▬▬▬

Goal

To understand the depth of research that goes into forecasting a trend.

Step 1

Study international news sources to monitor international trends. The goal is to identify interconnections among major markets (e.g., Europe, United States, Asia).

Identify one news topic of possible impact on fashion covered by multiple news sources. Renowned media resources include the following:

- *British Broadcasting Corporation (BBC):* www.bbc.co.uk or www.bbc.co.uk/worldservice/index.shtml
- *Cable News Network (CNN):* www.cnn.com
- *Guardian Unlimited:* www.guardian.co.uk
- *Institute for Global Ethics:* www.globalethics.org/newsline/members/currentissue2.tmpl
- *National Public Radio:* www.npr.org

Step 2

Study emerging and existing consumer trends, consumer shopping patterns, consumer groups, global manufacture, retail, and product branding that have an impact on apparel manufacture. Renowned trend services covering demographics and lifestyle market segment trends are as follows:

- *Cotton Incorporated* (click on Lifestyle Monitor): www.cottoninc.com
- *NPD Group Fashion* (click on View All Fashion Press Releases): www.npd.com/corpServlet? nextpage=fashion-categories_s.html
- *National Retail Federation* (click on the Industry Information tab and the links below the News head, and also Consumer Trend Data): www.nrf.com
- *Retail Forward* (sign up for Retail News Today): www. retailforward.com

Connect the news topic to a consumer lifestyle trend. For example, Apple introduced iPhones in the summer of 2007 (CNNMoney.com 2007). NPD Group (2007) reports mobile phone preferences vary primarily by age: young buyers prefer functional phones with "cool" design features; young to middle-aged consumers prefer a wide range of phone capabilities; and older consumers prefer a known brand with basic capabilities (NPD Group 2007). The iPhones, while expensive, fit best with the young consumer group identified by NPD. Its features include a sleek design, a large touch screen, and the ability to play music (CNNMoney 2007).

Step 3

Monitor directions for marketing and advertising specific market segments (e.g., men's). This step involves reviewing cars, entertainment, food, health, travel, spirituality, science, technology, and work that influence your product. Some search sites include these:

- *Forbes.com* (Click on a subcategory such as Tech or Forbeslife): www.forbes.com
- *BBC magazines:* www.bbcmagazines.com

To forecast, an individual makes linkages. For instance, Forbes.com reported that there are declining numbers of women in high-tech careers (Rosmarin 2007). Linking this information to the NPD study, one could forecast that with fewer women going into high tech positions, there would be less demand to market technological gadgets on mobile phones toward female executives. Forecasting is often an educated guess, rather than solid fact.

Step 4

Review the fashion inspiration direction. Trend forecasting is not complete without a review of global fashion trends. Some search sites are as follows:

- *Infomat* (Click on Trend subheadings): www.infomat.com/trends/index.html
- *Fashion Windows* www. fashionwindows. com (subscription)
- *Made In Italy* (Click on Fashion Houses) www. made-in-italy.com/fashion/fashion_houses/gattinoni/intro.htm
- *French Fashion* (Select branch, for example ready-to-wear): www.frenchfashion.com/searchprod.php

Step 5

Predict one trend that influences your consumer target market. Write a description of how you forecasted this trend.

PRODUCT DEVELOPMENT TEAM MEMBERS ■■■■■

The following product development team members were introduced in this chapter:

Trend forecasters: Experts on cultural indicators, consumer patterns, and long-term trends. Trend forecasters have extensive experience researching fashion, interiors, design, journalism, and media. An effective trend forecaster has a solid art or design education, a good eye for color, the desire to inspire, and significant experience working with numerous industry professionals.

KEY TERMS ■■■■■

Concept stores: Stores in which retailers test new products.
Consumer observation: Visually evaluating individuals and consumer groups for documentation and inspiration.

Design thinking: Designers' use of images to reinterpret or conceive of new products.

Fast-fashion: Knockoff garment styles from venues such as fashion weeks and trade which are shows offered quickly in the marketplace at a lower price point.

Findings: Functional fasteners (e.g., zippers and buttons) and construction components (e.g., labels).

Flagship store: A global retail store that offers experimental designs, innovative merchandise displays, and trend-setting ideas. It best conveys a company's vision.

From the street: Inspiration from consumer observation (Frings 2005).

Heuristic approach: A designer's approach to art-inspired product lines that involves becoming inspired without a plan before traveling.

Inspirational travel: Designers' review of colors, themes, fabrications, and silhouettes in global markets.

Literal translation: A designer's use of a design element, such as texture, that is the same as or close to the original inspirational source.

Memory trigger: A product in the marketplace or an existing object from which a designer can directly incorporate or modify elements to create an original idea (Dahl, Chattopadhyay, and Gorn 2001).

Minimum: The lowest quantity a buyer can purchase; minimum quantities vary among suppliers and fabric types.

Modification: The transformation of a design element by multiplying, deleting, and changing proportion to create a new design. Designers may simplify complex inspirational sources by selecting specific design elements (e.g., line, shape) or deleting details or intricacy from the inspirational source.

Planned approach: A designer's approach to art-inspired product lines that involves searching the Internet and books for art forms, fashion, travel, museums, and art galleries before traveling.

Prefabric: Art (including hand paintings, embroideries, and computer files) created by textile design studios or stylists that is translated into products.

Reference items: Products designers study or purchase to use in design development.

Reviewing retail store trends: Purchasing products, photographing window and interior displays, sketching ideas, and evaluating how a store combines product assortments.

Street couture: A consumer's unique twist of combining designer fashions with ready-to-wear clothing.

Symbolic interpretation: The way in which designers express abstract meanings. Examples are deriving geometric shapes, color schemes, or cultural icons (Eckert and Stacey 2003a, 2003b). The recognition of this symbolism leads to the recall of relevant, often abstract, knowledge from the designer's long-term memory.

Trade show: The wholesale offering of raw materials or services.

Trend forecast services: Organizations that analyze emerging trends and provide an interpretation of future seasons.

Trend shopping: Observing or purchasing multiple objects and then making connections between what is available and what is needed or desired (Hine 2002).

Trims: Decorative embellishments placed on garments, such as netting, fringes, and pom-poms.

WEB LINKS ▰▰▰▰▰▰▰▰▰

Company	URL
10 Corso Como	www.10corsocomo.com
ABM Fashion Sourcing	www.abm-usa.com
Accessories the Show	www.accessoriestheshow.com/trends.html
Alexander McQueen	www.alexandermequeen.com/flash.html
American Button	www.abm-usa.com/
Aquascutum	www.aquascutum.co.uk
Balenciaga	www.balenciaga.com
BBC Country Profiles	http://news.bbc.co.uk/2/hi/country_profiles/default.stm
Browns	www.brownsfashion.com
Burlington Arcade	www.burlington-arcade.co.uk
Camden Market	www.camdenlock.net/camden.html
Carlin International	www.carlin-groupe.com/home_uk.html
Catwalk Queen	www.catwalkqueen.tv
Colette Paris	www.colette.fr
Colour Design Research Center	www.colourdesign.com/Default2.htm
Dolce & Gabbana	www.dolcegabbana.it
Expofil	www.expofil.com/?page=01&lang=en
Galleries Lafayette	www.galerieslafayette.com/international/goFolder.do?f=home_en&sf=home_en_accueil&lang=en&fontLang=latin
Gianfranco Ferré	www.gianfrancoferre.com
Giorgio Armani	www.giorgioarmani.com/index.html
Global Color Research Limited	www.global-color.com
H&M	www.hm.com
Harrods	www.harrods.com/Cultures/en-GB/Home/homepageindex.htm
Harvey Nichols	www.harveynichols.com/output/Page1.asp
House of Fraser	www.houseoffraser.co.uk
Ideabiella	www.ideabiella.it
Ideacomo	www.ideacomo.com/default.asp?pag=fiera-tessile-ideacomo&IdLingua=2
Indigo	www.indigo-salon.com/index.php?p=2&lang=en
InfoMat	www.infomat.com
Interfilière Lyon	www.interfiliere.com
Interstoff	http//interstoff.messefrankfvit.com/global/en/home.html
Jones Apparel Group	www.jny.com/main.jsp?event=main
J. Jill	www.jjill.com
John Lewis	www.johnlewis.com/Default.aspx
Jones Apparel Group Inc.	www.jny.com/index.jsp
Karen Kane Inc.	www.karenkane.com/MainMenu.htm
la Rinascente	www.rinascente.it
Liberty	www.liberty.co.uk
London Edge	www.londonedge.com
Lyon, Mode City	www.lyonmodecity.com
Made-In-Italy	www.made-in-italy.com/fashion/about.htm
Marks & Spencer	www.marksandspencer.com

Metropolitan Museum Educational Resources	www.metmuseum.org/education/er_lib.asp
Metropolitan Museum Permanent Collection	www.metmuseum.org/Works_of_Art/collection.asp?HomePageLink=permanentcollection_1
Milano Unica	www.milanounica.it/eng_home.php
Mitsukoshi	www.mitsukoshi.co.jp/index.jsp
Mod'Amont	www.modamont.com/us/salon.html
Moda In Tessuto Accessori	www.modain.it/ehtm/home.asp
Mulberry	www.mulberry.com
My Met Museum	www.metmuseum.org/mymetmuseum/index.asp?HomePageLink=mymetmuseum_r
Omotesando Hills	www.omotesandohills.com/eng/index.html
Peclers Paris	www.peclersparis.com
Pitti Immagine	www.pittimmagine.com/en/
Pitti Immagine Filati	www.pittimmagine.com/en/fiere/filati
Prada	www.prada.com
Prato Expo	www.pratoexpo.com/newsite/english/defaultpratoexpo.asp
Première Vision Pluriel	www.premierevision.fr/?page=01&llang=en
Première Vision's Fashion Information	www.premierevision.fr/?page=13&lang=en
Pringle of Scotland	www.pringlescotland.com/index_flash.html
Printemps Department Store	http://departmentstoreparis.printemps.com
Promostyl	www.promostyl.com/anglais/accueil.php
Seibu	www2.seibu.co.jp/usrinfo/index.html
Selfridges & Co.	www.selfridges.com/index.cfm?page=1001
Shirt Avenue	www.shirt-avenue.com/inglese/home.htm
Sisley	www.sisley.com/Site/Index.php
Sixty Group	www.sixty.net
St. Christopher's Place	www.stchristophersplace.com
Takashimaya	www.takashimaya.co.jp/index.html
The Metropolitan Museum of Modern Art	www.metmuseum.org
Timberland Company	www.timberland.com/timberlandserve/timberlandserve_index.jsp?clickid=bottom_timserv/
Tischi	www.tischi.com
Topshop	www.Topshop.co.uk
United Colors of Benetton	www.benetton.com/html/index.shtml
Vivienne Westwood	www.viviennewestwood.com/flash.php
Worth Global Style Network	www.wgsn.com/public/home/html/base.html
Worth Global Style Network (WGSN)	www.wgsn.com/public/html/flash.htm
Worth Global Style Network–Education	www.wgsn-edu.com
Yves Saint Laurent	www.ysl.com

REFERENCES

Accessories the Show, n.d. About us. http://accessoriestheshow.com/about.html (accessed May 14, 2007).

Agins, T. 2007a. Boss talk. A special report. Goodbye, mainstream: Where do you find the latest fashion trends these days? Everywhere, says David Wolfe. *Wall Street Journal*, January 22, sec. R.7.

Agins, T. 2007b. Fashion journal. The future of luxury: Custom fashion, cheap chic; designer Tom Ford on finding individual style today; to have something different. *Wall Street Journal*, January 4, sec. B.7.

Anand, B., E. Carpenter, and S. Jayanti. 2005. Oscar de la Renta. *Harvard Business Review*, March 29. Reprint No. 9-704-490.

Beatty, S. 2004. From catwalk to sidewalk. *Wall Street Journal*, February 6, sec. B.1, B.3.

Borland, V. S. 2006. Function joins fashion for 2007–2008. *TextileWorld* November/December, 48-51. WilsonWeb

British Broadcasting Corporation (BBC) World Service. n.d. Our London: Shopping. http://www.bbc.co.uk/worldservice/specials/1711_Shopping/index.shtml.

Brown, P., and J. Rice. 2002. *Ready-to-wear apparel analysis*. 3rd ed. Upper Saddle River, NJ: Prentice Hall.

Bruni, F. 2004. Italy fights to remain the home of luxury fabrics. *New York Times*, February 24, sec. B.8.

Carlin International. n.d. Trends spotting. http://www.carlin-groupe.com/ home_uk.html.

CNNMoney.com. 2007. Apple's iPhone cleared for sale. http://money.cnn.com/2007/05/17/technology/bc.apple.iphone.reut/index.htm?postversion=2007051717.

Colorful inspiration. 2007, March. *Global Cosmetic Industry*. Vol 175 No. 3 p. 5–6.

Dahl, D. W., A. Chattopadhyay, and G. J. Gorn. 2001. The importance of visualization in concept design. *Design Studies* 22 (1): 5–26.

Dennis. S. 2006, September 29. Tradeshows, Indigo. Worth Globle Style Network http://www.wgsn-edu.com (Accessed May 19, 2007).

Eckert, C. 1997. Design inspiration and design performance. Paper presented at the 78th World Conference of the Textile Institute in association with the 5th Textile Symposium, Thessalonika, Greece.

Eckert, C., and M. Stacey. 2000. Sources of inspiration. *Design Studies* 21 (5): 523–38.

Eckert, C., and M. Stacey. 2003a. Adaptation of sources of inspiration in knitwear design. *Creativity Research Journal* 15 (4): 355–59.

Eckert, C., and M. Stacey. 2003b. Sources of inspiration in industrial practice. The case of knitwear design. *Journal of Design Research* 3 (1): 1–18. http://www.inderscience.com/search/index.pjp?action=record&rec_id=9826&prevQuery=&ps=10&m=or.

Epiro, S. 2007. Momentum builds for Italian mills at Unica. *Women's Wear Daily*, February 20.

Fodor's. n.d.(a). London: Shopping overview. http://www.fodors.com/miniguides/mgresults.cfm?destination=london@91&cur_section=sho&showover=yes.

Fodor's. n.d.(b). Milan: Shopping overview. http://www.fodors.com/miniguides/mgresults.cfm?destination=milan@103&cur_section=fea&feature=30004.

Fodor's. n.d.(c). Paris: Shopping overview. http://www.fodors.com/miniguides/mgresults.cfm?destination=paris@117&cur_section=sho&showover=yes.

Foreman, K. 2007. Art, jewelry inspire lace. *Women's Wear Daily*, February 27.

Frings, G. S. 2005. *Fashion from concept to consumer*. 8th ed. Upper Saddle River, NJ: Prentice Hall.

Frommer's. n.d.(a). Destinations: Asia: Tokyo: Shopping. http://www.frommers.com/destinations/tokyo/85_indshop.html.

Frommer's. n.d.(b). Destinations: Europe: London: Shopping: Street & flea markets. http://www.frommers.com/destinations/london/0055026556.html.

Frommer's. n.d.(c). Destinations: Europe: Paris: Shopping. http://www.frommers.com/destinations/paris.

Galadza, S. 2007. Ahead of hue. *Contract*, January.

Goel, V. 1995. *Sketches of thought*. Cambridge: MIT Press.

Goldschmidt, G. 1994. On visual design thinking: The vis kids of architecture. *Design Studies* 15 (2): 158–74.

Groves, E. 2007. Return to quality spurs confidence for Première Vision. *Women's Wear Daily*, February 13. http://www.premierevision.fr/index.php?page= 13&lang=en (accessed May 18, 2007).

Guerra, G. 2006. Tokyo. *Lucky Magazine*, March 255–62.

H&M. n.d. *Annual report 2005 in English*. http://www.hm.com/us/annualreportarchive.ahtml?y=2005.

Hine, T. 2002. I want that: How we all became shoppers. New York: HarperCollins.

Hirano, K. 2006. Bottega Veneta unveils flagship in Omotesando. *Women's Wear Daily*, April 25 (accessed June 11, 2006).

Interfilière Lyon. n.d. Home page. http://www.interfiliere.com

Karen Kane, Inc. n.d. About Karen. http://www.karenkane.com/aboutkaren.htm.

Lal, R., and A. Han. 2005. Overview of the Japanese apparel market. *Harvard Business Review*, June 14. Reprint No. 9-505-068.

London Edge. n.d. Home page. http://www.londonedge.com.

Lyon, Mode City. n.d. Home page. http://www.lyonmodecity.com.

Made-In-Italy. n.d. Home page. http://www.made-in-italy.com/fashion/about.htm (accessed March 19, 2004).

McAllister, R. 2006. Retailing the ZARA way. *California Apparel News*, June 9–15.

Metropolitan Museum of Art. n.d.(a). Educational resources. http://www.metmuseum.org/education/index.asp?HomePageLink=educational.

Metropolitan Museum of Art. n.d.(b). My Met Museum. http://www.metmuseum.org/mymetmuseum/my_main.asp.

Milano Unica. n.d.(a). A brief history: Ideabiella. http://www.milanounica.it/storia_1_ideabiella_eng.php (accessed April 20, 2007).

Milano Unica n.d.(b). A brief history: Ideacomo. http://www.milanounica.it/storia_2_ideacomo_eng.php (accessed April 20, 2007).

Milano Unica. n.d.(c). A brief history: Prato Expo. http://www.milanounica.it/storia_5_pratoexpo_eng.php (accessed April 20, 2007).

Milano Unica n.d.(d). A brief history: Shirt Avenue. http://www.milanounica.it/storia_4_shirtavenue_eng.php (accessed April 20, 2007).

Mitsukoshi, Ltd. n.d. Company profile: 2005 Annual report.

Mod'Amont. n.d. http://www.modamont.com/us/salon.html.

Momphard, D. 2007. What's the big idea? Fashion brands are increasingly turning to a network of sartorial spies to spot trends and make them their own. *South China Morning Post*, May 18.

Moore, B. 2004. Trends, London style: Topshop's knockoffs and originals satisfy the fashion imagination. *Los Angeles Times*, February 20.

Moore, B. 2005. Milan: The land of the spree. *Los Angeles Times*, April 24, sec. L.1, L.8–L.9.

Moore, B. 2006a. The fall 2006 collections. *Los Angeles Times*, March 4.

Moore, B. 2006b. Shopping London: Try it on for size. *Los Angeles Times*, May 7, sec. L.1, L.6.

Moore, B. 2007. The fall collections: Defining a certain je ne sais quoi. A quieter elegance, good craftsmanship, and subtle design elevate fashion week trends. *Los Angeles Times*, March 6, E1.

NPD Group. 2007. The NPD Group: What motivates mobile phone buyers to buy? Press release. February 27. http://www.npd.com/press/releases/press_070227.html.

O'Connell, V. 2007. Fashion journal: How fashion makes its way from the runway to the rack; J.C. Penney's "trend director" interprets style for the masses; "It is all about the turtleneck. *"Wall Street Journal*, February 8, D.1.

Palmer, H., and P. Watkins. 2006. Trade shows: Expofil. April 10. Worth Global Style Network.

Perks, H., R. Cooper, and C. Jones. 2005. Characterizing the role of design in new product development: An empirically derived taxonomy. *Journal of Product Innovation Management* 22, 111–27.

Pitti Immagine. n.d. Company: History and mission: Mission. http://www.pittimmagine.com/en/company/storia/mission.php (accessed April 20, 2007).

Pitti Immagine Filati. n.d. Pitti Immagine Filati N. 60. http://www.pittimmagine.com/en/fiere/filati/pressroom/2007.php accessed May 13, 2007).

Pitti Immagine Filati. 2007. Multimedia: Photo gallery: 2007. http://www.pittimmagine.com/en/fiere/filati/multimedia/gallery/2007/ed.php (accessed April 20, 2007).

Premiere Vision Pluriel. 2006a, February. Fashion Info February 2006 Salon. News release. http://www.premierevision.fr/index.php?page=01&lang=en (accessed 18 June 2006).

Première Vision Puriel. 2007. Fashion information. Press release. http://www.premierevision.fr/index.php?page=12&lang=en (accessed May 20, 2007).

Promostyl. n.d. Where does fashion come from? http://www.promostyl.com/anglais/accueil.php.

Purcell, A. T., and J. S. Gero. 1998. Drawings and the design process. *Design Studies* 19 (4): 389-430.

Regan, C. L. 1997. A concurrent engineering framework for apparel manufacture. PhD diss., Virginia Polytechnic Institute and State University.

Rosmarin, R. 2007. Tough, tech-smart—and female. *Forbes.com*, May 17.

Sanchanta, M. 2006a. Bags of fun: Where was Louis Vuitton's first prêt-a-porter show outside Paris? Tokyo, bien sur, says Mariko Sanchanta. *Financial Times*, June 10.

Sanchanta, M. 200b. Japan: Youngsters display a yen for expensive stuff. *FT.com*, June 5.

Sistema Moda Italia. 2005. September. Facts and figures for the Italian fashion system. http://www.sistemamodaitalia.it/home.php3.

Sixty Group. n.d. Brands. http://www.sixty.net/brands.php.

Stacey, M. K., C. M. Eckert, and J. McFadzean. 1999. Sketch interpretation in design communication. In *Proceedings of the 12th International Conference on Engineering Design (ICED '99)*, ed. U. Lindemann, H. Birkhofer, H. Meerkamm, and S. Vajna, vol. 2, 923–28. Munich, Germany: Technical University of Munich.

South China Morning Post. 2006. Young and healthy is trendy: Committee examines global preferences and identifies four themes in the apparel industry for this year. September 27.

Sunshine, B. 2002, July 26. Industry view: Trend forecasting. http://www.wgsn.com/public/home/html/base.html (accessed February 24, 2004).

Takashimaya Company Limited. n.d. 2006 Annual report. http://www.takashimaya.co.jp/corp/English/index.html.

The Timberland Company. n.d. Timberland: Make it better™. http://www.timberland.com/timberlandserve/timberlandserve_index.jsp?clickid=bottom_timserve_img.

United Colors of Benetton. n.d. Group overview—Company profile. http://www.benettongroup.com/investors.

U.S. Securities and Exchange Commission. 2006. February 28, 2006. *Form 10-K: Annual report for the fiscal year ended December 31, 2005, Jones Apparel Group, Inc.* http://www.sec.gov/Archives/edgar/data/874016/000087401606000010/form10k_2005.htm.

U.S. Securities and Exchange Commission. 2007. April 17, 2007. *Form 10-K: Annual report pursuant to section 13 or 15 of the Securities Exchange Act of 1934, for the fiscal year ended February 3, 2007, The Wet Seal, Inc.* Washington, DC: U. S. Government Printing Office.

Wikipedia. n.d.(a). Edvard Munch. http://en.wikipedia.org/wiki/Edvard_munch (accessed May 19, 2007).

Wikipedia. n.d.(b). Horst P. Horst. http://en wikipedia.org/wiki/Horst_P._Horst (accessed May 19, 2007).

Williams, C. 2007. Globe-trotters. *Women's Wear Daily*. May 1.

Women's Wear Daily. 2006a. Fashion Scoops: Tokyo fever . . . Russian around . . . oh brother. April 13.

Women's Wear Daily. 2006b. Tokyo time: The Japanese capital is a shopper's dream—especially the hip new area of Omotesando Hills—so WWDScoop asked Where to Wear (wheretowear.com), which publishes nine shopping guides worldwide, to highlight some of the latest must-visits. March 13.

Worth Global Style Network–Educational. 2002. WGSN-edu think tank: Consumer attitudes. http://www.wgsn-edu.com/edu/ (accessed February 25, 2004).

Worth Global Style Network–Educational. 2003a. WGSN-edu think tank: About think tank. http://www.wgsn-edu.com/edu/ (accessed February 25, 2004).

Worth Global Style Network–Educational. 2003b. WGSN-edu think tank: Consumer attitudes. http://www.wgsn-edu.com/edu/ (accessed February 25, 2004).

Worth Global Style Network–Educational. 2005a. Site map: Think tank archive: Consumer attitudes autumn/winter 2006/2007, core values. http://www.wgsn-edu.com/edu/ (accessed September 15, 2006).

Worth Global Style Network–Educational. 2005b. Site map: Retail talk archive: About retail talk. http://www.wgsn-edu.com/edu/ (accessed June 6, 2006).

Worth Global Style Network–Educational. 2006. Benefits. http://www.wgsn-edu.com/edu/ (accessed September 15, 2006).

Yoko, O. 2007. Japanese fashion business: Tradition and innovation. *Economy, Culture & History—Japan Spotlight Bimonthly,* March 3.

Communicating Product Strategy: Themes and Resources

THE BIG APPLE AND SORE FEET

Ten days later, Tamee wakes to the sound of the ringing phone. "What? What time is it? Who's calling so early? Breakfast? Twenty minutes?" She yawns and stretches, regretting that she's only had a few hours of sleep. Yesterday, she rearranged her flight so she could finish the Beauté theme board. Anne had insisted that Tamee finish the project because Kate expected to use it on their trip. The others flew in yesterday afternoon. She worked all day and took the red-eye flight, arriving at the hotel at 4:30 a.m. She thinks, "Let's see—I slept a few hours on the plane and a few here. Four hours. Back in college, that would have been plenty." With a busy day ahead of her, she slowly begins to get ready.

The group is already gathered at the deli around the corner from their hotel.

"Wow, have you ever seen so many bagels?" asks Jason.

"Not since I was last in New York," says Anne, ordering a large blueberry bagel with hazelnut cream cheese spread.

"They look too huge for me," says Lauren.

"You'd better eat up, Lauren. We have a big day planned. You're going to need a lot of energy. Has anyone seen Tamee this morning? Did she make it in on the red-eye?" asks Kate.

"I called her about 20 minutes ago to warn her about breakfast. It sounded like I woke her up," says Lauren, who was debating between a cinnamon apple bagel or a plain one with lox and cream cheese. "I wonder if they have any low-carb bagels."

Once their orders are filled, the group pushes two small deli-size tables together and sits down for breakfast.

"This is my first big fashion buying trip. Kate, I'm so glad that you insisted that all of us come to New York City to learn about industry clusters. Wow, can you believe how busy it is out there already this morning? The streets were about this crowded late last night. Does this city ever go to sleep? Here's to an exciting day!" Lauren says, as she holds up her orange juice in a mock toast.

Tamee rushes in to join the group after ordering a large coffee and a breakfast bagel. She plops down her oversized ochre soft leather tote and attaché case, and then collapses into a chair.

"Did you get any sleep at all? Good thing you got yourself a large coffee," says Jason, looking more like a professional than anyone can remember. Instead of his usual sport shirt and jeans, Jason has on a pair of chino slacks and a polo shirt. His usual spiked hair is combed down.

"Well, don't you look respectable?" Tamee says, smiling at Jason. "I'm pretty pooped, but once I start seeing fabrics and trims, I think I'll get a second wind."

Tamee carefully removes the theme board from her attaché case and hands it to Kate.

Kate scrutinizes it. "Your technique and layout are really good. I'm impressed!"

Jason looks over Kate's shoulder. "That looks awesome. Did you use the new software program?"

"Ooh, that's gorgeous. It looks like a Monet," Lauren says, peeking up from her tour guide. "You know, I did take an art history class in college."

Anne catches Tamee's eye with a knowing wink, and they exchange a smile, recalling the decision they made in Paris to use Monet for their inspiration.

Kate says, "Before we head out, let's go over our schedule. Today, we'll meet with apparel vendors. Tomorrow, Ron and Anne will have a meeting at Huntington Industries. Lauren, Jason, and Tamee, you will visit Huntington Industries' corporate showroom. As you attend your appointments, try to remember our design objectives. I asked Tamee to bring her theme board because it's important for you to see the connection between your theme and your company's mission."

Ron speaks up, "Our mission is to provide unique, youthful, artistic, professional women's clothing that helps them perform their jobs better."

Tamee brightens up after gulping down her first cup of coffee. "I was aiming for artistic and professional; I have put together a lot of theme boards, but Kate helped make the connection to our mission."

"And, we need to consider our target market, right?" Lauren asks.

"That's right. Creating design objectives means that the line's image is portrayed by core styles, colors, or fabrics, which are relevant to the target market. I want each of you to consider how 'artistic and professional' relates to the vendors' product lines. Do you have an idea of a core fabric, Anne?"

"We saw this fabulous silk/polyester blend at Première Vision and a cotton/cashmere yarn at Expofil. I think we can use it for multiple seasons."

Ron says frowning, "Mr. O'Dale has asked us to use the corporate textile vendors. I think we are going to discuss supplier partnership agreements in our meeting tomorrow at Huntington Industries."

"The samples we saw were for inspiration, and to anticipate your next question, yes, they were too expensive for our cost structure," Anne replies.

"You will be meeting four textile converters and manufacturers that have partnership agreements with Huntington Industries. Anne, you'll want to describe your fabric inspiration at those meetings." Lauren suddenly stands up as Kate continues, "Our first appointment is at Cotton Incorporated, a fiber marketing service. Here is our itinerary. We have a busy day!"

"Will there be time for sightseeing or shoe shopping?" Lauren asks, folding up a visitor's brochure and stuffing it in her purse.

Walking along, they come to Cotton Incorporated, Lauren looks up at all the tall buildings on Madison Avenue and walks right into Jason.

"Ouch! Watch those dagger heels of yours, Lauren," Jason says as they walk into the building.

The group settles into the Cotton Incorporated seminar room and forecaster begins her presentation. "For the spring season, we have two main inspiration color themes," the color forecaster begins, "water lilies and jewels." Anne and Tamee exchange smiles,

knowing their inspiration was in concert with the trends. The forecaster shows the group a DVD presentation of water lilies, extraordinary jewels, and color swatches, and then talks about color stories that will be popular in the upcoming season.

Ron's eyes glaze over at the color forecaster's presentation. He stands up, stretches, and says, "What is she talking about? Colors in your dreams are supposed to be gypsy lavender?"

Anne shushes him, "Pay attention!"

The forecaster smiles and says, "You are welcome to look at our fabric resource library. It's in the room down the hall." Taking the hint, Ron and Jason quickly escape.

Tamee, squirming in her seat with anticipation, starts sketching and taking notes. "The colors are so exciting. Sage green would work well with my Beauté theme, Anne. I like the cotton/linen blend with a touch of stretch for our skirts and pants."

After checking out the fabric library, the group makes a quick consensus to stop for lunch. "My stomach has been growling for the last hour," says Lauren.

"I saw a bistro on our way here. I think it's just down the street. Let's go check it out," says Jason, who is so hungry he could eat three meals.

"Shall we sit outside?" asks Jason as they approach a typical New York bistro with black and white striped canvas awnings and a wrought iron fence around the outdoor seating area.

"No, let's eat inside. I've been freezing since we landed. And with all these tall buildings there's no sunlight to warm me up," Anne says, shivering as she heads into the restaurant.

Lauren is excited to see Japanese-style Udon soup on the menu. "Oh, that sounds good. We'll see if it's as good as my mother makes."

Ron and Jason opt for the pasta special. Tamee chooses a personal brick oven pizza with goat cheese and basil. Anne and Kate laugh when they simultaneously announce that they are ordering the chicken and spinach salad. "I love spiced pecans and gorgonzola cheese," says Anne, anxious to start on hers.

"What did you think about the fiber marketing services?" Kate asks, her eyes scanning the others.

"I really liked the library. I can get on their Web site and check for multiple textile suppliers to locate fabrications," Jason says.

"Before today, I always thought of trends as a means to provide an economic forecast, such as the amount of disposable income that consumers have. But color and trend forecast is a completely new discipline," says Ron, scratching his brow. "I'm beginning to understand design thinking and why the design process is hard to explain to an operations person like me."

Kate smiles, "Now, who can tell me how this trend forecast fits into your product strategy?"

"Well," begins Anne, "Our strategy is to provide youthful professional clothes, so I need to rethink our color stories. Our spring palette has been too pastel. To fit with the youthful consumer and be on target with the trend services, I think we need to use more colors found in nature."

"Strategy! I love it when she talks about strategy," Lauren says, just as the food is being served. "Oh, this Udon smells good! I can't wait to taste it."

"So if we incorporate this trend information, our clothes will sell at full retail! Right?" Ron asks.

"It is one piece of the merchandising puzzle." Looking at her watch, Kate encourages everyone to eat as quickly as possible. "We have to get going, gang; we need to walk eight blocks to our next destination. We're headed toward the Fashion Center between 37th and 41st streets." Kate prods them along. "We will be seeing four different textile converters and manufacturer showrooms for 30-minute appointments. It is important to meet representatives face-to-face even though you will do most of your business on the phone or via the Internet or e-mail."

Once outside, Ron looks at his PDA and says, "Kate, I agree with you. Even though I'm a great fan of technology tools, there is nothing better than shaking a person's hand and looking him or her in the eye."

"Talk about technology... is that a new phone?" asks Jason as he gets a better look.

"This is the newest iphone. It has a phone, an MP3 player, a camera, and a video camera. It has Wi-Fi connectivity, as well as cellular quad band access and a touch screen," Ron says.

"That's really awesome! It has an iPod too, so you can listen to music," remarks Jason. By now, the two guys are lagging behind the women.

Later that afternoon, they walk by a trim supplier, and Tamee dashes inside. She noticeably inhales as she gazes at the seemingly unlimited array of buttons and trims. "This place has over 600,000 trims," Anne says, referring to the sign on the wall.

Ron sees the look in Tamee's eyes and states firmly, "Try to remember that we have a design budget. Don't go crazy!" Tamee just nods her head absentmindedly.

Lauren finds Jason wandering through the immense showroom. "Are we ever going to get Tamee out of this place? For someone who only got a few hours of sleep, she sure has a lot of energy! My feet are killing me. I need to sit down," Lauren says.

"It's no wonder in those four-inch high heels; I can tell you are not a native New Yorker. They walk everywhere in Manhattan!" Jason says.

About that time, Kate reminds the group of the textile design trade show. "It's only a block away."

Lauren lags behind the group as she limps down the block, and for the first time in her life, regrets her shoe choice.

"Wow, look at some of these prints, Anne. Wait! Look at this one with all the swirls, or this one; this is so cool!" Tamee says as she flips through various fabric paintings.

"Tamee, remember what I said about strategy? The prints we select must fit in with our product strategy or our designs will not sell. Now, do the neon swirls really fit into Rare Entities' strategy?" Kate asks, bringing Tamee back to reality.

"I guess they don't," Tamee says, the excitement in her voice subsiding.

Ron approaches Anne and Tamee as they are looking at a particular print at the show, "I had no idea there were so many paintings for fabrics. Have you found anything good?" Ron asks, nudging Anne's elbow.

"We were looking at this," she says, pointing to an Impressionist watercolor. "It looks like a kaleidoscope. I think it would really work well," she goes on, mentally visualizing what the design would look like for a skirt and jacket lining.

"How much does it cost?" Ron asks, with trepidation in his eyes.

"This one is $500, so not too bad," Anne says casually.

"$500! That is ridiculous; it is just a painting, and it's not even framed!"

"These paintings are original. We can use a painting like this in four or five pieces. It creates continuity in the line. We either pay for it, or there are no prints in the product line."

"If you say so...," Ron slowly replies, loosening his tie.

"You're a good man," Anne says as she gives him a playful pat on the cheek.

Ron starts to walk down the aisle to find Jason, who is in another hall visiting trim suppliers. He turns to catch a glimpse of Anne. She senses him looking at her and gives him a wink and a smile.

On their second day in New York, Kate waits patiently for the group to meet her in the hotel lobby to review their progress. She wants them to have clear design objectives.

Once the younger members of the team finally join her, Kate begins, "I hope everyone slept well last night. You will be meeting important people today, your retail customers. As you know, Ron and Anne are meeting with Mr. O'Dale this morning."

"Sleep? Were we supposed to sleep? I don't know about you, but I definitely need some coffee before I can do anything. Lauren kept me up way too late. We went down to SoHo," Jason says groggily as Lauren nods in agreement, rubbing her feet, sore from dancing late last night.

"Sorry I was such a party pooper, guys, but I had to get some sleep!" says Tamee, who had opted to stay in the hotel.

"Let's go...your retail buyers will be at Huntington Industries' showroom in an hour."

After a harrowing taxi ride in noisy traffic, the group arrives at the showroom. Tamee immediately spots Rare Designs' line at the back of the large room that showcases the ten companies that make up Huntington Industries.

They then meet the manufacturer representative who recently acquired Rare Designs' Northeast territory. The morning is hectic, with different retail buyers arriving every 15 minutes.

Later that afternoon, Jason visits a local bakery and returns to Huntington's showroom with his arms loaded. "I brought everyone some authentic New York cheesecake and coffee. Let's find a place to sit and take a break. I need to chill for a bit. I'm not used to listening to two people talking at the same time. It's hard to keep up with New Yorkers!"

"Our retail buyers are certainly very opinionated. It was a good experience to show them our current line. It will really help improve my designs. Next season, our line will be placed front and center in this showroom. It's going to be our best line yet!" Tamee says, gesturing to that area of the room.

"Market week is hectic," Lauren says. "I've never talked to so many people in one day. Oh, here come some more." She gulps down some coffee and a few bites of cheesecake, and then jumps up and greets the buyers. "Hi, I'm Lauren from Rare Designs."

Objectives

After reading this chapter, you should be able to do the following:

- Write decision-making activities on the time-and-action calendar, and understand their dependence on completing other activities.
- Comprehend how designers formulate a theme and its corresponding layout.
- Set design objectives for a product line.
- Understand the personal relationships that make up an apparel cluster and use best practices.
- Understand fiber marketing and color services.
- Grasp how designers buy textile designs.
- Identify the design services offered by textile converters and manufacturers.
- Create a theme board.

Designers and merchandisers often have many creative ideas to convey to their associates when they return from inspirational travel. Designers creatively mesh seasonal direction, design inspiration, and words from the company's mission statement to create a seasonal theme. Designers create a seasonal theme board as a launching point to create the seasonal product line direction. Once designers set the theme, they create a mental shopping list of services and supplier resources, which they buy from suppliers in industry clusters. Designers, as well as other business associates, use industry clusters to efficiently seek and purchase raw materials. This chapter focuses on traveling to an apparel cluster; however, some designers use alternate approaches, such as accessing Internet services and calling manufacturer representatives.

The Design Environment

Before discussing how designers set design objectives, it is beneficial to understand what a design space looks like. A common approach is to set a designer's job responsibilities and physical space by strategic business unit (SBU) as described in Chapter 3. Warnaco Swimwear Inc. 👕 is one company that has separate design spaces by brand. Lifestyle companies such as Patagonia 👕 and Hurley 👕 have design environments that reinforce their brand image. The company physically groups designers by brands or licenses. For instance, Warnaco Swimwear, Inc. has shared design space for its Nautica swimwear. The design team creates product line groupings on wall grids and meet with textile vendors in a group space, which is surrounded by individual offices. Many apparel manufacturers have an interior décor and architectural features that reinforce their company image. Warnaco Swimwear, Inc.'s ambience, typical of many

apparel manufacturers, is an industrial building with a maze of offices inside. Outside there is an Olympic-size pool that the company uses to photograph athletes wearing swimwear. Patagonia, a lifestyle company, has its headquarters located close to the Pacific Ocean. The reception area has a daily surf report that employees watch carefully. The company reinforces its commitment to the environment, by using energy-efficient lighting and recycled materials in its store display and interior design (Reinhardt, Casadesus-Masanell, and Freier 2004). At a company visit, the author observed Patagonia employees working in teams with designers working in close proximity to pattern makers. Their associates often discuss pattern and prototypes at outside picnic tables or in the company cafeteria. Hurley reinforces its lifestyle image by having a huge aquarium and large surf photographs in the reception area. Jennifer Quesada, Hurley technical designer, commented to the author that many company employees use the company's on site skate park or hang up their wetsuits in offices after surfing at lunchtime.

A design workroom is a colorful creative environment. Commonly, it has an organized messy ambiance with a large worktable, computer workstation, wall grids, sample garments on rolling racks, boxes with photographs, and colorful fabric in bins on shelves. It is common for designers to have large windows or a well-lit office space so they can critically evaluate aesthetic attributes such as color and texture.

Other company spaces frequented by designers include design inspiration and fabric libraries, such as those at the headquarters of Nike Inc. in Beaverton, Oregon. Although designers work individually in their design space, a practice seen at Karen Kane Inc. in Los Angeles, California, is that designers frequently work in close physical proximity to first pattern makers, samples makers, merchandisers, and other preproduction associates. This allows designers to quickly submit and receive prototypes. A three-dimensional prototype is aesthetically and technically important for designers, pattern makers, and sample makers to evaluate tactile, visual, and fit elements. According to designer Alona Ignacio, Seril designer and production manager, large companies have CAD graphic artists in close proximity to designers to create garment flats, catalogs, and line sheets, whereas small companies typically have designers do their own CAD graphic and illustration work. As seen at Byer California in Los Angeles, if designers are in a different physical location from first pattern makers, it is common to have teleconferencing capabilities in which designers and pattern makers review pattern fit.

When the design team returns from inspirational travel they meet to make concrete product line decisions. This process, shown in Figure 8.1, is decisions on product line themes, colors, and fabrics.

The Theme Board: A Synthesis of Decisions

By gathering inspiration from readily accessible resources and travel, designers accumulate a multitude of ideas, sketches, swatches, and reference items. The design team uses these inspirational resources to define a seasonal apparel product line. From this definition, the design team sets design objectives. These design objectives guide the team on

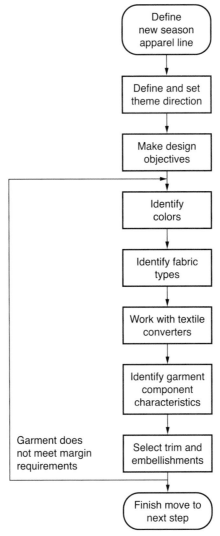

Figure 8.1 Beginning stage of merchandising the apparel line. (Illustration by Karen Bathalter.)

product line garment styling (Figure 8.1). There is time pressure at this stage because suppliers rely on designers to set their seasonal themes. These themes trigger subsequent designer decisions on colors, fabrics, and garments.

Designers create theme boards for a specific season. The deadline for theme board creation depends on the time constraints to select and/or develop fabric and sew garments in time for the company's most important trade show—market or fashion week. Because trade shows are approximately 4–6 months ahead of delivery, a designer creates a spring theme in the fall and a fall theme board in the spring.

Table 8.1 Addition of Shop Apparel Cluster Activities to Time-and-Action Calendar

TRADE SHOW: NOOVEAU COLLECTIVE AT THE NEW YORK PIER SHOWS (SEPTEMBER 4)

Activity	Week 1	2	3	4	5	6	7	8	9	10	11	12	13	14	15	16	17	18	19	20	21	22
Date	4/3	4/10	4/17	4/24	5/1	5/8	5/15	5/22	5/29	6/5	6/12	6/19	6/26	7/3	7/10	7/17	7/24	7/31	8/7	8/14	8/21	8/28
Write/revise mission statement	■																					
Write core strategy		■																				
Conduct primary and secondary data collection		■																				
Calculate minimum plan		■																				
Search online fashion forecast services			■																			
Read published literature			■																			
Collect visual images			■																			
Sketch			■																			
Review museum, entertainment, and sport resources			■																			
Review retail store trends				■																		
Attend European textile, prefabric, and apparel shows				■	■																	
Observe consumers				■																		
Create theme board					■																	
Visit fiber marketing and color services					■																	
Visit textile services, converters, and manufacturers					■																	
Key to seasons:																						
Fall	■																					
Winter	■																					
Spring	■																					
Summer	■																					

ACTIVITY 8.1 *Time-and-Action Calendar: Continued*

Using Table 4.10 and Company Project 3 in Chapter 4, add shopping apparel clusters to your time-and-action calendar, and create a time line for completing these activities.

- In cell A17 type, *Create theme boards*
- In cell A18 type, *Visit fiber marketing and color services*
- In cell A19 type, *Visit textile services, converters, and manufacturers*
- Designate one week for the activities in rows 17–19. These activities take place at the same time and start upon completion of inspirational travel. (Place your cursor in column F17:F19 and fill the cells with color.)

The Theme and Theme Board

The seasonal change of fashion styles is the impetus behind many female consumers buying new styles. A **theme** is a unified artistic representation of ideas (Dictionary.com n.d.) that expresses colors, textures, patterns, silhouettes, or details. A theme distinguishes various manufacturers from each other and is often one of the most important attributes of creating seasonal products. Instantaneous communication of fashion trends has eliminated the time lag of the masses adopting couture or designer trends. Rather, consumers purchasing at all retail channel levels simultaneously adopt and demand new styles. Thus, designers create new themes to entice consumers to buy garments and influence what consumers within a certain peer group should wear white at the same time maintaining one's personal style (Agins 2007).

A Company Mission Relationship to Seasonal Themes

A theme provides continuity to a product line. A **theme board** is a display of visual images. Its goal is to express a mood or idea with objects, fabric swatches, motifs, and cultural references (Eckert and Stacey 2003) (Color plate 3). Designers tie garments together by using recurring motifs or textures (Eckert 1997). A company must always stay true to its vision and mission; otherwise, consumers will become confused with a company's brand image. Thus, product line themes need to be consistent with a company's vision and mission statements. To understand this interpretation, this section explains how designers create theme ideas.

Apparel manufacturers and private-label retailers need a strong design strategy to beat their competition. Executives often look to innovative companies to understand what constitutes success. Although there is no one successful formula, often understanding success can answer questions such as what product features retail customers will want to buy, how to create a valuable brand at a reasonable cost, and how to beat the competition (Christensen 2003). One way is by creating new innovative designs.

As designers create theme boards, they are aware of business constraints and aesthetic principles. Business constraints include adherence to the company's vision and mission, as well as consistency with the company's core strategy (Regan 1997, 181). Consistency with the company's core strategy means that designers follow a product, operations, or customer strategy (see Chapter 2).

Formulation of a Theme

Designers formulate a theme by selecting descriptive words or phrases from the company mission. Levi Strauss & Co.'s use of *originality* is one example of combining a company mission statement term with a core strategy. Originality is a product core strategy meaning that the company creates innovative or new product attributes (Levi Strauss & Co. 2006). Levi's eco jeans are made with organic cotton, its buttons, rivets, zippers are made from recycled metal, and the jeans are dyed with natural indigo (Barajas 2006). A product line theme needs to be consistent with a company's vision and mission statement, so an appropriate theme board promoting Levi's eco jeans could be one with pictures of nature, such as plants, mountains, and greenery.

The design director lays out the SBU themes by delivery dates within a season. According to designer Kimberly Quan, these delivery dates influence fabric and color selection. For example, if one delivery is for early fall, the fabrics will be lighter weight because the garments will be on the retail floor in August, when the temperatures are warmer.

Layout of the Theme Board

There is no set formula for creating a theme board. Some guidelines are to use images that convey and impression and aesthetic design principles. Designers collect tear sheets that relate to the adjectives selected from the company mission (e.g., art inspired) and colors that trend services predict to be popular for the upcoming season (Color Plate 4). Even though some designers still cut pictures from magazines and other inspirational material, most use computer graphics programs to create theme boards. Designers use graphic images that are scanned or collected from Internet resources, or they use digital photographs. Designers select visual images that convey an impression, a scene, or a location, or emotions. They will sometimes include people in a theme board, but they generally do not use visual images of garments. Here we restate Rare Design's mission statement to understand how a designer connects phrases from a company mission to create a theme board:

> Rare Designs listens to the voice of its consumers to create innovative product features. We offer our young female upstart career consumers fashionable, art-inspired, high-quality, functional, professional apparel with a unique twist that has competitive value. We believe that we can compete by having a strong team of suppliers, customers, and employees working in an open, communicative, and creative environment.

When Anne and Tamee searched design resources and traveled to Europe, they looked for *art-inspired* ideas to create their theme. In Paris, Tamee and Anne looked at Impressionist paintings at the Musée de Orsay. Once they returned, art inspiration was Tamee's primary impetus for creating the Beauté theme board. The visual images Tamee selected are some images from French Impressionists Monet and Renoir and photographs that reinforce their art, such as the water lilies. Designers inclued a color story on a theme board, which enhance the theme and corresponds to seasonal color trend forecasts.

Designers use aesthetic principles* such as rhythm, balance, and emphasis to cre-
ate a theme board layout. Because a theme board is visual, its message should be clear
without a written description. Designers select a creative title that expresses their
reflection of the theme. This title needs to be prominent and not blend into the back-
ground. A designer uses a theme board's colors and visual images to subsequently select
and develop colors and fabrics from textile suppliers, and to draw garment designs
(Color plate 4).

Design Objectives

Once designers create a theme board, it becomes a trigger point to involve suppliers in the
product development process. First, the design director sets line objectives. Product devel-
opment associates meet for a fashion direction presentation. Senior executives, such as
the vice president of product development, set the line direction (Rikert and Christensen
1984). The executive presents seasonal styles, colors, and fabrics. A colloquial phrase is
that a company wants to be "trend right" for its market. **Trend right** means the design
team reinterprets the seasonal trend direction to fit its target market. For instance, Talbots
has a classic customer, so their design team uses classic styling and colors (Rangan and
Bell 2000). Setting specific design objectives is an important component of setting the
line direction. **Setting design objectives** means that the design team maintains their
basic line and identifies core items, fabric types, and garment components. Every apparel
company has product categories. A category is a fabrication, fiber, or garment style for
multiple SBU product lines. **Maintaining the product line** means that the design direc-
tor needs to offer a predetermined number of styles; however, the specific styling charac-
teristics have not been determined. For example, American Apparel's 👕 categories are
short- and long-sleeve T-shirts, tank tops, jackets, pants, and accessories. They maintain
their men's, women's, baby, and dog product lines by offering 181 styles in 86 different col-
ors (American Apparel n.d.[a]; 2007).

Maintaining the basic product line means the design team develops the product line
around established styles, colors, and/or fabrics. Design directors refer to these as core
products. The design director will incorporate seasonal fashion trends and themes into the
product line structure. A company starts with its SBUs. For instance, Patagonia has five
SBUs: men's, women's kids, travel gear, and extras (Patagonia n.d.). The company divides
its SBUs into product lines by fabric type and activity. For each product line, the design
director defines its core garment styling and fabrics. Alpine, one of Patagonia's product
lines, features garments with high-loft insulation. Edge, Storm, and Regulator are cate-
gories within the alpine product line. Edge garments are jackets and pants for skiing and
snowboarding. Storm is water- and windproof shells (pants and jackets worn over street
or athletic wear). Regulator is breathable water- and wind-resistant shells (Reinhardt,
Casadesus-Masanell, and Freier 2004). Regulator garments are further defined by fabrica-
tions used. For instance, Regulator 4 (R4) is a lightweight fleece fabric by Polartec LLC
👕, designed to protect the consumer from cold weather (Patagonia n.d.).

*Refer to books such as *Aesthetics for the Design Professional* by M. Fiore Kimle or *Drawing as an Expression:
Techniques and Concepts* by S. Brooke for a detailed description on design elements and principles.

By having a clear product line definition, the design director can then identify the core styling, colors, and/or fabrics. An apparel manufacturer refers to its **core** as a single garment style, color, or fabric that is in multiple product lines. A core style for American Apparel is its fine jersey short-sleeve T-shirt. Information provided by Sam Lim, senior partner of American Apparel, stated that their men's, women's and baby SBUs offer this style in the same styling (basic T) and fabrication characteristics (e.g., a 4.3-ounce jersey knit from thirty singles) (American Apparel n.d. [b]). The use of repeated fabrications is the foundation on which designers build a product line (e.g., baby rib). Companies introduce new fabrications to create a fashion or directional strategy. For instance, sustainable organic cotton is a directional fabric for American Apparel (American Apparel n.d. [b]).

Supplier Relationships

Designers use core items to build their product and to create their seasonal product line's "grocery list." A grocery list contains raw materials that designers want to purchase. Designers often find it advantageous to personally consult and meet with suppliers and service agencies. To locate desired products, they call suppliers to send samples to them, set up appointments, or travel to an industry cluster. An **industry cluster** is a group of interconnected companies and institutions from one specific field that are located in a geographic concentration (Porter 1998). New York City is a prominent apparel industry cluster. Designers refer to traveling to industry clusters as shopping domestic markets and buying reference items (Regan 1997, 182). Some companies, such as OshKosh B'Gosh, believe it is important for designers to work in apparel clusters such as New York City because it gives their design team direct access to readily accessible creative and compelling trends (U.S. Securities and Exchange Commission [SEC] January 1, 2005). New York City's apparel cluster is renowned for its numerous textile design studios, fiber marketing, textile sales offices, apparel services, trims, and findings (e.g., buttons, elastic). Industry clusters have dichotomous relationship of trust and competition. Industry associates build trust due to linkages and networks among personal knowledge, easier communication, and sharing technology. An industry cluster also promotes competition which encourages associates to be more productive when sourcing raw materials and finding ways to reduce their company's product cost (Porter 1998). Here, a market analyst explains how a trend service assists apparel industry associates: "Directives West assists our clients by traveling to important apparel markets. We prescreen for our clients by reviewing manufacturers' product lines. We then advise our clients on the product lines that are important for their market."*

The design team has set goals when going to an industry cluster. These goals are to identify colors, fabric types, trims, and garment components. To accomplish their goals, the design team works with textile services, converters, manufacturers, and trim resources.

*Reprinted by permission from Jessica Aragon, assistant market analyst, Directives West, Los Angeles, CA; pers. comm., April 14, 2006.

Valuable resources used by designers include fiber marketing, color services, fabric, and findings resources. Designers judge the trend direction provided by these resources on whether it is in concert with their target market.

Fiber Marketing

The selection of textiles is important during design inspiration because garment type often dictates the fibers used. Imagine creating a swimsuit out of 100 percent wool. Wouldn't Lycra be a much better choice? **Fiber marketing** is the promotion of a raw material from fiber selection and development of fabrics for use in end products. Fiber brands and organizations offer education, forecasting, and resources to the apparel manufacturers and private-label retailers that use their fibers. These marketing services are available through the Internet, offices in global industry clusters, and trade show seminars. Designers find fiber organizations' trend forecasts valuable because they tailor their presentations to specific yarns and fabrics. This provides specific insights to selecting fabrics when developing product lines. Fiber brands and organizations that offer marketing services include Cotton Incorporated 👕, Dow Fiber Solutions 👕, Invista (e.g., nylon, polyester) 👕, acetate 👕, Tencel 👕, and spandex 👕.

Fiber brands and organizations offer valuable trend and color projections. It is common for forecasters to present colors in groups called *color stories*. Trend services group color stories by value and intensity. Common color groupings are dark, bright, midtone, and colored neutrals, as well as natural hues. Color, fiber marketing, and trend services also present colors by market segment, such as by men's or women's markets (Cotton Incorporated 2005; Pantone, Inc. 2004). Grouping colors assists designers to develop themes and delineate among colors.

Fiber companies such as Dow Fiber Solutions and Cotton Incorporated present color and fabric trends to industry associates. Dow Fiber Solutions focuses its color forecast on select target markets, such as "Edgy Casual" which is targeted for the youth market. Cotton Incorporated presents multiple color groups for each season. They coordinate groups by similar values and intensities, such as hues that are pale, classic, or warm. Designers find a distinct advantage of using fiber organizations is that they introduce new fiber blends and finishes. Many fiber, yarn, and textile companies focus on developing technological fabrications, for instance to design fabrics that control bacteria, prevent odor, or the penetration of ultraviolet rays (Borland 2006). This focus assists apparel companies that use unique fabrications as one of its primary product line strategies. Fiber companies such as Invista develop innovative fabrics that combine specialty aesthetics with technical features. In 2007, Invista developed a double-faced fabrication with aesthetic characteristics of a hairy appearance on one side and a texture on the reverse. This fabric also had Teflon stain release and washable wool technical features (Borland 2006).

Fiber marketing services assist designers in the time-consuming activity of locating new textile suppliers. These resources reduce designers' time and frustration when seeking new textile mills and converters. The Cottonworks Global Fabric Library 👕 , Dow XLA Sourcing 👕 and Invista's 👕 resource list are reference libraries in which a fabric purchaser or designer can search for suppliers that manufacture specific fabrications (Cotton Incorporated, n.d.; Dow XLA n.d.; Invista, n.d.). Designers can see actual samples in global offices or access an online library to search for vendors that produce specific fabrics and fabrications.

ACTIVITY 8.2 *Exploring Fiber Services*

Look up one trend offered by these fiber organizations

- Cotton Incorporated: http://www.cottoninc.com/LifestyleMonitor/
- Asahi Kasei Group (aka spandex) http://www.dorlastan.com/
- Click on trend-information and read about fashion trends, color vision, and styling themes.
- Describe one lifestyle trend that influences your target market and one trend, color, or styling prediction you would like to incorporate into your product line.

Color Services

Designers rely on color services in apparel industry clusters to assist with color selection and development. **Color services** are specialized organizations that research and present color trends in multiple industries. They differ from fashion forecast trend services because they cater to a variety of industries, such as graphics, paint, interiors, and apparel. Color services help designers broaden their perspectives to other industries (The Color Association of United States [CAUS] n.d.). Specialized color services include Pantone Inc. ⌂ and Color Association of the United States (CAUS) ⌂. Specialized color service focuses in on a narrow topic (e.g., color) from a breadth of industries. For instance, Pantone Inc. forecasts color trends in graphics arts, textiles, plastics, architecture, and digital industries (Pantone Inc. n.d.), and CAUS features color seminars hosted by experts in a variety of industries such as paper or glass tiles (CAUS n.d.).

The ways in which design and merchandising associates use color services depends on whether the apparel manufacturer has a product, operations, or customer core strategy. These strategies all look at the color services from a different context: product focus places importance on color introductions, operations focuses on best-selling colors, and clients direct color in a customer strategy. How designers approach seasonal themes is another reason to use color services. For instance, at a CAUS presentation in New York, Director Margaret Walsh explained that CAUS has an archival color library, that dates back to 1915. The archival color library is a benefit for designers who want to use authentic colors from a specific historical designer (e.g., Christian Dior) or want to reference colors from a specific year (CAUS, n.d.). Like trend services, specialized color services have color experts that project colors. Color services forecast colors earlier than other trend services (i.e., 20 to 24 months in advance) (CAUS n.d.; Pantone Inc. n.d). Color services differ from trend services by offering color standards, formulating dye recipes for textiles and color matching on multiple surfaces (paper, textiles), and monitoring color preference patterns at retail (Pantone Inc. n.d.).

Color Decisions

Apparel designers make color decisions based on new key colors, historical sales, and core colors. A **key color** is one that the European and domestic trend services project as a strong selling color. Color projections influence the value and intensity of hues in a product line. For example, when viewing color services or fiber marketing, a designer may see

that it is a much redder season; that is, the varying hues from browns to blues will have red in the color pigment. An SBU product line often has strong selling colors. A core color refers to a color that is always in a product line because it is a consistent seller. Design directors are responsible for adopting new hues or for offering a core color in multiple values and intensities (e.g., pastel, midtone, saturated). Merchandisers assist design directors in analyzing historical color sales. By analyzing multiple seasons, merchandisers can identify numeric sales trend, For instance, results may show that a medium pink sold better than a lighter pink. Interpreting sales history can be tricky because there are multiple influences to a garment style's sell through. Design directors carefully consider color decisions such as dropping or changing a core color. They need to know when their target market will accept new colors because a company will lose money if it introduces new seasonal colors too early or too late.

Brand Marketing Through Color

Some apparel manufacturers work with companies that have strong corporate identity programs. Apparel companies that have a strong corporate identity are those that have food service, transportation, entertainment, and recreation uniforms. These companies require a strong customer core strategy for their manufacturing partners. Color is often a critical brand marketing attribute for companies who desire a strong corporate identity. These companies work with color services, such as Pantone, Inc. to create formulations to send to their manufacturing partners (Pantone Inc. 2006). Federal Express (FedEx) is one company whose brand strategy is to have identifiable color schemes based on the service it provides (Federal Express n.d.). Purple is FedEx's core color, which the company uses in its varying services. FedEx trademarked the use of purple and grey to designate Federal Express Corporation's typeface and expression and purple and orange for its FedEx freight division (Fed Ex n.d.; United States Patent and Trademark Office 2006). Whenever consumers see a FedEx advertisement, truck, employee, or packaging, they recognize the company's purple and orange signature. Apparel companies develop colors for uniforms that companies such as FedEx. According to Aaron Ledet, director of engineering for VF Imagewear Inc. uniform companies such as his must match their customers' colors exactly.

Color Communication

Color communication has become increasingly important as apparel and textile companies work in a global context. Apparel and textile associates use calibrated color matching systems, such as Pantone, to improve color communication (Color Plate 5). **Calibrated color systems** are numeric systems that identify color value and intensity. Calibrated color enables consistency among a designer's submits and new formulas, and verification of dye recipes for textile production (Pantone Inc. 2006). It is vital that proper color communication occurs at the start of any product line decisions. For example, some trend services present color on computer screens or paint chips. However, forecasted hues shown on a computer screen or printed on paper are not repeatable in textile dyeing. This often results in miscommunication and frustration between design and textile associates. Providing color reference numbers provides better communication because product

development associates can select and specify calibrated colors with dyeing and printing equipment. A designer can select a trend color; cross-reference it with swatches in reference books; and use it as their color standard for subsequent yarn dyeing, piece dyeing, or print fabrics (Pantone, Inc. 2004). Trend services such as WGSN and Fashion Snoops improve communication by providing a Pantone reference number for each hue projected (Fashion Snoops 2004; WGSN 2005) (Color Plate 6).

ACTIVITY 8.3 *Creating Color Stories*

Start by looking at color forecast services and then select colors that you would like to incorporate into your product line.

- Select a color forecast from the following resources:
 - Pantone Incorporated http://www.pantone.com/pages/pantone/pantone.aspx?ca=29 click on current trend forecast.
 - Lyocell http://www.lenzing.com/fibers/en/trends/115.jsp?menueld=33 Click on current trend forecast.
 - Color Marketing Group http://www.colormarketing.org/ click on major color trends, and then click on photos.
 - Color Association of the United States http://www.colorassociation.com/site/communicate.html click on color trends.
- Start a new graphic illustration drawing.
 - Draw six 1" × 1-½" rectangles.
 - Open a swatch library from within the computer graphic program (e.g., Adobe Illustrator has Pantone color libraries built into its program).
 - Match colors that correspond with the current fashion forecast.
 - Fill the rectangles with color.

Color Decisions

Designers make color decisions based on multiple forecast projections. Once designers gather colors from trend and specialized services, they will sort them. Fiore and Kimle (1997) noted that designers sort through trend information by abstracting. **Abstracting** is the identification of similarities or differences among groups of like products, such as color trend presentations. Once designers have shopped and gone to the color services, they set a color palette. The color forecasters, from specialized services, give designers yarn/silk samples of the forecast colors. One approach is to sort colors on a board by supplier or by color stories. Apparel designers make color decisions based on new key colors, historical sales, and core colors. Kim Quan, dress designer comments, "I look at the trend services' color palette. Most times, they are right on, but other times it will not work for my customers. For instance, mustard yellow is hard to retail in the junior market."*

*Reprinted by permission from Kimberly Quan, designer, Cerritos, CA; pers. comm., June 21, 2006.

Textile Design Services

Many designers shop for textile designs while they are selecting colors. An advantage of New York City's apparel industry cluster is that it has a wealth of textile design studios, textile marketing offices, and textile trade shows. Textile manufacturer representatives will visit designers, or conversely, designers will visit textile design studios, converters, and manufacturers when they travel to apparel clusters (Regan 1997, 182, 183). Some designers will purchase directly from textile studios, whereas others purchase from agents that represent artists from around the world. Italy, England, Spain, and Russia are renowned for their textile artisans (Design Works International n.d.). To locate textile studios and agents, design directors and designers refer to directories such as The Alexander Report ⬆.

Designers shop textile design studios or textile design trade shows for inspiration and to develop product line direction. Designers use textile art to create print patterns or inspiration for a product line. Engraving artists either hand paint or create CAD paintings or large-format digital files. Engraving artists create original fabric paintings using a variety of technique effects (Regan 1997, 217). Some common techniques include watercolor, airbrush, mechanical, and stipple. (Figure 8.2) An artist can create fabric designs to place at a specific garment location, for instance, at the center front, or as a repeat for print fabrics. A fabric design has specific size requirements because engraving artists will put the design into repeat. A repeat is a precise size to accommodate the size of screens used in fabric print production (Cranston Print Works 2003). Each season textile artists create new designs. For instance, Printsource, a textile tradeshow, featured many print designs in large geometrics, floral designs, stripes, and circles for spring 2008 (Borland 2007).

Textile Design Studios

Designers purchase fabric paintings at textile design studios and tradeshows. A **textile design studio** is a wholesale company that sells textile paintings for fabric prints and embellishment designs. For an example, refer to Design Works International's Web site ⬆. The inside of a textile design studio has a similar ambiance to a fine art studio. A large print studio will have multiple artists working for them so designers have access to a variety of technique effects. These textile stylists primarily use computer graphic programs; however, some manually paint. The studio manager commonly organizes fabric paintings in bins by theme. This enables designers to quickly flip through art prints and locate what they need.

Textile Design Trade Shows

Textile design trade shows have the same purpose as textile design studios. Textiledesign trade shows are convenient for designers because they can shop multiple textile studio offerings. Trade shows can be more time efficient for buyers because they can see more product lines in a shorter time at trade shows than visiting separate textile design studios (Borland 2007). The majority of studios participate in textile design trade shows and have the buyers come to them. DIRECTION ⬆ is the number one textile design show in America, and Indigo ⬆ is the number one textile design show in Europe. Both make

(a) (b)

Figure 8.2 Example of (a) stipple and (b) watercolor techniques used in textile paintings. (Illustration by C. DeNino.)

prints, knits, embroideries, and other kinds of surface designs available to customers. According to Lisa Mainardi,* Producer of the DIRECTION show, the benefit of textile design shows is that buyers can get an overview from trend displays and seminars so that they can shop among various studios before making decisions and purchases.

Textile manufacturers and converters purchase artwork with the goal of using them to create **open line** fabrics. According to Lisa Mainardi, these textile companies sell their original fabric designs at shows such as Première Vision and Sourcing at Magic .

Some textile studios and textile design tradeshows sell original artwork via the Internet, where designers can shop 24 hours a day, 7 days a week. Web-based services are convenient: They allow buyers to shop for textile paintings between trade shows and increase accessibility to customers not based in New York. One such service is DIRECTION Marketplace, which is a business-to-business site and online trade show where many textile design studios sell their original and vintage designs. Lisa Mainardi informed that after a purchase is complete, the studio sends digital files to companies. An apparel company's technical designers often revise designs to meet the company's **cost structure** and desired aesthetics. The apparel company's CAD artist can then submit files to a textile converter.

Activity 8.4 *Exploring Textile Studios*

Explore a textile design studio or textile trade show to see fabric designs and services.

- Go to Printsource New York textile trade show http://www.printsourcenewyork.com/psny.html.
 - Click on "global design database".
 - Click on "search". From the by industry role button, select "freelance designer" or "Printsource exhibitor".
 - Under category, select a company that indicates textiles, graphics, illustrator, or designer.

*Information adapted from Lisa Mainardi, producer DIRECTION show, New York, NY, April 5, 2004.

- Explore the designs. The artists designs are often under "gallery," "products," or "store".
- Find a design that inspires you for your product line. Draw a sketch of how you could incorporate the textile design into your product. Remember that original textile designs are protected by copyright laws.

How Designers Review Textile Designs

Designers tend to use a haphazard approach or a systematic approach, which is the same approach to the design thinking process as during inspirational travel. A designer's short-term memory deals with complex problems by breaking them into incremental sub-problems. Designers often need to sketch, collect artifacts, read books, and write notes to help them solve a design problem (Purcell and Gero 1998). Designers use a haphazard approach if they have not yet developed their theme board or have not yet selected colors. These designers will quickly flip through textile designs to see concepts and market direction. Even though a designer's approach is haphazard, he or she will mentally contemplate how to use the textile designs in garments. Some decisions include color usage, perceived value, uniqueness, and fabric requirements in the product line.

Designers use a systematic approach if they have already developed a theme. They can get lost in their thoughts because a simple idea may spark a creative idea for an entire garment or product line. They make decisions on art renderings based on their product line inspiration and whether the art complements color and trend projections for their market segment. An example of a systematic approach is a designer that refers back to the product line objectives to shop for a specific item on his or her *grocery list*. For instance, the designer will call textile studios and say, "I need a black and white geometric design; do not distract me with other products."

Designers will purchase textile designs because they like the idea, the elements, or the use of color. These designers will absorb all inspirational and review a multitude of resources before they purchase textile designs. When evaluating art, they often revise a print design to meet their market segment needs (Figure 8.3). Designers evaluate textile paintings on whether they will work or whether they can adapt them to their target market. For example, a designer may purchase a print design for a teen market and then textile stylists might manipulate the original for appropriateness in another market (e.g., women's clothing). Many apparel manufacturers have their own textile design teams, but more often than not, designers purchase their textile designs/prints from textile design studios. Because designers pay for original art, art prints are a design inspiration cost. Lisa Mainardi of DIRECTION stated that prices start at $350 for one textile design and can reach more than $1,200, particularly for a home fashion painting. When a customer purchases the design, he or she often buys the design copyright. This approach leads to more originality because the designers own the copyright. According to Lisa Mainardi, when designers purchase from an open line, the design can also be purchased by others.

A dress designer, explained how she used art prints:*

At one company I worked for, we bought artwork for embellishment inspiration. Artwork studios have embellishments and prints for sale. Often, they are selling

*Reprinted by permission from Kimberly Quan, designer, Cerritos, CA; pers. comm., June 21, 2006.

Figure 8.3 Example of a fabric painting in repeat form. (Illustration by C. DeNino.)

an actual garment, such as the front of a top or a mini jacket. Most of the time there is unique handwork and is definitely a one-of-a-kind design. The designs are expensive, ranging between $450 and $550 each, so I usually design five to six items from that one piece of artwork. Most artworks available to purchase are copyrighted, which explains the high fee for each design.

ACTIVITY 8.5 *Critical Thinking*

In the previous quote, the designer mentioned designing five to six items from one embellishment inspiration.

- Search on the Internet to find one embellishment design (e.g., embroidery, beading).
- Start a new computer graphic illustration (e.g., Adobe Illustrator).
- Draw a simple tank top or T-shirt.
- Copy and paste the top two times.
- Place the embellishment designs into your drawing. Use the scale tool to reduce the photograph size so that it is in scale with your top.
- Create three different arrangements of the embellishment. For instance one top can have a large embellishment design and the other can have repeated designs.
- What design feature stands out in your illustrations? What design feature do you believe will sell your garment?

Textile Converters and Manufacturers

Apparel design teams visit textile converters, manufacturers, and merchants while traveling to apparel clusters. It is common for textile companies to have marketing and sales offices in apparel clusters, such as New York. Textile converters, manufacturers, and merchants specialize in products offered (e.g., denim). Thus, designers work with multiple global textile suppliers to develop fabric for their seasonal product line.

The distinction between textile converters and manufacturers has blurred in recent years because the domestic textile mill industry has changed significantly since the 1990s. A traditional definition of a **textile manufacturer** is an organization that produces and finishes its own goods (Elsasser 2005) and a **textile converter** buys greige goods from a supplier and processes them into prints, textures, or solid-dyed fabrics for resale (Tex World n.d.). However, as domestic production has moved offshore, textile manufacturers also buy greige goods that they finish. Large textile manufacturers will produce and sell fabric from a company-owned global production or operate as converters whereby they purchase greige goods from global suppliers. A domestic textile company then prepares fabric for finish, dyes, or prints, and finishes the goods for resale. Apparel customers select to work with textile manufacturers if they produce the desired fabric, have partnership agreements with them, can develop colors for multiple fabrications, achieve cost advantages, and they want their supplier to control greige fabric production. Greige production control allows them to control attributes such as fiber contamination and inconsistent weaving or knitting. Apparel customers select converters if they have small or inconsistent production quantities or work with a wide variety of fabrics, or if the manufacturer wants to internally purchase greige goods. Textile converters and manufacturers differ from textile merchants. A distinguishing characteristic for a converter is that apparel customers buy and own their greige fabric inventory. A **textile merchant** does not manufacture or finish product; rather, they locate greige or finished fabric in large quantities from global resources and act as a sales representative to sell the fabric to apparel manufacturers and private-label retailers (Tex World n.d.).

How the Design Team Works with Textile Vendors

In apparel clusters, a design team buys from independent or manufacturer representatives that sell lines from domestic or foreign textile inventory houses at present lines at trade shows or in permanent showrooms. Porter (1998) noted that valued traits within an industry cluster are personal knowledge, trust, relationships, and communication. This trait is true for textile and apparel supplier-manufacturer business relationships. A design team will take the time to make personal visits to their textile and trim suppliers. The sole purpose of the meetings is *to meet and greet*. The purpose of visiting textile converters and manufacturers is to establish or maintain good working relations, see new fabric lines, and discuss textile concepts. Each season, textile suppliers contact major apparel customer accounts to discuss themes and concepts and throughout the remainder of the season, there is continuous contact between a textile manufacturer representative and the design team.

A textile showroom can have any type of ambiance from a pristine beautiful office to a hot, dirty warehouse with sales samples placed in a corner. Textile companies that offer design services are well established and generally have professional office environments.

In showrooms, a textile manufacturer or converter generally organizes textile products by fabrications. A manufacturer representative will either show fabrics from their product line or set up a concept meeting with the textile studio director. Traditionally, designers would select from a textile manufacturer's open line. Today, apparel manufacturers and private-label retailers buy from a textile product line, buy a revision of product offerings, or develop their own fabrications and prints. Intense global competition has prompted apparel manufacturers and private-label retailers to strategically select or develop specific fiber contents, fabric types, and fabrications. The purpose of creating proprietary fabric designs or fabrications is to offer a unique product mix.

Discussion of Textile Concepts

Textile converters and manufacturers have design departments, which provide design services. These services are available for customers that develop exclusive textile prints and fabrications. Most textile development work takes place at the apparel customers' offices when the design team works on merchandising the line. We focus on the concept meetings that take place in sales offices. Textile converters and manufacturers that offer design services have a different context than textile studios. A textile studio's primary business is to sell textile paintings and create fabric samples that designers use to develop print fabrics or embellishment designs. Textile converters and manufacturers concentrate on selling and producing fabrics. They offer a breadth of fabrics and fabrications. Textile design is one service these companies offer in order to sell fabrics.

When thinking of textile converters and manufacturers, remember the famous quote, "The best things in life are free" (DeSylva, Brown, and Henderson 1927). Both offer free design services to their customers based on the trust that apparel customers will purchase fabrics from them. An industry tradition is that that there is a verbal agreement to start development on proprietary fabrics. It is beneficial for the supplier and apparel customer to have an ongoing partnership. It is an unwritten rule that continual and consistent seasonal orders build a system of trust in which textile converters provide better customer service. Textile associates will *blacklist* designers that break this trust by communicating this unethical behavior throughout the industry cluster network. One benefit of using textile design services is that the studio director can understand an apparel company's specific design constraints and target consumer requirements.

Fabric development begins with an in-person discussion, followed by submission of a developmental fabric order and creation of samples (Regan 1997, 185). A meeting is set up with the textile studio manager, design manager, and designers. A design team meets in person with the studio manager to discuss fabric concepts. A **studio manager** is an individual who works with apparel customers and who directs textile artists in creating artwork for an apparel manufacturer or private-label retailer.

Designers use their theme boards or wall grids to communicate to the studio manager which visual designs and motifs to develop. They will also share experiences during inspirational travel and reference items purchased so the group can create ideas for the upcoming season. Because studio managers frequently travel internationally, they offer additional insight and trend information to the apparel design team. The group will brainstorm and share ideas. For example, a textile design manager might say, "I found these fabric swatches and art prints at PV [Première Vision] and these garments at a French boutique that are

perfect for your target consumer." The studio manager and design team will also set up or clarify constraints such as type of **base fabric** and cost structure. The group evaluates and selects the *usable* items as it discusses the seasonal theme and color direction.

At the end of the concept meeting, the studio manager has multiple ideas for developing fabric concepts. Studio managers will confirm the number of fabric prints and/or textures to develop and summarize the groups' consensus on the fabric theme direction with potential color ideas. They will confirm with the designer's direction with a comment such as "There are two theme ideas: Beauté and Romance in Paris." This leads to textile concept meetings with textile design managers, which is the next step in the process.

A textile concept meeting often commences with project assignments. The **textile design manager** will designate which associates will work on print development and create a time line. The textile design manager will assign textile artists to create thumbnail print or texture concepts based on the resources. A **thumbnail sketch** is a series of small sketches that expresses a design idea (Figure 8.4).

Best Practices: Apparel Clusters

It is a textile and apparel industry tradition to develop a personal connection among suppliers and customers, and carrying out this tradition is one of the primary purposes why designers visit apparel clusters in person. Designers usually schedule shopping in apparel clusters during the current season's market week. This personal connection extends to an apparel manufacturer's retail customers. Designers will go to their company showrooms in major cities and meet with retail customers. They will ask them for feedback on the current season's product line and get ideas for colors, fabrics, and silhouettes to carry over to the next season. Some best practices in working with textile suppliers and services are as follows:

- Look at the breadth of fabric, and buy for uniqueness.
- Be competitive about price. Look for good value for both what you are buying and what you are giving your consumer.
- Do not buy the cheapest fabric; along with cheap products comes potential quality problems.
- Determine if a textile design or an embellishment offers longevity and flexibility in working into a variety of products. Get two to three seasons out of a developed fabric design or texture.
- Make sure the cost will allow you to make margin requirements.
- Look at supplier availability, reputation, and flexibility.
- Look for flexibility in base materials.

ACTIVITY 8.6 *Analyzing Colors*

One best practice in color is to create designs with *good value, uniqueness,* and *style longevity*.

- Open your graphic illustration file with the three garment sketches from activity 6.9 or draw a simple T-shirt or top.

Figure 8.4 Examples of thumbnail drawings. (Illustration by C. DeNino.)

- Open a swatch library.
- Create three different color combinations to your three tops. (For example, color the binding and the body with two different colors.)
- Critically analyze and write down why each style provides a good value, uniqueness, or style longevity.
- Revise your illustrations if they do not meet these criteria.

Design Costs

Companies allow for creativity; however, they do apply fiscal responsibility to design inspiration. Design managers, responsible for their SBU's budget, must balance designers' creativity and design inspiration with fiscal responsibility. In an interview with the author, Steve Pearson, executive vice president for Guess? Inc. stated that a **design matrix** is a performance review criterion that ensures that inspirational costs do not get out of control.* The design director keeps track of both direct and indirect costs. Direct costs include purchasing reference items, such as textile designs and garments, and sample fabric. Design inspiration costs vary. Depending on what they find, designers can spend $700 to upward of $12,000 on a shopping trip. The time spent by an in-house CAD artist to manipulate a design is an indirect cost. This is because a CAD artist works on a variety of tasks, some of which support design (e.g., textile prints) and some of which support marketing (e.g., wholesale catalogs). Rather than evaluating the cost of each art rendering, apparel companies use matrices such as sample comparison against initial concept designs. Using the matrix, a designer's performance is an evaluation of garments passing line review. A portion of the design review concerns whether the art purchased translated into garments.

Finalization of Design Objectives

Inspirational search is like acquiring the pieces of a puzzle. Back at the office, designers put the puzzle pieces together to form a seasonal product line. This abundance of information is where the excitement comes to play. After designers return from industry clusters, they have several design review meetings. The information in this chapter thus far is related to the design team creating design objectives. The group identifies color preferences, directional

*Reprinted by permission from Stephen Pearson, executive vice president and supply chain officer; Guess? Inc.: pers. comm., May 30, 2007

strategy, and the number of styles to maintain the product line (Regan 1997, 183). According to Jennifer Barrios, senior merchandiser for Quiksilver Edition, these meetings are important because some merchandisers will assume responsibility for color and fabric development. Designers mentally contemplate ideas to develop their upcoming seasonal product line. They will use some reference items purchased for the current season, whereas they will use other items in future seasons. One could make an analogy that designers mentally organize inspirational materials by having an imaginary file cabinet in their heads. They will put an idea in their *fall season drawer* while mentally contemplating, "I was thinking about that for fall, and I will put it away for later." Designers will look at reference items bought, pictures in idea files, their memory, imagination, creativity, and decide to go forward with one idea or stop with another. **Go forward** is a colloquial term meaning that a design team will continue to develop a specific idea. Designers use their personal experience to decide whether they should stop or continue idea development. They have constraints such as SBU direction, product line strategy, company mission statement, calendar adherence, and budget (Regan 1997, 190). However, creative energy is important for strategic advantage. The design team often has more questions at the commencement of this meeting than answers. Some questions the design team will ask are as follows: "How will our consumer respond to our line direction?" "How can we make a niche for ourselves?" "Is this a unique item for the company?" "How can we create value in our products?"

SUMMARY

The design team schedules numerous appointments while shopping in apparel clusters, each often lasting only 20 to 30 minutes in length. Because the New York City apparel cluster is in a close geographic region, the design team often walks to their appointments. At this stage, suppliers become involved with seasonal product development. An apparel cluster offers a wealth of resources, including fiber marketing, textile design shows, textile studios, textile converters, and manufacturers. There is a finite amount of time by which designer's need to make decisions, so designers meet with merchandisers upon return to define the new season's apparel line. This meeting is the informal kickoff point for merchandising the apparel line. We discuss merchandising the apparel line in Chapters 9 to 11, where the design team selects and develops colors, fabrics, and silhouettes.

COMPANY PROJECT 7: THEME BOARD

Goal

To create two theme boards for a specific target consumer that relates to your business strategy, which you developed in Company Project 1 and 2 in which you described your company vision, mission, and target consumer.

Description

The theme boards are each a creation of a design concept that involves conducting the design process. Each theme board is a display of visual images that expresses a mood or idea with objects, motifs, and/or cultural references.

Step 1

- Revise and rewrite your company's vision, mission, and core product strategy as a summary statement (from Company Project 1 in Chapter 2).

Step 2

- Conduct design process activities of insight, exploration, refinement, and illumination, by visiting ten to twenty different Web sites. This book lists design inspiration web sites in Chapters 5, 6, and 7. Expand beyond a simple Internet image search and use a variety of sources. You may also scan photographs from magazines, catalogs, or other printed material.
- Scan color pictures from magazines or copy visual images from the Internet that inspire you to create two themes. Save these pictures or images as .jpg files (medium quality).
- Crop a picture or image using Adobe PhotoShop (if desired).
- Create a reference page listing the ten to twenty Web sites you visited or the magazines and printed material used. Reference citation includes [name of Web site, URL, retrieved on date] or [magazine title, month, day, year or volume/issue number, and page number].

Step 3

- Create *two* theme boards for the tradeshow season you selected for your time and action calendar (i.e., Company Project 4). An example is MAGIC August 2009 trade show is for the Winter/Spring 2010 season .
- Use a graphic illustration program to create your theme boards. (Note the remaining instructions use Abode Illustrator tools.) See color plate 2 for an example of a theme board.
- Start a new Adobe Illustrator drawing. Go to document setup and set the art board to be letter size, landscape layout, with units = inches.
- Use the Place command to insert the electronic images.
 - Note: electronic images are composed of pixels. Images used on a theme board should be clear. Small original images will blur. Be careful to not enlarge an image such that it becomes blurred.
- Group your visual examples so they reflect your theme, company mission, and product line strategy. Place with pictures so you have a nice arrangement and evaluate your placement according to the design principles. Ask yourself the following:
 - Are the pictures in symmetric, asymmetric, or radial balance?
 - Is there emphasis in the board (dominant elements)?
 - Is there rhythm? Do the pictures flow?
- Type a title using the text tool. Change the size by using Font - size. Change the color by highlighting the text and changing the stroke tool color.
 - The title should be a creative phrase that describes your theme.
 - Use a font size, style, and color contrast that is large enough to read from at least 3' away.
- Create a color bank.
 - Review the color forecast from a trend forecast service (e.g., WGSN-edu).
 - Select six colors that reflect seasonal color predictions and work with your theme

- To create a color bank, create shapes using the rectangle or ellipse tool that are approximately (1-½" × 2").
- Select one of the swatch libraries. Find the same colors in swatches as you selected above.
- Click on one rectangle with the select tool. Click on your shape to change the color.
- Use the align tool to straighten your color swatches.
- Print in black and white to check your theme board. Revise if necessary. Print in color.

Step 4

- Cut two foam core boards or cold press illustration boards (maximum size: 11" × 14").
- Securely and neatly glue your paper to the illustration board.
- Type a paragraph explaining how the theme reflects your mission and product line strategy.
- Glue (or attach) a 9" × 12" manila envelope on the back of one theme board. Put your abbreviated mission statement, references, and trade show description into the envelope.

Suggested Project Evaluation

Company vision and mission statement: The company vision and mission statement are well written and rewritten, if indicated from company project 1 and 2. Both the original and the revision are included. They are typed and included with the theme board.

Web sites: Student used multiple Web site resources

References: A complete list of references is included with the theme board. Each reference citation includes [name of Web site, URL, retrieved on date] or [magazine title, date, city, state of publisher, publisher's name].

Theme: The theme is clear and easily recognizable. Action words can be clearly linked from the company mission statement to the theme and product. The visual images clearly represent the theme. The theme board shows excellent creativity.

Design principles: The visual presentation shows excellent use of symmetric or asymmetric balance, emphasis (a focal point), and rhythm (visual movement). Good = two out of three design principles; fair = one out of three design principles (theme board one).

Details: The theme title and text are clear, large enough to see from a distance, and stand out from the background. The student turned in the theme board on a CD or included an electronic. The visual images/photographs are clear. The illustration board is the correct size and color.

Theme reflection and trade show: The trade show is identified. The student wrote one paragraph that describes why the theme is appropriate for the selected trade show, market week, or fashion week. The student wrote one typed paragraph explaining how the theme reflects the mission and product line strategy.

PRODUCT DEVELOPMENT TEAM MEMBERS ▬▬▬

The following product development team members were introduced in this chapter:

Studio manager: An individual who works with apparel customers and who directs and manages CAD artists who work for a textile manufacturer or converter.

Textile design manager: An individual who works with designers and assigns textile artists to create artwork for an apparel manufacturer.

KEY TERMS ▬▬▬▬▬▬▬▬▬▬▬▬▬▬▬▬▬▬

Abstracting: The identification of similarities or differences among groups of similar products, such as color trend presentations.

Base fabric: A fabric with specific characteristics such as weave, knit, or weight.

Calibrated color systems: A numeric systems that identify color value and intensity

Color services: Specialized organizations that research and present trends in multiple industries.

Core: An image projected by a company. A single garment style, color, or fabric that is in multiple product lines.

Cost structure: The finished fabric price range that a design director is willing to pay.

Design matrix: A performance review criterion to ensure inspirational costs are not exorbitant.

Fiber marketing: The promotion of raw material from fiber selection for use in end-products.

Go forward: A colloquial term that means a design team will continue development with a specific idea.

Industry cluster: A group of interconnected companies and institutions from one specific field that is located in a geographic concentration (Porter 1998).

Key color: A hue that trend forecast services project to be a strong seller for an upcoming season.

Maintaining the product line: The need to offer a predetermined number of generic garment style, color, or fabric categories.

Open line: a textile product line in select fabrications, fiber types, and patterns.

Setting design objectives: Maintenance of a basic product line, and identification of core items, fabric types, and garment components.

Textile converter: A company that buys greige goods from a supplier and then finishes them into prints, textures, or solid-dyed fabrics.

Textile design studio: A wholesale company that sells textile paintings for fabric prints and embellishment designs.

Textile manufacturer: An organization that produces and finishes its own goods.

Textile merchant: A company that does not manufacture or finish product but rather buys fabric in large quantities from global resources and sells it in smaller quantities.

Theme: A unified artistic representation of ideas that expresses colors, textures, patterns, silhouettes, or details.

Theme board: A display of visual images.

Thumbnail sketch: A series of small sketches used to express a design idea.

Trend right: A design team reinterprets a seasonal trend direction to meet a company's target market.

WEB LINKS

Company	URL
Acetate	www.celaneseacetate.com/home_public.html
American Apparel	www.americanapparel.net/
Color Association of the United States	www.colorassociation.com
Cotton Incorporated	www.cottoninc.com
Cotton Incorporated Global Factory Library	www.cottoninc.com/CWFL/
Design Works International	http://designworksintl.com/
DIRECTION	www.directionshow.com/content_flash5.htm
Dow Fiber Solutions	www.dow.com/xla/
Dow XLA Sourcing	www.dow.com/xla/sourcing/
Hurley	www.hurley.com/hurley/index.shtml
Invista	www.invista.com
Invista Resource List	http://lycraprl.invista.com/public_rl/producer_rl.asp
Lyocell	www.lyocell.net
Pantone, Inc.	www.pantone.com/pages/pantone/index.aspx
Patagonia	www.patagonia.com/web/us/intern_landing.jsp?OPTION=SAR&assetid=15546&target=%2Fhome%2Findex.jsp%3FOPTION%3DHOME_PAGE%26assetid%3D1704
Polartec LLC	www.polartec.com/
Première Vision	www.premierevision.fr/?page=01&lang=en
Sourcing at Magic	www.sourcingatmagic.com/sourcingatmagic/v42/index.cvn
Spandex	www.dorlastan.com
Tencel	www.lenzing.com/fibers/en/textiles/303.jsp
Warnaco Swimwear Inc.	www.warnaco.com

REFERENCES

Agins, T. 2007. Boss talk (A special report); Goodbye, mainstream: Where do you find the latest fashion trends these days? Everywhere, says David Wolfe. *Wall Street Journal*, January 22, sec. R.7.

American Apparel 2007. New, Classic, and Emerging Styles Spring Summer 2007.

American Apparel. n.d. [a]. Product Information. http://americanapparel.net/wholesaleresources/product_info.html (accessed May 26, 2007).

American Apparel. n.d. [b]. The fabrics of American Apparel. http://store.americanapparel.net/fabrics. html (accessed May 26, 2007).

Barajas, E. 2006. Levi's goes green. *California Apparel News* 62 (28): 11

Borland, V. S. 2006. Function joins fashion. *Textile World* 156 (6): 48–51.

Borland, V. S. 2007. Early indications for the new season. *Textile World* 157 (2): 55–57.

Christensen, C. M. 2003, March–April. Beyond the innovator's dilemma. *Harvard Business Review*. Reprint #S0303A, WilsonWeb.

Color Association of the United States. n.d. Benefits. http://www.colorassociation.com/site/join.html (accessed May 28, 2007).

Color Association of the United States. n.d. About us. http://colorassociation.com/site/aboutus.html.

Cotton Incorporated. n.d. Cottonworks Global Fabric Library. http://www.cottoninc.com/CWFL/ (accessed May 27, 2007).

Cranston Print Works. 2003. How our fabric is made: Step 5. http://www.cranstonvillage.com/about/aboutHowMade.aspx?id=122

Design Works International. n.d. Painting studio and CAD Studio. http://designworksintl.com/ (accessed May 28, 2007).

DeSylva, B. G., L. Brown, and R. Henderson. 1927. *Good news.* Musical.

Dictionary.com. n.d. Theme. http://dictionary.reference.com.

Dow XLA n.d. XLA Sourcing http://www.dow.com/xla/sourcing/ (accessed May 27, 2007).

Eckert, C. 1997. Design inspiration and design performance, in *Textiles and the Information Society.* Paper presented at the 78th world conference of the Textile Institute in association with the 5th Textile Symposium, Thessalonike, Greece, 369–87.

Eckert, C., and M. Stacey. 2003. Sources of inspiration in industrial practice: The case of knitwear design. *Journal of Design Research* 3 (1): 1–18. http://www.inderscience.com/browse/index.php?journalID=192&year=2003&vol=3&issue=1

Elsasser, V. H. 2005. *Textiles: Concepts and principles.* 2nd ed. New York: Fairchild.

Fashion Snoops. 2004. Tool box: Première Vision. http://www.fashionsnoops.com (accessed March 10, 2004; membership required).

Federal Express. n.d. About FedEx: Our Companies. http://www.fedex.com/us/about/today/companies/?link=4.

Fiore, A. M., and P. A. Kimle. 1997. *Understanding aesthetics for the merchandising and design professional.* New York. Fairchild.

Invista n.d., Resource list selection. http://lycraprl.invista.com/public_rl/producer_rl.asp (accessed May 27 2007).

Levi Strauss & Co. n.d. About LS & Co./Values and Vision, http://www.levistrauss.com/Company/ (accessed April 23, 2006).

Pantone, Inc. n.d. About Us. http://www.pantone.com/pages/pantone/pantone.aspx?pg=19295&ca=10 (accessed May 28, 2007).

Pantone, Inc. 2006. Custom color services. http://www.pantone.com/.

Patagonia, Inc. n.d.. Clothing and gear. http://www.patagonia.com/web/us/product/clothing_and_gear.jsp?OPTION=CLOTHING_AND_GEAR_LANDING_PAGE_HANDLER&catcode=MAIN_SP07_US.CLOTHING_GEAR.

Porter, M. E. 1998, November–December. Clusters and the new economics of competition. *Harvard Business Review.* Reprint #98609. WilsonWeb.

Purcell, A. T., and J. S. Gero. 1998. Drawings and the design process. *Design Studies* 19 (4): 389–430.

Rangan, V. K., and M. Bell. 2000. Talbots: A classic. *Harvard Business Review, Teaching Note.* Reprint #500082 (January 26, 2000). WilsonWeb.

Regan, C. L. 1997. A concurrent engineering framework for apparel manufacture. PhD diss., Virginia Polytechnic Institute and State University.

Reinhardt, F., R. Casadesus-Masanell, and D. Freier. 2004. Patagonia. *Harvard Business Review.* Reprint #9-703-035 (December 14, 2004). Boston: Harvard Business School Publishing.

Rikert, D., and C. R. Christensen. 1984. Nike. *Harvard Business Review.* Reprint #9-385-039 (October 16, 1984). WilsonWeb.

Tex World. n.d., Tex World textile definitions, converter http://textile.texworld.com/informationcenter/texdefinitions/TexGlossary_Continuous%20Filament%20Yarn-Convolution. html

United States Patent and Trademark Office. 2006. *Federal Express Corporation.* Serial #78933206 (July 19, 2006). Trademark electronic search system. (http://tess2.uspto.gov/bin/gate.exe?f=tess&state=gf6c1c.1.1).

U.S. Securities and Exchange Commission. 2005, March 14. *Form 10-K: Annual report ended January 1, 2005, OshKosh B'Gosh, Inc.* Washington, DC: U.S. Government Printing Office. http://www.sec.gov/Archives/edgar/data/75042/000095013705002975/0000950137-05-002975-index.htm.

Worth Global Service Network (WGSN). 2005. Trends info Womenswear Autumn/Winter 2006: Colours. http://www.wgsn-edu.com (subscription required).

Refining the Merchandise Line: Color Selection and Development

COLOR IT RIGHT!

A week after returning from New York City, Anne heads to Lauren's office and asks, "Did you look at the color numbers?"

"Yes, I did. We only have sell-in information because we were just connected to Huntington Industries' database. Crème sold best, followed by slate."

"Then crème is going to be the core color of our product line," decides Anne.

"I'm glad because I have a few pairs of crème shoes and I will need a new blouse or pants to go with them. Do you think you'll carryover the slate?"

"I'll talk to Tamee to see if slate will work into our Beauté theme."

Back in the design workroom, Anne and Tamee examine dozens of colorful yarns on the worktable in front of them, putting together color stories. Tamee strokes a bright green yarn and slides it to her pile. "I can't resist touching these yarns, they are so soft. This is good—bright green, sage, and purple with crème as our core. I like it! The sage and crème hues give a beautiful impression of our theme, and we can use them in multiple garments."

"I like the sage, and the crème is our top-selling color. In my opinion, that bright green ruins the continuity. It really has to go! Lauren just told me that slate was our second best seller. Should we replace the green with slate?" Anne asks, pulling the yarn away from the pile.

Tamee sighs and rolls her eyes. "That's ridiculous. The green adds the punch to this color palate. These colors and fabrics will set Rare Designs apart and make our label hot again—guaranteed! We need another opinion." Thinking Lauren will agree with her, Tamee leaves, then returns to her office a few minutes later, dragging Lauren behind her.

"I have to finish the cost analysis for Anne," Lauren protests just as she spots the piles of yarn. "Oh, that green is too bright; it sticks out. Yuck!"

"This isn't my day! First, I have to explain myself over and over to the pattern maker, I got cut off while waiting on hold for one of our sales reps, and now no one appreciates my fashion-forward colors!" Tamee says as Lauren heads back to her office, clomping her Italian kidskin three-inch platform heels.

"Calm down! We still need to work on color deliveries. You can use brighter hues for our late spring deliveries."

"That same bright green?"

"Yes, the bright green will work with the summer colors, which feature pink, purple, black, and crème as our core. We need another bottom color. This tan will work, or should we use the slate? I'll let you make the final decision. I'm fine with

either one, but remember to send the color submits right away—they're due today," Anne says, glancing at their new calendar.

"Okay, I'll submit each color to three different vendors as we have always done to see who comes up with the best choices."

"No, we can't do that anymore," Anne says, as they are interrupted.

"Hello, ladies! Hey, I like your outfit, Tamee." A striking, young man enters the room, carrying his attaché in one hand and a box of muffins in the other.

"Hi, Michael." Tamee coos, admiring the debonair man with dark hair. She giggles to herself, thinking "Handsome must be a job requirement for a textile manufacturer representative. And he has good taste—after all, he likes my outfit!"

"Thanks for the muffins, Michael; our old sales rep never brought us goodies, and these are delicious!" Tamee wipes a few crumbs off her skinny jeans and her bright red long T with side ruching.

"I am going to leave you two to work on colors," Anne says as she grabs a muffin and dashes out, her cascading Czech stone earrings swinging.

Tamee holds the crème swatch in her hand. "This needs just a smidge more yellow."

Inwardly feeling irritated, Michael—the consummate gentleman—calmly replies, "Didn't we do that on my last visit?"

"Yes, but it wasn't enough yellow. Don't you see?" says Tamee, as she points incessantly at the fabric swatch. She glances up at him, seeing the frustration on his face.

Michael sighs and says, "Okay, well, I'll submit this to the colorist and see what we can do." Meanwhile, he thinks, "I wonder if we'll ever satisfy this woman!"

"Wait! I have something that will help," she says, suddenly recalling Kate's advice to use color numbers such as Pantone to improve communication with manufacturing sales representatives. "I have a color fan right here; I didn't think of using this. Here's the color—it's 1205C."

With a look of utter relief, Michael says, "I will get that number to our colorist right away. Anne wanted this silk and cashmere yarn dyed, right?"

"Let me see," Tamee says as she shifts some papers and folders on her desk to get to her notes, "Yes, that's correct. Thanks again, Michael!" Tamee replies as Michael walks out of her office. He types an immediate e-mail on his PDA and collides into Lauren. "Sorry, I didn't see you." He bends down to help Lauren pick up her papers, and he asks, "Are you hurt?"

Flustered, she looks directly into his deep golden brown eyes. "No-o," is all she can manage.

"Have a great day. I've got to catch a plane to China." Michael says as he leaves, still typing into his PDA.

Lauren is a little disappointed that he doesn't stick around to talk. "Hmm," she thinks to herself. "He is such a fantastic dresser, and look at his shoes! I wonder if they are J Agostinos."

Two days later, from around the world, Michael dials Anne from his cell phone. "Hi, Anne. I'm in Shanghai in our Asian office. If I figured things out right, it should be late afternoon there now. I have your Impressionist swatch and crème submit, but I am expecting four more color submits that aren't here."

"FedEx picked up our package yesterday; you should have it tomorrow."

"It already is tomorrow in China," he teases. "Did you mail it to Shanghai or to our textile contractors' plant in Zhejiang Province, Hangzhou City?

"Where? Let me grab the slip. It appears we shipped it to Shanghai," Anne frowns at the phone. "Isn't your office in Shanghai?"

"Our sales office is in Shanghai. Our textile contractors are in Hangzhou, which is in southeastern China. This is my first visit to meet our textile contractors. I understand that Hangzhou is a modern city, and we are located in the textile and chemical fiber sector. I will take your package with me to the plant. It should work. I'm wrapping up business here in Shanghai and heading to Zhejiang late tomorrow afternoon. Talk to you soon."

The package from Rare Designs arrives just as Michael and Miss Wang, his translator, are heading to the airport. When Michael arrived in China and met Miss Wang, he was amazed at her flawless English. On their way to the textile plant, they chat while passing through streets crowded with hundreds of people and bicycles.

The driver stops outside a large industrial building with numerous steam vents. Michael glances over at the dirty river, noticing the pungent smell of industrial waste. He thinks, "This reminds me of our textile lagoon before the water is reprocessed into reclaimed water and recycled in our domestic plants."

"Does the river flow into your reprocessing plant?" asks Michael.

Miss Wang giggles as they step out of the car, "No, we don't do anything to our water. It's just black because the used chemicals go into the river. This is Mr. Wu, the General Manager." She introduces a slight man wearing a windbreaker and work pants. He is waiting for them at the plant entrance.

Mr. Wu greets Michael and shakes his hand for what seems like 10 minutes. Mr. Wu motions Michael to follow him.

The bright, clean textile laboratory, full of modern equipment, immediately impresses Michael. Miss Wang translates for the colorist, who explains the procedure for yarn dyeing. She goes on to explain that the company has a yarn knitting facility two kilometers from this plant. Taking a color swatch from the colorist, she says, "He receives a color submit and checks his fabric library for recipes. After that, he does three lab dips."

Michael asks, "How long does it take to dye a round?"

Looking puzzled, Mr. Wu, Miss Wang, and the colorist speak in rapid Mandarin. Michael thinks, "Uh-oh, I need to learn Mandarin!"

Miss Wang turns back to Michael. "What do you mean by a round? We are not familiar with that term," she says.

"A round is the time it takes to dye a color submit; it must be a colloquialism."

Miss Wang smiles, melting Michael's serious expression, and relays the information to the colorist, just as the lights flicker and go out. Michael hears Miss Wang giggle and say, "Welcome to China, the land of blackouts."

Back in the states at Rare Designs, Kate walks into the design room. "I am glad to see that you are using your new time-and-action calendar." Just then, Ron angrily stomps down the hall and shoves a handful of computer printouts in Tamee's face.

"Humph! I just learned that a major hang-up for our line last season was your responsibility! Michael just called and informed me that their Chinese contractor had

to re-dye your color submits eight times! You need to be more decisive up-front and do your work correctly! We lost eight weeks last season due to reworking colors! And, by the way, why did we use so many vendors? We worked with fifty textile vendors last season, half of which we had never used before! That is not a best practice! I should have known that your indecisiveness is a major bottleneck," he glared at Tamee.

Tamee looks at Ron sheepishly. "But I thought matching color was important. Let's get Anne in here," Tamee says as she dials her boss's number.

Anne comes rushing in, wearing a caramel-colored pencil skirt with a soft burgundy cashmere sweater. "What's going on in here?" Anne asks.

Tamee quickly answers her, "Didn't we discuss the importance of having an exact color match before we approve the colors? Ron seems to have a different opinion."

"Ron, developing our own unique colors is one of Rare Designs' strategic advantages."

"Yes, but having too many color submissions delays our shipment time line, which in turn slows down the remaining process and ultimately affects our delivery dates," Ron says as he slams a file on the workroom table. "Why can't we just use open-line colors and use what the textile vendors develop?" Ron asks, still perturbed.

Anne scowls at her partner. "You're not new to this industry! Can't you see that developing unique colors is one way we get an edge? And besides, our competitors are doing it."

"Shipping on time is of utmost concern. I'm trying to keep Rare Designs on schedule. Tamee's changes cost 8 to 10 weeks of time in color development. We flat out cannot afford the time. We have to tighten up our time-and-action calendar. We are producing four lines each year. You were already complaining how hard it is to simultaneously work on three seasons. Being late just makes things worse! Our overall development time should fall between 14 to 18 weeks!"

Hearing Ron's last statement, Jason glances up from his computer. He cheers and claps his hands. "Finally! I would love it if we could develop in 14 weeks! Being the CAD and technical designer, it's tough working on overlapping seasons. I never know what season Tamee is asking me to work on!"

"Oh, go ahead and pick on me. But, in my opinion, it's not my fault! The textile vendors always run late," Tamee says.

Observing the action all this time, Kate can no longer keep quiet. She clears her throat. "Uh-huh." Everyone looks at her. "A healthy exchange of opinions is good, but anger does not help anyone. Effective communication is of utmost importance with everyone here at Rare Designs and with our textile vendors. This reminds me of a quote: 'No one can be the best at everything. But when all of us combine our talents, we can and will be the best at virtually everything.'* For a team to succeed, its members must be on the same page. So, it is everyone's responsibility to adhere to deadlines."

Kate continues, "Ron made two good points. First, limiting the number of vendors you work with each season helps gain trust, continued support, and a more reliable timetable in which to work. Second, you need to be more reasonable with the

*Dan Zadra, ed., *Together We Can: Celebrating the Power of a Team and a Dream* (Lynnwood, WA: Compendium), 63.

number of color submits. However, Ron, what Anne said is true—you shouldn't use only open-line colors because unique and professional design, not cost, is Rare Designs' strategic advantage. You prioritize which colors to develop and which can be open-line colors. Tamee, textile manufacturers have their production schedules, so don't be blatant in your attitude that they run late. Dyeing, knitting, and weaving take time. If you communicate your product development schedule with your vendors, they will be willing to meet your deadlines."

Anne turns to Tamee and adds to Kate's lecture, "It's imperative to limit the number of submissions to no more than three. Delaying color approvals is time consuming and costly."

"Yeah, you're right. We all know how Ron is when it comes to money!" Tamee says sarcastically.

"And how many times have you submitted colors this season?" Ron exclaims as he storms out of the room.

Objectives

After reading this chapter, you should be able to do the following:

- Outline the color decisions in merchandising a product line.
- Write color decision and development activities on the time-and-action calendar, and understand their dependence on completing other activities.
- Distinguish among different types of color decisions made by the design team including color selection, classification, deliveries, and balance.
- Grasp the difference among core, carryover, fashion-forward, and reorderable colors.
- Differentiate between standard and developed colors.
- Calculate color quantity for a minimum fabric order.
- Understand the importance of using best practices when selecting, developing, and approving colors.
- Understand the complexity of designers' decisions when coordinating yarn-, piece-, and garment-dyed fabrics.
- Distinguish among yarn, piece, and garment dyeing processes.
- Create a yarn dye, and print a fabric design.
- Create color deliveries.

The design team creates its design objectives by synthesizing its design inspiration with information from vendors. The capstone **design objective** is to create or use a company's brand strategy (Regan 1997, 181), which ultimately creates a profitable product line. **Brand strategy** incorporates distinctive elements that a firm puts in its products to distinguish it from the competition (Kotler and Keller 2007). Apparel companies typically distinguish products from their fashion direction, competitive advantage strategy, and consumer value provisions (Regan 1997, 181). Designers

typically refer to their role in developing a brand strategy as merchandising the line. This process involves the selection of the color, fabric, and prototypes that the team develops for its seasonal product line. This chapter focuses on color* selection and development, the first piece of the merchandising puzzle.

Time Constraints in Color Development

We begin this chapter with a time constraint discussion because from this point on, there are several drop-dead dates that apparel associates must meet. A **drop-dead date** is the set calendar day by which an apparel associate must submit an item. According to Jennifer Barrios, senior merchandiser for Quiksilver Edition, there is no negotiation to a drop-dead date because design team associates must meet this date for vendors and other departments to achieve their deadlines. Apparel manufacturers and private-label retailers with best practices adhere to tight deadlines designated in the time-and-action calendar/workflow. Time pressures intensify during this period as vendors and other product development associates become dependent on designer decisions. It takes approximately 3 weeks to develop and approve color. Following color development, textile **converters** and manufacturers dye fabric.

ACTIVITY 9.1 *Time-and-Action Calendar: Continued*

Using Table 4.10 and Company Project 3 in Chapter 4, add color selection and development activities to your time-and-action calendar, and create a time line for completing these activities.

- In cell A20, type "Create color stories and color deliveries." Fill cell G20 so "Create color stories and color deliveries" is one week. It starts at the completion of "Visit textile services, converters, and manufacturers".
- In cell A21, type "Develop and approve yarn dye colors." This activity starts at the completion of create color stories and color deliveries. Fill H21-J21 to designate 3 weeks to start and finish this activity.
- In cell A22, type "Develop and approve piece dye color." Fill H22-J22 to designate 3 weeks to start and finish this activity.
- In cell A23, type "Select standard and develop trim and finding (e.g., thread, buttons) colors." Fill J23-K23 to designate 2 weeks to start and finish this activity.
- In cell A24, type "Develop and approve garment dye colors and finishes." Fill K24-L24 to designate 2 weeks to start and finish this activity.

Color Team Responsibilities

Color selection and development involves many product development individuals from executive management, merchandising, design, textile and trim vendors, technical design, and pattern making. Choosing, developing, and approving colors requires collaboration, teamwork, and proper communication. The design team meets to select and

*Also spelled *colour*.

group colors into core, carryover, reorderable, and fashion-forward. Once selected, designers or merchandisers work with textile vendors to match color tone, intensity, and value. The design director leads development of colors, fabrics, and prototypes for individual SBUs. He or she has a more holistic view than designers do, and focuses on all SBUs being cohesive so multiple SBUs are consistent and efficient in using core colors and fabrics.

When visiting apparel clusters, the design team makes an initial contact with vendors. At this stage, vendors are involved with an apparel company's product development process. **Textile manufacturing representatives** provide samples and communicate frequently with each customer design team and their own company's design team. From the apparel customer viewpoint, the color development team consists of a design director, designers, merchandisers, and textile manufacturer representatives. From the textile vendor viewpoint, the color development team consists of textile manufacturer representatives, **colorists**, **converting managers**, and a **textile quality assurance (QA) technician**.

To achieve strategic advantage, apparel companies need to have an excellent partnership with employees, vendors, and retail customers. A good partnership hinges on open communication, trusting vendor expertise, and respecting time constraints. As the director of sales and marketing at Milliken & Company indicated in the following quote, vendors take partnership agreements seriously: "We meet commitments as promised."*

Definition of Merchandising the Line

Merchandising the product line is a visual process in which the design team simultaneously selects and develops colors and fabrics, and illustrates garments. **Merchandising the line** is the action of creating product groups, developing fabrics, making color selections, and exploring and developing print techniques. An apparel associate who is not on the design team may view initial color selection as an unorganized mess because he or she sees the design team gathering in multiple brainstorming meetings in which there are colorful yarns, swatches, fabric cuttings, and CAD illustrations in piles on a design workroom table or pinned on a wall grid. The design team, however, makes concrete product line decisions at this stage in which color stories and color deliveries are its first visible output (Figure 9.1). Color decisions directly influence the extent of textile vendor involvement in product development and subsequently product cost. Nike Inc. described this process as follows: "Apparel is like a big jigsaw puzzle for us. We've tried to put the pieces together, but they don't quite fit, so we'll have to do a little scissoring" (Woodell, cited in Rikert and Christensen 1984, 8).

Color Decisions

Imagine shopping in the better sportswear department at the beginning of the fall or spring season. Visualize the store fixtures with designer and private-label selections. Retailers often display clothes as coordinate outfits, with matching skirts, pants, knit tops, and woven blouses. As consumers, we expect the yarns, fabrics, and print colors of these coordinate outfits to match. Designers make decisions based on how the garment colors coordinate on retail fixtures.

*Reprinted with permission of Jim Jacobs, Milliken & Company; pers. comm., September 13, 2005.

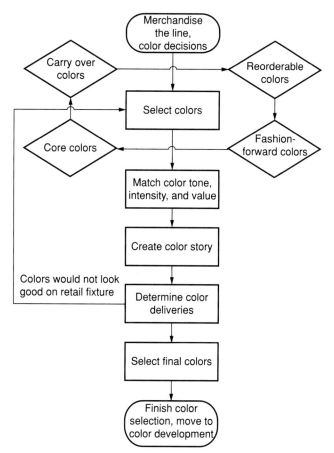

Figure 9.1 Merchandise the line: Color decisions. *(Flowchart by K. Bathalter.)*

Color selection is a creative, yet challenging, process for apparel and textile associates; thus, an effective design team uses design process phases to select and develop colors, as explained in Chapter 5. Providing a framework such as the design process provides cohesiveness and reduces rework. As explained in Chapter 5, design process phases are goal analysis, problem analysis, searching for design solutions, decision making, and verification. The design team identifies color challenges by analyzing color trends from previous seasons and subsequently sets numeric goals. During problem analysis, the design team divides a design problem and creates responsibilities for each team member. A company may create an action plan or assign color responsibilities in its product data management system. During the third phase, searching for design solutions, designers use core colors to evaluate and eliminate colors, create color stories, and set color deliveries. Decision making is the color development process in which designers submit, develop colors, and subsequently approve or reject them. As noted in this chapter's Rare Designs story, the design team and operations managers often disagree on the timing of the color selection and development process. Verification is quality assurance testing of colors and addressing potential color production problems.

Color Concept Meetings: Goal Analysis

The vice president of product development, design directors, and merchandisers establish and set the product line direction during strategic business planning. This direction remains constant for multiple years (see Chapter 3). This product line direction affects color decisions for consumer value provisions (Regan 1997, 181). For example, the design director determines whether to buy standard product line colors to save cost; develop colors to warrant target market uniqueness; use inexpensive or expensive dyestuffs to match quality standards; and/or use yarn, piece, or garment dye.

Apparel companies develop colors year-round. They create color stories seasonally for spring, summer, fall, and winter; however, multiple deliveries occur within seasons (e.g., every 4 weeks). Companies continually introduce new colors. For example, direct retailers such as L.L. Bean Inc. 👕 and J. Jill 👕 change their colors for each online or catalog publication. Color development can be separate from developing a seasonal product line or intermixed with garment style development.

The design director leads multiple color concept meetings in which designers from multiple SBUs participate. Design directors start color concept meetings by informing or reviewing design objectives (i.e., goal analysis). The concept-meeting goal is to select salable colors that relate to the product line. There are two primary objectives for the color concept meeting: Analyze color trends and style forecast, and identify carryover colors.

Analyzing Color Trends

Merchandisers evaluate selling reports to identify color trends. They will look at similar colors to track whether the sales are increasing or decreasing. For example, if merchandisers feel that purple has a potential sales growth, they will look at all solid fabrics, prints, embellishments, and garment styles made in varying values and intensities of this color. Merchandisers know that best-selling colors will generate a set sales volume; however, they also look at the use of color and combinations of colors. One designer commented, "You just get your sales out and take a look at something that is similar and track it to see where it's going . . . a good color will generate eight hundred dozen in sales volume" (Regan, Kincade, and Sheldon 1998, 22).

Quantitative Color Decisions

Design directors forecast color quantity with merchandisers at color concept meetings. Merchandisers need to determine how many new colors they can sell in the same color and fabrication. Quantitative color decision making begins with merchandisers reviewing prior season **sell-in** and **sell-through** figures.

ACTIVITY **9.2** *Making Quantitative Color Decisions*

To understand quantitative decisions and identify good-selling colors, analyze Figure 9.2 and its corresponding sales numbers in Table 9.1.

Calculation: sell through ÷ sell in = percent sell through

- Rank highest to lowest percentage for garment styles a, b, c, and d in Figure 9.2.
- What does the sell-in and sell-through information tell you about developing a future product line?

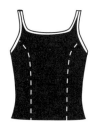
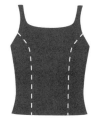

(a) WT115 tank
Midnight with
moonlight binding

(b) WT115 tank
Slate

(c) WT115 tank
Dusk

(d) WT115 tank
Diamonds

Figure 9.2 Garment style WT115 color assortment. *(Illustration by R. Fontanilla.)*

Table 9.1 Garment style WT tank top color sales analysis.

SKU WT115	Sell in	Sell through
(a) Midnight with moonlight binding	800	643
(b) Slate	480	480
(c) Dusk	1440	1400
(d) Diamonds	1360	670

Color Selection: Searching for Design Solutions

From the color concept meetings, the design director challenges designers to select the *right* colors. While selecting a color you like may be easy, selecting the right color is challenging because "right" means that the color sells. As noted by an apparel research firm, "If you are a brand, you're either right or you are gone. It's that simple" (B. Beemer, cited in Earnest 2007, C1). Color selection may overwhelm a first-time designer when sorting colors among the hundreds of yarns and silks gathered during the inspirational search. Experienced designers use design thinking to classify objects and finalize their color palettes. Color evaluation is a creative process in which a person perceives the problem and uses a variety of approaches to develop ideas.

Color Classifications

Experienced designers physically classify and sort silks, swatches, and cuttings to make their evaluative decisions. A **silk** is a colloquial name for yarns in a seasonal color story, which designers obtain from textile manufacturers, color forecast services, and fiber services (Color plates). A **cutting** is a piece of cut fabric or garment piece used as a sample. Textile vendors commonly give cuttings to designers so they can decide whether to use it in their product line and subsequently request sample fabric. A **swatch** can be a synonymous term with a cutting, or it can be used in a broader context to mean any visual media (e.g., fabric painting, a graphic design). Designers use evaluation methods, including open-ended

exploration or classifying based on previous experience, to solve tightly constrained problems. Brainstorming is important; otherwise, designers are mechanized and stagnant, using old solutions rather than being creative (Lawson 1990). Design thinking involves visualizing how to use colors in new or revised products.

Designers develop hundreds of color ideas; however, they use specific criteria to evaluate and specify their seasonal color selections. Here, we visualize a color concept meeting in which design directors and designers gather around a worktable. The design worktable has numerous color swatches, silks, and paint chips (refer to Color Plates 5 and 6 for examples). Designers select silks or color swatches for each core, carryover, reorderable, and fashion-forward color. Designers will next match the color tone, intensity, and value to create color stories. They evaluate color ideas and combinations and eliminate outliers (Refer back to Figure 9.1). Because seasonal colors need to coordinate among different garment types, designers will select a predominance of either warm or cool tones to balance color coordination. While classifying, designers make color decisions based on color category, stories, delivery, and product line balance.

Color Categories

A designer could categorize product line decisions into four words: *fame, success, demand,* and *risk.* Fame is how a company or designer creates a unique and valuable position; industry associates call this product a core product. Companies want successful designs, so they will carryover high-volume previously manufactured colors, fabrics, or garments to an upcoming season. Demand is a retail customer's request for frequent garment availability (thus called a reorderable garment). Risk is the introduction of fashion-forward color, fabric, or style.

The design team develops product lines around its core products. A **core color** is a specific hue on which an apparel company builds its reputation. Merchandisers determine seasonal core colors by reviewing last year's sell-through. Designers use core colors in multiple SBUs and/or product lines. Core colors can be for one season (each spring season), for multiple seasons (each fall and winter), or year-round (Regan 1997, 184). For instance, a company may always offer a light blue core in spring/summer and a brown core in fall/winter but may not offer both colors year-round. When creating color combinations, designers make sure that they harmonize with the company's core colors. Some apparel designers and brands market an identifiable image by consistently using core colors and combinations to build their seasonal product lines. For instance, Tommy Hilfiger trademarked the use of red, white, and navy in his logo (United States Patent and Trademark Office 2004).

A **carryover** color is one that sold well in the previous season. Apparel associates identify previously developed colors or a color combination that they will sell in a future season (Regan 1997, 183) (Color Plate 7). It can be a color from the previous season or an associated season from a prior year (e.g., Spring 2010 for Spring 2011 development). A merchandiser from Quiksilver Edition noted, "We always have basic colors that we carryover. Our designers look at the bookings by style, which lets us know which colors to carryover. We will carryover these colors, but make a shade change to update the hue."*

*Reprinted with permission of Jennifer Barrios, senior merchandiser, Quiksilver Edition; pers. comm., May 12, 2006.

A **reorderable** is a garment style that a retail customer can order in designated colors at any time during a season. Retail customers identify their sales objectives (Regan 1997, 183). For instance, a retail customer may state they want a new color delivery every 3 weeks. The manufacturer identifies its reorderable colors on sales and line sheets. A reorderable color can be a core or carryover color. Retail customers may dictate which colors they want as reorderables.

A **fashion-forward** is a trend color identified by forecasting companies as being an important seasonal color. The design team selects fashion forward colors based on the trend fashion direction (Regan 1997, 184) and whether it is right for the company. The vice president of product development and the merchandisers consider fashion-forward colors risky because the company has not sold the color before or because it was a low-selling color in past seasons. It is important that companies include fashion-forward colors to address target market needs and keep up with competitors.

Color Stories

After trend services identify color and print swatches that are the fashion direction, designers evaluate the colors (Regan 1997, 183, 184). A **color story** is the creative combination of core, carryover, and fashion-forward colors, which corresponds with a product line (Color plate 7). Designers create color stories after merchandisers identify core and carryover colors and any reorderable requirements.

An apparel manufacturer or private-label retailer selects color stories based on target market needs. Fiber marketing and trend services inform their clientele of color story groupings and provide examples of how to use them. For example, one color story may be based on a consumer interest in ecology. This environmental color story would feature green based on botanicals, blues the color of water, and neutrals found in rocks, stone, and soil. A second story based on nostalgia and heritage would feature colors associated with antique fabrics such as ember reds and subtle metallics (Colorful Inspiration 2007). Designers evaluate and eliminate color ideas from forecast services. They finalize color stories by how they relate to their seasonal theme.

Tying Color Selection into the Seasonal Theme

The next color evaluation stage is for designers to evaluate and narrow colors. Designers do this activity by grouping color swatches, eliminating outliers, and identifying missing colors. They evaluate each color for its perceived importance to the market and reorderable strategy (Regan 1997, 191). Colors are one way apparel brands create a competitive advantage. To be effective, a company needs to *tell a story*. An effective product line theme will catch the attention of consumers shopping in a store among the thousands of available private label and branded products. To be effective, a designer selects colors, fabrics, and garment styles that correspond with the seasonal theme. Designers connect colors to the theme by selecting certain hues and naming the colors which reinforce the seasonal theme.

Designers create a palette of five to seven colors for each theme (Eckert and Stacey 2003). Recall that French Impressionist paintings inspired Tamee, Rare Designs' designer. Tamee's color story needs to be in concert with Impressionist hues and art techniques.

The Impressionist painter Claude Monet was renowned for water lilies and his use of white, yellow, Chinese red, reddish-orange, cobalt blue, and chrome green (Giverny Organization n. d.). For authenticity, Tamee's Beauté product line theme should use similar colors; however, a designer needs to make a tradeoff of a hue's value or intensity so it corresponds to both the seasonal color direction and target market preferences. Rare Entities delivery 3 and 4 use cobalt blue and chrome green, similar to impressionist hoes balanced with trend colors (Color plate 7). Some of Tamee's color names for the Beauté theme are slate, stone, and clay, which relate to rock formations found in nature. These color names reinforce the idea of calm, natural scenes found in French Impressionist art.

ACTIVITY 9.3 *Telling a Story with Color and Fabric*

Visualize how to carry out your product line theme into colors and fabric combinations.

- Cut fifteen to twenty 2″×2″ fabric swatches or pieces of yarn in different colors that correspond to your theme board (see Company Project 7). Select the colors and fabric swatches in different fabrications so they correspond with the garment ideas you are thinking of for your product line (e.g., a wool for dress pants, polyester/silk for a blouse).
- Mix and match your fabric and yarn swatches to create different color combinations.
- Describe how the color and fabric combinations "tell a story" and convey your theme.

Color Decision Making

Referring back to the design process, the design team must make concrete decisions to keep pace with the drop-dead dates on the time-and-action calendar. The design team decides on color deliveries and color balance. The design team has a concrete "output," which is the color submit. The color submit starts a new process in which textile-, findings-, and trim vendors partake to develop color.

Color Deliveries

Although apparel manufacturers and private label retailers design a product line for a single season, they commonly offer multiple themes and color deliveries within a single selling season (e.g., Spring I, Spring II). Retail customers demand fresh merchandise assortments because they want to provide consumers with new fresh merchandise options. To meet retail customer requirements, apparel manufacturers create deliveries. A **delivery** is a retail customer's receipt of garment styles from an apparel manufacturer at predetermined times during a selling season. For each delivery, designers create garment collections based on a coordinated group or theme with a unique color and fabric story (Keiser and Garner 2003).

As noted earlier, a product line that "tells a story" is an effective approach. Designers create a story by developing continuity, such as grouping collectible T-shirts by their

unique designs (Momphard 2007). A retail customer can then visualize displaying these products in stores by collection, silhouette, or similar colors. A color delivery is one way to create a story. In a color delivery, designers coordinate garments for top and bottom combinations so that the products will harmonize on the store display fixtures. Using Tamee's theme as an example, her first delivery is Beauté with crème as a core color. She will carryover black, purple, and pink to the third and fourth deliveries, with a change in value and intensity (refer to Color Plate 7).

Seasonally, apparel companies change the value and intensity of core colors and add new colors. When color development is separate from the seasonal product line, the design team selects color stories two times a year and supports them in subsequent seasons. Assume that a designer creates two color deliveries for a spring season and two deliveries for a summer season. The value and the intensity of the spring color deliveries would harmonize because the retail customer may have some garments left over from delivery one when delivery two arrives in the store. For the summer season, it is important that the hue values and intensities change. In deliveries 1 and 2, the colors harmonize so that a consumer can mix and match the colors of the tops and the bottoms (refer to Color Plate 7 between pages 240–241), and therefore may buy a top from delivery one and a bottom from delivery two when shopping in a store. Deliveries 3 and 4 need to look different; otherwise the consumer will think that the merchandise offered is the same. Thus, in Color Plate 7, the color deliveries 3 and 4 are similar hues, but higher intensities (i.e., brighter).

ACTIVITY 9.4 *Understanding Themes and Color Deliveries*

To do this activity, go to a nationwide department store, mass merchandiser, or specialty retailer. Go to the children's department and look at a prominent product display in infants, toddlers, or children's clothing or accessories.

- Identify the theme (e.g., teddy bears, football).
- Identify all the colors used in the theme. Is there a dominant color? Which ones are accent colors?
- Describe how the colors reinforce the theme.
- Identify the core color(s).

Color Balance

Design directors are responsible for color balance. **Color balance** is the evaluation of whether the product line has an equivalent number of top and bottom color combinations (e.g., pink and black). Balancing color is a challenge because a company wants to sell out of colors at the end of each season and not have carryover inventory. Design directors balance color by the number of products and also by whether multiple SBUs will share colors. You can visualize this by picturing a trendy color, such as hot pink. Imagine having thousands of hot pink blouses without any coordinating bottoms to go with them; this is an example of a color inventory imbalance. Balancing colors requires an understanding of retail customer requirements. For instance, some retail customers

offer limited color selections in a product category, whereas other product categories change colors frequently.

The design team works on color balance after determining deliveries. A designer's context is the amount of one color used in tops and bottoms. If the design director believes that there is too much of one color combination, the product line is considered to be unbalanced. To balance the product line, the design director will change colors.

Color Submission: Verification from the Design Team

From the design team's context, there is a lapse in color decision making because they hand over the responsibilities to textile associates. The design team submits a color standard to their textiles-, findings-, or trim vendors who in turn start the order or development process. On completion of one or multiple rounds, the textile vendor will submit a color sample to the design team for approval. Ordering fabric colors from a textile company's open line is as simple as placing a phone call, faxing, or e-mailing the textile manufacturer representative. Conversely, developing original colors is a complex process.

Color Communication

Proper communication to textile associates is critical during color submission and development. Textile associates will commonly say of their design counterparts, "We do not speak the same language" (Regan 1997, 173). Miscommunication can dramatically increase product cost, rework, and time delays (Regan 1997, 173). Each individual sees color differently and two individuals would mix RGB (i.e., red/green/blue) mixtures differently if they looked at the same reference, such as an apple green (Eliasson and Oicherman 2007). A first step is for the design team to use commonly accepted color terminology. Resources such as Colour Click 🖱, an organization sponsored by the Society of Textile Chemists and Colorists 🖱, publish colors articles and educational resources, and TexWorld 🖱 publishes an online dictionary of textile terms.

Textile manufacturer representatives sell standard and developed colors. Proper use of the terms *standard color*, its *variations*, and *developed color* is important for textile-, findings-, and trim vendors to understand the design team's intent. A **color submit** is a swatch of yarn, a piece of fabric, a paint chip, or other tactile material that the design team wants the textile company to match. Textile associates will call a color submit a **standard**. A **standard color** is from a textile company's open line. Textile and trim companies develop a set of standard colors from trend forecasts. These standard colors have established dye recipes for specific fiber contents and fabrications that a textile vendor offers to all its customers. The phrase *color standard* can be confusing because it is similar to *standard color*. A **color standard** is an approved proprietary dye and fabrication. Product development associates will put color standards in a color standardization notebook, which are colors with corresponding fabrications used in a previous season that the design team approved (Regan 1997, 191). Companies reduce

process time if designers use color standards because a textile chemist uses different dyestuffs for different fabrications, and to get approval, there may be rework cycles (Regan 1997, 151).

Selecting Standard or Developed Colors

The design director and merchandiser select the use of standard or developed colors based on time constraints, costs, and the product line direction. Product development associates submit color submits and choose whether colors will be either standard or developed colors (Regan 1997, 191). A product line has multiple fabrics, fabrications, and colors, all of which designers need to coordinate. It is difficult to match tonal values and intensities of coordinate colors because a product line has multiple fiber contents and fabrications (e.g., polyester satin, cotton jersey). Although designers want a perfect match, there may be problems in achieving this (Regan 1997, 205). One reason is the inherent nature of fibers and fabrications. For example, a sweater made of 100% cotton normally has a matte appearance, whereas a blouse made of 100% polyester satin is bright and shiny. Using standard colors, these fabrications (e.g., knit, woven) differ with light refraction and often will not match when placed side by side. If the design team chooses to use standard colors, they will show the yarn to their textile manufacturer representative and say, "I want your closest match to this color submit." Fabric and color are interrelated; so designers and merchandisers need to have a foundation in textile quality, especially color matching.

Designers opt to develop colors to get the closest match possible so the consumer will wear their garments together. A **developed color** is a custom dye formulation for a specific apparel customer. Apparel companies develop colors to match a variety of fabrications for coordinate garments, to be renowned for specific colors and combinations, and to meet company quality standards. The careful matching of color among the various fiber and fabrication combinations is a quality standard for many apparel manufacturers and private-label retailers. With developed colors, colorists reformulate recipes and add or subtract dyestuffs so multiple fiber contents and fabrications match (Regan 1997, 204).

Although it is not necessary, some companies will trademark proprietary core color standards or combinations of colors. Apparel manufacturers and private-label retailers develop these custom dye recipes either in-house or with textile vendors. United Colors of Benetton, ⬛ for instance, trademarked the use of green and white to be a proprietary color combination (United States Patent and Trademark Office 2006).

Justification of Color Development

The design director and merchandisers decide whether to use standard or developed colors based on quality standards and quantity justification. Merchandisers look at competing brands to determine color quality standards. Apparel companies commonly match or exceed the color and fabrications found in competing products; thus, if the competition develops color, then the merchandiser would also develop color. The bottom line is to develop salable products in which color is one attribute.

Color development requires a high minimum order (e.g., 1,000 yards). The minimum requirement varies with the type of color and fabrication. A standard color has a lower minimum order requirement. Design directors and merchandisers need to justify color development costs and determine whether the number of garments in the same coloration is a solid business decision. A merchandiser commented on one order, "When I buy that [fabric] I have to buy 3,500 yards at a time . . . and that is 1,600 shirts in one color. That's a lot of shirts" (Regan 1997, 171). It is much easier for merchandisers who work for large apparel companies to meet developed color minimum quantities. A senior merchandiser from Quiksilver Edition explained, "When we place our initial buy for the season, we do it by color. There is usually a minimum order of five hundred to six hundred pieces per color. If we do not think we can sell that many of one color, we will not buy it."*

Color development calculation: Step one

This business decision requires the merchandiser to determine the category plan. A **category plan** is the product line forecast and size scale (Regan 1997, 198). The merchandiser works with the design director to determine the number and type of garments in which to offer a color. Some companies, such as Zara, base their category plan on fabric purchased, and its designers will create a product line based on fabric secured (McAllister, 2007) while other merchandisers forecast based on its SBU budget (Regan 1997, 195). The merchandiser derives numbers from the category plan. For instance, the merchandiser will say, "We could use X fabric in 2 styles."

Another approach is that a retail customer will purchase a number of styles from an apparel manufacturer's product line. Merchandisers commonly use this approach if the retail customer desires exclusivity of styles. The merchandiser works with the retail buyer to determine this information. For instance, a retail buyer may say we want four styles in our "A and B doors" and eight styles in our A, B, and C stores. *Doors* is a colloquial term for a ranking of comparable store sales. An "A door" is a top-tier store in terms of comparable sales. This store has the most variety in its merchandise assortment and often offers fashion-forward colors or styles. "C doors" rank the lowest in comparable store sales. The merchandise mix offered is typically basic with core and some reorderable items. "B doors" rank in the middle in terms of comparable store sales. From the retail buyer's directive, the merchandiser will calculate the number of styles per color.

Color development calculation: Step two

Determining size scale is the next piece of the color calculation puzzle. Manufacturers express a **size scale** as a ratio. For instance, 2:3:1 means two small, three mediums, and one large for a total of six sizes. An operations management department inputs size scale information into a company's database. Operations have size scale information because retail customers dictate their garment packing requirements. For example, Wal-Mart may require one size per carton, whereas Macy's Incorporated may require multiple sizes within a

*Reprinted with permission of Jennifer Barrios, senior merchandiser, Quiksilver Edition; pers. comm., May 12, 2006.

carton (e.g., six small, twelve medium, six large). Merchandisers use the size scale information to forecast quantities.

Color development calculation: Step three

The merchandiser also needs average fabric yield information, which he or she obtains from a company database. A **marker** is a fabric layout. The marker calculation has **fabric yield**, which is the yardage needed for an individual garment in designated sizes. The marker department submits the fabric yield to operations for each garment style produced (Regan 1997, 268). Merchandisers retrieve the fabric yield information for each style from the company database. A merchandiser calculates the minimum order with fabric yield provided by the textile vendor, and then he or she determines whether they can sell the quantity required.

Calculation of color quantity

To synthesize this information, we present a hypothetical scenario. Von Moritz Department Stores is buying two jackets in a 2:3:1 size ratio. The retail buyer wants exclusivity of the style and color. The jackets will be in thirty of Von Moritz's A doors. Minimum fabric order is 1,000 yards per developed color. The garment style average yield is 1.50 yards. Determine whether this is a good purchase.

Step one: Calculate the category plan. Multiply the (number of doors) × (garment style quantity)

Answer: 30 × 2 = 60

Step two: Add the size scale and multiply by the step one answer.

Answer: (1+3+2=6) × 60=360. You can sell 360 jackets per color to Von Moritz.

Step three: Divide the minimum quantity by fabric yield.

Answer: 1,000÷1.50 = 666.7

Rationale: In this example, the merchandiser can sell 360 jackets to Von Moritz but needs to make 666 jackets to justify the 1,000-yard minimum color development order. Because Von Moritz wants exclusivity of color and style, it would not be a good purchase decision because the merchandiser would have over 400 yards of excess fabric.

A merchandiser does not automatically say no if he or she has excess yardage. A merchandiser will meet with the design director to discuss alternative solutions. For example, they may adjust the size ratio to offer more sizes. The merchandiser may negotiate with the retail customer to offer the exclusive style in B stores in addition to A doors, or they may negotiate to offer exclusivity of garment style but not color. Nonexclusivity is advantageous to an apparel manufacturer because it can sell the color to other retail accounts or share the developed color with another SBU. Merchandisers will develop colors if they can sell more than the minimum yardage quantity.

ACTIVITY 9.5 *Purchasing Developed Colors*

You want to develop lapis blue, and the minimum quantity is 1,000 yards. You plan to use the color in a coordinate outfit, which consists of four garment styles (e.g., two skirts, two blouses). The average yield is 1.25 yards. You plan to sell all four styles with a size ratio of 1:1:2:1:1. The Von Moritz department store buyer wants exclusivity of both color and style and will put the garment styles into their thirty-five A and B doors. Calculate the potential sales to the Von Moritz department store. How many will you produce?* Should you develop the color? Why or why not? What are your alternatives?

Best Practices: Color Selection

Color selection is not an arbitrary decision. Best practices in color selection are those companies that promote creativity. Small companies can believe that they are constrained by fabric restrictions such as minimum orders. Apparel executives need to think outside the box. For instance, two companies in noncompeting markets (e.g., children's and misses) could share fabric color orders. McAdam and McClelland (2002) noted that textile company executives with best practices reward employees who

- Generate new ideas, take the time to think, and create ways to improve products or services.
- Are intricately involved with apparel customers to brainstorm and originate new products.
- Educate their customers on new textile products and processes.
- Rely on manufacturer representatives as a primary source for new ideas, especially requests from customers.
- Use teams to tackle product development problems.
- Make a conscious decision to be first to market rather than follow others in product introductions.

Textile Color Development: Decision Making

If you were a new designer, you might wonder how to develop color. Once the apparel associates finalize and submit colors, textile associates begin color development (refer to Figure 9.3). Color development appears hidden to designers because textile associates complete it *behind the scenes*. Throughout this section, we refer to *design team associates* because varying product development associates are responsible for color development. Depending on the apparel firm, color development is the responsibility of designers, design associates, design directors, or merchandisers, according to Jennifer Barrios of Quiksilver Edition.

*Activity 9.5 answer: Number produced = 4 styles × 35 doors = 140; 6 sizes × 140 = 840 (potential sales); 1000 yards ÷ 1.25 fabric yield = 800 garments. Yes, develop the color.

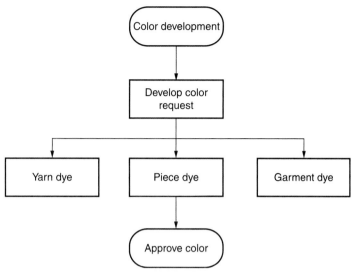

Figure 9.3 Color development. *(Flowchart by C. L. Regan.)*

Vendor Selection

Apparel manufacturers and private-label retailers develop colors with multiple textile vendors. To create a product line, designers work with multiple textile vendors because each specializes in printing or dyeing yarn, pieces, or garments (Figure 9.3). Design team associates have a holistic perspective in that they want to match and coordinate an outfit such as a plaid wool blazer, solid skirt, pants, and a knit top. Selecting a vendor depends on the type of fibers and fabrications that the textile company produces, the cost, and vendor certification. **Vendor certification** is a guideline in which a textile supplier guarantees specific textile quality specifications. Vendor certification improves turnaround time and product quality (Regan 1997, 170). To create a coordinate outfit, a design team associate could submit colors to three different textile vendors: yarn dye for a plaid, piece dye for the solid color skirt and pants, and garment dye for a knit top.

Color Ordering and Request

A design team associate starts the color development process by sending the color standard to the textile manufacturer representative (Regan 1997, 201) (Figure 9.3 and 9.4). Design team associates do not simply say, "Here, develop these." They work closely with textile manufacturer representatives to create the color development request. A **color development request** consists of a log of the color submit, company color name, fiber content, fabrication, finishing, quality standards, fiber origin, and instructions on how to match the color standard (Regan 1997, 201, 203). Design associates that have previously filled out a color development request know that there are many aesthetic and technical decisions. Textile manufacturer representatives will walk neophytes through the color request process. Ordering colors requires design team associates to have a textile foundation

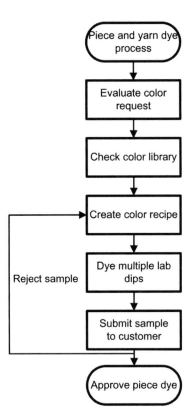

Figure ❾․❹ Yarn- and piece-dyeing process. *(Chart by K. Bathalter.)*

because they determine desired aesthetics, quality, and cost requirements. A neophyte design associate may look wide-eyed at textile manufacturer representatives while they explain varying dye processes: they pay close attention because they know it is important to match differing fiber contents and fabrications.

Aesthetics

Trend direction, season, and fabric type often dictate aesthetic decisions and acceptable dyestuffs (Regan 1997, 203). The manufacturer representative evaluates the color submit for the value and intensity. They will query design team associates to determine the dyestuffs and desired finish. Some aesthetic questions include the following: Do you want to use reactive dyes that will give you more color intensity but cost more, or do you want to use pigment dyes that cost less? Do you want to add softener for better hand? Do you want a matte, shiny, antique, or worn finish? The textile manufacturer representative will inform design team associates of varying dyes and finishes to achieve aesthetic effects. For instance, a 100% cotton plain weave has a matte appearance and is not shiny. A designer that expects a shiny appearance may be disappointed. However, varying finishing processes can add a shine to cotton fabric. Colorists will know before starting work whether they can achieve an aesthetic appearance with dyes; however, because they do not communicate

directly with customers, they may create a lab dip, even though they know designers will reject it (Regan 1997, 173).

Quality

From a designer's perspective, color aesthetics may be the most important issue; however, to the design director and the merchandiser, quality and cost are of equal importance. Quality and cost can be one reason a color sample is rejected (Figure 9.4). Haute couture, designer, bridge, and better brands often select solution or yarn dye because of its high color penetration and colorfast attributes. Moderate and better price point apparel companies often select piece dyeing because it has higher dye penetration than garment dye but less than yarn or solution. Garment dyeing has more color quality problems than yarn or piece (Elsasser 2005). Design directors obtain quality standards from the QA manager. The design director needs to be prepared to answer the degree of desired color quality, controlling for crocking, bleeding, shading, washability, and fading. Apparel manufacturers and private-label retailers use set standards (e.g., American Association of Textile Chemists and Colorists or American Society for Testing and Materials test procedures) or verbally convey desired outcomes (e.g., "I do not want the colors to bleed").

Cost

Textile manufacturer representatives play an important role in meeting a customer's target market price point and quality expectations. In the Rare Designs story, Ron wanted to use standard colors to save money, but his partner Anne knew that their competitors developed colors. She knew that their consumers would quickly disregard purchasing mismatched coordinate colors. Raw material includes fabric, trims, and findings (e.g., zippers) and accounts for the majority of a garment's cost (Reinhardt, Casadesus-Masanell, and Freier 2004). The design director carefully balances target market demands with that of fabric costs. Design managers look at their competing brands' predominant use of yarn, piece, or garment dye and their color coordination among different fabrications. For instance, Patagonia uses specialized fabrics and dyestuffs. They estimate that they pay 20% to 30% higher than competing companies to get this quality and fabrication (Reinhardt et al. 2004). Although costs vary significantly with dyestuffs and quality standards, a general rule is that yarn dyeing costs more than piece dyeing (Elsasser 2005). Design directors will juggle garment costs in a product line so they address color trends and keep within their margin requirements. Their philosophy is that if it is the right color for the market, they will put it in the product line even though the dyestuff costs more. Design directors guide their designers to put expensive dyestuff into a higher price point garment and have merchandisers price the line accordingly. In price sensitive categories, a design director will opt to use lower priced dyestuffs (Regan, Kincade, and Sheldon 1998).

Best Practices: Color Ordering

Apparel companies with best practices formalize the color development process. A formal process improves communication and decreases time delays. Having formal checkpoints ensures the design team makes concrete decisions before submitting color to textile manufacturer representatives.

A common communication problem is a lack of the design team's understanding dye effects from varying fiber contents (Regan 1997, 173). It is frustrating to a textile partner when a design team changes colors after development has begun. If a design team associate says, "That's really not the color we wanted, try this one, we'll give you a new color standard," it creates rework and time delays, causing the colorist to have to remake the color recipe (Regan 1997, 173).

Color development requires close attention to dates set on the time-and-action calendar because the design team works with multiple textile vendors. Late color development causes late and bulk ordering of fabrics, which subsequently affects the sample production schedule (Regan 1997, 164). Successful apparel manufacturers and private-label retailers develop and maintain partnerships among textile manufacturers, converters, and merchants. Best practices for color ordering are as follows:

- Submit the same fiber content and fabrication for color request as production fabric. This fabric standard gives the textile vendor a consistent color measurement and recipe formulation.
- Use correct textile terminology to avoid confusion. Poor communication can lead to excess inventory and lost revenue. Managing communication among textile vendors and their apparel customers is important in reducing lead times (Eckman 2004).
- Accurately communicate desired results before submitting the order. Provide clear instructions on desired aesthetics, quality, and cost structure.
- Finalize color stories before submitting color requests. Indecisive designers who request colors "just to see what they look like" can increase costs, rework, time delays, and confusion.
- Limit color requests to those approved by design directors. Designers create extra work for themselves by having to sort too many colors and then having to wait to make product line decisions until receipt of all color submits. Numerous color development requests create confusion, as well as excess paperwork and order tracking.
- Only submit complete color requests. Textile manufacturer representatives often set aside incomplete color development requests, which delays the process and causes errors because they have to contact designers for clarification.
- Have a basic knowledge of textiles. Miscommunication occurs when apparel associates are not cognizant of the general appearance of natural and manufactured fibers, as well as varying aesthetic variations among different fiber contents (Regan 1997, 173).
- Provide vendors with a time-and-action calendar/workflow schedule. Textile vendors will then work with customers weekly to evaluate color and fabric needs.
- Set dye schedules and block out time for regular customers.
- Know global vacation/holiday schedules. For instance, in China, firms typically close for 5 days to celebrate the Chinese New Year (Wikipedia, n.d.).
- Adhere to time-and-action calendar schedules to avoid excess costs, such as express shipping.

Process Time Reduction

It is important that apparel manufacturers and private-label retailers understand textile time constraints. Because dyeing takes place outside the apparel organization, it is easy for

uninformed apparel customers to underestimate the time it takes to turn around color submits. Textile vendors aim for a 2-week turnaround to order, develop, submit, and approve color. During heavy request periods, queue time also delays the process because apparel companies are commonly on the same development schedule; thus, when a textile vendor receives a large number of submits in a short time, it creates a queue and potential time delays.

Since a color submit is an actual fabric sample, companies need to include queue time and transport time to ship product. Transportation time can create a bottleneck if the dye house is in a foreign country. Express shipping and time zone changes can add another week to color development when dealing with global suppliers. Design team associates that digitally request, submit, evaluate, and approve color reduce process time. Colorists measure the color standard with a spectrophotometer, which appears as a digital image on a calibrated computer monitor for accurate color representation. Colorists send digital images and information to the customer on completion of the sample dye. The use of digital calibrated equipment reduces multiple shipping of color development requests. An additional advantage is the use of quantitative measures to evaluate color matching (Mulligan 2003). Spectral evaluation reduces the subjectivity of multiple individuals evaluating color (Eckman 2004). One technique is to study individual differences in color comparisons and average the results. The results, expressed as a number, represent how an average person compares color samples (Eliasson and Oicherman 2007).

Yarn Dyeing

Designers typically submit yarn dye color development requests first because they take the longest time, and the design team uses them to match corresponding piece and garment dye fabrics. Sweater designers commonly use yarn dyeing to create pattern effects (Eckert 1997). A textile manufacturer representative becomes intimately involved with product design because designers intertwine color, yarn, and fabric decisions.

Specific fabric styles dictate the use of yarn dyeing: These include plaids, stripes, (Color plate 8) patterned textures, and jacquard designs (Brown and Rice 2001). **Yarn dyeing** refers to immersion of spun and twisted fibers into a dye bath (Figure 9.5). Fiber and yarn attributes are inherent in achieving yarn dye quality (Elsasser 2005). Couture, designer, and bridge apparel manufacturers often yarn dye solid fabrics. Here, we use St. John 👕, an apparel manufacturer that produces high quality designer apparel and accessories. The Grays, founding family of St. John Knits, created a company that has innovative manufacturing and finishing of its products (St. John n.d.). Bruce Fetter,* CEO of St. John, in an interview with the author, communicated how St. John's yarn dying contributes to its high quality products. St. John has internal textile manufacturing associates who have spent years developing a unique yarn twist with special characteristics. They created yarn attributes with a soft hand (i.e., feel), excellent appearance retention (i.e., yarn memory to return to shape, colorfastness, and pilling), and durability. The St. John fiber buyers specify wool from the backs of sheep because it is the brightest and cleanest part of the fleece. This allows St. John's textile chemists to get higher consistent color

*Reprinted with permission of Bruce Fetter, chief executive officer, St. John; pers. comm., June 7, 2007.

Figure 9.5 Yarn dyeing begins with the spun yarn.

quality throughout the dyeing process. Company associates carefully track all dye baths, and when knitting garments, if a cone runs out of yarn, its replacement comes from the same dye bath. St. John guarantees that their core colors match, so consumers know that they can buy black pants one year and a black sweater the next, and both garment colors will match.

Yarn Dye Color Request

The textile manufacturer representative initiates the next step, which is to submit a color development request to the colorist (Regan 1997, 203, 212). The textile manufacturer will either purchase yarn from a yarn broker or spin it in-house. The textile company purchases yarn from a yarn broker if it costs less or if the textile company does not yarn dye the specific requested technique (e.g., mélange multicolor textured yarn). The textile manufacturer representative determines cost upon receipt of the color submit. Fiber prices vary daily because textile manufacturers purchase fiber and yarn from stock brokers who buy and sell commodities. After the textile manufacturer representative calculates cost, he or she submits a request to the colorist.

Colorists commonly work in a bright, clean facility with sophisticated technological equipment such as spectrophotometers and automated sample dye machinery. The colorist uses the **lab dip** process by which he or she mixes dyestuffs with yarn in a beaker (Figure 9.6). To create samples, the colorist uses sample package dyeing equipment, which

Figure 9.6 A caricature of a chemist mixing dyes and dyeing fabric. *(Illustration by C. DeNino.)*

Figure 9.7 An individual can visualize yarn dye by associating it with skeins of yarn.

is a smaller version of production equipment. The technicians wind yarn around perforated packages, which allow for dye penetration (Humphries 2000) (Figure 9.7).

The colorist focuses on an exact color match with the color submit. The colorist often creates three submits for each customer request. A reason for this is that the color depth is an important quality. When colorists compare the dyed sample to the standard, their goal is to be on target without correction; however, variations with special effect pigments (e.g., iridescent) or textured fabric, fiber, and yarn types are difficult to match (Mulligan 2003). For instance, when a colorist gets a spectrophotometer reading from a textured fabric, the color is read accurately; however, when the actual fabric accepts dyestuffs, there will be shade depth and yarn variations. If the depth produced is different than anticipated, the colorist either reworks the recipe or rejects it and starts over (Senthilkumar and Selvakumar 2006).

Yarn Dye Technical Package

Colorists send dyed sample yarn to textile technical designers who create a technical package and knit or weave samples. A textile technical package, commonly called a **tech pack**, is documentation of a prototype request. It includes prototype measurement specifications, with information such as gauge and stitch length (Eckert 2001). Textile technical designers create a swatch, called a **sock**. A sock is a knit or woven sample that intertwines technical design with yarn dye. Its result depends on the technical yarn properties, the

knit structure, and the garment shape. The technical designer submits the sock to the textile manufacturer representative, who in turn sends it to the design directors, who review and approve or resubmit yarn dye and patterning submits. Designers evaluate the socks for aesthetics and to work out color combinations (Eckert 1997).

The Piece Dye Development Process

To understand this next piece of the color puzzle, we return to Rare Designs' coordinate outfit in which Tamee designed matching solid knit shell top, woven pants, and woven skirts. The jacket fabric matches the pant fabric, but it has a print lining. When creating coordinate outfits, designers such as Tamee desire a close color match among differing fabrications from all vendors. To assist color matching, the approved yarn dye sample becomes the standard for piece- and garment-dyed fabrics.

Piece dye development involves evaluating color requests, checking the library, creating a recipe, and submitting the sample to the design team associate (Regan 1997, 204). **Piece dyeing** refers to the application of color pigment or dye to fabric rolls. Textile manufacturers commonly piece dye solid, striped, and iridescent fabrics (Elsasser 2005; Kadolph and Langford 2002). The color request has written instructions for fiber type, dyestuffs, special requirements, and dyeing instructions (Regan 1997, 204).

The first step is for colorists to test the **greige** (i.e., unfinished) fabric and create the dye recipe. The textile manufacturer or converter tests greige goods because it affects dye recipes and finishing processes. The colorist documents yarn or fiber country of origin, customer's standard, and desired fabrication. Greige good testing (e.g., shrinkage, weight, torque) allows the textile manufacturer or converter to determine how to prepare fabric. Because greige fabric gives varying results, colorists need this information before they can dye samples. For example, 100 percent California Acala greige cotton is naturally white, whereas 100 percent Mail cotton is yellow. This greige state affects how the colorist determines dyestuff recipes (Regan and Chi, in press). It is ideal to dye the color submit on the same greige fabric as production because the yarn that is used changes color values and intensities. Textile manufacturers have more prediction control because they use stock from their inventory, whereas converters rely on design managers or textile merchants to communicate greige fiber specifications.

The textile colorist reviews the color standard and creates the color recipe. A piece dye color recipe development is like selecting a recipe for a main course, such as lasagna. There are many ways to make the same main course, but each has slightly different ingredients and varying costs.

Piece dyeing is similar to yarn dye in which the colorist starts by reviewing the customer's request. The colorist reviews instructions and creates a color number with season and customer designation. Colorists look through their yarn/fabric library (Regan 1997, 204). The **yarn/fabric library** consists of dyed samples, fiber and yarn specifications, and dye recipes written on large index cards in file cabinets or written in a computer database. This information allows the colorist to compare the color standard with previously approved colors.

Colorists then evaluate the color standard with a spectrophotometer reading. The colorist uses the library reference and spectrophotometer reading to create a recipe. Using the dye recipe, the colorist calculates the dye formula. The colorist uses the lab dip process

in which the colorist mixes dyestuffs with a **prepared-for-finish (PFF)** fabric swatch in a beaker (Regan 1997, 204). During sample dyeing, the colorist checks the sample, and if needed, adjusts the recipe. A **round** is the completion of one lab dip. Normally, a colorist can do three rounds in one 8-hour shift. Some colorists will only do one submit at a time, whereas others simultaneously create three: one close to the standard, with two additional adjustments (e.g., lighter, brighter, darker). During dyeing, the colorist evaluates the color against the customer standard for percent color depth to determine whether to add or subtract dyestuff.

Sometimes design team associates do not understand that a lab dip is essentially the same dye time as in production and that the colorist cannot speed up dye time. Differing dyestuffs have varying requirements, such as to cure, age, or soap the greige fabric. The colorist compares the lab dip with the color standard and selects the best match to submit to the textile manufacturer representative (Regan 1997, 204).

Garment Dyeing

Another option is to garment dye, which is the application of color to a PFF product (Regan 1997, 213) (Figure 9.8). Garment dyeing is common for sweaters, T-shirts, and sweatshirts. Garment dyeing is flexible because vendors can produce small dye lots, which is especially suitable to small manufacturing companies. Garment dyeing is common for solid color and distressed finishes. A disadvantage is quality of dye consistency. It is difficult to control because sewn garments have findings and trims (e.g., thread, zippers, buttons, lace) that are made of varying raw materials. These varying fabrications often absorb dye differently. Thus, a solid-colored garment may have shade differences among the fabric, buttons, and thread (Elsasser 2005; Kadolph and Langford 2002).

Like yarn and piece dye, the textile colorist analyzes the customer's standard and checks the fabric library for similar colors and recipes. The colorist adjusts recipes based on aesthetic and quality requirements (Regan 1997, 212). The preparation process (e.g., bleaching) needs to be consistent with that of production and varies, depending on the type of sample dye process. The colorist uses sample tubs that mimic production (Figure 9.9). The colorist determines the yarn yield for each style (e.g., five pounds per dozen) and determines dye quantity. The colorist often uses previously produced irregular garments to create color submits (Regan 1997, 213). This is beneficial because it shows how constructed seams and trims take the dyestuff.

During sample dyeing, colorists will pull out a garment swatch to check it with the standard. A colorist evaluates the sample for an expected depth of shade. If the color depth produced is different than expected, the colorist will rework the recipe, add length to the dyeing process, or reject it and start over (Senthilkumar and Selvakumar 2006). Some colloquial terms in checking color include *needs a hand*, which means more dyestuff is needed; or *the color is too heavy*, which means the color is too dark and the colorist needs to weaken it (Regan 1997, 213). Color formulation and sample dyeing take from 4 to 8 hours, depending on the dyestuffs, the hue value and intensity, and the number of recipes. For example, each bright color submit takes 3.5 to 4 hours to dye, but a light color requires prebleaching of fabric, which adds an additional 1 hour and 45 minutes. Colorists can complete two rounds of a bright color. However, light colors require additional preparation,

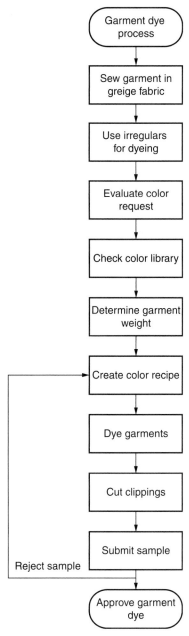

Figure 9.8 Garment dyeing process. *(Chart by K. Bathalter.)*

Figure 9.9 Characterization of garment dyeing process. *(Illustration by C. DeNino.)*

such as PFF bleaching, so they can only complete one round per day. The colorist submits a **cutting**, which is a swatch of dyed fabric mounted on an approval card which he or she gives to the QA department.

Best Practices: Color Development

The design team associate may become scattered when keeping track of numerous submits from multiple vendors. Designers are most concerned that coordinating fabrics match. Some best practices are as follows:

- Share color standards (submits) among textile partners. This practice facilitates selecting desired hue value and intensity among varying fabrications.
- Communicate openly among varying vendors.

- Partner with textile manufacturers and converters rather than treating them as adversaries.
- Respect time needed to develop color. Apparel manufacturers and private-label retailers within a product category (e.g., children's) have the same peak demand periods. If apparel customers do not plan and schedule ahead, they have to wait in queue to receive their color submits.
- Provide consistent business with textile and trim vendors. They will respond to your needs more quickly, especially if you need an immediate turnaround.
- Textile vendors and apparel customers establish a partnership by consistently ordering predictable quantities each season. Textile vendors will identify greige fabric needs so textile vendors order it and have prepared-for-finish (PFF) fabric ready to meet customer needs. When textile vendors can predict greige fabric needs, it reduces turn time because they prepare fabric before the dye request, identify it by customer, and have it in their in-process inventory.
- Do not expect design team associates or textile vendors to jump and stop everything.
- Anticipate and plan for occasional delivery delays. A vendor may experience raw material, dyeing, or finishing problems. Advise vendors and customers before a problem occurs, rather than after.

Verification: Color Approval

A textile quality assurance (QA) specialists compares the color submit to the customer's color standard. If they reject the color, it is resubmitted to the colorist, who will reformulate the recipe and dye another color sample. If QA approves the color, the textile manufacturer representative sends it to the customer. Apparel companies typically have a QA department that will receive the color submit. Both QA specialists and merchandisers are responsible for approving color. A QA specialist evaluates individual colors using textile testing equipment.

QA specialists are fastidious when they evaluate color submits and try to come as close to the standard as possible. They evaluate color match in the same and varying light sources. It typically takes two days to approve the color submit, or it can be as long as the QA specialist and merchandiser take to give their approval. Commercial match is one reason for the intent to perfect color matching. Allowing for a commercial match is an accepted practice in the apparel industry. **Commercial match** means a textile vendor is allowed a ±5 percent color difference between the approved colors and the production colors (Regan 1997, 175). The matching of different fabrication manufactured by different textile vendors is troublesome (Rikert and Christensen 1984). Designers call this effect *snowballing*, a colloquial term, because they know that with a commercial match one textile manufacturer may be 5 percent lighter and another may be 5 percent darker than the standard (Regan 1997, 175). **Snowballing** means that two fabrics that are supposed to color coordinate do not match (Regan 1997, 175) (Color Plate 9). This effect is often due to the use of textile production technology. Global textile vendors and converters use varying equipment. For instance, one textile manufacturer may use new computerized equipment that has advanced color matching. Another textile manufacturer may use older equipment, causing inconsistencies in water temperature, time, and dye lot size, which can cause problems in color quality (Regan 1997, 213).

You have probably at some time brought clothing home and thought, "The color looks totally different than it did in the store!" QA specialists can evaluate the effect of light on color quality by using a light box. **Flare** is an important quality test, in which QA specialists visually evaluate the color submits with the standard under fluorescent and incandescent lights. If the colors match under daylight (i.e., incandescent) but flare under cool light (i.e., florescent), QA specialists will reject a color submit (Regan 1997, 213). Some companies use artificial intelligence systems to eliminate an individual's subjectivity in evaluating color quality such as flare. These computer systems mimic how humans see color by first capturing data from a colorist's pass/fail evaluation. The artificial intelligence system learns from the individual's evaluation to create acceptable tolerances, which the system then uses to evaluate new color samples (Frugia 2000).

The design team also evaluates color submits. The context in which a design team associate visually evaluates color coordination differs from that of a QA specialist. You can understand this visual process by thinking about shopping for a new top to go with existing pants or skirt. As shoppers, if we put together an outfit from different brands or the same brand, we want the various pieces to match, and we become frustrated if they do not. This is the same visual context in which designers evaluate multiple color submits.

To understand the decisions designers make, we return to Tamee and Anne of Rare Designs. Tamee excitedly opened the express shipping packages and clipped the color submits and cuttings from the different vendors onto the wall grid. Physical evaluations of a color submit is common in the industry. A design manager and designer, just as with Tamee and Anne, are typically pleased with some submits and unhappy with others. Aesthetics and brand identity are important to designers (Mulligan 2003). Designers are highly skilled in evaluating aesthetic and technical attributes (Eckert 2001) because they work with the product line daily and know which colors need to coordinate. For instance, designers want jacket and pant fabrics to match perfectly. A designer can *cheat a little* with print fabrics, because the blotch (i.e., background) is intermixed with other accent colors. Merchandisers will accept colors that are the closest match to their original standard and reject those that are not. If apparel customers frequently reject color submits, it can create time delays.

ACTIVITY 9.6 *Matching Color*

The goal of this assignment is to understand matching multiple color tonal values and intensities.

- To begin, select a magazine or catalog picture of a men's or women's coordinate outfit with at least three fabrications (e.g., print, solid, texture).
- Go to a fabric store or shop retail fabric Web pages (e.g., Joann http://www.joann .com/joann/catalog.jsp?CATID=cat2699&rId=GOOGSBRFBRC&gclid=CKSojMq404 wCFQJMYgodDRfFuA). Shop for coordinate fabrics that are similar to the print and solid fabrics found in your magazine picture.
- Paste the fabric swatches or visual images to the magazine picture.
- Describe any difficulties encountered in finding matching hue values and intensities.

Color Approval Process

Design directors or merchandisers approve or reject color submits via a phone call, e-mail, or fax to the textile manufacturer representative. When this apparel associate approves a color submit, the textile company begins production. If the apparel associate rejects the color submit, the cycle repeats, and the colorist creates revised color recipes (Regan 1997, 214). Design managers and textile manufacture representatives are both frustrated with excessive color rejection. Color rejection annoys designers because they spend valuable time looking for physical samples to communicate desired aesthetics (e.g., warmer, brighter color). Textile manufacturer representatives become anxious and frustrated when they waste time and money making repeated samples and express shipping them (Frugia 2000). To avoid frustration, it is important that designers communicate clear and specific directions to the textile liaison and the colorist. Some apparel manufacturers and private-label retailers find that communication problems increase due to global production and language differences. One solution is for these apparel companies to directly communicate with the dye house. Some global textile companies hire technical mentors who are fluent in local languages and English to assist in color communication (Eckman 2004). The most difficult challenge is when designers give vague answers, such as "a tiny bit more red" or "I do not like it, just fix it."

Excessive rejection and resubmission of color creates time delays and increases production costs. Textile manufacturer representatives realize that designers match color submits among multiple fabrications; however, both parties are frustrated if there are too many reiterative cycles (e.g., six to twelve submits). Sometimes design directors approve a previously rejected color submit. This can occur when coordinating the colors and prints among the textile vendors. There is a compounding effect because if one manufacturer is limited or uses old equipment, they may not be able to match the color standard. The design director may state, "This is the best we can do," and design managers have to accept it (Eckman 2004). Design directors are usually honest with representatives that make corresponding fabrics and state, "Because of manufacturing problems, we'll go with the previously rejected color." Design and textile associates have to balance desired aesthetic match with time constraints. Some companies will limit the number of reiterative request, submit, and resubmit cycles to control production costs. Production costs increase if designers are indecisive and wait to approve color submits. If designers are off-calendar and there is not enough time to produce fabric (e.g., 45 days), the apparel company cuts time by using airfreight transportation. However, airfreight costs more than the typical ship or rail transportation.

Best Practices: Color Approval

Textile color education is an important success factor in developing best practices. Such education leads to better communication among merchandisers, designers, QA specialists, textile colorists, and manufacturer representatives. Some color best practices are as follows:

- Send color submits that are exactly right. When pressured for a short turnaround time, colorists will submit samples with which they are dissatisfied.
- Communicate and determine why there are excessive submits. If designers continually reject color submits, colorists will begin to believe that they cannot *get it right*. Their reactionary response may be to send the customer anything.

When approving color, designers need to abide by the following best practices:

- Limit the number of submit–reject–resubmit cycles to three or less. Each color submit cycle takes 3–10 days. If the design team rejects these three submits three times, the cycle time increases to 2–4 weeks.
- Be efficient and evaluate a color submit as soon as it arrives. Stalling and indecisiveness creates extra phone calls and faxes from textile manufacturer representatives who need answers.
- Be willing to admit that you do not know textile language rather than attempting to bluff your way through the approval process. Sometimes textile manufacturer representatives will receive a reject and resubmit, and their reaction to a designer's comment is, "This doesn't make any sense." To e-mail or call to clarify the request creates process delays.
- Collaborate with vendors to improve color communication. Submit approved color standards with a designated color name to all textile vendors. They specialize in dyeing different fabrications (e.g., jersey knit), and this improves excessive rejections.
- Use color numbering systems, such as Pantone, to state how to change a hue's value and/or intensity rather than using vague terms or guessing percentages. If a designer *fakes their knowledge* by stating "add more blue" to make a matte fabric shiny, the next round will be further from the standard.
- Communicate desired aesthetics (e.g., shiny) to textile manufacturer representatives. The aesthetic appearance may not be achievable with dye, but it may be achieved by using a fabric finishing process.
- Trust the colorist's expertise in color chemistry.
- Set up partnership agreements with scheduled dye time.

Color Dyeing Details: Trims and Findings

Once designers select, develop, and approve fabric colors, they make important detail decisions, which include the selection of trim and finding colors. Designers want trims, such as lace, ribbon, or beading, to complement the garment design. *Complement* means to coordinate with the existing color or styling of a fabric or garment. For instance, Tamee, Rare Designs' designer, created an Impressionistic design for a fabric print (refer to Color Plate 2 and Color Plate 11). She could complement her theme by using multicolor buttons that brought out the Impressionist colors. Findings include construction components such as fasteners, zippers, and thread (Brown and Rice 2001). An important aesthetic requirement is that findings either *disappear* into or complement the garment; to *disappear* means that the color of the finding blends into the fabric such that the consumer does not notice it (Color Plate 10). Designers work closely with thread companies such as American & Efird Inc. 👕 and Coats North America 👕 and findings companies such as YKK Corporation of America 👕 and IDEAL Fastener Corporation 👕. According to Phil Freese,* Director of Global Solutions for American & Efird Inc., thread companies offer a standardized color palette with more than 1,000 thread shades from which designers can select the best match. The wide choice of available standard colors accommodates the majority of apparel customers. If designers use standard colors, thread companies guarantee standard color manufacturing repeatability, which means that the color selected will

* Reprinted with permission of Phil Freese, director of global solutions for American & Efird Inc.; pers. comm, June 8, 2007.

be the same in production and can usually be delivered to the manufacturing locations much quicker than "Dye to Match" (DTM) color.

Phil Freese stated that 20–40 percent of apparel customers request dye-to-match (DTM) thread colors. Usually the reason for a DTM thread color is that the production fabric colors may sometimes differ from the original lab dip colors and the manufacturer wants to make sure they have the best possible thread to fabric match for the retailer. This helps to limit their liability in the color selection process. Dye-to-match development is similar to the yarn dye process. Technical designers submit color requests to thread and zipper manufacturer representatives. The manufacturing representative submits the standard to their company's color laboratory. Chemists formulate the recipe and submit one to two cones of thread. The color development process can take anywhere from two to four days: depending on travel time to the color laboratory, shade range, workload in the lab, and return time to the designer. Some colors are easy to match, whereas other colors (e.g., khaki, light blue) are difficult to match and may take multiple rounds for final color approval. When they receive the thread for approval, technical designers either visually evaluate the thread color, hopefully with the use of a controlled light source or light box, or sew the thread into the fabric. Sewing thread and zippers into a fabric sample is more accurate because although they may not visually match, they may blend beautifully when sewn. The process repeats if the technical designer rejects color submits. Usually after receiving dye-to-match approval, the thread company produces and ships thread to the apparel customer's production facility. This process typically takes 3–5 days from receipt of order to delivery.

SUMMARY

Color development is hectic and fast-paced. The lesson of this chapter is to be a consistent partner, understand and plan for time constraints, and treat textile vendors fairly. It is important that designers make concrete color decisions because textile associates outside their company depend on their decisions. Merchandisers make decisions on color development quantities. These decisions are difficult and dependent on accurate forecasting quantities. The designer receives guidance from design directors and merchandisers on which colors to use in the product line. The design team uses yarn, piece, and garment dyeing for fabrics used in a product line. Color development is a complicated process because designers work with multiple textile manufacturers and converters. A challenge is to coordinate and match colors among different products. Best practices provide guidance in working with textile vendors to ensure a smoother schedule and to reduce excess cost. In Chapter 10, we discuss fabric selection and development.

COMPANY PROJECT 8
CREATION OF FABRIC DESIGNS
AND COLOR DELIVERIES

Goal

The goal of this portion of your company project is to create a yarn-dye fabric design that corresponds with your product line theme and to create color deliveries. To complete the assignment, you will need a computer graphics program. The following instructions use Adobe Illustrator.

Creation of a Yarn Dye Design

- Start a new drawing. Set document setup as 8-½" × 11" portrait, units = inches.
- Select the *rectangle tool* and click once in the drawing. Set the size as ¼ × ¼" square. Set the fill as none and stroke as black. Zoom close on the square. Be sure to keep the square small to create a fabric design that is in scale with a 9-head croquis.
- Draw a straight vertical line with the pen tool. Draw the line so it meets the edges of the box. Click the select tool.
- Select *edit* and *copy* the line. Select paste the line multiple times. Move the lines into the box.
- Select *align* tool and select distribute (either left or right) to equally space the lines inside the box. Select align top, so the lines are even.
- Select every other line by holding down the shift key. From the *window* menu, select *stroke* and options. Select dashed lines. Set the dash to be 3 pts. (Some of your lines will be solid and other lines are dashed.)
- Change the line colors by clicking on *stroke* and a color from the swatch library.
- With the select tool, select all the lines. Select *edit, copy, paste*. Select the *rotate* tool and rotate the duplicate set of lines 90 degrees. Move the duplicate set so they rest horizontally on your vertical lines. You may want to change the line colors.
- Select the outside box only. From the *object* menu, select *arrange, bring to front*. Select the *stroke* tool to be none. (The outside box disappears.) With the select tool, select the box and the lines in your pattern. Select *object*, then *group*.
- Drag the pattern to your swatch menu. Save your drawing as "Fabric swatch."
- Open a drawing with a garment illustration. Select and copy a garment. Paste it into the "fabric swatch" drawing.
- Fill the garment with your yarn dye swatch. Check the scale and detail. Revise your design, if desired. (See Figure 9.10 for an example.)

Creation of Product Line Color Deliveries

To complete this activity, you will need Activity 8.3 in which you created color stories and to refer your theme boards (Company project 7). As explained in the text, retailers like a continuous flow of new colors. For this exercise, imagine that you will have a new color delivery for a retail store every 3–4 weeks.

- Open Activity 8.3. Type a title with your theme name and color deliveries (e.g., Beauté color delivery 1 & 2). Save your drawing as "color deliveries."
- Look at color plate 7 to see how to set up your drawing. Select one color to be a core color. Place this color block in the center. Using the color blocks from Activity 8.3, create six color blocks that correspond with theme 1. For additional color blocks and colors, follow the instructions in Activity 8.3. Align the color boxes in two rows. Visualize how you will use these colors. All of the colors need to coordinate as if you could mix and match the colors in the same or different outfits.
- Repeat the above step, except create six color blocks that correspond with Theme 2. Type a title with your theme name and color deliveries (e.g., Moonlight color deliveries 3 & 4).

(a) Examples of yarn dye designs

(b) Garments filled with yarn dye designs

Figure 9.10 Yarn dye and print fabric examples. *(Illustration by R. Fontanilla and C. Regan.)*

- Critically evaluate whether the core color and color stories correspond with your theme and whether you can visualize using them in garment styles.

PRODUCT DEVELOPMENT TEAM MEMBERS

Colorist: A chemist that creates recipe formulations for yarn dye, piece dye, or garment dye fabrications.

Converting Manager: A textile associate who is in charge of tracking open (in-progress) orders and timely delivery.

Quality Assurance (QA) Specialist: A position in both apparel and textile firms. QA specialists test to ensure fabrics and/or garments meet established quality standards. Some color tests include flare, color matching, and snowballing.

Textile Technical Designer: For textile firms, technical designers realize the concept of apparel designers to create a fabric design. They use computer graphics programs to create fabric designs. They also write specifications and develop fabric technical requirements (Eckert 2001).

Textile Manufacturer Representative: An individual who sells open-line, revised, and developed fabric to apparel manufacturers and private-label retailers.

KEY TERMS

Brand strategy: Distinctive elements that a firm puts in its products to distinguish it from the competition.

Carryover: A previously designed color or color combination that an apparel company will sell in a future season.

Category plan: A product line forecast and its corresponding size scale.

Color balance: The coordination of tops and bottoms in corresponding colors.

Color development request: A form and color standard submitted by an apparel manufacturer or private-label retailer to a textile manufacturer representative to develop a color.

Color standard: A swatch that is a standard from a textile product line, a proprietary color in approved dye and fabrication, or a swatch submitted by an apparel customer.

Color story: The creative grouping of core, carryover, and fashion-forward colors, which corresponds with a product line; also called a *standard*.

Color submit: A swatch of yarn, a piece of fabric, a paint chip, or other tactile material that a designer sends to a textile vendor.

Commercial match: A ±5 percent difference between the approved color submit and production.

Converter: A textile vendor that dyes and finishes fabric. The company does not own the greige fabric.

Core color: A hue that a company uses in multiple SBUs year-round or for corresponding seasons (e.g., every fall). Although the hue does not change, its value and intensity can change depending on trend forecasts.

Cutting: A swatch of dyed fabric or a garment piece.

Delivery: A retail customer's receipt of garment styles from an apparel manufacturer. The garment styles are in a coordinated group or theme.

Design objective: To create or use a company's brand marketing strategy, which ultimately creates a profitable product line.

Developed color: A custom dye formulation for a specific apparel customer.

Drop-dead date: The set calendar day by which an apparel associate must submit an item.

Fabric yield: The yardage needed for an individual garment.

Fashion-forward: A trend color identified by forecasting companies as being an important seasonal color.

Flare: A quality test that evaluates the color submits under fluorescent and incandescent lighting.

Greige fabric: Unfinished fabric that a textile manufacturer or converter prepares for finish or dye

Lab dip: The mixing of dyestuffs with prepared-for-finish fabric.

Marker: A fabric layout for a designated fabric width and garment sizes.

Merchandising the line: The action of creating product groups, developing fabrics, making color selections, and exploring and developing print techniques.

Piece dye: The application of color pigment or dye to fabric rolls.

Prepared-for-finish (PFF): Greige fabric that has undergone preparation processes such as cleaning, bleaching, and mercerizing.

Reorderable: A garment style that a retail customer can order in designated colors at any time during a season.

Round: The completion of one lab-dip sample.

Sell-in: The dollar amount of branded products that an apparel manufacturer sells to retailer customers.

Sell-through: The consumer's actual purchase in a retail store.

Silks: A colloquial name for yarns in a seasonal color story that designers obtain from textile manufacturers, color forecast services, and fiber services.

Size scale: A size ratio that indicates how a manufacturer packages garments.

Snowballing: A term designating that coordinate colors do not match because one fabric is 5% lighter and another is 5% darker than an approved color submit.

Sock: A colloquial term for a yarn-dyed textile sample.

Standard: A swatch that textile colorists match; also called a *color submit*.

Standard color: A color from a textile company's open line-to-sell product line.

Swatch: Any visual object used to make product line decisions..ch pack (yarn dye): Documentation of a prototype request, using prototype measurement specifications, with information such as gauge and stitch length (Eckert 2001).

Textile technical package: Commonly called a tech pack. Includes a technical drawing and specifications such as yarn gauge and stitch length.

Textile vendor: A vendor that owns greige fabric. The company may buy or manufacture their yarn and/or fabric. The company prepares fabric for finish and dyes, and finishes fabric.

Trims: Garment components that include trims, labels, thread, zippers, and buttons (Brown and Rice 2001).

Yarn dyeing: The immersion of spun and twisted fibers into a dye bath.

Yarn/fabric library: A record of dyed samples, fiber and yarn specifications, and dye recipes.

Vendor certification: A guideline in which a textile supplier guarantees specific textile quality specifications.

WEB LINKS

Company	URL
American & Efird	www.amefird.com
Coast North America	www.coatsddb.com/industrial/home
Colour Click	www.colourclick.org
IDEAL Fastener Corporation	www.idealfastener.com/index.html
J. Jill	www.jjill.com
L.L. Bean, Inc.	www.llbean.com
Society of Textile Chemists and Colorists	www.sdc.org.uk/ index.htm
St. John	www.sjk.com/sjkinternet/launch.cfm
Tex World Dictionary	http://textile.texworld.com/informationcenter/ texdefinitions/default.html
Tommy Hilfiger	www.tommy.com
United Colors of Benetton	www.benetton.com/html/index.shtml
YKK Corporation of America	www.ykkamerica.com

REFERENCES

Brown, P., and J. Rice. 2001. *Ready-to-wear apparel analysis.* 3rd ed. Upper Saddle River, NJ: Prentice Hall.

Colorful Inspiration. 2007, March. *Global Cosmetic Industry,* 5–6.

Earnest, L. 2007. Stores push aside designers. *Los Angeles Times*, June 8, C1:C6.

Eckert, C. 1997. Design inspiration and design performance, in *Textiles and the Information Society*. Paper presented at the 78th world conference of the Textile Institute in association with the 5th Textile Symposium, Thessalonike, Greece.

Eckert, C. M. 2001. The communication bottleneck in knitwear design: Analysis and computing solutions. *Computer-Supported Cooperative Work* 10(1):29–74.

Eckert, C., and M. Stacey. 2003. Sources of inspiration in industrial practice: The case of knitwear design. *Journal of Design Research* 3(1):1–18. http://www.inderscience.com/search/index.php?action=record&rec_id=9826&prevQuery=&ps=10&m=or.

Eckman, A. L. 2004, July 4. Bridging the gap. *Concept 2 Consumer AATCC Review* 7:33–36.

Eliasson, O., and B. Oicherman. Colour sensations: Study of the uncertainty of colour matching. *The Colorist*. 1 (6).

Elsasser, V. H. 2005. *Textiles: Concepts and principles.* 2nd ed. New York: Fairchild.

Frugia, R. 2000, August. Show your true colors: Today's color quality control is better than ever. *Quality Digest*, 3.

Giverny Organization. n.d. *The colors of Claude Oscar Monet.* http://www.intermonet.com/colors/

Keiser, S. J. and M. B. Gardner. 2003. *Beyond design: The synergy of apparel product development.* New York: Fairchild.

McAllister, R. 2007. Going to school on fast-fashion retailers. *California Apparel News*. June 8, 1.

Momphard, D. 2007. What's the big idea. Fashion brands are increasingly turning to a network of sartorial spies to spot trends and make them their own, writes David Momphard. *South China Morning Post*. May 18. Factiva.

Humphries, M. 2000. *Fabric reference.* 2nd ed. Upper Saddle River, NJ: Prentice Hall.

Kadolph, S. J., and A. L. Langford. 2002. *Textiles.* 9th ed. Upper Saddle River, NJ: Prentice Hall.

Kotler, P., and K. L. Keller. 2007. *Framework for marketing management.* 3rd ed. Upper Saddle River, NJ: Prentice Hall.

Lawson, B. 1990. *How designers think.* 2nd ed. London: Butterworth Architecture.

McAdam, R., and J. McClelland. 2002. Sources of new product ideas and creativity practices in the UK textile industry. *Technovation* 22:113–21.

Mulligan, S. 2003. *From the experts: How to ensure effective color in today's manufacturing processes.* http://www.datacolor.com/index.php?name=Sections&req=viewarticle&artid=32.

Regan, C. 1997. A concurrent engineering framework for apparel manufacture. PhD diss., Virginia Polytechnic Institute and State University.

Regan, C., and T. Chi. In press. Strategic advantage of cotton. *Journal of Textile Technology.*

Regan, C., D. Kincade, and G. Sheldon. 1998. Applicability of the engineering design process theory in the apparel design process. *Clothing and Textiles Research Journal* 16(1):36–46.

Reinhardt, F., R. Casadesus-Masanell, and D. Freier. 2004. Patagonia. *Harvard Business Review.* Reprint #9-703-035 (December 14, 2004). Harvard Business School Publishing.

Rikert, D., and C. R. Christensen. 1984. Nike. *Harvard Business Review.* Reprint No. 9-385-039 (October 16, 1984). WilsonWeb.

Senthilkumar, M., and N. Selvakumar. 2006. Achieving expected depth of shade in reactive dye application using artificial neural network technique. *Dyes and Pigments* 68:89–94.

St. John n.d. Company history. http://www.stjohnknit.com/sjkinternet/launch.cfm (accessed June 8, 2007).

U. S. Department of Labor Bureau of Labor Statistics, 2006–07. Occupational Outlook handbook: Fashion designers. http://www.bls.gov/oco/ocos291.htm.

United States Patent and Trademark Office. 2004. *Tommy Hilfiger.* Serial No. 78520904 (November 22, 2004). Trademark electronic search system. http://www.uspto.gov/index.html.

United States Patent and Trademark Office. 2006. *United Colors of Benetton.* Serial No. 3063794 (February 28, 2006).Trademark electronic search system. http://www.uspto.gov/index.html.

Wikipedia, n.d. Chinese New Year. http://en.wikipedia.org/wiki/Chinese_New_Year (accessed June 10, 2007).

Selecting and Developing Fabrics:
The First Piece of the Merchandise Puzzle

IT'S A GLOBAL FABRIC WORLD

A few days later in the early afternoon, Anne calls Michael. "Hello," a groggy voice answers. "Hi, Michael, it is Anne from Rare Designs. Did I wake you? You sound like you're asleep."

"Oh, hi Anne, I must have forgotten to turn off my cell phone. It's 4:30 in the morning."

"4:30? Where are you?"

"In bed right now," he laughs waking up. "I'm in Zhejiang Province, southeastern China."

"Oh, I am so sorry. I didn't realize you were still in China. I will call you back later."

"No, no, I'm awake now, and I even have a pen. Did you and Tamee figure out your base fabric?"

"We will order the 14 momme silk crepe. You quoted a base cloth price of $3.70 per meter. We are printing the silk with our Impressionist design and then yarn dyeing the cashmere/cotton blend in our developed colors."

"Remember, the price I quoted is the base cloth only. You will also pay for each screen color—you typically order eight colors that are screens for your prints." Michael looks around his room, thinking, "I wish I had some coffee. I'd even drink a cup of green tea!" He goes on, "The print minimum is 10,000 meters and 1,000 meters for solid fabrics with developed colors."

Anne looks at her budget, saying, "We will order the print minimum and 2,000 meters for each developed color. You have our painting for the Impressionist fabric, right?"

"Yes, I will be visiting our print textile contractor's facility today."

"That's it, Michael. I do apologize for waking you."

"No problem, Anne." He rolls over and pulls the covers over his head. He thinks, "Another 45 minutes to sleep before the alarm goes off."

Precisely at 5:30 a.m., Michael's alarm clock rings. He crawls out of bed, dons his workout clothes, and heads to the hotel's gym. Grateful to find an open treadmill, Michael begins his morning jog. His thoughts are preoccupied with trying to understand the Chinese culture and this new textile language. In his previous job, he traveled extensively as a manufacturer representative but mostly to trade shows selling restaurant equipment. He was in Shanghai for six days and flew to the mainland three days ago. He is tired of the humidity and longs for familiar foods. He is almost out of the American flag pens his company sent with him to give to the Chinese business people. He thinks, "It's funny how much the Chinese love these pens. Everything

seems so slow in China, and I'm used to making quick decisions. Plus, they never say 'no!' They participate in discussions and like to be involved in decision making. . . . " His thoughts are interrupted as the beeper goes off on the treadmill.

Once back in his hotel room, he hears the phone ringing as he finishes shaving.

"I apologize for being 10 minutes early, Michael," Miss Wang says.

"Not a problem, I will be down in a flash."

"A flash, what is a flash?" Miss Wang inquires.

"Five minutes." Michael shakes his head, remembering that Asians state exact times and they apologize for being early. He thinks, "Americans would never do that! Learning a different culture is quite an experience!" He quickly finishes dressing, and is happy to see Miss Wang waiting with an umbrella since he did not anticipate rain. She smiles and holds the umbrella open while Michael gets into the car. "We often have sudden rain showers with our subtropical climate; I thought you might need an umbrella." As they drive through the province's capital city, Hangzhou, she points out some of the sights. "That's West Lake, which is considered to be one of the most beautiful sights in China." Michael is amazed at the crystal clear blue water and the dark green hills. "There is Lingyin Temple, which is one of the ten most famous ancient Buddhist temples in China. It was built around 320 AD. Look over there. The hillside is covered with caves and carvings." Michael makes a mental note that he would like to visit the temple later if time permits.

Eventually, they make their way to the industrial section, and the driver stops in front of a new contemporary building.

Miss Wang says, "This is the print facility. You will see the studio and the factory. Mr. Chi, the manager, will be joining us here." They walk into a room full of computers, and Michael notices the hardworking artists, busily focused on a variety of projects.

Miss Wang speaks to a man in Mandarin and translates, "This is our textile-engraving studio." She points to a card with a color swatch with instructions and says, "This is a vendor card with the desired aesthetics and technical specifications. Our artists copy the designs that our customers give us. Sometimes it is just a swatch, while other customers give us a technical package. It is important to us that we please you."

"That's an interesting design," Michael says absently as his eyes move from the artist's rendering to Miss Wang. He follows her through the studio, thinking, "Miss Wang is so pretty. She moves like a gazelle. I wonder if she has a boyfriend."

Miss Wang leads the way into a huge, hot, and humid area. "We will get into a cart now." As they sit down in the golf cart, Mr. Chi joins them. He shakes Michael's hand and takes over the tour. The flurry of activity and loud humming noise of the production machines in the area make conversation virtually impossible. At one corner of the immense space, Michael sees workers loading huge washing machines.

"Not quite as cool in here," he shouts to Miss Wang as he feels the sweat trickle down his back. He wishes he could have dressed more casually instead of in his dark navy suit and tie, but his boss advised him to dress conservatively.

"This is our knit production. We have both flat bed and circular knitting. Printing is at the other end of the building." Michael stares closely at the fast-moving knitting machines, only able to detect the fabric coming out at the bottom of the machine. He follows Mr. Chi into his office, trying to discretely mop the sweat off his face.

"I have confirmed the order with our customers," Michael says, reaching into his attaché. "This is Rare Designs' order. They want to order 10,000 meters of their impressionist design."

It takes 2 hours to complete their business, and Mr. Chi says, "We are most pleased to work with Rare Designs. This evening, I have planned dinner at an excellent restaurant."

"I would be honored," Michael says, remembering what his boss said about business transactions taking place at dinner and wondering if Miss Wang will be there.

Michael has a chance to return to his hotel and take a shower before meeting his host for dinner in the lobby of the hotel. "We will be dining at Zhiweiguan Restaurant, which has a great view of West Lake. I think you will like it," Mr. Chi says in English, with a distinct accent.

As they enter the restaurant, Michael looks at his surroundings. It is the largest and most modern restaurant he has ever seen. The restaurant has four stories of fine dining. Mr. Chi explains that popular low-priced dishes are served on the first floor. The second floor serves seafood, which is where they will be dining. The third floor specializes in local cuisine and the fourth floor houses the banquet rooms, a bar, and a chess room.

"Select your fish," Mr. Chi says, as Michael peers into the large aquarium with live fish.

"This should be an interesting dinner," Michael thinks—selecting the smallest fish. He is surprised at the elegant ambiance in the dining room. At Mr. Chi's urging, Michael orders West Lake Sour Fish as his starter. It is presented in a small clay pot. His host explains that it was made with grass carp from West Lake. Michael enjoys its sweet-and-sour taste and is surprised that the lake fish tastes like sweet crabmeat.

They enjoy the rest of their dinner, and Mr. Chi says, "We are looking forward to expanding our business into the Western world. Shall we discuss our partnership agreement now?"

Three days later back in the states, Anne, Tamee, and Jason are chatting about the product line as they wait for their next vendor to show up. Jason stretches his muscled shoulders. "Vendor days can be tiring. Who's the next rep?"

"Color it Greige," Anne mumbles, concentrating on her notes. "We need to focus on fabrics that are functional and professional."

Jason frowns. "How do we decide that?"

"Tamee and I are thinking of creating a subgroup of garments that incorporate a special belt loop to hold an employee's ID badge," Anne says.

"Oh, I get it—*entities*—a discrete item, part of a garment. Hey, that's smart!"

"Hi, Anne!" Michael extends his hand to Anne, and then turns to Jason and asks, "Been surfing lately?" noticing Jason's sunburned face.

"As a matter of fact, a couple of buddies and I just got back from spending a long weekend up the coast. The waves were great!" Jason says.

Tamee admires Michael's impeccable dress and gracious gentlemanly charm as he sets up the numerous fabric headers. He flashes his perfect smile at them.

"You don't look like you have jet lag," Anne comments. "How was your trip to China?"

"I am glad to be home! I ordered your Impressionist design and your yarn dyes from our Chinese contractors."

"Thank you. Ron and I are finding that there are many changes taking effect. Jim O'Dale has directed that we do more consistent ordering from fewer vendors as part of our partnership agreement. We have selected Color it Greige to be one of our partners. (Michael smiles, thinking, "Music to my ears!") You and Ron will work out the vendor certification. But before we commit to an order, we need to know that you'll provide us with consistent inventory of base cloths, develop print designs, and provide quality control test results."

Michael quickly types in his PDA as Anne continues with her long list of requirements. "We meet commitments as promised. That's my motto! You mentioned base cloth as one of your requirements. This is a good way to build a brand. We have two hundred different styles in our silk open-line fabrics alone," Michael says, handing them several fabric headers for the upcoming summer season.

"Oh, this fabric is so soft...like a newborn baby," Anne says.

"I just brought it back from our Shanghai office. It has a beautiful hand! A grade, 100 percent silk, 3.5-ounce satin weave—that's only $6 per yard."

"That is more than the base cloth we just ordered. It's too high for our cost structure when you add the dye or printing costs. Next!" Anne slides the fabric header past her.

"This header is a silk crepe. It is within your cost structure, 100 percent silk, 18-momme crepe satin weave. We also have printed silk; it is cotton/silk blend. . . ."

Before Michael can finish, Tamee spots the perfect choice and says, "Anne, I like this one. What do you think? How much is it, Michael?"

"The prepare-for-finish cost is $4.50, plus dyeing and finishing costs. Minimums are 2,000 meters per color, FOB Shanghai. It comes in 120 centimeters, which is approximately 43-inch cuttable width."

"We want to make sure our Rare Entities product line is superior to our competitor, JMA Studio, so don't sell me anything you've sold them. Our fabric needs to be better than what they offer," Anne says arching her eyebrows.

"Then a design strategy is to develop your own fabrications."

"What is involved with developing our own fabrications?" Jason asks.

"You submit a standard."

Tamee interrupts Michael and says, "Like the Impressionist painting that we bought." Michael thinks, "Tamee could never work with the Chinese because interrupting is considered to be rude."

He patiently continues. "Yes, Tamee. Give me technical specifications such as fiber content, desired weight, and the standard. Depending on what you are developing, a standard, Jason, is yarn, a fabric cutting, or a painting. Tamee, I submitted your vendor card with the Impressionist fabric painting when I was at our Chinese production facility."

"We can decide that today! I will write down what we want," Tamee says, remembering that Kate told her to do so to avoid misunderstandings with vendors.

Later that week, Anne stands in the design workroom and examines the wall grid they were using to evaluate their designs. They have spent several hours arranging and rearranging swatches of color, fabric, and garments according to their Beauté theme. "We need to create some product groups, put REJ2001 and REWB1001 on the wall grid. You can develop some knit textures to go with these

styles, and then we will have a vest to build the Beauté collection. The purple uses reactive dye, so it will be more expensive than sage. Michael said that our minimum order is 1,000 yards per color. Do you think you can work your magic so that we sell 500 skirts and pants in each color?" Anne asks.

"Look how our painting and the colors in the yarn dye clash!" a frustrated Tamee comments, not answering her question.

Objectives

After reading this chapter, you should be able to do the following:

- Write fabric selection and development on the time-and-action calendar, and understand their dependence on completing other activities.
- Interpret maintaining a product line from a design team context of analyzing business history and developing strategic design advantage.
- Distinguish among the fabric parameters of core yarns, base fabrics, cost structure, and product flexibility.
- Comprehend how designers evaluate fabrics from multiple vendors.
- Distinguish how designers make fabric decisions in which they clarify goals, create solutions, analyze fabrics, evaluate, and make final decisions.
- Understand merchandising a line for fabric decisions by using the design process framework.
- Calculate fabric minimums.
- Grasp the fabric development process in which the design team communicates fabric attributes, creates a textile technical package, and approves fabric.

Have you ever wondered why many apparel product development positions require "experience"? Managers often attribute "experience" to an individual's understanding of the design process, namely he or she knows the thought process, expectations, and tasks to merchandise a product line. To understand why fabric selection and development requires this experience, we return to the design process phases introduced in Chapter 5.

Time Constraints in Fabric Selection and Development

Fabric selection and development requires coordination among many people and requires the expertise of individuals who have specialized knowledge (Kadolph and Langford 2007). Apparel manufacturers and private-label retailers need to have open

communication, trust supplier expertise, and respect vendor time constraints. Frequent inter-action among suppliers and customers is important for effective and timely fabric selection and development. It is common sense to think that if the design team does not have fabric, they cannot **go forward** with finalizing patterns and sewing prototypes. Thus, meeting cal-endar dates is critical because textile vendors need concrete decisions before they can start their process. According to Michael Rowley, owner of Straight Down Clothing Company, 👕 initial fabric development—including concept meetings and technical setup—typically takes 4 weeks.* The time to develop fabric depends on its complexity. For instance, a yarn dye stripe layout (stripe stocking) may take 1 week, whereas texture development takes 3–4 weeks. For yarn dyes, designers determine color placement simultaneously with fabric development. Once the designers approve colors and complete technical setup, a textile ven-dor can develop and produce a fabric style 2 weeks with a partnership arrangement. However, during peak production, the bulk arrival of fabric negatively affects production scheduling and a textile vendor's **turn-time** increases to five weeks (Regan 1997, 170).

The design director is in continual communication with textile manufacturer representatives for fabric delivery dates. The textile vendor must adequately determine development and construction constraints. If there are production problems that delay fabric development, the design director will postpone fabric introduction for a future season or cancel the project. Once the apparel company receives sample fabric, it adds in sample garment production time. Sample garment production varies, from 1–5 days in-house and 2–4 weeks if sewn by an international contractor. Thus, working backward, the design team starts fabric design and development 8–11 weeks before garment sample creation. The design team delays the time and action calendar if associ-ates change their minds on colors or fabrics. Indecisiveness results in the designers delaying product line decisions, which in turn creates a crisis state by being **off-calendar** (Regan 1997, 164).

ACTIVITY **10.1** *Time-and-Action Calendar: Continued*

Using Table 4.10 and Company Project 3 in Chapter 4, add fabric selection and devel-opment activities to your time-and-action calendar, and create a time line for com-pleting these activities.

- In cell A25, type "Determine fabric parameters." Designate one week and fill cell G25. Align this activity in the same column as the start of "Create color stories and color deliveries."
- In cell A26, type "Evaluate fabric options." Designate one week and fill cell G26. This activity is the same week as "Determine fabric parameters."
- In cell A27, type "Participate in fabric concept meetings." Designate one week and fill cell H27. This activity starts at the completion of "Evaluate fabric options."
- In cell A28, type "Develop fabric, evaluate submits, and approve fabric styles." Designate nine weeks and fill cells H28–P28. This activity starts the same week as "Participate in fabric concept meetings."

*Reprinted by permission from Michael Rowley, owner, Straight Down Clothing Company, San Luis Obispo, CA March 25, 2005.

The Design Process as Structure for Fabric Selection

To an experienced designer and merchandiser, fabric decisions are natural and they "just do" rather than think about each decision that they make. A person outside the design team may wonder why it takes up to 9 weeks to evaluate fabric alternatives, buy sample fabric, and finalize purchases. One reason is that fabric selection requires coordination among and the design team needs an output from multiple textile vendors to make decisions. We use the design process to understand the sequence of activities. The design team first meets informally to discuss maintaining the basic product line (i.e., goal analysis). The design director and merchandiser will identify garment parameters and convey this to the design team (i.e., problem analysis). Third, designers identify fabric types (i.e., search for design solutions). The design team merchandises the line (i.e., decision making), and they finalize fabrics by placing orders (i.e., verification) (Figure 10.1).

The vice president of product development gives strategic direction to design directors. This direction becomes the design strategy that guides product line development. One responsibility of the design director is to devise plans, projections, and growth for an SBU (Tran 2005a). The vice president of product development expands product lines if the company has a heterogeneous customer base and the existing product line is currently in high demand. This benefits a company because it enables the company to raise prices above margin (Putsis and Bayus 2001).

Figure 10.1 Merchandisers spend time discussing product line details with textile manufacturer representatives.

Fabric Goals and Challenges: Goal Analysis

The design director begins merchandising a line with a clear definition of the product group, as well as an understanding of customers and what motivates them to buy (Figure 10.2). A review of fabric goals and identification of challenges are main objectives in maintaining a product line (Regan 1997, 183). **Maintaining the product line** is how an SBU differentiates itself from the competition in products offered. A brand will disappear if it simply copies everyone else. Branded companies need to be sharp and quick because they have stiff competition from private-label retailers (Earnest 2007). To determine its strategic direction for fabric, merchandisers analyze the SBU business history. Based on this analysis, the design director provides strategic direction to the design team on whether they will implement or continue with a focus, differentiation, or cost leadership.

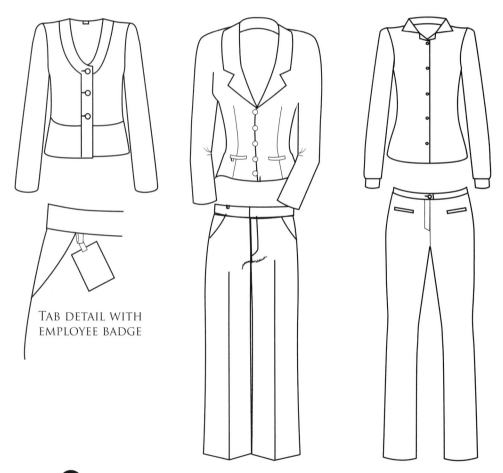

TAB DETAIL WITH
EMPLOYEE BADGE

Figure 10.2 Designers and merchandisers group design inspiration materials.
(Illustration by S. Lozano and E. Perales.)

Business History Analysis

Apparel companies create reports by **fabric codes**, which is a documentation of a single fabric style (Regan 1997, 151). A **fabric style** is one fiber content (e.g., 100% cotton), fabrication (e.g., interlock), and weight (e.g., 5 ounce) in a variety of colors. Apparel companies use a large number of fabrics, for instance, up to 200 fabrics each season (Regan 1997, 151). Merchandisers and their assistants compare fabric codes with garment style sell through to determine which fabrics, colors, trims, and garments sold the best. Merchandisers will then assign risk to specific fabric styles based on previous sell-through success or failure and fabric style recommendations for the upcoming product line. They will discuss whether a fabric style has peaked in sales and should be discarded, or if a prior poor-selling fabric should be included in the product line because trend forecasters recommend it. Designers use this information to determine the desired ratio of fabrications and trims in which to design garments in an upcoming season.

Strategic Advantage

A company achieves **focus** by using innovative strategies for a narrow industry segment, addressing a new market, or serving a segment better (Porter 1990). Body Glove International 👕 uses a focus strategic advantage by serving surfers and divers better through product improvement. Body Glove International was the first apparel manufacturer to use neoprene for its wetsuits in the 1950s (Nelson 2006) and the company continues to innovate its products. Vapor Flex and the Eco Wetsuits are two examples. Body Glove's Vapor Flex is a patent-pending technical fabrication with a nylon-spandex exterior laminated to neoprene themofiber interior (Body Glove International n.d. [b]; Tschorn 2005). Apparel companies embracing a focus strategic advantage will often collaborate with textile companies to develop unique fabrications or with inventors, such as Rock, Dionne, Haryslak, Lie, and Vainer (2007), who patented a composite fabric with moisture wicking and insulating attributes. Body Glove International eco wetsuits is another focus strategic advantage example. Eco wetsuits use a non-petroleum fabrication that uses 90 percent less energy to produce that its petroleum-based fabric counterpart (Body Glove International n.d. [a]).

 Differentiation allows a firm to command a premium price, which can lead to superior profits. A company achieves differentiation strategic advantage by offering improved product quality, special features, or superb customer relations (Porter 1990). In relation to fabric, differentiation includes controlling fabric specifications, offering unique finishes, and exceeding target consumer expectations. Controlling fabric specification is the quality assurance built into an apparel company's products. A company will offer product specifications such as dimensional stability (low shrinkage, stretch recovery), or special finishes (e.g., wrinkle resistance). Apparel companies that implement focus or differentiation strategic advantage commonly work with textile vendors to develop new fabrications, so product features or specifications are better than competition. Some screen-print companies use a differentiation focus through new fabrications, specialty inks or design placements to stay ahead of foreign competition. A new fabrication is a soft wash on a double knit polyester/cotton fleece. Specialty inks include water-based inks in which its intrinsic nature takes on a different color tone when printed on different fabric colors. New design placements include off-placement prints, such as across the shoulder (This year's ranking...2007).

A company achieves **cost leadership** strategic advantage by designing, producing, and marketing comparable products more efficiently than its competition (Porter 1990). Historically, the goal of private-label merchandise was to achieve cost leadership by being less expensive than branded merchandise. Today, many private-label brands, such as Macy's I•N•C, have strong brand recognition (Earnest 2007).

Types of Textile Vendors

Based on its strategic direction, the design team decides which textile companies to buy from and whether to buy open-line fabric styles or to develop fabric. A textile company classifies itself as an inventory house, a custom house, or a combination of both. An **inventory house** is a textile company that develops or buys fabric internationally and puts together a seasonal product line. A **textile manufacturer representative** from an inventory house offers a product line as **open line** in select fabrications, fiber types, and patterns. The textile manufacturer representative sells open-line fabric styles *as is*. An inventory house is comparable to an individual shopping at a retail fabric store and buying something that is in stock. Inventory houses do not guarantee pattern or fabrication exclusivity because multiple customers can purchase the same product. However, some inventory houses limit the quantity produced (e.g., 5,000 yards), which restricts availability.

Some companies create broad product lines to satisfy the needs of their retail customers (Putsis and Bayus 2001). These apparel companies often buy open-line fabric to meet cost, efficiency, merchandise assortment, or purchase-quantity requirements. Their goal is to seek a cost leadership strategic advantage by purchasing open-line fabric. According to Tom Tantillo* of Milliken & Company, the apparel manufacturer and the textile inventory house must have a business model that has inventory capacity to store open-line commodity products. Textile companies attain economies of scale when they manufacture open-line fabric in high quantities, and they may pass this efficiency onto customers.

Fabric – A Part of Brand Development

Fabric development is an important component of defining an apparel company brand; thus, some apparel manufacturers develop fabrics. A goal for design directors is to develop brand identity. They relay to designers how designs need to contribute to the company's brand. Successful product lines focus specifically on target market needs. For example, children's clothing consumers demand comfort and functionality; however, additional brand attributes include value-added characteristics such as competitive pricing, color, or style details similar to the teen customer (Griffin 2005).

Successful companies clearly distinguish product lines. One way is through the fabric used. Here we use the Marika Group Inc. 🖰 as an example. Marika has two female aerobic exercise product lines. One product line focuses on the 20- to 35-year-old female who wants sexy styling and trendy colors. This product line features fabrics with moisture management and a high spandex content. The Balance Collection product line is for women "on-the-go." Product styling is influenced by yoga; however, fabrics are comfortable so women can wear them for multiple lifestyle activities (Remarkable Growth . . . 2005).

*Reprinted by permission from Tom Tantillo, Milliken & Company; pers. comm., August 25, 2005.

A **developed fabric** is an exclusive fabrication, yarn dye, pattern, or print made to a customer's specifications. Textile companies make a fabric texture or print for one customer, rather than being available to anyone interested in buying. Apparel manufacturers and private-label retailers develop new textures and fabrications with suppliers to attain strategic design advantage. This process, explained later in the chapter, requires good communication and an understanding of time constraints.

Textile Partnerships and Vendor Certification

Through experience, a design director knows which textile mills and converters to contact for specific yarns, weaves, knits, fabrications, or fiber types. A design director who wants to look for a new textile vendor often uses resources such as InfoMat's guides 👕 Cotton Incorporated's Global Fabric Library 👕, Invista's Special Services 👕, or TexWorld's member directory 👕.

ACTIVITY 10.2 *Locating Textile Vendors*

Recall the retail store customers you identified in your business strategy project. Go to the Web site of one of those retail stores (e.g., Nordstrom: www.nordstrom.com).

* Look at a garment that has a fabric attribute similar to one you want to create in your product line. Click on the picture to get item detail and write down the fabric information (e.g., woven cotton).
* Go to the Web page for Cotton Incorporated's Global Fabric Library (www.cottoninc. com/CWFL/) or Invista's Special Services (www. invista. com/page_services_index_en. shtml). Note both organizations include resources that carry multiple fiber blends.
* Select a fabric construction (e.g., knit) from the resource list (e.g., lycra).
* Select a textile company name. Click on the textile company's Web page (not all companies have Web links). Click on "Sample Room" or "Products." Click on a fabric type that you found in the garment from above. If your garment has multiple fibers, select the one with the highest percentage.
* Write down the fabric specifications (e.g., weight, color, width). Save this information for Company Project 11.

Trust and a collaborative partnership are important attributes among apparel manufacturers or private-label retailers and their textile vendors. A designer emphasizes the importance of good customer service:*

> Most of the textile vendors are easy to work with and you can find out great information, such as what everyone else is sampling. Some reps have bad attitudes and do not believe in customer service at all. When that is the case, I choose another company to work with or ask to have a different sales representative.

Successful long-term business relationships include having open communication, trusting supplier expertise, and respecting time constraints. Apparel companies benefit from partnership agreements because it increases collaboration, improves customer service, offers on-time

*Reprinted by permission from Kimberly Quan, designer, Covina, CA; pers. comm., June 21, 2006.

shipment, and increases consistency in quality standards. An incentive for many companies is that partnership agreements reduce the time to market (Cottrill 2006).

Textile vendors benefit from partnership agreements because they have consistent order quantities. Thus, they can control their production schedules and lessen the need for unanticipated operational costs (e.g., hiring freelance labor). When a customer communicates fabric needs on an ongoing basis, the textile vendor can set up production scheduling for greige goods and finishing. If an apparel company partner places a fabric order, the textile company can ship it quickly because it has greige goods in inventory for that customer and has blocked out time to dye and finish the fabrics (Regan 1997, 170). Randall Baxter, a former production manager at Little Mass 👕, commented on informal partnership agreements:*

> Most companies work through sales representatives. Hopefully, you have a good relationship with your sales representative. The way it typically works is companies will push harder for you the more business you give them. If you are a small company with small quantities, you typically are at the mercy of the suppliers if you cannot make the minimum.

ACTIVITY 10.3 *Critical Thinking*

The production manager referred to having a good working relationship with textile sales representatives and giving them more business. Do you believe that consistently ordering product from the same textile company would help an apparel manufacturer? Explain your rationale.

Many apparel companies will limit the number of textile vendors that they work with by requiring certification (Regan 1997, 170). These companies require their vendors to sign a code of conduct, which guarantees that they will uphold U.S. labor laws. In addition, vendor certification often addresses that a vendor will undergo internal audits to ensure it maintains predefined quality assurance standards (U.S. Department of Labor n.d.).

Product Line Fabrication: Problem Analysis

Once the design team has a clear direction, they identify the fabric types to offer in the product line. Fabric identification means the design team selects parameters, and discusses textile vendor availability and the flexibility of using certain fabric types in multiple garments (Regan 1997, 183). Figure 10.3 shows the sequence of decisions that the design team makes to select fabric parameters, evaluate fabrics, evaluate and make decisions, and order fabrics.

Fabric Parameters

Parameters is a general term that describes the number and type of fabric and garment styles in an SBU and their corresponding production information. Corresponding production information is the number of new versus existing prototypes, send-outs, and manufacturing style quantities (Regan 1997, 183). The merchandiser determines the number of new and

*Reprinted by permission from Randall Baxter, former production manager, Little Mass, Los Angeles, CA; pers.comm., February 16, 2006.

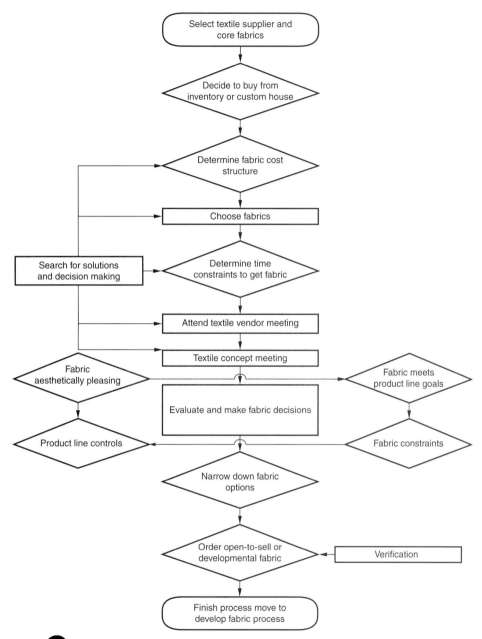

Figure 10.3 Merchandising the product line activities. *(Chart by K. Bathalter.)*

existing garment prototypes (see Chapter 4). **Send-out** is a colloquial term that refers to a portion of a garment that is sent to a contractor during production. Some examples are pleating, garment wash, embroidery, or screen-print (Regan 1997, 276). Manufacturing quantity is the number of garments forecasted for a production run. Operations associates need to

know fabric parameters because they assign garment styles based on contractor or production equipment types and styles previously sewn (Regan 1997, 261). **Fabric parameters** are the identification of a general fabric category (e.g., knit, woven). Garment contractors commonly specialize in the types of garments sewn, for instance, knit or woven sportswear. If the design team accepts a fabric in the product line, the purchasing department assigns a fabric code, to keep track of its supply chain process (e.g., order, delivery, sell through) (Regan 1997, 252).

Core Yarns and Fabrics

One fabric parameter is the identification of core yarns and base fabrics. Consumer expectation is an important criterion in specifying fabrics used in a product line. For example, consumers expect high-end cotton knit tops to have fabric characteristics such as a soft hand, body (i.e., fabric weight), no shading, and minimal shrinkage. The design team identifies fabric types based on information discussed in maintaining the product line (Regan 1997, 183). **Core**, an important attribute, is a product that an apparel company builds its reputation on and is consistent with the company's product strategy. Core is intrinsic with developing and building brands so customers and consumers recognize the company's brand as having specific yarns, fabrics, colors, or garment styling. For some apparel companies, its core fabrics are obvious. For instance, the Burberry plaid, trademarked in 1920, is renowned for its use in the company's product such as trench coats and accessories (Burberry Limited 2005).

An apparel company identifies core fabrics by its core yarn or base cloth, which is the use of a specific fiber content and fabrication for a product group. Here, we use American Apparel ⬡, a large sportswear vertical manufacturer, as a core yarn example. Their product line consists of approximately 70 garment styles. The company makes products out of 100 percent cotton or cotton-rich fabrics. The company globally sources yarns, in which they knit and dye fabric, and sew their own garments. American Apparel distinguishes fine jersey, one of its core fabrics, by using 4.3 ounce, 30/1 (thirty singles) combed ring-spun base yarn, which is knit in the United States (American Apparel n.d.). Combing fibers produces a fine, smooth, even yarn. Ring spun is a more uniform, finer yarn that has higher quality and fewer fabrication problems (Kadolph and Langford 2007). American Apparel's core yarn distinguishes them from its competitors that typically use spun open-end cotton (18/1 eighteen singles) (American Apparel n.d.). Open-end has weaker yarn strength, and it is a coarser yarn (Kadolph and Langford 2007).

Apparel companies often develop a core fabric by using a specific base cloth. **Base cloth** is a fabric with a specific fiber content, fabrication, and yarn count (i.e., number of pics per square inch), and weight that a company uses for multiple product lines (Regan 1997, 252). An SBU commonly uses base cloth to develop recognition for its product line (Figure 10.4). An example would be a 100 percent 4-ounce cotton shirting fabric that is plain weave, 68 square. Base cloth is available as greige (pronounced *gray*) or prepare-for-finish (PFF) fabric. **Greige fabric** is unfinished fabric. PFF fabrics can go through numerous preparation processes, such as such as bleaching and mercerizing (Kadolph and Langford 2007). Often apparel customers specify the desired preparation processes. The textile manufacturer representative assists the design director with selecting appropriate greige or PFF base cloths. For example, the textile manufacturer representative may state that a 60 square is a heavier, multipurpose, sturdy construction, whereas a 68 square is made of a finer yarn, with attributes of soft hand and lighter weight.

5 oz. cotton
plain weave
unprocessed

5 oz. cotton
plain weave
yarn dyed

5 oz. cotton
plain weave
printed

Figure 10.4 Example of a base fabric and how to create variety with the same base fabric. *(Illustration by A. Flanagan.)*

The perceived value of fabric and fabrication is an additional criterion. The base cloth used for a print affects how designers evaluate the textile prints. A **base fabric** has specific characteristics such as fiber content, weight, weave, or knit (e.g., a 6-ounce cotton twill). The textile vendors offer specific base fabrics (jersey knit) within different

groups (solid, yarn dyed). As designers gain experience evaluating fabrics and fabrications, they will recognize that there is a particular weight, weave, or pattern history. In addition, textile vendors will knit or weave fabric weight for aesthetic change, cost structure, or desired quality. Apparel industry associates are well aware of the relationship of specific fabrication characteristics, such as when a lighter fabric weight is a higher quality or when two different weaves are equal in their quality attributes.

ACTIVITY 10.4 *Core Fabric Identification*

Go to the Lucky Brand Jeans Web site (www.luckybrandjeans.com/default.aspx).

- Click on "Men" or "Women," then click on "Jeans."
- Click on "Shop By Weight" and select "Lightweight," "Midweight," or "Stretch." Write down the fabric finish description and then click on "View This Jean Fit in Additional Washes."
- Describe how many different finishes Lucky Brand Jeans used for one fabric weight and jean style.

Fabric Cost Structure

Apparel manufacturers and private-label retailers buy open-line fabric and develop proprietary designs, or a combination of both. Because raw material contributes the largest percentage of product costs (Glock and Kunz 2005), executives will tell the design team to buy fabric that is within a set wholesale price range, called a cost structure. According to Jim Jacobs, the director of sales and marketing for the Caribbean Basin Region of Milliken & Company, **cost structure** refers to the finished fabric price range that the design team is willing to pay.* Design directors need to decide a specific cost structure for its base yarn or cloth before textile vendor meetings.

Designer Kim Quan commented on fabric costs:*

> I always have a maximum fabric price. For example, at one contemporary company, I designed evening dresses, so I could use fabrics that cost up to $12 or $13 a yard. But, at a junior company I designed for, the fabric could not cost more than $3 a yard and anything under $2 was great! Sometimes it was hard to work with low fabric prices because textile companies are always coming up with new techniques, and sometimes you feel limited with fabric and trim prices. In the budget market, I would have to wait until fabric companies created large quantities of certain fabrics and lowered the price, or came up with a fabric variation.

Design directors and textile manufacturer representatives work together to select the right base yarn or cloth within a company's cost structure. The components to fabric costs are converting (e.g., dyeing), raw material (e.g., yarn), labor, packing materials, variable overhead (e.g., utilities), fixed overhead (e.g., depreciation), indirect labor, and profit (Curry 1997).

*Reprinted by permission from Jim Jacobs, director of sales and marketing Caribbean Basin Region, Milliken & Company; pers. com., August 25, 2005.
*Reprinted by permission from Kimberly Quan, Designer, pers. comm., June 21, 2006.

Developed Base Fabric Costs

When apparel companies develop fabrics, the design team selects yarn specifications and finishing from the textile vendor. According to Tom Tantillo of Milliken & Company, yarn specification costs vary, depending on fiber, yarn specifications, manufacturing equipment, quality specifications, and the time purchased.*

The design team reads about or relies on their textile manufacturer representatives to inform them about business and economic trends that affect fiber, base yarn or fabric costs. Literature resources include Worth Style Global Network (WGSN) materials information, which features aesthetic fabric attributes such as new blends, fabrications, and finishes (WGSN-edu n.d.). Textile World features technical information such as new fibers, dyestuffs, finishes, yarn prices, and company transitions. Design managers are interested in improved dyes, such as an improved colorfast black dye (Textile World n.d.).

It benefits design team associates to be educated about specific knitting or weaving equipment that their textile vendors use because they will know the machine knitting or weaving possibilities and limitations. A major cost contributor is machine run time. **Run time** is the time that it takes to produce a product (e.g., one fabric style) (Institute of Industrial Engineers n.d.). A variety of factors affect textile production run time, from the production quantity ordered to yarn type. For instance, mohair yarn is weak and will break if knitted into an elaborate cable design (Eckert 2001), which would lengthen the run time in addition to increasing potential fabric quality control problems. The design team associates refer to textile textbooks or their textile manufacture representative to answer questions on specific fiber, yarn, and dyeing attributes.

An apparel company's quality assurance department sets its desired garment performance, including fabric quality standards. The design team conveys acceptable quality standards information to their textile vendors (Regan 1997, 257). Tom Tantillo noted that the design team might opt for a higher yarn quality than its company standard to improve fabric aesthetic attributes (such as fabric hand).

The time that design team associates buy the yarn or base cloth affects the price they pay. Pricing varies depending on market demand, the export market, the yarn type produced, energy prices, and import competition. For example, customers generally pay a higher price for value-added yarns, such as ones with a soft-hand, recycled fibers, or organic fibers. Import competition affects yarn pricing. For instance, 18/1 yarns used for T-shirts typically have thin margins because domestic yarns have a lower demand (Phillips 2007).

ACTIVITY **10.5** *Calculating Yarn Prices*

Bimonthly, Textile World compiles current yarn prices for cotton, polyester, acrylic, rayon, and nylon. Go to the Textile World Web site at www.textileworld.com/ Default.htm.

- Under "Departments" on the left side of the Web page, select "Yarn Market." Read the current article affecting the yarn industry.
- Select "Current Yarn Prices" at the bottom of the page, and download the current yarn prices. Each yarn is listed by its lowest to highest quality.
- Identify which yarn is currently the highest priced (e.g., textured nylon).

*Reprinted by permission from Tom Tantillo, Milliken & Company, Spartanburg, SC; pers. comm., September 12, 2005.

- Assume you want to make a fine-gauge polo shirt that uses 1.1 pounds of yarn. Compare the yarn price for this polo shirt if you made it in 38/1 (38 singles) ring-spun combed cotton yarn versus if you made it out of an 18/1 (18 singles carded) cotton.
- Formula: Yarn weight × Price per pound = Yarn cost
- Example: 1.1 × $2.24 = $2.64 versus 1.1 pounds × .87 = $.96
- Keep in mind that these yarn prices are for comparison only. These prices reflect a direct greige goods purchase from the yarn market and does not include finishing, nor a broker or merchant's profit margin.

Product Flexibility

Once the design team selects its fabric parameters, they work with textile manufacturers to identify yarns and fabrics that offer product flexibility (Regan 1997, 183). **Product flexibility,** in relation to fabric, means the design team can use a fabric in multiple product lines, and it can be finished in a variety of ways while maintaining company quality standards.

A designer's selection of fabric flexibility is much like going to a restaurant and selecting from a menu or special order. Imagine going to a "fabric restaurant." The maitre d' comes up to you and says, "Here's your menu. Your textile manufacturer representative will be right with you; enjoy looking at your options."

You take the menu from him, feeling the heavy weight of the samples, and comment, "You must offer a tremendous selection; these samples are heavy."

"Oh, we do," the maitre d' replies, "there's more than 2,000 different selections, and if you don't see what you want, you can custom order."

You flip open to the knit cotton section as the textile manufacturer's representative sits down at your table. She glances at your page and says, "First, look at the type of cotton you want. Would you like open-end carded or combed ring spun?"

Creasing your brow you think, "That sounds vaguely familiar from my textile class."

The representative continues, "Would you like domestic cotton, such as California SJV Acala, or foreign cotton?"

"Is there a difference?" you ask.

"Absolutely. California SJV cotton is contamination free, is stronger, has a longer staple length, and is whiter. U.S. cotton brokers export cotton all over the world; for example, you can buy Memphis cotton domestically or from global sources such as Mexico. Or, if you prefer, you can import cotton from Australia, China, Pakistan, or Uzbekistan."

"Do I need to decide now?"

"Yes, cotton fiber color varies, so our colorists need to know in order to develop the correct color match. You also need to consider the fabrication. Do you want 1 × 1 rib, 2 × 1 rib, baby rib, interlock, jersey, sheer jersey, jacquard, or a texture? Alternatively, perhaps you want a blend such as mélange stretch jersey. We have these fabrics available in a 2, 3, or 4 ounce, and we have two hundred different standard colors from which you can select. These are available in both pigment and reactive dyes."

You grimace, gritting your teeth at the textile manufacturer's representative, thinking, "My textiles professor is getting back at me for dozing off in class!"

This scenario is common for a designer because fabric specifications are important when designing a product line. The design team works with multiple textile manufacturer representatives to come up with a clear fabric definition.

A Clear Line Fabrication Definition

The final stage is to have a clear line fabrication definition. Part of competitive strategy is to clearly distinguish one product line from another. One way to accomplish this is to clearly define a product line by identifying the fabric fabrication, weight, and finish. For instance, True Religion Apparel ⊺ denim product line is its largest SBU. The company's fabric parameters are to offer high-quality fabrics from the United States, Italy, and Japan. It's fabrication definition is to create vintage and premium wash finishes that give a gentle and natural aged finish. They embellish products by hand finishing and using bold stitching in multiple thread colors (U.S. Securities and Exchange Commission [SEC] March 28, 2007).

ACTIVITY **10.6** *Describing the Product Group*

Write a description of the product line you want to create. Write your fabric parameters and a line fabrication definition. Use the information from True Religion Apparel as an example of the desired degree of detail. Keep your definition for Company Project 11.

Evaluating Fabric Options: Search for Design Solutions

Once the design team has its fabric parameters, they review seasonal product lines from textile vendors. Apparel manufacturers and private-label retailers update garment styles by selecting new fabrics to meet the needs of continually changing fashion trends. Designer Kimberly Quan explained her approach:*

> The beginning of every month I call ten to fifteen vendors and ask them to present their line. I ask them to see new and old fabrics. I also listen to their presentation to hear about what is selling. Sometimes, I will sample 5 to 10 yards, especially with a new novelty fabric. Often, there is a surcharge on sample fabric, it could be 15 percent more than production or even double the cost, but it is important to test a new fabric.

Textile Vendor Meetings

Vendor days is a colloquial term for a time period in which fabric manufacturer representatives travel to apparel company headquarters and present wholesale fabric lines to designers. Vendor days are a whirlwind for product development associates because they meet with multiple textile manufacturer representatives and review a variety of textile lines, typically within a short time period (e.g., 3 to 5 days) (Regan 1997, 185). Designers may buy textiles from any textile vendor or only limit their supplier network to those vendors that meet certification agreements.

*Reprinted by permission from Kimberly Quan, designer, Cerritos, CA; pers. comm., June 21, 2006.

Euro-Tex
Pink Satin
100% Silk
Width: 45 inches
Weight: 4.5 oz.

Figure 10.5 A header has textile company identification, fabric description, and a cut fabric swatch. *(Illustration by A. Flanagan.)*

Textile manufacturer representatives "do their homework" before presenting fabrics to their customers. The textile manufacturer representatives have access to hundreds of fabric swatches, called headers. A **header** is a swatch of fiber type(s) and fabrication (e.g., 10″ ×10″), stapled to cardboard, in multiple colorways. The header includes a written description of fiber content, fabrication, weight, fabric width, and delivery dates (Figure 10.5). Textile manufacturer representatives prepare as if they were reference librarians seeking out fabric styles from their seasonal line and using a computer database or printouts that catalog fabric SKUs. The textile manufacturer representative organizes pertinent fabric headers, which are relevant to their apparel customer's product line and cost structure.

A textile vendor's presentation is usually a 30-minute to 1-hour presentation that takes place in a conference room or design room. The audience varies; sometimes it is only the design director, whereas other times multiple SBU design team associates attend.

TERRY

RASCHEL

Figure 10.6 A designer needs to know fabrications, such as the difference between a Raschel knit and terry cloth. *(Illustration by A. Flanagan.)*

At the front of a room or on a table, the textile manufacturer representative gives a brief seasonal color and fabric forecast for the company's market segment and then presents their seasonal fabric line. The textile manufacturer representative thematically presents hundreds of headers in an organized fashion, such as by fabrication or theme. It is important that designers know and use appropriate textile terminology because the textile manufacturer representative casually uses technical textile phrases such as *denier*, *30-single yarn count*, or weaves such as *basket* or *twill* (Figure 10.6).

From their presentations, design and merchandising associates get fabric ideas that they can incorporate into their product line. During the presentation, the design team has

its identified seasonal theme, and they have a preliminary idea of their product line. Thus, they contemplate how each fabric style would look in a new or existing garment.

ACTIVITY 10.7 *Analyzing Fabric Descriptions*

The purpose of this activity is to evaluate the fabric types and styles used in an apparel company's product line. Go the L.L. Bean online catalog (www.llbean.com).

- Click on one apparel product line (e.g., "Girls' Apparel," then "Shirts & Turtlenecks".)
- Write down the main styles (e.g., short-sleeve and sleeveless), and click on "view all".
- Click on each garment style. Read the overview and detail, and write down the fabric style description (e.g., unshrinkable cotton jersey). Write down the colors and/or prints.
- Assume each fabric style is from a different vendor. How many textile vendors is L.L. Bean working with for one product line (e.g., "Girl's Apparel: Shirts & Turtlenecks")? What is the average number of colors L.L. Bean offers for each garment style?

Fabric Decision Making

Once the design team has seen the vendor presentations, they decide which ones will work for the seasonal product line. This fabric decision-making stage involves several informal meetings in which they evaluate the textile vendors' fabrics and prints. One can envision this stage by visualizing a design workroom with colorful fabric swatches, illustrations, digital images, garments, magazine pictures, photographs, scraps of fabrics, trim, yarn, and color swatches haphazardly placed on wall grids, bulletin boards, and large worktables.

Design Refinement: Textile Concept Meetings

The design team participates in textile concept meetings after manufacturer representatives present their line (refer back to Figure 10.2). A **textile concept meeting** is the activity in which the design team collaboratively makes fabric decisions. The design team collaborates on and goes through a decision process that includes clarifying goals, generating solutions, analyzing, evaluating, and approving fabrics. Textile concept meetings are part of merchandising a product line (Figure 10.7). At these meetings, the design team selects colors, explores print ideas, and explores ways to combine fabrics (Regan 1997, 189). At the same time, the design team is defining their product groups by sorting inspirational materials and arranging colors.

For a small design firm, a single designer relies on his or her own design-thinking skills, whereas larger apparel firms commingle ideas and have collaborative textile concept meetings among associates from different SBUs. Some individuals may think that designers' decision making is arbitrary; however, it is a structured thought process. Associates are often aware of their own thinking and actions when solving design problems. We can look at fabric decision making in more detail by the actions that occur,

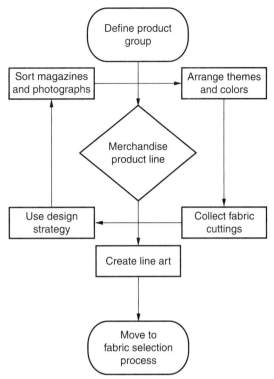

Figure 10.7 Fabric concept meeting activities. *(Chart by K. Bathalter.)*

which is called *design content*. Design content is how a team clarifies goals, generates solutions, and analyzes, evaluates, and makes decisions (Stempfle and Badke-Schaub 2002). Here, we discuss it in relation to how the design team finalizes fabric ideas.

Clarification of Goals

Evaluating multiple textile vendor product lines in a short time can overwhelm designers. Therefore, the design director starts textile concept meetings by clarifying product line goals. **Goal clarification** is communication of the number and relationship between elements (Stempfle and Badke-Schaub 2002). This structured thought process is similar to abstract category theory. The context of **category theory** is that objects comprise a group structure. Instead of studying the objects separately, an individual studies the structure between the objects. In an abstract sense, category theory allows an individual to clarify what related objects have in common (Wikipedia Contributors n.d.). Designers commonly group fabrics and designs into categories. They will categorize by motifs, visual, and tactile effects, or by fashion trends (Eckert and Stacey 2003). The goal is for designers to create different colors, fabrics, and/or garment styles that create newness, but also relate to each other.

Visualization tools Designers use their visualization skills to create ideas or to revise new products (Lewis and Samuel 1988). Designers start merchandising the line by pinning up magazine pictures, photographs, themes, colors, and fabric swatches on a wall grid, which allows them to start visualizing the seasonal product line. A wall grid is a metal unit onto which designers clip or hang objects. A colloquial phrase that encompasses this process is to "put everything up on the wall." Designers categorize cuttings or copies of fabric prints and textures that they collected from vendor days. Physically grouping fabrics on a wall grid to helps designers visualize ideas, group fabric cuttings by themes, and separate them by delivery. When finished merchandising the line, a designer will convey to merchandisers and other design associates, "this group is for delivery one and this group is for delivery two."

Fabric category terminology Designers use a common language to classify fabrics. Common fabric style categories are conversational, florals, and traditional. Any design can realistic or stylized. A **realistic design** shows detail and is close to the actual object. Figure 10.8 is an example of a realistic floral design. A **stylized** design is simplified or flattened; it can be cartoon-like. **Conversational styles** are juvenile, familiar, or theme objects that appeal to different audiences (Figure 10.9). Juvenile designs appeal to children; familiar objects are everyday items; and theme patterns include hobbies, activities, or period pieces. **Floral styles** are an artist's realistic, stylized, or abstract interpretation of trees, plants, and flowers. **Traditional styles** include foulards, paisley, ditsy, calico, or documentary designs (Figure 10.10). **Foulards** are classic, conservative grid patterns. **Paisley** is a detailed stylized design of a Persian palm. **Ditsy** designs are all-over prints, sometimes called "little nothings" after the shapes. **Calico** prints are small geometric shapes, florals,

Figure 10.8 Realistic floral design. *(Illustration by S. Lozano.)*

Figure 10.9 Conversational design. *(Illustration by S. Lozano.)*

Figure 10.10 Traditional fabric design. *(Illustration by S. Lozano.)*

stripes, or other motifs often associated with quilting. **Documentary styles** are those from a particular historic or cultural period (Fisher and Wolfhal 1987). Designers often convey product line themes by using recurring fabric motifs or one print to go with two different ideas.

Solution Generation

Solution generation is the next design content step and creates a forum for designers to propose ideas (Stempfle and Badke-Schaub 2002). Designers get the chance to use their personal experience and immersion in the profession in order to develop new designs (Goel 1995). These meetings often start with a free-form discussion. Designers will discuss and question the groups' reaction to fabric styles, motifs, and details seen during their inspirational shopping experiences. To an outsider, the designers' conversation sounds foreign because they describe ideas by origin and ways to combine or modify designs (Eckert and Stacey 2000). For example, they might say, "We could combine the Caribbean print sport shirt that we saw in Newport Beach with the animal print from Melrose, but we would have to tone it down because it's so LA."

Communication is important because groups often work together to accomplish problems that they cannot individually solve (Stempfle and Badke-Schaub 2002). The way in which the design team communicates affects the collaborative process, and a communication breakdown can create problems (Eckert 2001). For effective communication, fashion or design directors often lead and organize textile concept meetings. The design director often prompts designers to generate solutions by querying, "Which one is your favorite, or how would you use this?" The fashion director will challenge the designers to visualize how to use two or more seemingly disparate prints or textures (e.g., a ditsy and a stripe). A designer may say, "For this group, let's try mixing textures, stripes, and prints."

The design team also solicits information from textile vendors to make fabric decisions. Companies that involve textile vendors early tend to create more innovative products. In addition, supplier partnerships help manufacturers reduce lead times and production inefficiencies (Cottrill 2006). Designers tend to use cryptic language when referring to fabric styles. For instance, they will say "put that Milliken cheer up on the wall," which means they are referencing a VISA sport apparel fabric cutting from Milliken & Company ⬆.

Designers organize fabric cuttings, trims, and colors into groups. A **group** consists of coordinated products within an SBU that is organized by fabric type, theme, garment body, or category (e.g., coordinated sportswear) (Tate 2004) (Figure 10.11). To create groups, designers will use a fabric library and communicate with textile vendors. A **fabric library** is a notebook of fabric styles that the company has used in previous seasons (Regan 1997, 192); or for large companies, such as Nike Inc. a fabric library is a room of fabric headers. At an on-site visit, Nike's materials librarian commented to the author that they catalog textile vendor fabrics. "At once" fabrics are those that have gone through development and passed quality control tests, and the designers can quickly add them to product lines.

The designers will call textile manufacturer representatives during their concept meetings to answer questions (Regan 1997, 185). For instance, they will ask him or her

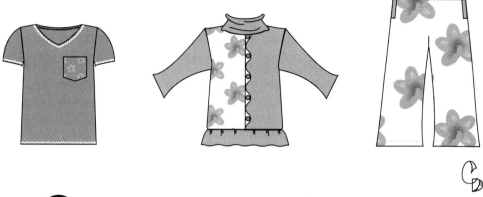

Figure 10.11 Fabric design creates continuity and coordination in a product line. *(Illustration by C. DeNino.)*

to send a ditsy or stripe to complete a fabric group. The designers also choose among different fabric options based on which vendor offers better quality or has a better reputation for on-time shipping.

Designers consider fashion and seasonal influences as they select styling for specific target markets. Fashion influences include color, line, silhouette, pattern, and shape (Eckert and Stacey 2003). Events and holidays that occur within a product line season also influence designers' decisions (Kunz 2005). When evaluating fabrics for themes, designers refer to inspirational shopping, competitor's designs, specific textile vendors' fabric styles, and aesthetic impression (e.g., romantic). There is no set method; when some designers focus on a theme, they may seek reinforcement by reviewing art books for common motifs or cultural designs (Eckert and Stacey 2003).

Analysis Phase

During the analysis phase, the design team discusses design requirements and constraints (Stempfle and Badke-Schaub 2002). Design requirements can include capturing a mood, following the projected fashion direction, eliminating what looks strange or is outdated (Eckert 1997), or adding newness to a product line or style. Although it is efficient to reuse fabric styles that were successful in the past, it is important to add newness. *Adding newness* is a colloquial phase that refers to updating a core fabric style. They will update good-selling core fabric styles by changing colors, prints, or finishes. Designers also want to incorporate new fabrics that the textile vendors showed them (Regan 1997, 187). Fabric constraints are the SBU parameters and quality assurance standards, and fabric availability in the market. For instance, a company may improve fabric durability by using a cotton/polyester blend rather than 100 percent cotton (Regan 1997, 185). Fabric availability means the fabric is available either open-line or within the company's cost structure. The design team will discuss whether they can develop new fabrics or be satisfied with open-line fabric styles.

Evaluation Phase

During the evaluation phase, designers generate, query and clarify misunderstandings, and evaluate ideas. They also present positive and negative opinions (Stempfle and Badke-Schaub 2002). The goal of the evaluation phase is to determine whether selected designs meet the company mission statement and SBU direction, which goes back to how the design director has defined the product line (Regan 1997, 185–86). Designers may change direction at any point by enlarging, narrowing, or discarding ideas (Goel 1995), or they may take a poor idea and transform it into a workable one. Designers will study an idea and then change, drop, modify, or interchange elements. For example, if the design director wants to use a strong-selling fabric style, designers may change or discard a fabric grouping, or debate how to incorporate the fabric into their product line themes.

At this stage, the design team starts to create their seasonal concepts. A concept-or storyboard is an illustrated representation of fabric ideas, texture ideas, garments, and prints (Regan 1997, 185). The designers may discuss how to change the fabric to work with an embellishment (e.g., screen print, embroidery) or garment features, such as a collar. Fabric efficiency is another criterion for a fabric style change or elimination. When designers develop prints or textures, they often share among multiple SBUs for multiple seasons and use them in large-volume styles.

Decision Phase

In the decision phase, designers vote for or against an idea. They determine whether a design solution is satisfactory; if it is not, the associates create alternative solutions. It is problematic if a designer cannot justify his or her designs to colleagues (Eckert and Stacey 2000). The design director and designers evaluate fabrics on the wall grid to determine if it is aesthetically in concert with an existing or a new garment style. Some unsatisfactory design solutions include not visualizing how to use a fabric in a garment style or not considering how to use it in multiple SBUs. This decision phase always allows for outliers, and disagreement can provoke further analysis (Stempfle and Badke-Schaub 2002). If a designer feels strongly about a design, he or she will continue development, even if it does not match a theme or price point (Eckert and Stacey 2003). Another option is that designers prematurely reject an idea that later becomes workable (Stempfle and Badke-Schaub 2002). In this case, designers will often use a fabric style for a later delivery or a forthcoming season. Designers need to balance their time during which they continue refining a design or simply stop development. Because apparel manufacturers and private-label retailers have multiple deliveries within a season, designers will introduce different fabric prints at different delivery points (e.g., every 4 weeks).

Fabric Approval and Ordering

Textile concept meetings end when the design team is satisfied with selections or the time-and-action calendar forces them to move forward to meet drop-dead dates. Once the design team approves fabric designs, the design team submits a sample order to fabric purchasing. An open-line fabric order is a simple process in which a fabric buyer calls,

e-mails, or faxes a sample order. The sample order identifies the piece goods and fabric specifications, such as fiber content, finish, and price. The fabric buyer simultaneously places an order for trims and findings that the design team needs to create garment samples (Regan 1997, 252).

As noted earlier, some apparel companies develop fabric colors, prints, and texture designs. This fabric approval becomes the kickoff point for a new process—fabric development. For fabric development, designers submit a color standard, a textile painting, or texture sample depending on whether he or she wants a developed color, print or knit texture to the textile manufacturer representative (Regan 1997, 201, 208, 232).

Fabric Minimums

During textile concept meetings, designers select both open-line fabrics and those they want to develop. At this point, designers identify the piece goods, which they submit to fabric buyers to place a sample fabric order (Regan 1997, 252, 253). An apparel customer buys fabric by minimums. Liz Riley, a former manager at California Market Center, explained that a **minimum** is the lowest quantity a customer can purchase. Merchandisers will evaluate whether they feel they can sell the minimum fabric quantity and negotiate fabric prices (Regan 1997, 252). Jim Jacobs of Milliken & Company noted that if apparel customers buy open-line fabric, the fabric cost is fixed; however, negotiating factors include quantity discounts and transportation costs. Transportation cost is a separate line item, or vendors add it into the fabric wholesale price.

Buying Open-Line Fabric

Apparel customers that operate on tight time schedules and demand efficiency commonly buy open-line fabric. A customer can receive open-line fabric quicker (e.g., 5–10 working days) than if they develop fabric, which Jennifer Barrios, senior merchandiser for Quiksilver noted takes 45 working days. Another reason to purchase open-line fabric is that a design director conscientiously desires to limit garment assortments and thus purchases lower fabric quantities. An advantage is that inventory houses offer low minimum purchase quantity, which is well suited to small and mid-size apparel manufacturers. Fabric minimums vary among textile vendors, although 100 yards is a common open-line minimum quantity.

Determining Whether to Buy Developed Fabric

Textile vendors require an upfront minimum verbal or written commitment before they develop fabric. Merchandisers evaluate whether they can sell enough garments to meet the required minimum order quantity. Fabric development and revision requires an investment from the textile vendor; thus, they require a higher minimum than ordering open line. Minimums vary among textile vendors. Knit textures (e.g., specialized patterns and jacquards) typically require an 800- to 1,600-yard minimum order. The quantities for knit woven, such as stretch denim, depend on whether the development is from a common warp or a unique warp. Print fabric minimums vary significantly. Most woven suppliers require a 10,000 yard minimum quantity. The minimum

quantity is per fabric style; however, the apparel customer has the option of multiple colorways. In addition, when apparel companies negotiate fabric revision or development, they agree to pay a **working loss,** which is an over- or under-quantity adjustment (Regan 1997, 167).

It is difficult for the design team to determine whether they can sell the minimum yardage required for developed fabrics. One approach is for merchandisers to solicit opinions from key account retail customers and from sales representatives on whether a fabric or garment will sell (Regan 1997, 171).

ACTIVITY **10.8** *Determining Fabric Feasibility*

You want to create a coordinate outfit in three different colors that consists of a print polyester blouse and matching solid 100 percent wool pants and jacket. The print textile manufacturer requires a 5,000 yard minimum order for each print design. The wool supplier requires a 10,000 yard minimum order that the company can dye into multiple colorways. You will order the same fabric for the pants and jacket. Based on previous style history, fabric yields for similar styles are blouse, 1.25 yards; pants, 1.5 yards; and jacket, 1.75 yards.

- Calculate the quantity you will make for the blouse, and for the jacket and pants by using the following formula:

 a. Divide the minimum fabric quantity by the number of solid colors (i.e., 10,000 ÷ 3).

 b. Add the fabric yield for the jacket and pant (they will be made out of the same fabric) (i.e., 1.75 + 1.5).

 c. Divide the number you got in "a" by the number you got in "b" above (minimum fabric quantity by fabric yield (i.e., 3,333 ÷ 3.25).

 d. Divide the minimum fabric quantity for the print by the blouse fabric yield (i.e., 5,000 ÷ 1.25).

- How many jackets and pants will you make? How many blouses will you make?* Is ordering only the minimum quantities a good business decision? Explain your answer.

Minimum Quantity Rationale

An individual might feel that minimum fabric orders are too high. Some factors that influence a textile vendor's development cost include peak demands associated with quick turn times and time delays for payments. Each season, the textile vendor and its apparel customer verbally agree to a specific number of developed fabrics (e.g., 10) at a guaranteed minimum order (e.g., 5,000 yards each). With partnership agreements, textile managers can anticipate hiring needs, raw material, and dedicated production time. They hire

*Pant and jacket answer: (10,000 ÷ 3 = 3,333) 3,333 ÷ 3.25 = 1,025 (outfits). Blouse answer: 5,000 ÷ 1.25 = 4,000.

full-time staff based on the company's production capacity. A textile vendor's salary and overhead are part of their cost of goods sold, and they work this figure into their wholesale costs and anticipated profit margin. However, if a textile vendor receives a large number of orders in a short time, the vendor has to rush orders. They will hire freelance CAD artists and other staff to complete work; however, this increases the textile supplier's cost and reduces profit margin (Regan 1997, 164).

The textile company absorbs employee, inventory, operation, and raw material costs during the 45 days for technical design, color development, sample or strike-off, and open production run. A textile company prints or dyes its minimum production, due to equipment setup time. However, at this point, the apparel customer only wants sample yardage, so the textile company partial-ships the opening production run (e.g., 600 of 5,000 yards). The textile vendor bills for sample yardage but holds the remainder of the fabric in inventory until the customer wants shipment. Payment cycles are highly variable. A customer will pay for "hot items"—fabrics in peak demand—rather quickly, whereas a textile vendor may wait up to 6 to 10 months to receive payment for regular fabrics. The director of sales and marketing at Milliken & Company commented, "The payment cycle for 'hot items' is faster than 6 to 10 months. The key is the customer agrees to bear the development expense within a reasonable amount of time."*

ACTIVITY 10.9 *Critical Thinking*

Place yourself in this scenario. In your office, you have a denim shirt with a new and interesting finish. It has been in development for 2 months. You get a call from the textile manufacturer representative who tells you there will be a 4-week delay because the development is not finished and quality control testing has not cleared, which delays production time. Your deadline is in 3 weeks, and it is too late to develop new fabric with another textile vendor. Describe what do you would do. Explain your rationale.

Development of Fabric Styles

When the merchandiser approves the minimum order, it launches the fabric development process (Regan 1997, 215). The design team is closely involved with and dependent on multiple global textile vendors to develop prints, knit textures, embellishments, and trims. Textile product development can be performed at a domestic company headquarters or at full-service global textile production facilities. Many global production facilities are located in developing countries such as China, Turkey, or Honduras.

Creating developed fabric involves collaborating with the studio directors or textile manufacturer representatives of multiple textile companies to design the fabric, perform the technical setup, and produce sample fabrics. Fabric **development** (Figure 10.12) starts

*Reprinted by permission from Jim Jacobs, director of sales and marketing Caribbean Basin Region, Milliken & Company; pers.comm., August 25, 2005.

Figure 10.12 Fabric development process. *(Chart by K. Bathalter.)*

with a concept meeting to communicate and order developed fabric, followed by the technical setup. Upon approval by the design team, fabric buyers follow up on cost and delivery considerations.

Communicate Textile Product Development

The first development step is to finalize fabric designs with the textile vendor. The design team either finalizes a fabric painting or selects a fabric texture to give to the textile vendor (Regan 1997, 192). Some apparel companies internally develop fabric paintings with their own **CAD artists,** whereas others work with the textile company's associates (Regan 1997, 193). An advantage of an in-house artist is that he or she is faster and more accessible. A disadvantage is that they can get stifled, as well as lack creative style and technique variation. Textile design studio and textile converters use multiple artists. Using multiple CAD artists increases design flexibility and adds breadth to art techniques; however, it can also delay the design process.

Textile manufacturers are continually developing new fabric finishes and fabrications. Because fabric development is specialty driven, textile studio directors work individually with apparel customers to present feasible ideas and come up with creative ways to incorporate new fabric applications (Borland 2005). From the development end, an apparel customer may request a textile company to develop a new fabrication for them, or they may market a new fabrication in conjunction with a textile manufacturer's development.

A **studio director** manages fabric development projects. This individual has technical expertise and is a liaison between the customer, textile manufacturer representative, and CAD artists. The studio director confirms the number of customer assignments, for example, by florals, stripes, or conversational fabric styles. They review and assign work to CAD artists depending on the specific artistic techniques needed (e.g., watercolor, mechanical, airbrush). They work closely with designers to develop new designs, make design modifications, and create colorways.

Companies such as Milliken & Company market specialty fabrics. One technological application is the use of antimicrobial finishes and fibers. *Freshness* is one fabric product line in which fibers eliminate trapped clothing odors. Freshness fits with a desirable American cultural connotation of cleanliness. One high-performance technological application is antimicrobial agents embedded during fiber formation or as a finish (Walzer 2005). It is the responsibility of the studio director to know whether textile applications, such as antimicrobial fabrics, are suited for an apparel customer's cost structure and target market. An apparel manufacturer that markets to specialty sport retail customers is in concert with the cost structure of antimicrobial applications; conversely, it is more difficult to create this finish and meet the cost structure to sell to mass merchandise retailers.

ACTIVITY 10.10 *Making Fabric Decisions*

Decide what fabrics you want to use for your company project. Are you going to develop fabric or buy open-line fabric? Explain how developed or open-line fabrics match your target market.

Development Discussion

To communicate effectively, designers will use reference objects as a starting point to develop new fabric designs (Eckert 1997). These reference items can range from a piece of yarn, garment, illustration, photograph, printed art motif, a sculpture, fabric cutting, or fabric painting (Eckert and Stacey 2003). Using reference objects is an effective communication tool to express complex ideas quickly because the reference item, called a **standard**, has the desired details (Eckert and Stacey 2000 535). Textile vendors refer to a designer's reference as a standard because they need to match it (Figure 10.13).

Fabric Aesthetics

Using the standard, textile manufacturer representatives will ask designers questions on desired fabric specifications (Regan 1997, 231). Fabric specifications are its desired aesthetic attributes and performance features. Aesthetic attributes include desired emotional appeal, design principles, visual appearance, or fabric hand. Some aesthetic expressive terms are

Figure 10.13 Submission of customer standard such as a fabric painting is the first step to technical fabric design. *(Illustration by C. DeNino.)*

feelings of calmness, relaxation, excitement, or energy (Fiore and Kimle 1997). They may also describe the fabric's design balance or rhythm, such as a bisymmetric foulard design. Visual characteristics refer to the color and luster of a yarn or fabric's surface appearance. Luster is a fabric's light reflection and is described in terms of appearance such as shiny (i.e., increased luster), dull, or matte (i.e., decreased luster) (Kadolph and Langford 2007).

Fabric hand—how fabric feels—is an important tactile dimension (Figure 10.14). Fabric hand attributes include hand, bulk, and cover, warmth, and stretch. Textile manufacturers can create different sensations by manipulating fiber stiffness, fineness, or construction. When fibers do not have trapped air, they feel clammy and uncomfortable; conversely, with trapped air, the fibers feel warm, bulky, and comfortable. Textile manufacturers purposely create bulk by trapping air in between fibers. They do this by changing the geometry of the yarn shape, using an imperfect fiber orientation, or by using textured yarns to entrap air (Demir and Behery 1997). While a consumer is not aware of the fiber and yarn manipulations, he or she appreciates fabric that feels warm, salt, or comfortable.

Figure 10.14 Multiple fabric design ideas using Adobe PhotoShop.

We use denim jeans as an example of how to develop fabrics to create specific aesthetic attributes. With the numerous denim finishes available, from stone washing and sanding to cat scratches, it can be a challenge for designers to create a new finish or application; however they will try techniques that are new or relatively unknown. One aesthetic approach is to change denim at the yarn level. For instance, Jean-Paul Gaultier introduced cashmere denim in Fall 2005 (Lucky Magazine 2005). Inventors often patent unique textile applications, such as the combination of cashmere and denim. Wright (1996) patented a yarn process composed of denim scraps that become shredded fibers and then are blended with premium virgin long-staple natural fibers, such as cashmere. The yarn process blends 75 to 90 percent recycled denim fibers with 10 to 25 percent premium virgin fibers. A textile vendor can create a variety of aesthetic appearances by increasing or decreasing the amount of natural cashmere with the nonstripped indigo-dyed denim.

ACTIVITY 10.11 *Exploring textile printing*

Stork is a large textile engraving and printing equipment company. Click on the Stork Web page (http://sdi.stork.com/page.html?ch=DEF&id=138). Read about new textile printing techniques by downloading the Stork Intervision magazine and by clicking on textile printing—design preparation.

Technical Specifications

Designers create developed fabrics for specific visual effects (Eckert 1997). Designers convey textile specifications in addition to aesthetic attributes. The textile manufacturer representative is the liaison who needs to convey designers' wants to textile development associates, and in turn relays production limitations to apparel customers (Regan 1997, 231). Studio directors try to meet apparel customers' requests; however, they will simplify fabric designs to lower costs if a developed fabric is too expensive (Eckert 2001).

Textile companies commonly have a reference library of existing textures. These libraries can be rows of fabric headers, index cards, or digital image archiving. Textile product development associates refer to their company's fabric library to see if they have an existing fabric design, which is similar to the customer's standard. If the textile company has an archive of a similar fabrication, the textile product development associate submits this sample to the designers to review (Regan 1997, 232). If the textile vendor does not have a similar fabric, the textile manufacturer representative checks with textile production to see whether development is feasible.

Fabric Technical Package

A technical knit designer is concerned with aesthetic appearance, technical considerations, and functional requirements (Eckert and Stacey 2000). **Textile product development associates** create a detailed technical package. In knits, for example, the associates will determine the fabric width, fabric yield, and any adjustment due to fiber type, pattern size, repeat, and drop (Regan 1997, 232). In prints, textile CAD artists create a print package with a pattern identification sheet, color pitch sheet, and detailed instructions (Regan 1997, 209).

Designers need to convey the desired aesthetic appearance. Communication problems can occur because the textile product development associates do not partake in the textile concept meetings (Eckert 2001). It is important that the designer's intent is communicated to these textile associates because if it is incomplete, the technician will interpret the customer's standard by referring to previously produced designs (Eckert and Stacey 2000).

Fabric designs can be technically complex (Eckert 2001). Some common technical considerations include fabric weight, fiber content, fiber type, weave or knit structure, yarn fineness or coarseness, and yarn size or knit stitch capabilities (Demir and Behery 1997). One technical consideration is yarn gauge. **Gauge** is the thickness of a needle and refers to the number of needles per inch. A high number (e.g., 28) refers to a fine stitch, whereas a low number (e.g., 13) is a heavier stitch (Kadolph and Langford 2002; Reichman 1961). A designer may want a high yarn gauge for a silk and rayon jewel neck top or a low yarn gauge for a thick wool sweater for a textured casual appearance.

Some technical knit designers design the garment pieces simultaneously with the knit pattern. The pieces are either fully fashioned (knit to shape) or cut from blankets (i.e., a rectangular piece of fabric) (Eckert 2001; Regan 1997, 229). Technical knit designers can predict a simple knit structure (e.g., jersey and purl stitch) and develop designs close to the designer's conceptual sketch or standard. A complex design (e.g., lace patterns) can be hard to predict (Eckert 2001).

Technical knit designers commonly create yarn dye designs using flatbed machines such as Shima Seiki 👕, Stoll 👕, or circular knitting machines. With a weave, technical

designers identify the specific plain, ribbed, basket, twill, satin, or special construction. With a knit, they identify whether it is a jersey (i.e., one needle), a rib (i.e., two needles), a purl (i.e., three needles), or a warp knit (e.g., tricot). The technical designers will also query designers as to the type of ribbing desired, such as 1×1 (one-by-one) or a 2×1 (two-by-one) (Reichman 1961).

ACTIVITY 10.12 *Understanding Developed Knit Patterns*

To explore developed knit patterns, go to the Shima Seika Web site (www. shimaseiki .co. jp/homee. html).

- Click on "Knit Samples" and click on a collection (e.g., "2008").
- Select one photograph and read the description.
- List 1-2 production benefits.
- List 1-2 consumer benefits.

Functional requirements determine whether textile product development associates can make the customer standard without modifications or whether it will need adjustments. These textile associates are responsible for realizing the design ideas, and they consider equipment constraints and calculate any adjustments needed to create the pattern size, fabric width, yield, and design repeat (Regan 1997, 232). Product development associates interpret the customer's standard and specifications into structural terms. They use CAD software (e.g., Shima Seiki) to create the design. To match technical machine requirements, these associates often have to adjust the pattern. The customer standard is treated as the ideal, and textile associates aim to get the patterns as close as possible to the design. A textile knit or weaving machine produces set designs (e.g., jersey or rib knit), and it can be difficult to translate a customer's standard to a production fabric. Textile product development associates have expertise in visualizing stitch patterns, machine capabilities, yarn attributes, and pattern designs. Yarn fiber content affects stitch capability. For instance, weak yarns, such as cashmere, will break with elaborate stitch patterns (Eckert 2001). Machine limitation may require that textile product development associates adjust yarn type, stitch patterns, or equipment (Regan 1997, 232).

Fabric Development Best Practices

It is important to communicate the desired texture or print design to textile product development. Some important communication points that Eckert and Stacey (2001) point out are as follows:

- Communicate clearly the intended design and include details such as measurements before beginning textile product development.
- Effective collaboration relies on communicating conceptual ideas. Recognize that designers think in aesthetic terms, whereas a textile product development associate thinks and describes in the context of knit or weave structure and machinery limitations.
- Include consistent information among sketches, verbal descriptions, and measurements.

- Reference prior fabric designs or clearly indicate the design newness because textile product development associates lean toward using past designs.
- Understand that a textile product development technician's goal is to realize the designer's intent.
- Work out details and give correct technical information (e.g., yarn size for machine type).

Approval Process

The textile manufacturer representative submits the developed knit or print fabric sample to the designer with the wholesale cost (Regan 1997, 232). Designers are skilled at evaluating both aesthetic and technical attributes and are responsible for either approving or correcting developed fabric (Eckert 2001). Some aesthetic evaluation factors include fabric hand (e.g., too stiff, soft, scratchy), weight (e.g., too light or heavy), and transparency. The designers continue the developed fabric process until they are happy with the visual and tactile effect (Eckert 1997). To assist in the approval process, some designers use template shapes as a visualization tool (Figure 10.15). A template helps designers determine whether the scale of a print design or texture is aesthetically pleasing, where it has correct spacing, and whether it is salable.

Upon approval of the print or texture design, the design director finalizes the purchase. The fabric buyer writes a purchase order and enters fabric code information into a

Figure 10.15 Use of a template shape to determine spacing and scale of a print fabric.
(Illustration by C. DeNino.)

company's database system. A fabric buyer assigns fabric codes to monitor sample and production fabric shipments, any late delivery, and payment (Regan 1997, 254).

SUMMARY

The design team makes a multitude of decisions to select, order, and approve fabric. This chapter used the design process as a framework to understand the design team's decisions. The design team starts by confirming its design goals and identifying any challenges. They then establish requirements such as base cloth and cost structure. During a search for design solutions phase, designers evaluate many fabric headers from a variety of texture vendors. During the decision stage, designers work closely with textile manufacturers to request samples and develop new fabrications. The final stage is the submission of the fabric order to textile vendors.

COMPANY PROJECT 9 FABRIC CREATION

Goal

To create properly scaled fabric swatches that you will use in your storyboard and line sheet (Company Project 11).

Step 1 Drawing Preparation

1. Find and scan a nine-head croquis from an illustration book. Save as a .jpg file.
2. Start a new drawing using a graphics illustration program. (The following instructions use Adobe Illustrator commands.)
3. Place the croquis into the computer graphics program. Click on "Layer" and rename the layer "Croquis." Lock the layer.
4. Create one new layer and label it "Fabrics."

Step 2 Fabric Creation

1. Create a new Adobe Illustrator drawing using 8½″ × 11″ landscape layout.
2. Create a ½″ × ½″ square that does not have a fill color and use black stroke for the outline. This rectangle is the maximum size of your pattern, so that it is in scale with the nine-head croquis. Zoom up close on the rectangle.
3. Open a symbol library (e.g., decorative elements). Select one decorative pattern and drag it into the drawing. Select the scale tool and drag the corner so that the shape gets smaller and fits inside your ½″ × ½″ square. You may repeat by using different symbols to fill up the ½″ × ½″ square.
4. To change the symbol color: Select the fill to be a color from your swatch menu. Select your symbol with the select tool. Move your cursor over to the Symbol Sprayer tool and hold down the button on your mouse. Drag until the pop-up window indicates Symbol Sprayer tool. Click on your symbol (it will change color).

5. Copy the original fabric design (always keep an original copy) before moving on to the next step (color plate 11).
6. Click on the square (only). Select the stroke tool. Select Dashed. Select Object menu—Arrange and bring to front. Select the stroke to be no color. With the Select tool, select the square and your design. Select Object menu—Group. (Note: You need to follow this order for your design to go into the swatch menu.)
7. Drag your design to the swatch menu. Double click on your swatch. In the pop-up menu, type a name for your swatch.

Step 3 Evaluation of Fabric Design Scale

It is important to create a fabrication or print that conveys the appropriate fabric design and will work with your garment designs.

1. Create a rectangle on top of the croquis that is approximately the size of a top or a skirt (no need to draw an actual design).
2. With the Select tool, select the rectangle. Select Fill with Your New Swatch Pattern. Check the scale and aesthetic design.
3. Copy the original fabric design. Use the Select tool to choose the design. Double click on the scale tool. Type in a percentage that is 50 percent of the original size. Repeat step 7 above. Place the new design into the Swatch menu. Double click on your swatch. In the pop-up menu, type a name for your swatch. Note: Swatches 1 and 2 look the same in the Swatch menu, but when you fill the rectangle, they are scaled differently.
4. Make one more copy of your original design. Double click on the Scale tool. Type in a percentage that is 150 percent of the original size. Repeat step 7 above. Place the new design into the Swatch menu. Double click on your swatch. In the pop-up menu, type a name for your swatch.
5. Select the rectangle you drew in step 1 above and select Fill with your patterns. Evaluate which scale works the best for your design intent.
6. Revise your fabric swatch idea, if necessary.
7. Create two more fabric swatches using the above steps.

PRODUCT DEVELOPMENT TEAM MEMBERS ▬▬▬

CAD artists: Individuals who work with specific textile computer design programs. They have expertise in textile materials, fabric design, and technical setup.

Studio director: An individual who manages textile CAD artists. He or she has technical expertise, and serves as a liaison between the customer, textile manufacturer representative, and CAD artists.

Textile manufacturer representative: An individual who sells open-line, revised, and developed fabric to apparel manufacturers and private-label retailers.

Textile product development associate: An individual who creates a developed fabric from a customer's standard and specifications. He or she has expertise in fabric, machine, and stitch capabilities.

KEY TERMS ▬▬▬▬

Base cloth: A fabric with a specific fiber content, fabrication, yarn count (i.e., number of pics per square inch), and weight that a company uses for multiple product lines.

Base fabric: A fabric with specific characteristics such as weave, knit, or weight (e.g., a 6-ounce twill).

Calico design: Small geometric shapes, florals, stripes, or other motifs often associated with quilting.

Category theory: Objects comprise a group. Instead of studying the objects separately, an individual studies the structure between the objects.

Conversational styles: A juvenile, familiar, or theme fabric design.

Core: A product on which an apparel company builds its reputation. It is consistent with the company's product strategy.

Cost leadership: A strategic advantage by designing, producing, and marketing comparable products more efficiently than the competition (Porter 1990).

Cost structure: The finished fabric price range that the design director is willing to pay.

Developed fabric: A developed fabric is an exclusive fabrication, yarn dye, pattern, or print made to a customer's specifications.

Differentiation: Strategic advantage by offering improved product quality, special features, or superb customer relations (Porter 1990).

Ditsy design: An all-over print, sometimes called "little nothings."

Documentary styles: Designs from a particular historic or cultural period.

Fabric code: Documentation of one fabric style.

Fabric parameters: Identification of a general fabric category (e.g., knit, woven).

Fabric style: One fiber content, fabrication, and weight in a variety of colors.

Fabric library: A catalog of fabric styles that an apparel or textile company has used in previous seasons

Floral styles: Fabric motifs such as trees, plants, and flowers.

Focus: Strategic advantage by using innovation for a narrow industry segments, addressing a new market, or serving a segment better (Porter 1990).

Foulards: A fabric grid pattern that is classic and conservative.

Gauge: The thickness of a needle. Also refers to the number of needles per inch.

Goal clarification: Communication of the number and relationship between elements.

Go forward: A colloquial phrase that means the design team can proceed. *Going forward*, also used, means in the future the design team will change its direction or selection.

Go to engrave: A colloquial phrase in which a designer approves the fabric design and releases it to production.

Greige fabric: Unfinished fabric.

Group: Multiple coordinated products within an SBU that are organized by fabric type, theme, garment body, or category.

Header: A swatch of fiber type(s) and fabrication (e.g., 10" × 10"), stapled to cardboard, in multiple colorways.

Inventory house: A textile company that develops or internationally buys and puts together a seasonal product line.

Maintaining the product line: How a SBU differentiates itself from the competition in products offered.

Merchandising the line: The action of creating product groups, fabric, and color selection, and development and print exploration.

Minimums: The lowest quantity a customer can purchase for a fabric style.

Off-calendar: A colloquial term that means the product development team is not meeting deadlines established in the time-and-action calendar.

Open line: A textile product line in select fabrications, fiber types, and patterns.

Paisley design: A detailed stylized design of a Persian palm.

Parameters: A general term that describes the number and type of styles in a SBU and corresponding production information.

PFF fabric: Fabric that has gone through preparation stages such as bleaching and mercerizing.

Product flexibility: A fabric can be used in multiple product lines, finished in a variety of ways, while maintaining company quality standards.

Realistic design: A fabric print that shows detail and is close to the actual object.

Run time: The time that it takes to produce a product (e.g., one fabric style).

Send-out: A colloquial term that refers to a portion of a garment that is sent to a contractor during production. Some examples are pleating, garment wash, embroidery, or screen-print (also called special operations) (Regan 1997, 276).

Standard: A reference item that a designer submits to a textile manufacturer representative.

Stylized: A simplified or flattened design.

Textile concept meeting: The activity in which the design team collaboratively makes fabric decisions.

Traditional styles: Foulards, paisley, ditsy, calico, or documentary designs.

Turn-time: A complete process cycle in which an individual or company receives an input, completes an activity, and returns it back to the originator; measured in time units.

Vendor days: A colloquial term for a time period in which fabric manufacturer representatives travel to apparel company headquarters and present wholesale fabric lines to designers.

Working loss: An over- and under-quantity adjustment.

WEB LINKS

Company	URL
American Apparel	www.americanapparel.net
Cotton Incorporated's Global Fabric Library	www.cottoninc. com/CWFL/
Infomat	www.infomat.com/guides/index.html
Invista's Special Services	www.invista.com/page_services_index_en.shtml
Little Mass	www.littlemass.com/
Marika Group Inc.	www.marika.com/default.asp
Milliken & Company	www.millikenapparelfabrics.com
Shima Seiki	www.shimaseiki.co.jp/homee.html
Stoll	www.stoll.com

Straight Down Clothing Company	www.straightdown.com
Textile World	www.textileworld.com/Default.htm
TexWorld member directory	http://textile.texworld.com/index.html (click on "member directory")
True Religion Apparel	www.truereligionbrandjeans.com/
Worth Global Style Network	www.wgsn.com/public/home/html/base.html

REFERENCES

American Apparel. n.d. Wholesale, Fabrics. http://americanapparel.net/wholesaleresources/fabrics. asp.

Body Glove International. n.d. The vapor wetsuit. http:/ /www. bodyglove. com/ vapor_wetsuit. html (accessed June 18, 2007).

Body Glove International. n.d. [b]. The Eco Wetsuit. http://www.bodyglove.com/eco.html (accessed July 14, 2007).

Borland, V. S. 2005. The fashion of fiber. *Textile World* 155 (5): 41–44.

Burberry Limited. 2005. About Burberry: History. http:/ /www. burberry. com/ AboutBurberry/ History. aspx.

Cottrill, K. 2006. Supply chain experts get their say on product design. *Harvard Business Review*. Reprint No. P0602A (February). Boston: Harvard Business School Publishing. WilsonWeb.

Curry, J. C. 1997. Is your product costing as good as you think? *Textile World* 147 (9): 100, 102, 104, 107. WilsonWeb.

Demir, A., and H. M. Behery. 1997. *Synthetic filament yarn texturing technology*. Upper Saddle River, NJ: Prentice Hall.

Earnest, L. 2007. Stores push aside designers. *Los Angeles Times*. June 8, C1, C6.

Eckert, C. M. 1997. Design inspiration and design performance, in *Textiles and the Information Society*. Paper presented at the 78th world conference of the Textile Institute in association with the 5th Textile Symposium, Thessalonike, Greece.

Eckert, C. M. 2001. The communication bottleneck in knitwear design: Analysis and computing solutions. *Computer-Supported Cooperative Work* 10 (1): 29–74.

Eckert, C., and M. Stacey, 2003. Sources of inspiration in industrial practice. The case of knitwear design, *Journal of Design Research* [on-line journal]. 3 (1): 1–18. Inderscience Publishers. http://www.inderscience.com/browse/index.php?journalCODE=jdr.

Eckert, C. M., and M. Stacey. 2000. Sources of inspiration: A language of design. *Design Studies* 21:523–38. Science Direct.

Fiore, A. M., and P. A. Kimle. 1997. *Understanding aesthetics for the merchandising and design professional*. New York: Fairchild.

Fisher, R., and D. Wolfhal. 1987. *Textile print design*. New York: Fairchild.

Glock, R., and R. Kunz, 2005. *Apparel manufacturing: Sewn product analysis* (4th ed.) Upper Saddle River, NJ: Prentice Hall.

Goel, V. 1995. *Sketches of thought*. Cambridge, MA: MIT Press.

Griffin, C. 2005. All grown up. *Sporting Goods Business* 38 (4): 32–35.

Institute of Industrial Engineers n.d. Terminology, Operations & Inventory Planning & Control, Run time. http://www.iienet2.org/Details.aspx?id=2436 (accessed June 16, 2007).

Kadolph, S. J., and A. L. Langford. 2007. *Textiles*. 10th ed. Upper Saddle River, NJ: Prentice Hall.

Kunz, G. I. 2005. *Merchandising: Theory, principles, and practice*. 2nd ed. New York: Prentice Hall.

Lewis, W. P., and A. E. Samuel. 1988. *Fundamentals of engineering design*. New York: Prentice Hall.

Denim trends. 2005, August. *Lucky Magazine*.

McAllister, R. 2007. Going to school on fast-fashion retailers. *California Apparel News*. June 8, 1.

Nelson, V. J. 2006. Diving Bill Meistrell July 30, 1928-July 25 2006; his body glove wetsuits revolutionized surfing. *Los Angeles Times*. July 29, B3. (Factiva).

Phillips, J. 2007, March/April. Yarn market: Export strategy positions spinners to thrive. *Textile World*. http://www.textileworld.com/Past_Issues.htm?CD=3679.

Porter, M. E. 1990. *The competitive advantage of nations*. New York: The Free Press.

Putsis, W. P., and B. L. Bayus. 2001. An empirical analysis of firms' product line decisions. *Journal of Marketing Research* 38 (1): 110–17. ABI/Inform.

Regan, C. 1997. A concurrent engineering framework for apparel manufacture. PhD diss., Virginia Polytechnic Institute and State University.

Reichman, C. (Ed.). 1961. *Principles of knitting outerwear fabrics and garments*. New York: National Knitted Outerwear Association.

Remarkable growth in women's sports. 2005, March. *Sporting Goods Business*. Factiva.

Rock, M., E. P. Dionne, C. Haryslak, W. K. Lie and G. Vainer. 2007. Plaited double-knit fabric with moisture management and improved thermal insulation. U.S. Patent 7,217,456 [electronic version], filed May 15, 2007.

Stempfle, J., and P. Badke-Schaub. 2002. Thinking in design teams: An analysis of team communication. *Design Studies* 23:473–96. Science Direct.

Tate, S. L. 2004. *Inside fashion design*. Upper Saddle River, NJ: Prentice Hall.

Textile World. n.d. Dyeing, printing, finishing news. http://www.textileworld.com/News_Archives.htm?CD=3592 (accessed June 9, 2007).

This year's ranking of top volume screen printers proves that fashion and design innovation help them adapt to new twists on our traditional distribution channel. *Impressions* (June 1). (Factiva).

Tran, K. T. L. 2005a. Swim exec Koplin joins Tommy Bahama swim. *California Apparel News* 61 (29): 14.

Tschorn, A. 2005. New Vapor boardshort unveiled; Body Glove's full line of men's apparel also to debut in Las Vegas next month. *Daily News Record*. 35 (29): 24. (ProQuest).

U.S. Securities and Exchange Commission. 2007, March 28. *Form 10-K: Annual report ended December 31, 2006, True Religion Apparel, Inc*. Washington, DC: U.S. Government Printing Office. http://www.sec.gov/Archives/edgar/data/1160858/000095013407006621/v28365e10vk.htm.

United States Department of Labor. n.d. Codes of conduct in the U.S. apparel industry. http://www.dol. gov/ilab/media/reports/iclp/apparel/2f. htm (accessed June 12, 2007).

Walzer, E. 2005, February. Milliken freshens up activewear. *Sporting Goods Business*. Factiva.

WGSN-edu. n.d. Materials. http://www.wgsn-edu.com/edu/edu-members/ (membership required).

Wikipedia Contributors. n.d. Category theory. http://en.wikipedia.org/wiki/Category_theory.

Wright, Herbert J. 1996. Cloth scrap recycling method. U.S. Patent 5,481,864 [electronic version], filed January 9, 1996.

Merchandising the Product Line : The Final Phase

11

THE RISK FACTOR

Kate is writing the words *design strategy, core, carryover, fashion-forward,* and *category plan* on the white board as the group walks into the conference room.

"Hello, professor!" Lauren says.

"Hi, Lauren. Hello everyone. You're all looking good this morning. Ready to get started? Today, we are going to work on developing your product line structure. . . . Anne, did you and Lauren work out the price tiers?"

Lauren leans over and whispers to Anne, "What's a price tier?"

Anne whispers back, "The retail price range in our assortment." Then, she turns back to Kate and answers, "Yes, we did. We should be selling four pants at $100 and two between $75 and $90. Three jacket styles should be above $225, and two should be between $150 and $175."

Tamee arrives breathless a minute later. "Sorry, Kate, I was talking to Michael. I was checking on the sample fabrics that he shipped from China. They should have arrived 2 days ago. The tracking shows the box was last seen in Hong Kong last Friday. Michael promised to ship new samples today."

"I wish I could talk to Michael as much as Tamee does," thinks Lauren, as she dangles her legs, revealing her olive ankle-strap Koffa Js wedge sling backs.

"Late people get to answer the next question," Ron teases.

"Actually, I am going to ask Tamee the next question," Kate says. "Did you work out your design strategy?"

"I came up with the idea," Tamee boasts, "but Anne figured out all the details. Our strategy is to create employee ID holders for professional women. Working with Jaynie Lee, our new pattern maker, we tossed around several ideas for the design and settled on a belt loop located near the waist, where it will be less conspicuous."

"And it will be sewn into an existing seam to save on production costs," Ron adds.

"Good, you met the criteria of creating a unique and valuable position in the market."

"Do you think the idea will really sell, professor?" Lauren asks.

"Creating something new is always a risk, but it is important for companies to establish their own unique brand identity. Some companies will patent a unique design."

"It will just be knocked off by one of our competitors. Why bother patenting a design?" Ron skeptically replies.

"Competition is a game of chess, Ron. 'There is hardly anything in the world that some man cannot make a little worse and sell a little cheaper,'* but you aim to be just one step ahead of the competition. My philosophy is, 'I don't meet competition. I crush it.'† You create something original that your competition did not think of, thought was too expensive, or believed the market was too small to support. A new design concept can be simple and functional. Consumers will like it because no one has thought of the idea. A bonus is that the first company to market a new and successful design will receive the bulk of the profits. You anticipate that others will knock off your design, so you aim to be just one step ahead. One of the advantages I see with this particular design is the flexibility of the loop. It's so subtle that if the consumer doesn't use an employee ID, it won't detract from the overall appeal of the garment."

"Creativity and flexibility sells. I like it—money and profit!" Ron quickly adds.

Pointing to Kate's list on the white board, Tamee asks, "What is a category plan?"

"It is the number of core, reorderable, and fashion-forward garments you will create."

"Why can't I create however many I want?" Tamee asks, perturbed.

"Putting structure to design is not supposed to squelch your creativity. The idea is to set parameters so you develop exactly how many you need for each core, reorderable, and fashion-forward style. This way, you don't waste your time overdeveloping styles that you throw away before line review." Professor Kate arches her eyebrow. "Tamee, excess work costs Rare Designs money. It's called a hidden cost. If you overdevelop your SKUs, then you have to sell double the quantity to make up for cost associated with running late on your time-and-action calendar, such as the cost of air freight versus ground transport."

"Oh, I never thought about it that way," Tamee quietly replies, thinking "I like Kate's taupe pants suit. I wonder if it's from Lambson's Knits."

" 'We will never be late again' is Ron's new mantra," Anne comments, grinning.

Passing out copies of a spreadsheet, Ron says, "Speaking of which, I have our new time-and-action calendar. I want everyone to try it out and give me feedback on deadlines."

Skeptically, Tamee takes it from him and then studies it. "Hmm. It's a calendar of mini-deadlines. But how do you know if I turn something in on time or not?"

Ron grins, "I put all the due dates into my PDA, which is synchronized with our e-mail program, and it will send you a reminder when something is due. You simply indicate whether it's completed."

"Great! Technology controlling my life!" Tamee says, as she picks up her new tweed Lincoln Nash cropped jacket, which had fallen on the floor.

Lauren sits up straight in her chair, wide-eyed. "The calendar says the category plan is due today, but before I can finish it, I need to hear the professor's instructions!"

"For your category plan, you calculate the number of tops, bottoms, and jackets for core, carryover, fashion-forward, and reorderable styles. You give those numbers

*John Ruskin, quoted in A. Applewhite, W. R. Evans, III, and A. Frothingham, *And I Quote* (New York: St. Martin's Press, 1992), 73.
†Charles Revson, quoted in A. Applewhite, W. R. Evans, III, and A. Frothingham, *And I Quote* (New York: St. Martin's Press, 1992), 73.

to Tamee. After Anne and Tamee review the styles, they will assign SKUs. For instance, your line plan states that you will carry over REWT1000," Kate instructs.

"Anne, what style is REWT1000?" Tamee asks. "I can never remember our SKUs."

"Let me help you with that. It's easy with Huntington's software program." Jason jumps in to share his experience. "It forces you to organize your SKUs by category, classification, and style. For instance, REWB2001 is Rare Entities' product line, women's bottoms, style 2001. We can then add color numbers, such as crème being 01. Once you get used to it, you will be able to remember your SKUs."

"Oh, I like that. Finally, SKUs that make sense! I will immediately know the product line, general category, and style," Tamee replies, then asks, "With this system, do we use the same numbers for each season or change them like we've done in the past?"

"Kate told us we need to manage our SKUs and use the same ones for year-round use. We want to create as few numbers as possible," Ron replies.

"I love organization! It makes life so much easier!" Lauren says, glancing at her new PDA.

Both Ron's cell phone and the conference room phone ring at the same time.

"Sorry, Kate. I've got to talk to this contractor!" Ron rushes out of the room.

"It's for you." Anne hands Tamee the phone, "It's Jaynie Lee."

"Hi, Jaynie Lee. Yes, uh huh, Jason's here, too. We're in a meeting. . . . Oh, the specs aren't right on REWT1001. I'll tell him. You need us now?" She looks at Kate, who nods and gives them permission to be excused from the meeting. "Okay, we'll be down in a sec."

"Anne and Lauren, you are my captive audience. We will finish discussing how to create your product line structure," Kate says.

Later that morning, Anne walks in on Tamee, who is busy sorting line art on her worktable. A number of design library notebooks are open on the table in front of her. At his cubicle in the corner of the workroom, Jason is busy at his computer filling in garment bodies, using CAD illustrations. "Tamee, build the product line around our core knit top RDWT1001 and core trouser RDWB2001," Anne instructs. "That's our bread and butter. You can design coordinate and separate fashion-forward jackets and pants to go with those styles."

"I am planning this jacket for our fashion-forward. What do you think?" Tamee asks holding up a CAD sketch.

"I like the fitted cropped styling. The print contrast lining is an interesting twist. Where will the employee ID holder go?" Anne wonders.

"I figured that out already. It's attached to the welt pocket. I am sure that the operators can insert it there, and I followed Ron's direction that the holder should go into an existing seam. Jason drew it—see, here it is," says Tamee, pointing to the technical drawing on Jason's laptop.

"Jason, pull up the file with the cropped jacket." While he does, Anne reads the words aloud on the poster above his workstation. "If you put your heart into snowboarding, snowboarding puts its heart into you.* Nice poster, Jason. Has Kate, the quote master, seen that?"

*Craig Kelly (1966–2003), snowboarding expert, quoted in Famous Snowboarders, www.shenandoah.k12.va.us.

"I'll have to point it out to her the next time she's in the workroom. That's a saying from Craig Kelly, who is considered the godfather of snowboarding. Here's the jacket style you wanted."

"I like how you drew hair on the woman croquis!" Tamee quips.

Anne ignores her and instructs, "Make it a notched shawl collar, shorten the length, and let's use covered buttons."

"Okay, Anne, you're the boss," Tamee grins, knowing that her boss is familiar with her teasing manner.

Anne continues, "We need to discuss our reorderable strategy. I met with Von Moritz's buyer yesterday. He gave me a preliminary seasonal plan and said he wants a continual flow of merchandise. He likes our Beauté theme and color stories. He wants a new coordinate group every 4 weeks."

"How many deliveries?" Tamee asks.

"We will have four deliveries, one each month. Spring I will consist of two deliveries and will use the same color story. Spring II will be deliveries 3 and 4, and we will use the brighter color story; and they will coordinate with Spring I so that if they have leftover merchandise, the styles can be worn together."

Ron answers phone calls and tons of e-mails that afternoon. He stares intently at financial figures and jolts upright as the phone rings again. He hears Jim O'Dale's voice: "Ron, I need you to write up an RFP. We have a potential airline company that likes your concepts. They might use them for their flight attendant uniforms. It could be a new division for Rare Designs. Get to work on it! We will meet with their marketing department in 2 weeks to discuss it. I want a storyboard and RFP presented at that meeting."

As usual, O'Dale is quick and to the point. After the short phone call, Ron stares at his phone, mumbling "RFP? What the heck is an RFP?" He decides to call Richard, president of RAC.

Richard laughs loudly as Ron tells him of his phone call from O'Dale. "An RFP is O'Dale's rite of passage; it means request for proposal. O'Dale is always looking for ways to grow our companies and has tried to get each one of us to start a uniform program. An RFP is a heck of a lot of work, and you said he wants this in 2 weeks. Good luck getting any sleep!"

Ron groans and thumps his head on his arm, "Ouch! This is not my day—more work and I just whacked my forehead on my new watch!" He picks up the phone again. "Annie! Help!"

Objectives

After reading this chapter, you should be able to do the following:

- Understand balancing creativity with meeting time-and-action calendar deadlines.
- Implement design strategy by building customer and/or consumer value into products.
- Learn how designers create garment ideas from a merchandising analysis.
- Distinguish the creation of a new product line from an existing product line.

- Interpret characteristics of core garments and illustrate them.
- Interpret characteristics of carryover garments and illustrate them.
- Interpret characteristics of fashion-forward garments and illustrate them.
- Differentiate reorderable garment creation and its interdependence on multiple seasonal deliveries.
- Understand what occurs at a design review.
- Comprehend the request-for-proposal process.

The final phase of merchandising the product line involves implementing design strategy, merchandising a product line, and illustrating garments. An apparel company's mission statement controls and promotes the design team to use the company's brand marketing strategy. From this, the design team creates a clear fashion direction, a competitive advantage strategy, and customer and consumer value provisions (Regan 1997, 181). Executives set goals from the established company strategy. These goals need to be well defined, and executives need to delegate who is responsible in an action plan (Harvard Business Essentials 2006). The vice president of product development and the merchandisers communicate the SBU direction to designers. This becomes the directive to create the product line strategy for core, reorderable, and fashion-forward items (Regan 1997, 184). Having a successful design strategy depends on having a successful design team and implementing strategy in products designed.

The primary players in merchandising the product line are the vice president of product development, the design director, the designer, the merchandiser, the CAD artist, and the patternmaker. The team also relies on opinions from retail buyers, the company president, and the manufacturer representatives. This chapter discusses design strategy and the primary roles of the design team as they prepare for the design review. Quiksilver Inc. 👕 explains its philosophy:

> We believe that our historical success is due to the development of an experienced team of designers, artists, sponsored athletes, engineers, technicians, researchers, merchandisers, patternmakers, and contractors. Our team and the heritage and current strength of our brands has helped us remain competitive in our markets. Our success in the future will depend on our ability to continue to design products that are acceptable to the marketplace and competitive in the areas of quality, brand image, technical specifications, distribution methods, price, customer service, and intellectual property protection. (U.S. Securities and Exchange Commission [SEC] January11, 2007c, 24)

No one has to tell an apparel manufacturer or private label retailer that the apparel industry is extraordinarily competitive. Apparel companies are successful when they research design to create the products that consumers desire. The goals of design research are to understand and create new ways to meet consumers' unexpressed needs. The design team uses practical methods to capture consumer needs, such as observing consumers shopping or using products (Lojacono and Zaccai 2004). Once the design team determines its design strategy,

merchandisers develop a product line structure, and designers illustrate designs that reinforce their strategic direction. The design team treats design strategy as a creative challenge, and they will ponder the following questions: How does this product follow our company's design strategy? Does it follow the current fashion direction? What consumer value is apparent in the design?

Brand Success Requires Design Strategy

What makes a brand successful? According to *Business Week*, which annually publishes Interbrand's list of the world's most valuable brands, successful brands have market leadership, stability, and the ability to appeal to multiple geographic and cultural markets. Renowned fashion luxury brands such as Armani 👕, Burberry 👕, Chanel 👕, Gucci 👕, Hermēs 👕, Louis Vuitton 👕, Prada 👕, and mainstream brands Nike 👕, Levi's 👕, Gap 👕, and Zara 👕 rank within the top 100 most valuable global brands (*Business Week* 2006).

Stiff competition requires successful manufacturers to be one step ahead of their competitors. "A company can outperform rivals only if it can establish a difference that it can preserve. It must offer greater value to customers or comparable value at a lower cost" (Porter 1996). Although there are many ways a company can distinguish itself, we focus here on product design.

Design strategy is an executive direction to control and use resources to promote a clear fashion direction and strategic advantage. In doing this, the design team creates a unique and valuable position. Strategic advantage means that a company's product is more distinctive by offering features that rivals find impossible or too costly to match (Porter 1996). The executive vice president of Warnaco Swimwear Inc. 👕 noted, "Brands need to step outside the box." Clothing styles need to stand out among the multitude of available competing products and not copy other companies' styling features. For example, Calvin Klein Swimwear is best known for clean, classic lines; Nautica features sporty swimwear in blue, yellow, red, and white; and each bathing suit designed by Anne Cole needs to be "classic, sophisticated, and sexy" (Seward 2005).

A Clear Fashion Direction

A company's design strategy involves choosing services or product features that are different from the competition. A strategic design position requires creativity and insight. The three key principles to strategic design are to reinforce a company's activities, make trade-offs by choosing what not to do, and create a unique and valuable position (Porter 1996).

Reinforce a Company's Activities

Reinforcing a company's activities means the design team develops product that relates back to a company's mission statement. Here we use TOMS Shoes for Tomorrow 👕, founded by Blake Mycoskie. TOMS Shoes for Tomorrow's mission statement—"To make life more comfortable"—has a moral focus: the founder donates

a pair of shoes to children in need for each pair of shoes purchased from TOMS (Moore 2006; TOMS Shoes n.d.). Shoes worn by Argentine workers inspired Mycoskie to start a shoe company in 2006. Mycoskie's design strategy was to adapt the Argentine shoe design, called *alpargatas*, for the U.S. market, and he claims his shoes "fit your foot like a glove, but are sturdy enough for a hike." He links his design strategy back to his mission by following through with his donation to needy children and as of October 2006, he had given away 10,000 pairs of shoes to Argentine children (Mustafa 2007).

Making Tradeoffs: Choosing What Not to Do

Innovation is risky, consumers are fickle, and imitators are quick to copy emerging successful companies or product design (Cottrill 2006). Choosing what not to do means a company does not copy others; rather it has a distinguishable position in the marketplace. One can measure effective innovation as products or services that competing companies cannot easily replicate (Inspiring Innovation 2002).

Companies can make the mistake of imitating and focusing too closely on their competitors (Inspiring Innovation 2002). Apparel companies easily fall into this trap, with ideals such as "we will copy fast-fashion companies because these companies are hot right now." Companies are tempted to chase easy growth by adding hot features, products, or services without adapting them to their own design strategy (Porter 1996). Companies such as Zara that successfully implement fast-fashion have a design strategy that other companies cannot easily imitate. Zara is a private label retailer in which store associates frequently communicate with the design team to inform them about consumer preferences, so company associates can order from and supply to each store. Their vertically integrated operation allows for a flexible supply chain among procurement, manufacturing, distribution, and logistics so they can achieve high inventory turnover (Inditex 2005). A design team that simply knocks off designs will not make its company a "fast-fashion" retailer; rather, these companies a need to have a highly integrated supply chain for success. Apparel companies need to be agile; otherwise, they will quickly have inventory shortages or overages, and products can quickly become obsolete (Cottrill 2006).

Successful strategy requires companies to make trade-offs, choosing what not to do, and purposely limiting what a company offers. A design strategy fit is well suited for needs-based positioning in which a company targets a specific customer (Porter 1996). One way apparel manufacturers accomplish needs-based positioning is by exclusively offering select brands to retail customers. For example, Jones Apparel Group 👕 has twenty different brands, each of which they clearly designate for a specific retail tier (SEC February 28, 2006). Designers make specific trade-off decisions so a garment's construction and quality meet those of retail customer expectations.

Creating a Unique and Valuable Position

Creating a unique and valuable position means that target cnsumers must recognize differences among companies that compete with each other. (Inspiring Innovation 2002). Part of a designer's job is to create value by designing products that are innovative, have

Figure 11.1 A boardshort design that would reinforce lifestyle apparel manufacturers' design strategy. *(Illustration by R. Fontanilla.)*

a new application, or possess useful features within the realm of products offered in the market (Galbraith, Downey, and Kates 2002). Creating innovation is stretching the rules and being imaginative. Sometimes when people hear innovation, they think that it requires a company to be a product leader. Successful companies are continually on the move. They can be a product leader or they may have a business model, or offer service that other companies do not offer.

Here we use surf, skate, and lifestyle companies, such as Billabong 👕, Hurley 👕, Ocean Pacific 👕, Quiksilver Inc., and Volcom 👕, that compete with each other (Hoover's 2007a, 2007b; 2006a, 2006b). These companies all offer boardshorts similar to those shown in Figure 11.1. One way to create a unique and valuable position is to identify ways to improve an existing product. Innovations can include new product categories or additions to existing products. It is important that companies embrace new ideas because the fear of trying new things often hinders innovation (Nadel 2004). For instance, Sally Biggerstaff, who was an inventor for Hurley, recognized a need to improve boardshorts, which led her to develop and patent a fly closure for garments (Biggerstaff 1999). Steven Fontes, an inventor for Quiksilver, patented a garment with an improved fly closure design (Fontes 2004). A patent must be clearly distinguishable from other product components or styles. Hurley's goal was to restrict flow of water and sand through a privacy shield, whereas Quicksilver's goal was to allow for a privacy shield and eliminate bulky seams. When a company patents a product, it needs to specifically identify and number the patented garment components. The numbers in Hurley and Quicksilver's patented fly closure identify overlapping flap construction and a privacy shield (Figure 11.2) (Biggerstaff 1999; Fontes 2004).

Creativity Deadlines

Because effective design strategy is so important, executives need to schedule activities that enhance creative thinking. Designers are most creative when they are under low pressure to explore ideas, such as when they seek inspiration from readily available resources or travel (see Chapters 6 and 7). Designers often come up with creative ideas

a b

Figure 11.2 Apparel companies will patent unique design features: Hurley boardshort garment (a) and Quiksilver boardshort (b). *(Illustration from U.S. Patent Office, U.S. Patent 6,199,215 by S. D. Biggerstaff Assignee Hurley International LLC and U.S. Patent 7,174,574 S. Fontes Assignee Quiksilver Inc., reprinted with permission.)*

when they can study materials and play with ideas like puzzle pieces. They can often develop ingenious solutions in a short time when given time to concentrate (Amabile, Hadley, and Kramer 2002). Executives can achieve a low-pressure setting by clearing petty obstacles and scheduling time for creative individuals to work alone or to collaborate with another person rather than participate in multiple design team meetings (Amabile, Hadley, and Kramer 2002). Company executives that create highly successful products support freethinking, encourage enthusiasm for new projects, and look for good ideas every day (Nadel 2004).

Some company executives believe that creative people generate their best ideas under tight deadlines; however, this environment often prevents individuals from creative thinking (Amabile, Hadley, and Kramer 2002). Executives need to understand how to balance timelines while getting the best creative output. It is important for executives to set deadlines; otherwise, it is easy for associates to procrastinate (Baldoni 2003). During high-pressure times, creative people work best when there is focus and they understand the importance of completing a job (Amabile, Hadley, and Kramer 2002).

Executives need to explain the importance of meeting deadlines rather than setting arbitrary deadlines.

In product development, time pressure intensifies as the schedule nears apparel release. To meet deadlines, the design team needs to stagger submission dates so that textile vendors can meet deadlines. If designers order fabrics within a short time span (e.g., 1 week), it causes a peak in textile production, and textile vendors may not be able to deliver on time (Regan 1997, 164). Textile suppliers are often willing to help the design team meet deadlines, especially if they can schedule their own production in advance.

ACTIVITY 11.1 *Time-and-Action Calendar: Continued*

A person might argue that creativity and deadlines are contradictory. Yet the reality is that successful companies keep tight deadlines and tight financial budgets (Inspiring Innovation 2002). As you fill out your time-and-action calendar, notice that the design team multitasks among color and fabric development with illustrating garments and reviewing concepts.

Using Table 4.10 and Company Project 3 in Chapter 4, add fabric selection and development activities to your time-and-action calendar, and create a time line for completing these activities.

- In cell A29, type "Develop line plan." Designate 1 week and fill cell G29.
- In cell A30, type "Design review meetings." Designate 4 weeks and fill cells H30–K30. Align this activity in the same column as the start of "Determine fabric parameters."
- In cell A31, type "Illustrate core, carryover, and fashion-forward garments." Designate 4 weeks and fill cells H31–K31. This activity starts the same week as "Determine fabric parameters."
- In cell A32, type "Determine reorderable plan." Designate 2 weeks and fill cells J32–K32. Align this activity in the same column as the start of "Participate in textile concept meetings."
- In cell A32, type "Submit core, carryover, fashion-forward and reorderable work kits to patternmaking." Designate 4 weeks and fill cells J32–M32. Align this activity in the same column as the start of "Determine reorderable plan."

Merchandising the Product Line

Merchandising the product line is a nebulous phrase, yet it is commonly used in the apparel industry. **Merchandising the product line** means the design team creates a product line structure and product groups (Figure 11.3). This requires the design team to pull together the theme, color, fabrics, and garments into a cohesive seasonal product line. A design team does not create new ideas overnight; rather, developing

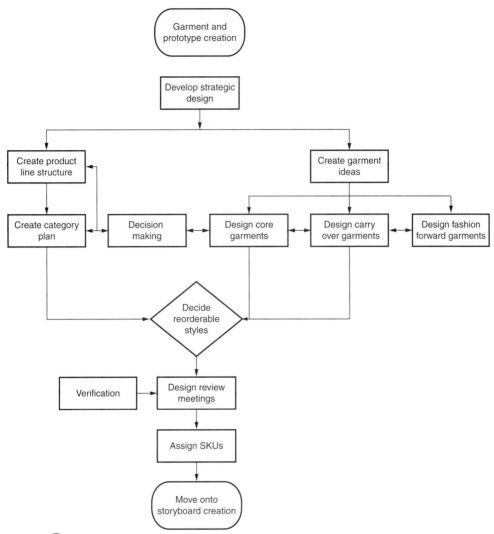

Figure **11.3** Merchandising the product line: Finalizing the line. *(Flowchart by K. Bathalter.)*

innovative ideas takes time, effort, and hard work. The design team's goal is to link garments designed to a company's mission, product line strategy, and seasonal theme, which can be challenging. A flurry of activities occurs to merchandise a product line. Merchandisers develop a product line structure that consists of creating parameters a category plan, and identifying fabric types. Designers pull together colors, fabrics, and illustrations to submit garment prototype requests to patternmakers. This process can be likened to a puzzle with many separate pieces, but once joined, they create the seasonal product line (Figure 11.4).

Figure **11.4** A designer has a multitude of puzzle pieces that he or she uses to visualize a product line. *(Illustration by C. DeNino.)*

Product Line Structure

Before designers can pull everything together, they rely on merchandisers to give them a product line structure. Creating a **product line structure** or **line plan** means that the design director and merchandiser identify the seasonal line and determine parameters (Regan 1997, 183). In the following, Jennifer Barrios, a senior merchandiser for Quiksilver Edition, discussed how designers and merchandisers work together to develop seasonal product lines and mentioned how they use classification reports, such as carry-over colors, to develop the new seasonal line:*

> Quiksilver teams up a designer with a merchandiser. We work on the product line together. We first give them an SKU plan or how big the line needs to be. The designers will create line art and then we review the bodies together. We narrow the bodies down to the SKU plan. For colors, the designer will put

*Reprinted by permission from Jennifer Barrios, senior merchandiser, Quiksilver Inc., Huntington Beach, CA; pers. comm., May 9, 2006.

together the color card. We analyze which colors sold well, if we are missing colors, or if we have too many colors. For fabric, the designers tell us which fabric to source and any trims that need to be developed. Once they give us the tech pack, we follow through with the development.

Apparel executives have extensive knowledge about a product line in which they know their manufacturing limitations, have a sales history, and know to keep wholesale prices within the company's cost structure (Regan 1997, 183). The design team creates a product line structure by identifying garment parameters, creating a basic line plan, identifying fabrications, and evaluating garment components. As mentioned in Chapter 10, **parameters** is a general term that describes the number and type of fabric and garment styles in an SBU and their corresponding production information (183). Garment parameters delineate styles by price tier and type. The merchandiser can then justify product line value, such as its fashion-forward and reorderable strategy, to retail customers.

Category Plan

A category plan is part of the line plan. The design director and merchandiser will receive instructions to either create new categories or update existing categories. A **category plan** consists of quantities or a percentage of core, reorderable, and fashion-forward garments. Merchandisers develop category plans from the minimum plan (see Chapter 4) (Regan 1997, 188). At design review meetings, merchandisers inform the design team of the parameters (e.g., twenty SKUs) they can create in the product line. They will also inform the team of the SBU direction, market trends, and how this fits with the company's direction (186, 199).

Account representatives meet frequently with retail customers to establish seasonal or annual plans and to maintain strong account relationships (SEC February 28, 2007). The representatives review the sell-through and sell-in information of large retail customer accounts to determine the percent allocation. They relay this information to design directors and merchandisers. Merchandisers use selling reports to develop their category plan. A **selling report** is a quantitative analysis of an SBU's business history. The various selling reports include an analysis of key items, prior season sell through, and growth categories (Regan 1997, 181). Apparel manufacturers retrieve selling report information from their company business history, or they hire market research services. Private-label retailers receive this information from their retail division.

Merchandisers evaluate selling reports to determine the category plan and which garment features to push, such as colors, fabrics, or components. They use information gleaned from the previous season's best sellers and their background experience to make judgments on consumer perceived value, company price structure, previous successful fabrics, and garment uniqueness. For example, if a T-shirt style is really selling in the stores, then the manufacturer will carry it over in another color or fabric.

Classification Analysis

Most apparel brands have some common garment styles in each seasonal product line. Apparel companies refer to the common use of core garment style(s), colors, and fabrics as *maintaining its basic product line* (Figure 11.5). Merchandisers conduct a classification

Figure ⑪⑤ Example of Rare Entities product line structure with set price range, fabrications, and garment styles. *(Illustration by A. Flanagan.)*

analysis to determine which garment styles, colors, and fabrics they should use and subsequently to determine the number of new styles to introduce.

Apparel companies need to stay abreast of fashion trends and the possibility of a quick turnabout because trends quickly change (Yen and Farhoomand 2006). A **classification analysis** is a quantitative evaluation of established SBU categories (Regan 1997, 186). In our story, Rare Entities' garment categories are *women's bottoms* consisting of pants and skirts; and *women's tops* consisting of jackets, vests, and tops. A classification analysis gives merchandisers information on which classifications are trending up (growing) or trending down (declining). In our Rare Designs story, the merchandiser, Lauren, found that jackets were trending up, whereas cardigan sweaters were trending down. This indicates that the Rare Entities product line should have more jackets and reduce cardigans. Design directors and merchandisers use their experience to determine the sell-through trends. Poor classification sell through is not solely due to product design; rather, as noted by Inditex, which owns Zara, an improper supply of goods can be due to mistakes between warehouses, poor logistics management, or a collapse of information exchange between the distribution center and stores (Inditex 2005). Merchandisers need to determine why products sold or did not sell.

Evaluating Prior Season Best Sellers

Merchandisers evaluate their SBU best-selling items by SKU. An **SKU** is an alphanumeric designation that identifies a product. Best-selling products inform merchandisers how consumers perceive products, which designs were successful, and which designs failed.

From evaluating best-selling styles, the merchandiser determines trend information about best-selling new and existing styles, price tiers, and prior success with fabrics and trims (Figure 11.6). Merchandisers use their experience to interpret the information. While merchandisers encourage designers to carryover successful designs, the decision can be difficult to interpret poor-selling garment styles. If a new style did not sell well, it could be that the company introduced a trend or garment style too early for their target market, and it might be successful in the upcoming season; or simply that their consumer rejected the idea. Some reasons to drop a garment style are that it is not current with fashion trends or because low-cost competitors are copying the company's garment style.

Price Tiers

Merchandisers also look at the report to analyze price tiers. A **price tier** is an apparel manufacturer's or private-label retailer's retail price range when planning an SBU product line. The merchandisers plan a specific percentage of products to be at a lower and a higher retail price point. As Jennifer Barrios explained:*

> Having a line plan is especially important when your company's SBUs target a different target customer and price range. We are currently repositioning our brand so we have business to protect with one customer base and new business to grow with a new target customer. Part of the differentiation between the established and new business is through price tiers. We determine the percentage of styles to be developed in particular price tiers by analyzing last year's bookings. For example, last year, most of our walkshort business was centered around $49.50. In recent seasons, styles in the $50.00 to $60.00 price range are booking better. Therefore, we will then say to our designers that they should design five styles for around $49.50 and ten styles between $50.00 and $60.00.

ACTIVITY **11.2** *Critical Thinking*

The merchandiser in the previous quote refers to retail price tiers. The goal of this activity is to establish your retail price points.

- Refer back to Company Project 2 in which you identified three retail customers that you would like to sell your product. Go to each retail customer's Web site (e.g., Dillard's at www.dillards.com).
- Look at a similar product that you want to create (e.g., women's dress pants). For each retail customer, identify the low retail price point and high retail price point.
- Average the low price points offered by the three retail customers. This is one price tier for your product.

*Reprinted by permission from Jennifer Barrios, senior merchandiser, Quiksilver Inc., Huntington Beach, CA; pers. comm., May 9, 2006.

RE WT 1001

~~||||~~ ~~||||~~ |||

REJ1001

~~||||~~ |

RE WT 4001

||||

REWB3001

~~||||~~ ~~||||~~ ~~||||~~

Figure 11.6 Rare Entities carryover garments, with selling report analysis. *(Illustration by C. DeNino and S. Lozano.)*

- Average the high price points offered by the three retail customers. This is the second price tier for your product.

Selling Reports

Some apparel companies use market research companies, such as Directives West, to analyze sales trends and best-selling styles by geographic region. The market analyst cross-references this information by bookings. Sell-in and **booking** refer to the same sales figure and is the dollar amount or quantities sold to a retail customer. Merchandisers or market analysts may not have sell-through information of styles that actually sold to the consumer because products may currently be for sale in the retail stores. Retail buyers follow current season selling reports; according to Jessica Aragon, an assistant market analyst for Directives West, this can trigger an urgent request for reorders, such as, "I want four hundred pieces delivered next week."

Although interpreting regional geographic sales trends is not always straightforward, it assists designers in selecting appropriate garment styles and fabric weights. For instance, a merchandiser may find that the company's spring styles sold best in the Southeast and Midwest regions of the United States. If these bookings were equal, then the sales trend shows that the company should push more spring styles in the Southwest. The designers should create warm-climate styles in appropriate lighter-weight fabrics. Jessica Aragon, a market analyst from Directives West, explained:*

> Selling reports are common in the industry. Directives West is a retail-consulting firm, and one service we offer our apparel-manufacturing clients is to analyze selling reports. A selling report is the number of SKUs sold versus purchased; for example, 41/100. It breaks down each SKU by colors sold and geographic region. When a retail customer buys merchandise, he or she might only put the style in one or two geographic regions; for instance, in the Central or Northeast region. It is important for designers to know what geographic region their clothes sold in because it tells you the style and the fabrication. Designers need this information because they may decide to do the same style in two different fabrications—a heavier fabric in the Northeast and lighter fabric in the South.

ACTIVITY **11.3** *Critical Thinking*

The market analyst explained that geographic region makes a difference in how designers select fabrics or create styles. Market analysts can learn temperature information by referring to the National Climate Data Center, part of the U.S. Department of Commerce. From this, merchandisers can determine the fabric weight that is suitable for different geographical regions.

- Go to Climate Maps of the United States at http://cdo.ncdc.noaa.gov/cgi-bin/climaps/climaps.pl. Select "Quick Search." Select "Lower 48 States." Select "Temperature," then the Continue button. Select "Mean Daily Average Temperature," and the "Continue" button.

*Reprinted by permission from Jessica Aragon, assistant market analyst, Directives West, Los Angeles, CA; pers. comm., April 14, 2006.

- Select the month that you plan to deliver your seasonal product line to your retail customer. For instance, Rare Entities is creating product for the spring season, and they will deliver to Von Moritz stores starting in February.
- Select "Lower 48 States, TEMPERATURE - Mean Daily Average Temperature pdf file" (center of page).
- Look at the color key for the temperature for two different geographic regions.
- Write or sketch how you would change a garment style that you are thinking about designing so it would sell in two geographic regions (e.g., light- or heavy-weight fabric, sleeves or no sleeves). For instance, Lauren, Rare Designs' merchandiser, found their tops sold well in the Midwest she would find a February mean temperature range of approximately 20 to 40 degrees in this geographic region. If Rare Designs wanted to market the same tops in the Southeast, it would be approximately 50 to 60 degrees. Tamee could create one knit top out of a cashmere/cotton blend and the same style in 100-percent cotton.

Fabrics and Fabrications

Each product line has dominant fabrics and fabrications. Merchandisers analyze reports to determine if they should increase or decrease their core fabrics (Regan 1997, 186). A fabric classification analysis report (by fabric code) ranks best-selling fabrications. This report may indicate that solid fabrics sold faster than prints, but prints had a 90 percent sell through, whereas solids had an 80 percent sell through. Merchandisers cross-reference the reports with a visual analysis of line sheets to understand what specific features sold the garment. They will make recommendations such as "We should incorporate more stripes or fabric blocking into our new designs." Jennifer Barrios explained that although it is important to analyze and use report trends, you also need to use your business instinct:*

> We analyze our business by fabrication. Right now, 60 percent of our walkshort business is in cotton twill, so we need to have a lot of cotton twill in the product line. There are core fabrics, such as cotton twill, that we always have in the line but the percentage varies. It's important to explore new fabrics, but you will always need to have your core fabric covered. When you are trying to build new business, you have to take some risk. It is important to not be afraid of how far you can push it. You also need to understand how much of the established business you need to protect.

ACTIVITY **11.4** *Critical Thinking*

For this activity, you need to have a WSGN-edu student account. The purpose is to look at and select a fabric or finish that you can use in your product line.

- Go to www.wgsn-edu.com and log in.
- Click on "Materials."

*Reprinted by permission from Jennifer Barrios, senior merchandiser, Quiksilver Inc., Huntington Beach, CA; pers. comm., May 9, 2006.

- Click on "Swatch Reports" (right side of page).
- Review the varying fabrics, finishes, and surface treatments, and write notes about one fabric you could use for your product line.
- Create a swatch in Adobe Illustrator. (See Company Project 9 for directions on creating swatches. Select "Swatch Libraries"—"Other"—"Gradients" if you want to create a fabric wash).

Garment Component Characteristics

Merchandisers use past reports and current directions to identify garment components. They look at details at this stage (e.g., brand and care labels) to determine whether what they currently offer is on target with what consumers previously perceived as having product value (Regan 1997, 183). A garment component classification is an analysis of specific styles and features, such as a dress and its specific components (e.g., long or short sleeves). A garment component classification identifies growth opportunities. For example, a sleeve analysis could show that short sleeves sell more than three-quarter-length or long sleeves. Merchandisers analyze category sell-through reports from a preceding season to anticipate the next season's figures, or they evaluate two corresponding seasons (e.g., Spring 2010 for Spring 2011). Identifying best-selling features is not straightforward; it can be challenging because there are numerous reasons why consumers buy apparel products. To understand ambiguous reasons, merchandisers visually review previous season line sheets. For instance, they can look at the styles that sold through and visually see that the styles were striped, embroidered, or fitted. This qualitative analysis is important for merchandisers to accurately discern accurate style trends.

ACTIVITY 11.5 *Developing a Category Plan*

The purpose of this activity is to practice creating a category plan.

- For this category plan activity, use the categories that you will develop for your company project.
- Describe your basic line; that is, the product you will be designing.
- Identify your core fabric types.
- List carryover colors. (**Note:** You do not have a previous business history so identify hypothetical carryover colors.)
- List carryover garments. (**Note:** You do not have a previous business history so identify hypothetical carryover garments.)
- List common garment component characteristics (e.g., neckline, sleeve, and/or collar types).
- Enter a total you expect to sell (e.g., 1,000).
- Enter percentages for each category (e.g., tops, bottoms).
- Enter the percentage of separates, coordinates, and sets you will have in your product line.

How Designers Create Garment Ideas

Simultaneous to merchandisers creating the product line structure, designers are illustrating core, carryover, and fashion-forward garments. Designers do not believe that the information provided by merchandisers is a hindrance; instead, they see it as a challenge. Creative people love a challenge and the feeling of accomplishment (Florida and Goodnight 2005). Successful companies encourage designers to create solutions to real problems rather than to simply be creative (Inspiring Innovation 2002). Experienced designers are successful in working out good solutions, even with complicated design details (von der Weth 1999). For instance, if the merchandiser told company designers that short sleeves are in, designers will think, "What can I do to update short sleeves?"

Although it is important for designers to have imaginative thoughts and collective control over their activities (Lawson 1990), a designer does not simply get out a pencil and paper and sketch anything that comes to mind. Each designer has a design method: some draw on napkins or scratch paper as they come up with ideas, whereas others have a more systematic approach. Designers that are results oriented tend to quickly sketch multiple ideas, analyze the product, and then work out the details (Eisentraut and Gunther 1997).

Designers categorize garments by core, carryover, and new. Designers typically illustrate core garments first; however, they do not necessarily complete core designs before moving on to carryover and new designs. Illustrating garments depends on designers' creative inspiration, so there is no set sequence (Figure 11.7). They may be having difficulty finishing a design concept and prefer to move on to another design rather than get frustrated. Designers may also stop working on a design if they have questions on fabric or trim or if they are waiting to receive sample fabric. Once designers create garment concepts, they work with merchandisers to determine reorderable styles. Pulling together the product line as a team takes talent, which is why a designer needs to be able to communicate well, problem solve, work well in a team, give proper instruction to other apparel associates, and have strong sales and presentation skills (U.S. Department of Labor 2006–2007).

Illustration Terminology

Similar to the way executives often write reports to convey company strategy, designers use manual illustrations or computer graphic programs to illustrate a design strategy. Although designers traditionally used pencils, pens, or markers to sketch designs by hand, they now commonly use a computer graphics program to illustrate garments and to experiment with different color, fabric, and trim combinations. Alona Ignacio, designer and production manager for Seril, noted that in large apparel firms, it is common to have **CAD artists** illustrate a designer's creative ideas; however, in small to mid-size firms, this is the designer's responsibility. For continuity, we separate the job functions and designate the CAD artist as the individual drawing with a computer graphics program.

CAD artists and designers use illustration terms to translate a designer's sketches and notes into computer graphic drawings. A **model**, or **body**, is a colloquial term for an individual garment design and distinct silhouette. Designers or CAD artists illustrate

Figure 11.7 A designer sketching and creating ideas.

models as line art or as a garment flat. **Line art** refers to a drawn silhouette that is not filled with color. It can refer to a computer graphic drawing or a manual illustration. CAD artists create line art for preliminary model review at design review meetings, for technical packages, and for line sheets. CAD artists typically use croquis templates to draw flats (i.e., garment flat). A **croquis** is a basic figure, measured in heads (Figure 11.8), that a designer or CAD artist uses as a foundation to draw illustrations or flats. A garment flat differs from fashion art. Fashion art is a garment drawn with a figure that conveys an attitude, silhouette, and fabrication. A **garment flat** is a two-dimensional garment without a figure that shows trim, fabric, and color (Stipelman 2005). **Fill bodies** is a colloquial term that means designers illustrate a garment flat and evaluate the best aesthetic design by changing colors, prints, fabrications, and trims. CAD artists make numerous color, fabrication, and styling changes as they work with designers to create the seasonal product line.

The design team commonly refer to coordinates, sets, and separates when discussing garments and creating a product line. A line plan includes a percent allocation for separates, coordinates, and sets. A designer will purposely coordinate colors and fabrications so a consumer will buy and wear a top and bottom. To **coordinate** means to use colors, fabric prints, or textures designed to be worn together in multiple garments (Keiser and Gardner 2003). Some manufacturers and private-label retailers focus their design strategy so each style is a coordinate combination of tops and

REWT1001

REWB1002

Figure 11.8 Garment flat illustration with croquis template used to draw two garments for Rare Entities product line. (Illustration by C. DeNino and E. Perales.)

bottoms. For example, The Talbots Inc. 👕, a private-label retailer, targets a busy confident woman who desires stylish classic clothes. Their design team's strategy is to create entire outfits of basic and fashion items with coordinating accessories. Designers create outfits that have consistent colors, fabrics, and fits which consumers can wear year-round (SEC April 10, 2007). The Talbots Inc. designers create classic styles in which they coordinate two to four garments with a jacket, blouse, skirt, sweater set, or pair of pants (Rangan and Bell 2000). Retailers and manufacturers price coordinates individually or as an outfit. Sienna and Kayla in Figure 11.9 are coordinate examples. A **set** is a two-piece garment, priced together, or an accessory item that coordinates with a specific garment style. One example is a winter scarf, hat, and glove set that a retailer sells with a long-sleeve knit top. Another example is two-piece swimsuits or tracksuits. Traditionally, retailers sold two-piece bathing suits as sets; however, a recent trend is to sell bathing suits as coordinates. Jamie, in Figure 11.9, is a set that a retail customer would sell together. A **separate** is a garment that a designer individually designs (Keiser and Garner 2003) and a merchandiser prices individually. A designer creates separates, such as Gracie and Lolita in Figure 11.9, to wear with a variety of tops or bottoms. Separate examples include men's and women's pants, knit tops, and casual shirts.

Each core, carryover, new, and reorderable style has a unique decision and creation process (Regan 1997, 184, 187, 188). Designers first create or revise core garments, and then they work on carryover garments. They add a pop to the product line with fashion-forward garments. Designers tie garments back to the seasonal theme, which will enable them to coordinate a collection by using recurring motifs or patterns (Eckert 1997).

Core Garments

Fame is important to a company's success. People often associate fame with an individual or a product achieving worldwide recognition, notable behavior, or wealth. A core garment is an apparel company's fame, but sometimes it is not on such a grand scale. Retail customers and consumers recognize a company's brand by its core garment; it is a common silhouette offered in many colors and fabrications.

Although some apparel designers are renowned for their name, consumers are generally more aware of an apparel company's core garments than its designers' names. For instance, 7 For All Mankind, LLC 👕 is a popular jeans company that has a highly recognizable brand (7 For All Mankind, LLC n.d.). The people behind its inception and continued success include the entrepreneur who created the jeans, Peter Koral, who is less known to the general public.

Defining Core Garments

Apparel companies refer to **core** as its primary products or target consumer (SEC February 28, 2007). **Core business** is how a company delivers its primary product. The core business of Polo Ralph Lauren 👕, a lifestyle company, is to have an efficient supply

SET

COORDINATE
Sienna
WT5604
Core

SEPARATES
Gracie
WT 5006

Jamie
S 1304

Kayla
WB 3054

Lolita
WB 8145

Figure 11.9 Designers create garment coordinates, sets, and separates. (Illustration by K. Bathalter and M. Bontempo.)

chain (Yen and Farhoomand 2006), and Carter's Inc. 👕, a children's apparel manufacturer, is to create products that deliver an attractive value (SEC February 28, 2007). A **core garment** is a style that is always in one or multiple product lines, regardless of the seasonal theme variation (Figure 11.10). A common assumption is that core garments are simplistic and basic. Conversely, designers and companies create core garments

Employee Badge Holder

Figure 11.10 One of Rare Entities' core garments is a fitted jacket with a loop to hold an employee badge holder. (Illustration by E. Perales.)

to create a unique and valuable position in the marketplace. Most retail buyers have core businesses with select manufacturers.

Some industry segments have common core garments. Infants and toddlers clothing have common core garments, which include bodysuits (onesies), pajamas, blanket sleepers, gowns, and play clothes (SEC February 28, 2007). Core garments can account for a significant portion of an apparel company's business. For instance, Carter's Inc. stated that their top ten core garments account for 80 percent of their baby and sleepwear net sales (SEC February 28, 2007b).

Companies also create core garments that are readily associated with its brand. Burberry is readily associated with its core outerwear products, such as its trench coat and its Burberry plaid fabric design (Burberry Group, PLC 2007). Executives often call a core garment its **bread and butter**. This colloquial phrase means that a product is a solid and consistent seller. Executives will sometimes say "Don't change our bread and butter" because this core garment pays the company's bills. Successful sell through is a requirement for core garments, and if there is a downtrend, the executives will drop this SKU. A mistake is if a designer forgets about having a successful sell through and creates designs that are too expensive for their target market or if they knock off existing designs.

Core Garment Strategy

Core garments are ones that apparel manufacturers and private-label retailers previously produced and often change little; however, competitive pressure forces apparel companies to update core garments to add value, create uniqueness, and follow the direction of the current fashion forecast (Yen and Farhoomand 2006). Company executives often have high design expectations for core garments. Carter's Inc. noted its focus on product design is a main reason for its leading market position. Its design team develops core garments with distinctive print designs, artistic applications, and quality products. Its design team differentiates its core garments from competitors through fabric improvements, new artistic applications, packaging, and presentation strategies (SEC February 28, 2007).

A designer can create a core garment for an individual season or for year-round (Figure 11.11). Designers call on merchandisers for information in classification and selling reports, to determine their core garment strategy. They will discuss best-selling styles, any construction constraints, and fabric cost structure (Regan 1997, 184). Some strategies include changing colors and fabric combinations, creating coordinate outfits, or designing an entire line around a theme. Figure 11.11 shows six Sienna core garment variations. For instance, the Wanderlust theme has a predominance of blue, so the designer used sporty fabrics and colors. In the Spring Forward theme, the designer chose softer colors to give Sienna a more feminine feel. The designer added a spark by creating style WT 5703 with a print back facing and contrasting sleeves and body, and a different look for style WT5604 with a combination facing with capped sleeves in striped fabric.

Company executives often expand a successful core garment from one product line to multiple product lines. For instance, Sienna (Figure 11.11) could be in women's, juniors, and 'tween top product lines. The pattern maker would adjust the pattern and measurements, but the aesthetic appearance would be the same for all product lines.

A core style can also be a garment component. To qualify, a company consistently uses this garment component in multiple SBUs for many years. This garment component is a distinguishing feature well associated with a company's brand. For instance, Polo Ralph Lauren is renown for its use of the polo-style rolled collar (Ralph Lauren n.d.), and American Apparel ⊤ uses a basic round/jewel neckline as one of the core garment components available in its men's, women's, and baby SBUs (American Apparel n.d.).

How Designers Draw Core Garments

Core garments can be the ultimate challenge for a designer because many of their attributes do not change. Core garments, however, can be any style from a simple to a detailed, complicated design. To understand core garment change, designers need to understand what constitutes pattern change. Designers will first decide whether to update core garment styling. Generally, the outside silhouette and major pattern pieces do not change. For instance, a core garment with a set-in sleeve would not change to a raglan sleeve. Instead, designers can often make minor pattern changes. This avoids the creation of a new style. Furthermore, although a core garment has the

Sienna
WT5705

Sienna
WT5704

Sienna
WT5703

Sienna
WT5602

Sienna
WT5603

Sienna
WT5604

Figure 11.11 Creating variations in a core garment. *(Illustration by M. Bontempo.)*

395

same stitch and seam construction, designers can add garment components, such as pockets or facings.

Some apparel industry segments will designate core fabrics. Carter's baby product line is primarily made of cotton, whereas OshKosh B'Gosh's 👕 playclothes category uses denim in different wash treatments (SEC February 28, 2007). Retailers will also develop an entire product line around a core fabrication. For instance, organic cotton—grown without pesticides, herbicides, or synthetic fertilizers—is the main fabrication in Wal-Mart's George Baby Organic line 👕 (Gunther 2006; Wal-Mart n.d.)

Important core garment style features, include the following:

- Core garments have the same construction and use the same major pattern pieces.
- Designers use core garments in multiple seasonal themes and deliveries.
- Companies have core garments year-round in their product line or have core garments for the same season each year (e.g., every spring).
- Design directors may opt to use a core design in multiple product lines (men's and women's) or specifically for one SBU.
- Core garments can be styled in different fabrics, colors, and embellishments.

ACTIVITY 11.6 *Illustrating a Core Garment*

- A designer creates a core garment to wear with other styles in a product line. It can be a coordinate, a separate, or a set.
- Find and scan a nine-head croquis from an illustration book. Save as a .jpg file.
- Start a new drawing using a computer graphics program. (The following instructions use Adobe Illustrator commands.)
- Place the croquis into the computer graphics program. Click on "Layer" and rename the layer as "Croquis." Lock the layer.
- Create two new layers. Title one "Drawing" and the other "Details." Lock the detail layer.
- Use the Pen tool to draw a garment. Some important drawing points are as follows:
 - Draw separate primary garment shapes using the Pen tool (e.g., draw the bodice, each sleeve, and each collar piece separately). You can draw half the garment shape and duplicate it to the other side. To do so, select a shape (e.g., one sleeve). Go to the Object menu, select "Transform – Reflect," and click on "Copy" to copy this shape to another side of your garment (e.g., one sleeve to two sleeves).
 - To curve a line, click at the start, click and hold down the left mouse button at the end of a line, and move your mouse to the left or right (you will see the line shaping on the screen).
 - Close each garment shape. Do not draw an entire outfit with separate lines. Make sure the lines connect. If you stop and start drawing lines, a small diagonal line shows up when you move the mouse to connect at an existing point using the Pen tool.
 - Fill a shape with any color from the Swatch menu to check to see that a shape is closed. If you have not drawn a closed geometric shape, the color will "leak," and you will see odd geometric, colored shapes in your garment.

- Once you have completed the outside silhouette, lock the drawing layer. Unlock the detail layer, and draw details such as stitching or trim. Drawing all stitching, embroidery design, and trim on a detail layer allows you to keep complete geometric shapes and to fill the silhouette with a pattern or color.
- To draw stitching, draw a solid line using the Pen tool. Select the line, and in the Stroke menu, select dashed line. Type in a low number (e.g., 3) to create a dashed line.
- Save your drawing for Company Project 10. Print your line drawing.

Carryover Garments

A carryover garment is easily confused with a core garment. A **carryover** is a successful fabric, color, or garment style previously produced and sold by an apparel manufacturer (Regan 1997, 155). The designer modifies garment components and fabrics to correspond to a new seasonal line and fashion direction. Carryover garments differ from core in that it is a successful selling style from the previous season. Merchandisers identify carryover garments according to their retail customer objectives, consumer preferences, and reorderable strategy (183). A manufacturer can decide to drop a carryover at any time. A core garment is in multiple product lines for multiple seasons or years. Company executives often have guidelines regarding carryover garments. For instance, Straight Down Clothing Co.⬚, which is a small golf-lifestyle apparel manufacturer, targets consumers who are upper income, ages 30 to 65, and who belong to premium golf resorts or who travel and pay a higher-end daily fee. Straight Down's owner, Mike Rowley, discussed his carryover strategy as follows:*

> Our general rule is that an SKU is good for three to four seasons, and then it's dropped. Approximately 40% of our product line consists of carryover garments. It is important that we add new colors and drop bad colors because it is rare if our consumer preplans to purchase our garments. Our consumers buy on impulse when they are golfing at a certain resort or club. We carry over our fit each season: It is a fuller cut for our classic look and a European cut for our younger look. Our 45- to 50-year-old consumer likes short-sleeve lengths below the elbow because they like the elasticity for movement.

Carryover Garment Strategy

Working on carryover garments is an ego boost to designers because it means that a previously designed garment was a successful seller. The design director, merchandiser, and designer work together to specify carryover features.

Merchandisers and designers meet at informal meetings to create carryover ideas. Designers will revisit their design inspiration in which they have observed the market environment, direction, and demand prediction (Regan 1997, 188). Each season, the

*Reprinted by permission from Michael Rowley, owner, Straight Down Clothing Company, San Luis Obispo, CA; pers. comm., January 9, 2005.

fashion industry pushes select colors (Agins and Galloni 2005). Designers know that whenever trend forecasters push a particular color or silhouette, these features need to be part of their product line. Because carryover garment silhouettes remain the same, designers rely on new seasonal colors to update their styles. To **bring freshness** is a colloquial phrase that means designers update existing silhouettes by introducing new colors, fabrications, prints, trims, or embellishments. For instance, in our story Anne instructs Tamee to update the RDWT1001 top. Tamee looks at her sketches and ideas from shopping the Parisian women's clothing stores and decides to use colors from Impressionist paintings.

The next step is for merchandisers to conduct a classification analysis and review the previous season's best sellers, which was explained earlier in the chapter. The apparel company's SBU direction, budget, and margin requirements constrain which successful selling garments the SBU will carryover (Regan 1997, 188). Merchandisers use extensive reference information, reports, and their own observation to learn about which features to carryover. Some reference material that merchandisers use includes core and product line strategy, number of SKUs per classification, line size control, and sales history (188). Merchandisers will discuss selling and classification analysis report results, identify best-selling garment features, and suggest features and garments to carry forward from previous seasons (188).

Designing Carryover Garments

Designing carryover garments presents designers with a creative challenge, and the thinking process differs from creating core and new garments. Designers use previously created garment styles as a starting point rather than beginning from scratch (Eckert and Stacey 2003). Because a carryover is a strong-selling product, the design team will take risks on these garment styles. One approach is to use fashion-forward colors and fabric that the trend forecast services predict as "hot" trends. Another approach is for designers to make subtle design changes from past silhouettes, such as in proportion, garment components (e.g., collar), or embellishments (Agins and Galloni 2005). They generally use successful garment components from previous seasons in new combinations or by adding new style details.

Designers work closely with pattern makers to create carryover garments (Regan 1997, 245). Designers need to know pattern construction (U.S. Department of Labor 2006–2007) to update carryover garments to know what constitutes a "significant" pattern change. To qualify as a carryover, pattern makers must use the same primary pattern pieces, and they can only make minor changes. A carryover garment does not change major pattern pieces; however, it can include the addition or subtraction of trim, components, colors, and fabrications. For instance, a designer can add a pocket to a top, attach ruffles to an existing neckline or sleeve hem, or create an overlay, such as a faux shrug or a vest attached at existing shoulders and side seams.

Designers give a "work kit" to pattern makers that reference an existing garment style, minor pattern changes, and fabric changes. Pattern makers create a new pattern, proof it, and give it back to designers for review (Regan 1997, 245).This process may be challenging for pattern makers because a designer may want a new carryover prototype in a short time, such as two hours, so they can present the idea at a design review meeting.

ACTIVITY **11.7** *Illustrating a Carryover Garment*

The purpose of this activity is to understand what a designer can change in a carry-over style by illustrating a garment and making design changes.

- Draw a carryover silhouette for your product line using a computer graphics program. Follow the drawing instructions in Activity 11.6 to illustrate one carryover garment.
- Copy your illustration so you have three bodies.
- Keep one as the original carryover garment. Draw two carryover garments by modifying the design but still keeping the major pattern pieces the same. Be creative: you can change color and fabric, add garment components (e.g., patch pocket), embellish (e.g., trim, piping, ruffles), or add details (e.g., sash or belt).
- Print and give your illustration to a colleague to evaluate whether your styles will have only minor pattern changes. Save your illustration for Company Project 10.

New Garments: Directional and Fashion-Forward

Designers create new garments to add *spark* to the product line. One can define new product ideas as *innovation*. Drucker (2000) recommended that innovations need to be simple and focused, and aim for leadership from its conception. Effective innovations start small, and a company can measure its success by being ahead of competing companies. Rare Designs' idea of creating an employee badge holder is an example of an innovation that Tamee, the designer, could put on core, carryover, or fashion-forward garments. Apparel companies may come up with new designs on their own or as a response to retail customers' or manufacturer representatives' requests.

There are several similar terms designers use and interchange when referring to new garments. A **new body** is a new product that an apparel company has not previously made. A new body is generally a directional or fashion-forward garment. There is a fine line between these two terms, and companies sometimes use these terms interchangeably. A **directional** garment is one that follows the current market direction. A directional garment may or may not be a risk. A low-risk directional garment is a design modification of garments readily available in the market. Apparel companies need to carefully implement modification as a design strategy. Modification is successful, such as with Zara, when the design team continually modifies existing garments that are successful in-season, best-selling garments. Their design team can modify garments and have them in stores within two weeks (Ghemawat and Nueno 2003). Modification often works for an apparel company that wants to sell a product at a lower price point. It is harder to successfully implement when an apparel company creates products for the better, bridge, contemporary, or designer markets because these companies need to continually differentiate themselves from the competition (Yen and Farhoomand 2006).

A **fashion-forward** garment is a garment that the apparel manufacturer takes a risk on when offering it as a new product or fabrication (Figure 11.12). A company will market its fashion-forward products by using phrases such as *market responsive, trendy, contemporary,* or *fashionable*. It is important that designers are not afraid of failure (Inspiring Innovation 2002)

Fashion Forward vs. Classic Style

Figure 11.12 A comparison of one Rare Entities' fashion-forward styles versus a classic style. *(Illustration by A. Flanagan, N. Pagtakhan, and S. Lozano.)*

and that they add newness to a product line. A designer creates fashion-forward bodies through color, fabrication, prototype styling, or a combination of these elements. In some garment categories such as dresses, retail buyers generally prefer a new look every month. In this instance, according to designer Kimberly Quan, designers need to come up with new garment styles and use carryover styles only at the request of a retail buyer.

Management of New Garments

Some beginning designers choose to create a wide variety of new styles, hoping that one will be a hit. Successful apparel companies manage the creation of new designs closely. They know that they need to focus on implementing product line strategy and meeting retail customer needs. Successful designers work diligently to create cohesive, meaningful designs, such as Zara's design team, which has a 1 percent failure rate for new design introduction versus the industry average failure rate of 10 percent (Ghemawat and Nueno 2003).

Designing New Garments

Creating a new garment gives designers a creative challenge because these items consist of new designs, patterns, and technical specifications (Regan 1997, 165). Designers start a new body by referring to a design library (186). A **design library** is a notebook or electronic catalog of company styles, fabrics, visual and inspirational artifacts, pictures, and samples or drawings of special operations (e.g., embroidery) (Eckert 1997; Regan 1997, 186) (Figure 11.13). Designers will go into a design-thinking mode in which they visualize what they saw during their search-for-design solutions phase. For

Figure 11.13 A design library is a notebook with garment styles, fabrics, and color ideas. *(Illustration by C. DeNino.)*

401

instance, Zara designers have trend spotters who seek the latest market direction at university campuses and clubs, in addition to reviewing industry publications, TV, the Web, and entertainment (Ghemawat and Nueno 2003). Designers generate many ideas, combining strategic advantage, product value, garment uniqueness, and the predicted fashion direction (Regan 1997, 186). They blend design inspiration with ideas from their design library.

Designers will sketch ideas and give them to a CAD artist (Regan 1997, 186). Some designers will simultaneously work on multiple ideas while others work on one product in a logical consistent manner (von der Weth 1999). CAD artists will either scan the designer's sketches into a digital format or create a computer drawing from scratch using the illustration as a reference (Laseau 2004). CAD artists fill the bodies with a variety of colors and prints.

Creating ideas for new bodies requires designers and CAD artists to frequently communicate. Some apparel firms will place designers and CAD artists in close physical proximity to enhance communication. However, with Web-based design tools, these two individuals in different locales can communicate electronically (Yen and Farhoomand 2006).

Designers will evaluate the design concepts and make revisions (Regan 1997, 194). One can visualize this decision process by envisioning a designer playing with paper doll garments. Designers will pick up an illustrated garment body, evaluate the silhouette, color, fabric, and trim, and decide whether to keep or change it. Part of their decision is judging whether their consumers will perceive value and think it is unique. Designers will spend many hours on and off the job, contemplating garment bodies and making subsequent revisions. They know it is important to correctly design garments because part of their annual performance review is based on whether their products sell. If the garment body passes this "mental test," designers will then calculate a first cost and submit it to the pattern maker to create a prototype (194).

Important new garment style points are as follows:

- Fashion-forward is a risk in which a designer creates an original concept. Inspiration often comes from predicted market direction for new colors, fabrications, prototype styling, or a combination of these elements.
- Fashion-forward can be an innovation in which a designer meets target consumers' needs by creating a functional design element into a design.
- There is a distinction between modifying existing garments and creating new graments in the ready-to-wear and fashion-forward markets.
- Designers should not fear failure.

ACTIVITY **11.8** *Illustrating a New Garment*

The purpose of this activity is to create a new innovative product. An innovative product can be a functional detail, such as Rare Designs' employee badge holder, or a design concept that meets an unmet consumer need.

- Manually sketch or create ideas for a new garment.
- Start a new drawing using a computer graphics program.

- Follow the drawing instructions in Activity 11.6 to illustrate one directional or fashion-forward garment body.
- Save and print your line drawing for Company Project 10.
- Write how your illustrated garment is a directional or fashion-forward garment.

Reorderable Garments

Thus far, we have discussed an apparel manufacturer or private-label retailer's viewpoint on illustrating core, carryover, and new styles. A **reorderable** is an existing core or carryover garment that is available from a season's opening delivery through the end of the season (Figure 11.14). Designing reorderable garments is a business decision rather than a creative decision. A reorderable is always associated with a garment style in set fabrications and colors. A reorderable garment is one that a company has previously produced and it can be a basic or highly-constructed garment. To understand the reorderable concept, we start with the decision process, merchandise planning, retail store requirements, and creating deliveries.

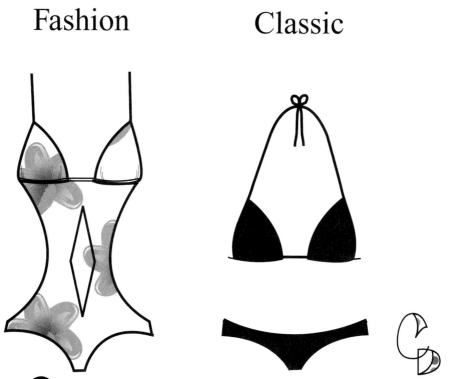

Fashion Classic

Figure 11.14 A reorderable style can be a fashion garment or a classic style. *(Illustrated by C. DeNino and K. Hilton.)*

Reorderable Decision Process

Designing reorderable garments begins with the vice president of product development, merchandisers, and retail customers who develop a reorderable style plan. Retail buyers and merchandisers negotiate an initial order and multiple delivery strategy (SEC February 28, 2007). A reorderable garment accommodates customer selling requirements. A reorderable is often retail-customer driven and the customers are involved in the decision process. This customer-driven process begins by a retail buyer stating to the account representative or merchandiser, "I want X number of reorderable styles" or "I want these SKUs to be reorderable."

Reorderable styles require the merchandiser to create a model stock. To do so, merchandisers analyze reports such as sell in, sell through, current season sales data, and quick inventory replenishment data. The goal is to determine a reorderable selling strategy for prior best-selling styles (Regan 1997, 184). Merchandisers need a model stock, which they get from the operations department, to create a reorderable plan. Apparel operations associates track units produced versus the units sold to create a model stock. A **model stock** is the planned combination of sizes, colors, and styles (Glock and Kunz 2005). However, an apparel company's model stock and retail units sold may be inconsistent. The apparel company may replenish reorderable merchandise based on this model stock rather than the sizes a retail customer sold. Retailers and apparel manufacturing partners need to share the same data to be accurate, efficient, and cost effective (Yen and Farhoomand 2006).

Supply Chain Requirements

Some retail customers that have an automatic replenishment inventory system (Figure 11.15) will generate a reorder based on styles sold rather than a model stock. The order replenishment process is a complex infrastructure that involves computer systems and communication between multiple retail customers and manufacturers. Each time a sales clerk rings up a certain SKU, the retailer's computer system tracks styles and colors sold (Friedman 2005). Automatic reordering of merchandise requires companies to manipulate a large amount of data (Yen and Farhoomand 2006). Automatic replenishment inventory systems control the reorder; that is, when the retail customer sells a certain number of each item, there is an automatic reorder to the vendor (Kunz 2005).

Automatic reorders are advantageous for apparel manufacturers and retail customers. For instance, Carter's Inc. uses an automatic reorder plan for its core apparel garments. This vendor-managed program allows them to plan fabric sourcing and garment production. Their key retail customers, including Target and Macy's Inc. benefit by having continual in-stock merchandise. Automatic reorders improve product sales and profitability (SEC February 2007). Gap Inc. finds automatic reorder program advantageous because it does not need to carry a large in-store inventory. Its system checks and restocks basic clothing styles on a daily basis. This requires apparel manufacturers that produce Gap's styles to have systems in place to quickly restock merchandise (Porter 1996).

Many large retailers insist that their vendors ship the right merchandise mix, in the right quantities, at designated times (Coughlan 2004). Some retailers, such as

Figure 11.15 A retailer's computer system often places an automatic reorder when a salesperson rings up a reorderable sale. *(Illustration by Christina DeNino and E. Perales.)*

Wal-Mart, require their vendors to manage their own inventory and physical space, which can be difficult for small vendors (Coughlan, 2004; Friedman 2005). Retailers that require vendor management require a supplier to write its own orders or have an automatic replenishment system. One advantage of a vendor-managed department is that the manufacturer has quick sell-through information (Friedman 2005), and these retailers will share their daily sales information with their manufacturers. Apparel manufacturers value these retail-selling reports because it allows them to better manage inventory and deliver product more frequently (Yen and Farhoomand 2006). According to Kathy Van Ness, former executive vice president at Warnaco Swimwear Inc., apparel manufacturers must respond quickly to fast-selling styles because a company that has styles that sell faster than anticipated must have production and distribution systems in place to submit reorders.

Reorderable Delivery Strategies and Garment Design

The simplest multiple delivery strategy is an automatic reorder of the same styles, fabrics, colors, and sizes. The retail buyer purchases each garment style in an assortment of colors and sizes. When the garment style reaches a predetermined inventory level, the automatic replenishment system generates a purchase order to restock needed colors and/or sizes. In this instance, reorderable design is not different than creating core or carryover garments.

Designing Multiple Delivery Garments

A second reorderable strategy is the retail customer orders multiple garment style deliveries. The manufacturer determines the multiple delivery seasonal colors, fabrics, and style variations. For instance, designers create two separate styles from one style by slightly varying the design. There can be additional sewing operations such as one garment style with a jewel neckline and a second style with a flat collar trim. This type of reorderable strategy can benefit manufacturers because **operations managers** can place large production orders and control inventory.

Each season, the merchandiser designates carryover garments. Because designers previously created styles that will be reorderable, the design manager expects them to quickly churn out ideas. Designers act quickly, instructing CAD artists to update garments. Many designers will spread a model with this reorderable strategy. **Spread a model** is a colloquial phrase that means the designer offers the same pattern in different colors, fabrications, or embellishments for set deliveries. Figure 11.16 shows a reorderable style with two deliveries. This reorderable model does not have a pattern change to the bikini body, but it does have a new print, the addition of ties, and change to the strap trim. If the reorderable has a fabrication and/or trim change, then the company designates a new SKU. (It helps prevent inventory confusion!) In Figure 11.16, retail customers will first receive style WS 1003. The automatic reorder will be for WS 1004 at the designated manufacturer's delivery date. When the retail customer receives the reorder merchandise, it replaces the first delivery. The retail buyer and merchandiser negotiate whether to put leftover stock from the first delivery on clearance or send it back to the manufacturer.

Reorderable Delivery with Style Changes

A third multiple delivery strategy is the retail customer orders the same garment model, but its colors and fabrics change. This reorderable strategy is common for private-label merchandise in which retail buyers designate the flow of merchandise. This reorderable strategy benefits the retail customer because it brings freshness to the selling floor or creates a flow of merchandise. **Flow of merchandise** is a colloquial phrase that means the designer creates product groups with different delivery dates. A product group is a coordinated theme to put on a fixture. Designers have control of how to put together the groups.

Some retailers, such as European retailer Marks & Spencer 👕, give their suppliers a seasonal color palette for apparel manufacturers to create their product groups (Eckert

Sour Apple Swim

WS1003 WS1004

Figure ⬤11.16 A reorderable style can be replaced in a new delivery within a season. It has a different SKU. *(Illustration by A. Flanagan and K. Bathalter.)*

and Stacey 2003). Designers will use the retailer's color palette to create a flow of merchandise. They will use imagination to create product groups, and they will visualize how to present garments on store fixtures. To flow merchandise deliveries, the reorderable garments need to blend from one theme to the next because garments may still be left on the retail sales rack from the first delivery. Here we use a hypothetical company called Intrigue Designs, and Jazzy Swing is its product line (color plate 13). Intrigue Designs' first reorderable delivery is Bubbles & Jazz, and its second is Moonlight Serenade. The designer used turquoise and violet colors to flow delivery 1 into delivery 2.

Important points when planning reorderable garments are that they

- Are from a core or carryover garment style previously produced by a manufacturer.
- Use the same construction and the same pattern.
- Use the same or similar fiber content and fabrications because the pattern maker uses the same pattern block specifications.
- Use different embellishments.
- Involve different deliveries, which are often dictated by the retail customer.
- Can be a different theme for each delivery.

ACTIVITY 11.9 *Illustrating a Reorderable Garment*

- Use a computer graphics program for this activity.
- Open your drawing from Activity 11.6 (core garment illustration), and save the drawing as "Reorderable."
- Open your drawing from Activity 8.3 (color stories). Resize the drawing window so it fills half of your computer screen, enabling you to see both the color story drawing and the core garment illustration.
- Select your reorderable garment silhouette. Copy the silhouette five times so you have six garments total.
- Select the color story window, and with the Select arrow, select one color box (the fill icon should change color).
- Click one of your garments with the Select tool. Click on the Eyedropper tool and then hold down the control key (CTRL on keyboard). Drag the eyedropper from your reorderable drawing to the color story drawing. The color of your garment should change to the fill from the color story illustration.
- Repeat so that you fill the garments with colors so three garments create one delivery and the other three create a second delivery.
- Write how your two deliveries flow and how these garments could be sold on the same retail fixture.

Design Review Meetings

It is time to pull the product line together. Refer back to the time-and-action calendar. Design review meetings take four weeks, because the design team stops and starts as they receive fabric samples, line art, and developed color submits. We return to the design room to visualize how the design team merchandises the product line. The design team clips line art, cuttings, fabric paintings, dye swatches, and embellishments on the wall grid (Figure 11.17). These visual samples allow design team associates to evaluate products with the designated theme. The design team's primary goal is to ensure that the design team has the correct strategy and to evaluate whether items in the product line are salable.

The design team schedules design review meetings as a time-and-action calendar event. These meetings are informal. The design team treats design review meetings as intermittent due dates so that they can meet the final seasonal product line deadline. At design review meetings, designers show core, carryover, and fashion-forward illustrations to other team members. They discuss concepts, make revisions, and eliminate unworkable designs. Some apparel company presidents will participate in design review meetings, often acting as the watchdog to ensure that the design team maintains its core garments. For instance, Patagonia's president will step in and correct a design team's products if he feels they are getting away from core garments, are too numbers driven, or are influenced by too much fashion (Reinhardt, Casadesus-Masanell, and Freier 2004).

The design team is not continually in review meetings; rather they leave samples on the wall grid, and designers work individually to develop or revise creative concepts. To work through a design problem, designers will solicit advice from design directors, merchandisers, or anyone that can answer questions. They may stop an employee in the hallway or ask the

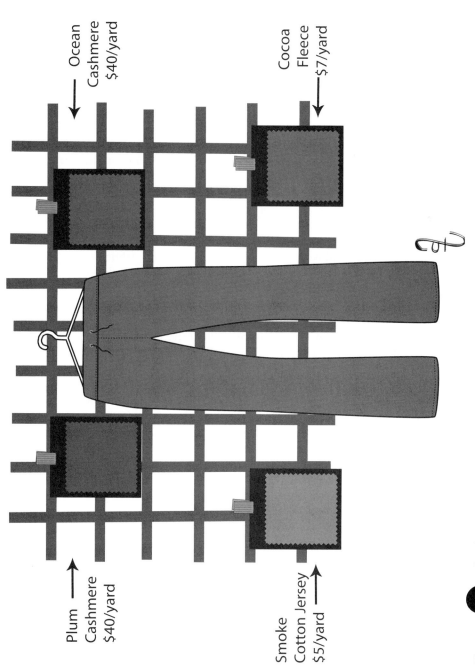

Ocean
Cashmere
$40/yard

Cocoa
Fleece
$7/yard

Plum
Cashmere
$40/yard

Smoke
Cotton Jersey
$5/yard

Figure 11.17 The design team evaluates garment bodies to determine salability and volume potential. *(Illustrated by A. Flanagah)*

company president to review design ideas. During this time, the design director will also come unannounced into the design workroom to ask designers to show them line art or filled bodies. Casual interaction, visibility and accessibility, are often more effective than having preset scheduled weekly meetings (Goodnight 2005).

How the Design Team Evaluates

The purpose of design review is for the design team to decide on the optimum solutions for the seasonal product line. This review consists of identifying the best styles, identifying questionable bodies, and selecting final fabrics (Regan 1997, 195). The design team evaluates garment bodies in the context of separates, coordinates, or sets. Some garment designs can come together easily, whereas others need a lot of work. Designers may work on a design concept for a week and then end up tossing it because the concept does not come together or work in the product line.

The design team evaluates design concepts by filling the garment bodies with colors, prints, and fabrications (Regan 1997, 194).

Designers evaluate product aesthetics for the desired use of design elements and principles. To do so, they need fabric and color submits from textile vendors. Web-based design tools allow textile vendors and the design team to collaborate more on decisions (Yen and Farhoomand 2006). Textile vendors will often send electronic files to their apparel customers. CAD artists can fill bodies, and designers can evaluate fabric designs. Designers evaluate fabrics based on design elements and principle attributes such as correct spacing, mood, and accurate coloration. The design team often makes fuzzy remarks such as "That design is so cute" or "It needs to flow more." Upon evaluation, designers and CAD artists often request their textile vendors to adjust fabrication and print designs. If a company develops prints, they will not approve painting from the textile vendor until the team approves its aesthetics and cost structure. They will formulate product groups, edit line art concepts, and decide on pattern and color combinations.

Merchandisers look at garment bodies, colors, and fabrics from the context of salability and to determine volume potential (Regan 1997, 190). If merchandisers identify a successful selling fabric from a previous season, they will ask designers to reuse or create a slight fabrication variation. This can be a risk because there is no guarantee that a previously successful fabric design will be popular again. Merchandisers critically evaluate questionable garment bodies (196) and he or she might surprise a designer with a comment such as "We have one model up there that is doable. I want to kill the rest." Design directors will then direct designers to change the questionable styles, eliminate them, or keep them as is (196). The designer will change the body by using different prints, color blocking, pleated fabrics, or embellishments.

Some designers have to work within design constraints when they evaluate garment bodies. For instance, children's clothing often uses licensed designs, such as Mickey Mouse or content from the latest movie releases. These designers create ideas using the licensed characters, but they will abandon some designs if they do not translate into satisfactory designs (Eckert and Stacey 2003). Another constraint is to clearly delineate among differing retail customers. Retail customers desire exclusive private label or branded merchandise assortments from apparel manufacturing partners (SEC February 26, 2007) so the design team will discuss seasonal themes in the context of designing for each key retail customer account.

Design Review Approval

Design approval means the design team approves fabrics and colors. This approval becomes the "communication of solution," which is a "go-ahead" to textile vendors that they can print or dye the first production run. Once approved, designers will request fabric so they can sew samples. At this point, they will sign a contract with the textile manufacturer representative (Regan 1997, 214). The textile vendor then produces sample fabric that the apparel company uses to makes its sample garments (223). Design review approval may require the company's quality assurance associates to evaluate piece good quality (202). The reason for evaluating quality at this point is that developed fabrics and colors are in multiple product lines and they require a significant financial investment. Design directors are meticulous about making fabric decisions. A change in core fabrics often requires an investment in textile product testing, consumer wear tests, and focus group evaluation. For instance, if a company states "satisfaction guaranteed" on products, this often means that consumers can return the product to the retail store, which in turn can send it back to the manufacturer without prior authorization. If a company attests to high quality standards, then any new fabric or developed color must pass textile quality assurance tests. Design directors will submit samples to the quality assurance supervisor to test fabrics in-house, by textile vendors, or by independent textile laboratories for its apparel quality standards (e.g., dimensional stability) (257).

Merchandisers may show design concepts to retail customers to get their reaction (Regan 1997, 196). Barneys New York 🏠, for example, has exclusivity arrangements with both established and emerging designers (SEC February 26, 2007), which means the design team needs to get approval from this retail customer before final approval.

Assignment of SKUs

Design directors determine, in line planning, the number of SKUs in each product group and theme name. Designers translate the number of SKUs into actual designs. Once the designers evaluate garment bodies and decide which ones they will use in the product line, they label approved garment bodies with a style name, SKU, and color. These garment bodies may go through further revisions, but the design team has selected a primary silhouette. At this point, designers clip line art to the wall grid and the merchandisers assign SKUs, which are alphanumeric characters that designate the garment style. If consumers look closely on a garment hand tag, they may find the manufacturer's SKU.

A design is accountable once the design team assigns a style number (Eckert 1997). From this point forward, product development associates commonly refer to a garment style by its SKU. At the design review, the design director and merchandisers will designate which SKUs will be reorderable styles. Each apparel company has their own SKU system. Each distinct style has a separate SKU. According to Will Duncan of TC2, a common SKU designation approach is to use an alphanumeric abbreviation of a classification, followed by a style number. An SKU can have intelligence in its structure; for instance, it is a category, product line, style, color, and fabric number. As an example to illustrate this concept, an SKU such as REWT130410 could represent Rare Entities' product line—Women's Tops category, numeric style 130 for quarter 4, in color 10. Some manufacturers

separate colors and fabrics from the SKU designation. This company's SKU is by style, with color and fabric listed separately. The manufacturer lists the style—for instance, blouse REWT130—and its availability in crème, moss, and peach.

Computer planning software has influenced how apparel manufacturers create SKUs. Henry Cherner, a principal and partner of Apparel Information Management Systems (AIMS), explained:*

> Traditionally, apparel manufacturers created styles for each season. Every season, the merchandisers created new SKUs. Now, apparel manufacturers need to adjust their SKUs to match whatever computer program they use. I suggest to manufacturers that they create season Y, which means year-round. They should then subclassify each by product grouping and color. A sales rep may write an order that has men's, women's, and children's on the same order. To match the computer system, your classifications would be men's, women's, and children's. Then, you can subclassify by style, color, and/or delivery (e.g., style YWT12301 for 9/13 delivery). Y means year-round, WT means women's tops, 123 is the style. Colors—for instance, pink—could be a number or abbreviated. All the colors and the styles are in the computer system, but a designer chooses which seasonal colors and styles they want; for instance, pink would not be in your fourth quarter (i.e., fall). A manufacturer can run their report by women's tops (WT), color (e.g., 01/pnk), or delivery date.

ACTIVITY 11.10 *Assigning Style Names and SKUs*

This assignment identifies SKUs for your product line and color stories.

- Create a style name (e.g., Jane).
- Identify your company with one or two initials (e.g., RD for Rare Designs).
- Identify your product category with two initials (e.g., WS for women's swimsuits).
- Create a style number (e.g., 1001).
- Identify what quarter you will sell this garment. For simplicity, designate 1 for Resort/Winter, 2 for Spring, 3 for Summer, 4 for Fall, or Y for year-round.
- Write color names or designate numbers for each color you will be using (e.g., Whisper).

New Product Lines

In addition to existing product lines, apparel manufacturers and private-label retailers will add new product lines. New product lines include the expansion of an apparel company's existing portfolio of brands or creation of new products for a specific customer. The design team typically includes the vice president of product development and division engineers in the creation of new product lines (Regan 1997, 183).

*Reprinted by permission from Henry Cherner, vice president, AIMS, Los Angeles, CA; pers. comm., April 27, 2006.

Expansion of a Company's Brand Portfolio

A **specialty product** is a new product category, often involving the creation of a specific product for a customer. A new brand or specialty product category adds growth to a company. It may first start as a subdivision of an existing product line, and then once established, it becomes its own SBU. An example is the expansion of American Apparel into Classic Baby and For the Kids. According to Sam Lim, co-owner of American Apparel, the product line began with one senior partner's idea to increase fabric efficiency. He decided to create a baby apparel line, called Classic Baby, because its small pattern pieces the company could use excess fabric generated from cutting the other product lines. Classic Baby garments began with re-created styles from the established men's and women's Classic Styles product line. This expanded into the product line, For the Kids, for which the Kid's merchandiser creates new styles each season. Some garment bodies include one-piece, gowns, pants, and hoodies for newborns, infants, toddlers, and youth (American Apparel n.d.).

New Products for a Customer Product Strategy

Some apparel manufacturers, especially in the uniform industry, are heavily reliant on the continual development of new product lines. Creating a specific product line for customers differs from designing a seasonal product line; however, the design team conducts many of the activities explained in the above sections.

Apparel uniform design is a viable industry segment. Apparel uniforms are a part of corporate brand identity for restaurants, airlines, law enforcement, retail stores, transportation services, and the medical field. Uniform design commonly uses a **customer product strategy** in which products are designed specifically for customers. Many companies clearly market their name through employee uniforms, and executives feel it is one way to enhance a company's image and reputation. For instance, in 2007 Wal-Mart changed employees wearing a vest with a "How may I help you?" on the back to a navy blue polo shirt with the Wal-Mart logo worn with khaki-colored chinos. Wal-Mart executives noted that focus groups felt the uniform change made employees seem more knowledgeable and helpful (McGinn 2007). Many companies, such as Air France, feel that distinctive fashionable clothing is an important attribute of its company's brand (Arnoult 2005).

Design Process as a Guide for a Uniform Program

If the originating company selects an apparel manufacturer to respond to an RFP, the apparel manufacturer treats it as a project. This comprehensive project uses design process phases, including goal analysis, problem analysis, search for design solutions, decision making, and verification. Aaron Ledet, in an interview with the author, explained the uniform program used by VF Imagewear Inc.*

Goal Analysis During goal analysis, a customer initiates an RFP by sending it to multiple apparel manufacturers. Customers will submit RFPs when they want better service

*Much of the content in this section was adapted by permission from an interview with Aaron Ledet, director of engineering, VF Imagewear Inc., Nashville, TN; pers. comm., March 16, 2006.

or have a new marketing program. Apparel manufacturers that service these companies match their core strategies with their customers. For instance, VF Imagewear Inc. 👕 is one apparel manufacturer that develops apparel uniforms for specific customers. VF Imagewear's core strategy is to "design a comprehensive uniform program that helps strengthen your organization" (VF Imagewear Inc. n.d.).

According to Aaron Ledet, a company that wants employee uniforms starts the process by sending out a request for proposal. A **request for proposal (RFP)** is a written request that a company sends to multiple vendors inviting them to submit a bid for services. Multiple competing vendors respond to an RFP by detailing information on their technical capabilities, products, and services, as well as providing estimated completion time and budgetary information.

Problem Analysis The apparel manufacturer representative establishes uniform requirements during the problem analysis phase. VF Imagewear Inc.'s potential customer provides its marketing plan, logo design, colors, and marketing strategy. The product development team will then evaluate the customer's uniform requirements. If the team needs clarification, the manufacturer representative is the liaison that contacts the potential customer. Some companies have strict uniform color, fit, fabrication, and performance requirements.

The product development team will submit an initial RFP response to the customer. The team works on various RFP parts, depending on each group's area of expertise. The design team discusses questions such as potential volume, current suppliers, customer location, delivery of the product, and pricing targets. Merchandising has direct contact with the customer. The marketing department will submit a project definition and sales strategy.

Search for Design Solutions Designers search for design solutions by having multiple product strategy meetings. They then illustrate multiple uniform designs and create prototypes that directly address RFP requirements. A company such as Air France has used famous couture designers, such as Dior and Balenciaga, to design its uniforms (Arnoult 2005). Aaron Ledet noted that merchandisers create fabric swatches and a line plan for each uniform style. Once all RFPs are sent in, the customer will evaluate the submissions. Manufacturers that did not meet their requirements will be eliminated, and the competition will be narrowed down to two to five candidates.

Once the customer has selected its apparel-manufacturing supplier, the design team repeats the problem analysis and search-for-design solutions phases. For the second RFP round, the customer wants detailed specifications, prototypes, and pricing. The detailed specifications include fit, fabric, and performance, which are the most important evaluation criteria. Another consideration can be a flight attendant's role. Since September 11, 2001, security issues and the need to project authority to keep people under control are important criteria for uniform design (Arnoult 2005). The product development team will go through each uniform design and determine where to manufacture it. They will detail construction, fabric, and production. There may be a quick turnaround; the customer may want details within 24 hours to 4–6 days. Customers will often award an RFP to the manufacturer that offers the best customer service and pricing. According to Aaron Ledet, an RFP can be challenging because apparel manufacturers often work with marketing associates that do not know textiles and garment construction.

Verification This verification stage demonstrates that the apparel manufacturer can implement its uniform program. During the verification stage, the design team develops a certification sample. The apparel manufacturer and customer will approve the garment design. During certification, it is common for the customer to conduct field-wear tests (Wilson 2006). Employees will wear test a basic wardrobe consisting of a jacket, pants, or skirt with matching blouses or shirts and outerwear (Arnoult 2005). The design team will revise prototypes until the customer accepts the product.

Part of the approval stage is for the customer to complete a financial analysis (Wilson 2006) because some companies give their employees an allowance to purchase its clothing. When the customer approves the certification sample, the apparel manufacturer develops its maintenance program. Customer service attributes, such as a Web site for ordering uniforms, are an important part of a maintenance program. Aaron Ledet explained:*

> In a uniform program, it is important to thoroughly understand not only what the customer wants but also what it needs. For instance, for flight attendants uniform durability is a primary concern, whereas protection from fire is secondary. Another customer may be most concerned with aesthetics and say they want a 100% wool flight attendant uniform. Aesthetically, the 100% wool will look great, but we know from our experience that with the amount of rubbing up next to airline seats, the fabric would wear out. It is up to us to propose and convince them to use a stronger fiber combination. In this case, 55% polyester and 45% wool would meet flight attendants' needs.

ACTIVITY 11.11 *Critical Thinking*

In the previous quote, the director of engineering for VF Imagewear Inc. discusses educating customers on product attributes (e.g., fiber content). Think about your company project and how you could adapt your garments for a uniform.

● Select and print one illustration from Activity 11.6, 11.7, or 11.8 that you could adapt to create corporate brand identity for a restaurant, airline, law enforcement agency, transportation services, or medical field.
● Describe the end use of your product and who will wear it.
● Describe your product's aesthetic requirements (e.g., style, color) and technical attributes (e.g., fiber content, construction).

Design and Innovation Best Practices

Some ways to develop or sustain design strategy and to encourage creativity are as follows:

● Design strategy means that a designer looks for opportunities that competitors have overlooked.
● Designers need to be flexible and respond quickly to competition and market changes.

*Reprinted by permission from Aaron Ledet, director of engineering, VF Imagewear Inc., Nashville, TN; pers. comm., March 16, 2006.

- Designer managers need to encourage new ideas and creative solutions to real problems.
- Managers need to encourage innovation every day and encourage employees to suggest ideas.
- Managers should roll up their sleeves and delve into value-added work.
- Managers can encourage output that is more creative by providing technology to the design team. Managers need to determine whether the technology saves enough employee time to warrant the investment.
- Managers that encourage a collaborative environment and hire people that are smart, verbal, and assertive will generate more creativity.
- Listen to customers. They will tell you why something does not work, how to be better, and how to improve product design.
- Maintain authenticity with your core consumer.
- Managers need to promote risk, bend the rules, make mistakes, and not fear failure (Florida and Goodnight 2005; Inspiring Innovation 2002; Nadel, 2004; Reinhardt et al. 2004; Porter 1996).

SUMMARY

Although the process can be challenging, companies need to develop a design strategy that creates a unique and valuable position. Successful companies create products that are innovative or have useful features and stand out among those in the marketplace. Merchandisers create a line plan in which they determine the quantities of prices, fabrications, and garment styles. A primary goal is for merchandisers to maintain the basic line. To do so, merchandisers identify best-selling fabrics, colors, and styles. Designers illustrate core, carryover, and fashion-forward styles. Both core and carryover garments are successful-selling styles, whereas a manufacturer takes a risk with new styles. Apparel companies desire to grow their business, and to do so, executives will create new product lines. Some companies, such as those that create uniforms, are continually involved in creating new products.

COMPANY PROJECT 10: CORE, CARRYOVER, AND NEW GARMENT ILLUSTRATIONS

Goal

The goal of this project is to create six garment bodies that correspond to the two theme boards you created in Company Project 7. You will use these six illustrations to create your storyboard and line sheets in Company Project 11 in Chapter 12.

Step 1—Preparation

- Open your core garment drawn in Activity 11.6. Start your computer graphics program again and open your color delivery file (Activity 8.3). (You should have two windows). Copy your color deliveries and paste them to your core garment drawing (Activity 11.6). Open Company Project 9 and copy the original fabric designs you created. Paste them to your core garment drawing. Save the illustration as "Core Garment 1."

- Open your carryover garment drawn in Activity 11.7. Start your computer graphics program again and open your color delivery file (Activity 8.3). (You should have two windows). Copy your color deliveries and paste them to your carryover garment drawing (Activity 11.7). Open Company Project 9 and copy the original fabric designs you created. Paste them to your carryover garment drawing (Activity 11.7). Save the illustration as "Carryover Garment 1".

- Open your new garment drawn in Activity 11.8. Start your computer graphics program again and open your color delivery file (Activity 8.3). (You should have two windows). Copy your color deliveries and paste them to your new garment drawing (Activity 11.8). Open Company Project 9 and copy the original fabric designs you created. Paste them to your new garment drawing (Activity 11.8). Save the illustration as "New Garment 1."

Create Designs

You will create six garments. Three garments correspond to theme one and three garments correspond to theme two that you created for Company Project 7. You will have two core garments, two carryover garments, and two new garments.

Theme 1 Core Garment

- Open "Core Garment 1." Put the colors and fabrics into your swatch menu by selecting one color or fabric at a time and dragging it to the swatch menu.
- Open one theme board from Company Project 7 (you made two).
- Refine your line drawing illustration so that the garment style lines complement your theme. Add details such as buttons or embellishments.
- Duplicate your line drawing four times. Fill your garment with different color combinations and/or fabric designs.
- You may need to create new fabric designs. Save your drawing for Company Project 11 in Chapter 12.

Carryover Garment

- Open "Carryover Garment 1." Put the colors and fabrics into your swatch menu by selecting one color or fabric at a time and dragging it to the swatch menu.
- Refine your line drawing illustration so that the garment style lines complement your theme. Add details such as buttons or embellishments.
- Duplicate your line drawing four times. Fill your garment with different color combinations and/or fabric designs.
- Save your drawing for Company Project 11.

New Garment

- Open "New Garment 1." Put the colors and fabrics into your swatch menu by selecting one color or fabric at a time and dragging it to the swatch menu.
- Refine your line drawing illustration so that the garment style lines complement your theme. Add details such as buttons or embellishments.

- Duplicate your line drawing four times. Fill your garment with different color combinations and/or fabric designs.
- Save your drawing for Company Project 11.

Theme 2 Core, Carryover, and New Garments

- Open your second theme board.
- Illustrate one more core garment by following instructions in Activity 11.6. The garment style lines should complement both theme one and theme two.
- Illustrate one more carryover garment by following instructions in Activity 11.7. The garment style lines should complement theme two.
- Illustrate one more new garment by following instructions in Activity 11.8. The garment style lines should complement theme two.

Design Review

Evaluate each garment design you created to see if it corresponds to the appropriate theme (theme one or theme two). If the design does not, revise it. Next, identify your design strategy. How does each garment design convey your design strategy? You now have six garment designs to put into your storyboard and line sheet (which will be Company Project 11).

PRODUCT DEVELOPMENT TEAM MEMBERS

CAD artist: An individual who illustrates a designer's creative ideas using a computer graphics program. In a small apparel firm, this is the designer's responsibility.

Operations manager: An individual who plans and determines production quantity and allocation of work. He or she is concerned with efficiency, process improvement, and quality assurance.

KEY TERMS

Booking: The dollar amount or quantities sold to a retail customer.

Bread and butter: A colloquial phrase meaning that a product is a solid and consistent seller.

Bring freshness: A colloquial phrase that means designers update existing silhouettes by introducing new colors, fabrications, prints, trims, or embellishments.

Carryover: A successful selling garment previously produced and sold by an apparel manufacturer.

Category plan: Quantities or percentage of core, reorderable, and fashion-forward garments.

Classification analysis: A quantitative evaluation of established SBU categories.

Coordinate: The use of the same color, print, or fabric in two or more garments.

Core business: How a company delivers its primary product.

Core garment: Style that is always in a company's product line, regardless of the seasonal theme variation.

Croquis: A basic fashion body that an artist uses as a foundation or layer in a computer graphics program.

Customer product strategy: A strategy in which products are designed specifically for customers.

Design library: A notebook or electronic catalog of previously used silhouettes, fabrics, and special operations (e.g., embroidery).

Design strategy: An executive direction to control and use resources to promote a clear fashion direction, a competitive advantage strategy, and customer and consumer value provisions.

Directional: A garment that follows the current market direction.

Fashion-forward: A garment with which the apparel manufacturer takes a risk to offer a new product or fabrication.

Fill bodies: A colloquial term that means designers illustrate a garment flat and evaluate the best aesthetic design by changing colors, prints, fabrications, and trims.

Flow of merchandise: A colloquial phrase that means the designer creates groups with different delivery dates.

Garment flat: A two-dimensional garment without a figure that shows trim, fabric, and color.

Line art: A drawn silhouette that is not filled with color. It can refer to a graphic illustration program drawing or a manual illustration.

Line plan: Identification of the seasonal line and finalization of fabric and garment parameters.

Merchandising the product line: The design team creates a product line structure, creates garment ideas, assigns SKU numbers, and creates storyboards.

Model or body: A colloquial term for an individual garment design and distinct silhouette.

Model stock: The planned combination of sizes, colors, and styles.

New body: A new product offering by a company that incorporates new colors, raw materials, and/or silhouette.

Parameters: Describes the number and type of fabric and garment styles in an SBU and their corresponding production information.

Price tier: An apparel manufacturer's or private-label retailer's retail price range when planning an SBU assortment. The merchandisers plan a specific percentage of the product line to be at lower and higher retail price points.

Product line structure: Identification of the seasonal line and finalization of fabric and garment parameters, carryover colors, and carryover garments, as well as the review of the sales history.

Reorderable: A core or carryover garment that is available from a season's opening delivery through the end of the season.

Request for proposal (RFP): A written request that a company sends to multiple vendors inviting them to submit a bid for services. Multiple competing vendors respond to an RFP by detailing information on their technical capabilities, products, and services, as well as providing estimated completion time and budgetary information.

Selling report: A quantitative analysis of an SBU's business history.

Separates: Garments that a merchandiser prices individually.

Set: A two-piece garment, priced together, or an accessory item that coordinates with a specific garment style.

SKU: An abbreviation for stock-keeping units. Alphanumeric characters that designate the garment style.

Specialty product: A new product category, often involving the creation of a specific product for a certain customer.

Spread a model: A colloquial phrase that means the designer offers the same pattern in different colors, fabrications, or embellishments for set deliveries.

WEB LINKS

Company	URL
7 For All Mankind, LLC	www.7forallmankind.com/
American Apparel	www.americanapparel.net/
Armani	www.armani.com/index.html
Barney's New York	www://barneys.com/b/;jsessionid=cafCqUqidx9augLowXBpr
Billabong	www.billabong.com
Burberry LLC	www.burberryusaonline. com/home/index.jsp
Carter's	www.carters.com/index.aspx
Chanel	www.chanel.com/index.php?zone_lang=USAEN& wt.mc_n=psearch
Gap	www.gapinc.com/public/index.shtml
Gucci	www.guccigroup.com
Hermēs	www.hermes.com/
Hurley	www.hurley.com/hurley/index.shtml
Jones Apparel Group	www.jny.com/
Levi Strauss & Company	www.levistrauss.com/
Louis Vuitton	www.louisvuitton.com
Marks and Spencer	www.marksandspencer.com/gp/note/n/42966030/202-8078068-6362257?ie=UTF8&mnSBrand=core
Nike	www.nike.com/nikebiz/nikebiz.jhtml
Ocean Pacific	www.op.com
OshKosh B'Gosh	www.oshkoshbgosh.com/
Prada	www.prada.com/
Quiksilver Inc.	www.quiksilver.com/index.aspx
Ralph Lauren	www.ralphlauren.com/home/index.jsp?direct
Straight Down Clothing Co.	www.straightdown.com/
The Talbots Inc.	www1.talbots.com/talbotsonline/index.aspx
TOMS Shoes for Tomorrow	www.tomsshoes.com/
VF Imagewear	www.vfsolutions.com/
Volcom	www.volcom.com
Wal-Mart-Organics	http://walmart.triaddigital.com/Walmart-Organics.aspx
Warnaco Swimwear Inc.	www.warnaco.com/index.cfm/category/2/brand/18/
Zara	www.zara.com/v07/index.html

REFERENCES

7 For All Mankind, LLC. n.d. "About us."

Agins, T., and A. Galloni. 2005. The new black is . . . black. *Wall Street Journal*, June 10, B1.

Amabile, T. M., C. N. Hadley, and S. J. Kramer. 2002. Creativity under the gun. *Harvard Business Review Online*. Reprint No. 1571 (August). Boston: Harvard Business School Publishing. WilsonWeb.

American Apparel. n.d. Wholesale styles guide. http://www.americanapparel.net/wholesaleresources/product_info.html.

Arnoult. 2005, June. Dressed for success, *Air Transport World*, 58-60. ProQuest.

Baldoni, J. 2003. The discipline of creativity. *Harvard Business Review Online*. Reprint No. C0303A (March). Boston: Harvard Business School Publishing. WilsonWeb.

Biggerstaff, S. 1999. Fly closure for garment. U.S. Patent 6,199,215 [electronic version], filed September 8, 1999.

Burberry Group, PLC. 2007. Results and presentations, reports, annual report, and accounts 2006/2007. http://www. burberryplc.com/brby/rp/reports/, filed June 12, 2007. SEC ARS filing [paper]. http://www.sec.gov/cgi-bin/browse-edgar?company=burberry&CIK=&filenum=&State=&SIC=&owner=include&action=getcompany.

Business Week. 2006, August 7. The 100 top brands scoreboard, 60–64.

Cottrill, K. 2006. Supply chain experts get their say on product design. *Harvard Business Review Supply Chain Strategy Online*. Reprint No. P0602A (February). Boston: Harvard Business School Publishing Corporation. WilsonWeb.

Coughlan 2004. Michaels craft stores: Integrated channel management and vender-retail relations. Kellogg School of Management. *Harvard Business Review* Reprint No. KEL036. Boston: Harvard Business Review Publishing. Wilson Web.

Drucker, P. F. 2000. The discipline of innovation. *Harvard Business Review Online*. Reprint No. R0208F (February). Boston: Harvard Business School Publishing. WilsonWeb.

Eckert, C. 1997. Design inspiration and design performance, in *Textiles and the information society*. Paper presented at the 78th world conference of the Textile Institute in association with the 5th Textile Symposium, Thessalonike, Greece, 369–87.

Eckert, C., and M. Stacey. 2003. Sources of inspiration in industrial practice: The case of knitwear design. *Journal of Design Research* 3 (1): 1–18. http://www.inderscience.com/browse/index.php?journalCODE=jdr.

Eisentraut, R., and J. Gunther. 1997. Individual styles of problem solving and their relation to representations in the design process. *Design Studies* 18:369–83.

Florida, R., and J. Goodnight. 2005. Managing for creativity. *Harvard Business Review* 83 (7), 124–31.

Fontes, S. 2004. Garment with improved fly closure. U.S. Patent 7,174,574 [electronic version], filed June 10, 2004.

Friedman, T. L. 2005. *The world is flat: A brief history of the twenty-first century*. New York: Farrar, Straus, and Giroux.

Galbraith, J., D. Downey, and A. Kates. 2002. *Designing dynamic organizations: A hands-on guide for leaders at all levels*. New York: AMACOM.

Ghemawat, P., and J. L. Nueno. 2003. Zara: Fast fashion. *Harvard Business Review*. Reprint No. 9-703-497 (April). Boston: Harvard Business School Publishing. WilsonWeb.

Glock, R., and R. Kunz. 2005. *Apparel manufacturing: Sewn product analysis*. 4th ed. Upper Saddle River, NJ: Prentice Hall.

Goodnight, J. 2005. The beauty of an open calendar: James Goodnight on meetings. *Harvard Business Review Online*. Reprint No. F0504L. Boston: Harvard Business School Publishing. WilsonWeb.

Gunther, M. 2006, August 7. The green machine. *Fortune* 154 (3): 42–57.

Harvard Business Essentials. 2006. Marketing strategy: How it fits with business strategy. In *Marketer's toolkit: The 10 strategies you need to succeed*. Boston: Harvard Business School Publishing. WilsonWeb.

Hoover's. 2006a. Ocean Pacific Apparel Corporation [ProQuest Hoover's company records].

Hoover's. 2006b. Billabong International Ltd. [ProQuest Hoover's company records].

Hoover's. 2007a. Quiksilver, Inc. [ProQuest Hoover's company records].

Hoover's. 2007b. Volcom, Inc. [ProQuest Hoover's company records].

Inditex 2005. Information for shareholders and investors: Corporate performance annual report 2005. http://www.inditex.com/en/shareholders_and_investors/investor_relations/annual_ reports.

Inspiring Innovation. 2002. *Harvard Business Review*. Reprint No. R0208B (August). Boston: Harvard Business School Publishing. WilsonWeb.

Keiser, S. J., and M. B. Gardner. 2003. *Beyond design: The synergy of apparel product development*. New York: Fairchild.

Kunz, G. I. 2005. *Merchandising: Theory, principles, and practice*. New York: Fairchild.

Laseau, P. 2004. *Graphic thinking for architects and designers*. New York: Wiley.

Lawson, B. 1990. *How designers think*. 2nd ed. London: Butterworth Architecture.

Lojacono, G., and G. Zaccai. 2004, Spring. The evolution of the design-inspired enterprise. *MIT Sloan Management Review Online*. Reprint No. 45313. Boston: Harvard Business School Publishing. WilsonWeb.

McGinn, D. 2007, June 25. Changing clothes. *Newsweek* [ProQuest ABI-Inform].

Moore, B. 2006, May 20. They're flipping for alpargatas. *Los Angeles Times*, E1, E20.

Mustafa, N. 2007, February 5. A shoe that fits so many souls. *Time*, C2.

Nadel, B. 2004, December 13. Turn your company into an idea factory. *Fortune* 150 (12): S1–8.

Porter, M. E. (1996). What is strategy? *Harvard Business Review*. Reprint No. 4134 (November–December), 61–78.

Ralph Lauren. n.d. History. http://about.ralphlauren.com/history/history.asp.

Rangan, V. K., and M. Bell. 2000. Talbots: A classic. *Harvard Business Review*, Teaching Note. Reprint No. 500082 (January 26). WilsonWeb.

Regan, C. 1997. A concurrent engineering framework for apparel manufacture. PhD diss., Virginia Polytechnic Institute and State University.

Reinhardt, F., R. Casadesus-Masanell, and D. Freier. 2004. Patagonia. *Harvard Business Review*. Reprint No. 703-035 (December 14). Boston: Harvard Business School Publishing.

Seward, N. J. 2005, July 15. Warnaco in the swim. *California Apparel News* 61 (30): 13.

Stipelman, S. 2005. *Illustrating fashion: Concept to creation*. 2nd ed. New York: Fairchild.

TOMS Shoes. n.d. *Our cause*. http://www.tomsshoes.com/ourcause.aspx.

U.S. Department of Labor 2006–2007. Fashion designers. *Occupational Outlook Handbook 2006–2007*. http://www.bls.gov/oco/ocos291.htm.

U.S. Securities and Exchange Commission. (SEC). 2006, February 28. *Form 10-K: Annual report ended December 31, 2005, Jones Apparel Group Inc*. Washington, DC: U.S. Government Printing Office. http://www.sec.gov/Archives/edgar/data/874016/000087401606000010/form10k_2005.htm.

U.S. Securities and Exchange Commission. 2007, April 10. *Form 10-K: Annual report ended February 3, 2007, The Talbots Inc*. Washington, DC: U.S. Government Printing Office. http://www.sec.gov/Archives/edgar/data/912263/000095013507002170/b64813tie10vk.htm.

U.S. Securities and Exchange Commission. 2007, February 28. *Form 10-K: Annual report ended December 30, 2006, Carter's Inc*. Washington, DC: U.S. Government Printing Office. http://www.sec.gov/Archives/edgar/data/1060822/000110465907014975/a07-5344_110k.htm.

U.S. Securities and Exchange Commission. 2007, January 11. *Form 10-K: Annual report for the fiscal year ended October 31 2006, Quiksilver Inc*. Washington, DC: U.S. Government Printing Office. http://www.sec.gov/Archives/edgar/data/805305/000089256907000018/a26370e10vk.htm.

U.S. Securities and Exchange Commission. 2007, February 26. *Form 10-K: Annual report for the fiscal year ended December 31, 2006, Jones Apparel Group Inc.* Washington, DC: U.S. Government Printing Office.

VF Imagewear Inc. n.d. Managed uniform programs. http://www.vfsolutions.com/pages/managed. htm.

von der Weth, R. 1999. Design instinct: The development of individual strategies. *Design Studies* 20 (5): 453–63. Science Direct.

Wal-Mart. n.d. Organics at Wal-Mart. http://walmart.triaddigital.com/Walmart-Organics.aspx.

Wilson, B. 2006, May 24. US Airways tragets mid-2007 to unveil new service uniforms. *Aviation Daily.* 7 ProQuest.

Yen, B, and A. Farhoomand. 2006. Polo Ralph Lauren & Luen Thai: Using collaborative supply chain integration in the apparel value chain. *Harvard Business Review Online.* Reprint No. HKU595. Boston: Harvard Business School Publishing. WilsonWeb.

Finalizing the Product Line: Design and Production Review

GETTING READY FOR THE SHOW

Sipping his morning coffee, Jason heads toward his cubicle at the rear of the work-room. He notices Tamee, hands on hips and tapping her feet as she hovers over the printer. "Faster! Faster! Oh come on, will ya?"

"Hey, Tam, what's wrong?" Jason asks.

"The printer jammed! My inspirations are finally coming together! I want to show my storyboard to Anne. And I want to show her NOW!" She grimaces at Jason as he opens up the printer.

"I found where the paper jammed. All fixed," he grinned.

Tamee continues talking as she dashes back to her computer to send another print file. "I'm excited about my product groups. I made sure the garments work on the retail fixtures, just like Kate said. I'm anxious to see if I did the deliveries right for Von Moritz's reorderable plan. The new terms are kind of confusing: *core, carryover, directional, fashion-forward*." She stops midsentence "Oh cool; this look s great! I'm going to show Anne." She dashes out of the room.

Jason chuckles to himself, shakes his head, and thinks "I'm sure glad I didn't bring Tamee any coffee this morning. She's so wound up." He sees Kate walking down the hallway. "Kate?"

Kate turns and walks into the design room.

"Yesterday you mentioned something about saving time if I create a product line template file. Can you help me set it up? I haven't created one before," Jason says as he sits down at his computer.

Kate walks over to Jason's computer and instructs him to open a new computer graphic file. "Bring the color story and fabrications you have already created into this drawing." She points at the screen and says, "Create swatches and then name them."

Jason picks up the color story, slowly saying, "So I copy and paste the color story and make swatches for Whisper, Clay, Bashful, Victoria, Sage, Slate, Stone, and one for kaleidoscope, our print." Pondering his own comment, he says, "Oh, I get it. Then I just copy and paste in these separate files, and the swatches are ready to use to fill the garment bodies. I was treating the drawing for each style individually; this will be faster! Thanks, Kate!"

Tamee walks back in and heads toward Jason and Kate. "Good news, bad news." Anne liked my storyboard, but she said that I did the deliveries wrong. Kate, can you help me?"

Kate smiles, walks over to the worktable, and writes "Beauté Delivery 1" and "Beauté Delivery 2" on two blank sheets and places them on the worktable. She

picks up Tamee's trouser and V-neck knit shell line art and says, "You build your product line around your core garments. These two SKUs are your core bodies. The yarn dye jersey knit for your shell was developed with Michael's help in China. Then you select an open-to-sell wool gabardine fabric for pants and jackets. The jersey and wool become your core fabrics. According to Ron, last year these garment styles sold best in the Northeast. It is still cold there in early spring, so you will want to use mid-weight gabardine wool. But for the South and West, you can offer the same style in a lightweight gabardine. The selling reports indicate that Whisper and Slate were your best-selling colors—so those will be your core colors." She places duplicate trouser and top-line art illustrations on each sheet. Kate explains, "The core garment styles go on both boards."

"So Jason will fill REWT1001 V-neck top and REWB2001 trousers with crème and slate only?" Tamee asks, cocking her head with an inquisitive expression.

Jason restates Tamee's question, "So, those are the only colors for the core styles?"

"No, the V-neck top and trousers are your core styles. Try each core style in each color story hue, and then evaluate whether they coordinate."

"But Victoria—our purple—and sage—our green—would look horrible in these trousers," Tamee grimaces.

"You can just use Victoria and sage in the V-neck top and not the pants."

"Oh, so I don't have to use every hue in my color story for core garments; I just start there. Then our consumer can do an all-crème outfit with Whisper top and trousers, or our Victoria V-neck and Whisper or Slate trousers. I like this; it's like being in a fitting room and trying on different outfits!" Tamee excitedly moves the garment flats around on the worktable.

Just then, Anne walks into the design room. "I've been talking with Von Moritz's new buyer. He said that with the retail takeover, all department store names will change to Von Moritz, and corporate is pushing fresh deliveries each month. We worked out our reorderable plan. For our first reorderable delivery, he wants two directional colors and three basic. For the second delivery, he wants one fashion-forward and three basic colors."

"So we offer every single garment style in every color?" Tamee asks wide-eyed.

"No, just the reorderables. She wants four reorderable styles: one top, skirt, pant, and jacket—one coordinate for each delivery."

Tamee clarifies, "So I need to design one jacket, top, and pant coordinate for Delivery 1, and then I can add the skirt for Delivery 2. Wait! How is that different from a core style? Aren't those styles on both boards?"

"A selected core style can be reorderable throughout an entire selling season. However, our retail buyer wants a flow of merchandise so that one delivery blends into the next. Some styles can carry over from one delivery to the next, whereas other styles are available for only one delivery. Every time we deliver, the merchandise needs to look fresh and new. Unsold inventory will be subject to markdown," Anne replies.

"So, I'm like a magician—I use some of the same styles, add some new, and some disappear. And I make the product line look different for each delivery." Tamee shakes her head and says, "Let me see if I have this straight. I design two core styles,

which are in Beauté Delivery 1 and 2 storyboards. We will carry over Stacey, my straight skirt, and Coco, my jacket, from our winter product line. I can put them in either Delivery 1 or 2. The reorderables are my choice, as long as I have four to make the buyer happy. Tamee crinkles her nose. "I think I am getting it. Now, the fashion-forward is on both storyboard deliveries."

"No!" Kate and Anne say in unison. Kate continues, "A fashion-forward is a risk, so we produce them in low quantities and different styles for each storyboard."

"So the fashion-forward vest that we talked about at our design meeting can be on Delivery 2, and it doesn't have to be on Delivery 1," Tamee says as she adjusts an oversized pumpkin sweater on her lean shoulders. She glances down at her new black high-heeled scrunch boots, wishing she had bought a second pair in brown, and thinks about what Kate and Anne have been saying.

"That's right," Kate smiles.

"Did you get all that, Jason?" Tamee asks. "You will be illustrating each story-board and line sheet."

Nodding to Tamee, he turns to Anne, "In the past, I filled all the bodies with color, overlapped the styles, and wrote each SKU and style name. I shrunk some of the garment bodies to make them fit on the page. Are we still doing it that way?"

Kate replies first, "You don't want to shrink your garment bodies because the retail buyer will get confused. They're accustomed to seeing garment flats on a nine-head croquis."

"But I don't think I can fit all the illustrations on the page," he retorts.

"Then you can fill one garment body with color and do a mini-color story right next to each garment. The retail buyer will understand that the style is available in each color square."

Ron pops his head in the door and says, "Kate and Anne, are you ready for our lunch meeting? We will be doing margin review."

"I can't wait to be an executive," Tamee says to Jason under her breath. "All I have for lunch is a cold peanut butter sandwich!"

"I'm not sure you'd want to do margin review," Jason replies, teasing Tamee. "That's where the execs stress over how little money they will make on your designs. I'll go get us some white chocolate macadamia nut cookies the next time I make my coffee run. It will help us absorb all the information on deliveries that Kate told us about."

The next day, Jason borrows Lauren's iPod and is humming along as he creates his storyboards and line sheets. "I like the mini-color stories next to each garment style; it has a cleaner look," he says, talking to himself. He frowns while staring at the product line sheet, and then picks up the phone. "Anne, I'm ready to do the product line sheet. I need the size scale, price, and delivery."

"I'll be right down. You can go ahead and start with a new drawing. Label the top of the drawing with 'Beauté' and its delivery date. I'll bring you the rest of the information in a minute."

"Nice outfit, and for me to notice, it has to really stand out!" Jason says to Anne as she walks into the design room wearing a new peat-colored deep V-neck sweater and matching dress pants. Her smokey quartz stone earrings jingle as she sits down next to Tamee.

Anne studies the cost sheets that she has in her hand. "At margin review we priced Jane, our V-neck shell, at a $21.50 wholesale price. We can suggest a retail of $44. For Von Moritz's Anniversary Sale, they will use a 33 percent markdown to sell it for $30.99." She quickly calculates and determines, "Good! That still gives us a 44 percent margin." She looks at the vest cost sheet. "Brooke, our vest, has only a 25 percent margin at full retail."

Tamee looks up from her storyboards. "I know the margin is low. The Impressionist print and ribbon fabrics were expensive."

"Maybe we can increase our wholesale price on Brynn, our trousers. We need to make a 35 percent average margin and anticipate that most garments will sell at a markdown or promotional price."

She points at Jason's computer monitor and says, "Designate core styles Jane and Brynn to be regular price. Our promotional styles will be Coco, the carryover jacket, and Stacey, its coordinate skirt. Brooke, our vest, will have to be full retail."

"Are the minimums the same as in the past?" Jason asks.

"Yes, minimum four with a size scale of 1:2:1. The retail buyer can buy this scale in our 2–14 size range," Anne says.

"On the product line sheet, I designated sizes 2 to 14 as 1:2:1. So when we go to the trade show in 2 weeks and a buyer wants to buy 4, 6, and 8, they buy one size 4, two size 6, and one size 8."

"That's right. Are you anxious to sell at your first trade show?"

"You bet!" Jason says enthusiastically.

Tamee brushes by Anne and Jason and says, "I will get the other first costs to you. Jaynie Lee just called, and I need to run to the pattern room to answer her questions."

She takes the elevator down one flight and enters a room filled with computers and a plotter. "Hi Jaynie Lee!" She notices the clean, organized computer workspace. The cutting table is clear, and three dress forms are placed in a row. A rolling rack with samples and patterns is placed against the far wall. "You sure straightened up the pattern room!"

"Hello, Tamee. I learned to be organized at Huntington Industries. It's the key to finding patterns, files, and samples," Jaynie Lee says in her soft southern drawl.

"I love your accent. Where are you from?"

"South Carolina, but I've moved around quite a bit, and now this is home."

"Well, we're sure happy to have you," says Tamee. "Before you came, we sent samples to our contractors, and that was a disaster because the prototypes took so long!"

Jaynie Lee reflects to herself, "Wow, Tamee sure talks fast. I hope I can catch everything she is saying. Rare Designs has lots of challenges but my coworkers seem to be friendly." She then replies to Tamee, "I'm looking forward to working with you. I just might be here 15 years, just like I was at my old job at Huntington Industries. The 15 years went by quickly!" She and her husband were already considering a relocation when Mr. O'Dale came up to her out of the blue and flattered her by saying she was one of their sharpest, most astute pattern makers. He then offered her a new position with a large pay increase if she was willing to move to Rare Designs' headquarters.

Jaynie Lee focuses back on Tamee, and points to the dress form. "I finished the knit pattern block. It's best to create a pattern block first, but since I'm trying to catch up on the work around here, I'm creating the pattern blocks and having the

prototypes sewu simultaneously. As you can tell, I don't mind multitasking. I'll take out this bust wrinkle here," Jaynie Lee says, pointing to the dress form. "Other than the wrinkle, do you like the fit? Huntington Industries has an adamant policy that prototypes and first samples match production. We use pattern blocks to have consistent fit and measurements."

Tamee slowly shakes her head in disbelief. "You finished the pattern block already! In the past, we started each new design from scratch." Tamee turns the dress form around and says, "The fit is nice. I am glad Huntington Industries sent you! You are a great addition to our staff!"

"I'll finish this pattern block today. I also have a question on REJ3001, the Mimi jacket."

Tamee follows Jaynie Lee to the cutting table and picks up the jacket shell. "My Mimi jacket is starting to look good. You are so fast! I just gave you the prototype requisition this morning," Tamee says.

"That's right," Jaynie Lee smiles. "I'm known for being fast and efficient." She points to the jacket pocket and says, "Now, here's the reason I asked you to run down here. The sewers can't put the employee ID loop into the welt pocket as drawn on the tech pack." She points to some sheets of paper that are neatly placed next to her computer. "Because they use an automatic welt pocket setter, it's impossible to add an extra fabric piece. Is it okay if we put the loop into the princess seam?"

Tamee looks at Jason's technical sketch and then at the prototype, pressing her lips together while concentrating on what she sees. "I like having it hang straight off the low waist."

"On the vest, it's inserted into the princess seam," Jaynie Lee says, pointing to another technical drawing.

"Oh, I missed that . . . both the jacket and the vest should look alike. So, tell the sample sewers that we approve the change."

Jaynie Lee writes a note on the pattern card. "Don't you worry; I'll have the protos ready for the line review meeting next week."

She smiles, sits down at her computer, and composes an e-mail to her colleagues at Huntington Industries. "I like my new job here, but I miss ya'll. My kids are settled in their new school, and my husband loves his new job. The weather is beautiful and is rumored to be like this most of the year. The employees here at Rare Designs are nice, and the owners give everyone respect. In fact, this morning, I saw Ron complimenting the janitor. . . ."

Objectives

After reading this chapter, you should be able to do the following:

- Write create storyboard, line sheet, and prototype activities in the time-and-action calendar.
- Comprehend storyboard components including a designer's thought process in how to setup the layout.

- Distinguish the varying roles of core, carryover, and new garments on storyboards.
- Understand how merchandisers use storyboards
- Comprehend the details that go into a sales package
- Calculate the dollar value of wholesale orders by size scale, size and color, and total dollar quantity.
- Understand the prototype request and approval process
- Interpret the context of a design review

Time to get ready for the show! Thus far, designers and merchandisers have been exploring, visualizing, and making decisions on how to merchandise their product line. We have now reached the final step before the company releases its seasonal apparel line. Designers pull together the product line into storyboards. The completion of storyboards triggers multiple simultaneous activities: CAD artists create line sheets, merchandisers preline to major retail customers, and first pattern makers develop patterns and prototypes. The design team uses storyboards, line sheets, preline information, and prototypes to evaluate products at line review meetings. These visual tools are important to communicate the product line direction, sales, and inventory information to the design team, executives, sales representatives, and retail buyers. This chapter steps through the creation of storyboards, line sheets, and prototypes. We discuss preline meetings and line reviews in which associates determine whether products meet company margin goals and retail customer needs.

In Chapter 11, designers illustrated line art for core, carryover, and new garments. Designers now work with CAD artists to develop storyboards. During this process, designers fill, evaluate, and revise core, carryover, and new garments to create a cohesive statement. Once designers are satisfied with their design concepts, they request prototypes, select preline concepts, and calculate first costs (Regan 1997, 194).

Activities to Get Products Ready for Review

After the design team has approved designs, they collaborate with CAD artists, costing specialists, forecasters, purchasing, quality assurance, and technical designers to get the product line ready for review (Regan 1997, 197). The design team is abuzz getting storyboards, line sheets, and prototypes ready for product line review. Regular meetings are important to keep creative associates focused (Goodnight 2005), so it is important for the design director to schedule meetings and communicate frequently. If any fabrics, embellishments, or other raw materials arrive late, tensions will mount because the trade show date looms near. This date is a hard deadline in which the team presents the line to wholesale customers.

Activity **12.1** Time-and-Action Calendar: Continued

After the design review is complete, schedule the following activities in your time-and-action calendar:

- In cell A33, type "Create storyboards." Designate 2 weeks and fill cells N33–O33. This activity starts the last week of "Submit core, carryover, fashion-forward, and reorderable workkits to pattern making."
- In cell A34, type "Create line sheets." The designer needs to complete the storyboards to compile information needed for line sheets. Designate 2 weeks and fill cells P34–Q34. Align this activity in the same column at the end of "Create storyboards."
- In cell A35, type "Show concepts to key accounts." Designate 1 week and fill cell Q35. This activity starts the last week of "Create line sheets."
- In cell A36, type "Revise patterns and sew prototypes." Designate 5 weeks and fill cells L36–P36. This activity starts 1 week after "Submit core, carryover, fashion-forward and reorderable workkits to pattern making."

Creation of the Storyboard

The excitement mounts as the design team moves on to the next stage in which it transforms line art into storyboards. Both storyboards and line sheets present the seasonal product line. A **storyboard** is a collection of sketches, fabric, and color swatches that express the design direction (Keiser and Gardner 2003) (Figure 12.1). A completed storyboard consists of computer-illustrated garments with corresponding style names and SKUs in multiple color ways and fabric styles. Designers create a storyboard to present the product line to company associates and major retail customers (Regan 1997, 190). A **line sheet**, by comparison, includes illustrations and sales description including SKUs, wholesale prices, delivery dates, and size range.

A storyboard is an important communication tool for company associates in marketing, merchandising, and operations. Marketing associates use the storyboard to develop promotional strategies and generate sales forecasts. Merchandising associates use storyboards to present to retail customers and sales representatives. Production associates review storyboards to identify equipment needs, costs, and where to manufacture garments (Regan 1997, 199).

A storyboard is a designer's vision that a CAD artist implements. When designers and CAD artists create storyboards, they think in the context of their retail customers. Sometimes designers create storyboards for all potential clients. Often this context is for an upstart designer or designers that sell to boutiques. More often, a designer creates a storyboard specifically for one retail customer. A proprietary merchandise mix enables a retail customer to distinguish itself from its competitors. Here we use Calvin Klein Collection, ck Calvin Klein, and Calvin Klein labels, produced by Phillips-Van Heusen, in which its designers create a proprietary merchandise mix for each of its major retail customers (Phillips-Van Heusen 2005). Calvin Klein Collection is sold in its flagship store and conveys sophistication, luxury, and high-quality products. ck Calvin Klein is a bridge brand that primarily sells in Europe and Asia. Calvin Klein is a moderate brand that sells

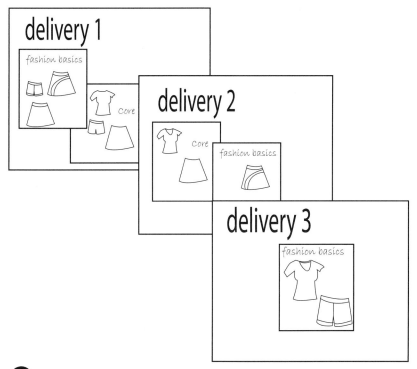

Figure 12.1 Designers create storyboards that correspond to seasonal themes and deliveries. *(Illustration by C. DeNino and E. Perales.)*

in national, regional, midtier department and specialty stores (U.S. Securities and Exchange Commission [SEC] April 5, 2007).

There is no one set way of putting together a storyboard; however, there are trade tricks that industry associates use to be efficient; to create a logical decision sequence; and to transform line art, colors, and fabrics into a cohesive whole. Designers first create product line templates to pull in seasonal theme colors and fabrications. They then merge line art and fill bodies with different colors and fabric combinations. Once designs are finished, designers will calculate first costs and make any design adjustments to increase margin results.

Relationship of Storyboards to Seasonal Theme

Designers have mental images of how to relate the seasonal theme to storyboard creation. Designers and CAD artists work synchronously to translate the theme into garment concepts. Designers first contemplate how to combine seasonal colors and fabrications into garment concepts, and CAD artists create product line templates to share seasonal colors, prints, and fabrications among multiple files. Designers then use the seasonal theme as their foundation to coordinate the storyboard's colors, fabrics, and line art. For example, the style of garments in Rare Entities' Beauté theme could take

Figure 12.2 Rare Entities' Beauté spring storyboard. *(Illustration by A. Flanagan.)*

many directions (Figure 12.2). It could have a romantic feel with sheer lacy bodies, consisting of casual professional attire using Impressionist-inspired fabric prints, or take on a historical feel by using nineteenth-century garment component features such as set-in puff three-quarter-length sleeves. It would be incongruous for the Beauté theme to have athletic or masculine garment styles.

Designers who work for a mid- to large-size apparel company do not sell their own line to retail customers, so it is important for sales representatives to convey the designer's vision and styling features to retail customers. Sydney Blanton, the owner of Amelie, a boutique in Claremont, California, explained:*

> Before I attend a show, I have a mental product list of product lines that I have bought before, but I always visit new product lines. When I work a new line, I want them to *sell me the sizzle*. I want to hear about the company history, where the designer grew up, and the designer's vision for the collection. If I am going to give you my money, I need to know why I should buy your product. It is especially important to know *why* in the contemporary market. I need to be able to explain to my customers why a pair of jeans is worth $150.

*Reprinted by permission from Sydney Blanton, owner, Amelie, Claremont, CA; pers. comm., May 1, 2006.

Activity 12.2 *Critical Thinking*

In the previous quote, the owner of a boutique discusses how it is important to understand a company's history and a designer's vision.

- Write a description of your company history and vision that a sales representative would present to potential buyers.
- When you have completed your storyboard (Company Project 11), paste this description to the back.

Setup of a Product Line Template

Storyboards and line sheets have some visual and written consistent information. CAD artists spend numerous hours creating the fabrications and prints, merging filled bodies, and setting up the layout. To save time, CAD artists create product line templates. A **product line template** is a computer graphics file (e.g., Adobe Illustrator) with common elements to all seasonal storyboards and line sheets (Figure 12.3). Product line templates include company information, seasonal colors, fabrications, and prints. Product line templates save time and reduce potential omissions among multiple storyboards and line sheets.

Figure 12.3 A template drawing file with colors and fabrics. *(Illustration by A. Flanagan. Adobe product screen shot(s) reprinted with permission from Adobe Systems Incorporated.)*

Rare Entities - Spring

beauté

Colors and Fabric Print

Rare Designs

Figure 12.4 Addition of company title and product line information. *(Illustration by A. Flanagan.)*

A product line template starts as a blank computer page. A CAD artist will merge color stories and fabric designs from each delivery into the product line template. (You created your color deliveries and fabric designs in Company Projects 8 and 9.) The CAD artist creates a color swatch for each color, fabrication, and print. The designer and CAD artist work together to assign color and fabric style names. Designers often use creative names, which might not be associated with generic color, textile fibers, or fabrications. Here we refer to Rare Designs' story. Tamee, the designer, labeled Beauté theme colors to capture an emotional sensation for her Impressionist theme. She labeled her color palette *Whisper* (i.e., crème), *Clay* (i.e., rust), *Bashful* (i.e., rose), *Victoria* (i.e., purple), *Stone* (i.e., grey), and *Slate* (i.e., dark grey). The CAD artist merges or writes all common phrases such as the theme name, company name, and logo (Figure 12.4). Next, the CAD artist labels color and fabric swatches. These labels will be used on the line sheet. The theme title, company name or logo, and any other common elements are typed on the template by the CAD artist. This product line template becomes a foundation for each seasonal storyboard and line sheet.

ACTIVITY 12.3 *Creating a Product Line Template*

The purpose of this activity is to define common elements for your storyboard and line sheets and to create a product line template. You need to complete Company Project 10 before starting this activity.

- Open *Core garment 1* from Company Project 10. Decide your storyboard size. The minimum storyboard size is letter (8½" × 11"), and the maximum is tabloid (17" × 11"). Your color printer's maximum paper size may restrict the document size. From the File menu, select the Document setup, and change the page setup to landscape orientation. Save this drawing as "Product line template."
- In Company Project 1 you dragged your theme colors and fabric designs into the swatch menu. Click twice on one of your color swatches. In the pop-up menu, rename each new swatch with your color or fabric name. The color mode needs to be CMYK in order to change the color name.
- Type your theme name, company name, or logo. Use the align tool, or select "Show grid" and "Snap to grid" to align titles.
- Save as a regular drawing (e.g., Adobe Illustrator Document). Your drawing should look similar to Figure 12.3.

A Designer's Thought Process

The CAD artist brings line art into the product line template and then talks to the designer about how to combine colors, fabrications, and prints. This requires designers to envision their storyboard and convey this concept to the CAD artists. Their approach depends on how complex or novel a design situation is and how much time they have. Designers who have to develop a line in a rush tend to simplify their design decisions (von der Weth 1999) and rely heavily on using existing styles and silhouettes. An experienced designer will draw on his or her knowledge of design strategy and previous solutions as a response to a new design problem (von der Weth 1999).

Storyboards include core, carryover, and new garments that an SBU offers for its seasonal product line. Companies tend to have a set approach for creating seasonal product lines. Designers group potential garments by theme, fabrication, or established product line. They use a storyboard as a working document to visualize how to pull the product line together. Designers often organize their storyboard by how their retail customer prefers to purchase their product. Common ways to organize a storyboard are by garment classification, delivery, or retail customer account.

To set up a storyboard by classification—or by retail product groups—is common for a separates-only apparel manufacturer. Here we use denim jeans as a classification example. A jeans designer would set up a "classification" storyboard by use or activity; for instance one storyboard for casual jeans and one for evening/dress jeans.

Designers commonly set up a storyboard by delivery if they want to stress coordinate groupings or if they are on a reorderable plan with a retail customer (Figure 12.5). A career clothing designer would set up coordinated groupings on each storyboard to include pants, skirts, tops, and jackets. For instance, Jones Apparel Group designers create multiple groups for their sportswear product lines. Each group includes separates such as skirts,

Rare Entities - Spring

beauté

Collection One: Von Mauritz Department Store　　Collection Two: Flanino Specialty Stores

Coco / Jane / Kate / Stacey / Brynn / London / Mimi / Jane / Brooke / Lola / Brynn / Halle

Rare Designs

Figure 12.5 Designers evaluate whether the core, reorderable, or new garments form a cohesive sellable product and creation of two collections. *(Illustration by A. Flanagan. Adapted from work by S. Lozano, N. Pagtakhan, and E. Perales.)*

pants, blouses, and sweaters. Their goal is to update classic styles with contemporary fashion trends (SEC February 26, 2007).

Another way to organize is by customer account. Designers use similar silhouettes for multiple accounts, but they change the colors, fabrications, and merchandise mix for each customer. Designers use this storyboard approach for exclusive product lines or private label merchandise made for a retail customer. One example is the Donald Trump line made by Philips-Van Heusen that sells exclusively in Macy's stores (SEC April 5, 2007).

Core Garments

Designers build a product line around core garments, colors, and fabrics. Core garment styles are used in each seasonal product line theme and delivery; therefore, they are placed on all storyboards for a seasonal product line. Designers will say that core garments should ideally support everything that you are flowing in for that season, so they will fill core garment bodies with numerous options. The colloquial phrase **flowing in** means that designers purposely tie colors, fabrics, and silhouettes back to a core garment.

Rare Entities - Spring

beauté

Possible color combinations

Good match

Brooke
REWT2001

Brynn
REWB2001

Jane

Goes with all three

London

Stacey

Ali

No...doesn't go

Coco
REJ1001

Lola
REWB4001

Mimi

Hallie

Maybe...

Rare Designs

Figure 12.6 Designers have multiple fabrics, colors, and sketches that they need to tie together to create a product line. *(Illustration by A. Flanagan. Adapted from work by S. Lozano, and E. Perales.)*

Core garments become a constraint that designers use to create fashion-forward and directional products.

As consumers, we can understand this concept as being able to mix and match tops and bottoms in your own wardrobe (Figure 12.6). Designers start with their core garments and place them on the storyboard. They combine them with carryover, fashion-forward, and directional silhouettes to create a cohesive group. Designers mentally evaluate different pattern, fabric, and color combinations based on how cohesive it is to the core garments.

We use Rare Entities to explain a designer's decisions (Figure 12.6). Jacket REJ1001 is a Rare Entities core style. Designers such as Tamee use a heuristic approach by trying multiple combinations of garment styles to see if they coordinate with this core jacket. The design lines of Lola—fashion-forward cropped pants (REWB4001)—do not complement Coco jacket's styling (REJ1001). For a sporty look, a designer could combine the vest (REWT2001) with core pants (REWB2001). These styles have similar design lines and casual sporty ambiance. Next, designers need to evaluate whether the styles correspond to the selected theme. Designers will contemplate how the products and theme will be carried through on retail fixtures.

Updating Core Garments

Each season has a 2.5- to 3-month window of selling time on the retailer's floor before the season changes. For any given season, the feel of core garments and the product line must be different, according to Lonnie Kane, CEO and president of Karen Kane Inc. ⏏ Core and carryover garment styles are not identical year-round. A core garment is the same body silhouette; however, designers change design details so it is updated for each season. Some common changes include color, fabrication, fabric weight, sleeve length, leg length, or a change in embellishments.

Changing Colors and Fabrications

As mentioned previously, companies have core colors, fabrics, and garment bodies. These variables can be used in any combination. A designer will commonly start with the product line core garment and design it in core, or signature, colors and fabrics. Quiksilver Inc. ⏏ uses its signature colors of orange and blue, along with a twill core fabric year-round for its boardshort product line, according to senior merchandiser Jennifer Barrios. Each storyboard and theme includes an SBU signature/core colors and fabrics, which designers designate as *year-round* or *seasonal*.

Designers use the entire seasonal color story for their product line; however, they do not necessarily have every color in the color story for all garments. Designers do not limit core garments to be only in its core colors; rather they use their experience in grouping and combining colors to develop a coordinated seasonal theme. Designers will explore different color combinations by filling core garment bodies with many different color combinations. Often, hues in a color story do not have equal usage. For instance, Rare Entities' product line includes Whisper, Clay, Bashful, Victoria, Stone, and Slate. Some of these hues can be accents, used in buttons or trim, whereas others dominate and are used throughout a coordinate outfit or garment. Designers tend to be visual and want to see how a color-combination will look. Computer graphic programs greatly assist designers because they can fill garment bodies with endless color and fabrication possibilities with which to visually evaluate them.

Dress manufacturers often use seasonal fabrics. For example, a designer may use chiffon as a core fabric every season in core colors such as black and ivory. Then according to the color trends, they add in a few fashion colors such as green, purple, or pink. Designer Kimberly Quan explained how she chose fabrics based on her theme and delivery dates:*

> I just finished an Old Hollywood theme. My theme portrayed glamour, subtle sexiness, vintage sophistication, and elegance. The fabrics I used were chiffon, satin lux, peau de soie, taffeta, and shantung. I selected jewel-toned colors in aubergine, muted purple, deep teal, chocolate, black, and gold. Seasonal colors do not change drastically; they make a gentle transition, so for my Fall I delivery, I used lighter values of my hues and matte fabrics. For my 9/30 delivery, which is Fall II or holiday, I added in brocade—a novelty metallic fabric with Lurex threads—and used shiny trims.

*Reprinted by permission from Kimberly Quan, designer, Cerritos, CA; pers. comm., June 21, 2006.

ACTIVITY **12.4** *Critical Thinking*

In the previous quote, the designer identified specific dress fabrics and explained how she changed colors and fabrics from the first delivery to the second delivery.

- Identify specific fabrications you will use in your product line.
- Identify how you will transition your colors and fabrics from your first theme/delivery to your second theme/delivery.

Carryover Garments

Designers develop their storyboard's carryover and reorderable styles simultaneous to core garment color and fabric selections. Merchandisers provide designers with a carryover plan before they work them into the storyboard. The carryover plan includes a construction description, size scale, and packaging combinations (Regan 1997, 188). A carryover plan depends on both the retail channel and the product category. According to Kimberly Quan, some categories, such as dresses, have few carryover styles from one season to the next. Other styles, such as infant garments, have consistent carryover styles (SEC February 28, 2007C). Merchandisers work with their retail customers, who will inform designers which styles to carry over to the next season (Regan 1997, 184). Although operations and production managers welcome the continuity of carryover construction, they cannot depend on an ongoing year-round carryover business. The carryover business is unpredictable because a style can be a solid seller for a short time, followed by a dramatic drop in sales; or sales can remain solid over a period of years.

Think about the decisions you make when you look into your closet to decide what to wear. A designer, much like you, poses questions such as, "Would I wear this top with these pants, or would I wear this jacket, knit top, and skirt?" A requirement of carryover garments is that they need to go with new garments and bring freshness to a product line. When a designer brings a carryover into a product line, they need to manipulate design details and change colors, fabrications, trim, or special operations (e.g., embroidery or screen prints) to entice consumers to buy. For example, in an infant product line, a designer may have spring carryover styles with a teddy bear print and embroidery, and a summer theme with sailboat screen prints.

Some apparel manufacturers offer the same garment bodies for each season's deliveries. A designer can use a carryover style for one theme/delivery or for multiple deliveries. It is important that designers change details if a carryover is used for multiple deliveries so that they look different. We use Rare Entities as an example. Skirt REWB1001 is a designated carryover style. To achieve a different look, Delivery 1 skirts are in solid Bashful and Slate colors. Delivery 2 skirts have a contrasting waistband and faux welt pockets in Sage and Stone (Figure 12.7).

New Garments: Directional and Fashion-Forward

As noted, designers create new garment bodies that are directional (follow current market direction) or fashion-forward (a risk garment). Designers view directional and

Rare Entities - Spring

beauté

Carryover Skirt

Spring Delivery 1

Spring Delivery 2

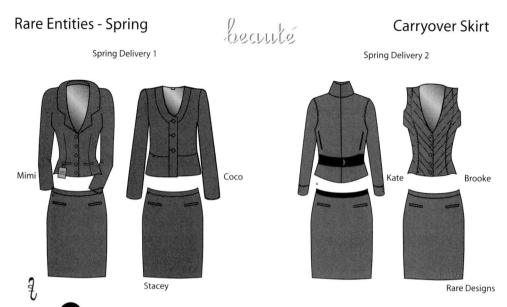

Mimi

Coco

Kate

Brooke

Stacey

Rare Designs

Figure 12.7 An example of how a carryover skirt changes for multiple deliveries within a single season. *(Illustration by A. Flanagan.)*

fashion-forward items much as a retail buyer does. Both know that designers need to follow current trends and take risks to attract consumers to buy products. Companies continually create new product options to woo customers from established positions or to draw new customers into the market (Porter 1996).

Emphasis is important when placing new garment bodies on a storyboard because these products need to attract the retail buyer's attention. While there are many approaches, we use color as an emphasis example. Designers first contemplate their color delivery. On a storyboard, designers may position fashion-forward items so they draw attention and complement the other garment bodies in the product line. Refer to Figure 12.7. The Kate jacket is a fashion-forward product, the Mimi jacket is a directional product, and the Stacey skirt is a carryover. Jason, the CAD designer, should fill the Kate jacket with a fashion-forward color and position it so that it draws attention. For instance, he could place the Kate jacket in the center of the storyboard and fill it in Victoria, which is a fashion-forward color. The remaining colors should complement rather than draw attention away from the Kate jacket. For instance, Jason could fill the Coco jacket and the Stacey skirt, which are in the same delivery, in neutrals Whisper, Slate, and Stone, or Victoria, the fashion-forward color.

Retail buyers associate storyboard placement with visual merchandising in stores. An assistant director of general merchandise commented on how important it is to have a spark that draws shoppers into their department: "A hot pink sweatshirt draws the

Rare Entities - Spring Fashion Forward Garments

Mimi
REJ3001

Lola
REWB4001

Kate
REJ2001

Rare Designs

Figure 12.8 New garments add a pop to a product line and are individual for each delivery. *(Illustration by A. Flanagan, N. Pagtakhan, and E. Perales.)*

shopper over to the rack, and, almost always, they buy the item that is hanging next to it. I know that I need to carry trendy items to add interest to the floor."*

Designers develop new garments to correspond to one theme or delivery. We refer to Rare Entities. The new garments are the Mimi jacket (REJ3001), the Lola cropped pants (REWB4001), and the Kate jacket (REJ2001) (Figure 12.8). When creating a product line, a designer needs to think in the context of a consumer wearing a coordinate outfit and consider how the garments will "hang"; that is, how they will look and coordinate with other products on the retailer's fixture. Because the Mimi jacket and the Lola cropped pants blend well stylistically, Tamee, the designer, would put these two styles into the first delivery and the Kate jacket style into the second delivery (Figure 12.8). Tamee will coordinate the Mimi jacket's colors and fabrics with the Lola cropped pants. Because the idea of directional and fashion-forward garments is to add a pop or spark, the Mimi and Lola coordinate styles would be available only for the first delivery and replaced with the Kate jacket for the second delivery. In delivery 2, the Kate jacket will coordinate with a core pant and carryover skirt style because their design lines are aesthetically pleasing.

*Reprinted by permission from Clint Aase, assistant director and general merchandise manager, Bronco Bookstore, Pomona, CA; pers. comm., February 2006.

Retail customers measure the worth of an apparel manufacturer's product based on sales groups. A retail buyer expects good sell through on fashion-forward items. A design director will reduce risk by limiting color, fabric, and size range availability. Clint Aase, assistant director of general merchandise, explained:*

> Our campus bookstore apparel groups are fashion, collegiate, and dollar volume. When I buy an apparel product, it is expected to turn.* Each group has a specific purpose. The purpose of fashion is to bring freshness into the department. I use our information system to analyze sales per facing. For instance, a four-way fixture has four facings. As a merchant, I have expectations for each sales group: Fashion needs to turn once, collegiate 2–3 turns, and the big sellers 4–5 times. We do not concentrate as much on margin, which is different from other colleges. I would rather have more turns than only buying product that generates dollars. I feel there is strength in numbers: I would rather have more people wearing our clothing than reaching fewer people with the same dollars.

ACTIVITY **12.5** *Critical Thinking*

In the previous quote, the assistant director of general merchandise noted that the design team is accountable for creating a product line that generates the predetermined sales per fixture (e.g., four-way fixture). For this activity, use your CAD illustrations created in Company Project 10.

- Consider how the garments will "hang" on a retail fixture. Fill your core, carryover, and new garments with different color and fabric combinations to create a salable product group that will fit on one retail fixture.
- Justify (either written or oral) how the display of your product group will sell on the retail floor.

Storyboard Layout

Designers work on multiple themes and storyboards simultaneously, and these continually change as the product line progresses. Sometimes designers will change themes midway through development, which increases the possibility of mistakes occurring. It helps to have another design team member review storyboards for any mistakes or omissions. For instance, one children's designer accidentally carried over a fish motif when the product line theme changed from ecology to football. The designer did not notice it until a sales representative asked her, "What is a fish doing in your football theme?" (Regan, Kincade, and Sheldon 1998, 44).

Correctly Reading Garments

Retail buyers, sales representatives, and executives must read the storyboard correctly so they understand the designer's decisions on SKUs, colors, and fabrics for each theme and

*Reprinted by permission from Clint Aase, assistant director and general merchandise manager, Bronco Bookstore, Pomona, CA; pers. comm., February 2006.
*Stock turn is the ratio of between net sales during a given period and the average stock for that same period (e.g., a fashion goods sales group has $10,000 in net sales and an average inventory of $40,000).

delivery. "Reading correctly" means that the drawing communicates the design well. Designers and CAD artists display garments so the arrangement enables the retail buyer to visualize how a set delivery will look in their store. CAD artists arrange a storyboard from the context of a first-time viewer having fresh eyes when looking at the product line.

Grid Format

A storyboard must accurately convey garment designs. The design team wants retail customers to understand garment styling, prints, and details. To communicate garment styling, CAD artists commonly arrange a storyboard in a grid format in which the garments line up horizontally, vertically, or both. In Figure 12.9, the garment bodies are aligned as coordinate selling pieces. Stylistically, a consumer could wear the Kate jacket and London pants; thus the grid not only helps by having a clean layout; it also helps the buyer visualize garments. Once CAD artists set the garment bodies on a grid format, they bring in the available garment colors and fabrications. One approach is to place a color story next to the garment (Color plate 14). The CAD artist fills one garment with color and then a color story of small rectangles is placed next to it. For instance, Jason, Rare Designs' CAD artist, filled

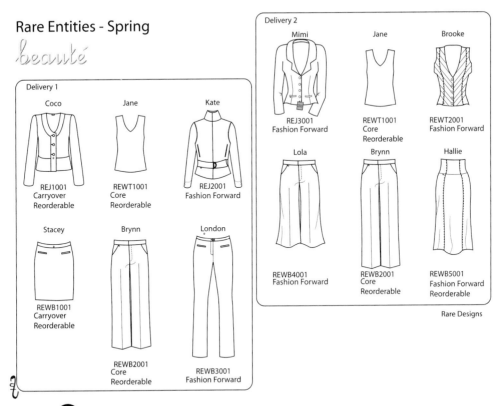

Figure 12.9 An apparel manufacturer designates style name, SKU, and product type for its garment style. *(Illustration by A. Flanagan, E. Perales, and S. Lozano.)*

Brynn pants (REWB2001) in the color Whisper. This SKU is also available in Slate, Stone, and Clay, as shown by the small color boxes next to the SKU (Color plate 14).

Garment labeling is a small but important detail. Retail buyers evaluate numerous designs from multiple apparel lines at trade shows or market weeks. Their shopping experiences can easily become a blur; thus the illustration and SKU description are important for ordering the correct product. A storyboard includes correct garment labeling. The CAD artist labels each garment with its style name, SKU, and whether it is a core, fashion-forward, or reorderable garment. For a clean layout, the CAD artist aligns product descriptions.

Overlapping Garment Bodies

Another approach is to fill all garment bodies with all available fabrics and colors (color plate 15). CAD artists may slightly overlap some illustrations to fit garments on the story board. When overlapping, CAD artists critically assess the layout for readability. Overlapping can hide garment details, such as type of fit, or garment components, such as sleeve type or pocket placement. The CAD artist wants to make sure retail buyers and manufacturing representatives correctly interpret design details. A general rule is to not overlap garments more than 50 percent. Color plate 15 shows an approximate 50 percent overlap. However, it does depend on garment body, and a garment with detailed construction may only allow for a 30 percent overlap. It helps to have another person review storyboards for clarity, missing details, or a confusing layout.

Scale Integrity

CAD artists need to be careful to keep garments in proper scale. Although there is no written guideline, the nine-head croquis is considered the "standard" to use on storyboards and line sheets. Designers draw a croquis accurately so that the figure gives a realistic representation of the clothes worn and how to market them (Riegelman 2007). Designers generally draw garment bodies using a croquis as their guide. CAD artists can be tempted to reduce a garment scale to try to fit a complete delivery on a page. Retail buyers and product development associates are accustomed to a nine-head scale and will misinterpret a garment body size if the CAD artist does not maintain scale integrity. Look back at Figure 11.9. This illustration of the Gracie blouse and Lolita jeans is for a 'tween consumer (ages 8–12). If the designer intended this illustration to be for an older consumer—for instance a 16-to 20-year-old—the scale is too small. A retail buyer could mistakenly buy it for a 'tween shopper and consequently would be angry when the garments arrived in the store too large. Likewise, each garment on the storyboard needs to be the same scale. In Color plate 14, the hip width is approximately the same width for the tops (e.g., Kate) and the bottoms (e.g., London).

Showing Concepts to Key Retail Accounts

Merchandisers present garment concepts to their major retail customers before trade shows and market weeks (Regan 1997, 196). **Preline** is a colloquial term for this product line preview. Merchandisers typically travel to the retail customers' corporate headquarters to present storyboards. Thus, these scheduled appointments become an intermediate

deadline for designers and CAD artists to finish storyboards and line sheet information. The two primary purposes of a preline meeting are to present product to major customers to get their reaction and to plan a retail customer's private-label merchandise.

Retail Customer Reactions

Merchandisers use storyboards as a presentation piece to show the product line to retail customers. Apparel manufacturers typically have their merchandisers preline seasonal product lines to the SBU's large retail accounts. Preline is a formal presentation, and in order to prepare, merchandisers study SBU forecast information, sell-through reports, and business trends such as growth categories (Regan 1997, 196).

Retail buyers communicate to the merchandisers about their target market needs and product exclusivity requirements. Merchandisers are familiar with competing brands, so they may provide comparison features such as cost structure and garment construction. A merchandiser may use a context such as "this garment body is like brand X, which your consumer wants to buy but cannot afford." It is up to the merchandiser to convince retail buyers to purchase directional and fashion-forward colors, fabrications, and garment bodies. Retail buyers may be reluctant to buy innovative designs unless they have seen similar garments by competitors or high-status companies (Eckert and Stacey 2003).

Upon return of multiple preline meetings, the merchandiser will present the retail customers' reactions. The design team reviews these reactions; however, mixed opinions can be difficult. One merchandiser commented about retail customer reactions to product lines, "One retailer will love a design, while the next retailer thinks it's the ugliest thing they've ever seen" (Regan, Kincade, and Sheldon 1998, 44). The design team identifies best styles, evaluates questionable bodies, and calculates first costs (Regan 1997, 196). Identifying best styles means retail buyers had a consistent good reaction to a garment body. The merchandiser will assign high production numbers to this style, sometimes called an "A" style. If retail buyers did not readily accept some of the garment styles, the designer will quickly change the garment body style characteristics or change embellishments. The design team will eliminate a garment body if these retail customers had a poor reaction to it.

Private Label Merchandise

Many retailers are increasing private label product assortments and many apparel manufacturers, such as Jones Apparel Group, help retail customers create private label assortments (SEC February 26, 2007). The design team creates storyboards to plan private-label merchandise with retail customers. The storyboard is an important communication tool in developing private-label merchandise.

A strong sell through is important for private label brands, so retail buyers often want fashion designs that closely resemble designer labels (Eckert 1997 379). At a private label meeting, multiple apparel-manufacturing partners will present their seasonal merchandise strategy to the retail product development team. Apparel manufacturers will participate in breakout sessions in which retail buyers often expect manufacturing partners to **bring concepts to the table**. This phrase means that apparel manufacturers create apparel design concepts that they show to the retail customer (SEC April 5, 2007).

Merchandisers use storyboards to present concepts to retail buyers. Retail buyers review the designs in relation to building and marketing private-label brands. For instance, Philips-Van Heusen develops Puritan and George dress shirts for Wal-Mart and John W. Nordstrom for Nordstrom Department Stores (SEC April 5, 2007). Retail buyers evaluate storyboards in a different context for private-label merchandise than for branded merchandise. Retail customers review storyboards to discuss merchandise mix, to buy product, to differentiate brand assortments, and to create private-label color palettes and themes. The retail buyers select which items to carry in their store from the manufacturers' product line. They may provide a seasonal color story to coordinate private-label merchandise mixes among differing manufacturers (Eckert 1997). Retail customers may also change the colors or garment details in the product line.

Creation of Sales Package

When merchandisers return from prelining, the design team starts working on the sales package. The product line may require revision depending on preline meeting feedback from key retail customers, especially if the design team decides to eliminate a garment body from the product line (Regan 1997, 196). The design team creates a sales package to enable sales representatives to sell the product line. This **sales package** includes computer graphics, a price book, samples, swatch cards, garment samples, and a catalog (198). CAD artists are responsible for line sheets, pattern makers work with sample supervisors to create samples, and merchandise associates (or interns) create swatch cards.

As a general term, a line sheet is a document with detailed product description (Color plate 16). Some apparel companies use the term *line sheet* interchangeably with *sales sheet* or *catalog offerings*, whereas other companies distinguish these as separate documents. Thus, a line sheet can refer to an electronic document that the design team and preproduction associates use to develop the product line into a manufacturable product, and a **sales sheet** can mean a product line description that a sales representative gives to retail buyers (Regan 1997, 197). We use the general term for line sheet. Line sheets include the same CAD visual and sales description as a storyboard. A line sheet also includes delivery date(s) fabric type description, size scale, SKU, and trim description (198). It can also include a size range and wholesale price.

Line Sheet Creation

The line sheet is a team effort requiring multiple inputs from design team associates. Merchandisers provide a product line forecast, size information, SKU plan, and fabric and trim details. The CAD artist organizes the information to create the sales package (Regan 1997, 198). The design team thinks in the context of a retail buyer when putting together the product line sheet description. They think, "What do we need to know to buy this product?" It boils down to what, when, and how. *What* describes the garment's style description, *when* is the delivery date or window, and *how* refers to the garment wholesale cost, size scale, and whether the garment is reorderable.

Sales Description

To create a line sheet, a CAD artist copies the storyboard computer graphics file and renames it "line sheet." This ensures a consistent sales description of the garment body, style name, SKU, colors, and fabric designs with the storyboard. In addition, the line sheet sales description includes fabric type description and trim information.

Apparel companies vary on the fabric type information they provide. Some companies highlight specific fabric types as a competitive strategy or as part of the company brand. Ashworth Inc. �空 uses high-quality performance fabrications as a competitive strategy for its Silver Label product line. The company develops fabrications that appeal to a select target market at topnotch global golf clubs and resorts (SEC January 16, 2007). Healthtex's Kidproof �, Another example is a patented knit fabric treatment to protect against stains, uses fabrication in association with a company brand (LT Apparel Group n.d.).

Companies often abbreviate fiber content. For instance, 70 percent cotton and 30 percent polyester would be abbreviated as 70C/30P. It can be difficult to distinguish embroidery, patch, screen print, or type of garment wash from a computer graphics illustration. The line sheet will include a concise embellishment, trim, or finding description and sometimes an enlarged illustration. Some common special operation abbreviations include emb (embroidery) or screen (screen print).

Consistent information is of utmost importance with all sales package documents. A sales description seems straightforward, but it takes diligence for CAD artists to have complete and consistent sales descriptions between the line sheet and storyboard. The storyboard, line sheet, and catalog must have the same sales description; otherwise it creates havoc and a potential financial loss. Thus, CAD artists triple check sales descriptions to ensure consistency between the storyboard line sheet and catalog. CAD artists will check SKUs, sales descriptions, and the designation of core, carryover, directional, fashion-forward, or reorderable garments.

Delivery Dates

To understand delivery dates, an individual needs to understand how retailers plan their merchandise receipt. Retailers plan the productivity of their store floor space for each 6-month period (i.e., their financial season). Retailers plan every square inch to be productive selling space. A retail buyer orders goods based on their retailer's productivity plan.

Each month within the 6-month plan has a subplan. Retailers plan purchases using the 4-5-4 calendar, published by the National Retail Federation, ⏟ which divides each year into complete weeks. According to Lonnie Kane,* CEO of Karen Kane Inc., a new purchase month generally opens anywhere from the 20th to 25th day of the previous month. Monthly productivity goals start at the beginning of each purchase month; however, these goals are also dependent on the previous month's sell through. Retail buyers plan to have a flow of goods throughout their purchase month. To do this, they time products to reach the floor to achieve the best productivity. Thus, an apparel manufacturer must ship so the goods arrive when planned.

*Information adapted with permission from an interview with Lonnie Kane, CEO of Karen Kane Inc., Los Angeles, CA; pers. comm., June 26, 2006.

Lonnie Kane emphasized that it is important for apparel manufacturers to ship on time. Retailers give their vendors a 6- to 7-day window to ship product. If the vendor misses the 6- to 7-day shipping window, the contract for those goods expires. Most retail buyers will cancel the order, and the manufacturer will be stuck with the goods. The reason for this is that the retailer will miss valuable selling time on the floor, and the goods will not have adequate time to meet a buyer's planned sales goals. Sometimes a retail buyer will extend the order, but at a considerably lower price. The retailer believes the goods are worth less because it has less time to sell through on the retail floor before the retail buyer has to mark them down.

Delivery Dates and Windows

Apparel manufacturers and private-label retailers designate either a set delivery date or window of when retail customers can order goods. A set **delivery date** means the manufacturer ships all merchandise on the same calendar day. A set calendar day is advantageous for private-label retailers because the merchandise will be in all stores, regardless of the location, at the same time.

A **delivery window** is a set time period in which the manufacturer will ship goods. Color plate 16 has a delivery window. The retail customer can choose when it wants delivery during this delivery window. For instance, a spring delivery window could be February 1 through March 15. A retail customer chooses a set calendar date, during the delivery window, for receipt of merchandise. Manufacturers that ship to numerous retail customers find that a delivery window is a selling feature because it gives retail customers flexibility in meeting budgets and in scheduling advertising and store promotions.

On the product line sheet, the apparel manufacturer states the delivery date on a prominent location if all garments in the product line have the same delivery. If garment styles have differing delivery dates, they are included in the SKU description. A delivery date is not arbitrary. Apparel executives take the delivery date seriously because it is a contract that the manufacturer makes with the retailer. For instance, Rare Entities' Spring I delivery window is 2/1 to 3/15. A retailer could choose to have delivery on 2/18, which the sales representative writes on the purchase order.

Lonnie Kane explained that operations managers determine delivery dates or windows because the manufacturer must have finished inventory in stock during the entire delivery window. Operations managers determine the delivery window by the production location and transportation time, and buffer for any delays. Apparel manufacturers must carefully calculate delivery dates because the goods must leave the company's distribution center on a designated date. Most retailers require apparel manufacturers to use electronic invoicing and a designated transportation company. Because the manufacturer does not control the carrier, retailers generally give suppliers a start date and a cancel date. For the Rare Entities example above, the retailer would set a start date of 2/18 and a cancel date of 2/24. A cancel date is the last day the retailer gives the manufacturer to ship the goods. Occasionally, the retailer's cancel date is the date the goods arrive at the retailer's distribution center. This scenario is rare because the manufacturer does not contract with the carrier and cannot control the date that the goods actually hit the retailer's docks. Apparel manufacturers have to manage the supply chain for all garments within a product line because their customers rarely allow partial shipment (L. Kane, pers. comm.).

Calculating Wholesale Prices

Designers continually think about the garment cost structure as they select fabrics and trims. They have to meet a certain price point to maintain margin goals (Regan, Kincade, and Sheldon 1998). Designers are responsible for calculating first cost for each garment in the product line and then providing it to merchandisers and forecasters (Regan 1997, 196). **Margin**, in this context, is the difference between the cost of goods and an individual garment style's wholesale price (265); whereas, gross margin is an overall figure of net sales minus cost of goods sold (Standard and Poors 2005).

First Cost

First cost is an estimated garment cost. With experience, designers can visually assess garment bodies to estimate costs and determine whether they can afford the raw materials or construction. It is best for designers to actually calculate a first cost so they do not assume that a garment is unaffordable and stop development.

Designers rely on production planners to assist them with calculating first costs and setting wholesale prices. Production planners may give designers guidelines such as maximum fabric cost, a labor estimate, or a style cost estimate based on style history. Production planners input cost information into a company database (Regan 1997, 265). Designers can look up a past comparable style cost for the designer to use as a foundation to estimate the new style. Designers will also calculate additional costs, such as trim or special operations. It is extremely important that designers meet cost targets. Designer Kimberly Quan provided one example of garment costs in the juniors' market:*

> In juniors, a 35 percent margin is typical. I had to be very careful with my garment costs. Generally, a typical garment had $3.50 fabric cost with trims that were no more than $1.50 total. I would have to be careful on how to construct the garment to make sure the labor was low. While it depended on whether the garment was going to be made domestically or in South America, my labor cost had to be $3.00 or less.

ACTIVITY **12.6** *Critical Thinking*

The designer discussed the importance of garment costs. Although designers purchase from the wholesale vendors, you can get an idea of garment costs by shopping at a retail fabric store. Table 12.1 is a manual cost sheet template that helps you gather the information needed to calculate a first cost. This template has a raw material section and labor cost section.

Part 1 Raw material guesstimate

- Write down one garment body SKU description (e.g., style, season, colors).
- Go to a fabric store or shop online at an online fabric store directory (www.asg.org/html/links.html) or a fabric chain such as Jo-Ann Fabrics (www.joann.com/joann/).

*Reprinted by permission from Kimberly Quan, designer, Cerritos, CA; pers. comm., June 21, 2006.

Table 12.1 First cost sheet template.

Season:	Description:		SKU:	
Description:			Season:	
			Selling Price	$ 95.00
Size Range			Margin	100%
Size Scale				
Colors				
Mareker Yardage	Yards	Price	AMT.	
Material 1	0	$ –	$ –	
Material 2			$ –	
Material 3			$ –	
Lining			$ –	
Interlining			$ –	
Total Material Cost	0	$ –	$ –	
Findings, Send outs, and Trims	Quantity	Price	Ext. Amount	
Buttons/Snaps/Hooks	0	$ –	$ –	
Pads			$ –	
Zippers			$ –	
Belts			$ –	
Embroidery			$ –	
Pleating, tucking			$ –	
Screen-print			$ –	
Wash			$ –	
Elastic			$ –	
Ribbon			$ –	
			$ –	
			$ –	
Total Findings, Send out, Trim Cost	0	$ –	$ –	
Labor	Rate	Time	Amount	
Cutting			$ –	
Sewing			$ –	
Marking			$ –	
Garding			$ –	
Fusing			$ –	
Total Labor Cost	0	$ –	$ –	
Total Cost	0	$ –	$ –	
Remark				

- Select the fabric(s) and trim you will use in one of the garments that you are creating for your company project.
- Shop online for a pattern that is similar to your style, (www.voguepatterns.com/list/whats_new/page-1) or look at a pattern in a fabric store. Write down the yardage needed (industry associates refer to this amount as marker yield).
- Estimate the wholesale fabric price by using this formula (Use the full retail fabric price rather than a markdown or clearance price):

 Regular retail fabric price × Yardage needed × 0.50 = Wholesale fabric price
- Look at the "notions" on the pattern envelope and calculate the trim and findings prices by using this formula:

 Regular retail trim yardage × 0.50 = Wholesale trim Price
- A send out operation (e.g., screen print, embroidery) is an additional cost.
- A typical cost for small lot (i.e., >100) screen print or embroidery setup per ink color or thread color is $1.40–2.00 for each garment. Write these amounts in the cost sheet (if applicable).

Part 2 Labor guesstimate

- One way to calculate labor cost is to use a rough percentage of total raw material cost. A typical percentage is 30 of the wholesale fabric and trim price. If in the above your fabric and trim cost came to $10.00, then your labor guesstimate for cutting and sewing is $3.34.
- Most apparel costing specialists calculate standard times and wages to complete a garment. It is common to refer to a garment by the number of minutes it takes to sew (e.g., a 10-minute garment). Although it is more accurate to refer to methods engineering standard data, you can get a rough estimate by summing the minutes it would take you to cut or sew a garment.
- Estimate the number of minutes it would take to sew your selected garment.
- Multiply the minutes to cut and sew by minimum wage. Note the federal minimum wage is $5.85/hour; however this wage does vary from state to state (U.S. Department of Labor n.d.). Convert the hours to minutes (e.g., $5.85 ÷ 60 = $.098 per minute. Then use the following formula:

 Minutes to sew garment × Labor rate per minute (e.g., 120 minutes
 × 0.098 = 11.17).

Part 3 Total

- Sum your total cost (Raw materials + Labor).
- Use the typical 35 percent margin to determine your wholesale cost. To calculate, divide your total in the answer above by 0.65 (e.g., $28.00 ÷ 0.65 = $43.08). Round the total to the nearest whole dollar. This will be your wholesale selling price.

Setting Wholesale Prices

Once the design team submits a line sheet to production, costing specialists calculate regular cost. Costing specialists obtain actual product cost data. Typical information includes

fabric type, findings and trim, send-out instructions, and each vendor's bill of materials. They calculate direct costs (e.g., sewing labor) and indirect labor (e.g., percentage allocation for management) for each garment sample. Upon completion of garments in the product line, merchandisers, costing specialists, and production managers will have a margin review meeting (Regan 1997, 265).

Merchandisers prepare for a margin review by analyzing comparable costs with competing garments. At the margin review meeting merchandisers, costing specialists, and **production coordinators** review the margin for each garment style. The team will review cost sheets and decide whether to keep or eliminate garment styles from the product line (Regan 1997, 265). Although margins vary and are heavily dependent on product category, a 35 percent margin is a common percentage.

If merchandisers do not have complete information on cost of materials, they will price a product line by using the margin goal. Here we use a 35 percent margin goal. The merchandiser divides the wholesale price by the margin complement. (A complement is 100 minus the margin percentage multiplied by 0.01.) To calculate a product cost of $19.48 with a 35 percent margin:

Subtract: 100 − 35 = 65

Multiply: 65 − 0.01 = 0.65 (margin complement)

Divide: Product cost ÷ Margin complement ($19.48 ÷ 0.65 = $29.97)

Price line (i.e., round) of the wholesale amount: $30.00 (wholesale price)

Merchandisers, the vice president of product development, and the vice president of marketing meet to determine prices for all accepted garment styles in the product line (Regan 1997, 265). The wholesale price, listed in the sales package, is available to all retail customers. It does not indicate discounts (e.g., quantity) that retail buyers use to negotiate a better price. Core garment styles stay within the same general price range, and often merchandisers only increase these wholesale prices once a year. Merchandisers set carryover garment wholesale prices that are consistent with the previous season.

Setting Minimum Purchase Quantities

Setting **minimums**—the minimum quantity—is the last variable on a line sheet. Fabric utilization is an important financial consideration, so operations planning associates direct the design team on minimum quantities (Regan 1997, 268). Common minimums are by size scale, size and color, or total dollar quantity.

CAD artists write the minimums and size designations on the product line sheet. Apparel manufacturers reduce confusion by keeping the same or similar size scales, ranges, and minimums throughout a product line. Merchandisers may add additional sizes for anticipated strong sellers. If an apparel manufacturer varies the size range among styles, they include a size range in each SKU description. If the size range is the same for the entire product line, the CAD artist writes type of minimum in a prominent location. The size range in Color plate 16 is 2–14.

Size Range and Scale

Line sheets include a **size range**, which is the smallest to largest size in which a manufacturer offers its garments (e.g., sizes 2 to 14). Product categories have common numeric or

Wool Gabardine

Linen

Color Plate **9** A snowball effect in which one textile manufacturer dyed a color 5% lighter and another textile manufacturer dyed a color 5% darker for a coordinate outfit. *(Illustration by A. Flanagan.)*

Color Plate **10** Dyed-to-match thread is supposed to blend into the fabric. *(Illustration by C. DeNino and M. Bontempo.)*

Print Idea 1

Print Idea 2

Print Idea 3

Color Plate ⑪ Multiple fabric design ideas using Adobe PhotoShop. *(Illustration by C. DeNino.)*

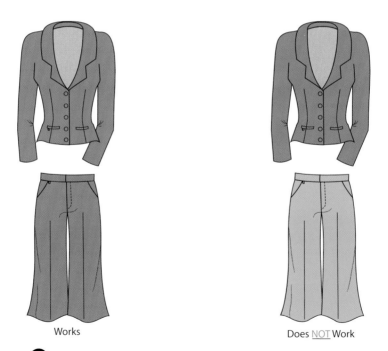

Works

Does <u>NOT</u> Work

Color Plate ⑫ A designer fills garment bodies to decide which color and fabric combinations effectively convey the theme. *(Illustration by A. Flanagan.)*

Bubbles & Jazz
ID001508
Reorderable
Delivery 1

Bubbles & Jazz
ID002508
Reorderable
Delivery 1

Moonlight Serenade
ID005508
Reorderable
Delivery 2

Moonlight Serenade
ID006508
Reorderable
Delivery 2

Bubbles & Jazz
ID003508
Reorderable
Delivery 1

Bubbles & Jazz
ID004508
Reorderable
Delivery 1

Moonlight Serenade
ID007508
Reorderable
Delivery 2

Moonlight Serenade
ID008508
Reorderable
Delivery 2

Color Plate 13 A designer needs to think about how the retailer will display colors on a store fixture. The colors of each delivery need to flow so they can display separate deliveries together. *(Illustration by M. Reyes.)*

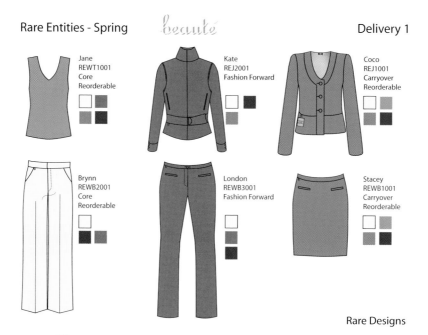

Rare Entities - Spring *beauté* Delivery 1

Jane
REWT1001
Core
Reorderable

Kate
REJ2001
Fashion Forward

Coco
REJ1001
Carryover
Reorderable

Brynn
REWB2001
Core
Reorderable

London
REWB3001
Fashion Forward

Stacey
REWB1001
Carryover
Reorderable

Rare Designs

Color Plate 14 A completed Rare Entities Beauté storyboard for Delivery 1. The CAD artist filled one garment body and included color boxes with alternate color choices. *(Illustration by A. Flanagan.)*

Rare Entities - Spring *beauté* Delivery 2

Jane
REWT1001
Core

Mimi
REJ3001
Fashion Forward

Brooke
REWT2001
Fashion Forward

Brynn
REWB2001
Core
Reorderable

Lola
REWB4001
Fashion Forward

Hallie
REWB5001
Reorderable

Rare Designs

Color Plate 🄵 A completed Rare Entities Beauté storyboard for Delivery . The CAD artist filled each garment body in each color and fabric combination. *(Illustration by A. Flanagan.)*

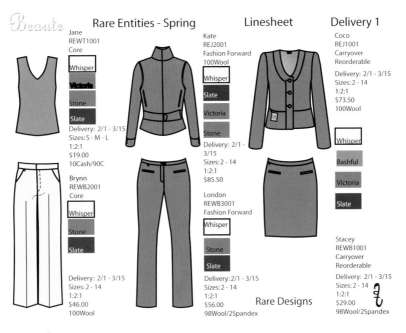

Beauté Rare Entities - Spring Linesheet Delivery 1

Jane
REWT1001
Core

Whisper
Victoria
Stone
Slate

Delivery: 2/1 - 3/15
Sizes: S - M - L
1:2:1
$19.00
10Cash/90C

Brynn
REWB2001
Core

Whisper
Stone
Slate

Delivery: 2/1 - 3/15
Sizes: 2 - 14
1:2:1
$46.00
100Wool

Kate
REJ2001
Fashion Forward
100Wool

Whisper
Slate
Victoria
Stone

Delivery: 2/1 - 3/15
Sizes: 2 - 14
1:2:1
$85.50

London
REWB3001
Fashion Forward

Whisper
Stone
Slate

Delivery: 2/1 - 3/15
Sizes: 2 - 14
1:2:1
$56.00
98Wool/2Spandex

Coco
REJ1001
Carryover
Reorderable

Delivery: 2/1 - 3/15
Sizes: 2 - 14
1:2:1
$73.50
100Wool

Whisper
Bashful
Victoria
Slate

Stacey
REWB1001
Carryover
Reorderable

Delivery: 2/1 - 3/15
Sizes: 2 - 14
1:2:1
$29.00
98Wool/2Spandex

Rare Designs

Color Plate 🄶 Rare Designs line sheet. *(Illustration by A. Flanagan.)*

alphabetical size designations.* Common numeric size ranges include misses (even sizing), petite (noted with a P), juniors (odd sizing), and men (by chest or neck/sleeve length). Alphabetical sizing is generic for all categories and noted as XS through XXXL (Keiser and Gardner 2003).

Most apparel companies develop their own size specifications (Keiser and Gardner 2003), although they can use standard size data such as SizeUSA. SizeUSA data indicates most American women ages 18–65 have a bust size range of 39.1" to 43" and hip size range of 41.8" to 45.9" for all ethnic groups (SizeUSA 2004). Using a standard body measurement table, the average woman would be size 14 to18. However, since apparel manufacturers create their own size specifications, they might label these measurements as sizes 10, 12, and 14 (Keiser and Gardner 2003). A company's size range depends on its target market. For instance, Torrid's size range is 12–26 (SEC March 22 2006), whereas Talbots carries a wide range of sizes, including women's sizes 12–24 (SEC April 10 2007), misses sizes 2–20, and petites sizes 2P to 16P (Talbots 2006).

To increase fabric utilization and the reorderable plan, apparel companies may designate minimums by size scale. **Size scale** is the quantity of a product in sizes that an apparel manufacturer sells. A size scale is in conjunction with minimum quantities and is a set quantity per size, expressed as a ratio. Common size scales are 1:2:1, 1:2:2:1, or 2:3:1. A 1:2:1 size scale means the retail customer buys each style in quantities of four: one small, two medium, and one large (see color plate 16). Marker making associates create cost markers to determine a company's size scale (Regan 1997, 268). Using a size scale assists apparel manufacturers with production planning.

The minimum quantity a retail buyer can purchase depends on the size scale. We use Rare Entities' Kate jacket and London pants as a size scale example. A minimum by size scale does not designate colors; however, many retail buyers will purchase a size scale per color.

To calculate:

1. Total the size scale (e.g., 1:2:1 = 4 in sizes 8, 10, 12).
2. Multiply the answer in step 1 by the wholesale price (e.g., Kate jacket: $85.50 × 4 = $342; London pants: $56 × 4 = $224).
3. Multiply the answer in step 2 by the number of desired colors (e.g., Kate jacket: $342 × 3 = $1,026; London pants: $224 × 3 = $672).
4. Add the subtotals (e.g., $1,026 + $672 = $1,698).
5. A retail buyer would pay $1,698 to buy a coordinate outfit with the Kate jacket and London pants. This outfit would be available in the retail store in three colors and three sizes.

Size and Color

Selling styles by size and color is another minimum approach that apparel manufacturers use. This manufacturer may have low minimums. Retail customers are not limited to buying preset size scales; rather, they can buy whatever sizes match their consumer buying patterns. On the product line sheet, a size/color minimum designation is per color. For

*Refer to books such as *Ready-to-Wear Apparel Analysis* by Patty Brown and Janett Rice for a description of common product sizing.

example, a minimum of three means that the retail customer will buy three of each desired size. If the retail customer ordered S, M, L, and XL, the order quantity would be twelve.

Suppose that a retail buyer purchased Rare Entities' Jane knit top and Brynn tailored pants. Assume the retail buyer wants to purchase three of the available colors. To have a product mix, the retail buyer would purchase a size range, such as 2–12.

To calculate:

1. Add the number of sizes (e.g., 6 for sizes 2 to 12).
2. Multiply by the wholesale price (e.g., Jane knit top: $19.00 × 6 = $114; Brynn pants: $46.00 × 6 = $276).
3. Multiply by the number of desired colors (e.g., Jane knit top: $114 × 3 = $342; Brynn pants: $276 × 3 = $828).
4. Add the subtotals (e.g., $342 + $828 = $1,170) to calculate the wholesale purchase price of the Jane knit top and Brynn pants outfit.

ACTIVITY 12.7 *Calculating a Per-Color/Size Purchase*

You want to order a brushed twill zip jacket. Calculate the dollar value of the wholesale order if you order *two* different colors from a size range of XS–XL. The wholesale price is $28.50. The minimum per size is 3 and you want to order a complete size range. The available colors are navy, black, ivory, red, and brown. What is the answer?*

Total Dollar Quantity

Some apparel manufacturers do not dictate color and/or size for wholesale orders; rather, they require a minimum dollar purchase (e.g., $500). A minimum dollar purchase is the least restrictive for retail buyers because they can buy individual sizes and colors. This option can make it difficult for production planners to forecast quantities because they only know how much to cut and sew after the retail buyers place orders. A misnomer is for apparel manufacturers to state that they have no minimums. Literally, no minimums equate to a zero quantity and, to place an order, a retail buyer must buy at least one item. It is more accurate for apparel manufacturers to state that they have no restrictions. This indicates that the retail buyer can purchase any size and quantity desired.

To calculate:

1. Establish the minimum dollar amount (e.g., $500).
2. Add the number of sizes and colors you want (e.g., 3 sizes in 1 color).
3. Multiply the answer in step 2 by the wholesale price (e.g., 3 × $15.00 = 45).
4. Divide the dollar minimum by the answer in step 3 (e.g., $500 ÷ $45 = 11.1).
5. Round to the next whole number. You can buy 12 pieces. Your order will be $540. (Note you cannot order under the minimum amount.)

*$855.00 (15 garments × $28.50 × 2 colors).

Activity 12.8 *Calculating a Minimum Amount Purchase*

Rare Designs has a $500 minimum. You own a boutique and only want to buy enough merchandise to display on a fixture; therefore, you want to buy as close to the minimum amount as possible. You can buy from a size range of 2–14 and the most colors offered for a style is 4. For a visual and wholesale price, refer back to Color Plate 16.

Prototype Request and Approval

First pattern makers create prototypes simultaneously to CAD artists developing line sheets. Pattern making is a discipline in itself.* The focus of this discussion is the verbal and written communication that first pattern makers and sample makers need to create accurate prototypes. First pattern makers interpret a designer's sketch or reference information to design pattern pieces using a computer. They are responsible for following through with prototypes and its review Regan (1997, 244, 246). Pattern makers must understand textiles and three-dimensional space (U.S. Department of Labor 2006–2007). Successful first pattern makers are organized, detail oriented, able to work in a fast-paced setting, and able to meet multiple deadlines.

It is important for the design team to use proper terminology when requesting prototypes. A neophyte can easily confuse prototypes, samples, and production samples. A **prototype** is a pattern that a first pattern maker creates and sample makers sew (Regan 1997, 244). It turns an illustration into a three-dimensional product. The primary reason to create prototypes is to present them at the product line review meeting so the team can evaluate whether it will be a profitable product (256). Designers use prototypes to evaluate a design concept and to present the product line to the design team and company executives. The design team approves prototypes and submits a line sheet to create garment samples. Sales representatives show **samples** as part of the product line at trade shows or market weeks, or to accounts. Colloquial phrases for samples include *duplicates* or *road samples*, meaning that the sales representatives take these garments on the road with them. A **production sample** is an exact visual example of how to construct the garment. Manufacturing associates will call a production sample a **sew-by** because operators use it to determine how to sew a garment. Production planners use a sew-by to determine construction, sewing sequence, and final costs. In manufacturing line supervisors and sewing operators use production samples as a quality control comparison. One could liken a sew-by to a visual *contract* in which production must match it.

Sewing Prototypes

Apparel companies will develop prototypes in-house or with contractors (Figure 12.10). First pattern makers need experience because they have to quickly create patterns that sample makers sew to meet tight line review deadlines. Time is often tight to create prototypes. According to Catherine Loeffen, sample coordinator for American Apparel Inc. 🇺🇸, in-house prototype creation has a quick turnaround (1 day), whereas with international

*See pattern-making books such as *Patternmaking for Fashion Design* by Helen Joseph Armstrong.

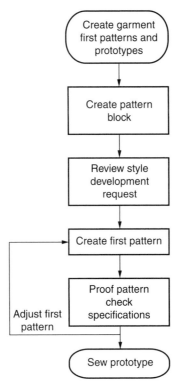

Figure ⓬.⓾ Requesting, creating, and sewing first prototypes. *(Chart by Karen Bathalter.)*

contractors it typically takes 2 weeks. It is common for designers to say, "Just go ahead and make something you can do. We will evaluate it when we get it and change or accept it."

The designer initiates the prototype process by submitting a request to the first pattern maker or sample developer. The author observed in a tour of American Apparel that creating first prototypes can be an informal process in which a designer hands or faxes a sketch to a pattern maker and says, "I need this prototype today." Some companies have a formal prototype development process. A formal process involves writing up a technical package (Regan 1997, 246, 247), which a technical designer creates. A technical package, commonly called a **tech pack**, is documentation of a prototype request; pattern creation; and prototype sewing, measurement specifications, and preproduction information. At the prototype stage, tech pack information includes a cover sheet, general description, fabric, pattern, and trim information. Technical illustration includes a short written description, size dimensions, and garment sketch (Eckert and Stacey 2003). Submitting a prototype request requires designers to know garment construction. For instance, if a designer simply indicates that he or she wants a pleat down the front and gives no additional clarification, the pattern maker decides whether to use purchased pleating fabric or create pleats in the pattern.

Some apparel companies create prototypes for every garment in the product line, whereas others will only sew new garments. New styles are challenging because pattern makers develop measurement specifications, create a new pattern, and produce multiple

Figure 12.11 Pattern makers create first and production patterns using CAD programs. *(Courtesy of TUKAgroup, 2006.)*

prototypes. First pattern makers refer to the tech pack instructions to create patterns. These instructions include a sketch, fit specifications, assembly information, special operations instructions, and price structure. So the design team can accurately review garments, pattern makers use the same fabric specifications, such as weight, stretch, and fiber content, as what will be used in production (Regan 1997, 244). According to Kimberly Quan, designers will either order sample fabric or use in-stock inventory to create prototypes.

Pattern makers use pattern blocks or a similar garment style as a starting point to create first patterns (Figure 12.11). Companies create and use pattern blocks to ensure a consistent fit within its brand. A **pattern block** is an established garment fit for each fiber type and fabric (e.g., 100 percent cotton knit). The pattern maker creates a block for each base style, fiber content, and fabrication (Regan 1997, 240). Establishing fit is extremely important because it creates a loyal consumer base of return purchasers. Some companies that work with international contractors use pattern block hosting. According to Ram Sareen of Tukatech, **block hosting** is a dedicated computer pattern service for apparel companies who deal with multiple full-package contractors. Companies, such as Tukatech ⏁ offer this service. The computer service company stores master pattern blocks in a generic CAD format. Contractors can only assess their clients' pattern block via a reference number associated with a garment design. Block-hosting advantages include accessibility of downloading the pattern block at any time, achieving a consistent garment fit among multiple contractors, and downloading generic pattern-making files for use in multiple CAD formats.

Apparel manufacturers or contractors often sew prototypes in a sample/prototype department. Operators sew prototypes on production equipment because it is a test for full

production. A **sample coordinator reviews** prototype requests with pattern makers. **Sample line supervisors** oversee operators that cut and sew prototypes and samples. A sample line supervisor needs to interpret how to construct garments without instruction and relay this to sample-sewing operators.

Sample line supervisors and sample makers rely heavily on illustrations. CAD line art is the ideal submission because it often includes construction details that sample makers need. A properly drawn sketch is more important than a verbal explanation, which is often incomplete or inaccurate. If a designer submits a quick and incomplete sketch, he or she will most likely receive an incorrectly sewn prototype.

Prototype Review

The advantage of seeing the transformation from a two-dimensional sketch to a three-dimensional prototype is that the design team can clearly evaluate its aesthetics and functionality. They will compare the prototype to their instructions or the tech pack (Regan 1997, 248). Designers check prototypes for aesthetics and fit. Designers need to understand pattern making to accurately communicate how to construct garments (U.S. Department of Labor 2006–2007) and to evaluate fit. Ideally, a designer has a positive response, such as, "Oh, wow, this is cute!" If they are dissatisfied with aesthetic or technical features, they discuss the prototype with the first pattern maker. If designers and pattern makers are in the same physical locale, they discuss pattern or construction changes in person. Face-to-face meetings among design, pattern making, and production decrease prototype and subsequent production errors (Regan 1997, 174, 248).

It is difficult to communicate pattern making when preproduction associates are not physically located with the design team. When designers work with international contractors, they often review patterns and prototypes through e-mail, phone calls, or facsimiles. It is challenging to verbalize or write about the process of making pattern adjustments without visually comparing a pattern with its corresponding prototype.

Teleconferencing and shared computer systems are methods that enable physically distant first pattern makers and designers to visually evaluate garment fit and corresponding pattern pieces. At Byer California both the design team and first pattern makers, in different locales, use two different fit models, one in each locale. Their designers and pattern makers will view the fit models using teleconferencing facilities. They discuss needed pattern changes and reevaluate a second time if needed. Alternatively, according to Stephen Wolfson of Tukatech, apparel companies will body scan live fit models and use these measurements to develop custom dress forms (Figure 12.12). Distinct advantages are that custom dress forms meet a company's measurement specifications, standardized fit is achieved among domestic and international cut-and-sew contractors, and the design team and contractors can have duplicate forms in differing geographic locations. The use of custom dress forms increases communication among the design team with contractors because they use the same custom dress form to communicate and thus see the same design, fit, or pattern-making problems.

The prototype review may require pattern, specification, or construction revisions. Sometimes, the design team requires prototype design revision in order to accept it into the seasonal product line. Time is short. Multiple prototype revisions create chaos because of time pressures. The design team has to balance perfecting prototypes with the time allotted to complete samples.

Figure 12.12 Designers and pattern makers use custom dress forms developed from body scan measurement data to duplicate and share live fit model dimensions with contractors. *(Courtesy of TUKAgroup, 2006.)*

Once the designer and patternmaker approve the prototype, it is used at design review and production review meetings (Regan 1997, 248, 273). Designers submit approved prototypes as part of a sample package to the sample/coordinator, who in turn oversees sample production (275). It is imperative that a company has correct garment samples. A sample, in essence, is a visual agreement that this is the product a retail buyer will receive at purchase. An incorrect garment sample is a deterrent to a garment's sales potential.

Best Practices in the Prototype Process

It is important to clearly communicate instructions to prevent prototype delays or frustration. Some best practices are as follows:

- Submit clearly drawn detailed illustrations and tech pack instructions. Incomplete and inaccurate information leads to rework because a sketch is easily misinterpreted.
- Stagger prototype development so it does not jam up during sample making. The peak prototype time is 1–2 weeks before line release.
- Learn how to communicate the correlation between pattern making and fit.
- Use consistent measurement fit models or custom dress forms among the design team, pattern makers, and contractors.

Line Review Meeting

Imagine the flurry of activity as the design team completes storyboards, line sheets, and prototypes and makes final line review preparations. A **line review** meeting is a set date on the time-and-action calendar in which the designers and merchandisers present the product line to company associates. Line review meetings, also called *concept* or *merchandise committee meetings*, comprise the final step before line release (Regan 1997, 199). Designer Kimberly Quan explained that line review meetings occur in conference rooms with wall grids on which associates set up prototypes, storyboards, and other inspirational ideas. The overriding factor of a line review meeting is that company associates either accept or discard garments from the product line.

A line review meeting is not simply a presentation; rather its purpose is to convey seasonal product lines to company associates to project units and identify any potential manufacturing problems. Merchandisers, design directors, and designers lead line review presentations. Many company associates participate in this presentation, including those from forecasting, operations, pattern making, and purchasing. At the line review, the design team addresses current market trends and the direction that each SBU will take, as well as product line analysis and projected units (Regan 1997, 199).

Market Trends and SBU Direction

Designers work closely with their design director, after which they need to convince company associates that the interpretation of market trends fits with SBU direction (Regan 1997, 199). The main objectives of design review are to convey a clear product line, present a strategic design strategy, and determine the relevancy of products designed (Porter 1996).

A designer's context is the desire to create beauty (Florida and Goodnight 2005), so they will often point out the seasonal line's aesthetic elements and fashion trends. Designers need to be able to sell their ideas and stimulate executives to listen. Thus, designers gear their presentation on their design strategy and explain any additional costs, risks, time, or associates needed to implement new ideas (Levitt 2002). Designers show their storyboards and identify how they developed their concepts (Regan 1997, 199). For each storyboard, the designer explains core, carryover, reorderable, and new garment body silhouettes. For core and carryover styles, designers explain how they updated seasonal silhouettes, made fabric changes, or added special operations.

Designers anticipate that participants will ask questions on garment construction, fabric, and trim selections. Designers elaborate on new garment construction; especially garment bodies that the company has not produced before. Fabric details include new developed fabrics (e.g., sheer jersey knit), fiber content, fabrication, expensive dyestuffs, or washes. The audience may scrutinize newly developed fabrics; for example, whether they will be in one or multiple fabrications and whether multiple SBUs will share them. Some concerns include whether a print will be on multiple fabrications, such as a knit and a woven; whether designers will use the same vendor for multiple fabrications; and how the design team will ensure color matching. For special operations, designers detail any new send-out application such as garment wet processing or distressing finishes. Company associates evaluate the designer's garment ideas to ensure that the designer's interpretation

meets target market needs. If company associates question a garment body, design directors respond by justifying how the products that are offered meet target consumer needs and value provisions. Design directors also explain potential best-selling styles, and talk to production and operations managers about any construction restraints.

The design team must balance the meeting of margin goals with the designing of products that target consumers will buy. Designers might create garments that are priced above the company's price point. At line review, designers present margins that they calculated on cost sheets. Designers do not immediately rule out expensive fabrics, colors, or trims. Rather, executives evaluate the overall product line based on margin requirements. If a designer develops a risky, more expensive product that does not meet margin goals, the group may decide to produce the style in limited quantities, change the garment to improve margin requirements, (e.g., remove embroidery), or drop it from the apparel line. Designers will have to convince executives to keep a low margin garment in the product line, but as one merchandiser commented, "Embroidery may be why the consumer buys the garment" (Regan 1997, 171). Designer Kimberly Quan described what occurs at a design review:*

> At the design review, I will hang up samples. I talk about where I came up with ideas and how it will translate into our market. For the most part, executives want to make sure that all our bases are covered. For example, certain customers always need cap sleeves, so they will ask me to add a sleeve onto a dress or add more styles with sleeves. Sometimes they will eliminate a garment because the price is too high. It can be the cutest dress in the product line, but if it does not meet our margin goals, then it will be dropped. A designer always has to remember that nothing is personal. Executives will change your designs for many reasons, so you need to have a tough skin. Everyone in the company works for its best interest, and our ultimate goal is to help the company and the business grow.

ACTIVITY 12.9 *Critical Thinking*

In the previous quote, the designer talks about how she came up with ideas and how these ideas will translate into her market.

- For your company project, write how you came up with your garment ideas.
- Explain how your ideas translate into your target market.
- Explain why your target consumer will buy your products.

Projecting Unit Quantity

Projecting how many products the company will produce is an important part of line review meetings. The design team evaluates each product for its salability and manufacturability. Merchandisers present their line parameters and major retail customers' reactions from preline meetings. The focus of the merchandiser's presentation is, "Will these garments sell, and how many will sell?" Merchandisers identify predicted best-selling styles, questionable garment bodies, fabric and trim selection, and first costs (Regan 1997, 196).

*Reprinted by permission from Kimberly Quan, designer, Cerritos, CA; pers. comm., June 21, 2006.

Merchandisers present a numeric breakdown of core, carryover, fashion-forward, and reorderable styles. They will detail the product line prediction for growth categories and any prediction for new garment bodies. Merchandisers will address any questionable garment bodies in which key account retail buyers had mixed reactions. They will explain how the design team addressed product line changes. Naturally, apparel manufacturers and private-label retailers relish the times when select products become hot sellers for their retail customers and, finally, the consumer. Retail customers and apparel manufacturers know all too well that consumers ultimately determine which products will be viable retail offerings (Federated Department Stores 2005).

Merchandisers are well aware that their retail customers have stringent productivity requirements. They develop their line plans to maintain margin goals. Shuba Pillai, Target Stores' executive team leader—Softlines, explains:*

> Buyers have margin goals that are sometimes hard to reach. Apparel manufacturers need to think about their products in relation to their retail customers' margin requirements. A Target buyer may plan to bring in T-shirts at $12.00, but something may happen, such as they ordered too many, we have extra stock, or other reasons, so we will mark down the start price to $8.50. While it may decrease profit margin of the individual product, it doesn't for the overall classification. We need to do this to sell product. Another situation is not selling all the pieces. For instance, our buyer bought 10,000 pieces to sell at $12.00, but we only sold 50% of the stock. We have to mark it down to sell through. So now, 5,000 pieces sell at $7.99, which makes the buyer's margin below cost.

ACTIVITY 12.10 *Critical Thinking*

Referring to the previous quote, provide an example of a seasonal product for which delivery to the store on a certain day is critical. How would you get maximum sell through if your seasonal product arrived late?

SUMMARY

Finalizing product lines involves strategic thinking, creativity, and the time pressure to pull everything together. This chapter is the culmination of how the design team relates inspiration and trend forecasts to a company's vision, mission, and product line strategy. To achieve this, designers create storyboards, line sheets, and prototypes that unify their efforts.

The sales package, which includes storyboards, line sheets, and prototypes, requires attention to detail. CAD artists write information on line sheets that design team associates provide. Some information includes style descriptions and minimums. The pattern maker leads the creation of prototypes, which they review for aesthetics and fit with

*Reprinted by permission from Shuba Pillai, executive team leader—Softlines, Target, Upland, CA; pers. comm., May 25, 2007. This is a personal statement. The views and opinions expressed do not necessarily reflect those of Shuba Pillai's employer.

designers. Merchandisers and designers are responsible for meeting margin goals in which they work with costing specialists.

At line review, the design team conveys its goal of continually changing product offerings to increase the company's profitability and/or market share. "Never stand still" is an important motto in the apparel industry.

COMPANY PROJECT 11
STORYBOARD AND LINE SHEETS

The goal of this project is to create two storyboards and corresponding line sheets that match your company's mission, consumer target market, and theme for a future seasonal release. Design associates create storyboards and line sheets to sell a line to retail buyers and communicate internally to company associates about upcoming seasonal product lines.

Step 1 Preparation

1. Create/use a product line template following the instructions in Activity 12.3.
2. Place core garment 1 and core garment 2, one carryover body and one new garment body from Company Project 10 into your product line template. Save your drawing as "Storyboard_your last name."
3. Repeat steps 1–2 except your second storyboard should have a different carryover and new garment body. You need to have the following on each storyboard:
 a. Two core garments (*same two styles go on both storyboards*)
 b. Two carryover garments (*one style per storyboard*)
 c. Two new garments (*one style per storyboard*)
 d. One reorderable garment (*one style per storyboard*)

Step 2 Storyboard Layout

1. Create one storyboard for each theme you created in Company Project 7 (theme boards).
2. Fill your core, carryover, and new garment bodies with color and fabric patterns from the swatch menu. You should have three to four multiple colors or prints for your garment bodies (e.g., each design in three to six colors). Follow Activity 12.5 guidelines for creating salable product groups.
3. Read and follow the information in the Storyboard Layout section. Arrange your garments on an imaginary grid, and use the design principles (i.e., balance, emphasis, rhythm). See Color plates 14 and 15 for two storyboard examples.
4. Create color boxes or fill garment bodies with color and fabric designs following the information in the Grid Format or Overlapping Garment Bodies sections of this chapter. You do not need to use all colors in your color delivery for all garment bodies.
5. Type each garment body style name, SKU, and whether the style is a core, carryover, directional, fashion-forward or reorderable garment. See Chapter 11 for information on assigning SKUs.
6. Print a proof copy in black and white. Correct spelling, inconsistencies, or font size. Print in color.

7. Mount the storyboard on two foam core boards or cold-press illustration boards (recommended size: 11″ × 14″).
8. Turn in a CD with your drawing (or post to a class website). Label your file as "Storyboard_your last name." Your drawing needs to be a computer graphics file (e.g., Adobe Illustrator, not PDF).
9. Paste Activity 12.2 to the back of your storyboard.

Step 3 Line Sheet Layout

1. Open your storyboard file. Save as "Linesheet_your last name."
2. Read and follow the information provided in the Creation of Sales Package section in this chapter. Add a sales description that has delivery dates, fabric type, size range, minimums (size scale, size and color, or total dollar quantity) and wholesale price (Refer to color plate 16 for an example).
3. Printing and page setup: A sales sheet is $8\frac{1}{2}″ × 11″$ (landscape or portrait). You may print multiple line sheet pages, if desired. Be sure images are within the margin. Print a proof copy in black and white. Verify that SKUs, colors, and style names are consistent with the storyboard.
4. Print a final color copy.
5. Turn in a CD or post to a cross website with your drawing file labeled as "Linesheet_your last name." Do not mount line sheets on illustration board. Sales representatives hand out sales sheets to potential retail buyers at trade shows and market weeks.

PROJECT EVALUATION ▬▬▬▬▬▬▬▬▬

Suggested criteria for project evaluation are as follows:

Completeness: One can easily identify your theme in your garment designs. The garment designs relate to phrases used in your company vision and mission statement. The designs are appropriate for your target market.

Product design: You drew six designs. Your line sheet(s) has two core, two carryover, and two fashion-forward garments. At least one garment is a reorderable. The fashion-forward and carryover styles coordinate with the core garment.

Drawing skill: Your drawing technique is excellent, you have smooth lines, smooth curves, filled garment shapes with color, smooth and connected corners, and added shaping to your silhouettes.

Scaling: You drew and maintained the garment scale (according to the nine-head croquis). Garments are not scaled such that they are too small or too large. Each garment has the same scale.

Design clarity: A buyer can *read* what the garment style looks like, the details are clear (e.g., a collar looks like a collar). Garments do not overlap too much as to cause confusion. You have used layers to draw. You grouped garment shapes so it moves as a whole. The garment colors are from your theme board.

Use of design principles: Your visual presentation shows excellent use of symmetrical or asymmetrical balance, emphasis (a focal point), and rhythm (visual movement). Good = two out of three design principles, fair = one of three design principles. You aligned color swatches, labeling, and garments.

Fabric creation: You created two properly scaled original fabric designs (print, texture, or wash). You put fabric designs in two or more garment bodies or an embellishment. You put your color story and fabric designs in swatches and labeled them with color names.

Consistency: Your line sheet is creative and includes proper labeling. The sales sheet includes style name, SKU wholesole, price, delivery date, minimums, colors, and size, range and fabric. The concept board labeling is consistent with the line sheet.

Completeness: You posted both storyboard and line sheets to Blackboard project. You created a line sheet and storyboard(s) for each theme and printed them in color. The sheets are the correct size ($8^1/_2'' \times 11''$).

Professionalism: Your project is professional and neat. Your spelling is correct. You securely glued, neatly cut, and mounted the storyboard to illustration/foam board. You neatly cut the illustration board.

PRODUCT DEVELOPMENT TEAM MEMBERS

Costing specialist: An individual that calculates regular garment cost and margins and reviews cost sheets. Traditional apparel manufacturers assigned costing specialists to engineering departments. Many companies have transitioned this position to the finance department.

First pattern maker: An individual who can interpret a designer's sketch, create CAD patterns, and follow through with prototypes and review. Successful first pattern makers are organized, detail oriented, able to work in a fast pace setting, and able to meet multiple deadlines. They are able to work in multiple fabrications using CAD pattern-making programs.

Production Coordinator: An individual that plans and schedules production. For companies that contract production, the production coordinator locates and negotiates production with contractors. For companies that cut and sew internally, the production coordinator determines assigns production to sewing operators or teams based on style forecast and raw material inventory.

Sample developer: An individual that assists in developing prototypes, samples, and send-outs (screen printing). This individual must have a college degree in apparel and textiles. He or she also needs to possess garment construction knowledge and computer skills (U.S. Department of Labor 2006–2007).

Sample line supervisor: An individual that supervises sample-sewing operators. He or she also needs to possess extensive garment construction knowledge and bilingual skills.

KEY TERMS

Block hosting: A dedicated computer pattern service for apparel companies who deal with multiple full-package contractors.

Bring concepts to the table: A colloquial phrase that means apparel manufacturers are responsible for creating design concepts, which they present to retail buyers.

Delivery date: A calendar day on which the manufacturer ships product to retail customers.

Delivery window: A set time period in which the manufacturer will ship goods.

First cost: An estimated garment cost.

Flowing in: A colloquial phrase that means designers purposely tie colors, fabrics, and silhouettes back to a core garment that drives a company's fashion and new products.

Line review: A meeting in which the designers and merchandisers present the product line to company associates.

Line sheet: A document with detailed product description. It includes garment illustrations and corresponding sales description such as SKUs, wholesale prices, delivery dates, and size range.

Margin: The difference between the cost of goods and an individual garment style's wholesale price.

Minimums: The lowest quantity that a retail buyer can purchase. Three common minimums are by size scale, size and color, and total dollar quantity.

Pattern block: An established garment fit for each fiber type and fabric (e.g., 100 percent cotton knit).

Preline: A meeting in which the merchandiser presents storyboards to retail customers.

Product line template: A computer graphics file with common elements to all seasonal storyboards and line sheets, such as company information, seasonal colors, fabrications, and prints.

Production sample: An exact visual example of how to construct the garment. Also called a *sew-by* because operators use it to determine how to sew a garment.

Prototype: An approved garment body. A first pattern maker creates a pattern and then sample makers sew to create a three-dimensional model.

Sales package: Documents and products used to sell a product line, including computer graphics, a price book, samples, swatch cards, garment samples, and a catalog.

Sales sheet: A product line description that a sales representative gives to retail buyers. Also an interchangeable term with *line sheet*.

Samples: Product shown at trade shows or market weeks, or to accounts.

Sew-by: A production sample that operators use to determine how to sew a garment.

Size range: A product's smallest to largest size (e.g., sizes 2–14).

Size scale: The quantity of a product that the manufacturer sells.

Storyboard: A collection of sketches, fabric, and color swatches that express the design direction (Keiser and Gardner 2003).

Tech pack: An abbreviation for technical package. Documentation of a prototype request; pattern creation; and prototype sewing, measurement specifications, and preproduction information.

WEB LINKS

Company	URL
Amelie	www.shopamelie.com
American Apparel	www.americanapparel.net/
Ashworth Inc.	www.ashworthinc.com/
Byer California	www.byer.com/
Healthtex Kidproof	www.healthex.com
Karen Kane Inc.	www.karenkane.com

National Retail Federation	http://www.nrf.com/modules.php?name=Pages&sp_id=391
Philips-van Heusen	www.phv.com/
Quiksilver Inc.	www.quiksilverinc.com
Target Stores	www.target.com/gp/homepage.html
Tukatech	www.tukatech.com/

REFERENCES ▬▬▬▬▬▬▬

Eckert, C. 1997. Design inspiration and design performance. In *Textiles and the information society.* Paper presented at the 78th world conference of the Textile Institute in association with the 5th Textile Symposium, Thessalonike, Greece, 369–87.

Eckert, C., and M. Stacey. 2003. Sources of inspiration in industrial practice: The case of knitwear design. *Journal of Design Research* 3 (1):1–18. http://www.inderscience.com/ browse/index.php? journalID=192&year=2003&vol=3&issue=1.

Federated Department Stores. 2005. Annual report. Macy's Inc. Annual reports 10-K archives. http://www.federated-fds.com/company/ann_archives.asp.

Florida, R., and J. Goodnight. 2005. Managing for creativity. *Harvard Business Review* 83 (7): 124–31.

Goodnight, J. 2005. The beauty of an open calendar: James Goodnight on meetings. *Harvard Business Review Online.* Reprint No. F05041 (April). Boston: Harvard Business School Publishing. WilsonWeb.

Keiser, S. J., and M. B. Gardner. 2003. *Beyond design: The synergy of apparel product development.* New York: Fairchild.

Levitt, T. 2002. Creativity is not enough. *Harvard Business Review Online.* Reprint No. R0208K (August). Boston: Harvard Business School Publishing. WilsonWeb.

LT Apparel Group. n.d., Our brands, Healthtex. http://www.ltapparel.com/OurBrands/Healthtex/ tabid/58/Default.aspx.

Philips-Van Heusen. 2005. Investor relations: Corporate strategy. http://www.pvh.com/ InvestorRel_AnnualReports_04_05.html.

Porter, M. E. 1996. What is strategy? *Harvard Business Review.* Reprint No. 4134 (November–December), 61–78.

Regan, C. 1997. A concurrent engineering framework for apparel manufacture. PhD diss., Virginia Polytechnic Institute and State University.

Regan, C., D. Kincade, and G. Sheldon. 1998. Applicability of the engineering design process theory in the apparel design process. *Clothing and Textile Research Journal* 16 (1): 36–46.

Riegelman, N. 2006, 9 *Heads* 3rd. ed. Upper Saddle River, NJ: Pearson Education.

Standard and Poor's. 2005, September 8. *Apparel and Footwear Industry Survey.* New York: Standard and Poor's Corporation.

Talbots. 2006, July 24. New survey reveals most women shop by size, but don't know their measurements. Press release. https://chat.talbots.com/netagent/default.asp?BID=&h=Mc.

U.S. Department of Labor. n.d. Wages, minimum wage. http://www.dol.gov/dol/topic/wages/ minimumwage.htm.

U.S. Department of Labor 2006–2007. Textile, textile product, and apparel manufacturing. *Occupational Outlook Handbook.* http://www.bls.gov/oco/cg/cgs015.htm.

U.S. Securities and Exchange Commission. 2006, March 22. *Form 10-K: Annual report for the fiscal year ended January 28, 2006, Hot Topic, Inc.* Washington, DC: U.S. Government Printing Office. http://www.sec.gov/Archives/edgar/data/78239/000007823907000011/tenk20407.htm.

U.S. Securities and Exchange Commission. 2007a. January 16. *Form 10-K: Annual report for the fiscal year ended October 31, 2006, Ashworth, Inc.* Washington, DC: U.S. Government Printing Office. http://sec.gov/Archives/edgar/data/820774/000093639207000026/0000936392-07-000026-index. htm.

U.S. Securities and Exchange Commission. 2007b. February 26. *Form 10-K: Annual report for the fiscal year ended December 31, 2006, Jones Apparel Group, Inc.* Washington, DC: U.S. Government Printing Office. http://www.sec.gov/Archives/edgar/data/874016/000087401607000006/0000874016-07-000006-index.htm.

U.S. Securities and Exchange Commission. 2007c. February 28. *Form 10-K: Annual report ended December 30, 2006, Carter's Inc.* Washington, DC: U.S. Government Printing Office. http://www.sec.gov/Archives/edgar/data/1060822/000110465907014975/a07-5344_110k.htm.

U.S. Securities and Exchange Commission. 2007d, April 5. *Form 10-K: Annual report for the fiscal year ended February 4, 2007, Philips-Van Heusen Corporation.* Washington, DC: U.S. Government Printing Office.

U.S. Securities and Exchange Commission. 2007e, April 10. *Form 10-K: Annual report ended February 3, 2007, The Talbots Inc.* Washington, DC: U.S. Government Printing Office.

von der Weth, R. 1999. Design impact: The development of individual strategies. *Design Studies* 20 (5): 453–63. Science Direct.

SHOWTIME!

"Hi, everyone!" Tamee says as she prances into the conference room displaying an air of confidence and wearing a deep purple knit fit and flare dress with Juliet set-in sleeves. Tamee completes her look with tights and ankle boots, which emphasize her creative personality.

"Tamee, you're early!" a shocked Ron says.

"Can you believe it? I actually like using the time-and-action calendar. It keeps me on schedule, and I have everything ready," she grins broadly.

Tamee begins arranging the prototypes on the wall grid. Jaynie Lee enters with another stack and helps Tamee with her display. "I love your outfit!" whispers Jaynie Lee, not wanting to bother Jason as he furiously sets up the conference room.

"You're calmer than last week," Jason says to Tamee, crouching in front of a laptop, camera, the conference room phone, and large screen monitor while organizing the video conferencing equipment.

"I was really anxious that the sales reps wouldn't like my designs, so I treated myself to a day spa. It was great!"

Lauren enters the room in time to hear about Tamee's visit to the spa. "How can you be so calm? I am so nervous. It would take more than a day spa to unwind me!" She grabs Tamee's arm and whispers into her ear, "Ron is really anxious to please Mr. O'Dale. Did you see him today? He's even wearing a suit! What if Mr. O'Dale says my merchandising analysis is terrible and your designs are all wrong?"

Tamee grins. "Oh, relax, Lauren. This is the best part! It's showtime! We've done our homework. Our product line is great! As Kate would say, 'Nothing great was ever achieved without enthusiasm.'* Be enthusiastic! Win Mr. O'Dale over!"

"I think we've got the video conferencing system working," Jason says as he turns on the projector with the remote. He looks at the large screen and can see Mr. O'Dale moving around a conference room. "Look, there he is, thousands of miles away!" Jason slicks back his hair and smoothes out the wrinkles in his purple polo shirt and tan chinos.

"We match!" Tamee exclaims. "We're both wearing Victoria, Rare Designs' signature purple! I am going to stand right next to you, Jason!"

Jason grins, "I get to be in the audience." Just then, a number of independent sales representatives and additional Rare Designs' employees enter the conference room. Jason greets them and hands out the line sheets.

*Ralph Waldo Emerson, quoted in A. Applewhite, W. R. Evans, III, and A. Frothingham, *And I Quote* (New York: St. Martin's Press, 1992), 130.

Ron visits with some of the operations and production associates, while Anne welcomes sales reps that have showrooms in the major market centers, including Dallas, Los Angeles, Chicago, and Florida. The room suddenly gets quiet as everyone looks at the screen and hears Mr. O'Dale's voice prompting, "I'm anticipating good news for our shareholders."

Ron smiles confidently at the camera and says, "Jim, I'm happy to say that we've come a long way, and all of our hard work is finally paying off. I am determined! No more chargebacks from late deliveries or disposing of merchandise because we didn't make the right design decisions!"

"I'm looking forward to your presentation."

Ron clears his throat. He looks directly at Kate, and then the audience. "First, I would like to introduce our mentor Dr. Kate Roberts. I am proud to report that Rare Designs is on the cusp of a comeback. For the past 3 months, Dr. Roberts has been instrumental in guiding us through the product development process. We started by formalizing Rare Designs' vision and mission, developing a time-and-action calendar, and learning design strategy. I am pleased to announce that our product line is on schedule and ready to go to preproduction."

At this announcement, several sales representatives cheer and clap. Ron smiles and goes on "I'd now like to turn things over to my partner, Anne, who will begin this morning's presentation."

O'Dale smiles, thinking "I knew they would like having Kate as their mentor." He sees that Anne is ready to talk. All eyes are on Anne, who projects power and authority in her black-and-tan Chicane pantsuit. Her antique jet earrings and matching bracelet complete the look.

She says, "I think you'll see that our product line will meet this market perfectly. The product line that we are presenting today will reinvent Rare Designs and put our company back on top! We aim to stay one-step ahead of our competitors so we need a unique strategy. The women's career wear market is extremely competitive, and our research indicates that our target market is looking for unique, professional, stylish, and classic apparel that is moderately priced. By studying our young female career consumers, we recognize that they often take great care in selecting their attire and accessories, only to detract from their look by wearing the clunky and unattractive employee ID badges used by many companies. Our team designed an alternative to the existing lanyard by creating a loop for an employee badge. We believe that professional women will like the new look. It will blend into, rather than detract from, their attire. The loop is discreet and looks like a unique design element, which is important for customers who aren't required to wear an ID badge."

Several of the sales representatives nod in agreement and comment, "Good idea! This will be easy to sell!"

Lauren is standing nervously at the front of the conference room listening to Anne and quietly setting up the storyboards. Anne turns to Lauren and says, "My merchandise assistant, Lauren, will now present the product line plan."

Lauren nervously begins, "Good afternoon, ladies and gentlemen. I analyzed our selling reports and found that our trousers and knit shells are our solid-selling core products."

Someone from O'Dale's side pipes up and asks, "Can you speak up? We can't hear you."

Lauren takes a deep breath and says, speaking louder, "Let me explain our seasonal parameters. We developed fifteen SKUs for the Rare Entities product line. . . ." She continues to explain colors and price points, finding her nervousness and apprehension slipping away.

"I am now going to turn over the presentation to my colleague, Tamee, who is one of Rare Designs' top designers," Lauren confidently says as she sits down.

Tamee explains her theme: "Our inspiration was French Impressionist artists. . . ." She continues to smoothly explain her designs and colors at great length.

Feeling the scrutiny in Mr. O'Dale's expression, Lauren stares at the large screen. His eyes question everything Tamee says; he arches his eyebrows when Tamee elaborates on the features of the employee ID badge. Lauren freezes, amazed that Tamee can go on. Lauren thinks, "How can she be so calm? Can't she see Mr. O'Dale's expression?"

"Any questions?" Tamee asks.

"Yes," O'Dale's voice booms. "Did you analyze your competitors to see if anyone else has come up with this design strategy? How much will the ID loop trims cost? Won't it be expensive to attach a small loop to an existing garment?"

Tamee confidently replies, "Yes, 20 cents, and no."

Anne gets up and says, "Let me elaborate on Tamee's response." She explains their thorough competitor analysis. "We found a binding contractor. . . .", and she elaborates on the source. She continues, "Ron was concerned with the labor cost, so he recommended attaching the ID loop in a seam. We calculated the handling and sew time during prototype sewing, and the labor cost is the same as attaching label". Anne concludes with a confident smile as she peruses the room. "By the expressions on the faces of the sales reps, I think we've hit the mark!" she thinks.

"Your design strategy seems logical. I wonder why we haven't thought of creating an ID loop before. The true test is, will it sell?" Mr. O'Dale says, with a thoughtful reflection in his voice.

There is a buzz around the room as the sales representatives' comments can be heard. "I think it will sell." "It's unique." "Once we explain the features, our buyers will like it."

The following week, Rare Designs' team arrives in New York. This is the company's first tradeshow. In the past, each season's release was sold through sales reps at the marts.

"Well, this is it—Nouvenu Collective, a New York pier show! I can't believe we're actually here!" Lauren says in astonishment as tears well up in her eyes.

It is 1 hour before the tradeshow opens. Their New York sales representative gathers the younger members of the design team around the small sales table in the booth. "I know this is your first time showing, so let me explain a few things. First, retail buyers *work the market*, which means that they have set up appointments ahead of time. They are on a tight schedule. They will take numbers, and they will want to know your minimums. Some will ask whether you have immediates. Tamee, many buyers want to hear about the design concept so they can share that with their own consumers. Before they leave, you will want to ask them if you can HFC their choices."

"What does HFC mean?" a wide-eyed Lauren asks.

He smiles, "Hold for confirmation. We need to sell, sell, sell!"

"Here they come!" Jason says, seeing the doors open and people start to mill about.

"Let me add a bit of advice," Ron says. "Retail buyers have this philosophy: Do I know this person? Do I trust this person? Do I honor this person? Okay, now we can fight about price."

"We'll remember that, Ron," Jason says, while Lauren and Tamee nod in agreement.

Two days later Jason exclaims, "The last day at the tradeshow—we were busy! How many appointments did we have? It's all a blur!."

Ron grins, "Success! The retail buyers loved our design concept. Hey, here comes Mr. O'Dale and Kate!" He turns to them and says, "We have good news for you. You're not going to believe this—we have huge orders. I feel great!"

"That's what I like to hear! I've been checking online and following your advance orders, and I'm pleased. Let's go out tonight and celebrate. I'll make the arrangements. We'll dine at one of my favorite Manhattan hotspots," Mr. O'Dale says.

Later at Chef Tony Masi's restaurant, Al Ceppo's, Lauren and Tamee are acting like two young schoolgirls as they decide between the thin flat pasta tossed with New Zealand baby clams, lemon, cream, and white wine and the chicken breast stuffed with goat cheese and sun-dried tomatoes. "I'm starving!" they both say simultaneously and then giggle.

Mr. O'Dale speaks up "It has really been a pleasure to see Rare Designs make a solid rebound. I knew from the beginning that this company had potential because of its good people, and with Kate as your mentor, you couldn't help but succeed. Frequently, I ask my employees what they have learned at work. I think it's important to continue to learn in life. I am going to ask you the same thing. After this interesting experience, what have you learned?"

Tamee is the first to share. "I learned that I actually like the time-and-action calendar. It keeps me organized."

"And I have realized that I have found the perfect job for myself. I love analyzing data," Lauren says as Tamee laughs and adds, "And that's not all you love to analyze. I've seen how you check out Michael from Color at Greige," which makes Lauren blush.

"I learned that having a solid vision and mission is the reason you get up and go to work every day," Ron says.

"I learned that Rare Designs needs to implement a strong design strategy. Design strategy is comprehensive. It means you create a design element that no one else has, whether it's developed fabrications and colors, or a design detail like our ID holder." Anne takes a deep breath and continues, "And most important, you must keep on your toes so that you remain one step ahead of the competition."

"And that means you need to communicate clearly with your textile and trim vendors," Tamee adds.

Jason jumps in with "And with your own team, too."

Kate smiles and holds up her glass. "Success is a learned skill. You must practice it. This is a cause for celebration."* Kate toasts them. "The true test is whether you can

*Bryan, M., J. Cameron, and C. Allen. 1998. *The Artist's Way at Work: Riding the Dragon* (New York: William Morrow and Company), quoted in B. A. Marton, *Releasing the Artist Within: Developing Creativity at Work*. 2000. Harvard Business Review Reprint #C0002C, p. 1.

continue what you have learned for next season's development."

"Oh, we will!" Tamee, Jason, Anne, and Lauren all say at once.

"To Rare Designs and its newfound success!" Anne says as she raises her glass with one hand and reaches for Ron's hand with the other.

"You can count on us," Ron chimes in. "Now, I have a lot of work to do. We need to get all these orders into production!"

Objectives

After reading this chapter, you should be able to do the following:

- Complete the time-and-action calendar.
- Grasp the role of design, merchandising, preproduction, marketing, operations, production, and sales representatives at a sales meeting.
- Summarize the importance of accurately communicating the product line.
- Understand the role of corporate and independent sales representatives in selling the product line to retail customers.
- Understand the differences between fashion weeks, market centers, tradeshows, and virtual showrooms.

You can feel the energy as the design team nears presentation of their seasonal product line. Think about your own reaction the hour before a big presentation. Are you nervous, excited, anxious, calm, or relaxed? It is showtime for design and merchandising associates, and they react just as anyone would as they get ready for the sales meeting. The design team prepares for the formal sales meeting, where they present the SBU sales package to sales representatives. This triggers a product review in which the design team meets with operations and production associates to evaluate garment manufacturability (Figure 13.1). The first half of this chapter presents topics covered in a sales meeting and explains how this information affects multiple apparel company departments within product development, operations, production, and distribution. The second half of the chapter discusses selling the seasonal product line to retail customers at fashion weeks, tradeshows, and market centers. During the sales meeting and line release, company associates and sales representatives may simultaneously compliment and criticize the SBU team for products designed.

ACTIVITY 13.1 *Creating a Time-and-Action Calendar: Continued*

- In cell A38 type "Sales meeting." Fill cell S38. This date starts at the completion of "Revise patterns and sew prototypes."

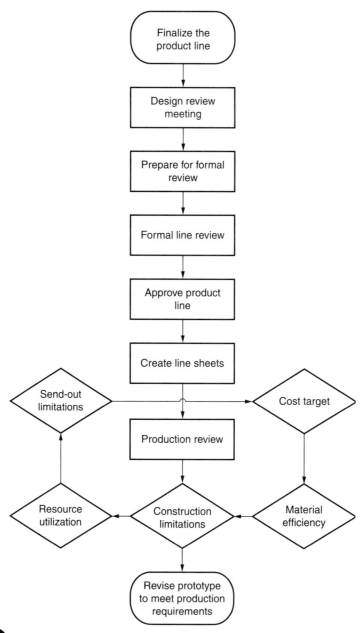

Figure 13.1 Finalize the product line. *(Flowchart by K. Bathalter.)*

- In cell A39 type "Production meeting." Fill cell S39. This meeting occurs the same week as the sales meeting.
- In cell A40 type "Revise patterns and sew samples." Schedule 3 weeks and fill cells S40-U40. This date starts at the completion of the production review.
- In cell A41 type "Complete sales package and ship samples to tradeshow and sales representatives." Fill cell V41. This date starts at the completion of "Revise patterns and sew prototypes."
- In cell In cell 42 type "On-sale date." Fill cell W42

Your seasonal time-and-action calendar is complete! Turn in your completed time-and-action calendar (from all calendar activities in Chapters 4–13).

Sales Meetings

Apparel associates describe the **sales meeting**, also called the "line freeze," as an end and a beginning. The sales meeting occurs on a set calendar date. The design team calls the line freeze "the end" because they can no longer change garments, so it represents the end of the design phase. To preproduction associates the sales meeting is the beginning because they receive line sheets and start preproduction activities, so for them it is the beginning of the production phase.

The purpose of the sales meeting is to communicate direction to product development, preproduction, production, and sales representatives. Apparel manufacturers typically have a sales meeting either at the company headquarters or off-site (Regan 1997, 199). Some off-site locales include meetings at the tradeshow location or at a resort. If the sales meeting is not at the company headquarters, the design team presents to company associates before the sales meeting. With the majority of apparel manufacturers and private-label retail customers being involved with global production, company associates may set up videoconferencing equipment for live interaction or Webcasts. These tools enable off-site industry associates to participate in the sales meeting.

A wide variety of company associates attend these meetings including vice presidents, designers, design directors, merchandisers, purchasers, and sales representatives, as well as personnel from distribution, manufacturing, marketing, operations, and production. Mike Rowley, the owner of Straight Down Clothing Company 👕, noted the importance of working with sales representatives:*

> You are building a relationship with sales people and getting them to buy into a full package. For us, it is lifestyle golf and to provide among the best in products, customer service, delivery, and distribution. We present our vision, which is to sell to the best private golf clubs throughout the country. Of the 25,000 golf courses, we target the top 500 classic golf, modern clubs, and resort accounts. We emphasize to our sales representatives to keep it clean, build our brand, and target the green grass.

*Reprinted with permission from Mike Rowley, owner, Straight Down Clothing Company, San Luois Obispo, CA; pers. comm., March 25, 2005.

Marketing Presentation

One can envision the topics presented at a sales meeting like a funnel, from broad to narrow. The vice president of marketing presents broad issues that influence the company. Merchandisers, for each SBU, present specific numeric forecasts, and designers present a narrow focus in which they detail seasonal themes and garment concepts. The audience actively listens; according to Saul Smith, vice president of operations for Superba Inc. ⬜, they know to ask now because it will be too late to question products tomorrow.

The executive responsible for retail customers starts the sales meeting. This individual, dependent upon the respective company, may be the company owner, vice president of marketing, or director of retail operations. (For our purposes, we refer to this person as the vice president of marketing.) The vice president of marketing covers topics within his or her realm of responsibility, including the management of services for all accounts, marketing, sales, and factory outlets.

Any significant changes to top retail customer accounts directly affect an apparel manufacturer's net sales and quantity projections. Large retail account activities directly influence an apparel manufacturer's total production forecast. These changes include mergers, sales decline, or sales growth. When retail stores merge, such as Federated and May Company in 2005, it can bring an unpredictable swing in production from the loss of large production orders to a substantial increase in production quantities. For instance, in 2003, the Tarrant Apparel Group developed American Rag Cie, an exclusive private label that was sold in one hundred Macy's stores. By 2006, American Rag Cie production increased to six hundred Macy's stores ("Tarrant Apparel breaks. . ." 2006). If a major retail customer has a poor selling season, it would be hard for them to catch up their sales for the remainder of the fiscal year; thus, their executives may project flat sales for the next year. An apparel manufacturer's quantity projections are dependent on their major retail accounts, so operations and production associates pay close attention to this information. If a major customer expects flat sales, then the vice president of marketing needs to project whether there will be growth with other retail customer accounts. If one retail customer anticipates a sales increase, but their executives do not sign this off, apparel manufacturer associates gamble whether to increase their own unit production numbers. According to Saul Smith,* customer service account representatives pay close attention to this information because they are responsible for overseeing retail customers' orders, including logistics of raw material, finished inventory transport, and distribution of product into stores.

ACTIVITY **13.2** *Understanding the Sales Impact of Retail Customers*

- Select two different retail customers from the following NASDAQ retail store list to target as buyers for your product line: Click on the Web links (listed below) to link to apparel corporations for specialty stores, department stores, or mass merchandisers.
 - NASDAQ Listing of Specialty Stores:
 /www.nasdaq.com/reference/BarChartSectors.stm?page=sectors&sec=apparel~ stores.sec&level=2&title=Apparel+Stores. Click on the company symbol. Scroll to

* Much of this section was adapted by permission from a conversation with Saul Smith, vice president of operations, Superba, Beverly Hills, CA pers. comm., March 8, 2005.

the bottom of the company's summary quote and read the company description. Click on "More." Use the keyboard command for "Find" (e.g., control-F) and type "Net income" or "Net earnings." Look for the "Statement of operations."

- NASDAQ Listing of Department Stores: www.nasdaq.com/reference/BarChartSectors.stm?page=sectors&sec=department ~stores.sec&level=2&title= Department+Stores. Click on the company symbol. Scroll to the bottom of the company's summary quote and read the company description. Click on "More." Use the keyboard command for "Find" (e.g., control-F) and type "Net income" or "Net earnings." Look for the "Statement of operations."

- NASDAQ Listing of Mass Merchandisers: www.nasdaq.com/reference/ BarChartSectors.stm?page=sectors&sec=discount~ variety~stores.sec&level=2&title=Discount+Variety+Stores. Click on the company symbol. Scroll to the bottom of the company's summary quote and read the company description. Click on "More." Use the keyboard command for "Find" (e.g., control-F) and type "Net income" or "net earnings." Look for the "Statement of operations."

- Project whether the retailer has increased, flat, or declining sales growth. Determine how one retail store's net income or loss could affect potential sales of your product line. Note: Income is in millions (e.g., 4.1 means a gain of 4.1 million dollars). A loss of income is in parentheses [e.g., (4.1) means a loss of 4.1 million dollars].

- Project whether you should increase or decrease your production, based on this retail customer's sales figures.

Positive Forecast Projections

The vice president of marketing needs to be an expert on the company's customers, overall retail trends, and their own company's inventory quantities for full retail and factory outlets. This individual projects sales forecasts, which is partly heuristic (i.e., a gut feeling) and from analyzing past numeric sales history.

An executive management team consisting of a president, vice president of marketing, factory outlet manager, and vice president of product development use heuristics and reports. These executives literally play the numbers game in which they balance projected overages (more than committed sales or forecasts) with end-of-season inventory that must be marked down. Forecast numbers must be accurate, even though initial and final forecasts vary slightly. It is equally disastrous for a company to be out of stock as it is to be overstocked at the end of a season.

The vice president of marketing **brings to the table** information from sales, merchandising, and consumer marketing. This colloquial phrase means that the vice president of marketing presents people's opinions and marketing reports. Opinion statements are from sales representatives who provide feedback on garment styles or early bookings. The vice president of marketing will present a line prediction for new categories, any line corrections, and a sales estimate for each SBU (Regan 1997, 199).

The vice president of marketing may be conservative or proactive in the company's sales forecast. Conservative decisions mean that initial manufacturing commitments are less than anticipated and will be a reduction from last year's production quantity. This

decision affects the production manager because the company will have lower quantities and use fewer contractors; or if they own production, they will need fewer sewing lines and operators. A proactive decision will increase production quantity in anticipation of selling to new accounts. **Chase it up** is a colloquial phrase that means to place additional manufacturing orders for strong-selling styles during the season. When the forecast chases it up, a production manager anticipates a quick turn of garment production, which may require the use of local fast-turn contractors.

Negative Forecast Projections

A **charge-back** is a monetary fine from a retail customer to an apparel manufacturer. Neiman Marcus notes that markdown allowances (i.e., chargebacks) are consistent with industry business practices. Retail customers will charge back manufacturers to reimburse them for markdowns taken on their merchandise (U.S. Securities and Exchange Commission [SEC], September 28, 2006). One primary reason why operations and production associates attend sales meetings is to avoid chargebacks. The vice president of marketing is most concerned with markdown merchandise, whereas an operations manager tackles shipment and inventory problems. Retail buyers rationalize that a markdown charge-back is reasonable because the style, as designed, was not worth its price tag. A charge-back differs from **promotional merchandise,** which is a product that an apparel manufacturer specifically makes for a retailer to sell at a reduced price. **Markdown merchandise** is a product that did not sell at its intended retail price. There are two primary reasons for excessive chargebacks: being "out of sync" or "retail ganging." Out of sync is a reflection that the company's pricing structure does not match consumer preference. Saul Smith, vice president of operations, defines retail ganging as multiple retail customers joining forces to exert pressure on their suppliers.

Inaccurate forecast projections result in selling merchandise in factory outlet stores or off-price retail customers such as Marshall's ⬭ or T. J. Maxx ⬭. The phrase **disposing of additional** means that an apparel manufacturer sells merchandise at reduced values in these outlets. A factory outlet differs from a private-label operation. A private-label retailer (e.g., Express) manufactures and sells the majority of their merchandise in company-owned stores. An apparel manufacturer uses its own factory outlets to sell experimental styles, garments made specifically for outlets from excess fabric, and inventory overages. It sells excess inventory through jobbers or directly to retail discounters. An apparel manufacturer does not make a profit when it disposes of additional merchandise to off-price retail customers. At best, when a company sells excess inventory to an off-price retail customer, it recoups raw material and manufacturing costs. Saul Smith gives some advice:*

> Manufacturers often think that their products are the best! They liken them to fine wines, but unlike the exceptional vintage, garments—especially the fashionable types—do not improve with age. All they do is gather dust. Dump the dogs as fast as you can for whatever cash you can get and use it to try again!

*Reprinted with permission from Saul Smith, vice president of operations, Superba, Beverly Hills, CA; pers. comm., March 8, 2005.

Excess inventory affects all product development associates. The design team is responsible for developing products that will sell at a specific price structure. A design director will reprimand designers who consistently create closeout products because it implies that they are developing products that do not match the company's product strategy. A high number of closeouts mean that designers are developing designs that are too forward for their target consumers, available at a lower price by competitors, or rejected by their consumers.

The manufacturer can earn a profit by selling in factory outlets; however, because retail and manufacturing have different operational requirements, it is easy for manufacturers to stretch themselves too thin if they are overly reliant on selling in their own outlet stores. The vice president of marketing, vice president of operations, and **factory outlet manager** will analyze sales history and projected growth. According to Saul Smith, this group determines the factory outlet strategy; for example, whether the factory outlets sell only the company's mistakes or whether they produce garments specifically for their outlets.

SBU Merchandise Presentations

Once the vice president of marketing presents the overall business picture, individual merchandisers present the SBU line parameters. Merchandisers plan each selling style. Some merchandisers present general selling information whereas others detail each style by delivery, color, and size. Merchandisers present information on the seasonal product line and individual styles.

Seasonal Product Line

Seasonal product line information incorporates overall business trends for the SBU. It can include product line prediction for new categories and future line corrections (Regan 1997, 199). An example of a new category is a children's manufacturer that expands into the 'tween market. Line corrections means either elimination of a product line, reduction of quantities produced, or individual style elimination (199). Merchandisers commonly base this information on preline meetings and on how key retail buyers reacted to the seasonal product line.

Presentation of each SBU category plan is an important aspect of the merchandiser's presentation. The category plan is the merchandiser's product line analysis and final line parameters (Regan 1997, 199). Final line parameters are the increase or decrease of demand and numeric quantities for garment styles, fabrics, and send-outs. Garment parameters are the sub-classification of selling styles (e.g., tops, bottoms, separates, coordinates). A **selling style** is one prototype in multiple colors and sizes with a specific delivery date. A merchandiser classifies selling styles by the number of new prototypes, revised prototypes, and special projects (199). New prototypes are garment styles that are new to the company. A revised prototype is a core, carryover, or reorderable garment. Special projects are any private-label or apparel uniform program, for a retail customer. Apparel companies tend to want consistency in the number of new garment styles versus existing styles. However, with intense competition, an apparel company may need to increase its new prototype development. If there is an increase, the merchandiser justifies why the company needs more new garment bodies. Some reasons include that an apparel

manufacturer was not in tune with consumer needs, their garment designs are stagnant, they are introducing a new product line, or they have a new special project.

An operations manager listens for a substantial increase in coordinate styles because there can be logistics and distribution challenges to synchronize garment manufacture with a variety of contractors and simultaneously deliver coordinate pieces to retail customers. A drastic change in the category plan affects the selection of contractors, and the operations manager may need to locate new resources to sew the garment styles. An operations manager may request delivery delay of styles or production units until later in a season (e.g., Fall II vs. Fall I) in anticipation of any logistic or transportation problems. Operations managers and merchandisers must work out delivery details before the creation of line sheets. Once the company executives set and convey delivery dates to potential retail customers, it becomes a hard deadline.

Individual Style Information

Merchandisers detail information on each manufacturing style. Manufacturing styles are the total quantity of products produced. They indicate whether they will introduce new styles for each delivery or if one delivery has more new styles than the other deliveries. They also establish whether there are more separates, one-piece, or coordinate styles. For instance, dresses are an important growth category starting with fall 2007 deliveries (Earnest 2007).

Wholesale Demand

Merchandisers also present the predicted wholesale demand, which is total production quantity for the SBU. They will indicate whether there is an increase or decrease in total production quantities. Merchandisers, as many apparel associates speak in "apparel lingo" in which they abbreviate an explanation. For instance, they will say "Manufacturing styles are 175, wholesale demand is 1.65 million, which is a 4 percent increase over last year." Merchandisers will detail manufacturing styles by delivery. For instance, they will release 15 styles for delivery 1 and 20 styles for delivery 2. This information is important for production schedulers who need to ensure that they have the production capacity to produce the styles.

Developing a new garment style is a sensitive topic in which the design team has to balance retail customer needs with production. Manufacturing new garment styles can be challenging, so operations and production managers listen closely to identify any potential problems. A production manager will need to set up new sewing lines and train operators if there is a substantial increase in new prototypes for companies that own global or domestic manufacturing facilities. For apparel companies that contract production, the production schedulers need to ensure that they have enough contractors that can sew the requested styles.

Fabric and Finishing Information

The merchandiser continues the presentation by explaining fabric parameters, which include the number of fabric codes, textile vendors, and finishing. A company designates one fabric code per fiber content and fabrication (e.g., 60/40 cotton polyester jersey).

Textile manufacturers call this a fabric style or SKU. Depending on relationships with textile vendors, the company may consistently buy fabrics from vendor partners or conversely from a wide variety of suppliers.

Merchandisers generally focus this part of their presentation on new fabrics, fabrications, constructions, or send-outs. A new fabric or fabrication is one that the company has not sewn before (e.g., organic cotton). A new construction is the combination of multiple fabric types (e.g., woven and knit in the same garment) or a different assembly method. The audience may query designers for fabric details such as width, trim specifications, and availability. A **send-out** is any garment operation sent to a specialized contractor during production. Send-outs can include a garment that is being wet processed or finished, or one that has embroidery, screen print, or appliqué. Finishes are mechanical or chemical treatments on fabric (e.g., sanded) or completed products (e.g., garment dye) (Brown and Rice 2001). The contractor returns the cut or sewn pieces to production for completion.

Impact on Production

Company associates listen for valuable details that affect their own position and job responsibilities. For example, according to Saul Smith, production associates evaluate whether they can manufacture the items, and distribution associates evaluate whether they can pack and ship products as intended. QA managers, purchasers, and production managers listen closely to fabric, trim, and send-out details. The QA manager is most concerned with new vendors, untested fiber content, and new fabrications. The production manager is concerned with cutting and sewing new fabric types, combinations, and finishes (Regan, Kincade, and Sheldon 1998). Fabric combinations and garment finishing can be potential sewing problems, which the production manager or contractor will not be able to address until the product is on the sewing floor. The operations manager will ask the design team if there will be any delivery delays. Merchandisers highlight any calendar delays in which the design team is late. For example, they may be in the process of approving prints, embroideries, screen print strike-offs, lab dips, vendor partnership agreements, or samples, but they should have already approved fabrics so textile vendors can start their production. If the design team runs late or submits fabric orders on the same day, it creates time delays or a bottleneck due to bulk submission for both textile suppliers and sample production. Because the sales meeting is a kickoff point for other product development associates, it is important that the design and merchandising associates meet calendar deadlines (Regan 1997, 164).

Designer Presentations

Designers present their apparel line to company associates for approval and support. At sales meetings, designers discuss the current season's business, product line direction, and delivery flow (Regan, Kincade, and Sheldon 1998). They present their interpretation of the company's mission, product line strategy, seasonal theme, garments designed, and margin goals using the storyboard as a visual. At the line review, according to designer Kimberly Quan, designers explain their theme, its interpretation into a product line, and how to sell products to retail buyers. The connection between a storyboard, seasonal theme, and SBU product line strategy must make sense to sales representatives and retail

buyers. Designers will explain how garment attributes, such as embellishment, design authenticity, size scale, and color, meet their target market needs (Regan, Kincade, and Sheldon 1998).

It is important that designers address the needs of their audience. For instance, achieving sales quotas inspires sales representatives (Florida and Goodnight 2005 to evaluate the presentation in the context of whether the designs presented will help them achieve this goal. Some designers will quip, "If a design sells well, the salesmen did a good job; if something doesn't sell, it is the designer's fault." Designers are well aware that if sales representatives do not like a garment design, they will not take it on the road (Regan, Kincade, and Sheldon 1998). Thus, they need to sell sales representatives on features and design attributes. With experience, criticism does not offend designers because they know that everyone has his or her own opinion.

Designers calculate first costs on garments before the sales meeting. The design team is well aware that they need to design product to meet specific price points and margin goals (Regan, Kincade, and Sheldon 1998). If a garment has expensive trim or any construction limitations, production managers will query whether the wholesale price will support the extra costs. Design details, such as trims and fancy buttons, increase perceived garment value to consumers. Value-added design is an important selling point to management (Regan, Kincade, and Sheldon 1998). If trim, labor, and material costs are too high (e.g., 40 percent of wholesale cost), merchandisers will explain why the selected unique trim adds product value or why they would lose sales if they replaced it with a cheaper trim.

The audience is interactive at sales meetings, and attendees may come up with alternative ideas that could reduce manufacturing costs or improve production. Production associates pay close attention to new garment styles because they are the most challenging. Company associates may also query the design team about the garment production limitations. Some examples include changes to the sewing sequence, inability to use automated equipment (Regan 1997, 163, 165) or the use of contractors that have previously sewn the fabrication or garment style. Company associates may request garment changes to make them more salable or to address any prior company problems.

Sales Meeting Summary

At the end of the sales meeting, merchandisers will recap any important issues such as confirming questionable manufacturing styles, line corrections, or product changes (Regan 1997, 199). They will also summarize any delays to the time-and-action calendar and determine how the design team will get back on schedule.

When the sales meeting commences, technical designers will return to their computers to make any line sheet revisions. The design team submits an internal **line sheet**, which starts the preproduction process for operations, production and support services including forecasting, purchasing, patternmaking, and technical design (Regan 1997, 197). Technical designers give line sheets to all product development departments, including marker making, forecasting, merchandising, operations, and production. This triggers the preproduction process, which extensively involves product development and the marketing and production departments (197). Ideally, line sheet submission has a staggered sample production schedule. If company associates are *off calendar*, they will rush garment samples

through production to meet seasonal release at tradeshows and market weeks. Manufacturing associates have "their backs up against the wall" to deliver garment samples at any cost, even if it requires nonstandard transportation, such as shipping samples air freight (169).

Sample Production Review

Designers meet with production associates for a sample production review soon after the sales meeting (Figure 13.2). In fact, apparel companies have multiple sample production reviews. The first sample production review occurs before the product line release to sales representatives. Production associates refer to the receipt of garment samples for approval as the *top of production* (J. Barrios, pers. comm.). The **sample production review** is an evaluation of a garment's sewing operations and potential quality problems. Company associates determine if there will be any prototype adjustments and where to produce the garments (Regan 1997, 272). **Sewing operations** refers to the number of different machines and the sequence in which they are used to produce garments. Later, production

Figure 13.2 Production associates evaluate garment construction and specifications. *(Photograph by author.)*

planners will work with the cut-and-sew contractor or in-house production to determine specific production details such as assembly and operator rates.

Sample presentation

The associates that attend this sample production review include the **production manager,** the sample coordinator, designers, **line supervisors, quality assurance manager** and production coordinator. Sample production review generally occurs in a conference room.

The designer starts the meeting by showing a technical illustration, prototype, and tech pack. Construction issues are the focus of this presentation, so designers must be flexible to create fashionable garments while also adhering to quality and production requirements. A designer's presentation comes from the context of having the same construction as competing companies. A senior merchandiser noted that merchandisers and designers often scrutinize competing products for design features, construction, and material quality and country of origin. A designer may anticipate questions from production or quality assurance associates on a particular garment body, so he or she may bring a competing garment to show the team that their company must offer comparable construction and material quality.

Production managers pick up small but important details from the designer's presentation, and they identify any potential manufacturing problems (Regan 1997, 172). For instance, a designer choice of an unusual button (e.g., triangle shape) alerts the production manager. Any anomaly means that the production manager will need to ensure a contractor has the specialized equipment and can address possible sewing problems. The QA manager is most interested in fabrics and trims, especially if a garment body uses multiple fabrics or fabrics they have not sewn with before, or if the design team wants to use new textile vendors. Each situation can create process delays. For instance, if the designer requests a new textile vendor, the QA department does not know whether the fabric will pass quality control tests. Substandard fabric will cause time delays. Such delays can be especially troublesome with the tight production schedules common in the apparel industry (Regan 1997, 162).

Evaluation of Garments for Standard Operations

The production manager and line supervisor evaluate each garment for **standard operations** and nonstandard operations, and they calculate final costs (Regan 1997, 273). A standard operation is a feature that an apparel company commonly uses in its garments. For instance, they may always use a ¾″ hem sewn with a coverstitch machine.

Proactive apparel companies have sample operators write any sewing difficulties incurred when they sew samples (Regan 1997, 276). Sample-sewing operators provide valuable feedback to design and production. Comments from sewing operators enable the design team to make early aesthetic and construction changes before full production occurs. For accuracy of identifying potential manufacturing problems, it is important that operators sew samples using the same sequence of operations and the same production equipment. The cost to change at the sample stage is minimal compared to the financial loss for mistakes made on thousands of garments during full production. Production and operations managers are experts in sewing operations, and a seemingly small construction

detail, such as a trim item, may develop into an animated discussion during the production review. Production managers do not want to change the aesthetic appearance of a garment; however, they will send up a red flag if a garment's details appear too expensive or require too many operations.

Designers need to understand the context in which production managers evaluate garments. Here we use two hoodie styles shown in Figures 13.3 and 13.4. A designer for the style in Figure 13.3 may state "It is just a basic sweatshirt." From a designer's context, he or she generally means that the garment is a classic design or a wardrobe staple. A production

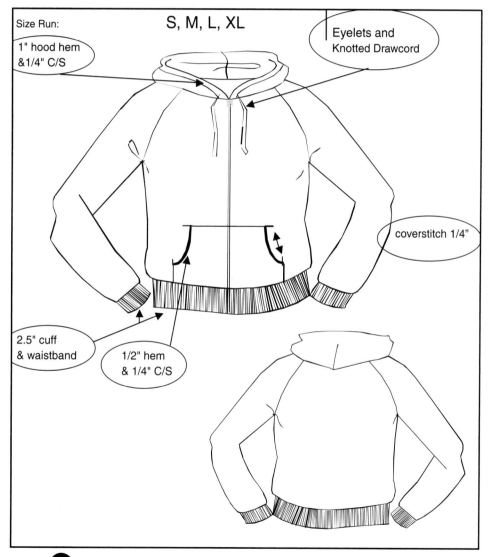

Figure 13.3 The review team refers to the prototype and technical illustration to determine production details. *(Illustration by J. Courson.)*

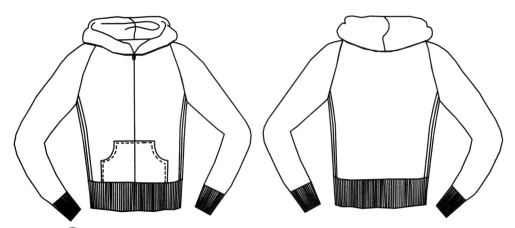

Figure 13.4 Production sample review involves an analysis of standard and nonstandard operations. *(Illustration by R. Placencia.)*

manager defines *basic* as a style that does not change in its construction, pattern, fit, and material season after season. Basic styles are profitable for a company due to their high volume, and production associates have worked out production problems such as construction sequence, machinery, and line balancing. However, many basic garments are extremely price sensitive and have high competition. Because every penny counts, production associates will standardize garment design to increase efficiency. Standardized designs are less expensive and easier to produce (Cottrill 2006) and thus help a company meet its margin goals. Shuba Pillai, Target executive team leader—Softlines, discussed this price sensitivity in the context of products sold to mass merchandisers:*

> Target is involved with the manufacture of branded products. Our buyers seek out sources for a product, such as a knit top. The buyer will state to the manufacturer. "We will invite you to bid to place product in our stores." At this point, it becomes the control of our finance people, who do not know the identity of the manufacturers. The manufacturers will log into our Web page at a set date and time for a one-hour webcast meeting. We will state the opening bid is $5.00 for a finished piece, and then a reverse auction* starts. Manufacturer A types in $4.95 and manufacturer B types $4.89, and so on. We want both the manufacturer and Target to make a profit, so we do play fair.

ACTIVITY 13.3 *Critical Thinking*

Looking at the previous quote, can you think of any other retail stores that might do reverse bidding? Select one of your garment illustrations. How could you reduce cost while keeping the same aesthetic design?

*Reprinted by permission from Shuba Pillai, executive team leader–Softlines, Target, Upland, CA; pers. comm., May 25,2007. This is a personal statement. The views and opinions expressed on this site do not necessarily reflect those of my employer.

* In a reverse auction, a vendor places a bid to obtain business from a buyer. The goal of the buyer is to drive the purchase price down (Wikipedia Contributors n.d.).

Evaluation of Garments for Nonstandard Operations

The production manager and sample coordinator also evaluate prototypes for nonstandard operations. A **nonstandard operation** is any assembly that the company or its contractors have not previously sewn, or one that increases costs. Let us refer back to Figures 13.3 and 13.4 to understand nonstandard operations. In Figure 13.3 and 13.4, the technical illustration shows a lined hood and the designer's prototype has a lined hood. Sweatshirt hoods are lined and unlined. A production manager would ask the designer, "What is the unique trait of your garment? Is it the hood? If it is, then we should line it. If not, then it should be unlined." A production manager focuses on any area where they can improve fabric yield because fabric is one of the most expensive attributes of garment cost. A hood, as shown in Figures 13.3 and 13.4 is a large pattern piece and has an approximate fabric yield of ⅜ yard. Assume the wholesale cost for the fleece is $4.00/yard. This lined hood adds $1.50 to the garment cost (i.e. .375 × $4.00). In evaluating the garment styling in Figure 13.4, the contrast side panels and wide cuffs are its unique design detail, so for this prototype, a production manager would recommend an unlined hood.

Resource utilization is how efficiently the sewing operators can assemble the garment and whether the design creates production line inefficiency. The hoodies in Figure 13.3 and 13.4 have cuffs sewn onto the sleeves. A designer may request high-quality construction, such as an enclosed seam with no raw edges shown on these cuffs. Resource utilization means that a production manager evaluates a garment construction for equipment availability and any potential bottlenecks. Thus, if this garment style's standard sewing operation was to close a raglan sleeve before operators attach it to the armhole, he or she would initially reject the designer's request. It is up to the designer to convince the production manager to construct a garment with any nonstandard operation, such as an enclosed seam at the cuff. To accomplish this, a designer needs to understand garment construction.

After the sample production review, operations managers will identify existing or new contractors that can produce garments and send-outs. This often triggers other production discussions between a production manager and the design team. Production samples are extremely important in determining whether the garment maintains its design integrity (e.g., a yoke seam falls where it is supposed to). If production samples have too many problems in the pattern or construction, the merchandiser may drop the style from the product line. This, however, can be problematic if retail customers have already ordered the style during preline meetings.

Calculation of Final Cost

Consumers love a bargain, and they often buy merchandise when it is marked down or is on a promotion. Merchandisers address pricing strategies to calculate the SBU's gross margin percentages. This includes a seasonal forecast for the number of SKUs sold at regular, markdown, and promotional retail prices. Large retail customers often direct a manufacturer's markdown policies. It is common for large retail customers to state to a manufacturer, "We need twelve promotional SKUs each month during the fall season," or "Create a holiday promotional group." Promotional merchandise comes into the store at a sale price, and retail customers often advertise it as a special purchase or valued at a stated dollar amount. The design team will create a select number of styles as promotional merchandise.

Production coordinators calculate final costs on completion of this sample production review. This detailed process involves the calculation of sewing sequence and methods engineering.* Production coordinators provide final costs to merchandisers. Merchandisers calculate margins and update wholesale prices.

Merchandisers need to consider markdown merchandise when they calculate wholesale prices because in today's competitive environment, many products sell at markdown prices. Markdown merchandise comes into a store at full retail. The retail customer then discounts it according to its policy; that is, it may discount merchandise 25 percent at 10 days of receipt and 33 percent at 20 days of receipt. The retailer charges back the apparel manufacturer for the quantity discounted because the buyer views the merchandise as less valuable and they need to clear the floor to bring in new merchandise (Panel presentation, Chargebacks, Los Angeles, CA, November 2005).

We use the hoodie in Figure 13.4 to see how a markdown and corresponding chargeback affects margin goals. Assume that the hoodie's wholesale price was $25.00. Using a common 35 percent margin, the apparel manufacturer's cost would be $16.25 (i.e., 25.00 × .65). Using a common keystone markup, a retailer would bring the hoodie in the store for $50.00 retail. After 10 days, assume the majority of the hoodies do not sell and the buyer decides to put the hoodie on sale for $39.95. The retailer charges back the manufacturer the wholesale portion (i.e., $50.00 − $39.95) = $10.05 × 50% = 5.025). Thus, if an apparel manufacturer initially charged a $25.00 wholesale, the realized wholesale price is $19.98 (i.e., $25.00 − $5.03). Their margin on this garment is 22.9 percent ($19.98 − $16.25) = $3.73 ÷ $16.25).

Production Review Summary

Garments approved for the product line may change to improve manufacturability. Design, production and quality assurance associates evaluate garment construction to ensure samples will be ready for full production. The purpose is to improve garment construction and assembly and identify any potential manufacturing problems. Once approved, production coordinators schedule, oversee sample production, and the packing and shipping of samples to sales representatives (Regan 1997, 278).

Process of Selling the Line

The design team's energy mounts as the tradeshow date draws near. Marketing associates ready the booth and garment samples for shipment to the tradeshow. The ultimate test is whether retail customers will place orders. Apparel companies select a venue depending on their product type. Often designers and couture present their seasonal product line at global fashion weeks. Specialty store retail customers are the primary target market for market centers and tradeshows (Haber 2007).

Fashion Weeks

At the biannual global fashion weeks, excitement and energy transpire in the apparel industry (Figure 13.5). A **fashion week** is the presentation of influential and new apparel

*See B. Niebel, *Time and Motion Study*, 9th ed. (Burr Ridge, IL: Irwin Methods, 1993), engineering and time study chapters.

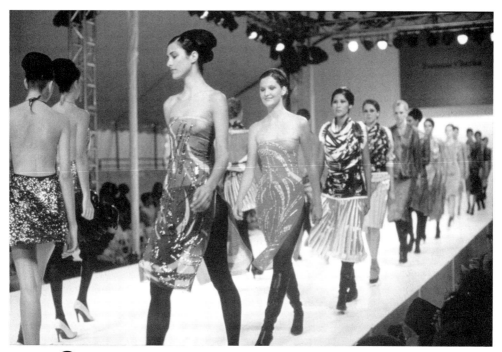

Figure 13.5 Fashion week show.

designers' seasonal product lines. Only a select few designers participate, mostly due to the expense. Apparel companies typically budget $350,000 for a fashion show (Lal and Han 2005). Numerous newspapers cover these global fashion weeks as journalists vie to report new fashion trends.

The primary locations for the international fashion scene (i.e., fashion weeks) are Milan, Paris, London, and New York (Fodor's 2007a, 2007b). Japan Fashion Week is becoming an influential market attracting 650 journalists and 600 buyers (Hirano 2007). Italian entrepreneurs have established Milan as the global fashion capital with famous designers such as Giorgio Armani, Cavalli, and Versace (Zargani 2007). Four weeks a year, Milan's fortissimo (i.e., Milan fashion week) occurs. Italian designers are among the most watched for inspiration of next season's international styles. Italian men's fashion week shows are in June and January, and the women's shows are in February and October (Fodor's 2007a, 2007b).

IMG is a primary producer of global fashion weeks. IMG's Mercedes Benz Fashion Weeks 👕 are in Berlin, Los Angeles, Miami, and New York. FashionWeekLive! also sponsored by IMG is a fashion week event at regional market centers such as Chicago, Dallas, Houston, and San Francisco (IMG 2007). New York's Bryant Park is renowned for its focus on both up-and-coming designers such as 12th Street by Cynthia Vincent 👕 and established U.S. apparel designers, such as Michael Kors 👕.

The traditional audience for fashion weeks includes journalists, retail customers, and socialites. A recent trend is for the general public to watch fashion weeks as entertainment to see over-the-top fashion and to watch celebrities (Poggi 2007). A designer invites journalists with the goal of getting press in electronic and print publications. Fashion

journalists include writers, photographers, publicists, and stylists from fashion consumer publications, general newspapers, trade publications, and Web sites. Retail customers attend fashion weeks to write advance orders. Designers also invite celebrities and special consumers for prestige. Fashion week photographs and articles are widely available in trade newspaper publications such as *Women's Wear Daily* 👕 to online trend services, such as Wire Image 👕 live web casts, such as those from IMG during the shows, and Web publications such as The Daily Front Row 👕.

Envision going to a fashion week show. You walk into a tented room; it is dark, adding to the mystique of the event. Staff directs you to your chair, where there is a gift from the designer and fashion show sponsor. Chairs lined up around the catwalk allow the audience to view runway models, while photographers crowd together at the end of the runway. Before the show, music plays to convey the designer's mood for his or her product line, while organizers, wearing black, run around. The show begins with a loud blast of music and flashing lights. Models glide down the catwalk, never missing a beat. The show, in vignettes, presents the designer's seasonal product line. The photographers' cameras flash brilliantly as they try to capture the perfect image. Retail buyers follow the program closely and write comments for potential orders. The show ends with designers walking out on the catwalk to take a bow and receiving flowers from admirers or family members. The audience quickly diminishes as photographers and publicists head to the next show.

Market Centers

One could describe a fashion week as being about the glitz and glamour, whereas a market center, or mart, is about the "nuts and bolts." A **market center** consists of sales representatives who offer wholesale product lines to retail customers in permanent showrooms or temporary exhibitor space. The primary U.S. apparel wholesale markets are located in New York, Los Angeles, Dallas, Atlanta, and Chicago. Apparel manufacturers sell product in primary and regional market centers, either in addition to or as an alternative to New York showrooms. According to Liz Riley, a former manager for California Market Center, a market center consists of centralized permanent and temporary showrooms where individual and multiple apparel sales representatives sell whole apparel and fashion accessory lines under one roof.

New York does not have a market center in one locale; rather, retail customers visit individual showrooms and tradeshows in multiple venues. New York, like other market centers, offers spring/summer release in January or February, fall/winter release each May, and holiday/resort in August. Infomat Calendar lists New York tradeshows and subscriptions to Fashion Calendar 👕 or Accessories Council 👕 provide information on events, contacts, and how to schedule appointments at specific apparel showrooms.

Primary market centers are highly competitive because they vie for the same core customer—primarily the specialty and boutique store buyer/owner (i.e., retail customer). Large apparel customers (e.g., Kohl's) typically have merchandisers present concepts to them during preline meetings at the retail customers' corporate headquarters.

Retail customers evaluate a market center in the context of their store image, merchandise mix, price range, and target consumers. The retail buyer may shop one market center over another based on which one has the most versatile and largest number of appropriate product offerings for their store. Sydney Blanton, the owner of Amelie 👕, a boutique in Claremont, California, described her market center and tradeshow choices:

I mostly shop the Los Angeles market weeks. It is the most convenient, and I can usually find everything that I need. I am going to a large shoe market and the Coterie* in New York this year. I need to because my store has more competition. When I shop the tradeshows, I often visit the independent fashion shows, especially in Los Angeles. I also go to gift shows. Since I have a boutique, I need add-ons, such as jewelry, perfume, and lotions. Gift shows have colorful, fun ideas that I can use in the store, and I get great display ideas.[†]

Market Center Benefits

Retail customers may choose to go to a market center that offers buyer incentives or services, such as parties, fashion shows (Williamson 2007b) seminars, assistance with sourcing appropriate products, trend forecasting, discounted hotel accommodations, or contributions toward travel costs, as well as a pleasant shopping experience. According to Liz Riley, sales representatives may choose a market center locale based on the territory assigned to them, as well as accessibility and marketing efforts. Market centers often send collateral pieces to new and existing retail customers. According to Liz Riley, **collateral pieces** are promotional pieces such as newsletters, market guides, postcards of upcoming market weeks, and event calendars that get the product name and image in front of the retail customers. On behalf of tenants, a market center identifies new and existing retail customers whose merchandise mix matches that of the mart for this type of mailing. Collateral pieces are important because they get the product name and image in front of the buyer. This assists the sales representative in getting appointments for market. For a new product offering, visuals are especially important (Figueroa, Chensvold, and McAllister 2003).

Market accessibility is important to core retail customers who shop market centers because they often manage and operate their own stores; thus, time away from the store is valuable. **Market accessibility** refers to the hours of market center operation and ease in which a retail customer can find both new and established sources.

Primary Market Centers

Large market centers located in Atlanta, Chicago, Dallas, and Los Angeles have permanent showrooms and temporary venues during market weeks. Most large market centers are open 52 weeks a year. The primary market centers offer a breadth of product lines. However, they target select retail customers by specializing in product types.

AmericasMart® Atlanta ⬜ bills itself as the world's next fashion center. This mart emphasizes growth in the contemporary category. They divide its contemporary lines into NY/LA co-op and high-end designers. The NY/LA co-op started by featuring denim and now includes new designers. Its high-end designer showrooms include 12th Street by Cynthia Vincent and Christopher Deane ⬜ (Bond 2007). AmericasMart® Atlanta draws domestic and international retail customers who shop diverse merchandise mixes.

*A temporary trade show that takes place at the New York shows piers on the Hudson River during market week.
[†]Reprinted with permission from Sydney Blanton, owner, Amelie, Claremont, CA; pers. comm., May 1, 2006.

The Merchandise Mart 👕, located in Chicago, caters primarily to Midwestern retailers (Wilson 2007); however, any retail customer that owns a dress shop would go to the Merchandise Mart, which has an extensive selection. The Merchandise Mart also claims it has the largest domestic biannual bridal market weeks. StyleMax, one of the Merchandise Mart's primary shows, features strong customer service and a variety of merchandise offerings (Wilson 2007). The Merchandise Mart has two hundred and fifty permanent wholesale apparel showrooms featuring women's apparel, children's apparel, and accessories (Styre max n.d.)

Fashion Center Dallas, the world's largest wholesale apparel market center, has retail customers who place over 7.5 billion dollars annually in orders (Williamson 2007b). Fashion Center Dallas has 1,200 permanent and temporary apparel showrooms representing 12,000 apparel lines. The sheer size of the Fashion Center Dallas, encompassing 1 million square feet, has an extensive breadth of women's, men's, boy's, and children's apparel (Dallas Market Center 2007). In addition, Fashion Center Dallas expanded its accessory offerings for both temporary and permanent venues. Accessories are an important category for boutique and specialty retailers to diversify their merchandise mix (Williamson 2007a).

Southern California apparel companies comprise a $24.3 billion dollar industry (Kyser and Huang 2003). This region is a strong rival to the New York apparel industry with its number employed in design, technology and speed-to-market (Kyser 2007). Southern California is renowned for and has a strong international demand for its LA style. Southern California is a leader in contemporary, activewear, and surfwear. In comparison, New York is a leader in outerwear and tailored clothing (Kyser and Huang 2003).

Los Angeles has multiple apparel showroom buildings. The apparel wholesale centers are downtown in the fashion district; however, the industry is spread out in Orange County. The Los Angeles fashion district intersection is composed of wholesale apparel market centers, including California Market Center, Cooper Design Space, Gerry Building, and New Mart all open 52 weeks a year (Kyser and Huang 2003). The Los Angeles market centers are best known for representing regional design talent and contemporary fashion.

Many retailers have buying offices located at the Los Angeles marts. Los Angeles market weeks are held five times annually, and retail customers write billions of dollars (Kyser and Huang 2003). The mainstay of the California Market Center 👕 is young designer and lifestyle apparel, whereas its contemporary classification is a growth category. Contemporary apparel (i.e., young designer, street wear, or street couture) consists of fashion-forward, design-driven, and unusual designs (McAllister 2004a, 2004b). This target consumer is older than 25 years, and garments offered consist of high-quality fabrics and construction (Nieder 2004). The Cooper Design Space 👕 features men and women's urban apparel. The Gerry Building 👕 has an eclectic mix of apparel, accessories, and textile showrooms. Its mainstays are edgy, urban T-shirts and denim classifications. New Mart 👕 offers products for upstart contemporary designers.

Market Weeks

Each season, retail customers shop market weeks in multiple locations. Retail customers shop market weeks to buy established brands, but in order to keep a fresh mix of merchandise they are always interested in new designers that offer unique styles (Tucker 2007).

Liz Riley, a former manager for California Market Center, explained that the primary market week audience is composed of specialty and boutique retail customers that target moderate to upper socioeconomic consumers. Market centers also offer shows targeted for the **majors,** which is a colloquial term for shows that target department stores or large national chains, and require buyers to meet high manufacturer minimums.

Showrooms

Permanent showrooms are the mainstay of market weeks, and retail customers make appointments at corporate or multi-line showrooms (Figure 13.6). Liz Riley explains that a **corporate showroom** is an exclusive showroom that offers an apparel manufacturer's brands. A **multi-line showroom** is an independent representative that has a business contract with two or more manufacturers to represent similar product lines. Atmosphere is an important attribute to a showroom. Retail customers prefer a friendly welcoming showroom in which representatives have displayed merchandise in a creative manner. They will quickly pass by showrooms in which merchandise is cluttered, or if there are too many people or no pepople in the showroom (Musselman 2007).

Figure 13.6 Example of a permanent showroom. This one is for American Apparel.
(Photograph by A. Espinas, printed with permission.)

How Sales Representatives Show Product

Sales representatives prepare for market by calling retail customers, putting together photo packages, and mailing seasonal product line illustrations to potential retail customers. Sales representatives will also take time to learn about the designer's inspirations for their collection so that they can present an image of the brand and its company. After market, some sales representatives will also give designers feedback on the positive and negative reactions retail customers had to their product line (Daswani 2007).

Showroom representatives learn about their customers before appointments. The showroom representative will present a manufacturer's seasonal line by delivery date and by how retail customers are meant to present the product in their store: by coordinates, separates, or important categories. They explain product features, prices, and delivery dates. According to a To the Max 👕 sales representative, a seasonal release may be a one-time delivery or be composed of multiple deliveries (e.g., monthly). With some apparel lines, such as seasonal garment silhouette, styling is consistent; however, each delivery has different colors and fabrics. Sydney Blanton commented:*

> I will ask the sales representative questions about the company's best sellers, what they have previously done with the style, delivery dates, and technical information, such as fabric weight. I let the sales representative tell me what is selling, but I never leave the showroom without looking at the rack. Just because the sales representative doesn't like it does not mean it will not work for me.

ACTIVITY **13.4** *Critical Thinking*

Think about features in your garment line other than the obvious (e.g., color, size).

● Write down why a retail buyer wants to purchase your line.
● What information can you provide about your product features?

Shopping the Product Lines

During market weeks, crowds of people mingle around the market center lobby. Retail customers standing in the registration line are anxious to start taking numbers. Let us Visualize how a retail customer shops a line. When buying, industry professionals rely on their knowledge to use specific terminology to purchase, sell, or discuss products, and make transactions. A good resource for the neophyte is California Market Center's New Buyer's Kit, 👕 which contains a glossary of industry terms (California Market Center n.d.).

Astute buyers work the market by preplanning appointments, yet they may be anxious to seek new resources. The phrase **working the market** means a retail customer preplans a market trip to arrange the order of appointments, to budget time, and to maximize efficiency. In a showroom, a retail buyer may examine a sample closely to evaluate quality and aesthetic features. Retail customers may take numbers during short (e.g., 20-minute)

*Reprinted with permission from Sydney Blanton, owner, Amelie, Claremont, CA; pers. comm., May 1, 2006.

Figure 13.7 Retail buyers take numbers during appointments.

appointments with showroom sales representatives (Figure 13.7). **Taking numbers** is a colloquial phrase meaning that retail customers write style descriptions, prices, minimum order quantity, and shipping terms for any product they are considering to purchase. To purchase, a retail customer buys according to **minimums**, which is the smallest quantity of either styles or dollars required by the manufacturer. According to Liz Riley, the majority of merchandise offered at market centers is for delivery at a future date. These delivery dates range in availability (e.g., 6–12 weeks). Most retail customers often do not write orders for immediate delivery; rather, they may prefer to wait as long as they can to commit to orders.

Some manufacture representatives sell **immediates**. This term refers to merchandise that is ready for shipment. Some retail customers buy immediates to fill in stock in stores. Other retail customers focus exclusively on buying immediates. According to Jason Kim, manager of the San Pedro Wholesale Mart, these retail customers will shop regional markets devoted to immediate delivery. These sales representatives stock merchandise in warehouses. Sydney Blanton, the owner of Amelie, provides insight into how buyers think several months in advance when shopping market centers:*

> As a buyer, you have to simultaneously manage the current season and future seasons. I buy every 2 months. As a buyer, you are not buying product for more

*Reprinted with permission from Sydney Blanton, owner, Amelie, Claremont, CA; pers. comm., May 1, 2006.

than 3 months at a time, but I look at product to bring into the store for the next 6 months. In March, I bought July, August, and September deliveries. In June, I will buy for October, November, and December. Any time I go to market, I also buy immediates to fill in store merchandise.

Market weeks are very important for apparel manufacturers. Retail customers are astute and want merchandise that appeals to many consumers. Follow though from apparel manufactures is important to retail customers and they will not tolerate poor product quality or late deliveries (Tucker 2007). Paloma Bautista, a former design assistant for True Meaning, noted that apparel companies make last-minute product line changes based on retail customers' reaction to their product line:*

We respond to our representatives in the showroom. We talk to them every couple of days, and they tell us how the meetings went with the buyers. If several buyers ask for an earlier delivery or a style, we try to respond. We call this a "flash cut," which means that we throw a style into the product mix. It may be an existing body, but sometimes it is a new body. Our owner loves to do that! Most recently, the buyers requested a similar style to Marc Jacobs' boxy jacket.

ACTIVITY **13.5** *Critical Thinking*

In the previous quote, the design assistant discussed "flash cut." What services will you provide to help sell your line?

Temporary Venues

Temporary exhibits are an excellent venue for retail customers to locate new resources and provide exposure and visibility to apparel lines (Figure 13.8). Temporary venues can be stand-alone tradeshows or ones that are a part of a market week at the major market centers. Large corporations produce stand-alone and market center tradeshows. These corporations include Advanstar Communications⬦, ENK International Trade Events⬦, and Designers & Agents⬦. **Tradeshows** are temporary venues in which corporate and independent sales representatives offer their upcoming seasonal product lines to retail customers. These shows are open to industry individuals and the press. Tradeshows focus on selling wholesale products to customers who buy for broad or specialty apparel market segments.

Stand Alone Tradeshows

Apparel manufacturers commonly have permanent showrooms that are geographically close to their corporate headquarters. To increase exposure, they will show designs at tradeshows. Sue Wong ⬦ is an example of a Southern California apparel manufacturer that has a permanent showroom at the California Market Center and exhibits at Coterie, one of the Show Piers in New York city. Showing product lines in multiple venues increases an apparel company's exposure and potential sales with international and regional retail customers.

*Reprinted with permission from Paloma Bautista, design assistant, True Meaning, Vernon, CA; pers. comm., April 6, 2006.

Figure 13.8 Rare Designs booth at the Show Piers on the Hudson is an example of a temporary venue. *(Illustration by C. DeNino, S. Lozano, and E. Perales.)*

A stand-alone tradeshow means it is not located at or sponsored by a market center. New York and Las Vegas are important U.S. locations for fashion tradeshows. Numerous tradeshows take place during New York apparel market weeks. Most New York City tradeshows are located at The Javits Center 👕, Show Piers on the Hudson 👕, and nearby hotels. The Javits Center has many fashion tradeshows including Coterie, 👕 Fashion Avenue Market Expo (FAME) 👕, Moda Manhattan 👕, and Children's Club 👕. The Show Piers on the Hudson include Collective 👕, for men and Accessorie Circuit 👕. Other temporary venues during New York market week include Nouveau Collective 👕.

Las Vegas is an important locale for MAGIC tradeshow, which features multiple product categories, and specialty tradeshows. Advanstar Communications is a large corporation that organizes U.S. tradeshows. Advanstar fashion tradeshows include MAGIC, WWD Magic, MAGIC Kids, and Pool. MAGIC is a biannual tradeshow held in February and August in Las Vegas, Nevada. MAGIC marketplace bills itself as the largest and most comprehensive fashion tradeshow with more than 4,000 apparel companies presenting product (MAGIC 2007). Over 120,000 retail customers attend MAGIC (MAGIC 2007). Retail buyers quickly learn that they must focus and go directly to the booths that have the product lines of most interest. Thus, the MAGIC floor plan has products organized by garment

category, which assists retail customers. Product categories include men's designer and contemporary, board sports, WWDMagic, MAGIC kids, PROJECT, Pool, and sourcing at MAGIC.

A retail customer shopping a tradeshow, such as MAGIC or at the Javits Center, will quickly notice the crowded convention center and the fast pace of attendees in the registration area. Once in the exhibition halls, each market segment has its own unique atmosphere. The apparel manufacturers take visual presentation of merchandise seriously because they know that retail customers quickly assess product with a fleeting glance as they walk the aisles. At MAGIC, Men's designer and contemporary exhibits have a quiet ambiance of opulence, while street wear, with one section featuring music-inspired clothing, has a drastically different feel with its exotic dancers enticing retail customers into booths. MAGIC Kids has its sense of fantasy and cuteness, as each company tries to outdo each other with fun and colorful visual merchandising displays.

Retail customers quickly learn that they must preplan to see well-known brands because these corporate representatives show product by appointment only. Many of the popular brands encase their booth with walls or curtains, completely hiding interior displays. Once a retail customer is inside the booths, sales representatives present product by thematic grouping and delivery dates. Tradeshows, such as MAGIC, offer special services such as seminars and fashion shows. Seminar topics range from color forecasting, market research, business operations, importing, and exporting.

Las Vegas and New York are important locales for specialty tradeshows. Specialty tradeshows target a specific audience (e.g., golf apparel, athletic sportswear). Infomat Calendar 👕 lists specialty fashion tradeshows. Some specialty shows are exclusively in Las Vegas, such as World Shoe Organization 👕, or in New York City and Las Vegas, such as Lingerie Americas 👕, and Accessories The Show 👕.

Market Center Temporary Venues

Temporary venues are common during market weeks at the major market centers. The Chicago Merchandise Mart has StyleMax 👕, a temporary exhibit with 4,000 lines for women and children (StyleMax n.d.). The California Market Center and New York Market offer the Brighte show 👕. The Los Angeles New Mart and New York's Lehigh Building offer the Designers & Agents show 👕 (California Market Center 2004b). Dallas offers a fashion week, four days of fashion shows (Williamson 2007b), and Scene 👕, a juried temporary exhibit show, featuring bridge and design apparel and accessories (Dallas Market Center 2007).

Retail customers often shop temporary exhibits, between appointments. According to Liz Riley, retail customers often allocate a small percentage of open-to-buy to purchase new apparel and accessory product lines. This is because temporary space often features new companies, which is appealing to many retail customers. Temporary exhibits are attractive booth displays filled with rolling racks and shelves of sample garments. Stopping at booths, retail buyers scrutinize product lines. Retail customers will quickly disregard a product line when they know the company has inconsistent product quality or delivers late (Tucker 2007). Often, there is a crowded booth, and a retail customer's natural reaction is to think that the line must be interesting. A sales representative typically asks about the retail customer's store and its consumers, and shows them appropriate pieces. New retail customers may be bewildered when a sales representative asks them questions with unfamiliar acronyms, such as

"Shall I HFC this for you?" Befuddled, these new customers may walk away thinking, "What is HFC?" They soon realize the usefulness of guides such as the California Market Center's New Buyer's Kit, which defines industry sales terms. Sydney Blanton, owner of Amelie, commented that trust is the most important criterion for repeat business:*

> Trust is the most important asset that a person can have. If a person breaks my trust, he/she loses my business; it's that simple. A short time back, I bought purses from a designer who had terrific styles. They were expensive, but I felt they were worth the price. The designer's inspiration was unique, and it came from her extensive travel. I was excited to get the purses into the store. However, she lost my trust. She shipped late and a couple weeks after I had the purses in the store, I learned that she shipped to Nordstrom, and they were retailing for $80.00 less. I never bought anything from her again.

By the end of the day, a retail customer is tired from walking all day, from the pressure of numerous 20-minute appointments, and the blur of the hundreds of garments seen. Yet, the buyer's day is still not finished because it is common for key resources (i.e., a primary supplier) to host a dinner or for the buyer to attend a market center party.

Online Sales

Start-up design entrepreneurs may find it difficult to finance a booth at a tradeshow or to have a permanent showroom in a mart. An alternative is a **virtual showroom,** which is a Web page host that supports the sales of wholesale product lines. Although companies can have their own Web pages, it is sometimes difficult for retail customers to learn about new product lines. A virtual showroom is a Web page with permanent showroom description, feature images, and showroom contact (McAllister 2003). Some virtual showrooms include AmericasMart® Atlanta Virtual Storefront 👕, Apparel Link 👕, Showroom Access 👕, and 7thOnline's eSHOWROOM 👕. Some virtual showrooms offer additional services to design entrepreneurs. For instance, Apparel Link has business forms such as electronic line sheets, purchase orders, and new account qualifiers that design entrepreneurs can use.

SUMMARY

We have reached the end and the beginning. Once apparel associates present the product line at sales meetings and wholesale markets, they reach the end of the design phase. Apparel companies will then start preproduction. Preproduction requires extensive planning and involves putting together technical packages; receiving production fabric, trims, and findings; creating production patterns and samples; and planning production. As Ron commented in our Rare Designs story, "Now, I have a lot of work to do. We need to get all these orders into production!"

*Reprinted with permission from Sydney Blanton, owner, Amelie, Claremont, CA; pers. comm., May 1, 2006.

COMPANY PROJECT 12
ASSUMING THE ROLE OF A SALES REPRESENTATIVE
AND RETAIL CUSTOMER

Goal

The final step to your company project is to sell your product line. The goal of this project is to present your product line to retail customers. You assume two roles: one as a manufacturer's sales representative selling your product line and the other as a storeowner who buys product for a small store.

Preparation

Your instructor provides a brief description of your role as a retail customer in which there are multiple retail customer descriptions for class members. You may be a small storeowner or a buyer for a large store. An example is "You are a store owner for a boutique in Newport Beach. You cater to women who are married to CEOs. Your target consumers enjoy socializing, going to fundraising events, and to the country club. You want to provide clothing and accessories in your boutique that best match your target consumers' activities."

Step 1 Participation in a Tradeshow

- Divide the class in half so that half acts as manufacturer representatives and half acts as retail buyers. Swap after a designated time (e.g., 20 minutes).
- As a manufacturer representative, present your *product line* to prospective retail buyers. Your conversation includes an explanation of theme, core, reorderable, and new garments. Explain your minimums and delivery dates.
- As a prospective retail buyer, you *work the market* by visiting those representatives from whom you are most interested in purchasing, but you also shop the entire tradeshow. Fill out a worksheet using Table 13.1 as a guide and ask questions on delivery date, style description, colors, size scale, and minimums.

Step 2 Open to Buy

- Fill out the Excel spreadsheet as shown in Table 13.1. Row 2 shows an example of the information to put into the worksheet. You need to write in the delivery date, company name, style description, SKU, color minimums, wholesale price, and retail price. A built-in Excel formula multiplies the quantity by wholesale price and quantity by retail price.
- Your goal is to buy a balanced merchandise mix with deliveries that follow each other. You want to buy the entire amount, but you do not want to spend more than your budget ($25,000 at retail).

Step 3 Justification

1. Type a description of your store. Describe why the products purchased create a good merchandise mix for your store.

Table 15.1 Cumulative purchase orders (Open-to-Buy is $25,000 at retail)

Organize by delivery date

Retail buyer name:

Delivery Date	Company or Product Line	Style Description	SKU	Color	Size scale	Total Minimums or quantity	Wholesale Price	Planned Retail Price	Sub total by delivery	Retail Total
9/1/07	Rare Designs	Kate, knit top	RDWT1001	Rose	S, M, L	10	$ 25 00	$ 49 00	$ 250 00	$ 490 00
									$ —	$ —
									$ —	$ —
									$ —	$ —
									$ —	$ —
									$ —	$ —
									$ —	$ —
									$ —	$ —
									$ —	$ —
									$ —	$ —
									$ —	$ —
Total for delivery 1									$ —	$ —
									$ —	$ —
									$ —	$ —
									$ —	$ —
									$ —	$ —
									$ —	$ —
									$ —	$ —
									$ —	$ —
									$ —	$ —
									$ —	$ —
									$ —	$ —
									$ —	$ —
Total for delivery 2									$ —	$ —
Total all deliveries									$ —	$ —

PRODUCT DEVELOPMENT TEAM MEMBERS

Factory Outlet Manager: This individual works with the vice president of marketing, during product development, to determine the factory outlet merchandise strategy. They determine how to use excess raw materials and overstock garment styles to sell in outlet stores and to off-priced retailers.

Line supervisors: Individuals directly responsible for cutting, sewing, or packaging operators.

Production manager: Individual who oversees garment manufacture. If the company produces in-house, the product manager supervises production planners, preproduction, and production line supervisors; negotiates customer orders; and is responsible for distribution. Apparel companies that manufacture product globally use the title of operations manager. Operations managers that produce globally coordinate the supply chain from production planning, logistics, and transportation to all international legal business transactions.

Quality Assurance (QA) Manager: During product development, this individual oversees quality assurance testing of raw materials and testing raw materials from new textile vendors.

Sales representative: Individual responsible for selling the product line to retail customers. The sales representative may be independent (i.e., not direct company employees) or manufacture representatives (i.e., company employees). They typically have a territory and sell product in market centers and at tradeshows.

Vice president of marketing: An individual that oversees all retail: online, direct; and accounts. He or she manages customer service, marketing, sales, retail merchandise associates, and Internet services. This individual pays close attention to current retail business trends and how they will affect the company.

KEY TERMS

Brings to the table: A colloquial term that means a person conveys apparel industry associates' opinions to internal company associates.

Charge-back: A monetary fine from a retail customer to an apparel manufacturer for late shipment, markdown merchandise, inventory discrepancies, or packaging and shipment violations.

Chase it up: A colloquial phrase that means to place additional manufacturing orders for strong-selling styles during the season.

Collateral pieces: Promotional pieces that get the product name and image in front of the retail customers.

Corporate showroom: An exclusive showroom that offers an apparel manufacturer's brands.

Disposing of additional: Phrase meaning that an apparel manufacturer sells merchandise at reduced values either in company-owned factory outlets or to discount mass merchandisers.

Fashion week: The presentation of influential and new apparel designers' seasonal product lines.

Immediates: A term referring to merchandise that is ready for shipment.

Line sheet: A form submitted by design or merchandising that starts the preproduction process for support services.

Majors: A colloquial term for shows that target department stores or large national chains and require buyers to meet high manufacturer minimums.

Manufacturing styles: The total quantity of an item produced.

Markdown merchandise: A product that comes into a retail store at full retail. The retail customer then discounts it according to its policy.

Market accessibility: The hours of market center operation and ease in which a retail customer can find both new and established sources.

Market center: Permanent showrooms or temporary exhibitor space in which sales representatives offer wholesale product lines to retail customers.

Minimums: The smallest quantity of either styles or dollars required by the manufacturer.

Multi-line showroom: An independent showroom that has a business contract with two or more manufacturers to represent similar product lines.

Promotional merchandise: Merchandise that comes into a store at a sale price. It is often advertised as special purchase or valued at a stated dollar amount.

Nonstandard operation: Any assembly that the company or its contractors have not previously sewn, or one that increases costs.

Sales meeting: Also called the "line freeze." A meeting at which marketing, design, and merchandising associates communicate seasonal product direction to product development, preproduction, and production associates.

Sample production review: an evaluation of a garment sewing operations and potential quality problems.

Selling style: One prototype in multiple colors and sizes, with a specific delivery date.

Send-out: A garment that has a special operation (e.g., embroidery, screen print, appliqué) that the manufacturer sends to a contractor. The contractor returns it for sewing and finishing.

Sewing operations: The number of different machines and the sequence in which they are used to produce garments.

Standard operation: An operation that an apparel company commonly uses in its garments.

Taking numbers: A colloquial phrase meaning that retail customers write down style descriptions, delivery dates, wholesale prices, size range, and minimums that they consider purchasing.

Tradeshows: Events in which corporate and independent sales representatives offer their upcoming seasonal product lines to retail customers.

Virtual showroom: A Web page host that supports the sales of product lines.

Working the market: A colloquial phrase that means that a retail customer pre-plans a market trip to arrange the order of appointments, budget time, and maximize efficiency.

WEB LINKS ▬▬▬▬▬▬▬▬▬▬▬▬

Company	URL
Accessorie Circuit	http://enkshows.com
Accessories Council	www.accessoriescouncil.org/
Accessories The Show	www.accessoriestheshow.com
Advanstar Communications	http://web.advanstar.com/advanstar/v42/ index.cvn?ID=10001
Amelie	www.shopamelie.com/productcart/ pc/mainIndex.asp
AmericasMart® Atlanta	www.americasmart.com/markets/
AmericasMart® Atlanta Virtual Storefront: Apparel	www.americasmart.com/buyers/exhibitor_ dir/virtual_storefronts/apparel/
Apparel Link	www.apparellink.com
Brighte show	http://enkshows.com/brighte/
California Market Center	www.californiamarketcenter.com
California Market Center's New Buyer's Kit	www.californiamarketcenter.com
Children's Club	http://enkshows.com/childrensclub/
Christopher Deane	www.christopherdeane.com
Collective	http://enkshows.com/collective/
Cooper Design Space	www.cooperdesignspace.com
Coterie	http://enkshows.com/coterie/
Designers & Agents	www.designersandagents.com/english/main.html
ENK International Trade Events	www.enkshows.com
Fashion Avenue Market Expo (FAME)	www.fameshows.com/
Fashion Calendar	www.fashioncalendar.net/
Gerry Building	www.gerrybuilding.com
Infomat Calendar	www.infomat.com/calendar/index.html
Javits Center	www.javitscenter.com/events/default.asp
Lingerie Americas	www.lingerie-americas.com
Marshall's	www.marshallsonline.com
Mercedes Benz Fashion Week	www.mercedesbenzfashionweek.com
Merchandise Mart	www.merchandisemart.com/mmart/
Michael Kors	www.michaelkors.com
Moda Manhattan	www.modamanhattan.com
New Mart	www.newmart.net/Thenewm.htm
Nouveau Collective	www.nouveaucollectivetradeshows.com
7ᵗʰOnline's eSHOWROOM	www.7thonline.com
Scene	www.dallasmarketcenter.com/dmc/V40/ index.cvn?ID=10219
Show Piers on the Hudson	www.showpiers.com
Showroom Access	www.showroomaccess.com
Straight Down Clothing Company	www.straightdown.com
StyleMax	www.merchandisemart.com/stylemax/
Sue Wong	www.suewong.com
Superba Inc.	www.superbainc.com/default.asp
T.J. Maxx	www.tjmaxx.com/index.asp
The Daily Front Row	www.fashionweekdaily.com
To the Max	www.tothemaxusa.com
12th Street by Cynthia Vincent	www.cynthiavincent.net/

Wire Image: Fashion	www.wireimage.com/EventListings.aspx?cl=2&ci=13
Women's Wear Daily	www.wwd.com
World Shoe Organization	www.wsashow.com

REFERENCES

Bond, P. 2007. New looks: Americasmart expands its showrooms offerings. *Women's Wear Daily*, March 29.

Brown, P., and J. Rice. 2001. *Ready-to-wear apparel analysis*. 3rd ed. Upper Saddle River, NJ: Prentice Hall.

California Market Center. n.d. New buyer's kit. www. californiamarketcenter. com/pdfs/ new% 20buyer.pdf.

Cottrill, K. 2006. Supply chain experts get their say on product design. *Harvard Business Review Supply Chain Strategy Online*. Reprint No. P0602A (February). Boston: Harvard Business School Publishing. WilsonWeb.

Dallas Market Center 2007, August 30, apparel market attracts new buyers and more product. Press release. http://www.dallasmarketcenter.com/dmc/V40/press.cvn?id=11&p_id=210 (Accessed July 2, 2007).

Daswani, K. 2007. Marked difference; A new showroom offers sales and assistance to emerging designers. *Women's Wear Daily*. Vol 193, Iss 111, p 20B.

Earnest, L. 2007. "The dress is back – with a new attitude." Los Angeles Times. June 30. http://www.latimes.com/business/la-fi-dresses30jun30,1,108106.story?ctrack=1&cset=truesection=fea&feature+30004.

Figueroa, C., C. M. Chensvold, and R. McAllister. 2003. Cautious buying at crowded L.A. market week. *California Apparel News* (November 7–13): 1, 3, 11, 21.

Florida, R., and J. Goodnight. 2005. Managing for creativity. *Harvard Business Review* 83 (7), 124–31.

Fodor's. 2007a. Milan, Lombardy & the Lakes: Shopping overview. http://www.fodors.com/miniguides/mgresults.cfm?destination=milan@103&cur_.

Fodor's. 2007b. Paris: Shopping overview. http://www.fodors.com/miniguides/mgresults.cfm?destination=paris@117.

Haber, H. 2007. Retailers are in a buying mood at Dallas market. *Women's Wear Daily*, February 7, Vol. 193, Iss. 29, p. 36.

Hirano, K. 2007. International presence grows at Japan fashion week. *Women's Wear Daily*, April 4, Vol 193, Iss. 71, p. 17. ProQuest.

IMG Press Room. 2007, January 22. IMG announces Fashionweeklive presented by Sephora in Chicago, Houston, Dallas, and San Francisco. Press release.

Kyser, J. 2007. *Manufacturing in southern California*. Los Angeles: Los Angeles County Economic Development Corporation, Economic Information & Research Department. http://www.laedc.org/reports/index.html.

Kyser, J., and G. Huang. 2003, December. *The Los Angeles area fashion industry profile*. Los Angeles: Los Angeles County Economic Development Corporation, Economic Information & Research Department. http://www.laedc.org/reports/index.html.

Lal, R., and A. Han. 2005. Overview of the Japanese apparel market. *Harvard Business Review*. Reprint #9-505-068 (June 14). Boston: Harvard Business School Publishing.

MAGIC. 2007, February 28. MAGIC puts fashion industry in motion. Press release. http://show.magiconline.com/magic/v42/press.cvn?id=11&p_id=102&associationID=0&PrintFR=true (accessed July 2, 2007).

McAllister, R. 2003. Apparel link connects manufacturers, retail customers with e-showrooms. *California Apparel News* (November 7–13): 10.

McAllister, R. 2004a. CMC's new look for the *new* misses. *California Apparel News* (January 2): 9–15.

McAllister, R. 2004b. CMC to open *street couture* section. *California Apparel News* (January 16–22): 2.

Musselman, F. 2007. Open to buy; Retailers dish about what makes showrooms inviting or not. *Women's Wear Daily*, May 24.

Nieder, A. A. 2004. Menswear new concept: Contemporary. *California Apparel News* (January 30–February 5): 1, 3, 5.

Poggi, J. 2007. Retail experts expect more consumers to tune into fashion weeks. *Women's Wear Daily*, February 5. Vol. 193, Iss. 27, p 34. ProQuest.

Regan, C. 1997. A concurrent engineering framework for apparel manufacture. PhD diss., Virginia Polytechnic Institute and State University.

Regan, C., D. Kincade, and G. Sheldon. 1998. Applicability of the engineering design process theory in the apparel design process. *Clothing and Textile Research Journal* 16 (1): 36-46.

StyleMax. n.d. Press, 2006 April Fact Sheet. http://mmart.com/stylemax/springpreview/press/press_room. asp (accessed July 2, 2007)

Tarrant apparel breaks up with another licensor. 2006, August 2. *California Apparel News* 62 (35): 18–24.

Tucker, R. 2007. Buyers narrow focus. *Women's Wear Daily*. January 25. Vol 193, Iss. 18 p. 12. ProQuest.

U.S. Securities and Exchange Commission. 2006. September 28. Form 10-K: *Annual report ended July 29, 2006, Neiman Marcus, Inc*. Washington, DC: U.S. Government Printing Office. http://www.sec.gov/Archives/edgar/data/1358651/000110465906063514/0001104659-06-063514-index.htm.

Wikipedia Contributors. n.d. Reverse Auction. http://en.wikipedia.org/wiki/Reverse_auction (Accessed July 25, 2007).

Wikipedia Contributors. n.d. Reverse Auction. http://en.wikipedia.org/wiki/Reverse_auction (Accessed July 25, 2007).

Williamson, R. 2007a. Alternative investments; FashionCenterDallas makes the most of its accessories offerings. *Women's Wear Daily*, May 17.

Williamson, R. 2007b. Dallas market center unveils fashion week. *Women's Wear Daily*, March 28. Vol. 193, Iss. 66, p 19. ProQuest.

Wilson, B. 2007. Strong sales at Chicago's StyleMax. *Women's Wear Daily*, April 9, Vol. 193, Iss. 75, p. 16. ProQuest.

Zargani, L. 2007. Milan fashion week to show over 5 days. *Women's Wear Daily*, January 30. Vol 193 Iss. 21 p. 2. ProQuest.

Epilogue

Apparel Product Design and Merchandising Strategies illustrated that apparel product development is a complicated, yet exciting process. Chapter 1 gave a concise definition of the apparel product development process, which you may not have fully understood when beginning the study of this book. Let's return to the apparel product development definition to summarize its parts. Apparel product development is

> *The use of company strategy to generate design concepts that are developed from a simple idea to a more complex stage to produce a salable apparel product. This process involves the organization and coordination of people, machines, and processes.*

The first part of this definition states the "use of company strategy." Chapters 2 and 3 discussed how companies develop a vision and mission to guide their business. From the vision and mission, company associates develop a product line strategy for each SBU, which commonly occurs during strategic planning. The next part of the definition—"to generate design concepts"—involves first understanding an apparel company's retail customer and consumer, which was the focus of Chapter 3. From this understanding, designers start the inspiration process to create design concepts for an upcoming seasonal product line. Chapters 5, 6, and 7 described the resources that designers use for inspiration. Beginning with a "simple idea" (next part of the definition), the design team goes through development; thus "a more complex stage." This complex stage starts with using apparel cluster resources and selecting textile and trim vendors, as discussed in Chapter 8. The complexity lies in the launching of textile product development in which textile vendors and the design team create ideas, and submit and develop colors, fabrics, and trims, which Chapters 9 and 10 explained. Apparel companies use a time-and-action calendar—introduced in Chapter 4 and continued to the end of the book—for the "organization and coordination of people, machines, and processes." The book concluded by pulling everything together, which the industry refers to as *merchandising the product line.* Apparel industry associates, like you, hope that after many weeks of hard work, the product line will sell at fashion weeks, market centers, and/or tradeshows.

Photo Credits

Chapter 2

Figure 2.2: Images.com; Figure 2.4a: Rob Crandall/Stock Boston; Figure 2.4b: Sergio Piumatti; Figure 2.5: Churchill & Klehr Photography.

Chapter 3

Figure 3.3a: PhotoEdit Inc. ; Figure 3.3b: Romilly Lockyer/ Getty Images Inc.–Image Bank; Figure 3.5: AP Wide World Photos; Figure 3.6 (left): © Tim Mosenfelder/CORBIS; Figure 3.6 (right): © S.I.N. / Corbis; Figure 3.9a: Philip Gatward © Dorling Kindersley; Figure 3.9b: David Young-Wolff/ PhotoEdit Inc.; Figure 3.9c: M. Timothy O Keefe/ Omni–Photo Communications, Inc.

Chapter 4

Figure 4.2: Barry Rosenthal/ Getty Images, Inc. – Taxi.

Chapter 5

Figure 5.1: David de Lossy, Ghislain & Marie/ Getty Images Inc.–Image Bank; Figure 5.3a: Keren Su/ Getty Images, Inc.–Taxi.

Chapter 6

Figure 6.2a: Dorling Kindersley Media Library; Figure 6.6 (bottom left): Laurie Campbell/ Getty Images Inc.–Stone Allstock; Figure 6.6 (bottom right): Lynn M. Stone/ Nature Picture Library; Figure 6.6 (top left): © Dorling Kindersley; Figure 6.7: Steve Gorton © Dorling Kindersley, Courtesy of Next.

Chapter 7

Figure 7.5: Getty Images Inc.–Hulton Archive Photos; Figure 7.12a: John Heseltine © Dorling Kindersley; Figure 7.14: Getty Images Inc.–Hulton Archive Photos.

Chapter 9

Figure 9.5: © Lowell Georgia/CORBIS; Figure 9.7: Cary Wolinsky/ Aurora & Quanta Productions Inc

Chapter 10

Figure 10.1: Lockyer, Romilly/ Getty Images Inc.–Image Bank; Figure 10.14: Aurora & Quanta Productions Inc.

Chapter 11

Figure 11.7: Lockyer, Romilly/ Getty Images Inc.–Image Bank

Chapter 12

Figure 12.2a: Claude Monet (1840–1926), "Bathers at La Grenouillere," 1859. Oil on canvas, 28 1/2 in. × 35 7/8 in. National Gallery, London. Copyright Art Resource, NY; Figure 12.2b: Corbis/Bettmann; Figure 12.2c: Tony Souter © Dorling Kindersley; Figure 12.2e: Farrell Grehan/National Geographic Image Collection

Chapter 13

Figure 13.5: Jeff Greenberg/ PhotoEdit Inc.; CORBIS Zefa Collection.

Index